GREAT EVENTS
FROM
HISTORY II

GREAT EVENTS FROM HISTORY II

Business and Commerce
Series

Volume 1
1897-1923

Edited by
FRANK N. MAGILL

SALEM PRESS
Pasadena, California Englewood Cliffs, New Jersey

Library of Congress Cataloging-in-Publication Data
Great events from history II. Business and commerce
series / edited by Frank N. Magill.
 p. cm.
Includes bibliographical references and index.
 1. Economic history—20th century—Chronology.
2. Business—History—20th century—Chronology.
3. Commerce—History—20th century—Chronology.
I. Magill, Frank Northen, 1907- . II. Title: Great
events from history 2. Business and commerce series.
III. Title: Business and commerce series.
HC55.G68 1994
330.9—dc20
ISBN 0-89356-813-9 (set) 94-27299
ISBN 0-89356-814-7 (volume 1) CIP

PRINTED IN THE UNITED STATES OF AMERICA

PUBLISHER'S NOTE

Great Events from History II: Business and Commerce Series is the fourth set in the *Great Events from History II* series in the Magill family of reference books. This new series was inaugurated by *Great Events from History II: Science and Technology Series* (1991) and continued with *Great Events from History II: Human Rights Series* (1992) and *Great Events from History II: Arts and Culture Series* (1993). The current series supplements the original twelve-volume series *Great Events from History: Ancient and Medieval* (three volumes, 1972), *Modern European* (three volumes, 1973), *American* (three volumes, 1975), and *Worldwide Twentieth Century* (three volumes, 1980). Combined, the volumes in the *Great Events* series survey the major historical events throughout the world from 4000 B.C.E. to the 1990's.

The current five volumes of *Great Events from History II: Business and Commerce* address the major developments in the worldwide evolution of business and commerce in the twentieth century. The history of business and commerce provides a unique perspective on history as a whole, showing how economic life progressed and describing the forces that shaped it. Description of these business events illustrates the many linkages among politics, culture, technology, and all the other elements of history. Like the original *Great Events*, the articles in *Great Events from History II: Business and Commerce* are arranged chronologically by date of event, beginning in 1897 with the first publication of the Dow Jones Industrial Average and ending in 1994 with the effective date of the North American Free Trade Agreement. A broad range of topics is addressed. Business is defined broadly to include any activity concerned with the production of goods or with the rendering of financial or other services. Commerce involves the exchange of commodities or services. The stages of these activities can be seen as a cycle, from the creation of a product or service (including its conception, design, and manufacture); through marketing, distribution, and sales; and back to investment in the product's creation, expansion of the business that produced it, or genesis of a new business or product. Within this cycle are the daily concerns of business practice: The business enterprise must be organized and have sufficient financing to survive until it receives sales revenues. It must be managed according to some plan, and labor must be employed. The product or service must be made known to the public through advertising and made available through a distribution system. Accounts must be kept of the revenues that derive from sales, taxes must be paid, and laws and regulations must be satisfied. The outcomes of these activities, in turn, influence managers' decisions regarding investment, research and development, and the future of the enterprise. Business and commerce may furthermore refer to activity on a scale from individual enterprises to the economic transactions of nations.

Significant twentieth century events in the evolution of all these aspects of business and commerce are described in 374 articles, arranged chronologically in five volumes. Eleven articles discuss advertising; twenty discuss the business practices of firms and individuals (including criminal practices); eighteen discuss consumer affairs and

business activities related to consumerism; thirty-two relate events touching on finance and financial operations, including banking systems; twenty-six concern the foundings and dissolutions of businesses, both individually and in groups; sixty-four focus on how government has interacted with the business community through various laws, government-operated businesses, and agencies; thirty-five discuss international business and commerce, both at the level of the firm and in relation to governmental actions that affect the business of entire countries; forty-one discuss aspects of labor, including contracts, strikes, and labor law; thirteen focus on management; seven discuss manufacturing; fifteen concern marketing; twelve describe important mergers and acquisitions or events that changed how such deals were accomplished; twenty discuss monopolies and cartels, describing major business combinations and the law related to them; thirty-six describe new products and how they affected the conduct of business and commerce; eight describe innovations in retailing; and sixteen discuss changes in transportation.

The articles in this series run somewhat longer (2,500 words) than the entries in the original *Great Events* set, allowing for more in-depth coverage of events that may have years of background and many areas of long-range significance. The format of these essays, while retaining the basic outline of the articles in the original series, has been revised somewhat to reflect the needs of the new subject orientation.

Each article still begins with ready-reference top matter listing the *category* of the event discussed, from advertising to transportation; the *time* the event occurred; the *locale* where it occurred; a brief *summary* of the event's significance in the history of business and commerce; and descriptions of *principal personages* who were key players in the event. The text of each article follows and is divided into two subsections: *Summary of Event* describes the event itself and the circumstances leading up to it, and *Impact of Event* (a feature not appearing in the original *Great Events* series) analyzes the influence of the event on the evolution of business practice and/or a major industry in both the short and long terms. There follows a select *Bibliography*, which lists publications to consult for further information, accompanied by annotations indicating the focus and usefulness of each source, chosen for relevance to the topic in question and accessibility through most libraries. Finally, each article ends with a listing, headed *Cross-References*, of the other articles in this set of books that may be of particular interest.

Special features of the set include six indexes: the Chronological List of Events, giving the titles of all articles in the set, by volume, in the date order in which they appear; the Alphabetical List of Events, which organizes the articles in the order of their titles, alphabetically; the Subject / Key Word Index, listing topics by key terms appearing in their titles and by main topics or areas of concern, where appropriate, to allow multiple means of access to the events; the Category Index, in which the articles are arranged by their major subcategories in the realm of Business or Commerce (such as advertising, management, or international business and commerce); the Geographical Index, identifying events by the country or region in which they occurred; and finally an index of Principal Personages, listing the names of all Principal Personages

identified in the top matter of the articles and the page numbers on which those personages will be found. At the end of every volume, the first index, the Chronological List of Events, appears for the reader who requires quick access to the set's contents. In all these useful indexes, both the relevant volume number and the page number appear.

All articles are written by experts in the various fields of business and economics, the vast majority of whom are academicians in these fields. *Great Events from History II: Business and Commerce Series* lists the full names of the scholars who wrote these articles, both at the end of the article and in a listing of Contributors that follows this Publisher's Note. We gratefully acknowledge their participation in this project and thank them for making their expert knowledge accessible to the general reader.

CONTRIBUTING REVIEWERS

George P. Antone
Appalachian State University

Kamala Arogyaswamy
University of South Dakota

Christina Ashton
Independent Scholar

Sue Bailey
Tennessee Technological University

Siva K. Balasubramanian
Southern Illinois University at Carbondale

Richard Barrett
Elmira College

Jonathan Bean
Ohio State University

Bruce Andre Beaubouef
University of Houston

Jack Blicksilver
Georgia State University

John Braeman
University of Nebraska, Lincoln

Anthony D. Branch
Golden Gate University

Carmi Brandis
Independent Scholar

Patrick Bridgemon
Independent Scholar

John Britton
Francis Marion University

Brenda Carlyle
St. Mary-of-the-Woods College

Jon R. Carpenter
University of South Dakota

Brian J. Carroll
California Baptist College

Fred V. Carstensen
University of Connecticut

Gilbert T. Cave
Lakeland Community College

Elisabeth A. Cawthon
University of Texas at Arlington

John Dennis Chasse
State University of New York College at Brockport

Charlotte Crystal
Independent Scholar

LouAnn Faris Culley
Kansas State University

Edward J. Davies II
University of Utah

Jennifer Davis
Independent Scholar

Bill Delaney
Independent Scholar

Robert R. Ebert
Baldwin-Wallace College

Satch Ejike
Independent Scholar

Eric Elder
Northwestern College

Corinne Elliott
Independent Scholar

Loring D. Emery
Independent Scholar

Chiarella Esposito
University of Mississippi

Daniel C. Falkowski
Canisius College

John L. Farbo
University of Idaho

Mohammad O. Farooq
Iowa Wesleyan College

James Feast
Baruch College of the City University of New York

Dale L. Flesher
University of Mississippi

John C. Foltz
University of Idaho

Andrew M. Forman
Hofstra University

Susan Frischer
Independent Scholar

Joan D. Gailey
Kent State University

Eugene Garaventa
College of Staten Island of the City University of New York

Elizabeth Gaydou
Jordan College

Richard Goedde
St. Olaf College

Nancy M. Gordon
Independent Scholar

William L. Hagerman
University of Southwestern Louisiana

Sam Ramsey Hakim
University of Nebraska

Mark D. Hanna
Miami University

Baban Hasnat
State University of New York College at Brockport

Sarah Holmes
University of Connecticut

Frederick B. Hoyt
Illinois Wesleyan University

Marsha M. Huber
Otterbein College

Alan C. Iannacito
Independent Scholar

Julapa Jagtiani
Syracuse University

Jeffry M. Jensen
Independent Scholar

Rajiv Kalra
Moorhead State University

Dan Kennedy
Independent Scholar

Benjamin J. Klebaner
City College of the City University of New York

Douglas Knerr
University of Cincinnati

Theodore P. Kovaleff
Center for Study of The Presidency

Sumner J. La Croix
University of Hawaii

Mitchell Langbert
Clarkson University

Victor J. LaPorte, Jr.
University of Central Florida

GREAT EVENTS FROM HISTORY II

Eugene Larson
Pierce College

Martin J. Lecker
Rockland Community College

Daniel Y. Lee
Shippensburg University

Jim Lee
Fort Hays State University

Jose C. de Leon
Society for Technical Communication

Ralph W. Lindeman
Kent State University

Guoli Liu
College of Charleston

Sandra G. Loeb
University of South Dakota

David C. Lukowitz
Hamline University

Robert G. Lynch
University of Dallas

Robert McClenaghan
Independent Scholar

Marie McKendall
Grand Valley State University

Paul Madden
Hardin-Simmons University

Anne Magnuson
Independent Scholar

Lewis Mandell
University of Connecticut

Gregory P. Marchildon
Johns Hopkins University

S.A. Marino
Westchester Community College

Christopher T. Mark, Jr.
Independent Scholar

James D. Matthews
Lynn University

Patricia C. Matthews
Mount Union College

Andre Millard
University of Alabama at Birmingham

Robert A. Nagy
University of Wisconsin— Green Bay

Jay Nathan
St. John's University

William T. Neese
University of Arkansas at Little Rock

Anthony Patrick O'Brien
Lehigh University

John F. O'Connell
College of the Holy Cross

Lisa Paddock
Independent Scholar

Anita B. Pasmantier
Seton Hall University

Virginia Ann Paulins
Ohio University

Steven K. Paulson
University of North Florida

Iris A. Pirozzoli
University of Wisconsin

Nancy J. Rabolt
San Francisco State University

Srinivasan Ragothaman
University of South Dakota

Nim M. Razook, Jr.
University of Oklahoma

Patrick D. Reagan
Tennessee Technological University

Betty Richardson
Southern Illinois University at Edwardsville

John Richardson
Pepperdine University

Kirsten M. Rosacker
University of South Dakota

Robert E. Rosacker
University of South Dakota

Joseph R. Rudolph, Jr.
Towson State University

Jack M. Ruhl
Western Michigan University

Larry Schweikart
University of Dayton

Arthur G. Sharp
Independent Scholar

Elaine Sherman
Hofstra University

Paul A. Shoemaker
University of Nebraska, Lincoln

A. J. Sobczak
Independent Scholar

Robert Sobel
Hofstra University

Paul G. Spitzer
The Boeing Company

Alene Staley
Saint Joseph's College

Timothy E. Sullivan
Towson State University

Kambiz Tabibzadeh
Eastern Kentucky University

John R. Tate
New Jersey Institute of Technology
Montclair State College

Randal Joy Thompson
Independent Scholar

Alecia C. Townsend
University of Redlands

Paul B. Trescott
Southern Illinois University

George S. Vascik
Miami University

Sharon C. Wagner
Missouri Western State College

M. Mark Walker
University of Mississippi

William J. Wallace
Monmouth College

Theodore O. Wallin
Syracuse University

William C. Ward, III
Kent State University

Timothy R. Whisler
Saint Francis College

Jot Yau
George Mason University

Rassoul Yazdipour
California State University, Fresno

Clifton K. Yearley
State University of New York— Buffalo

Charles Zelden
University of Texas at Arlington

VOLUME I

GREAT EVENTS
FROM
HISTORY II

THE WALL STREET JOURNAL PRINTS THE DOW JONES INDUSTRIAL AVERAGE

Category of event: Finance
Time: 1897
Locale: New York, New York

Dow, Jones and Company began publishing its Dow Jones Industrial Average, a measure of the stock prices of important industrial companies, in The Wall Street Journal

Principal personages:
CHARLES HENRY DOW (1851-1902), a financial analyst and reporter
EDWARD DAVIS JONES (1856-1920), a reporter and businessperson
CHARLES MILFORD BERGSTRESSER (b. 1858?), a partner in Dow, Jones and Company

Summary of Event

Charles Dow, a financial analyst, thought it important that members of the financial community have access to a summary measure of prices on the New York Stock Exchange. He believed that such a measure would aid in predicting financial trends. As cofounder of Dow, Jones and Company (the comma was later dropped from the company name) and cofounder and editor of *The Wall Street Journal*, he was able to publish various indices and promote his own theories of the behavior of the stock market.

At its founding in 1882, Dow, Jones and Company was a news-gathering organization focused on and located in New York City. The company soon expanded its focus to include any major news that would affect the business community. Coverage of financial news certainly was not new; various publications had discussed the New York Stock Exchange (NYSE) and news connected with it since its founding in 1792. Soon after the founding of that stock market, James Oram began publishing *The Shipping and Commercial List and New York Prices Current*, stating the facts and news that affected shipping, finance, and commerce in the region. By 1825, this newspaper had been taken over by the *Journal of Commerce*, which was still being published in 1993. New York had established itself as the financial center of the young nation, and financial news was both created there and disseminated from there.

Early business reporting was filled with speculation and rumors. The few hard facts that were available were valuable to investors, and reporters were sometimes paid for delivering information in advance of publication or for holding back information. John J. Kiernan saw a need for speedy and accurate business reporting. He borrowed funds from family and friends and started the Kiernan News Agency, offering subscribers hand-delivered newsletters containing up-to-date information on all aspects of business. Charles Dow began working for the agency in 1880. Several months

later, Dow recommended Edward Jones to fill another reportorial position.

By 1882, Dow and Jones had struck out on their own, forming Dow, Jones and Company. The new enterprise had a total of six employees and was located at the back of a candy store. In 1883, the company began publishing *Customers' Afternoon Letter*, a daily newspaper of two pages. The workload soon became overwhelming, and the company added Charles Milford Bergstresser as a third partner, though his name was not added to the company's name.

By 1889, Dow, Jones and Company had a staff of about fifty, including its first out-of-town reporter, stationed in Boston. The partners realized that their two-page newspaper could not hold all the information that the company gathered; they reorganized the publication as *The Wall Street Journal* in that year. The paper stated that it aimed to give full and fair information regarding fluctuations in the prices of stocks, bonds, and some commodities and was intended to be a paper of news rather than of opinions. A policy statement further explained that the paper would "give a good deal of news not found in other publications, and will present . . . a faithful picture of the rapidly shifting panorama of the Street."

One of the main ideas developed by Dow and Jones was a composite list of major stocks and an index of their prices. Company publications began carrying lists as early as 1884. The Dow Jones Industrial Average (DJIA), one version of these lists, is generally recognized as having first been published in 1897. That first DJIA averaged the prices of twelve major companies. The list was expanded to twenty companies in 1916 and to thirty in 1928. The companies included have changed over time, reflecting mergers and dissolutions, but the DJIA is adjusted for such changes so that the index number has the same meaning, with no jumps in its value because of such changes.

Charles Dow thought that such an index would be useful as an indicator, or even predictor, of general trends in the market. He promoted the Dow theory of market behavior, which identified primary trends in stock prices and identified types of market fluctuations. Daily fluctuations in a market price index had no significance other than as part of a primary upward or downward trend, or as part of a reaction (a temporary reversal in an upward trend) or rally (a temporary reversal in a downward trend). In identifying primary trends, the theory looks for the market index to move outside (or "break out") of a set of upper and lower boundaries. The trend continues until a secondary movement confirms that it has ended, as when the bottom of a reaction falls below the level of the previous reaction or the peak of a rally rises above the peak of the previous rally.

Dow's theories found wide followings and were discussed in books by various market theoreticians. The Dow theory was first labeled as such in book form in Samuel Armstrong Nelson's *The ABC of Speculation* (1902). After Dow's death in 1902, William Peter Hamilton, who had worked under Dow, continued to promote the Dow theory. In 1922, his book titled *The Stock Market Barometer: A Study of Its Forecast Value Based on Charles H. Dow's Theory of the Price Movement* assessed how the Dow theory had performed since 1897. Robert Rhea later promoted the

theory, enlarging its scope to incorporate information on the number of shares traded daily. He emphasized, as had Dow, that the theory was designed as one tool to help read the marketplace, to be used in combination with other indicators and theories rather than on its own.

Jones sold out his share of Dow Jones and Company to his partners in 1899; they sold the company in 1902 to Clarence Barron. *The Wall Street Journal* continued as primarily a financial newspaper until 1941, when a new managing editor, Bernard Kilgore, broadened the paper's coverage to major news events and in-depth articles on business.

Impact of Event

The growth of Dow, Jones and Company, from a two-man organization to a corporation ranked in 1990 among the largest five hundred in the United States and the thousand largest in the world, involved expansion of the firm's basic business of providing news of the marketplace. Even though the company underwent changes of ownership and expanded its scope, provision of accurate, timely financial news remained an important part of the company. In a contemporary world filled with different stock markets and theories of them, the DJIA is the most recognizable index of market performance. News of movements in the DJIA is enough to affect prices in markets other than the NYSE, which is the only market measured by the DJIA.

The company is best known as publisher of *The Wall Street Journal*, which branched out into European and Asian editions. The firm's business publications division also produced *Barron's*, a respected business magazine, and the *National Business Employment Weekly*, among other publications. Business publications, however, accounted for less than half the company's revenues by 1989. Various information services, including the Dow Jones News/Retrieval on-line computer service and Telerate, an international supplier of up-to-the-minute market data, accounted for most of the remainder. In 1990, for the seventh year in a row, *Fortune* magazine ranked Dow Jones first in its industry for quality of products and services.

Other industrial nations have developed stock markets, and stock market indicators, of their own. The DJIA is unusual in being based on only thirty stocks, with adjustments made when an included company announces a stock split (changing the price of the stock) or when one company's stock is substituted for that of another, which becomes necessary when companies dissolve. The Japanese stock market is measured by the widely reported Nikkei index. Canada has several different stock markets. The Vancouver market concentrates on mining stocks, while the Toronto exchange closely resembles the NYSE. Even within the United States, several different indices and markets exist. The Standard and Poor's S&P 500 index, for example, measures the average price level of five hundred individual stocks, thus providing a broader base than does the DJIA. Regional markets such as the Pacific Stock Exchange and the Philadelphia Stock Exchange allow traders to work in cities other than New York, and specialized markets such as NASDAQ (National Association of Securities Dealers Automated Quotations) and the American Stock Exchange allow

national trading in stocks not carried on the NYSE. The advent of computerized trading has allowed investors to trade worldwide and around the clock, making the Dow Jones product of current, accurate information all the more important.

Stock traders have become increasingly sophisticated, using increasing numbers of tools and amounts of data to make their trading decisions. The Dow theory still forms the background for many theories, and many theories use movements in the DJIA as a predictor of stock market price changes. The NYSE has grown tremendously, making information concerning it meaningful to many more people. During the 1920's, perhaps five million shares would change hands on a busy day. By the 1990's, trading of two hundred million shares daily was common, and many more individuals had entered the market to buy small amounts of stock. Indicators of the markets assumed prominence and even became the subjects of trading. Markets developed for the combinations of stocks on which various indices were based; investors thus could place bets on which direction they thought the market as a whole would move. Advances in the level of the DJIA and other market indices offered data to support the theory that over the long term (depending on the precise period measured), the U.S. stock market usually offered a rate of return on investment higher than rates offered on most alternative investments.

The DJIA has attained stature, as have other stock market indices to a lesser degree, as a measure of overall economic activity, something for which it was not intended. Financial writers commonly make reference to the level of the DJIA when referring to future economic prospects or past performance. Although there is a link between stock prices and economic activity—stocks tend to be worth more when companies are profitable, which occurs when business activity is at a high level and unemployment rates are low—the link is far from perfect. The DJIA, however, has become recognized as an important measurement even by those who know almost nothing about financial markets.

Bibliography

Neilson, Winthrop, and Frances Neilson. *What's News: Dow Jones.* Radnor, Pa.: Chilton Book Company, 1973. Provides a history of *The Wall Street Journal* and the involvement of various individuals in its publication. Discusses content of the newspaper during different eras as well as describing innovations made by the paper.

Rosenberg, Jerry M. *Inside the Wall Street Journal.* New York: Macmillan, 1982. Gives the newspaper's history and describes its impact. Shows the evolution of the paper from a two-page newsletter through its ownership by Clarence Barron and beyond, discussing various advances and difficulties.

Seligman, Joel. *The Transformation of Wall Street.* New York: Houghton Mifflin, 1982. Describes the changes that have occurred since the advent of the Securities and Exchange Commission in the 1930's. More generally discusses the evolution of the financial markets on Wall Street.

Stillman, Richard J. *Dow Jones Industrial Average.* Homewood, Ill.: Dow Jones-

Irwin, 1986. A history, with pictures, of Dow, Jones and Company, focusing on the DJIA. Discusses how the DJIA is computed and describes the contributions of various people to its development and use.

Wendt, Lloyd. *The Wall Street Journal.* Chicago: Rand McNally, 1982. A history of the newspaper and those who headed it at different times. Good on the origins of the paper and its original publishers as well as on the transformation from a New York to a national publication.

Carmi Brandis

Cross-References

The U.S. Stock Market Crashes on Black Tuesday (1929), p. 574; The Securities Exchange Act Establishes the SEC (1934), p. 679; Insider Trading Scandals Mar the Emerging Junk Bond Market (1986), p. 1921; The Boston Celtics Sell Shares in the Team (1986), p. 1939; The U.S. Stock Market Crashes on 1987's "Black Monday" (1987), p. 1953.

CATALOG SHOPPING BY MAIL PROLIFERATES

Category of event: Retailing
Time: The early 1900's
Locale: The United States

Mail-order catalogs, introduced by Montgomery Ward and Sears, Roebuck and Company, changed consumption patterns and expectations of consumers in the United States

Principal personages:
AARON MONTGOMERY WARD (1843-1913), the founder of Montgomery Ward, the first company to offer a mail-order catalog
RICHARD W. SEARS (1863-1914), an entrepreneur who issued the first Sears, Roebuck and Company catalog and who founded the company
ALVAH C. ROEBUCK (1864-1948), a watchmaker hired by Richard W. Sears and later a partner in the mail-order venture that later became Sears, Roebuck and Company
JULIUS ROSENWALD (1862-1932), an investor who bought Roebuck's interest in Sears, Roebuck and Company, later running the company

Summary of Event

The Industrial Revolution in the United States, well under way by the end of the nineteenth century, enabled mass production of many products. Items ranging from apparel, jewelry, and dressing accessories to household furniture, kitchen tools, and appliances were manufactured in factories. Inventions abounded during this time of great technological development. Many products were touted as time savers, money savers, and health enhancers. Americans delighted in modern inventions and "store-bought" items. Ready-made apparel became increasingly available as the factory system developed. Although factories could produce huge quantities of goods, availability of new products and fashions to American consumers was limited by logistics of travel to stores and conservative inventory practices of general stores.

During the last decades of the nineteenth century, many residents of the United States lived in small rural communities. Rural Americans were eager to demonstrate to their friends and acquaintances that they were aware of the newest trends and could keep up with city dwellers in fashionable acquisitions. Small country stores, providing staple products and a limited number of "fashionable" items, served these consumers. Country general stores were often located many miles from their customers. People living in the rural United States during this time period had no efficient method of transportation. They could not leave their homes often to shop, as many were farmers who needed to tend to their duties at home. They often faced threats of inclement weather during the off-season, making travel risky. Farmers also commonly complained that their earnings did not allow them to pay the prices charged in traditional retail stores.

When the United States Post Office introduced postal money orders and rural free delivery in the late 1800's, the stage was set for mail-order catalog shopping. As a traveling salesman for a wholesale company, Aaron Montgomery Ward realized that rural consumers' needs for household and apparel products at reasonable prices could be filled through postal delivery. He was genuinely concerned for the mass of people rather than for the privileged few who could afford expensive goods. In 1872, Ward issued a one-page list of thirty items, selling at competitive prices, that could be delivered by mail to the purchaser. He bought directly from a wholesaler and sold directly to consumers, eliminating the overhead cost of a store building. He dealt only in cash, a practice that kept his business safe through the panic of 1873. In 1874, the business expanded to an eight-page catalog. The catalog was 150 pages long by 1876 and included illustrations of products.

Richard W. Sears worked for the Minneapolis and St. Louis Railroad and was a small-time merchant on the side. He delivered coal, lumber, food products, and watches. In 1886, a jewelry store refused shipment, because the freight charges had not been paid on some watches he had received from a wholesaler. Sears, in an effort to unburden himself of the watches, wrote letters describing the watches and offering them at bargain prices. This venture proved successful, and Sears continued in the watch business, selling via mail, under the name of the R. W. Sears Watch Company. In 1886, Sears issued a catalog that offered watches. He stood behind the watches he sold and eventually needed a repairman in his firm. He hired Alvah C. Roebuck, a watchmaker, in 1887. Sears sold his business in 1889, and after a brief period as a banker he returned to start business again, with Roebuck as a partner. Together they began a mail-order business, A. C. Roebuck & Company, selling watches and jewelry by mail. Sears had agreed to an anticompetition clause upon the sale of his original business and could not use the Sears name for three years. Later, the company became Sears, Roebuck and Company. By 1895, the company catalog was 507 pages, and Sears reported sales in excess of $750,000.

The range of products offered through these catalogs continually expanded as the business profited. An excellent assortment of goods, especially in comparison to the variety in local general stores, was offered through mail order. At one time Sears even offered automobiles in the catalog. Catalogs offered variety and convenience to customers and afforded them access to the latest fashions and inventions. People could now revel in the luxury of factory-made goods and shop in the comfort of their homes. The catalogs could even substitute for coveted fashion magazines, which previously had been passed from neighbor to neighbor. The catalogs truly catered to their customers, encouraging orders from new customers, reassuring customers about their purchases, and providing step-by-step instructions for ordering. Montgomery Ward promised his customers "satisfaction or your money back," and Sears guaranteed all of its products.

Montgomery Ward established a market niche by manufacturing some of its own products. Customers became accustomed to the quality and performance of specific products offered by the company and became loyal customers. Sears began offering

its own products as well and established its own customer base. Consumers became accustomed to the advantages of dealing with familiar, established companies. They began to rely on the latest issues of the catalogs to replenish their clothing needs, update their home furnishings, and supply themselves with the latest gadgets and appliances.

By the beginning of the twentieth century, the Sears, Roebuck and Company catalog contained several thousand pages and offered thousands of different products. The Ward catalog had grown to similar proportions. The catalogs were considered staples in modern households and were used as sources of reference for fashions as well as sources of access to goods. The "Wish Book," as the Sears catalog was known, was eagerly awaited by families each year. The catalogs became an expected annual arrival, and delivery of merchandise, while still anticipated with excitement, became commonplace in the early years of the twentieth century.

Impact of Event

The availability of mail-order catalogs had a major impact on consumer expectations. Rural consumers were no longer content to wait for rare trips to town to purchase goods. They expected to be able to browse through the "Wish Book" and the Montgomery Ward catalog to leisurely select new fashions and household furnishings.

As mail-order sales grew for Montgomery Ward and Sears, Roebuck and Company, a new market of consumers was tapped. At the beginning of the twentieth century, the concept of retail department stores was not fully developed, nor were such stores accessible to rural consumers. Because so many customers could be reached via mail and because there was little competition from retail stores, the potential for catalog sales was enormous.

The advantages of the mail-order companies over traditional store operations were many. Catalog shopping from home was convenient. Mail-order companies were able to offer greater variety in styles of merchandise, and they were therefore able to meet the needs of almost every consumer. Inventory variety for mail-order businesses could be much greater than for individual stores because the customer base was nationwide. The large volume of goods purchased by the mail-order companies also allowed them to offer low prices to their customers. Competitive prices resulted in increased sales for the catalog companies. These factors of convenience, selection, and price caused consumers to view the catalog companies favorably.

The competition between retailers rose to a national level from local or regional levels as a result of catalog distribution. Geographic location was no longer a barrier to shopping for and purchasing merchandise. People in the West had access to the same items as people in the East, who traditionally had been privy to a better selection of goods. Prices, too, were the same for people regardless of their place of residence. The availability of catalogs increased communication and reduced barriers that previously had separated consumers in the United States.

Mail-order catalogs introduced a new vehicle for communication. The catalogs increased the availability of information about fashionable apparel. This information,

along with access to the merchandise advertised in the catalogs, influenced the fashion industry tremendously. The concept that current fashions could be available to the masses rather than just to the upper classes spread early in the twentieth century. It was facilitated by widespread availability of fashion merchandise at reasonable prices through the mail-order catalogs. The frequency with which the catalogs were published affected the speed at which fashions changed. The fashion adoption process was facilitated through the presentation and availability of apparel. Catalog customers learned through the catalogs what would be in fashion each year or as each new catalog came out. The earliest catalogs were published once a year, but by the early 1900's they were published twice a year. Consumers of the 1990's could expect seasonal catalogs, sometimes arriving as often as once a month, and even special supplemental holiday or sale catalogs, all offering new fashionable merchandise for sale.

The early catalog companies were among the first retailers to offer private-label goods. This practice, in which a retailer arranges for the production of goods through a manufacturer and then offers those goods exclusively to customers, encourages an association of brand name and retailer name and leads to customer loyalty. As a result, consumers recognize and purchase specific store brands such as Craftsman tools, sold only by Sears.

Policies set in the first Montgomery Ward and Sears, Roebuck and Company catalogs were precursors to modern retail policies. The "Consumers Guide" in the 1897 Sears, Roebuck and Company catalog stated that employees were expected to treat all customers as they would like to be treated themselves. Policies addressing merchandise returns, competitive pricing, payment methods, and terms of shipping were all clearly explained in the catalogs. Modern retailers, following the lead of Sears, Roebuck and Company and Montgomery Ward, generally offer liberal return policies and strive to satisfy customers.

Modern conveniences such as credit cards, telephones, and private delivery services have greatly increased the appeal of catalog shopping for consumers in the late twentieth century. The established mail-order industry provides a market for institutions offering credit cards and provides a great deal of business for delivery companies. The trend of mail-order catalogs changed from offering a "warehouse" of goods to specialization in a type of merchandise. The market of consumers has changed as transportation has improved, making trips to retailers more convenient. The concepts of retailer loyalty and product identification through intensive advertising and private labels developed well beyond the beginnings set forth by Richard W. Sears and Aaron Montgomery Ward. The Sears catalog operation, however, was suspended in the early 1990's as an unprofitable business.

Bibliography

Asher, Louis E., and Edith Heal. *Send No Money*. Chicago: Argus Books, 1942. A biography of Richard W. Sears, written by a colleague of Sears who was employed as manager of the advertising and catalog department and then as general manager

of Sears, Roebuck and Company. Chapters 3 and 4 in particular address the mail-order business.

Herndon, Booton. *Satisfaction Guaranteed: An Unconventional Report to Today's Consumers*. New York: McGraw-Hill, 1972. A philosophy of mass merchandising is presented, based on the concept of the Montgomery Ward Company. Chapter 5 deals with the catalog.

Hoge, Cecil C. *The First Hundred Years Are the Toughest: What We Can Learn from the Century of Competition Between Sears and Wards*. Berkeley, Calif.: Ten Speed Press, 1988. Comprehensive information is provided in essays written about specific stages of the companies' development. Relates events to economic, social, and worldwide influences.

Sroge, Maxwell. *The United States Mail Order Industry*. Homewood, Ill.: Business One Irwin, 1991. Statistics, history, and marketing strategies of mail-order companies in the United States are discussed.

Weil, Gordon L. *Sears, Roebuck, U.S.A.* New York: Stein & Day, 1977. Discusses the history of the Sears, Roebuck and Company business. The roles of Sears, Roebuck and Rosenwald in the growth of the company are explored. Chapter 5, "The Mail-Order War," reflects the Sears-Ward competition.

Virginia Ann Paulins

Cross-References

The First Major U.S. Shopping Center Opens (1922), p. 380; Sears, Roebuck Opens Its First Retail Outlet (1925), p. 487; Invention of the Slug Rejector Spreads Use of Vending Machines (1930's), p. 579; Sears Agrees to an FTC Order Banning Bait-and-Switch Tactics (1976), p. 1631; A Home Shopping Service Is Offered on Cable Television (1985), p. 1909.

KODAK INTRODUCES THE BROWNIE CAMERA

Category of event: New products
Time: 1900
Locale: Rochester, New York

With the introduction of the Brownie camera, Eastman Kodak became the first company to exploit the mass-market potential of photography

Principal personages:
GEORGE EASTMAN (1854-1932), the founder of the Eastman Kodak Company
FRANK A. BROWNELL, a camera maker for the Kodak Company who designed the Brownie
HENRY M. REICHENBACH, a chemist who worked with Eastman to develop flexible film
WILLIAM H. WALKER, a Rochester camera manufacturer who collaborated with Eastman

Summary of Event
In early February of 1900, the first shipments of a new small box camera called the Brownie reached Kodak dealers in the United States and England. George Eastman, eager to put photography within the reach of everyone, had directed Frank Brownell to design a small camera that could be manufactured inexpensively but that would still take good photographs.

Advertisements for the Brownie proclaimed that everyone—even children—could take good pictures with the camera. The Brownie was aimed directly at the children's market, a fact indicated by its box, which was decorated with drawings of imaginary elves called "Brownies" created by the Canadian illustrator Palmer Cox. Moreover, the camera cost only one dollar.

The Brownie was made of jute board and wood, with a hinged back fastened by a sliding catch. It had an inexpensive two-piece glass lens and a simple rotary shutter that allowed both timed and instantaneous exposures to be made. With a lens aperture of approximately f/14 and a shutter speed of approximately 1/50 of a second, the Brownie was certainly capable of taking acceptable snapshots. It had no viewfinder; however, an optional clip-on reflecting viewfinder was available. The camera came loaded with a six-exposure roll of Kodak film that produced square negatives 2.5 inches on a side. This film could be developed, printed, and mounted for forty cents, and a new roll could be purchased for fifteen cents.

George Eastman's first career choice had been banking, but when he failed to receive a promotion he thought he deserved, he decided to devote himself to his hobby, photography. Having worked with a rigorous wet-plate process, he knew why there were few amateur photographers at the time—the whole process, from plate

preparation to printing, was too expensive and too much trouble. Even so, he had already begun to think about the commercial possibilities of photography; after reading of British experiments with dry-plate technology, he set up a small chemical laboratory and came up with a process of his own. The Eastman Dry Plate Company became one of the most successful producers of gelatin dry plates.

Dry-plate photography had attracted more amateurs, but it was still a complicated and expensive hobby. Eastman realized that the number of photographers would have to increase considerably if the market for cameras and supplies were to have any potential. In the early 1880's, Eastman first formulated the policies that would make the Eastman Kodak Company so successful in years to come: mass production, low prices, foreign and domestic distribution, and selling through extensive advertising and by demonstration.

In his efforts to expand the amateur market, Eastman first tackled the problem of the glass-plate negative, which was heavy, fragile, and expensive to make. By 1884, his experiments with paper negatives had been successful enough that he changed the name of his company to The Eastman Dry Plate and Film Company. Since flexible roll film needed some sort of device to hold it steady in the camera's focal plane, Eastman collaborated with William Walker to develop the Eastman-Walker roll-holder. Eastman's pioneering manufacture and use of roll films led to the appearance on the market in the 1880's of a wide array of hand cameras from a number of different companies. Such cameras were called "detective cameras" because they were small and could be used surreptitiously. The most famous of these, introduced by Eastman in 1888, was named the "Kodak"—a word he coined to be terse, distinctive, and easily pronounced in any language. This camera's simplicity of operation was appealing to the general public and stimulated the growth of amateur photography.

The Kodak was a box about seven inches long and four inches wide, with a one-speed shutter and a fixed-focus lens that produced reasonably sharp pictures. It came loaded with enough roll film to make one hundred exposures. The camera's initial price of twenty-five dollars included the cost of processing the first roll of film; the camera also came with a leather case and strap. After the film was exposed, the camera was mailed, unopened, to the company's plant in Rochester, New York, where the developing and printing were done. For an additional ten dollars, the camera was reloaded and sent back to the customer.

The Kodak was advertised in mass-market publications, rather than in specialized photographic journals, with the slogan: "You press the button, we do the rest." With his introduction of a camera that was easy to use and a service that eliminated the need to know anything about processing negatives, Eastman revolutionized the photographic market. Thousands of people no longer depended upon professional photographers for their portraits but instead learned to make their own. In 1892, the Eastman Dry Plate and Film Company became the Eastman Kodak Company, and by the mid-1890's, one hundred thousand Kodak cameras had been manufactured and sold, half of them in Europe by Kodak Limited.

Having popularized photography with the first Kodak, in 1900 Eastman turned his

attention to the children's market with the introduction of the Brownie. The first five thousand cameras sent to dealers were sold immediately; by the end of the following year, almost a quarter of a million had been sold. The Kodak Company organized Brownie camera clubs and held competitions specifically for young photographers. The Brownie came with an instruction booklet that gave children simple directions for taking successful pictures, and "The Brownie Boy," an appealing youngster who loved photography, became a standard feature of Kodak's advertisements.

Impact of Event

Eastman followed the success of the first Brownie by introducing several additional models between 1901 and 1917. Each was a more elaborate version of the original. These Brownie box cameras were on the market until the early 1930's, and their success inspired other companies to manufacture box cameras of their own. In 1906, the Ansco company produced the Buster Brown camera in three sizes that corresponded to Kodak's Brownie camera range; in 1910 and 1914, Ansco made three more versions. The Seneca company's Scout box camera, in three sizes, appeared in 1913, and Sears Roebuck's Kewpie cameras, in five sizes, were sold beginning in 1916. In England, the Houghtons company introduced its first Scout camera in 1901, followed by another series of four box cameras in 1910 sold under the Ensign trademark. Other English manufacturers of box cameras included the James Sinclair company, with its Traveller Una of 1909, and the Thornton-Pickard company, with a Filma camera marketed in four sizes in 1912.

After World War I ended, several series of box cameras were manufactured in Germany by companies that had formerly concentrated on more advanced and expensive cameras. The success of box cameras in other countries, led by Kodak's Brownie, undoubtedly prompted this trend in the German photographic industry. The Ernemann Film K series of cameras in three sizes, introduced in 1919, and the all-metal Trapp Little Wonder of 1922 are examples of popular German box cameras.

In the early 1920's, camera manufacturers began making box-camera bodies from metal rather than from wood and cardboard. Machine-formed metal was less expensive than the traditional hand-worked materials. In 1924, Kodak's two most popular Brownie sizes appeared with aluminum bodies.

In 1928, Kodak Limited of England added two important new features to the Brownie—a built-in portrait lens, which could be brought in front of the taking lens by pressing a lever, and camera bodies in a range of seven different fashion colors. The Beau Brownie cameras, made in 1930, were the most popular of all the colored box cameras. The work of Walter Dorwin Teague, a leading American designer, these cameras had an art deco geometric pattern on the front panel, which was enameled in a color matching the leatherette covering of the camera body. Several other companies, including Ansco, again followed Kodak's lead and introduced their own lines of colored cameras.

In the 1930's, several new box cameras with interesting features appeared, many manufactured by leading film companies. In France, the Lumiere Company adver-

tised a series of box cameras—the Luxbox, Scoutbox, and Lumibox—that ranged from a basic camera to one with an adjustable lens and shutter. In 1933, the German Agfa company restyled its entire range of box cameras, and in 1939, the Italian Ferrania company entered the market with box cameras in two sizes. In 1932, Kodak redesigned its Brownie series to take the new 620 roll film, which it had just introduced. This film and the new Six-20 Brownies inspired other companies to experiment with variations of their own; some box cameras, such as the Certo Double-box, the Coronet Every Distance, and the Ensign E-20 cameras, offered a choice of two picture formats.

Another new trend was a move toward smaller-format cameras using standard 127 roll film. In 1934, Kodak marketed the small Baby Brownie. Designed by Teague and made from molded black plastic, this little camera with a folding viewfinder sold for only one dollar—the price of the original Brownie in 1900.

The Baby Brownie, the first Kodak camera made of molded plastic, heralded the move to the use of plastic in camera manufacture. Soon many others, such as the Altissa series of box cameras and the Voigtlander Brilliant V/6 camera, were being made from this new material.

By the late 1930's, flashbulbs had replaced flash powder for taking pictures in low light; again, the Eastman Kodak Company led the way in introducing this new technology as a feature on the inexpensive box camera. The Falcon Press-Flash, marketed in 1939, was the first mass-produced camera to have flash synchronization and was followed the next year by the Six-20 Flash Brownie, which had a detachable flash gun. In the early 1940's, other companies, such as Agfa-Ansco, introduced this feature on their own box cameras.

In the years after World War II, the box camera evolved into an eye-level camera, making it more convenient to carry and use. Many amateur photographers, however, still had trouble handling paper-backed roll film and were taking their cameras back to dealers to be unloaded and reloaded. Kodak therefore developed a new system of film loading, using the Kodapak cartridge, which could be mass-produced with a high degree of accuracy by precision plastic-molding techniques. To load the camera, the user simply opened the camera back and inserted the cartridge. This new film was introduced in 1963, along with a series of Instamatic cameras designed for its use. Both were immediately successful.

The popularity of the film cartridge ended the long history of the simple and inexpensive roll film camera. The last English Brownie was made in 1967, and the series of Brownies made in the United States was discontinued in 1970. Eastman's original marketing strategy of simplifying photography in order to increase the demand for cameras and film continued, however, with the public's acceptance of cartridge-loading cameras such as the Instamatic.

From the beginning, Eastman had recognized that there were two kinds of photographers other than professionals. The first, he declared, were the true amateurs who devoted time enough to acquire skill in the complex processing procedures of the day. The second were those who merely wanted personal pictures or memorabilia of their

everyday lives, families, and travels. The second class, he observed, outnumbered the first by almost ten to one. Thus, it was to this second kind of amateur photographer that Eastman had appealed, both with his first cameras and with his advertising slogan, "You press the button, we do the rest." Eastman had done much more than simply invent cameras and films; he had invented a system and then developed the means for supporting that system. This is essentially what the Eastman Kodak Company continued to accomplish with the series of Instamatics and other descendants of the original Brownie. In the decade between 1963 and 1973, for example, approximately sixty million Instamatics were sold throughout the world.

The research, manufacturing, and marketing activities of the Eastman Kodak Company have been so complex and varied that no one would suggest that the company's prosperity rests solely on the success of its line of inexpensive cameras and cartridge films, although these have continued to be important to the company. Like Kodak, however, most large companies in the photographic industry have expanded their research to satisfy the ever-growing demand from amateurs. The amateurism that George Eastman recognized and encouraged at the beginning of the twentieth century thus still flourished at its end.

Bibliography
Collins, Douglas. *The Story of Kodak*. New York: Harry N. Abrams, 1990. The first book to present the complete story of the Eastman Kodak Company. Emphasis is on the tremendous contributions Kodak has made to science, art, and popular culture. The author had unlimited access to the company archives as well as the opportunity to interview Kodak's leading researchers.

Eder, Josef Maria. *History of Photography*. Translated by Edward Epstean. New York: Columbia University Press, 1945. A history of the early developments in photography. Originally published in Europe; makes use of many sources not available to American writers. Includes a valuable account of Eastman's initial experiments, inventions, and business practices. Contains many descriptions of photographic chemistry and technology, but explains these in a way that the average reader can grasp.

Freund, Gisele. *Photography and Society*. Boston: David R. Godine, 1980. Deals first with photographic history, then proceeds to a discussion of the ways in which artistic expression and social forms continually influence and reshape each other. Also discusses photography's essential role in contemporary life and its indispensable position in both science and industry.

Taft, Robert. *Photography and the American Scene*. New York: Dover, 1964. Traces the effects of photography on the social history of America and the effect of social life on the progress of photography. Includes a good account of Eastman's early career, with an outline of the Goodwin patent dispute.

Wade, John. *A Short History of the Camera*. Watford, England: Fountain Press, 1979. A year-by-year account of the development of camera technology and the various companies involved. Well illustrated, with photographs of most of the cameras

discussed in the text. Recommended for any reader who has a limited knowledge of how cameras actually work.

LouAnn Faris Culley

Cross-References
Gillette Markets the First Disposable Razor (1903), p. 75; Walter Dill Scott Publishes *The Theory of Advertising* (1903), p. 80; Eastman Kodak Is Found to Be in Violation of the Sherman Act (1927), p. 527; Land Demonstrates the Polaroid Camera (1947), p. 896; Sony Introduces the Betamax (1975), p. 1573.

GENERAL ELECTRIC OPENS AN INDUSTRIAL RESEARCH LABORATORY

Category of event: Business practices
Time: December 15, 1900
Locale: Schenectady, New York

The opening of General Electric's research laboratory marked the integration of science as a fundamental and ongoing factor in manufacturing

Principal personages:

CHARLES PROTEUS STEINMETZ (1865-1923), a German émigré and electrical engineer who first proposed the idea of a research laboratory to General Electric

EDWIN W. RICE (1862-1935), the vice president of General Electric responsible for manufacturing and engineering

WILLIS R. WHITNEY (1868-1958), a chemist who became the first director of General Electric's research laboratory

IRVING LANGMUIR (1881-1957), a General Electric lab member who became the first industrial scientist to win a Nobel Prize, in 1932

WILLIAM D. COOLIDGE (1873-1975), a physicist for General Electric

ROBERT KENNEDY DUNCAN (1868-1914), a chemist who won a reputation as a popularizer of science

CHARLES A. COFFIN (1844-1926), one of the founders of the Thomson-Houston Electric Company and the first president of General Electric Company

Summary of Event

The opening of the General Electric (GE) research laboratory in 1900 marked the first effort by an American corporation to integrate science, on an ongoing basis, into its competitive strategy. Faced with innovations in lamp design and materials developed by the competition, GE decided that its survival depended on using scientific talent dedicated to basic research. Adopted as a defensive measure to preserve GE's dominance in the market, the research lab soon developed a number of new products that would significantly broaden GE's market. Once seen as a risky and possibly unnecessary venture, the research lab captured a central role in giving GE a major place in the electrical industry.

Formed by the merger of Thomson-Houston and Edison General Electric in 1892, GE immediately dominated the lamp market and looked forward to a profitable future. The company soon confronted hard times, as the 1893 depression crippled the electrical market. Charles A. Coffin, GE's president, sold millions of dollars of holdings of securities issued by local power companies and significantly trimmed the company's work force during the mid- and late 1890's. Eventually these policies restored GE's financial stability.

The company faced threats from other quarters. Engaged in one of the first industries based on the combination of science and technology, electrical manufacturers always faced the possibility of innovations undermining their stability. As insurance, GE and the other major electrical manufacturer, Westinghouse, had exchanged patents on key technology in 1897. This arrangement enabled GE to hold a strong position in the lamp market.

Reluctant to spend money on basic research, GE depended on buying research undertaken by independent inventors. In the 1890's, for example, GE bought the services and patents of inventors Charles Bradley and Ernst Danielson to regain a competitive edge against Westinghouse, which had made advances in a number of key areas. These relationships were always short term, limited in cost, and outside the company's daily activities. As important, Coffin and others at GE subscribed to the notion that people who engaged in such innovation demonstrated work habits and personality traits ill-suited for the highly structured corporate workplace.

Despite GE's cautious attitude toward innovation and its practitioners, the company maintained a number of laboratories. These usually focused on testing materials used in manufacturing and in standardizing measurements. Basic long-term research was not part of their mission.

The director of GE's calculating department, Charles Proteus Steinmetz, realized as early as 1897 that his company's future rested with a research lab. Rebuffed in his early efforts, Steinmetz finally succeeded in winning approval for a research laboratory in 1900. Steinmetz also grasped the threat posed to GE by work done in Germany on lamp design and materials.

Germany had pioneered research labs in the late nineteenth century. By 1900, the country's scientists had developed innovations that made gas lamps competitive and had enhanced filaments for incandescent lamps. Both of these innovations challenged GE's position. In the United States, research on the mercury vapor lamp by Westinghouse-employed Peter Cooper-Hewett also created a potential threat to GE. Supported by Edwin W. Rice, the GE vice president responsible for manufacturing and engineering, Steinmetz successfully urged that a new GE research lab focus on these threats to GE's dominance in the market.

Rice contacted Professor Charles R. Cross at the Massachusetts Institute of Technology (MIT). Cross, a longtime advocate of applied research, had established close ties with industry. He suggested colleague Willis R. Whitney, who had earned his Ph.D. in physical chemistry at the University of Leipzig. Wedded to the academic environment, Whitney reluctantly agreed to part-time work in the lab. Eventually the demands of his new position forced Whitney to petition for a one-year leave from MIT in August, 1901, a leave that soon became permanent.

Whitney expressed uneasiness over the long-term nature of the lab's basic research in the light of the company's cost-conscious administration. He sought ways to justify the lab's continued existence by using the lab's resources to assist company engineers in solving production problems. These applied research projects demonstrated the lab's usefulness and brought visible returns to the company. Whitney broadened this

policy to include manufacturing of specialized items including X-ray and radio tubes. This activity reached such proportions that GE created the commercial department in 1916 to sell these products.

Whitney maintained a balance between the demands of the corporation and the morale of his staff. He provided a large and growing library of scientific journals and books that served as guides for literature searches by the professional staff members when they began new projects. He urged his scientists, however, to rely on experimentation rather than on scholarly theories that were untested in the marketplace. Whitney also scoured the professional staff reports for results that could pass the scrutiny of patent officials and guarantee GE a lock on new commercial technology. Demanding in many ways, Whitney still made every effort to develop a keen understanding of his staff's abilities. Above all, he emphasized the cooperative approach, an important notion in a team-based effort. He reinforced this policy by refusing to reward any single person in the case of a successful patent that seemed to promise great profits for GE.

Aware of the academic backgrounds of his scientists, Whitney deliberately retained some elements of a university setting. He actively encouraged independent research and urged publication of his staff's work once GE attorneys had secured patents or when the research promised no immediate commercial application. Whitney's own academic commitment was manifest in his associations with professional societies such as the American Chemical Society and the American Electrochemical Society.

Whitney's university ties proved useful in recruiting talented scientists for GE's lab. In 1904, he lured the brilliant William D. Coolidge from MIT to work on GE's most pressing problem, that of the tungsten filament. His work produced the ductile tungsten filament, far superior to the more delicate tungsten filament developed in Germany. Patented in 1913, Coolidge's discovery secured for GE the long-sought dominance in the lamp market and generated a fortune in profits for the company. Coolidge's work demonstrated conclusively the necessity of basic research in technology-based industries.

Whitney also recruited physical chemist Irving Langmuir from the Stevens Institute of Technology. More than other members of the professional staff, Langmuir showed incredible talents in theoretical work that frequently translated into commercial products. His gas-filled bulb solved the problem of GE's light bulbs blackening after extended use. He also developed a vacuum tube in 1912 that brought GE into the radio market. Langmuir's achievements earned him the Nobel Prize in 1932. He was the first industrial scientist to merit this prestigious award.

The work of Coolidge, Langmuir, and others facilitated the lab's move from the defensive posture that dominated its early years to a more aggressive product development strategy. The lab's ongoing research opened up markets in radio, medicine, the military, and consumer appliances. The efforts of GE's researchers guaranteed the company's dominance in the electrical industry and made possible the transition from the trial-and-error methods of nineteenth century inventors to the team approach based on high-level skills in chemistry, physics, and engineering.

Impact of Event

The confluence of large companies at the end of the nineteenth century and the emergence of a sophisticated scientific community created conditions that encouraged the spread of research labs once GE had demonstrated their worth in the market. By the early 1900's, numerous and highly specialized professional societies had appeared in all the areas essential to technology-based companies. The American Institute of Chemical Engineering, for example, included professionals trained in chemistry, engineering, management, and even physics.

Universities had also developed curricula appropriate to preparing students in these fields. As early as 1882, MIT offered a bachelor's degree in electrical engineering, while institutions such as Carnegie Tech devoted their energies to the scientific and technical disciplines. During the late nineteenth century, chemistry and physics training grew faster in the United States than in any industrializing country except Germany. These changes occurred at the same time that America's new corporations demanded scientific training and specialized knowledge acquired only in universities.

Until the first decades of the twentieth century, the attitudes of most companies toward innovation differed little from those at GE. Overburdened by intense competition until the merger waves of the 1890's, large-scale enterprise confronted huge fixed expenditures and investors who demanded as high a rate of return as possible. The giant corporations certainly had the resources but lacked the vision to foresee markets geared to scientific innovation. The majority pursued GE's practice of relying on independent inventors coupled with a protective wall of patents that secured whatever innovations the large-scale enterprise had purchased.

GE's startling successes caught the attention of leading technology-driven corporations. Over the years, Whitney provided detailed accounts of his lab's policies to Eastman Kodak, Du Pont, and American Telephone and Telegraph (AT&T), among others. Members of GE's professional staff also took their knowledge of industrial research to other research facilities when they joined new companies. In some industries, most notably textiles, furniture, construction, and printing, very little basic research occurred because the simple mechanical technology in use generated none of the demands found at GE.

As early as 1910, communications giant AT&T adopted the GE lab model. AT&T administrators discovered that engineers with backgrounds in physics and chemistry were indispensable to the company's future. Favorably disposed toward basic research, the company set up a lab akin to the GE model. The research facility soon enjoyed lavish company patronage, unlike the meager resources made available to the GE research laboratory. The success of the AT&T lab in developing long-distance lines by early 1915 justified the trust that the company's leadership placed in the lab. By the late 1920's, AT&T labs had acquired a staff of thirty-six hundred with a budget of $12 million. By this decade, corporations from Eastman Kodak to chemical giant Du Pont had incorporated industrial research to improve their commercial products, develop new ones, and even create synthetic materials.

Typically, these companies matched their growing scientific prowess with an

almost inexhaustible supply of legal talent. For all large-scale enterprises, research labs and patent attorneys went hand-in-hand, a pattern integral to GE strategy. Without the legal protection of the patent, new discoveries in the lab carried little potential for the company, since the research could quickly be copied and brought to commercial application. Patent lawyers advised the companies on the originality of the research, a policy developed at GE whereby attorneys regularly inspected the reports submitted by the professional staff, a task once undertaken by Whitney. Patent protection shielded the research from theft and, more important, guaranteed dominance in the market. By 1925, AT&T's Bell labs controlled more than nine thousand patents in an industry in which it exercised almost monopolistic control, in part because of these very patents. GE had used a similar strategy to secure its lamp market.

Industrial research moved beyond large-scale enterprise by the 1920's. Individually lacking sufficient capital, smaller companies collectively set up their own labs, usually through the medium of a trade association. Private research facilities also appeared before the end of the decade. The Mellon Institute of Industrial Research, affiliated with the University of Pittsburgh, owed its existence to the generosity of the Mellon family and the foresight of Professor Robert Kennedy Duncan. He established the industrial fellowship system at the University of Kansas. It created a symbiotic relationship between industry and the university, the first of its kind. This idea served as the basis for the Mellon Institute, which Duncan first headed. At the national level, the National Research Council made permanent its wartime coordination of the country's scientific activities in the years after 1918. These trends made basic research a pervasive part of the American economy. By the 1990's, thousands of research labs operated throughout American industry, with combined annual budgets in excess of $40 billion.

Bibliography

Birr, Kendall. *Pioneering in Industrial Research: The Story of the General Electric Research Laboratory*. Washington, D.C.: Public Affairs Press, 1957. The first scholarly work on the topic. Provides a good overview of the development of the GE lab and the roles of its participants. The first two chapters outline the background to industrial research and the GE lab.

—————— . "Science in American Industry." In *Science and Society in the United States*, edited by David Van Tassel and Michael G. Hall. Homewood, Ill.: The Dorsey Press, 1966. Provides a brief background on the evolution of science and its increasing interaction with industry. Discusses the rise of organized research in the twentieth century. Reviews in brief paragraphs the impact of the chemical industry on other sectors of the American economy.

Galambos, Louis. "The American Economy and the Reorganization of the Sources of Knowledge." In *The Organization of Knowledge in Modern America*, edited by Alexandra Oleson and John Voss. Baltimore: The Johns Hopkins University Press, 1979. Includes an effective description of the relationship between science and the rise of large-scale companies. Notes the slowness with which the giant corporations

that appeared during the merger waves of the late nineteenth and early twentieth centuries integrated research as part of their competitive strategies.

Hughes, Thomas P. *American Genesis: A Century of Invention and Technological Enthusiasm, 1870-1970.* New York: Viking, 1989. A must read for an understanding of technology's role in American society. Provides an extremely effective description of independent inventors and, in chapter 4, analyzes the appearance of industrial labs in key industries. Good coverage of the GE, AT&T, and Du Pont labs. Includes an indispensable discussion of technological systems and system builders.

Kline, Ronald R. *Steinmetz: Engineer and Socialist.* Baltimore: The Johns Hopkins University Press, 1992. Provides a detailed account of Steinmetz's role in the formation of the GE lab and his disagreements with Whitney that led to Steinmetz's departure. Essential reading to understand much of the immediate background to the creation of the GE lab.

Mees, C. E. Kenneth, and John A. Leersmakers. *The Organization of Industrial Scientific Research.* New York: McGraw-Hill, 1950. Mees served as vice president in charge of research at Eastman Kodak. His perspective provides invaluable information on the ways research labs were organized and functioned, from finance and building design to patents and associations for industrial research. Includes numerous examples of industrial research labs from many industries.

Noble, David F. *America by Design: Science, Technology, and the Rise of Corporate Capitalism.* New York: Alfred A. Knopf, 1977. A work very critical of the impact of science and technology on American society. Valuable insights into the changes in American industry during the late nineteenth and early twentieth centuries. An effective analysis of the role of patents in scientific research and the importance of universities to industry.

Rae, John. "The Application of Science to Industry." In *The Organization of Knowledge in Modern America, 1860-1920*, edited by Alexandra Oleson and John Voss. Baltimore: The Johns Hopkins University Press, 1979. Covers the roles of government and private industry in research and the impact of World War I, particularly the naval consulting board, on basic research.

Reich, Leonard S. *The Making of American Industrial Research: Science and Business at GE and Bell, 1876-1926.* New York: Cambridge University Press, 1985. Provides a systematic comparison of the industrial research at GE and Bell. It should be a starting point for anyone interested in understanding the origins and evolution of this process in American industry. An essential work in the field.

Wise, George. *Willis R. Whitney, General Electric, and the Origins of Industrial Research.* New York: Columbia University Press, 1985. Provides an effective analysis of Whitney's role in the creation of the GE lab. Also includes a detailed discussion of his policies in running the lab and his relationships with key professional staff members from William Coolidge to Irving Langmuir. Explains the reasons for Whitney's decreasing role as an active participant in research. Highlights Whitney's role in the larger scientific community.

Edward J. Davies II

Cross-References

Bell Labs Is Formed (1925), p. 470; Du Pont Announces the Discovery of Nylon 66 (1938), p. 798; Land Demonstrates the Polaroid Camera (1947), p. 896; Morita Licenses Transistor Technology (1953), p. 1009; Genentech Is Founded (1976), p. 1616.

DISCOVERY OF OIL AT SPINDLETOP TRANSFORMS THE OIL INDUSTRY

Category of event: New products
Time: January 10, 1901
Locale: Texas

The discovery of oil at the Spindletop field was the beginning of the Texas oil boom and led to the growth of a number of important present-day oil corporations

Principal personages:
PATILLO HIGGINS (1862-1955), a Beaumont resident, the first to find evidence of petroleum reserves in the area
ANTHONY F. LUCAS (1855-1921), an Austrian geologist and engineer, the first to act upon the theory that salt domes in the Gulf Coastal Plains were associated with petroleum reservoirs
JAMES M. GUFFEY (1839-1930), the head of the J. M. Guffey Petroleum Company
JOHN H. GALEY (1840-1918), the partner of Guffey
WILLIAM L. MELLON (1868-1949), an investment banker who helped finance Guffey
JOSEPH S. CULLINAN (1860-1937), a manager of a Standard Oil subsidiary who formed the Texas Fuel Company from discoveries made at Spindletop
JOHN D. ROCKEFELLER (1839-1937), the head of Standard Oil Company

Summary of Event

On January 10, 1901, at 10:30 A.M., the first major "gusher" came in at the Spindletop oil field. Spindletop was named for the salt dome known as the "Big Hill," just south of Beaumont in southeastern Texas. This first major oil well at Spindletop at first produced 75,000 to 100,000 barrels per day, approximately 800,000 barrels before it was brought under control nine days after oil was struck. This dramatic discovery made the Spindletop area the first major oil "boom town" of Texas and shifted the focus of petroleum entrepreneurs to Texas. Texas was the leading petroleum producing state in the United States for much of the twentieth century and was one of the fastest-growing areas in terms of population. The Spindletop discovery also led to the formation and development of a number of important oil corporations.

Prior to the discovery of oil in Texas, the primary and best-known oil fields were in Pennsylvania. Officials of the Standard Oil Company believed that there were few, if any, productive oil fields west of the Mississippi River. By 1890, however, there was evidence of petroleum in Texas, primarily in Corsicana, just south of Dallas. The opportunity to develop the Corsicana oil fields brought two Pennsylvania wildcatters, James M. Guffey and John H. Galey, to Corsicana. The need to provide pipeline

transportation facilities in the area also brought Joseph S. Cullinan of Pennsylvania, head of one of Standard Oil's pipeline subsidiaries, to Corsicana. The Spindletop discovery, which would dwarf the production at Corsicana, brought these three men and many others to the oil fields of southeastern Texas. These three would form the oil-producing and refining companies that would become Gulf Oil Company and the Texas Company (Texaco).

Patillo Higgins, a Beaumont resident, was the first to find evidence of petroleum reserves at the Spindletop salt dome. Higgins, despite receiving ridicule for believing that there were commercial quantities of petroleum in the Spindletop hill, formed the Gladys City Oil, Gas, and Manufacturing Company in 1892 to exploit the oil and gas reserves. Higgins ran out of funds before he had drilled deep enough to reach the oil. In 1899, he placed an advertisement in a trade journal to lease the field. Anthony F. Lucas, an Austrian mining engineer and consultant, answered the advertisement. In his work as a consultant, Lucas had traveled through the Texas and Louisiana Gulf Coast Plains. He often found seepages of petroleum in and around the salt dome formations that occurred throughout the region. Lucas contended that these salt domes were associated with vast reservoirs of petroleum.

Lucas drilled a well on Spindletop in 1899. Although he reached some crude oil, he too ran out of funds for the project. Lucas had difficulty obtaining additional financial backing because there was no proof in any of the other oil fields of the world to back up his contention that salt domes were associated with petroleum reservoirs. Through associates in the University of Texas geology department, Lucas came into contact with John H. Galey, a partner in the J. M. Guffey Petroleum Company of Pittsburgh. With $400,000 borrowed from the Mellon Bank of Pittsburgh, Guffey, Galey, and Lucas renewed efforts to find oil at Spindletop.

On January 10, 1901, these efforts reached fruition. After weeks of continual drilling problems, the drilling crew reached a depth of 1,160 feet. At 10:30 A.M., an oil gusher that could be seen three miles away erupted. In contrast to the first major oil discovery in Pennsylvania in 1859, which flowed at 20 barrels per day with the aid of a pump, the first Spindletop gusher spewed 75,000 to 100,000 barrels per day. In 1902, the Spindletop field produced more than eighteen million barrels of crude oil, which amounted to 20 percent of the production of the United States. This was 93 percent of the year's national increase in production. By the end of 1902, almost four hundred wells were bunched together at Spindletop. By 1904, that number had reached nearly twelve hundred.

The fist six oil wells drilled at Spindletop accounted for more oil than all the other oil wells in the world at that time. Such rapid and massive exploitation of the Spindletop's petroleum resources, accompanied often by extravagant waste, meant that the petroleum reservoirs in the Spindletop field were rapidly depleted between 1902 and 1904. Such exhaustion of petroleum resources, at Spindletop and later elsewhere in Texas and throughout the nation, would lead to concerns about conservation. In the very early twentieth century, however, at a time of economic opportunity and prosperity, concerns about conservation were rare.

William L. Mellon, whose family bank had substantially funded the Guffey operations at Spindletop, soon realized that a greater level of financial and personal involvement was necessary to maintaining profitability and expansion. The Mellons bought out Guffey's interests and in 1907 removed Guffey as president of the J. M. Guffey Petroleum Company. William L. Mellon was subsequently named president, and the company was renamed the Gulf Oil Company.

Cullinan also realized that the opportunities at Spindletop were much greater than at Corsicana. In January, 1902, Cullinan formed the Texas Fuel Company, an organization designed to refine and market the vast amounts of crude oil being produced in the area. Cullinan also formed the Producers Oil Company to ensure his company a continual source of supply. The Texas Fuel Company proved too small to meet the increasingly immense task of refining all the crude produced, and in March, 1902, its assets were transferred to a new corporation, the Texas Company, capitalized at three million dollars. Cullinan's renown from his days with Standard Oil led to the continual growth and success of the Texas Company at a time when approximately two hundred competitors and other entrepreneurs at Spindletop were failing.

Other major petroleum corporations were born or grew stronger at Spindletop. Shell Oil Company had its origins at Spindletop. The Shell Transport and Trading Company of London had signed a twenty-year contract in which Guffey's operations would produce oil for the British Navy. Shell's petroleum transportation investments later led it to engage in the other major functions of the oil industry. The Sun Oil Company, another Pennsylvania organization, grew much stronger at Spindletop. The Magnolia Oil Company, a Standard Oil affiliate, had its origins at Spindletop. It later became part of the Mobil Oil Company. The group of Texas oilmen that ultimately became the Humble Oil and Refining Company individually got their starts at Spindletop. After the Humble Oil and Refining Company merged with Standard Oil of New Jersey, the Humble organization later became the Texas branch of Exxon, a Standard Oil subsidiary.

Impact of Event

The discovery of oil at Spindletop had a number of important long-run consequences. It proved that there were vast reservoirs of petroleum reserves west of the Mississippi River and that petroleum was not limited to the eastern half of the United States. The discovery of oil at Spindletop spurred other research and discoveries in the Texas and Louisiana salt dome fields, establishing the area as an oil region of permanent importance. This new research in turn propelled further oil-seeking activities and development of oil fields in northern and western Texas, making Texas the leading petroleum state in the union for much of the twentieth century. By 1929, Texas was the leading producer of petroleum in the United States, producing 35 to 45 percent of the national total, and it became one of the leading oil-producing areas in the world. Texas held the position of the top-producing state in the union until the 1970's, when Alaska and Texas each produced approximately 30 percent of the national total.

The progress of the oil industry in Texas led to rapid growth of highly lucrative

associated industries. In their very first oil strike at Spindletop, Lucas and his team used new techniques such as rotary drilling, drilling mud, and airlift of oil that afterward became standard operating procedure for oil producers. All these methods created a demand for an industry to produce drill bits and other tools and supplies. The most prominent of the companies supplying this equipment was the Hughes Tool Company, source of the initial fortune of Howard Hughes. The growth of petroleum transportation pipelines created a demand for firms to service and supply them. These organizations, growing in a symbiotic relationship with the large oil corporations and many other smaller independent oil-producing organizations, were all crucial to the rapid growth of Texas beginning especially in the 1920's and continuing into the 1950's and 1960's. Urban areas such as Houston and the Spindletop-Beaumont-Port Arthur-Orange complex, with ports giving access to the Gulf of Mexico, became the sites of many large refining and petrochemical plants. Because of its location on the Trinity River and its proximity to the highly productive fields of northern Texas, the Dallas-Fort Worth area grew dramatically beginning in the middle of the twentieth century.

The Spindletop discovery opened up economic opportunity in an industry that had been monopolized by John D. Rockefeller's Standard Oil Company. The Texas Company, Gulf Oil Company, and Shell Oil Company were born at Spindletop, and the Sun Oil Company grew stronger at Spindletop. All of these would later provide competition to Standard Oil. Although all these growing oil companies remained independent of Standard Oil, practically all had ties to that company, whether selling crude oil to be refined or refined oil to be marketed and sold to the general public. The growth of these corporations would, however, transform the oil industry from one characterized by monopoly (Standard Oil) to one that was more oligopolistic in nature.

The dramatic discovery at Spindletop, by proving that there were major untapped areas of petroleum in the United States, opened the door for other opportunistic, risk-taking entrepreneurs and organizations. This led to the formation of the afore-mentioned major corporations as well as many smaller independents that helped boost the economy of Texas and the Gulf Coast region.

Bibliography

Clark, James A., and Michel T. Halbouty. *Spindletop.* New York: Random House, 1952. Written in a popular style, without footnotes or documentation. Effectively captures the drama and impact of the birth of the Texas oil industry at Spindletop. Good for those seeking an introduction to the Spindletop discovery and the early Texas oil industry.

King, John O. *Joseph Stephen Cullinan: A Study of Leadership in the Texas Petroleum Industry, 1897-1937.* Nashville, Tenn.: Vanderbilt University Press, 1970. Gives an excellent account of Cullinan's life, his establishment of the Texas Company, and the early Texas oil industry in general.

Larson, Henrietta M., and Kenneth Wiggins Porter. *History of Humble Oil and*

Refining Company: A Study in Industrial Growth. New York: Harper, 1959. A thorough, encyclopedic study of a small Texas company whose founders started at Spindletop and later merged with Standard Oil of New Jersey. Excellent in its analysis of intraindustry relationships.

Melosi, Martin V. "Oil Strike! The Birth of the Petroleum Industry." In *Coping with Abundance: Energy and Environment in Industrial America.* Philadelphia, Pa.: Temple University Press, 1985. Concisely details the events and impact of Spindletop as well as the early oil industry in Pennsylvania and California. The book as a whole is an excellent study of industrial-governmental relationships in the twentieth century United States.

Pratt, Joseph A. *The Growth of a Refining Region.* Greenwich, Conn.: JAI Press, 1980. A good comprehensive study of the growth of the oil organizations in the Texas-Louisiana Gulf Coast region.

_____ . "The Petroleum Industry in Transition: Antitrust and the Decline of Monopoly Control in Oil." *Journal of Economic History* 40 (December, 1980): 815-837. A very good, concise analysis of the growth of the oil firms at Spindletop that challenged Standard Oil's control of the oil industry.

Bruce Andre Beaubouef

Cross-References

The Supreme Court Decides to Break Up Standard Oil (1911), p. 206; Oil Is Discovered in Venezuela (1922), p. 385; OPEC Meets for the First Time (1960), p. 1154; An Offshore Oil Well Blows Out near Santa Barbara, California (1969), p. 1374; Arab Oil Producers Curtail Oil Shipments to Industrial States (1973), p. 1544; Pennzoil Sues Texaco for Interfering in Getty Oil Deal (1984), p. 1876.

MORGAN ASSEMBLES THE WORLD'S LARGEST CORPORATION

Category of event: Mergers and acquisitions
Time: February 26, 1901
Locale: New York, New York

Financier J. P. Morgan, seeking stability for his steel, railroad, and financial interests, purchased Carnegie Steel, creating U.S. Steel, the first billion-dollar corporation

Principal personages:

J. P. MORGAN (1837-1913), a financier who assembled U.S. Steel and vastly extended his financial empire

ANDREW CARNEGIE (1835-1919), an industrialist and philanthropist who sold the Carnegie Steel empire to Morgan

CHARLES M. SCHWAB (1862-1939), a partner of Carnegie, president of Carnegie Steel and of U.S. Steel, and a main factor in the Morgan-Carnegie deal

ELBERT HENRY GARY (1846-1927), a Morgan associate, for years U.S. Steel's chairman of the board

HENRY CLAY FRICK (1849-1919), a chairman of Carnegie Steel and a U.S. Steel director

GEORGE WOODWARD WICKERSHAM (1858-1936), a noted U.S. attorney general who pressed antitrust charges against U.S. Steel

Summary of Event

Formal incorporation of the United States Steel Corporation (U.S. Steel) on February 26, 1901, was an epochal event in American industrial and financial history, merging Andrew Carnegie's steel empire—the country's largest—into a giant holding company assembled by the manipulative genius of J. P. Morgan, the nation's most powerful financier. Preliminary talks between Morgan and Carnegie interests became a prelude to serious negotiations on December 12, 1900, at Manhattan's University Club. With Morgan seated next to him, Charles M. Schwab, an intimate of Carnegie and president of Carnegie Steel, delivered a speech contrived for Morgan's ears. Schwab spoke of the prospects of an orderly, stabilizing, more efficient organization of the nation's steel-making capabilities, a reorganization that would end cutthroat competition and cure the industry's cyclical depressions.

Morgan was interested and convened a meeting at his home on Madison Avenue early in January, 1901. Attending were Schwab, who at his own risk had not yet reported events to Carnegie, along with Morgan partner Robert Bacon and financial speculator John W. "Bet a Million" Gates. Their discussions lasted through the night, concluding with Morgan's offer to purchase Carnegie Steel. Shamefaced, Schwab

conveyed word of Morgan's proposition to his boss, who laconically asked his junior associate to meet with him the following morning.

Overnight, Carnegie scribbled his calculations and weighed his options. He was close to absolute dominance over the American steel industry, which included Morgan's own Federal Steel, the National Tube Company, and American Bridge Company. The last of those, like many other competing facilities, was overcapitalized and dependent on Carnegie for steel ingots, and thus was vulnerable. Carnegie already was committed to the construction of huge new steel and seamless tube plants and was planning a thousand miles of rail line to challenge Morgan's railroad interests, over which the two men had clashed years earlier and about which Morgan had insulted Carnegie. Also weighing against a sale to Morgan was Carnegie's pride in the unmatched quality and efficiency of his operations as well as in the relative solidity of their financing.

On the other hand, Carnegie was sixty-five years old. For his own sake and his wife's, he was eager to retire. His wealth was practically boundless, and he was eager to work as hard giving it away as he had earning it. His philanthropies, along with his golf, were passions. He wanted nothing more to do with the operations of, or financial holdings in, his industrial empire, desiring instead to convert his wealth into easily negotiable securities that would transfer simply to his existing and prospective charities, organizations, and endowments. With these things in mind, he decided to sell. Estimating that an acceptable price would be $480 million, he had Schwab deliver news of his decision to Morgan, who at a glance remarked: "I accept this price."

Several days later, Morgan summoned Carnegie for a final meeting and handshake at the financier's Wall Street office. Carnegie's pointed response was a countersummons to Morgan for a meeting in Carnegie's own West Fifty-first Street mansion. The two met there for exactly fifteen minutes, ending with Morgan congratulating Carnegie (erroneously) for being the richest man in the world. Details of the negotiation took a bit longer and were resolved by the principals' respective boards and associates by February 26. On March 2, public announcements proclaimed creation of the United States Steel Corporation, a holding company trust. The United States Bureau of Corporations subsequently estimated the value of the U.S. Steel transaction at $682 million, but the declared capitalization in 1901 was $1.403 billion, make it the world's first corporation of such immensity.

What Morgan had sought in buying out Carnegie and fashioning the new trust was foremost, but not solely, a restriction of competition. Morgan enjoyed a superior university education as well as a considerable knowledge of Great Britain and of Europe. Only two years younger than Carnegie, the acknowledged leader of American capitalists, he was an accomplished banker-financier whose gold, loans, and securities offerings had launched, backed, or helped fight many of the country's major industrial empires. In 1895, his actions had even saved the U.S. federal government from acute financial embarrassment.

A logical thinker, an orderly, meticulous planner with a penchant for bringing

greater coherence and predictability to the country's economic life while promoting his own legitimate profits, he detested cutthroat competition and the disorder and unpredictability attending it. Carnegie, in his opinion, was one of industry's rogues, prone to underpricing his goods during economic downturns and forgoing profits to keep plants in operation, in the meantime driving his scrambling competitors to the wall. Moreover, Carnegie's plans for a giant new pipe and tube plant at Conneaut Harbor, Ohio, and Morgan's suspicion that Carnegie intended to shift his steel mills into production of finished products and build railroads confronted the financier with prospects of renewed industrial warfare, with its accompanying chaos and costs. The purchase also afforded Morgan opportunities to proceed with a full-scale rationalization and vertical integration of steel-making and closely related industries.

With his massive new cartel-like corporation and his ability to draft into its direction the tested capacities of such men as Elbert Henry Gary, Henry Clay Frick, and Charles M. Schwab, Morgan appeared able to turn his priorities into realities. Under the rubric of U.S. Steel were half of the twenty major business combinations formed between 1897 and 1901, during the opening years of the nation's greatest wave of mergers. Seven-tenths of the country's steel concerns, including twelve of its biggest producers, had joined in Morgan's grand merger. The capacities of these huge companies were augmented by the inclusion of 138 firms of varying size.

Impact of Event

Despite its formidable potential, U.S. Steel was far from being a monopoly. At its inception, it controlled only 44.8 percent of American steel production. It had plenty of competition from those steel companies that still accounted for more than half of the industry's products, among them Bethlehem, Jones and Laughlin, Lackawanna, Cambria, Colorado Fuel and Iron, and Youngstown Steel and Tube. Consequently, the primary objective of Morgan's giant firm was to further the integration of its own facilities while avoiding the renewal or exacerbation of cutthroat competition.

U.S. Steel underwent expansion between 1902 and 1908. The objective was to enhance its independence from the rest of the industry by vertical integration of its operations, that is, by owning and managing every constituent of production through to the finished products, including land, ore deposits, coal and coking properties, transportation facilities such as iron ore railroads and Great Lakes shipping, plants to produce heavy steel ingots, and mills designed to satisfy various specialty steel orders. By 1901, it was a common belief within the steel industry that the limits of the technically possible were being approached. Schwab himself had called attention to this purported fact. It therefore became trade wisdom that additional efficiencies and profits would derive chiefly from precisely the type of reorganization planned by Morgan. Furthermore, expansion and vertical integration, paralleled by managerial changes, meant that U.S. Steel divisions would no longer pay their potential profits to other firms for transforming raw steel into the thousands of products and specialties (most steel was produced for specific orders) that characterized the industry.

Elbert Henry Gary, the former head of Morgan's Federal Steel and one of the

principals behind the assemblage of the giant trusts, led U.S. Steel's expansion, both organizational and geographical, as chairman of its board of directors. Between 1902 and 1908, U.S. Steel purchased seven major steel-related companies, among them Union Steel and Clairton Steel, with their substantial iron ore and coking coal deposits. Of all the purchases, the most important was the Tennessee Coal Iron and Railroad Company. With headquarters in Ensley, Alabama, it was the South's largest steelmaker, specializing in the production of open hearth steel rails and accounting for 59 percent of U.S. production of this item. Equally significant, Tennessee Coal owned more coal and iron ore than any firm except U.S. Steel, and with its raw materials literally on site it manufactured steel at lower cost than anyone else. When Gary negotiated the purchase, the Tennessee company posed a real threat, for its was planning to double its steel-making capacities.

U.S. Steel's own expansion was extensive. It built a large steel mill at Duluth, Minnesota, close to iron ores of the Mesabi Range. Through a subsidiary, it constructed a huge cement mill near Chicago. Nothing, however, matched the cornerstone of its growth, the world's largest steel-making facility. Technically the peer of any, the plant in Gary, Indiana, cost more than $62 million. Despite the immensity of expenditures for its new acquisitions and mills, U.S. Steel was able to pay them out of its profits. It realized a return of about 12 percent on its investments while increasing its capitalization.

Notwithstanding these achievements, U.S. Steel steadily lost its share of national steel production to other companies. Competitors marketed 60 percent of American steel by 1911. In the meantime, the price of steel, which had risen shortly after Morgan created the trust, remained relatively stable during these years. Clearly, the earlier era of cutthroat competition had given way—though fears of regression remained—to an era of price stability and intraindustry cooperation, as Morgan hoped that it would. U.S. Steel appeared to produce below its full capacity, accepting lower profits in order to forestall outbreaks of price warfare.

Industrywide cooperation and the stabilization of steel prices have been imputed to a number of causes, two of which were singularly important: the "Pittsburgh plus" basing point system and the so-called Gary dinners. Both had drawn the attention of federal antitrust investigators prior to 1911 and figured in Attorney General George Woodward Wickersham's suit filed against U.S. Steel. They had also brought running attacks on the corporation by muckraking journalists, congressmen, reformers, and members of President William Howard Taft's administration. The "Pittsburgh plus" basing point system meant simply that no matter where a steel product was manufactured and no matter where it was delivered, the quoted price plus rail charges was the same as if the product had been made in Pittsburgh and delivered from there. Producers used this basing system to stabilize prices, but for many customers it purportedly resulted in geographic price discrimination. The basing system remained a matter of contention between the corporation and the federal government until the 1920's. The Gary dinners, eventually abandoned while suits against U.S. Steel were pending, began on November 20, 1907, and continued periodically over the next

fifteen months. They were designed to bring steel executives together, first to fend off their possible reversion to price slashing as a result of the Panic of 1907 and subsequently, with Gary taking the lead, to exhort industry executives to share information, to work for price stability, and above all to cooperate.

When government suits to dissolve U.S. Steel on grounds of monopolistic practices were decided in New Jersey's federal district court and reaffirmed in 1920 by the U.S. Supreme Court, the corporation was exonerated. It had strived for a monopoly, yet the fact remained that 60 percent of the nation's steel-making capacity was in the hands of its competitors. Similarly, its intraindustry exchanges of price information and the like were ascertained to be reasonable business practices. Essentially, U.S. Steel was found by the judiciary to be a "good trust" rather than a harmful monopoly.

Bibliography

Carosso, Vincent P. *The Morgans: Private International Bankers, 1854-1913*. Cambridge, Mass.: Harvard University Press, 1987. Massive, authoritative, and fine reading. Surpasses other studies in use of fresh primary sources. Excellent on historical context. Good photos, extensive notes to pages in lieu of bibliography, and a valuable index. Splendid and essential, with detailed materials on U.S. Steel.

Jones, Eliot. *The Trust Problem in the United States*. New York: Macmillan, 1921. Old but useful analysis resting on public rather than private documentation. Chapter 9 deals with U.S. Steel in some detail. Sections discuss antitrust suits against the corporation. Informative notes, useful index.

Ripley, William Z., ed. *Trusts, Pools, and Corporations*. Boston: Ginn and Company, 1916. Valuable for U.S. Bureau of Corporation documents and an essay by trust specialist Edward Meade. Chapters 6 and 7 concentrate on U.S. Steel's organization, production, and prices. Useful for lay readers. Informative notes and good index.

Sinclair, Andrew Corsair. *The Life of J. Pierpont Morgan*. Boston: Little, Brown, 1981. Briefer, breezier, and less authoritative than Carosso but a good journalistic review of Morgan and friends. In places warmer about the subjects than are more scholarly works. Interesting photos, chapter notes, and extensive select bibliography, useful index. Enjoyable and informative deployment of the Morgan papers.

Wall, Joseph Frazier. *Andrew Carnegie*. New York: Oxford University Press, 1970. Authoritative, written sensitively and well. Easily the best biography of Carnegie. The book's length should not discourage readers, for Carnegie not only was one of the world's most powerful private citizens but also was fascinating. Fine photos, extensive notes to pages, splendid index.

Whitney, Simon N. *Antitrust Policies: The American Experience in Twenty Industries*. 2 vols. New York: Twentieth Century Fund, 1958. Scholarly and authoritative. One of the best overviews of U.S. Steel's organization and activities is in chapter 11. Whitney updates events to the early 1950's. Many notes and tables. No bibliography, but a fine working index.

Clifton K. Yearley

Cross-References

Cement Manufacturers Agree to Cooperate on Pricing (1902), p. 35; The Supreme Court Decides to Break Up Standard Oil (1911), p. 206; The Supreme Court Breaks Up the American Tobacco Company (1911), p. 212; The Supreme Court Rules in the U.S. Steel Antitrust Case (1920), p. 346; The U.S. Government Loses Its Suit Against Alcoa (1924), p. 431.

CEMENT MANUFACTURERS AGREE
TO COOPERATE ON PRICING

Category of event: Monopolies and cartels
Time: 1902
Locale: The United States

Formation of the Association of American Portland Cement Manufacturers, a short-lived trade association, marked the beginning of a concerted effort to cooperate on pricing to avoid harmful competition

Principal personages:
THEODORE ROOSEVELT (1858-1919), the president of the United States, 1901-1909
WOODROW WILSON (1856-1924), the president of the United States during passage of the Clayton Act and creation of the Federal Trade Commission
JOSÉ FRANCIS DE NAVARRO, a businessman who secured American patent rights to manufacture Portland cement
EMANUEL CELLER (1888-1981), a congressional coauthor of antimerger legislation
ESTES KEFAUVER (1903-1963), a Senate coauthor of antimerger laws
FRANK A. FETTER (1863-1949), an economist who argued against cement industry pricing practices

Summary of Event

In the century following the close of the Civil War, three great waves of mergers—combinations of two or more previously independent enterprises into a single enterprise—swept the American economy. The first wave, from 1899 to 1904, accounted for the disappearance of nearly thirteen hundred firms, a figure almost matched by the second wave that commenced about 1926 and collapsed about five years later. A more modest wave with two crests washed over the business community between 1945 and 1955. Mergers are an ancient part of business history. The significance of these three waves was that they each contributed substantially to the emergence of large enterprises that exercised salient or dominant positions within their industries and often within the economy as a whole.

Although "bigness" has often been propitiated in the United States, the power that attends it simultaneously has been suspect. Power, particularly of business enterprises, therefore has been held to close scrutiny, as close as varying political climates have allowed. Accordingly, from the time of an initial upsurge of American industrial and financial expansion late in the nineteenth century, antimonopoly or antitrust campaigns have marked the nation's economic growth. The evolution of the peculiarly American institution of antitrust laws is marked by the Sherman Antitrust Act of 1890,

the Clayton Antitrust Act of 1914, the Robinson-Patman Act of 1936, and the Celler-Kefauver Act of 1950. Each sought to patch weaknesses in earlier laws and to strike at new variations on restraints of trade. The Portland cement industry, of modest size but with a strategically important role in the economy, fell subject to all these acts.

Named for its resemblance to Isle of Portland stone, Portland cement was a British invention patented by Joseph Aspdin in 1824. Its manufacture spread to France in the 1840's, to Germany a decade later, and by 1875 to several plants in Pennsylvania. The superiority of Portland cement to natural cement was demonstrated at the Philadelphia Centennial Exposition in 1876. Portland cement began developing its own market shortly afterward. José Francis de Navarro secured American patent rights in 1888 and established his own mill in Coplay, Pennsylvania. Plants proliferated, first in the Lehigh Valley of Pennsylvania, then elsewhere, spurred by Frederick Ransome's development of the rotary kiln. Imports of Portland cement exceeded domestic production until the mid-1890's, but the unprecedented industrial surge that brought the American economy into the premier position in the world also propelled the expansion of American Portland cement producers.

Economists have argued that characteristics of the cement industry naturally predispose its operators toward collusive or cooperative behavior rather than competition. Its product is standardized; only a mill's advertising and sales services differentiate one brand of Portland cement from another. To normally informed buyers, cement is cement. In addition, Portland cement mills share relatively constant costs per additional unit and relatively large fixed, or overhead, costs. Mills tend to be widely separated geographically or in small clusters. Their product is of low value per pound, making transportation charges relatively high as compared with price. Demand for cement tends to be "inelastic"—unresponsive to change in its price. Although the maintenance of free and fair competition is a basic tenet of American belief and public policy, it had a ruinous ring in the cement trade at the opening of the twentieth century and during the price wars and mergers of the next few years. The structure of the industry, as outlined above, led firms to cut prices in attempts to gain market share.

Ostensibly to escape cutthroat competition and stabilize their trade, several operators in Pennsylvania's Lehigh Valley who produced nearly 60 percent of the trade's cement founded the Association of American Portland Cement Manufacturers (AAPCM) in 1902. By 1904, members of the organization had resolved to set their prices based on costs in the Lehigh Valley. This effort failed, but in 1907, a new trade organization—sixteen firms headed by the Atlas Company—established a basing point price system. The trade organization failed, but the pricing system stayed in place. That system was similar to those developed in other industries, prominent among them the "Pittsburgh plus" system of steel prices developed by U.S. Steel.

Under a basing point system, mills quoted delivered prices to dealers as the mill price plus costs of transportation, but transportation costs included in this reckoning were not the actual costs. Instead, they were costs calculated from some given manufacturing area, known as a basing point. Manufacturers agreed to quote deliv-

ered prices that were identical, matched to the price from the nearest basing point. The multiple basing point system employed by the cement industry permitted each mill, wherever located, to quote its price to customers anywhere as the lowest delivered price from the nearest designated base point.

Economist Frank A. Fetter, among others, noted that the multiple basing point system was the cement industry's way of fixing noncompetitive prices. More than 300,000 pages of judicial documentation accumulated between 1916 and 1948 confirmed that the object of the five "Big Brothers"—Universal, Lehigh, Lone Star, Penn-Dixie, and Alpha—was not to beat "competition" prices but merely to meet them. For decades, industry spokespeople argued that the pricing practices were essential for stability and were arrived at voluntarily. Many economists and lawyers, to the contrary, perceived monopoly price setting aimed at the restraint or elimination of healthy competition.

Impact of Event
Legal probes of the cement industry began in 1916, well into the administration of President Woodrow Wilson. Wilson had already shepherded an unprecedented bundle of reform legislation through Congress. This bundle included the Clayton Antitrust Act (1914), which amended—some believed put teeth into—the Sherman Act (1890), and creation of the Federal Trade Commission (FTC). The FTC's investigatory functions embraced corporate price discrimination among different customers, preventing corporations from holding stock in other corporations if the practice restrained competition, and ending interlocking directorates among companies serving the same market.

Two major cement industry trade associations were brought under examination. The AAPCM had changed its name to the Portland Cement Association and described itself as a research and advertising organization. After investigation, it was cleared of antitrust law violations. The Cement Manufacturers Protective Association (CMPA) was composed mainly of Lehigh Valley producers. It collected and disseminated monthly trade information on production, inventories, freight charges from each basing point, customer credit reports, and specifics on job contracts. A successful 1916 antitrust conviction and fining of nine West Coast mills for price fixing and apportioning markets led logically to antitrust suits against the CMPA and its members in 1919. They were charged with restricting production, fixing prices, and quoting uniform prices for their delivered orders; that is, for employing a multiple point basing system.

The red flag that the CMPA waved in the face of antitrust investigators was implicit in its multiple point basing. By the time of the CMPA's initial conviction in federal district court (New York) four years later, investigations had shown that purportedly innocent acquisition and circulation of trade information and statistics had resulted in cement supplies lagging behind demand, thereby producing uniform, noncompetitive prices.

Defeated in court, the CMPA dissolved. In 1929, however, on the advice of an FTC commissioner, it emerged in another guise, mustering industry leaders under the fresh

rubric of the Cement Institute. The Cement Institute promptly appealed the decision against the old CMPA to the U.S. Supreme Court. This was not a singular event, for the fate of eight interrelated cement cases hinged on the Supreme Court's review, as did the fates of several other industries' trade associations.

By the time the Cement Institute's appeal was considered by the Supreme Court, however, the reform enthusiasm of the Wilson Administration had been supplanted by conservative, probusiness Republican presidencies such as Herbert Hoover's. These administrations smiled upon an unparalleled increase in the number of trade associations, encouraged another wave of mergers, and displayed marked complacency in discovering restraints of trade. The Court showed sensitivity to these conservative tendencies.

In 1925, the Court reversed the CMPA's restraint of trade conviction by federal courts. It seemed partially persuaded by evidence from some economists that the cement industry's standardized product, standard freight rates, similar trade practices, and sales to informed buyers—that is, that the character of the industry—made price uniformity inevitable as a result of unrestrained competition. It is an oddity of antitrust study that uniform prices can result either from collusion or from intense competition among identical producers, competition that results in the lowest sustainable price. The Court concluded that the CMPA's open collection, dissemination, and discussion of minute details of industry operations was voluntary and involved no concerted action regarding either production or prices, although the Court acknowledged that cement prices were uniform throughout the industry. Critics of the decision noted that market conditions naturally justifying price uniformity did not justify a pricing system that required such uniformity.

Meanwhile, as cement producers sought to acquire mills closer to their markets, mergers continued through the 1920's and for the next two decades. The trend toward concentration also continued. Major companies, in fact, operated chains of mills. By 1929, the eight leading producers owned half of the industry's mills and accounted for half of the country's cement production. Concentration among the largest firms increased slightly for the next two decades, then leveled off after passage of the Celler-Kefauver Act of 1950.

What the Supreme Court left unconsidered in 1929, however, the FTC and the Justice Department pursued, namely the multiple point basing system. The government had won its first cases against the steel industry's single base point practices ("Pittsburgh plus") in 1927 and then turned to multiple point systems. These attacks were interrupted only temporarily by President Franklin D. Roosevelt's waiver of antitrust actions, sanctification of trade associations (which revived basing point systems), creation of industrial code authorities, and tolerance of price fixing as integral parts of the National Industrial Recovery Act of 1933. In 1937, the FTC targeted the cement industry's basing system as the key to the industry's activities in restraint of trade. By 1943, the FTC had filed an order against the Cement Institute which, after some setbacks for the government, reached the Supreme Court in 1948. Speaking for a 6-1 majority, Justice Hugo Black vigorously swept aside a gamut of

Cement Institute defenses and outlawed usage of basing point systems, with their freight absorption and "phantom freight" schemes, not only in the cement industry but also throughout American industry.

Bibliography

Edwards, Corwin D. *The Price Discrimination Law: A Review of Experience.* Washington, D.C.: Brookings Institution, 1959. Interesting and informative reading. A recapitulation of political, industrial, and judicial battles at the center of pricing in the U.S. economy. Can be used selectively for the Portland cement industry. Extensive notes replace a bibliography. Appendices and excellent index.

Nelson, Ralph L. *Merger Movements in American Industry, 1890-1951.* Princeton, N.J.: Princeton University Press, 1959. Brief and scholarly, but with intelligent summations of materials, confirmed by dozens of tables. Ample notes replace a bibliography. Many tables and charts, useful index. Invaluable resource on mergers and trends toward concentration in cement and related trades.

Seager, Henry R., and Charles A. Gulick. *Trust and Corporation Problems.* 1929. Reprint. New York: Arno Press, 1973. Scholarly but interesting. A solid standby excellent for older events. The Portland cement industry's practices and problems are discussed primarily in chapters 16 and 21. Extensive bibliography, table of cases, and fine index.

Stocking, George W., and Myron W. Watkins. *Monopoly and Free Enterprise.* New York: Twentieth Century Fund, 1951. Wonderful, still invaluable work. Interesting and authoritative, if in places controversial. See chapter 7 on the basing point system in the cement industry and chapter 8 on cement trade associations. Ample notes in lieu of bibliography, tables of cases, fine index.

United States Laws, Statutes, etc. *The Federal Antitrust Laws, with Summary of Cases Instituted by the United States, 1890-1951.* Chicago: Commerce Clearing House, 1952. Useful in keeping cement-related antitrust cases in order and in perspective. Part 1 provides texts of antitrust statutes; part 2 summarizes cases chronologically. Accurate and very handy.

Whitney, Simon N. *Antitrust Policies: American Experience in Twenty Industries.* 2 vols.: New York: Twentieth Century Fund, 1958. Clear, authoritative, interesting, and detailed. Lengthy chapter 19 concentrates on Portland cement and antitrust. Criticized for close attention to prices and concentration on history to the exclusion of contemporary conditions of the cement trade. Ample notes replace bibliography. More than one hundred tables, including legal cases.

Clifton K. Yearley

Cross-References

Morgan Assembles the World's Largest Corporation (1901), p. 29; Tobacco Companies Unite to Split World Markets (1902), p. 57; The Supreme Court Rules Against Northern Securities (1904), p. 91; The Federal Trade Commission Is Organized

THE ANGLO-JAPANESE TREATY BRINGS JAPAN INTO WORLD MARKETS

Category of event: International business and commerce
Time: January 30, 1902
Locale: London, England

The Anglo-Japanese Treaty of 1902 ended Great Britain's "splendid isolation" and brought Japan into the circle of great world powers

Principal personages:

SIR FRANCIS BERTIE (1844-1919), an assistant undersecretary in the British Foreign Office, 1894-1903, and head of the Asiatic Department, 1898-1902

ROBERT ARTHUR TALBOT GASCOYNE-CECIL, LORD SALISBURY (1830-1903), the prime minister of Great Britain, 1885-1892 and 1895-1902

HENRY CHARLES KEITH PETTY-FITZMAURICE, LORD LANSDOWNE (1845-1927), the British foreign secretary, 1900-1905

HAYASHI TADASU, BARON HAYASHI (1850-1913), the Japanese minister to Great Britain, 1900-1905

KATSURA TARO, GENERAL COUNT KATSURA (1847-1913), the prime minister of Japan

KOMURA JUTARO, MARQUIS KOMURA (1855-1911), the foreign minister of Japan, 1901-1905

Summary of Event

The Anglo-Japanese Treaty was signed on January 30, 1902, by Lord Lansdowne, the British foreign secretary, and Baron Hayashi, the Japanese minister to Great Britain. The treaty raised Japan from a second-class to a first-class world power and signaled the end of Great Britain's uncontested dominance of the industrial world and world trade.

As the major European powers and the United States became increasingly industrialized in the latter half of the nineteenth century, their governments were spurred to search for, and secure, foreign markets for the goods pouring out of the new factories. The Far East was an area of particular attraction for both Great Britain and the United States. Since mid-century, both had been building commercial contacts and outlets, first in China, then later in Japan.

China in particular was ripe for plucking. After the British had forced their way in, in the 1840's, they continued to expand their influence. They had already acquired Hong Kong in 1842, and they established trading centers in many other cities of China. Badly misgoverned, China was unable to withstand the demands for special status and favorable trade opportunities.

Japan, though it had resisted contact with the West, was finally opened to Western

influence by the naval expeditions of Commodore Perry in 1853 and 1854. In 1858, in the Edo Treaty, it extended trading privileges to a number of Western nations, along with some special privileges common in the Far East, particularly extraterritoriality, or the right of foreign nationals to be tried for criminal offenses by their own consular officials, not in courts of the land where the alleged offenses occurred.

Japan experienced rapid Westernization during the Meiji era, beginning in 1868 and extending into the twentieth century. At the same time, Japan began to build a modern military machine, particularly a navy, about which the country sought British advice. Most of the ships added to the growing Japanese navy between 1870 and 1900 were built in British shipyards. The leading Japanese naval officers were sent to Great Britain for training, and British naval practice became the standard in the new Japanese navy.

A mark of Japan's modernization was a commercial treaty signed by Great Britain and Japan in 1894. This treaty provided for the ending of extraterritoriality for British subjects in 1899 (a major aim of the Japanese, for they regarded the concession of extraterritoriality as a mark of inferiority) and made possible the introduction of a modern ad valorem customs tariff, similar to that in use in Great Britain and other major industrial powers.

Japan signaled its arrival on the world scene by invading China in 1894. Its modernized army quickly overwhelmed the backward Chinese, conquering both Korea (which previously had been a Chinese protectorate) and parts of Manchuria as well as seizing Port Arthur. The Chinese sued for peace and concluded the Treaty of Shimonoseki with Japan in 1895. The European powers intervened to force Japan to give up some of its gains; they were anxious to preserve unrestricted trade access to all of China. This access was enshrined in the famous "Open Door" policy of the United States toward China, announced in 1899; all the other great powers nominally agreed to it.

Meanwhile, in Europe, Great Britain was becoming increasingly conscious of its isolated state. Most of the European powers now had large industrial sectors of their own and competed with Great Britain for marketing outlets in what is now called the Third World. Great Britain was not seriously in competition with Japan. Great Britain was the major European nation trading with China and was anxious to preserve access to that market, but the possibility of an alliance with Japan began to look increasingly attractive as Great Britain found itself overstretched, particularly in naval strength. An alliance with Japan would enable significant elements of the British navy kept in the Far East to be returned to the European theater.

There were advantages for Japan, too, in a close alliance with Great Britain. For one thing, it would assure Japan of access to British financial markets, a particularly important consideration at the turn of the century, because Japan's successful war with China had almost totally depleted military and naval supplies, and the country would need outside financing to rebuild its military and naval resources. Many Japanese saw Japan as the Pacific counterpart of Great Britain, an island nation protected from invasion by the surrounding sea but needing the nearby continent for the natural

resources largely lacking on the island. Of particular importance to Japan was Korea. Although Japan had secured recognition of its predominant influence there (Korea was nominally independent), it feared Russian desires. Above all, though, Japan wanted to join the "club" of the world's great powers.

Japan and Great Britain carried on an elaborate courtship. Circumstances in Japan were favorable. Both Prime Minister Katsura Taro and Foreign Minister Komura Jutaro favored such a relationship. The Katsura government had just come to power, and the successful conclusion of an agreement with the world's leading industrial nation would be a tremendous feather in its cap. Moreover, the Japanese minister in London, Baron Hayashi, was also an ardent advocate of such an alignment. In mid-April, Hayashi telegraphed to his government the outlines of an agreement as he saw it. It would include joint recognition of the "open door" in China, freedom of action for Japan in Korea, and military alliance. Should one party to the agreement become involved in war with a third power, the other power would remain benevolently neutral; but if one party should become involved in war with two other powers at the same time, the other party would come to the aid of its ally. The agreement would be confined to the Far East.

In Great Britain, the idea of an alliance with Japan met with a favorable reception in two quarters. The British naval leaders, who had long advocated that Great Britain should maintain a navy equal in strength to that of any two other navies, were finding this a costly program. If they could secure naval protection in the Far East by an alliance, much of the British navy stationed there could be reassigned to Europe, where the buildup of the German navy was causing increasing concern. The idea of an Anglo-Japanese alliance also found a fervent supporter in one of the leading permanent officials of the Foreign Office, Sir Francis Bertie. In July, 1901, Bertie prepared a memorandum in which he outlined the advantages to Great Britain in such an alliance. It would forestall any agreement between the Japanese and the Russians for dividing up northern China between themselves. Great Britain could offer naval support to Japan to help protect its dominant position in Korea, and with British support Japan's navy would far outrank the growing Russian naval presence in the Far East. In return, the Japanese would recognize Great Britain's paramount commercial interest in the Yangtze Valley of China as well as in southern China; that is, Hong Kong and the adjacent mainland.

Although the British doubted at first that the benefits to them of such an alliance would make it worthwhile, by November the notion was beginning to look more attractive. Lord Lansdowne had secured the approval of the prime minister, Lord Salisbury, in October. In November, serious negotiations between Lord Lansdowne and Baron Hayashi began. Great Britain added to the items under discussion a proposal that both navies would cooperate in providing dockyard and coaling facilities for each other.

In the end, the public clauses of the treaty were rather general. Both parties agreed to maintain the *status quo* in the Far East. Both parties recognized the territorial integrity of both China and Korea. Great Britain recognized Japan's special position

in Korea, while Japan recognized Great Britain's special position in the Yangtze Valley. Each party acknowledged the other's right to act should public tranquillity in either area be threatened. Should either party become involved in war with a third power, the other party agreed to remain neutral.

The treaty, to last for five years, was signed on January 30, 1902. No ratifications were required, and the treaty became operative immediately. After five years, the treaty would continue but with each signatory entitled to terminate it on one year's notice. Diplomatic notes were exchanged, providing for close naval collaboration.

Although there were a few carping criticisms in the British press when the alliance became public in February, generally the British press reacted favorably to the treaty. For the Japanese government, it was a triumph to be trumpeted. The favorable Japanese public reaction helped substantially to give the Katsura government an unusually long lease on power.

Impact of Event

Although there were no immediate and obvious business and commercial advantages arising from the treaty, in a larger sense it had extensive long-range effects. The alliance had one important financial consequence: It made it much easier for the Japanese government, and for private businesses as well, to borrow money in Great Britain. There was still much to be done in rebuilding Japan's military and naval resources, depleted by the war with China in 1894-1895, and a conflict with Russia over dominance in Korea and Manchuria was looming.

There were commercial advantages for the Japanese in the Far East as well. Japanese businesses were encouraged to develop the Korean market, and many Japanese emigrated to Korea, largely in connection with Japanese enterprises there. By 1903, there were thirty thousand Japanese living in southern Korea. Japanese nationals had acquired numerous parcels of important waterfront real estate in Korea, though mostly as part of a Japanese government initiative to deny them to Russia, which sought land in Korea for a warm-water naval base.

For Great Britain, the advantages were less obvious. To be sure, the fact that the Japanese and British fleets would now work together in the Far East meant that less money would have to be spent on maintaining a full-scale British naval presence there; that in turn would mean lower taxes. The British commercial presence in China was now more secure, too; since Great Britain had a larger trade with China than did all other foreign countries combined, that was a significant advantage. British firms in Hong Kong and Shanghai could look forward to the future with confidence. The risk that other European powers would challenge their dominance in the Yangtze Valley was effectively removed.

The alliance was more important for what it did to the constellation of world powers. It made it possible for the Japanese to challenge, and defeat, the Russians in the Far East in three short years, without fear of intervention by another great power, because such action would have triggered British intervention on Japan's side under the terms of the treaty. Even though the mediation of President Theodore Roosevelt

prevented the Japanese from reaping all the fruits of their victory, no one could now doubt that Japan was indeed a great power.

The alliance was revised in the light of the Japanese victory over Russia. In 1905, a new, more extensive agreement was signed. Japan sought a tighter guarantee, fearing that Russia would seek revenge for its defeat. Great Britain, fearful that Russia would turn its expansive tendencies southward, toward Afghanistan and India, looked for an expansion of the Japanese commitment. Although the Japanese declined to be bound to provide a specific number of troops in the event India was attacked (in retrospect, many British military experts concluded that using Japanese troops in India would not be a good idea anyway), the area covered by the treaty was extended to include India, not only the Far East. Japan received Korea, in effect, as a colony. Each party agreed to assist the other were either of them attacked in the area of interest defined by the treaty, thus binding the two nations more closely in the event of war than had the treaty of 1902. This latter treaty was extended in 1911, continued automatically during World War I, and terminated in 1923 only as a result of the Washington Naval Conference in 1921.

Bibliography

Dennis, A. L. P. "The Anglo-Japanese Alliance." In vol. 1 of *University of California Publications in International Relations*, edited by Edwin Landon and Frank M. Russell. Berkeley: University of California Press, 1934. A relatively short account of the specifics of the negotiations leading up to the signing of the treaty, based on published sources only.

Monger, G. W. "The End of Isolation: Britain, Germany, and Japan, 1900-1902." In *Transactions of the Royal Historical Society*, 5th ser. 13 (1963): 103-121. A brief summary of the material, treated much more extensively in the same author's book published the same year.

——————. *The End of Isolation: British Foreign Policy, 1900-1907*. London: Thomas Nelson and Sons, 1963. Monger devotes one chapter of his book to the Anglo-Japanese Treaty and the alliance. His account is based on access to the British diplomatic records as well as the published sources used by Dennis.

Nish, Ian H. *The Anglo-Japanese Alliance: The Diplomacy of Two Island Empires, 1948-1907*. 2d ed. London: Athlone Press, 1985. This is the definitive work on the Anglo-Japanese alliance, for it is based not only on British diplomatic records but also on Japanese records. Moreover, it covers the period from 1894, the date of the Treaty of Commerce, to 1907, the end of the Russo-Japanese War and the completion of the second Anglo-Japanese Treaty. It treats all the negotiations in exhaustive detail. It is doubtful that anything more conclusive will ever be written on the subject.

Steiner, Zara. "Great Britain and the Creation of the Anglo-Japanese Alliance." In *Journal of Modern History* 31 (1959): 27-36. A straightforward account based only on British sources.

Nancy M. Gordon

Cross-References

Hashimoto Forms the Roots of Nissan Motor Company (1911), p. 185; The General Agreement on Tariffs and Trade Is Signed (1947), p. 914; Japan Becomes the World's Largest Automobile Producer (1980), p. 1751; Great Britain and China Agree on Control of Hong Kong (1984), p. 1887.

THE AMERICAN AUTOMOBILE ASSOCIATION FORMS

Category of event: Foundings and dissolutions
Time: March 3, 1902
Locale: Chicago, Illinois

The formation of an organized national automobile club, the American Automobile Association, helped improve conditions for automobile drivers and increased popularity of the automobile

Principal personages:
FRANK C. WEBB, the father of the American Automobile Association and treasurer of the Long Island Automobile Club
FRANK C. DONALD, an organizer of the first meeting of the American Automobile Association and the first vice president of the association
SAMUEL A. MILES, the manager of the Chicago Automobile Show and an organizer of the first meeting of the American Automobile Association
WINTHROP E. SCARRITT (1857-1911), the first president of the American Automobile Association
PAUL R. VERKUIL (1939-), the president of the American Automobile Association in 1992

Summary of Event

The American Automobile Association (AAA) is a national organization that was formed by eight local automobile clubs. Since its formation, the American Automobile Association has been an advocate of the automobile driver. This association continues to work toward improving the conditions of highways and roads. The American Automobile Association has become involved in every aspect of travel and has developed many services that aid the traveler.

Frank C. Donald, the president of the Chicago Automobile Club, and Samuel A. Miles, the manager of the Chicago Automobile Show, helped organize the first national meeting of automobile clubs in the United States. Until this time, automobile clubs were only local organizations, not national. A letter was sent to all the automobile clubs in the United States inviting them to attend a meeting in order to organize a national association of clubs.

The primary reason that automobile clubs formed was hostility toward the automobile driver. Most people in the late 1890's and early 1900's disliked the automobile, preferring the traditional horse and buggy. In 1902, there were twenty-three thousand automobiles on the road, compared to seventeen million horses. The general public regarded automobiles as unsafe, since they traveled much faster than a horse. The driver had many problems to contend with, including getting stuck in mud or having a flat tire and thereby blocking traffic. In 1902, an automobile driver received a ticket for blocking traffic regardless of the reason. Many horses were frightened by the noise

of an automobile, causing many accidents and adding to the dislike of automobiles.

When an automobile driver joined the club, driving became more pleasant. Club members went on trips together so that if one had a problem, the others were there to assist. The number of unpleasantries received from horse and buggy drivers decreased when several automobiles traveled together. The clubs originally formed as social, not as service, groups. Soon, however, many clubs became involved in improving driving conditions. Most roads were intended for horse and buggy use and were not in good condition for automobile use. Few signs existed to indicate the routes to cities; horse and buggy drivers seldom went someplace to which they did not know the way. The advent of the automobile meant that one could travel much farther in a day, and travelers became more adventurous. Many clubs became involved in improving roads and installing signs. One difficulty that some clubs experienced was that they could not provide signs to all surrounding cities. The distances were too great, and it became too expensive. Many clubs worked together to put up signs, but their efforts were limited. Although the local clubs did accomplish some things, the need for a national club increased.

At first, a New York automobile club headed by Frank C. Webb wanted to establish control over the other clubs around the United States. This proposal met with disapproval by other clubs. Webb then suggested that a national association be formed, with all clubs to have equal power. This proposition was received with more optimism, and the process of creating a national organization began.

In the letter inviting clubs from across the United States to attend the Chicago meeting, there were several goals listed. These included improving roads, sharing ideas, pushing for national regulations and laws for automobiles, protecting the rights of automobilists, and improving the automobile. The letter was sent under the aegis of the New York club (called the Long Island Automobile Club), the Automobile Club of America, the Philadelphia Automobile Club, the Chicago Automobile Club, and the Rhode Island Automobile Club.

At the first meeting in Chicago on March 3, 1902, there were representatives from eight automobile clubs in attendance: the Chicago Automobile Club, Automobile Club of America, Automobile Club of New Jersey, Long Island Automobile Club, Rhode Island Automobile Club, Philadelphia Automobile Club, Automobile Club of Utica, and Grand Rapids Automobile Club. Dozens of other relatively large clubs failed to send members. The meeting accomplished four goals. The first was to establish a constitution, which kept the same priorities as the invitation letter. The second was to name the organization; the American Automobile Association (AAA) was chosen as a name. Third, the attendees voted for officers, electing Winthrop E. Scarritt from the Automobile Club of America as president and Frank C. Donald as vice president. Last, the attendees scheduled a second meeting.

On April 1, 1903, the American Automobile Association had its second meeting, in New York City at the home of the Automobile Club of America. Members discussed a variety of topics related to motoring and came out in favor of the Grownlow-Latimer bill. The bill was for a three-year program, starting in 1904, which was to spend some

$24 million to improve roadways across the nation. The federal government was to pay half the cost, with states picking up the remainder. Following initial improvements, states had to keep up the roads at their own expense. One of the clubs donated ten thousand dollars to help promote this bill. The members also decided at this meeting not to focus their efforts on trying to persuade other clubs to join the AAA at this time.

The AAA proved successful in combating the persistent dislike of automobiles. In New York City, a bill was proposed that would restrict any automobile from carrying gasoline within the city. With the help of the AAA, this bill was defeated.

It was not until 1907 that the AAA started to offer some of the services for which it is well known. Members were able to receive information concerning roads, laws, and facilities. Not long after, the AAA started producing its own maps, since other maps were found to be inadequate for the automobile driver. Prior to that time, most maps had been created for bicyclists and were not very helpful to the automobile driver.

Another important service to the automobile driver was adopted in 1915. The service provided assistance to motorists in trouble. Some of the most common problems were getting stuck in mud, having a flat tire, running out of gas, and having engine failure. Automobile clubs had been formed in large part to assist with these problems, but having a national organization to help all members was a great accomplishment. Since many automobile difficulties occurred when a driver was far from home, a national organization was a wonderful aid. Drivers no longer had to travel with local club members to be secure.

Impact of Event

The American Automobile Association is a not-for-profit federation. In 1993, there were 139 automobile clubs affiliated with the AAA. Since the relationship between the AAA and its affiliated clubs varied, the services provided for members varied depending on the member's home club. There were more than one thousand offices in the United States and Canada and approximately thirty-two thousand employees. The AAA offered many services to its thirty-four million members. These services included emergency road service, travel-related services, and a car buying guide.

In 1936, the American Automobile Association made it mandatory for all affiliated clubs to provide emergency road service. The services included towing, opening a locked vehicle, supplying gas, and fixing mechanical failures. There were more than thirteen thousand facilities contracted by the AAA to provide these services in 1992. In that year, the AAA fielded approximately twenty-two million calls for emergency assistance. Towing was free of charge to members for a tow no more than three miles. Members also received flat tire service, battery recharging, and lockout assistance free of charge. Members who ran out of gas got free delivery of gas but paid for the gas itself.

A slightly more expensive membership called AAA Plus included several other services free of charge. These included tows of up to one hundred miles, delivery of two gallons of gas, reimbursement of up to $700 for trip interruptions resulting from

an accident, and insurance of $300,000 for an accident. The exact services varied from club to club, and not all affiliated clubs offered extended service.

Nearly 950 AAA travel agencies throughout the United States and Canada provided maps and guidebooks for all states free of charge to members. In 1992, there were more than seventy different maps available for the United States and Canada, along with nine foreign maps. Approximately forty-two million maps were produced for 1992 alone. A member could even request a map highlighting the best route to his or her destination, free of charge. This service was first offered in 1932. In 1992, the AAA provided members with more than eight million of these highlighted maps. These maps included information on construction, detours, total miles, driving time, and schedules for ferries.

The AAA published its first guidebook in 1917. The guidebooks produced by the AAA in 1992 contained information on more than thirty thousand hotels, motels, bed and breakfast inns, and restaurants. Several books covered Europe, Mexico, and the Caribbean. In 1992, the AAA distributed thirty-seven million travel-related books.

AAA travel agencies provided services for purchasing airline, cruise, and train tickets. In 1992, these agencies sold airline tickets to nearly three million customers. Services from these agencies also provided traveling customers with reservations for rental cars and hotel accommodations. Members could purchase travel insurance policies from the AAA travel agencies, which sold more than $1.6 billion worth of services in 1992.

In 1989, the AAA added another publication to its vast list, an automobile buying guide. It included information on more than one hundred new vehicles, reporting on safety, driving performance, emission rates, and maintenance. This book was not free to members but was available at most clubs.

The American Automobile Association has also been involved in community services. It offered courses to train driver education instructors and educate people about drinking and driving. The AAA also organized safety patrol programs at elementary schools across the United States, greatly reducing the number of accidents involving child pedestrians. The AAA has also sponsored traffic safety courses in high schools.

The AAA remained or became involved in every aspect of travel. The goal of making travel easier for the automobilist was maintained and applied to all types of travel. The board of directors approved of mandatory seat belt laws in 1985. Shortly after, the AAA started a program advocating the use of seat belts.

The fight against increased taxes on automobiles has always been a priority. A tax on registration fees and wheels was defeated in 1914 with the help of the AAA. In 1921, a federal tax on all cars and trucks was vetoed as a result of efforts by the AAA. The American Automobile Association constantly supports bills aiding the automobilist, including bills increasing safety and improving highways.

After reaching thirty million members in 1989, the AAA moved its headquarters to Heathrow, Florida. The AAA continued to fight for better roads and highways in the United States, as it had throughout its history. The AAA helped automobilists get the

best price for gasoline by inspecting stations and reporting prices. After conducting several studies, the AAA supported the increased speed limit of sixty-five miles per hour outside major cities. Advanced technology was continually used by the AAA to better serve its customers. A system to link databases in order to provide better service for roadside emergencies was completed in 1991. A joint venture with American Express provided travelers with weather reports. In 1992, Paul R. Verkuil became the president of the American Automobile Association, promising to maintain and further the established ideals of the association.

Bibliography

Csere, Csaba. "Is the AAA on Our Side Again?" *Car and Driver* 38 (May, 1993): 25. Discusses the AAA decision to support the sixty-five-mile-per-hour speed limit. Describes the conflict between the different divisions of the AAA and studies supporting the higher speed limit.

Eng, Paul M. "Bits and Bytes." *Business Week* (August 12, 1991): 64D. Discusses the AAA's use of technology to link data of service stations to provide better service for roadside emergencies.

"Gasoline Prices Higher." *The New York Times*, May 19, 1993, p. D20. A report by the American Automobile Association to assist automobile drivers. Discusses prices and costs of gasoline and the most economical methods to get gas.

Partridge, Bellamy. *Fill' er Up*. New York: McGraw-Hill, 1952. Discusses the life of an automobile driver during the first fifty years of the automobile. Gives details on automobile clubs and the formation of the American Automobile Association. Describes hardships and setbacks experienced by the automobilist. Discusses laws concerning the automobile.

Weaver, Peter. "Weather Reports for Travelers." *Nation's Business* 79 (April, 1991): 61. Discusses joint services from American Express and the AAA, including a new weather service available to travelers.

Dan Kennedy

Cross-References

Hashimoto Forms the Roots of Nissan Motor Company (1911), p. 185; Ford Implements Assembly Line Production (1913), p. 234; The Number of U.S. Automakers Falls to Forty-four (1927), p. 533; General Motors and the UAW Introduce the COLA Clause (1948), p. 943; Arab Oil Producers Curtail Oil Shipments to Industrial States (1973), p. 1544; The United States Plans to Cut Dependence on Foreign Oil (1974), p. 1555; Carter Orders Deregulation of Oil Prices (1979), p. 1699.

INTERNATIONAL HARVESTER COMPANY IS FOUNDED

Categories of event: Foundings and dissolutions; mergers and acquisitions
Time: August 12, 1902
Locale: New York, New York

The formation of International Harvester created a manufacturing giant and brought some order to the fiercely competitive farm machinery industry

Principal personages:
CYRUS HALL MCCORMICK (1809-1884), an inventor and manufacturer of mechanical reapers, founder of the McCormick Harvester Company
WILLIAM DEERING (1826-1913), an industrialist and manufacturer of harvesters and grain binders, founder of the Deering Harvester Company
GEORGE W. PERKINS (1862-1920), a partner at J. P. Morgan & Company, architect of International Harvester and member of its board of directors
NETTIE (NANCY) FOWLER MCCORMICK (1835-1923), the wife of Cyrus Hall McCormick who upon his death presided over the family business
CYRUS H. MCCORMICK (1859-1936), the son of Cyrus Hall and Nettie McCormick; the first president of International Harvester
ELBERT HENRY GARY (1846-1927), an attorney and chairman of the United States Steel Corporation

Summary of Event

After much deliberation and several failed attempts, International Harvester Company was formed on August 12, 1902. With assets valued in excess of $110 million and control of nearly 85 percent of harvester and reaper production in the United States, the company was a combination of McCormick Harvester Company; Deering Harvester Company; Warder, Bushnell & Glessner Company; Plano Manufacturing Company; and Milwaukee Harvester Company. The creation of International Harvester, along with similar mergers that led to the formation of Allis Chalmers in 1901 and Deere and Company in 1911, grew out of the severe economic hardships and uncertainty of the 1890's and the fierce competition that had come to dominate the harvester and farm machinery industries. Competition had become so harsh and so damaging to its participants that the era is referred to as the "harvester wars." The consolidation of bitter rivals, most notably the union of McCormick and Deering, was an attempt to bring stability and ultimately profitability back to an industry reeling from years of cutthroat competition and costly patent disputes.

The manufacture and distribution of harvesters and reapers was by the late nineteenth century one of the most conspicuous industries of the United States. It was also an industry dominated by a few large firms held within families, notably the McCormicks and the Deerings. The McCormicks had been in the reaper business from its

inception. Cyrus Hall McCormick secured his first patent on a mechanical reaper in 1834 and began selling reapers in 1841. By 1847, he was building a factory in Chicago that would help make him one of America's most prosperous business leaders. William Deering was not an inventor and entered the harvester trade in 1870, a generation after McCormick, but through aggressive policies and business abilities made a formidable challenge for leadership in the industry. Despite being challenged by Deering and a handful of other firms, and even after the death of Cyrus Hall McCormick in 1884, the McCormick Harvester Company remained the dominant force in the harvester industry.

The heated rivalry that existed between McCormick and Deering had over the years taken its toll on each company's profits and had created costly inefficiencies in distribution, losses to dealers, and oversaturation of the domestic reaper and harvester markets. Even though the so-called reaper kings recognized that an end to their costly rivalry would in the end be in both of their interests, all earlier attempts at combination had failed. In 1891, 1897, and again in 1901, some type of an agreement seemed close at hand, but differences and old rivalries were always too great to overcome. When William Deering retired in 1901, his sons, Charles and James, took over the management of the company. This renewed hopes that some sort of an agreement finally could be reached in the harvester industry.

The merger was accomplished with the intervention of outside business interests and the assistance of some of the nation's most prominent business leaders who had a vested interest in restoring and promoting economic stability in a leading American industry and who also had personal ties with both the McCormick and Deering families. One of these businessmen was John D. Rockefeller, Jr., whose sister Edith had married one of the sons of Cyrus Hall McCormick, Harold, in 1895. Along with Elbert Henry Gary, chairman of the United States Steel Corporation and a former attorney for William Deering, Rockefeller helped foster the merger that ultimately would bring an end to the harvester wars.

Established business leaders had reason to fear the instability and destructiveness produced by price wars and cutthroat competition. In early 1902, Gary telephoned the McCormicks to discuss what he and others perceived as a disruptive development in the harvester industry. In an attempt to cut the rising cost of raw materials, the Deerings recently had purchased iron ore deposits and were building their own rolling mill. These developments held the potential to prolong and intensify the harvester wars. Even worse for Gary and other industrialists, it could have broadened the type of predatory competition that monopolies and established business leaders were eager to avoid. The last thing Gary and U.S. Steel wanted was large manufacturing firms beginning their own steel operations. It became apparent that a consolidation of the leading harvester companies held distinct economic advantages for firms in that industry as well as for others.

The details of the merger were worked out over the summer of 1902 in various New York hotel rooms and in the Wall Street offices of J. P. Morgan. The chief negotiator for Morgan was George W. Perkins. Perkins, at the time the youngest partner at

Morgan, is widely credited with accomplishing what for so long had seemed beyond reach, the creation of a harvester trust. The merger that created International Harvester was organized by the Morgan firm and carried out by Perkins. Even the name of the new corporation was suggested by Perkins. The McCormicks and the Deerings both acknowledged the fact that overseas markets were going to be a large and profitable part of future expansion, prompting inclusion of the word "international" in the new company's name.

International Harvester was the sum of the assets of the five smaller harvester companies. To avoid costly antitrust litigation, the merger called for the purchase of the physical assets of the companies rather than of stock in them. After the merger, to provide continuity, to protect the new corporation from speculators, and in an attempt to keep peace between the McCormicks and the Deerings, control of the new corporation was placed in a voting trust for the first ten years. This voting trust was given absolute control over the operation of the corporation and acted on behalf of all stockholders. The trust was made up of Cyrus Hall McCormick's eldest son, Cyrus, William Deering's eldest son, Charles, and George Perkins.

The operation of International Harvester was at first a literal combination of the properties and departments of the five companies that had merged. The corporation's executive officers were named to provide a balance of power among the old rivals, but given the initial leverage of the McCormick Harvester Company, the balance leaned somewhat in favor of the McCormick family. Cyrus H. McCormick was named the first president of International Harvester, while Charles Deering was named chairman of the board. Harold McCormick, James Deering, J. J. Glessner, and William H. Jones of the Plano Manufacturing Company all were named vice presidents of the new corporation.

Impact of Event

The creation of International Harvester, like similar mergers in steel, electrical manufacturing, and other heavy industries, signaled both an end to the traditional, family-oriented firms that had dominated in the nineteenth century and the emergence of the modern corporations that would come to dominate in the twentieth century. Modern corporations tend to hire professional managers, exploit economies in production, operate across large markets, and rely upon more public and sophisticated methods of finance. Ultimately, International Harvester would accomplish these things and become a modern corporation, but first it had to be forged out of the rivalries of the leading and distrustful harvester companies.

The emergence of International Harvester also signaled the importance and the impact of the interaction between many of America's leading industries. Industrialists attempted to protect their markets and to rely upon large trusts to provide a more stable economic environment. Clearly, the involvement of Elbert Henry Gary in the negotiations to create International Harvester demonstrates that U.S. Steel, the nation's largest steel manufacturer, was concerned about protecting its market. The list of prominent American bankers and industrialists involved in the creation of the har-

vester trust implies that many business leaders had influence and interests across industries.

The substantial role played by J. P. Morgan & Company in the formation of International Harvester emphasizes how the role of financing had changed by the turn of the century. Because of the size and complexity of emerging corporations, the days of widespread internal and family-based financing were gone. Corporations and even the federal government had been turning to J. P. Morgan in the 1890's and 1900's to help settle financial problems. In addition to its role in the International Harvester merger, Morgan's firm had played a role in the formation of General Electric, American Telephone and Telegraph, Federal Steel, and U.S. Steel.

The formation of such large manufacturing enterprises as General Electric in 1891, U.S. Steel in 1901, and International Harvester in 1902 was indicative of the trend by American corporations to develop and exploit economies of production. Larger firms hoped that by increasing their scale of output they would accordingly lower their average costs of production, distribution, and financial management by avoiding duplication of tasks. After the merger, International Harvester pursued a policy of enlarging both its scale of production and its scope of operations.

In the years after the merger, International Harvester expanded its own production facilities, acquired additional machinery shops, and developed new product lines. The development of new product lines was easier after the merger, since intense competition during the harvester wars had led to reductions in research and development budgets. The company now could afford to devote resources to long-term research. It began experimenting with gasoline engine tractors in 1905 and within a few years was marketing a successful line of tractors. Eventually, product lines included trucks, automobiles, construction and earth-moving equipment, lawn and garden equipment, compressors, generators, and pumps for mining natural gas.

Another significant aspect of International Harvester was the company's part in the movement of American manufacturing firms into international markets. In the years from 1903 through 1909, International Harvester opened production facilities in Canada, Sweden, Germany, France, and Russia. True to the name of the new corporation, it began to aggressively market its growing line of farm machinery across Europe, Africa, South America, and Russia. In four years, the volume of trade with Russia reached a level equal to the total volume of U.S. farm machinery exports at the time of the merger.

The formation of International Harvester created a manufacturing giant but did not immediately end the years of rivalry within the harvester industry. Although the merger technically had created a harvester trust, the corporation retained the old companies as separate divisions of the new corporation. These separations were easy to define, since the new corporation kept separate brand names as late as 1909. Despite the efforts of George Perkins, it became obvious that old rivalries were not going to disappear simply because of the merger.

Unfortunately for International Harvester, there was a price to pay for the continuation of these old, but now internal, rivalries. Its early years did not produce the

economic bounty that was expected. Profits were lower than anticipated, and production declined. Perkins, again with the help of Gary, sought in 1906 to negotiate a settlement between the McCormicks and Deerings. This time the agreement meant a reorganization and restructuring of the company. After these reforms, which further reduced the direct influence of the family managers, the corporation went public in 1908. International Harvester entered into an era of substantial expansion and prosperity marred only by a protracted antitrust battle with the justice department.

Bibliography

Casson, Herbert N. *The Romance of the Reaper.* New York: Doubleday, Page, 1908. A history of the mechanical reaper in the United States. Tells the story of the McCormick, Deering, and International Harvester companies.

Garraty, John A. *Right-Hand Man: The Life of George W. Perkins.* New York: Harper & Brothers, 1957. A well-written and thorough biography of the person who negotiated the creation of International Harvester. Contains a detailed and documented account of the formation of the harvester trust.

Hutchinson, William T. *Cyrus Hall McCormick.* 2 vols. New York: D. Appleton-Century, 1935. The standard and detailed biography of McCormick. The volumes are subtitled *Seedtime, 1809-1856,* and *Harvest, 1856-1884.* They deal with the invention of the reaper, the operation of the company's factory in Chicago, numerous patent disputes, and aspects of McCormick's public and private life.

McCormick, Cyrus. *The Century of the Reaper.* Boston: Houghton Mifflin, 1931. A history of the reaper and farm equipment industry written by the grandson of Cyrus Hall McCormick.

Roderick, Stella Virginia. *Nettie Fowler McCormick.* Rindge, N.H.: Richard R. Smith, 1956. The life and times of the wife of Cyrus Hall McCormick. She played a significant role in the family business; in a different era she likely would have been its president after her husband's death in 1884.

Tarbell, Ida M. *The Life of Elbert H. Gary: A Story of Steel.* 1925. Reprint. New York: Greenwood Press, 1969. A valuable biography of Gary, describing his career as one of America's leading industrialists.

Wendel, C. H. *One Hundred Fifty Years of International Harvester.* Sarasota, Fla.: Crestline, 1981. An insightful history of the reaper and the companies that came together to form International Harvester. Contains an impressive collection of pictures and diagrams that provide a wonderful overview of the farm equipment industry as illustrated by the evolution of its products.

Timothy E. Sullivan

Cross-References

Morgan Assembles the World's Largest Corporation (1901), p. 29; Cement Manufacturers Agree to Cooperate on Pricing (1902), p. 35; Singer Begins Manufacturing Sewing Machines in Russia (1905), p. 103; Ford Implements Assembly Line Production (1913), p. 234.

TOBACCO COMPANIES UNITE
TO SPLIT WORLD MARKETS

Category of event: Monopolies and cartels
Time: September 27, 1902
Locale: England and New York, New York

The American Tobacco Company, a classic trust, and Britain's Imperial Tobacco Company combined to form the British-American Tobacco Company and agreed to divide world markets

Principal personages:

JAMES BUCHANAN DUKE (1856-1925), a founder of American Tobacco and the force behind its drive to near monopoly

RICHARD JOSHUA "JOSH" REYNOLDS (1850-1918), a onetime Duke competitor, then collaborator with American Tobacco

WILLIAM COLLINS WHITNEY (1841-1904), a financier, philanthropist, and principal director of American Tobacco

WILLIAM HENRY WILLS (1830-1911), a British financier, member of Parliament, and chairman of W. D. & H. O. Wills

Summary of Event

Establishment of the first American Tobacco Company (dissolved in 1911) and passage of the Sherman Antitrust Act occurred almost simultaneously in 1890. The two events revealed the two principal sides of America's unprecedented thrust toward the premier position among the world's industrial and financial giants. One side, manifested initially by evolution of the country's great railroad empires during the last third of the nineteenth century and then by the trustification of scores of enterprises (tobacco among them), reflected individual as well as national pride in sheer size, productivity, power, and economic freedom, attended by all of their social, political, and economic consequences. The other side registered widespread populist inclinations and the fears of interest groups that perceived corporate trusts and monopolies as threats to themselves and to the United States' economic system and its spirit of free competition.

The American Tobacco Company within two decades became a classic trust with international ramifications. It sprang from the entrepreneurial drive and genius of James Buchanan Duke, who was born poor near Durham, North Carolina, in 1856. His family, particularly his father, Washington Duke, had considerable experience in the complexities of tobacco culture and marketing. When Duke finished his modest education at the Eastman Business College in Poughkeepsie, New York, he joined his father in 1878 in the business enterprise of W. Duke Sons and Company. The company devoted its manufacturing efforts chiefly to cigarettes, which had gained popularity rapidly after the Civil War. Although the Dukes prospered, their sales for years

regularly lagged far behind leading brands such as W. T. Blackwell's famed Bull Durham line.

What propelled the Duke firm to leadership among the nation's cigarette manufacturers by 1890 was James's gamble a few years earlier on the acquisition of secret contractual rights to James A. Bonsack's cigarette-making machine, the first of several that would ensure the company's technological edge on competitors. Eager to direct the firm's interests personally, Duke moved to New York in 1884. In 1890, he founded the American Tobacco Company (chartered in New Jersey), representing a merger of five of the country's principal cigarette makers. American Tobacco controlled 90 percent of the nation's cigarette business and had annual profits exceeding $4 million.

Duke's subsequent campaigns were aimed at driving all manufacturers of tobacco products, competitors or not, into sellouts, mergers, and other forms of control by his firm, or out of business. Employing the profits from American Tobacco's cigarette business, Duke sought primacy over the plug tobacco (compressed cakes of chewing tobacco) trade. A corporate battle from 1894 to 1897 involved American Tobacco's purchase of five firms producing smoking tobacco, snuff, cheroot, and plug tobacco. These firms provided the wedge for American Tobacco's successful entrance into plug production. Continuing reliance upon cigarette profits to finance his battle, Duke underpriced many competitors and so wearied others, such as Richard Joshua "Josh" Reynolds' Liggett & Myers, that he was able in 1898 to absorb competitors into a new plug combination, the Continental Tobacco Company, essentially a holding company dominated by Duke and his American Tobacco directors.

Almost simultaneously, powerful eastern financiers including William Collins Whitney, Thomas Fortune Ryan, and P. A. B. Widener acquired two major smoking tobacco firms, along with stock in others, to form the Union Tobacco Company. In this case too a deal was struck, and Union was sold to Duke for $12.5 million. The financiers obtained or retained directorships in American and in Continental, and Duke enjoyed access to the financiers' vast capital resources. By 1900, Duke's Continental Tobacco and American Tobacco were producing 62 percent of the nation's plug tobacco, 59 percent of its smoking tobacco, 80 percent of its snuff, and more than 92 percent of its cigarettes. Only cigar manufacturing, an anomaly because large cigars were handmade products, lay substantially outside Duke's control.

Integrating American Tobacco and Continental, Duke and his cohorts formed the Consolidated Tobacco Company (a holding company) in 1901. With augmented capital, the company turned to overseas markets. It was no stranger to these, for in the 1890's Duke had established dealerships in Australia, Canada, Germany, Japan, and England. Declining profits in England, however, persuaded Duke to mount a serious invasion of the British market that began with Consolidated's purchase of Ogden's Limited, a major British tobacco manufacturer.

Instantaneously alarmed, thirteen of Britain's largest tobacco manufacturers combined to form the Imperial Tobacco Company of Great Britain and Ireland, Limited. These manufacturers included the formidable firms of W. D. & H. O. Wills, John

Player and Sons, Lambert & Butler, Hignett's Tobacco Company, and J. & D. MacDonald of Glasgow, led by William Henry Wills. To hold its turf, Imperial early in 1902 proffered bonuses to businesses that consented to boycott American's products, hoping thereby to marshal the allegiance of Britain's major retailers. Through Ogden's, Duke countered by agreeing to distribute the entire net profits from his firm's British sales over the next four years, plus an additional £200,000 annually to retailers who handled American's products. Although Imperial initially threatened to counterattack by establishing factories in the United States, seven months after its formation it entered into a contractual agreement with American Tobacco. Under terms of the agreement, reached on September 27, 1902, the two great combinations parceled out world markets between them.

Impact of Event

Negotiations between James Duke's trusts and the Imperial combination presided over by William Henry Wills produced two documents. The first provided for the transfer of Ogden's and all of its assets to Imperial, so that the American trust and the British combination could proceed with profitable territorial divisions. To achieve this, a second document created a new corporation, the British-American Tobacco Company, Limited. The new company was subject to joint but unequal ownership by American (the controlling partner) and Imperial and controlled the export trade.

Imperial retained the right to purchase and cure the U.S. tobacco leaf that was essential to its British operations but consented, except when in company with American or its subsidiaries, not to sell its products in the United States or in American dependencies such as Cuba, Hawaii, Puerto Rico, and the Philippines. American Tobacco, in return, agreed to refrain from interference in Imperial's domestic markets, except when and if Imperial interests invited it to do so. The British-American Tobacco Company, as the designated authority over international markets and exports of Imperial, Ogden's, American Tobacco, Continental Tobacco, Consolidated Tobacco, and American Cigar Company, was authorized to purchase all the assets—tangible and intangible—of the export businesses already managed by these companies. These included, for example, W. D. & H. O. Wills' Australian division as well as American Tobacco's German subsidiary, George A. Jasmatzi Company, along with many others around the globe.

Capitalized at $2.3 million, two-thirds of which in 1904 belonged to Duke's American Tobacco, and further buttressed by the capitalization of constituent companies of the combination in excess of $235 million, British-American soon conducted export business of its constituent companies in every country in which tobacco was not a state monopoly or in which tariffs or taxes—as in Germany, France, Italy, and Japan, as examples—largely precluded extensive or profitable sales.

British-American enjoyed immense advantages in many international markets. When it commenced operation in 1903, it produced 89 percent of the world's snuff, 84 percent of its cigarettes, about 76 percent of its fine cut and its plug tobacco, and 67 percent of its smoking tobacco and little cigars. As time and market dictated, it sold

its products under its own name or under the various brand names of the companies for which it exported. As had been the practice of both American Tobacco and Imperial, British-American showed no compunction about marketing its brands as if they were the products of independent companies or even of competitors' manufacture. Advertising campaigns were heavily subsidized. Special, sometimes secret, incentives or rebates were offered to brokers and to dealers. British-American resorted to local price cutting through "fighting brands" when it wanted to undercut a competitor's price. Competitive brands frequently were imitated, and customers themselves were beguiled by such bonuses as free cigarettes or coupons.

James Duke's irrepressible leadership marked every operation throughout his tobacco empire. With the affairs of American Tobacco and its ancillary trusts well in hand by 1903, he turned eagerly to the new prospects offered by British-American. Europe offered few profitable enticements for the enterprise, but the contrary was true of mainland Asia and nearby islands. He devoted close attention to the cultivation and expansion of markets in these areas.

Like many American entrepreneurs in the years around the opening of the twentieth century, Duke shared the dream of almost limitless profits to be garnered from the dense populations of the Far East. The countries there did not present identical pictures of market potential. The tobacco trade in Japan was what the government decided it was. The markets of India and Australia, like those in nearly all parts of the British Empire, already had been richly developed by Imperial Tobacco prior to 1902. China was another matter. It was fast being carved into spheres of influence by Western as well as by Japanese governments and special interests during the last years of the nineteenth century and early decades of the twentieth. Britain's strongholds on mainland China centered on Shanghai and the access it afforded to the sixty to seventy million people who lived along the first thousand miles of the Yangtze River. This was the prime market and potentially the world's richest and most expansible export market for British-American Tobacco.

The tobacco smoking habit had come to China, as it had to the West, in the seventeenth century. By the early 1900's, this habit was satisfied overwhelmingly in China by cigarettes, British-American's specialty. The Chinese were witness, therefore, to every promotional tactic Duke had employed so successfully elsewhere, including massive advertising and the distribution of millions of free cigarettes to entice brokers, dealers, and customers. There was no lack of competition. The Chinese also manufactured cigarettes and other tobacco products. The Jian family's Nanyang Tobacco Company, for example, capably withstood competition from British-American into the 1920's. It finally failed as a result of tax policies of the Chinese government.

British-American was a persistent, omnipresent force in many markets. When the Japanese, for example, opened the Manchurian port of Dalny (now Dairen), Duke's export trust immediately opened for business there, offering substantially underpriced wares to beat Japanese competition. British-American succeeded worldwide and continued to do so after its legal "dissolution," along with that of the rest of Duke's

American Tobacco empire, by the U.S. Supreme Court in 1911. In fact, substantively very little changed as a result of the Supreme Court's antitrust decision against American Tobacco. Between 1910 and 1920, Duke companies accounted for the lion's share of U.S. exports of tobacco.

Bibliography

Durden, Robert Franklin. *The Dukes of Durham, 1865-1929*. Durham, N.C.: Duke University Press, 1975. A solid, engaging study of the fascinating James Duke, his family, and his intimates. Good material on Duke's dealings with Ogden's and creation of British-American. Many excellent photos. Ample notes replace bibliography. Useful index.

Jacobstein, Meyer. *The Tobacco Industry in the United States*. New York: Columbia University Press, 1907. A still useful, readable, and widely available study, with extensive coverage of American Tobacco and British-American. Many statistical tables. Ample, informative notes but no bibliography or index.

Jones, Eliot. *The Trust Problem in the United States*. New York: Macmillan, 1923. Old but very valuable. Chapter 8 is excellent on the development of the Duke empire and useful on British-American. Tables, ample notes, extensive and still pertinent bibliography. Fine index. Solid, clear, objective approach.

Ripley, William Z., ed. *Trusts, Pools, and Corporations*. Boston: Ginn and Company, 1916. Useful because of its fine selection of documents on many of the great trusts. Chapter 8 deals with the Environmental Tobacco empire and its expansion by means of British-American, using U.S. Bureau of Corporations documents. Informative, easily read, and valuable. Tables and notes. One of the standbys among scholars and laypeople.

Seager, Henry R., and Charles A. Gulick. *Trust and Corporation Problems*. 1929. Reprint. New York: Arno Press, 1973. Chapters 1-6 provide splendid background on the emergence of trusts and the arguments for and against them. Chapters 10 and 11 deal in detail with American Tobacco and its related companies, including the deal to form British-American. Some tables, full notes, extensive and still valid bibliography, and fine index.

Stevens, William S., ed. Industrial Combinations and Trusts. New York: Macmillan, 1913. Valuable edited documents and commentary relevant to the development of major trusts. Chapters 7 and 8 are extremely valuable. In them are the Imperial-American Tobacco agreements. Tables, some notes, no bibliography or index.

Whitney, Simon N. *Antitrust Policies: American Experience in Twenty Industries*. 2 vols. New York: Twentieth Century Fund, 1958. Sophisticated and authoritative, yet readable. Chapter 11 deals with the Tobacco Trust, American Tobacco, Imperial, and British-American. Centers on the dissolution of American Tobacco. Useful notes replace a bibliography. Some tables and an excellent index.

Clifton K. Yearley

Cross-References

Morgan Assembles the World's Largest Corporation (1901), p. 29; Cement Manufacturers Agree to Cooperate on Pricing (1902), p. 35; The Supreme Court Rules Against Northern Securities (1904), p. 91; The Supreme Court Decides to Break Up Standard Oil (1911), p. 206; The Supreme Court Breaks Up the American Tobacco Company (1911), p. 212.

CHAMPION V. AMES UPHOLDS FEDERAL POWERS TO REGULATE COMMERCE

Category of event: Retailing
Time: 1903
Locale: Washington, D.C.

The U.S. Supreme Court, through its broad interpretation of the commerce clause in Champion v. Ames, *sustained federal powers to prohibit and regulate commerce*

Principal personages:
MELVILLE W. FULLER (1833-1910), the Chief Justice of the United States, 1888-1910
JOHN MARSHALL HARLAN (1833-1911), an associate justice of the U.S. Supreme Court, 1877-1911
JOHN MARSHALL (1755-1835), the Chief Justice of the United States, 1801-1835
ALBERT J. BEVERIDGE (1862-1927), a U.S. senator, 1899-1911, influential in passage of the Meat Inspection Amendment

Summary of Event

In 1903, the U.S. Supreme Court upheld the federal government's potential to prohibit or restrict commerce. The case of Champion v. Ames, also known as the Lottery Case, altered the delineation between interstate and intrastate commerce under article I, section 8, clause 3 of the U.S. Constitution, the so-called "commerce clause."

The circumstances brought before the Court originated in 1895 with an act of Congress. This act made it illegal to transport or conspire to transport lottery tickets from state to state. On February 1, 1899, C. F. Champion sent two Pan-American Lottery Company lottery tickets from Dallas, Texas, to Fresno, California. The tickets were transported by a vehicle owned by the Wells-Fargo Express Company. Champion was arrested in Chicago under a warrant based on his alleged violation of the act.

In 1903, the case was appealed to the U.S. Supreme Court for final review. The Court rendered its opinion in a five-to-four decision to uphold the conviction. Justice John Marshall Harlan delivered the majority opinion of the Court, while Chief Justice Melville W. Fuller gave the dissenting opinion.

When the Lottery Case appeared before the Court, the power to regulate interstate commerce was a concurrent power shared by the states and the federal government. Prior to the Lottery Case, several decisions had begun the process of liberalizing the connotation of "interstate," favoring federal control. One such case is *Gibbons v. Ogden* (1824). This decision played a major role in the Court's final disposition of the Lottery Case by initiating a method for analyzing commerce issues. A review of the facts in *Gibbons* shows that the state of New York granted a monopoly to Robert

Livingston and Robert Fulton in the operation of steamboats in the waterways of New York. Aaron Ogden managed, under the monopoly, two licensed steamboats ferrying between New York and New Jersey. Thomas Gibbons obtained a coasting license under a 1793 act of Congress and began competing with Ogden.

Gibbons' steamboat was not licensed to operate under the New York monopoly. The pressure of additional competition encouraged Ogden to bring action in a New York Court to prohibit Gibbons from operating. Writing for the majority, Chief Justice John Marshall delivered the opinion of the Supreme Court, which held the New York monopoly law to be unconstitutional. In *Gibbons*, the Court aspired to denote interstate commerce. Gibbons' attorneys argued that it is traffic, to buy and sell, or the interchange of commodities. The Court agreed that interstate commerce includes traffic but added the notion of intercourse.

Generally, intercourse portrays exchange between persons or groups. With this notion, the Court reasoned that interstate commerce does not end at external boundary lines between states but may be introduced into the interior. They determined that commerce may pass the jurisdictional line of New York and act upon the waters to which the monopoly law applied, thus concluding that the transportation of passengers between New York and New Jersey constituted interstate commerce.

In the *Champion v. Ames* decision, the Court went on to reference other decisions that sanction federal authority. These cases continued to expand the essence of interstate commerce. Consequently, the Court resolved that commerce embraces navigation, intercourse, communication, traffic, the transit of persons, and the transmission of messages by telegraph.

In the Lottery Case, the use of a vehicle from Wells-Fargo Express traveling from state to state was relevant. The Court held that this travel provided sufficient intercourse with interstate commerce to allow federal domination. Further, the Court viewed the congressional justification for the creation of the act as being rational. It determined that the federal government is the proper means for protecting U.S. citizens from the widespread pestilence of lotteries. The Court deemed that such an evil act of appalling character, carried through interstate commerce, deserves federal intervention.

Chief Justice Fuller's dissenting opinion stated that the Court had imposed a burden on the state's powers to regulate for the public health, good order, and prosperity of its citizens. To hold that Congress has general police power would be to defeat the operation of the Tenth Amendment. This argument would constitute the foundation of many later dissenting opinions. This particular conviction never became the majority view.

At the time of the Lottery Case, there was an escalating struggle between a desire for a strong federal government, called federalism or nationalism, and the states' right to regulate themselves. This conflict roots itself as far back in U.S. history as the Constitution itself. After the war for independence with England, the states regarded themselves as independent sovereigns. The Articles of Confederation allowed only minimal intrusion into states' internal affairs by the Continental Congress.

Faced with the inability of the confederation to function properly, provincial patriotism had to concede. The delegates at the Constitutional Convention, in an effort to fabricate a more concentrated federal government, made many compromises. They maintained within the Constitution, however, certain seemingly inescapable limits on the federal government. As a consequence, the judiciary generally discerns the Constitution as being a limitation on federal power. Without an expressed or implied grant of authority from within the Constitution, the federal government cannot regulate.

This policy is not easily implemented in cases concerning commerce. Under the commerce clause, Congress has the authority to regulate commerce with foreign nations and among the several states and with Native Americans. The commerce clause seems to conflict with the Tenth Amendment. This amendment assigns all rights to the states, unless such control is prohibited or delegated to the U.S. government by the Constitution. The Tenth Amendment is said to contain the states' police powers. Further, the Constitution does not expressly exclude states from regulating interstate commerce. It simply limits the federal government's jurisdiction over interstate trade and precludes interference with purely local activities.

To add another complication, consider the supremacy clause, article VI, paragraph 2. This states that if legitimate state and federal powers are in conflict, then the national interest will prevail. This power is enhanced by the Court's broad interpretation of the "necessary and proper clause" (article I, section 8) in *McCulloch v. Maryland* (1819). This ruling gave Congress a discretionary choice of means for implementing implied powers.

From a political perspective of the Court, it is notable that *McCulloch* and *Gibbons* were before the Court while John Marshall was chief justice. Marshall served under President John Adams as the secretary of state and was a devout federalist. During Marshall's tenure as chief justice, the Court vested within its jurisdiction an unusual allotment of power. It assigned to itself final interpretation rights over the constitutionality of all federal and state laws brought before the Court.

Impact of Event

The ruling given in the Lottery Case had an immediate influence on society. Social reformers quickly seized upon the rationale provided by the Court and began prompting Congress to regulate. In 1906, Senator Albert J. Beveridge successfully proposed a Meat Inspection Amendment to an appropriations bill. The amendment prohibited the interstate shipment of meats that had not been federally inspected.

The amendment received an influential recommendation from President Theodore Roosevelt. Additionally, Upton Sinclair's novel *The Jungle* (1906) greatly intensified popular support for Beveridge's cause. Sinclair was an active socialist. His publication characterized the life of a worker in the Chicago stockyards and induced President Roosevelt to investigate the meatpacking industry. During the same term, Congress also approved the Pure Food and Drug Act.

Later, Beveridge would propose another bill based on the commerce clause. This

legislation attempted to exclude from commerce goods produced by child labor. Beveridge was certain that the Lottery Case settled the constitutionality of his proposal. Convincing his colleagues of this would prove to be arduous and unsuccessful. When Congress finally passed the Child Labor Act of 1916, the Court would declare it unconstitutional in *Hammer v. Dagenhart* (1918). It would take another decade before such a law would be held valid under constitutional scrutiny by the Court.

Despite this setback, the precedent established in the Lottery Case was adequate to sustain a wide variety of laws. These statutes limit the movement of harmful goods. During the early twentieth century, the Court upheld the exclusion from interstate commerce of impure foods, white slaves, obscene literature, and articles designed for indecent and immoral use.

With only some antithesis, the Court continued to reform the meaning of interstate commerce to enhance federal control. A greatly extended application of the clause can be found in *Heart of Atlanta Motel v. United States* (1964). This case implicated the constitutionality of Title II of the Civil Rights Act of 1964. The act strives to eliminate racial discrimination in hotels, motels, restaurants, and similar places. The owners of the Heart of Atlanta Motel disputed the constitutionality of the act. It was the motel's policy to refuse lodging to people of color. It advertised in several surrounding states, and approximately 75 percent of its guests were from other states.

The Court upheld the constitutionality of the act. The tests employed by the Court were whether the activity is commerce that concerns more than one state and whether the act showed a substantial relation to a national interest. The Court postulated that the operation of a motel might appear local in nature, but it did affect interstate commerce. The Court resolved that a motel accommodating interstate travelers is engaged in commerce that concerns more than one state.

Again, as in the Lottery Case, the Court determined that the evil averted by the act was a legitimate national concern. The rationale offered by the Court in *Heart of Atlanta Motel* exhibits the accumulation of many years of precedents. The Court asserted that the same interest that led Congress to deal with segregation prompted it to control gambling, criminal enterprises, deceptive practices in the sale of products, fraudulent security transactions, improper branding of drugs, wages and hours, members of labor unions, crop control, discrimination against shippers, the protection of small business from injurious price cutting, and resale price maintenance at terminal restaurants. The Court affirmed that Congress, in many of these examples, was regulating against moral wrongs. It concluded that segregation is a valid moral issue that would support the enactment of the Civil Rights Act.

The Court has applied various constitutional tests to interstate commerce throughout its history. Initially, the Court viewed interstate commerce as physical movement between states. Soon it began examining federal jurisdiction based on the direct versus indirect influences the law in question has on interstate commerce. By the middle of the twentieth century, the Court began examining if the purely local activity had an appreciable affect on interstate commerce.

Another offspring of the commerce clause is the Interstate Commerce Commission (ICC). The ICC consists of experts who aspire to protect and represent the public in matters of transportation in interstate commerce. This agency has immense powers and is not without its opponents.

The need to unite the country necessitated a strong centralized government, but debates persist over the effects ensuing from the expanding role of the federal bureaucracy. Some critics perceive the federal government as an inadequate regulator of business, particularly in the area of environmental protection. Other commentators reason that businesses have become dependent on, and continue to use the government as, a form of protection from competition. Still others sense that business enterprises cannot mature and flourish because of excessive government control.

The judiciary appears to recognize one conspicuous restriction on the federal government's authority. Regardless of how significant the legal arguments are, most courts hesitate to make decrees that will prohibit major industries from operating. In addition, certain potential negative economic effects, such as the loss of many jobs, particularly in the automotive, steel, and oil industries, act as subtle legal shields from overly zealous government intrusion.

Bibliography

Cox, Archibald. *The Court and the Constitution.* Boston: Houghton Mifflin, 1987. A well-organized approach to major Court decisions. The author was a former solicitor general and the first Watergate special prosecutor. He details how the Court has kept the Constitution an important instrument.

Fellmeth, Robert C. *The Interstate Commerce Omission.* New York: Grossman, 1970. Presents an encompassing view of the problems haunting the Interstate Commerce Commission. The Center for Study of Responsive Law produced the report, and Ralph Nader wrote the introduction.

Gunther, Gerald. *Cases and Materials on Constitutional Law.* 10th ed. Mineola, N.Y.: Foundation Press, 1980. A well-written textbook that discusses the immense area of constitutional law. The text has remarkable depth but has a tendency to ask more questions than it answers. It provides a superior foundation in beginning constitutional research.

Hilsman, Roger. *To Govern America.* New York: Harper and Row, 1979. An admirable compilation of data describing all features of government, including many peripheral aspects, such as philosophy and the future of American democracy.

Mason, Alpheus T., and Donald B. Stephenson, Jr. *American Constitutional Law: Introductory Essays and Selected Cases.* 10th ed. Englewood Cliffs, N.J.: Prentice-Hall, 1993. A commendable review and analysis of constitutional law. The authors take this complex subject and present it in a discernible manner.

Tindall, George B. *America: A Narrative History.* 2d ed. New York: Norton, 1988. A constricted narrative that shapes U.S. history into an eventful story. The account presents history in themes such as judicial nationalism.

Brian J. Carroll

Cross-References

The U.S. Government Creates the Department of Commerce and Labor (1903), p. 86; The Supreme Court Strikes Down a Maximum Hours Law (1905), p. 112; A Supreme Court Ruling Allows "Yellow Dog" Labor Contracts (1908), p. 140; The Supreme Court Rules Against Minimum Wage Laws (1923), p. 426; Congress Requires Premarket Clearance for Products (1938), p. 787; Roosevelt Signs the Fair Labor Standards Act (1938), p. 792; The Civil Rights Act Prohibits Discrimination in Employment (1964), p. 1229; The Supreme Court Orders the End of Discrimination in Hiring (1971), p. 1495.

DELAWARE BEGINS REVISING LAWS FOR INCORPORATION

Category of event: Government and business
Time: 1903
Locale: Delaware

The state of Delaware liberalized its corporation code to attract more companies to the state in an effort to establish a new source of revenue

Principal personages:
 WOODROW WILSON (1856-1924), the governor of New Jersey, 1910-1912
 ALFRED I. DU PONT (1864-1935), the chief executive of the Du Pont Corporation in 1902
 EBE TUNNELL (1844-1917), the governor of Delaware, 1897-1901
 SIMEON PENNEWILL (1867-1935), the governor of Delaware, 1909-1913
 CHARLES R. MILLER (1857-1927), the governor of Delaware, 1913-1917

Summary of Event

Under the leadership of Governor Ebe Tunnell, Delaware passed its original corporation law in 1899. The law was modified for the first time in 1903. The legislature made periodic changes to make the state more attractive to business owners outside Delaware. By 1915, Delaware had acquired a reputation as one of the easiest states in the country in which to incorporate. The legislature nurtured Delaware's reputation as a business-friendly state and continued to make changes to entice businesses. Many of these changes were encouraged by members of the state's famed Du Pont family. Others were prompted by outsiders, such as Governor Woodrow Wilson of New Jersey, whose changes in New Jersey's laws gave Delaware the chance to attract businesses that fled from New Jersey.

That the Du Ponts would influence Delaware's approach to incorporation was no surprise. Ever since Pierre Du Pont established his thriving explosives business in Delaware in the early 1800's, the family had influenced events in the state. By the end of the nineteenth century, Du Pont had established a virtual monopoly in the explosives industry. In fact, the government filed an antitrust suit against the company in 1907. That suit forced Du Pont to compete with two new companies created in response to the government's action, Atlas and Hercules. Both companies, however, were owned largely by members of the Du Pont family. Both were incorporated in Delaware, but neither of them manufactured any explosives in the state. The Du Ponts learned early how to circumvent antitrust laws, and they applied their knowledge to create liberal incorporation laws in Delaware.

Several members of the Du Pont family, most notably Alfred, Pierre, and Henry, encouraged the revisions in the state's corporation laws in the early 1900's. For example, at the urging of Governor Simeon Pennewill, the legislature modified its

corporation code in 1911 to permit incorporation of the Du Pont Boulevard Corporation, which formed to build and operate Delaware's first cross-state highway as a private enterprise. This was one of the earliest indications that the state legislature would revise the corporation laws as necessary to attract businesses and the income they would provide.

Ironically, one of the biggest boosts the legislature received in its pursuit of corporations came from the governor of New Jersey. Woodrow Wilson inadvertently became one of the biggest benefactors to Delaware's drive to attract businesses through liberalization of its corporation laws. New Jersey was one of the first states in the country to pass incorporation laws. By the mid-nineteenth century, New Jersey, along with Connecticut, Massachusetts, and New York, had passed general incorporation laws that applied to manufacturing, banking, and transportation companies. The Delaware government, on the other hand, was in no hurry to lose control over businesses.

In general, state governments in the late nineteenth century did not recognize, or chose to ignore, the benefits of corporations. They thought that corporations were by and large devices for making legal many acts that were detrimental to the public interest. In general, corporate leaders were viewed as people who used their power to exploit labor, stockholders, and the public.

There certainly was good cause to think that way. For example, in October 8, 1882, William H. Vanderbilt, president of the New York Central Railroad, allegedly said "the public be damned" in response to a reporter who asked whether he would compete with the Pennsylvania Railroad's newly introduced express service. There was a public uproar over his statement, which he subsequently denied making. Whether he said it, the words typified some tycoons' approaches to business and the public and accounted in part for Delaware's reluctance to establish corporation laws.

Legislators in Delaware, like their counterparts in many other states, preferred to pass a specific act to create each company instead of enacting general laws of incorporation. Therefore, more progressive eastern states, particularly New Jersey, more often became homes to large corporations. It took Delaware a while to recognize the benefits of general laws of incorporation. Once the state's leaders did, however, Delaware became the home to thousands of corporations of all sizes, engaging in a wide variety of businesses.

Perhaps the biggest boost to Delaware's switch from strict regulation of business to liberal incorporation laws was the antitrust movement that swept the United States in the late nineteenth and early twentieth centuries. There was a growing tendency to form trusts in many industries in the country in the late 1800's. Perhaps the most significant trust was that formed by the Standard Oil Company. The company, incorporated in New Jersey, became a symbol of all that was wrong with trusts. John D. Rockefeller used his position as the head of the world's largest oil company to ruthlessly squash competition, force railroads into giving him secret rebates, and influence political contests. By 1879, his company controlled 95 percent of the refining capacity in the United States. Rockefeller gave trusts a bad name.

Under a trust agreement, the stockholders of the companies whose boards of directors formed the trust deposited their certificates of shares of common stock with a board of trustees and received in exchange certificates of deposit from trustees. Boards of trustees were invested with the power to vote the number of shares of the operating companies they held. Thus, boards of trustees were able to elect members of the boards of directors of the operating companies whose common stocks were deposited with them and thereby control those companies' policies. These interlocking boards of trustees controlled entire industries, with trusts operating in railroads, tobacco, and oil. There were 266 trusts in existence by December 31, 1903, 234 of which had been formed between 1898 and 1903. The growth in trusts occurred despite the fact that federal laws such as the Sherman Antitrust Act and Interstate Commerce Act had been put in place to curb them. The zeal to limit trusts filtered down to state levels.

Governor Woodrow Wilson of New Jersey was a staunch antitrust advocate. Consequently, he strove to reduce the powers of the large corporations incorporated in New Jersey. In so doing, he opened the door to other states, most notably Delaware, to lure companies away. Before leaving office to assume the presidency of the United States, Wilson induced the New Jersey legislature to pass laws that severely inhibited corporations domiciled in the state. For example, the acts forbade holding companies, curtailed interlocking directorates, and provided for the revocation of charters as penalty for infractions of the laws. The laws were not received well in New Jersey, but they were in Delaware.

Corporate leaders believed that Wilson had transcended common sense in promoting these laws. They viewed the laws as personal affronts. Not only did the laws place severe restrictions on corporate activities, but they also attempted to make corporate guilt personal. One of Wilson's goals was to make corporate leaders responsible for companies' misdeeds. This did not sit well with executives, who believed that corporate charters should protect them from responsibility. Faced with the possibility of personal culpability, corporate leaders preferred to move elsewhere. Delaware was a promising choice.

By the beginning of the twentieth century, Delaware's legislators had grown envious of New Jersey's reputation as a home to corporations. Government leaders realized that there existed tremendous financial potential in liberalizing corporations laws. The turmoil in New Jersey presented them with a unique opportunity to lure companies into their state. New Jersey legislators were not about to lose, without a fight, their state's status as a home to thousands of companies and the financial advantages they presented. In 1920, under the leadership of the state's Democratic governor, Edward I. Edwards, the legislature repealed the laws promoted by Wilson, but the damage already was done.

Delaware liberalized its incorporation laws considerably during the early 1900's in an effort to attract businesses. Governors such as Simeon Pennewill (1909-1913) and his successor, Charles R. Miller (1913-1917), pushed for new laws designed to facilitate incorporation. The legislature gave up its traditional method of incorporating

one company at a time in recognition of the fact that the practice discouraged entrepreneurs from establishing businesses in the state. General incorporation quickly became the practice in Delaware.

One of the by-products of the new approach was an easing of the severe limits on executives' abilities to run their companies as they saw fit. The state's new laws allowed managers to run things as they liked with little or no interference from stockholders, directors, or government officials. The law also addressed the issue of executive responsibility. The corporation code, which became the model for other corporation codes across the country, empowered companies to purchase and maintain insurance against liability for their executives in the event of any wrongdoing "whether or not the corporation would have the power to indemnify [them] against such liability under the provisions" of the rest of the code. Loosely interpreted, Delaware's code was an invitation to corporations to provide executives with insurance protection that went beyond heretofore lax indemnification standards. This inclusion in the code provided added incentive for corporations seeking to move.

Other provisions in the code cut back on stockholders' interference in corporate operations. For example, the certificate of incorporation included a phrase "creating, defining, limiting and regulating the powers of . . . the stockholders . . . if such provisions are not contrary to the laws of this State." The vague wording did not actually stipulate that stockholders could not inspect company books. It did, however, give the corporation the right to establish exactly when stockholders could inspect the books and for what purpose, limiting inspections to times when they did not interfere unreasonably with the company's business.

The laxity in the code encouraged executives to experiment with their corporate bylaws with an eye to letting the courts decide whether the provisions were legal. One company included in its bylaws a provision that its board of directors alone would have the power to determine when—if at all—stockholders would be able to inspect its books. The specific bylaw stated explicitly that "except as provided above, no stockholder shall have any right to inspect any account, record, book or document of the Corporation."

The Delaware legislature imposed lower corporate franchise taxes than did competing states such as New York and Illinois. When corporate leaders in New Jersey looked for a new home, they did not have to search any farther than the state's southern boundary. There was a mass exodus to Delaware from New Jersey as well as other states, and new companies increasingly made Delaware their legal home.

Impact of Event

Applications for incorporation flooded Delaware. By 1974, there were seventy-six thousand corporations headquartered in the state, including such giants as General Motors, General Electric, and International Business Machines. Many of the companies emigrated from other states to take advantage of Delaware's liberal corporation code. Overall, the list included about one-third of the companies listed on the New York and American stock exchanges. The number of corporations translated to one for

every seven residents in the state. The state's liberal corporation laws gave people engaged in all types of businesses the opportunity to incorporate without ever setting foot in the state.

According to the state's code, corporations do not have to have any employees. In fact, they do not even have to maintain a physical presence in the state. All they have to do is operate legally within the liberal provisions of the code and pay the necessary franchise taxes. That means simply that they must, according to the code, "engage in any lawful act or activity for which corporations may be organized."

The income Delaware derived from the liberalization of its laws represented the biggest benefit to the state and had a major effect on its tax structure. The franchise taxes brought in by the influx of corporations became the state's second largest source of revenue. In addition, liberalization of the code created a thriving business among lawyers and incorporating firms whose primary goal was to help people from outside Delaware to establish their own corporations.

Perhaps the biggest advantage to Delaware lay in the way the corporation code affected the state's fiscal policies. In effect, the large number of corporations led to a two-tier financial structure. The state government obtained its revenues mostly from business and corporate taxes. Local income, on the other hand, came primarily from property taxes. Eventually, the state's tax structure changed to include a progressive income tax, but corporate franchise taxes continued to play an important role in Delaware's finances. Moreover, since a large number of the corporations headquartered in Delaware did not maintain a presence in the state, there was no need for large numbers of government workers to process paperwork. Thus, Delaware operated on a budget smaller than those of some major cities in the area, such as Baltimore and Philadelphia.

Companies, as well as the state, benefited from the liberalized laws. Executives realized early that Delaware's corporation code presented them with a set of well-established corporate law precedents. Over the years, many cases that reached the courts were settled quickly in management's favor. The stability in the judicial system alleviated executives' fears about falling prey to whimsical court decisions and strengthened their resolve to remain in Delaware. This stability had a dual effect: It discouraged people such as disgruntled stockholders from filing lawsuits against corporations, and it provided managers with a knowledge of exactly what they could and could not do. Executives knew that if they did end up in court for some reason, decisions would be handed down quickly, generally in management's favor. These were simply added incentives for corporations to move to Delaware.

Delaware's political and government leaders took advantage of other states' short-sightedness at the beginning of the twentieth century to build a strong, lucrative corporate base. Their success led other states to emulate Delaware's approach to liberalization in corporate codes. Consequently, competition among the states cut into Delaware's success to some extent. The number of new incorporations in the state diminished somewhat over the years. Nevertheless, Delaware remained the acknowledged leader in providing a liberal home for corporations of all types.

Bibliography

Aranow, Edward Ross, and Herbert A. Einhorn. *Proxy Contests for Corporate Control.* 2d ed. New York: Columbia University Press, 1968. This scholarly but simple to read book focuses on aspects of corporation life to which Delaware paid special attention.

Cunningham, John T. *New Jersey: America's Main Road.* Maps by Homer Hill. Garden City, N.Y.: Doubleday, 1966. Presents an excellent analysis of Woodrow Wilson's governorship in New Jersey and how his legislation encouraged Delaware to liberalize its corporation laws.

Federal Writers' Project. Delaware. *Delaware: A Guide to the First State.* New and rev. ed. by Jeannette Eckman. New York: Hastings House, 1955. A concise history of Delaware that includes references to the state's corporation laws.

Myers, William Starr, ed., *The Story of New Jersey.* 5 vols. New York: Lewis Historical Publishing Company, 1945. This multivolume history thoroughly documents the state's status as a home to corporations and details Wilson's role in driving companies to Delaware.

Peirce, Neal R., and Michael Barone. *The Mid-Atlantic States of America: People, Politics, and Power in the Five Mid-Atlantic States and the Nation's Capital.* New York: Norton, 1977. Provides a concise history of Delaware with particular emphasis on the state's corporation code.

Stone, Christopher D. *Where the Law Ends: The Social Control of Corporate Behavior.* New York: Harper & Row, 1975. Stone's book provides an excellent description of the relationship between corporations and society and discusses the importance of corporate charters and executives' responsibilities.

Tuttle, Frank W., and Joseph M. Perry. *An Economic History of the United States.* Cincinnati: South-Western, 1970. Presents an excellent overview of antitrust sentiment in the early 1900's and how it contributed to Delaware's rise as a home to major U.S. corporations.

Arthur G. Sharp

Cross-References

Morgan Assembles the World's Largest Corporation (1901), p. 29; The U.S. Government Creates the Department of Commerce and Labor (1903), p. 86; The Supreme Court Rules Against Northern Securities (1904), p. 91; The Tariff Act of 1909 Limits Corporate Privacy (1909), p. 168; The Supreme Court Decides to Break Up Standard Oil (1911), p. 206; Congress Passes the Clayton Antitrust Act (1914), p. 275; The Securities Exchange Act Establishes the SEC (1934), p. 679.

GILLETTE MARKETS THE FIRST DISPOSABLE RAZOR

Category of event: New products
Time: 1903
Locale: Boston, Massachusetts

The disposable razor allowed the Gillette Company to become an important company in the United States

Principal personages:
KING CAMP GILLETTE (1855-1932), the inventor of the disposable razor
STEVEN PORTER, the machinist who created the first three disposable razors for King Camp Gillette
WILLIAM EMERY NICKERSON (1853-1930), an expert machine inventor who created the machines necessary for mass production
JACOB HEILBORN, an industrial promoter who helped Gillette start his company and became a partner
EDWARD J. STEWART, a friend and financial backer of Gillette
HENRY SACHS, an investor in the Gillette Safety Razor Company
JOHN JOYCE, an investor in the Gillette Safety Razor Company
WILLIAM PAINTER (1838-1906), an inventor who inspired Gillette
GEORGE GILLETTE, an inventor, King Camp Gillette's father

Summary of Event

In 1895, King Camp Gillette thought of the idea of a disposable razor blade. Gillette spent years drawing different models, and finally Steven Porter, a machinist and Gillette's associate, created from those drawings the first three disposable razors that worked. Gillette soon founded the Gillette Safety Razor Company, which became the leading seller of disposable razor blades in the United States.

George Gillette, King Camp Gillette's father, had been a newspaper editor, a patent agent, and an inventor. He never invented a very successful product, but he loved to experiment. He encouraged all of his sons to figure out how things work and how to improve on them. King was always inventing something new and had many patents, but he was unsuccessful in turning them into profitable businesses.

Gillette worked as a traveling salesperson for Crown Cork and Seal Company. William Painter, one of Gillette's friends and the inventor of the crown cork, presented Gillette with a formula for making a fortune: Invent something that would constantly need to be replaced. Painter's crown cork was used to cap beer and soda bottles. It was a tin cap covered with cork, used to form a tight seal over a bottle. Soda and beer companies could use a crown cork only once and needed a steady supply.

King took Painter's advice and began thinking of everyday items that needed to be replaced often. After owning a Star safety razor for some time, King realized that the razor blade had not been improved for a long time. He studied all the razors on the

market and found that both the common straight razor and the safety razor featured a heavy V-shaped piece of steel, sharpened on one side. King reasoned that a thin piece of steel sharpened on both sides would create a better shave and could be thrown away once it became dull. The idea of the disposable razor had been born.

Gillette made several drawings of disposable razors. He then made a wooden model of the razor to better explain his idea. Gillette's first attempt to construct a working model was unsuccessful, as the steel was too flimsy. Steven Porter, a Boston machinist, decided to try to make Gillette's razor from his drawings. He produced three razors, and in the summer of 1899 King was the first man to shave with a disposable razor.

In the early 1900's, most people considered a razor to be a once-in-a-lifetime purchase. Many fathers handed down their razors to their sons. Straight razors needed constant and careful attention to keep them sharp. The thought of throwing a razor in the garbage after several uses was contrary to the general public's idea of a razor. If Gillette's razor had not provided a much less painful and faster shave, it is unlikely that the disposable would have been a success. Even with its advantages, public opinion against the product was still difficult to overcome.

Financing a company to produce the razor proved to be a major obstacle. King did not have the money himself, and potential investors were skeptical. Skepticism arose both because of public perceptions of the product and because of its manufacturing process. Mass production appeared to be impossible, but the disposable razor would never be profitable if produced using the methods used to manufacture its predecessor.

William Emery Nickerson, an expert machine inventor, had looked at Gillette's razor and said it was impossible to create a machine to produce it. He was convinced to reexamine the idea and finally created a machine that would create a workable blade. In the process, Nickerson changed Gillette's original model. He improved the handle and frame so that it would better support the thin steel blade.

In the meantime, Gillette was busy getting his patent assigned to the newly formed American Safety Razor Company, owned by Gillette, Jacob Heilborn, Edward J. Stewart, and Nickerson. Gillette owned considerably more shares than anyone else. Henry Sachs provided additional capital, buying shares from Gillette.

The stockholders decided to rename the company as the Gillette Safety Razor Company. It soon spent most of its money on machinery and lacked the capital it needed to produce and advertise its product. The only offer the company had received was from a group of New York investors who were willing to give $125,000 in exchange for 51 percent of the company. None of the directors wanted to lose control of the company, so they rejected the offer.

John Joyce, a friend of Gillette, rescued the financially insecure new company. He agreed to buy $100,000 worth of bonds from the company for sixty cents on the dollar, purchasing the bonds gradually as the company needed money. He also received an equivalent amount of company stock. After an investment of $30,000, Joyce had the option of backing out. This deal enabled the company to start manufacturing and advertising.

Impact of Event

The company used $18,000 to perfect the machinery to produce the disposable razor blades and razors. Originally the directors wanted to sell each razor with twenty blades for three dollars. Joyce insisted on a price of five dollars. In 1903, five dollars was about one-third of the average American's weekly salary, and a high-quality straight razor could be purchased for about half that price. The other directors were skeptical, but Joyce threatened to buy up all the razors for three dollars and sell them himself for five dollars. Joyce had the financial backing to make this promise good, so the directors agreed to the higher price.

The Gillette Safety Razor Company contracted with Townsend & Hunt for exclusive sales. The contract stated that Townsend & Hunt would buy 50,000 razors with twenty blades each during a period of slightly more than a year and would purchase 100,000 sets per year for the following four years. The first advertisement for the product appeared in *System Magazine* in early fall of 1903, offering the razors by mail order. By the end of 1903, only fifty-one razors had been sold.

Since Gillette and most of the directors of the company were not salaried, Gillette had needed to keep his job as salesman with Crown Cork and Seal. At the end of 1903, he received a promotion that meant relocation from Boston to London. Gillette did not want to go and pleaded with the other directors, but they insisted that the company could not afford to put him on salary. The company decided to reduce the number of blades in a set from twenty to twelve in an effort to increase profits without noticeably raising the cost of a set. Gillette resigned the title of company president and left for England.

Shortly thereafter, Townsend & Hunt changed its name to the Gillette Sales Company, and three years later the sales company sold out to the parent company for $300,000. Sales of the new type of razor were increasing rapidly in the United States, and Joyce wanted to sell patent rights to European companies for a small percentage of sales. Gillette thought that that would be a horrible mistake and quickly traveled back to Boston. He had two goals: to stop the sale of patent rights, based on his conviction that the foreign market would eventually be very lucrative, and to become salaried by the company. Gillette accomplished both these goals and soon moved back to Boston.

Despite the fact that Joyce and Gillette had been good friends for a long time, their business views often differed. Gillette set up a holding company in an effort to gain back controlling interest in the Gillette Safety Razor Company. He borrowed money and convinced his allies in the company to invest in the holding company, eventually regaining control. He was reinstated as president of the company. One clear disagreement was that Gillette wanted to relocate the company to Newark, New Jersey, and Joyce thought that that would be a waste of money. Gillette authorized company funds to be invested in a Newark site. The idea was later dropped, costing the company a large amount of capital. Gillette was not a very wise businessman and made many costly mistakes. Joyce even accused Gillette of deliberately trying to keep the stock price low so that Gillette could purchase more stock. Joyce eventually bought out

Gillette, who retained his title as president but had little say about company business. With Gillette out of a management position, the company became more stable and more profitable. The biggest problem the company faced was that it would soon lose its patent rights. After the patent expired, the company would have competition. The company decided that it could either cut prices (and therefore profits) to compete with the lower-priced disposables that would inevitably enter the market, or it could create a new line of even better razors. The company opted for the latter strategy. Weeks before the patent expired, the Gillette Safety Razor Company introduced a new line of razors.

Both World War I and World War II were big boosts to the company, which contracted with the government to supply razors to almost all the troops. This transaction created a huge increase in sales and introduced thousands of young men to the Gillette razor. Many of them continued to use Gillettes after returning from the war.

Aside from the shaky start of the company, its worst financial difficulties were during the Great Depression. Most Americans simply could not afford Gillette blades, and many used a blade for an extended time and then resharpened it rather than throwing it away. If it had not been for the company's foreign markets, the company would not have shown a profit during the Great Depression. Gillette's obstinance about not selling patent rights to foreign investors proved to be an excellent decision.

The company advertised through sponsoring sporting events, including the World Series. Gillette had many celebrity endorsements from well-known baseball players. Before it became too expensive for one company to sponsor an entire event, Gillette had exclusive advertising during the World Series, various boxing matches, the Kentucky Derby, and football bowl games. Sponsoring these events was costly, but sports spectators were the typical Gillette customers.

The Gillette Company created many products that complemented razors and blades, including shaving cream, women's razors, and electric razors. The company expanded into new products including women's cosmetics, writing utensils, deodorant, and wigs. One of the main reasons for obtaining a more diverse product line was that a one-product company is less stable, especially in a volatile market. The Gillette Company had learned that lesson in the Great Depression. Gillette continued to thrive by following the principles the company had used from the start. The majority of Gillette's profits came from foreign markets, and its employees looked to improve products and find opportunities in other departments as well as their own.

Bibliography

Adams, Russell B., Jr. *King C. Gillette: The Man and His Wonderful Shaving Device.* Boston: Little, Brown, 1978. A biography of King Camp Gillette and the complete details of the Gillette Company. A detailed account of all the company's major investments and profits.

"Gillette: Blade-runner." *The Economist* 327 (April 10, 1993): 68. Discusses Gillette's response to competition in the razor and pen markets. Describes acquisitions,

improved products, and investments in better manufacturing. Discusses Gillette's purchases of Parker Pen Holdings PLC, which gave Gillette a 41 percent share of the United States pen market.

LaPlante, Alice. "IS Departments Help End-Users Design Their Own Solutions." *InfoWorld* 14 (July 20, 1992): 62. Discusses how Gillette's financial consolidation system, MicroControls, provided too much information and was not easy to use. Describes how other employees outside this department created a better system that was much easier to use, illustrating the entrepreneurial spirit of Gillette employees.

Maremont, Mark. "A New Equal Right: The Close Shave." *Business Week*, March 29, 1993, 58-59. Discusses a new product by Gillette, the Sensor razor for women, that was very successful.

Reingold, Jennifer. "Above the Fray." *Financial World* 162 (March 2, 1993): 24-25. Discusses the fact that the majority of Gillette's sales and profits come from foreign markets. Describes Gillette's situation in the United States and other countries.

Dan Kennedy

Cross-References

Kodak Introduces the Brownie Camera (1900), p. 11; Howard Hughes Builds a Business Empire (1924-1976), p. 442; Land Demonstrates the Polaroid Camera (1947), p. 896; The Pocket Calculator Is Marketed (1972), p. 1517; Coca-Cola Introduces a New Formula (1985), p. 1904.

WALTER DILL SCOTT PUBLISHES
THE THEORY OF ADVERTISING

Category of event: Advertising
Time: 1903
Locale: Boston, Massachusetts

By placing advertising on a scientific basis, Walter Dill Scott taught American businesspeople how to manipulate consumers' tastes and buying habits

Principal personages:
WALTER DILL SCOTT (1869-1955), an American professor of psychology and education
WILHELM WUNDT (1832-1920), a professor of psychology at the University of Leipzig, where Scott received his Ph.D.
EDWARD BRADFORD TITCHENER (1867-1927), a professor of psychology at Cornell University who influenced Scott's career
WILLIAM JAMES (1842-1910), a famous American philosopher whose theories about applied psychology had a strong influence on Scott
HERBERT SPENCER (1820-1903), a prominent English philosopher whose ideas on psychology and human progress influenced Scott's entire generation

Summary of Event

Walter Dill Scott received his Ph.D. in 1900 at the University of Leipzig, where he studied under the famous Wilhelm Wundt, who was attempting to make an exact science of psychology. Scott was fascinated with the potential of this budding science and devoted his life studying its principles. He was associate professor of psychology and education at the prestigious Northwestern University from 1901 to 1908, professor of psychology from 1908 to 1920, and president of Northwestern from 1921 until he retired in 1939.

Scott published many books on the application of scientific psychological principles to business practice. He was imbued with the spirit of progress that characterized the early part of the twentieth century and sincerely believed that the free enterprise system would provide nothing but good things for the American people. Several of his books dealt with the subject of advertising, and all were popular with businesspeople because he offered advice that was badly needed and unavailable from other sources.

Advertising was in its infancy in the early part of the twentieth century. Many businesspeople understood its awesome potential, but no one understood how to make it work effectively and predictably. It was not enough merely to attract attention to a product; businesspeople wanted to know how to make potential consumers remember their products and to desire them to the extent that they would purchase them instead

of competitors' products, perhaps even paying a premium for the privilege. In Scott's first book on advertising, *The Theory of Advertising: A Simple Exposition of the Principles of Psychology in Their Relation to Successful Advertising* (1903), he offered six fundamental rules for attracting attention. He went on to discuss in simple language how to make a product remembered, how to make it desirable, and how to motivate buyers to act.

One reason for the success of Scott's books on advertising was that they were copiously illustrated with actual advertisements, taken from popular newspapers and magazines. It should be remembered that television did not exist and that radio advertising was insignificant until the 1920's; advertising in print media was thus the primary method. Furthermore, advertising of the early twentieth century was mainly illustrated with line drawings or black-and-white sketches, because printing in colors and reproduction of photographs were both in primitive stages of development. Essentially, magazines published "institutional ads" designed to create an appealing image of the company, while newspapers published "retail ads" designed to motivate people to make immediate purchases. The illustrations in Scott's books show the dominant forms of advertising of the period.

Scott's first book on advertising had a powerful impact on American businesspeople for other reasons. Scott had a distinguished reputation as an innovator in both education and psychology. His book was well written, easy for lay persons to understand, and illustrated with actual advertisements that were often amusing as well as thought provoking. He not only explained his theories in clear terms but also proved them, or at least illustrated their applicability, with numerous examples. Being an expert in the field of applied psychology, he knew how to apply his own psychological principles to influencing his readers. Furthermore, he made it obvious that advertising as it existed in 1903 was very much a hit-and-miss operation. No one in the business world knew how to obtain results on a consistent basis.

Readers could clearly see that Scott knew what he was talking about. If an ad he reprinted in his book was effective, he could explain why it was effective; if an ad was ineffective or actually repellent, he could explain exactly why this was the case based on the psychological principles he expounded.

The ads reproduced in Scott's books may seem quaint and innocuous to the modern reader in comparison with dynamic television advertising campaigns that sometimes cost millions of dollars. The principles of psychological manipulation laid down by Scott and illustrated in these advertisements, however, can be seen at work even in the most recent products of Madison Avenue advertising agencies. It is easy for the modern reader of Scott's books to understand why a particular ad would have been effective and why another would have been a waste of the advertiser's money.

Scott discussed the importance of using direct commands, such as "Buy it now!" In his explications of certain ads, he explained how the use of a picture of an authority figure, such as a doctor, can enhance the effectiveness of direct commands. He discussed the art of using coupons and questionnaires to make the reader remember the product through interaction with its maker. He also discussed the importance of

repetition, one of the most annoying but effective aspects of modern advertising on television.

In later books on advertising, Scott went even deeper into applied psychology. Probably his most portentous observations had to do with the notion of appealing to basic human instincts such as self-preservation, hunting, parenting, and gaining social status. It is now common practice to appeal to human instincts to sell almost any kind of product or service. For example, if a group of happy and obviously affluent people are shown in an ad drinking a certain brand of wine at a dinner party, the ad will probably appeal to the viewer's desire to belong and to be important. Ads showing people buying their children expensive clothing or driving them to school in luxury cars appeal to the viewer's parental instinct.

Because advertising was still in its infancy, the idealistic and well-meaning Scott did not foresee the potential abuses of advertising that have been amply described by scholars, popular writers, and politicians since his time. In this respect, he was a bit like Baron Von Frankenstein, who created a monster he could not control.

Impact of Event

Many of Scott's ideas on the use of applied psychology in advertising seem elementary and obvious to modern readers who are used to being bombarded by sophisticated commercials on their television screens. In Scott's time, however, the principles he expounded came as a revelation to many businesspeople, who knew that advertising was the secret of success but did not understand exactly how to use it.

Within a short time after publication of *The Theory of Advertising*, many companies began employing advertising experts rather than leaving ad creation up to their merchandising departments. Others found it expedient to employ the services of independent agencies that specialized in every aspect of advertising, including layout, illustration, copywriting, market testing, and deciding in which publications to place ads in order to reach specially targeted consumers. These agencies prospered because they could offer their services free of charge to the client; they customarily received payment from the media—the newspapers and magazines, then later radio and television stations—in the form of a percentage of the fee charged to the client.

Advertising began to reshape Americans' consciousness. People were conditioned to want more and better things. Automobile advertising is an interesting example. Manufacturers stopped bragging about the durability of their cars and began appealing to such instincts as the desire for prestige and the desire to appeal to members of the opposite sex. Advertising helped produce the phenomenon of planned obsolescence by magnifying minor stylistic changes in automobile design in order to make older models seem undesirable.

At first, advertising was largely confined to newspapers, magazines, and billboards. With the advent of radio and especially with television, advertising became a powerful force in manipulating not only American buying habits but also American voting habits. Political candidates found that they had to hire advertising experts to shape their public images and present them to the public in an appealing light.

Advertising enabled companies to grow and thus drive smaller competitors out of business. Many businesspeople learned that advertising could be used to raise profits by increasing demand without improving quality. It may truthfully be said that advertising, using psychological principles first enunciated by Scott, revolutionized American business.

Beer provides some good examples of the power of advertising because it is such a heavily advertised product. At one time, there were thousands of small local breweries in the United States; with mass advertising, the market came to be dominated by only a few well-known brands. Large companies can afford expensive advertising campaigns, keeping their names in the public's mind.

The world of franchising offers another interesting example of the power of advertising. It was mainly through advertising that the American landscape came to be covered with franchises of national firms, McDonald's and other fast food outlets prominent among them. Although these enterprises are independently owned, the owners have found it profitable to operate under a common name precisely because that common name can be made known to the public. Travelers unfamiliar with their surroundings know what they will get at a McDonald's restaurant; they do not have to risk trying a local establishment.

Scott was essentially a scholar and idealist. He did not foresee the harmful ways in which his psychological theories could be used by entrepreneurs who were more interested in profit than in science. It was not long after the publication of Scott's book that outcries were heard against abuses of advertising. Over the years, critics of advertising have made many charges. They claim that advertising encourages materialism, greed, and selfishness; that it contributes to environmental decay by encouraging consumption and waste; that it promotes alcohol and tobacco consumption, which kill half a million Americans annually; that it perpetuates class differences by tempting low-income people to waste their money on lotteries, liquor, and other products; and that it encourages class hatred by creating dissatisfaction, envy, and insecurity.

Advertisers defend themselves by appealing to the First Amendment to the U.S. Constitution, which guarantees freedom of speech and of the press. The sheer power of advertising to shape people's minds, however, brought about a counterreaction that gradually forced some measures of government regulation and self-regulation by the industry. In 1912, the Associated Advertising Clubs of America adopted a "Truth in Advertising Code" in an attempt to protect members from more stringent regulation by the government. In 1938, the Wheeler-Lea Act gave the Federal Trade Commission jurisdiction over false or misleading advertising. In 1970, after considerable debate, cigarette ads were banned from U.S. radio and television. In 1971, the National Advertising Review Board was established. In 1976, the Federal Trade Commission issued a set of rules on the preparation of advertising directed at children.

The heated debate over advertising continued. Its defenders contend that government censorship limits the free circulation of ideas and could lead to consumers being misinformed or unaware of beneficial opportunities. Further, they claim that advertising has stimulated the economy, created jobs, encouraged the creation of new goods

and services, kept the public informed of important developments in commerce and politics, and promoted wholesome competition for the consumer's dollar. The anti-advertising faction calls for censorship and regulation, blaming advertising for a multitude of modern problems, including crime, pollution, and trade deficits. Psychoanalyst Erich Fromm went as far as suggesting that advertising could be responsible for insanity because its overall effect is to create a false conception of reality, leading to frustration and disorientation.

Trillions of dollars are at stake, as well as a whole way of life. The debate will undoubtedly continue, because there are no easy solutions or compromises. The American, and world, economy has become so heavily dependent upon advertising that massive regulation might easily plunge the country, and the entire industrialized world, into an economic depression.

Bibliography

Goulart, Ron. *The Assault on Childhood*. London: Gollancz, 1970. Discusses the many ways in which children are being psychologically manipulated to equate consumerism with success and happiness, along with being conditioned to crave useless products such as "pet rocks" and even harmful products such as cigarettes. Calls for greater public awareness of the growing problem and stronger government control.

Jacobson, Jacob Z. *Scott of Northwestern: The Life Story of a Pioneer in Psychology and Education*. Chicago: L. Mariano, 1951. The first full-length biography of Walter Dill Scott. Has been criticized for being too laudatory in his discussion of the subject's contributions to the science of psychology. The book is based on notes compiled by Scott himself.

James, William. *Essays in Psychology*. Cambridge, Mass.: Harvard University Press, 1983. A collection of James's writings on psychology, showing the scope of psychological knowledge in the early twentieth century, its direction of inquiry, and James's ideas about the practical application of psychological principles.

Ogilvy, David. *Confessions of an Advertising Man*. 9th ed. New York: Atheneum, 1984. The founder of one of the world's largest advertising agencies discusses the psychological aspects of advertising and concludes with a chapter titled "Should Advertising Be Abolished?" He thinks advertising should be reformed but not abolished. A witty, entertaining, and informative book.

Scott, Walter Dill. *The Psychology of Advertising*. New ed. Boston: Small, Maynard, 1913. An enlarged version of Scott's 1903 work, with additions and modifications. Contains many illustrations of magazine ads of the period along with Scott's analyses of their effectiveness.

Bill Delaney

Cross-References

Advertisers Adopt a Truth in Advertising Code (1913), p. 229; WEAF Airs the First

Paid Radio Commercial (1922), p. 396; The Wheeler-Lea Act Broadens FTC Control over Advertising (1938), p. 775; Congress Limits the Use of Billboards (1965), p. 1254; The U.S. Government Bans Cigarette Ads on Broadcast Media (1970), p. 1443; The U.S. Advertising Industry Organizes Self-Regulation (1971), p. 1501; The FTC Conducts Hearings on Ads Aimed at Children (1978), p. 1658.

THE U.S. GOVERNMENT CREATES THE DEPARTMENT OF COMMERCE AND LABOR

Category of event: Government and business
Time: February 14, 1903
Locale: Washington, D.C.

With the establishment of the Department of Commerce and Labor in 1903, the federal government became actively involved in matters of business, labor, and the national economy

Principal personages:
THEODORE ROOSEVELT (1858-1919), the president of the United States, 1901-1909
CARROLL D. WRIGHT (1840-1909), the labor commissioner before the cabinet position was created
GEORGE B. CORTELYOU (1862-1940), the first secretary of the Department of Commerce and Labor
JAMES R. GARFIELD (1865-1950), a member of the U.S. Civil Service Commission who became commissioner of the Bureau of Corporations

Summary of Event

The Department of Commerce and Labor Act of 1903 created the Department of Commerce and Labor, a cabinet department within the executive branch of the U.S. federal government. The department included the Bureau of Corporations and the Bureau of Labor. The staffs of these bureaus were to investigate and provide information on corporations, industrial working conditions, and labor-management disputes. The creation of this department and its attendant federal agencies presaged an increasingly activist federal government in the twentieth century, one that would investigate, publicize, and intervene in the dealings of industry, labor-management disputes, and other matters deemed to be of importance to the national economy.

In June, 1884, Congress established a Bureau of Labor as part of the Department of the Interior. In 1888, Congress gave the bureau independent status as the Department of Labor, but its commissioner did not have a position with the president's cabinet. The commissioner reported directly to the president.

Theodore Roosevelt became president in 1901, when public opinion was increasingly concerned with the growing power that large corporations, monopolies, and trusts had in American economic, social, and political life. The anthracite coal miners' strike of 1902 (in Pennsylvania, Illinois, and Ohio), which lasted six months and threatened the nation's coal supply, exacerbated public and political concern over industrial labor-management relations and was itself a major spur to the creation of the Department of Commerce and Labor.

Political pressure from the public and from other elected officials encouraged

Roosevelt to try to arbitrate the coal miners' dispute by inviting representatives from labor and management to the White House. Although the meeting did not resolve the crisis—the owners refused to accede to the union's demands—it was significant in that the president had brought labor representatives to the negotiating table. Previous presidents had tended to take the side of business in labor-management disputes. Representatives from the railroads that owned the coal mines attended the meeting, as did Roosevelt's commissioner of labor, Carroll D. Wright, and John H. Mitchell, president of the United Mine Workers (UMW).

The crisis still unresolved, Roosevelt created an arbitration commission to investigate the strike. Although no official representatives of the UMW were part of this arbitration commission, as the operators refused such recognition, labor commissioner Wright as well as other unofficial labor representatives were part of the commission. With winter closing in, making coal supplies an increasing concern, pressure from public opinion, influential business leaders, and other elected officials encouraged the strikers to go back to work on October 23, 1902, while the commission arbitrated the dispute. The commission finally forced a resolution on March 22, 1903, giving the coal miners wage increases but no official recognition of their union from the operators. The incident convinced Roosevelt of the need for a permanent federal agency to prevent or help resolve, through arbitration, any such future national economic crises. He also was convinced of the need for an increased federal role in the economy.

It was in this context that in early January, 1903, Roosevelt called for the creation of a Department of Commerce and Labor, to include a Bureau of Labor and a Bureau of Corporations. The functions of those agencies would be to investigate the operations and conduct of corporations and to provide information about business structure, operations, and working conditions. The bill creating the department also provided for six other bureaus within the department, dealing with matters of immigration, the census, navigation, fisheries, standards, and business statistics.

Roosevelt adroitly used the opposition of business leaders to enlist the support of the public and Congress for the bill. He used a letter from an attorney representing John D. Rockefeller's Standard Oil, written to Matthew Quay, a senator from Pennsylvania, protesting against such governmental interference. Roosevelt portrayed such opponents of the Department of Commerce and Labor bill as those very forces of economic and industrial injustice that public opinion was increasingly worried about. By winning public support to his side, Roosevelt obtained overwhelming congressional backing. The bill to create the new department was passed on February 14, 1903.

Roosevelt named George B. Cortelyou, his private secretary, as the first secretary of the Department of Commerce and Labor. Roosevelt and Cortelyou did not view the Department of Commerce and Labor as an agency to attack business but as an empowerment of government to expand services to businesses, particularly in providing market information. Cortelyou advised the president on labor disputes as well as on antitrust prosecution. Cortelyou also advised Roosevelt on the issue of the union

shop in the Government Printing Office.

James R. Garfield, as commissioner of the Bureau of Corporations, used the agency to investigate many corporations. He shared Roosevelt's view that federal government should regulate businesses, not randomly break them up. Garfield received some outside criticism that the bureau was too lenient in dealing with the "trusts," particularly regarding an investigation of the United States Steel Corporation, which he and the president thought was a "good" trust. He initiated stringent investigations of the beef and oil industries. The investigation of Standard Oil led to an antitrust suit, and ultimately the Supreme Court ordered the dissolution of Standard Oil in 1911.

Impact of Event

The creation of the Department of Commerce and Labor set an important precedent for the growing role of the federal government in the national economy. It was a significant departure from the policies of the legislative and executive branches in the late nineteenth century, which said that public agencies should not intervene in the private business sphere. The increased federal role in the economy was at times antagonistic to corporations. Investigations by the Bureau of Corporations led to antitrust litigation and dissolution of the American Tobacco Company and Standard Oil.

For the most part, however, the Department of Commerce (which split from the Department of Labor in 1913) has by design functioned to help business and commerce in the United States. By distributing commercial and business statistics as well as agricultural and population censuses, the Department of Commerce makes available information that can help an industry or business learn about the market in a region or across the nation. This type of comprehensive information can be very important, particularly to individuals starting businesses, but would probably be prohibitively expensive to collect privately. The department's national standards for weights and measures facilitate interstate commerce by standardizing the basis for trade and ensuring honesty. The department also helps industry by protecting its assets through patent and trademark registration. The Department of Commerce also provides information useful to the maritime and aviation industries by publishing nautical and aeronautical charts. All these actions represented a desire by both politicians and businesspeople to stabilize industry while promoting economic growth.

In 1913, President Woodrow Wilson signed a bill that created the Department of Labor, separating it from the Department of Commerce. The presidential campaign of 1912 had reflected the growing public concern with industrial-labor relations and the rights and powers of labor unions. Presidential candidates Roosevelt and Wilson had differences on the issues of labor and corporation regulation, but both advocated continuing government activism on these issues. Wilson came into the presidency in 1913 with a series of progressive commitments, with an added focus on the rights of labor chief among them. Wilson worked with Congress to establish a separate Department of Labor, creating a new cabinet position for a secretary of labor. President Wilson's choice for this position, William B. Wilson, president of the UMW,

reflected his concerns over the rights of labor organizations. William Wilson was the first labor union representative to be named to the cabinet. President Wilson wanted a representative from the ranks of labor to have the authority of a cabinet-level position in representing executive branch efforts to arbitrate labor-management disputes. Secretary of Labor Wilson strengthened the Labor Department's Division of Mediation and Conciliation and played a significant role in President Wilson's efforts to arbitrate the Ludlow, Colorado, coal mine strike of 1914. President Wilson also pushed through Congress the Keating-Owen Act, barring from interstate commerce goods produced with child labor; the Adamson Act, which gave railroad workers an eight-hour day; and the Workmen's Compensation Act, providing workplace insurance to federal employees. The enforcement of these new laws became the responsibility of the Department of Labor.

The functions of the Department of Labor grew dramatically through the twentieth century. In the interests of workers, the Labor Department enforces laws regarding labor-management relations, child labor, equal pay, minimum wages, overtime, public contracts, workmen's compensation, health and safety in the workplace, and industrial accidents. The Department of Labor also aids businesses by providing market information. This includes collecting economic information; analyzing trends in prices, employment, and productivity; and analyzing costs and standards of living. The department also created a number of agencies designed to relieve unemployment, such as the Neighborhood Youth Corps, the Job Corps, and the Bureau of Apprenticeship and Training.

In 1914, President Wilson and Congress created the Federal Trade Commission to replace the Bureau of Corporations as the federal government's primary antitrust and corporate investigatory agency. The Federal Trade Commission was the agency established to enforce the Clayton Antitrust Act of 1914. That act also represented the continuing and growing concern over competition, economic opportunity, and antitrust that grew from the precedent of the creation of the Department of Commerce and Labor in 1903.

Bibliography

Blum, John Morton. "Theodore Roosevelt and the Definition of Office." In *The Progressive Presidents: Theodore Roosevelt, Woodrow Wilson. Franklin D. Roosevelt, Lyndon B. Johnson.* New York: W. W. Norton, 1980. Good for an introduction to the progressive politics and policies of Theodore Roosevelt and Woodrow Wilson; also good chapters on Franklin D. Roosevelt and Lyndon B. Johnson. Concise, yet detailed and analytical.

Gould, Lewis L. "Immediate and Vigorous Executive Action." In *The Presidency of Theodore Roosevelt.* Lawrence: University Press of Kansas, 1991. Excellent history of the foreign and domestic policies of both of Roosevelt's administrations. Also good for students beginning study of the Progressive Era.

Kolko, Gabriel. *The Triumph of Conservatism: A Reinterpretation of American History, 1900-1916.* New York: Free Press of Glencoe, 1963. Excellent for those

seeking an in-depth and challenging analysis of business-government relationships in the Progressive Era. Kolko contends that new regulations were not a victory for the "people" over the "interests." Leaders of industry desired regulation, which they would help formulate and influence, to avoid competition and stabilize their industries.

Miller, Nathan. *Theodore Roosevelt: A Life*. New York: William Morrow, 1992. The treatment of the Northern Securities case is particularly concise and well done, characteristics that hold for the book as a whole. Good for those with some familiarity with Roosevelt and the Progressive Era.

Pringle, Henry F. "Trimming Sail." In *Theodore Roosevelt: A Biography*. New York: Harcourt, Brace, and Company, 1931. Perhaps the most in-depth biography of Roosevelt. Very detailed on the policies of his administration, especially on the establishment of the Department of Commerce and Labor.

Bruce Andre Beaubouef

Cross-References

The Supreme Court Rules Against Northern Securities (1904), p. 91; The Supreme Court Decides to Break Up Standard Oil (1911), p. 206; The Supreme Court Breaks Up the American Tobacco Company (1911), p. 212; Congress Passes the Clayton Antitrust Act (1914), p. 275; The Wagner Act Promotes Union Organization (1935), p. 706; The Social Security Act Provides Benefits for Workers (1935), p. 711.

THE SUPREME COURT RULES AGAINST NORTHERN SECURITIES

Category of event: Monopolies and cartels
Time: March 14, 1904
Locale: Washington, D.C.

By prosecuting and ordering dissolution of the Northern Securities Company, the federal government showed that it would regulate corporations and set the precedent for later antitrust cases

Principal personages:
THEODORE ROOSEVELT (1858-1919), the president of the United States, 1901-1909
PHILANDER CHASE KNOX (1853-1921), the attorney general under Roosevelt
J. P. MORGAN (1837-1913), a prominent investment banker who financed and organized the U.S. Steel Corporation as well as a number of important railroads
EDWARD H. HARRIMAN (1848-1909), the head of the Union Pacific Railroad
JAMES J. HILL (1838-1916), the head of the Great Northern Railroad

Summary of Event

On March 14, 1904, the Supreme Court of the United States ordered the dissolution of the Northern Securities Company. This was one of the first large-scale holding companies, formed in November, 1901, by James J. Hill, Edward H. Harriman, and J. P. Morgan to gain greater control over and efficiency of three railroad companies: the Great Northern Railroad, the Northern Pacific Railroad, and the Chicago, Burlington, & Quincy Railroad line. Responding to the general antitrust sentiment of the time, in March, 1902, President Theodore Roosevelt instructed Attorney General Philander Chase Knox to bring suit against the Northern Securities Company for violation of the Sherman Antitrust Act of 1890. The Northern Securities case went to the Supreme Court of the United States, ultimately ending with the case of *Northern Securities Company v. United States* (193 U.S. 197). The Supreme Court found the Northern Securities Company to be in violation of the Sherman antitrust law and ordered it to be dissolved.

The Northern Securities case came at the end of the great consolidation period in U.S. business history, during which nearly two thousand business mergers occurred from 1896 to 1900. General public suspicion of large corporations had been growing in the United States, evidenced by support for the Interstate Commerce Act of 1887 and the growth of the reform-minded Populist Party. These concerns, and consequent political movements, had pressured Congress into passing the Sherman Antitrust Act

of 1890, which illegalized "every contract, combination in the form of trust or otherwise, or conspiracy, in restraint of trade or commerce." Any hopes that this law would control corporations, however, were undermined by the probusiness laissez-faire policies of the legislative, executive, and judicial branches of the federal government at this time. As a result, the Sherman Act had very little effect upon corporations in the United States for more than a decade after its passage. Between 1893 and 1903, the federal government initiated fewer than two dozen cases under the Sherman Act. Furthermore, the Supreme Court decision in the case of *United States v. E. C. Knight Company* (1895) undermined the strength and credibility of the Sherman Act. In that case, the Supreme Court ruled that the American Sugar Company and its subsidiary, the E. C. Knight Company, although perhaps a monopoly in manufacturing, had not monopolized or restrained interstate commerce. This gave a very strict and limited interpretation to the Sherman Act.

In May, 1901, James J. Hill of the Great Northern Railroad and Edward H. Harriman of the Union Pacific Railroad engaged in a competition to purchase controlling stock in the Northern Pacific Railroad. That railroad company in turn held a controlling interest in the Chicago, Burlington, & Quincy Railroad, the tracks of which provided a highly desirable line into Chicago and ran throughout the northern Midwest region. Harriman worked through the Kuhn Loeb investment house, with the backing of the Rockefeller family; Hill enlisted the considerable financial services of J. P. Morgan. As Hill and Harriman fought for control of Northern Pacific, the price of its stock soared to $1,000 per share. In their efforts to obtain liquid capital to purchase Northern Pacific shares, Hill and Harriman dumped other holdings at very low prices. These actions caused stock prices to fluctuate wildly, generally disrupting the stock market. After neither Hill nor Harriman was able to gain a controlling interest in Northern Pacific, they decided that cooperation was preferable to market disorder. In November, 1901, Hill and Harriman had Morgan arrange for the incorporation of the Northern Securities Company, a $400 million holding company that would, they hoped, bring order and efficiency to the northwestern railroad market by bringing their combined interests—the Great Northern Railroad, the Northern Pacific Railroad, and the Chicago, Burlington, & Quincy Railroad line—under the aegis of one board of directors. Morgan had a history of improving rail systems through his own reorganization and consolidations efforts. In the sixteen years since 1885, Morgan had made thousands of miles of railroads throughout the East more efficient, including saving the New York Central Railroad from financial collapse. In his book *Highways of Progress* (1910), Hill stated that the formation of the Northern Securities Company was "a device contributing to the welfare of the public by assuring in the management of great properties that security, harmony and relief from various forms of waste out of which grow lower rates just as surely as dividends." He argued that consolidation was in the public interest, as it contributed to efficiency.

To the public and much of the rest of the business world, however, the actions of Hill, Harriman, and Morgan appeared to be the very worst of the disruptive, careless, and crude abuses of power attributed to the "robber barons" of that era. Public opinion

was further enraged by the fact that the episode had resulted in one of the largest holding companies yet formed in this era of large business trusts. Even *The Wall Street Journal* criticized Harriman and Hill for their actions. Responding to these pressures, in March, 1902, President Theodore Roosevelt instructed Attorney General Philander C. Knox to bring suit against the Northern Securities Company.

Working with the governor and attorney general of Minnesota, the home of Hill's Great Northern Railroad, Knox filed the federal suit in a circuit court in St. Paul on March 10, 1902. The federal circuit court ruled against the Northern Securities Company on April 9, 1903. The company then appealed to the Supreme Court. On March 14, 1904, the Supreme Court found the Northern Securities Company to be in violation of the Sherman Antitrust Act. In a five-to-four decision, the Court affirmed the decision of the lower court and ordered the dissolution of the Northern Securities Company.

Impact of Event

Roosevelt and Knox, through successful prosecution of the Northern Securities Company, gave meaning and legitimacy to the Sherman Antitrust Act that it had not had since its passage in 1890. Knox built up the legitimacy and the credibility of the Justice Department, which at the time of the Northern Securities case was nothing more than a small team of independent lawyers. In his efforts to prosecute the Northern Securities case, Knox built the legal machinery of the Justice Department necessary to bring antitrust suits in the future. Roosevelt stated that Knox had "done more against trusts and for the enforcement of the antitrust law than any other man we have ever had in public life." Vigorous presidential action also influenced the jurisprudence of the Supreme Court, making it more sympathetic to the cause of antitrust in the future.

The dissolution of the Northern Securities Company opened the door for many other prosecutions by the Justice Department for antitrust violations. Just after the Justice Department brought suit against the Northern Securities Company in 1902, Roosevelt instructed Knox to bring suit against the "Beef Trust," a number of Chicago packinghouses including Swift and Company. Like the Northern Securities case, the suit against the "Beef Trust" was supported by widespread public opinion, especially since meat prices were on the rise. In the 1905 *Swift & Co. v. United States* case (196 U.S. 375), the Supreme Court enjoined the "Beef Trust" from engaging in collusive practices that kept prices stable or rising. This case was significant in that it expanded federal jurisdiction to include manufacturing combinations whose products were later traded in interstate commerce, a line that had been rejected in the E. C. Knight case. In 1906 and 1907, Roosevelt had the Justice Department bring suit against the American Tobacco Company, the E. I. Du Pont Chemical Corporation, the New Haven Railroad, and the Standard Oil Company. The Supreme Court ordered the dissolution of the American Tobacco (1910) and Standard Oil (1911) companies. In the years between 1890 and 1905, the Department of Justice brought twenty-four antitrust suits. The Theodore Roosevelt Administrations brought fifty-four suits, and

the single administration of William Howard Taft prosecuted ninety antitrust cases. In the decade from 1905 to 1915, there were at least eighteen antitrust cases each year.

Perhaps the most important legacy of the Northern Securities case was that it answered the question of whether the federal government had the ability and willingness to aggressively regulate large corporations. Roosevelt later wrote that in 1902 the question had not been how large corporations should be controlled. "The absolutely vital question," said Roosevelt, "was whether the government had power to control them at all." Before the federal government could compose the rules and create the agencies for regulation, it had to show that it had the willingness and ability to do so. The prosecution and dissolution of the Northern Securities Company proved that the federal government had both.

The Northern Securities case proved that the federal government could regulate and punish large corporations and also set the precedent for federal intervention in the national economy. The Hill-Harriman battle had disrupted the stock market. The overwhelming pressure of public opinion provided a favorable arena for the reform philosophy of Roosevelt and Knox. Just after the announcement of the antitrust suit against the Northern Securities Company, Roosevelt said that the prosecution aimed to prevent violent fluctuations and disaster in the market. In April, 1902, Roosevelt stated that "after the combinations have reached a certain stage it is indispensable to the general welfare that the Nation should exercise . . . the power of supervision and regulation."

Roosevelt did not oppose the fact of large corporations. He believed that with their ability to provide economies of scale, vertically integrated operations, and consolidations that prevented ruinous competition, corporations could achieve a degree of organizational efficiency that smaller concerns could not. Roosevelt believed in an increased regulatory role for the federal government, one that involved policing corporate behavior and actions rather than size itself. A few days after Roosevelt announced the suit against the Northern Securities Company, the president told J. P. Morgan, concerned for his much larger United States Steel Corporation, that it would be prosecuted only if it had "done something that we regard as wrong."

Perhaps because of Roosevelt's accommodationist regulatory policy, the trend toward large corporations grew at the same time that the number of antitrust cases increased. The economic concentration that had increased dramatically in the late nineteenth century continued to rise in the early twentieth century. In addition, in the Standard Oil and American Tobacco cases, the Supreme Court ruled that not every restraint of trade was illegal in terms of the Sherman Act, encouraging merger activity.

The prosecution and dissolution of the Northern Securities Company sent shock waves through the business world. It may have slowed the growth of mergers, but the trend continued through both Roosevelt administrations. Mergers decreased dramatically between 1902 and 1904 but increased from 1904 to 1906. By 1909, just 1 percent of the industrial firms in the United States were producing nearly half of its manufactured goods, illustrating how large the largest firms had become.

The Supreme Court had ruled in the Standard Oil case that through the "rule of

reason" it would determine whether combinations restrained trade unreasonably, thus violating the Sherman Act. The Clayton Antitrust Act of 1914 would be passed, in part, to eliminate interlocking directorates, and also to obtain statutory specifics on antitrust prohibitions rather than relying upon the shifting opinions of the federal judiciary. The Clayton Act was supplemented by the Robinson-Patman Act of 1936, which sought to further clarify and codify types of illegal price discrimination. The Celler-Kefauver Act of 1950 again sought to reinforce the Clayton Act, in much the same manner as had the Robinson-Patman Act. In 1976, Congress passed the Hart-Scott-Rodino Act, or Concentrated Industries Act. This was a mild reform law that attempted to strengthen provisions of existing antitrust laws.

The trend toward business mergers and economic concentration continued throughout the twentieth century. With the war efforts of both World War I and World War II, the federal government accepted economic and industrial concentration necessary for high production levels. This also was true of the federal efforts to deal with the economic depression of the 1930's. The laissez-faire policies of the 1920's were born of political philosophy rather than of necessity. Finally, the post-World War II economic prosperity also lessened desire for antitrust regulation, as the system seemed to be working for the benefit of most.

Several important antitrust cases, however, did reach the courts following the main period of antitrust prosecution. In 1945, the Aluminum Company of America was found to be in violation of the Sherman Antitrust Act. In 1948, the federal government forced a number of major U.S. film studios to divest themselves of studio-owned theaters. In 1961, the Supreme Court ordered the Du Pont Company to divest itself of its holdings in General Motors Company. In 1967, the Federal Communications Commission ordered the American Telephone and Telegraph Company (AT&T) to lower its rates. In 1982, under continuing federal pressure, AT&T agreed to be broken up, and a number of rival telephone companies entered the market to challenge AT&T's control.

Bibliography

Blum, John Morton. "Theodore Roosevelt and the Definition of Office." In *The Progressive Presidents: Theodore Roosevelt, Woodrow Wilson, Franklin D. Roosevelt, Lyndon Johnson*. New York: W. W. Norton, 1980. Good for an introduction to progressive policies and politics, as well as foreign policies, of Roosevelt and Wilson. Good also on Franklin D. Roosevelt and Lyndon Johnson.

Clark, John D. *The Federal Trust Policy*. Baltimore: The Johns Hopkins University Press, 1931. Analytical, detailed, and still brief enough to be of use both to the reader seeking an introduction to antitrust policy at the federal level and to those seeking to expand their knowledge of the subject.

Gould, Lewis L. "Immediate and Vigorous Executive Action." In *The Presidency of Theodore Roosevelt*. Lawrence: University Press of Kansas, 1991. Excellent history of the foreign and domestic policies of Roosevelt's administrations. Good on the Northern Securities case. Provides more depth on the Roosevelt presidency, but

also good for students beginning study of the Progressive Era.

Hill, James J. *Highways of Progress*. New York: Doubleday, Page, & Company, 1910. Hill's own account of the process of railroad building in the United States is very useful. Provides an enlightening and different perspective on the Northern Securities case and the railroad industry in general.

Meyer, Balthasar Henry. *A History of the Northern Securities Case*. Madison: Bulletin of the University of Wisconsin, 1906. Reprint. New York: Da Capo Press, 1972. Meyer, a member of the Railroad Commission of Wisconsin, gives a valuable contemporary treatment of the Northern Securities case and the trust issue itself. Places the case in context by presenting, briefly, the growth of the antitrust movement at the state and federal levels. Contains copies of relevant documents.

Thorelli, Hans B. *The Federal Antitrust Policy: Origination of an American Tradition*. Baltimore: The Johns Hopkins University Press, 1955. Comprehensive and in-depth treatment of U.S. antitrust policy. Covers economic, social, and political formation of the antitrust movement in the legislative, executive, and judicial branches of government in the late nineteenth and early twentieth centuries. For those seeking a highly sophisticated and detailed treatment of U.S. antitrust policy.

Bruce Andre Beaubouef

Cross-References

The Supreme Court Upholds Prosecution of the Beef Trust (1905), p. 107; The Supreme Court Decides to Break Up Standard Oil (1911), p. 206; The Supreme Court Breaks Up the American Tobacco Company (1911), p. 212; The Federal Trade Commission Is Organized (1914), p. 269; Congress Passes the Clayton Antitrust Act (1914), p. 275; The Supreme Court Rules in the U.S. Steel Antitrust Case (1920), p. 346; Alcoa Is Found in Violation of the Sherman Antitrust Act (1945), p. 869; The Celler-Kefauver Act Amends Antitrust Legislation (1950), p. 970; The Supreme Court Orders Du Pont to Disburse GM Holdings (1961), p. 1164; AT&T Agrees to Be Broken Up as Part of an Antitrust Settlement (1982), p. 1821.

THE ARMSTRONG COMMITTEE EXAMINES THE INSURANCE INDUSTRY

Category of event: Business practices
Time: 1905
Locale: New York, New York

In 1905, evidence of chicanery sparked a New York State investigation of the insurance industry that prompted the passage of reform legislation

Principal personages:
CHARLES EVANS HUGHES (1862-1948), a premier American attorney selected as chief counsel for the Armstrong Committee
J. P. MORGAN (1837-1913), the most powerful American investment banker of the era
WILLIAM A. READ (1858-1916), a former head of Vermilye and Company, accused of unethical practices
JACOB SCHIFF (1847-1920), an Equitable Life Assurance Society director and head of the influential investment bank of Kuhn Loeb
JAMES HAZEN HYDE (1876-1959), the president of Equitable Life

Summary of Event

Late in 1904, Thomas W. Lawson, a former Wall Street speculator turned muckraking journalist, charged that the assets of several major insurance companies were being used by powerful investment banks to manipulate the stock market. This caused an uproar in the New York State capital of Albany, followed by demands for an investigation. A brief inquiry was mounted that came up with no evidence to substantiate the charges, but something was stirring. New York Life Insurance president John McCall resigned suddenly and without explanation, causing brief but intense speculation in the newspapers. Interest in the subject mounted. These developments were followed by rumors of a shakeup at the Equitable Life Assurance Society that gave some credence to Lawson's allegations.

What attracted the press's attention were the activities of the flamboyant James Hazen Hyde, who five years after graduating from college was earning $100,000 a year as vice president of the Equitable, which he controlled after his father's death. It was a sizable, wealthy company, with 600,000 policyholders and assets of $400 million.

Hyde lived well and ostentatiously. He was famous for his many elaborate parties, all of which were paid for by the Equitable. One of these, held on January 31, 1905, caused a sensation. Hyde redecorated Sherry's restaurant to resemble Versailles at the time of the reign of King Louis XIV, hired a French actress to recite Racine to the guests, and served a lavish and expensive meal. The entire cost, as estimated by reporters, came to $200,000.

The ball had political repercussions. Alarmed at the impact of Hyde's spendthrift

ways on the insurance company's image, company president James W. Alexander and thirty-five other officers and agents brought charges of malfeasance against him, utilizing the services of Charles Evans Hughes, who was to become one of the country's leading attorneys but then was about to initiate an investigation of the state's natural gas business.

The directors demanded that the Equitable be converted to a mutual company, one therefore owned and controlled by policyholders. This would have resulted in Hyde's departure. A war for control of the company followed, one in which E. H. Harriman and J. P. Morgan clashed, albeit indirectly. Both men hoped to use the Equitable's cash reserves to finance some of their deals. The battle ended when Hyde sold his shares to Thomas Fortune Ryan, a Morgan ally, for $2.5 million.

This maneuver resulted in demands for investigation. On August 1, 1905, a state investigatory committee was established, to be chaired by Senator William W. Armstrong. The senator promptly offered Hughes the position of chief counsel to the committee. The attorney, who had just completed his investigation of the gas industry, was at the time in Europe on a vacation. Hughes accepted the offer and returned home. In September, Armstrong opened an investigation that lasted until December 30. The committee, named for Armstrong, began its investigations with the Equitable situation, but its inquiries soon spilled over to other insurance companies as well.

Hughes uncovered many episodes of mismanagement, fraud, falsified statements, and bribery of public officials. Among other things, he disclosed that since 1896 Mutual Life had maintained a "house of mirth" in Albany for the entertainment of state legislators. During the next few months, insurance industry scandals, as they were called, dominated the news. Each week another lurid illustration of corporate chicanery turned up. Prominent politicians were involved with Hyde. Senator Thomas Platt confessed that most of the city's large insurance companies had each paid him $10,000, which he turned over to the Republican State Committee for use in the election campaigns of individuals supportive of the industry. Senator Chauncey Depew, who had ties with the Morgan bank, spoke of having received a $20,000 annual retainer from the Equitable, of which he was a director. Other politicians came forward and, under Hughes's skillful interrogation, all but conceded that they were on the payrolls of one or more insurance companies.

It was not long before investment bankers were drawn into the investigation. Hughes revealed that in order to conceal bribes and losses, several investment banks, Kuhn Loeb being the most prominent, had made year-end loans to and sales for several insurance companies. These actions would increase reported cash balances for the insurance companies, while the investment banks would report inflated figures for outstanding loans and holdings. When the fiscal year ended, the insurance company would repay the loan and make payment for the sales, and the bank would receive a fee for its services.

Jacob Schiff, both a Kuhn Loeb partner and an Equitable director, admitted having sold almost $50 million in securities to the insurance company for this purpose during a period of five and a half years. This was in clear violation of a state law forbidding

such actions by a company officer. Before Hughes was finished, he had demonstrated flagrant infractions of law and ethics involving scores of prominent politicians and businesspeople.

In November, the name of Vermilye and Company, a relatively small but respected investment bank that recently had gone out of business, was dragged into the investigation. Building upon what had been revealed about Kuhn Loeb, Hughes attempted to show that the Metropolitan Life Assurance Company had made large loans to Vermilye at interest rates lower than those prevailing in the market and that these were used to mask irregularities. He introduced evidence that two loans, one for $200,000 and the other for $1 million, had been made the previous year. In addition, Hughes claimed that Metropolitan had sold stock either to or through Vermilye below market prices, after which Metropolitan's president, John R. Hegeman, was given a substantial rebate. Hughes thus suggested that some of the principals at Vermilye had engaged in duplicitous practices for personal gain. They stood in infraction of state law and, in the matter of rebates, in violation of New York Stock Exchange regulations. If proven, these allegations could have resulted in the lodging of criminal charges against those involved.

William A. Read, a former head of Vermilye, denied all implications of wrongdoing and demanded specifics and proof of the claims. These appeared to come the following month, when a Metropolitan vice president, Haley Fiske, testified that Vermilye had sold Metropolitan 3,333 shares of Lake Shore and Michigan Southern Railway, then quoted at $400 per share, for $350 per share, and that Vermilye did not receive a commission from the buyer on the transaction, but rather obtained one from the seller. This last matter would have been a violation of law and New York Stock Exchange rules, since Vermilye would have been serving both buyer and seller as agent, without the former knowing of the relationship with the latter. In other words, the Metropolitan would not have known that Vermilye had that incentive from the seller. Nothing further was heard for a while about the commissions. Apparently Hughes lacked evidence to corroborate allegations of wrongdoing on that score. He turned instead to the matter of price movements in the Lake Shore stock and the spread between the bid and offer prices.

Read answered the assertions. In a letter to the editor of the *New York Daily Tribune*, he pointed out that Fiske had not complained about the price. Rather, the Metropolitan officer had informed the Armstrong Committee, "I do not want to do any injustice to Mr. Read. He is quite certain that his transaction was entirely justified by the rules of the Street and by right dealing." Alluding to the half-forgotten matter of the commission, Read added, "Whether or not the commission was reasonable is comparatively immaterial, but it is vital to my reputation in the community that the refutation of the charge that I took a commission without the knowledge of my client be given equal publicity with the charge itself." He might also have added that Lake Shore was a thinly traded issue and that large changes in price when so large a block of stock changed hands were fairly common.

With this, the matter dropped. Clearly Hughes thought that he lacked sufficient

evidence to continue. Still, doubts and suspicions remained. Even if Read were not guilty of having acted improperly in the matter of the Lake Shore stock, the issue of rebates given to Metropolitan by Vermilye required further investigation. Were there rebates, and if so, who gave them? Hughes said that he had proof of Vermilye's involvement and indicated that the evidence would be introduced at the proper time.

It was not until the following year that the public learned just who was culpable. It was not Read but rather Donald and George Mackay. The father and son received a hearing before the New York Stock Exchange Governing Committee, were charged with violation of exchange rules forbidding rebates, and on January 5, 1906, were found guilty. By inference, Read was found blameless.

This was not the end of the matter. The Mackays sued Read, charging that he had improperly retained commissions earned in the Metropolitan transactions. A month later, Read issued a statement in which he attempted to clarify the situation. He charged the Mackays with attempting to appropriate for themselves commissions of slightly less than $50,000 that he had earned through dealings with Metropolitan during the last few months of Vermilye's existence. In this statement, he said that

> Acute differences then existed between the partners, and Messrs. Mackay, Fish, and Hollister were engaged in an effort to appropriate to themselves the name and goodwill of the firm of Vermilye & Co., excluding me from any interest therein. Under these circumstances I undertook and carried out on my individual account the three transactions which are the subject of this lawsuit. The acts of my partners prevented me from doing the business in any way but individually. As to all of these matters, I acted under the advice of counsel, and am content to abide by the decision of the court.

With this the matter ended. The Mackays did not initiate a lawsuit against Read, evidence that their claims were without foundation. Read came out of it with his honor and reputation intact, while the Mackays might have considered themselves fortunate for having received little more than a rap on the knuckles, perhaps because of Donald Mackay's age and former eminence—he had served as president of the New York Stock Exchange.

Impact of Event

The investigations affected the way Wall Street and the insurance industry conducted business. The revelations prompted demands for reform and regulation that intensified after the Armstrong Commission made its report on February 22, 1906.

The commission stunned the financial community by announcing its intention to "revolutionize" the way new securities issues were awarded to underwriters. Up until that time, all new issues were placed on a negotiated basis, which is to say that the company issuing a security would approach a banker or vice versa. The bank and the company would then work out the terms of the financing, including price, amount, and maturity and interest rates. The commission proposed that all future underwritings for companies over which it had authority be placed on a competitive basis, with any investment bank able to bid for the business, which would presumably go to the one

making the best offer. The concept was rejected, but it remained a source of contention. As it was, the old ways prevailed, with banks wooing customers on the basis of personal relationships, service, placement power, and reputation. New York and other states did prohibit insurance companies from participating in investment banking.

In addition, Hughes helped draft new insurance legislation that prohibited companies from making contributions to political campaigns as well as requiring registration of lobbyists and curbing their activities. Congress followed his lead, passing the Corrupt Practices Act of 1907 and giving credit to Hughes for inspiration. According to the *St. Louis Post-Dispatch*, he managed to transform the insurance business from "a public swindle to a public trust."

The Armstrong Committee investigation also led to changes in the way insurance companies were run. The investigations revealed that some of the larger companies were run as autocracies, with trustees having little control over management. Salaries of high corporate officers were increased without the knowledge of trustees. In addition, the committee pointed out problems in the incentives for general sales agents. Those agents earned commissions on all policies sold and often had large territories, leading them to sell as many policies as possible with little follow-up and little concern for the long-term welfare of the buyers. Following the committee's report, general agents were made salaried, and policy salespeople were required to take training courses in how best to serve customers.

The Armstrong Committee did much to inform the public of how and why Wall Street bankers conducted their affairs. The shock of learning how much money was involved and the fees earned for various services helped accelerate the movement toward reform, which then was lagging. As for the Equitable itself, its joint ownership of National Bank of Commerce, New York's second largest financial institution, was challenged. Equitable and Mutual Life Insurance were obliged to sell their control shares, which were purchased by J. P. Morgan, First National Bank, and National City Bank. Ironically, the Armstrong investigation, which was aimed at limiting financial concentration, resulted in this move that further consolidated the power of the Morgan group.

Hughes went on to run for the New York State governorship in 1906, defeating Democrat William Randolph Hearst. One of his programs in office involved the establishment of a Public Service Commission that was granted investigative and regulatory powers, including the authority to review all new utilities issues. On the basis of his record, Hughes obtained the Republican presidential nomination in 1916, narrowly losing the election to Woodrow Wilson. He later became secretary of state and chief justice of the United States.

Hyde left the country and wound up in Paris two days before the conclusion of the Armstrong Committee investigation. He denied intentions of relinquishing his citizenship. "I am too good an American for that. That report was circulated by enemies to injure me, but they have failed." He remained in Paris for the next thirty-five years, devoting much of his time to Franco-American relations. Hyde returned to the United States for visits after World War II, and he died in Saratoga, New York.

Bibliography

Beebe, Lucius. *The Big Spenders*. Garden City, N.Y.: Doubleday, 1966. Contains a colorful sketch of James Hazen Hyde and the backdrop for the Armstrong investigation.

Carosso, Vincent. *Investment Banking in America*. Cambridge, Mass.: Harvard University Press, 1970. The classic history of American investment banking, with a section on the Armstrong investigation.

James, Marquis. *The Metropolitan Life*. New York: Viking Press, 1947. Contains an account of the Armstrong investigation from the vantage point of the Metropolitan.

Logan, Sheridan. *George F. Baker and His Bank, 1840-1955*. New York: Author, 1981. A view of the Armstrong investigation from the point of view of an ally of J. P. Morgan.

Pusey, Merlo. *Charles Evans Hughes*. 2 vols. New York: Macmillan, 1951. Volume 1 has a chapter on the Armstrong investigation, explored from Hughes' point of view.

Robert Sobel

Cross-References

A Financial Panic Results from a Run on the Knickerbocker Trust (1907), p. 134; The Corrupt Practices Act Limits Political Contributions (1925), p. 476; The Securities Exchange Act Establishes the SEC (1934), p. 679; Merrill Lynch Concentrates on Small Investors (1940's), p. 809.

SINGER BEGINS MANUFACTURING SEWING MACHINES IN RUSSIA

Category of event: International business and commerce
Time: 1905
Locale: Podolsk, Russia

Singer developed a major factory in Podolsk, Russia, in response to consistently growing Russian sales

Principal personages:
> WALTER F. DIXON, the Podolsk factory manager, 1900-1917
> ALBERT FLOHR, the managing director of Kompaniya Singer, 1902-1915
> GEORGE NEIDLINGER (1843-?), Singer's general agent in Hamburg, Germany, 1865-1902

Summary of Event

In 1905, the Podolsk factory of Kompaniya Singer, the wholly owned subsidiary of America's Singer Manufacturing Company, began making sewing machines (called machine heads to distinguish them from the cast iron stands) for the Russian market. The development of this factory, which within a few years would be Singer's third largest manufacturing plant, was the natural outgrowth of the growing size and importance of the Russian market for Singer machines.

The Singer Company had its roots in the 1850's, when Isaac Singer brought together the elements that were central to any successful design of a sewing machine and his partner Andrew Clark developed an effective marketing approach using a form of installment credit. Singer quickly sought foreign markets, establishing general agents first in London, in 1862, and then in Hamburg, in 1865. The Hamburg agent, George Neidlinger, quickly established links to Russia, selling through an independent agent. During the 1870's, Singer perfected its marketing approach, using myriad small shops with door-to-door canvassers, and decided to take direct control of all of its sales, whether in America or abroad. In 1877, Neidlinger took control of Russian sales and began building an organization nearly identical to that already in place in the United States, Great Britain, and parts of Western Europe.

Sales of Singer sewing machines in Russia grew steadily through the 1880's and early 1890's. With a quickening tempo of Russian economic development in the 1890's, it was increasingly likely that Russia would develop into a major market, perhaps second only to that of the United States. To position the company to take advantage of this opportunity, Singer's management in New York City decided to create a wholly owned subsidiary in Russia and to develop a factory to help supply the rapidly increasing needs of the Russian sales organization. Neidlinger incorporated Kompaniya Singer in 1897, soon acquired what was perhaps the finest commercial location on St. Petersburg's premier business street, Nevskii Prospekt, and began

an intensive search for a site suitable for a major factory. In the spring of 1900, Kompaniya Singer acquired its preferred site in the town of Podolsk, twenty-six miles south of Moscow. To supervise construction of the new factory and then to manage its operation, Neidlinger hired William F. Dixon, an English-born civil engineer with extensive industrial experience, first in the United States, then for seven years in Russia.

Dixon proceeded cautiously, following a pattern Singer had used in developing factories in Scotland and Germany. At first, Podolsk made only the easily fabricated, heavy, cast iron stands, which were then assembled with imported machine heads. This permitted slow and careful development of a skilled work force. Neidlinger and Dixon knew that Russia did not have the kind of skilled industrial workers available in the West. They brought experienced workers from Singer's plant near Glasgow to begin operations. Each of these hands worked in tandem with a single Russian worker until the Russian knew how to do the work precisely, then each would take on another Russian. To guard against bringing in bad practices from other Russian factories, Dixon hired only peasants with no previous industrial experience. His approach was remarkably successful: The Podolsk plant achieved quality and productivity levels near those of its sister factories in New Jersey and Scotland and was, according to one official American survey, the only factory in Russia to approach Western standards.

In 1905, the Podolsk factory employed only 398 people. It was able to produce nearly 150,000 stands, coming close to satisfying the needs for the Russian market. The well-trained work force then began making machine heads. The first 450 were ready by April. During 1907, the factory made 190,000 stands and shipped nearly 100,000 machine heads. In 1908, Podolsk employed more than thirteen hundred workers and was by far the largest machinery producer in the Moscow region; in 1912, with nearly three thousand employees, output reached 245,000 stands and 425,000 machine heads. This extraordinary growth required almost continuous additions to the factory and led to acquisition of nearly forty adjacent acres to accommodate yet more factory expansion. The scale of output created pressure in another quarter—the need for lumber for machine covers. In 1912, Dixon sought and eventually won approval to buy 186 square miles of forest in the Vetluga district, four hundred miles northeast of Podolsk.

This prodigious expansion of output at Podolsk did not, however, keep up with growth in sales of sewing machines in Russia. Russia was Singer's largest growth market between 1902 and 1914. Sales grew threefold, jumping from 15 percent of Singer's total sales to 30 percent, and Russia became the most important market after America itself. The man who directed this remarkable achievement was Albert Flohr, a German who had begun working for Neidlinger in the 1890's and had taken control of Kompaniya Singer and the Russian marketing organization in 1902. Flohr was an uncommonly skillful leader, energetic, creative, and tough. By 1914, he headed a sales organization that was the largest nongovernmental organization in Russia. It had twenty-seven thousand employees, supervised through fifty district offices and working out of nearly five thousand retail shops.

Impact of Event

The growth and evolution of Singer's Russian sales and manufacturing organization followed a pattern typical of many major American industrial firms. As firms grew, they often found that sales in their existing markets were growing slowly or were even stagnant; in order to sustain growth, they needed to develop new markets. Singer was unusual only because it began this process so early, driven in significant measure by the disruptions that the American Civil War brought to its domestic market. Singer quickly discovered how profitable foreign sales could be, and by the 1870's it was committed to selling machines everywhere in the world that it could find a market. In some countries, Austria and Canada for example, it found that it had to do some local production, either to escape heavy tariffs or to protect patent rights, and thus established small foundries that made only stands. In larger markets such as Great Britain, Germany, and Russia, Singer recognized that it had to have local manufacturing capacity to retain its competitive position and sustain growth. Its American facilities simply could not meet the demand. Indeed, Singer's first overseas production began on the initiative of its London agent, who could not get enough machines from America following the American Civil War. This evolution from developing a market to supporting that development with local manufacturing was a pattern that many other firms followed, including Ford and Eastman Kodak.

Singer's Russian experience is interesting because of the virtual absence of government involvement. Historians have often characterized late Imperial Russia, especially under Finance Minister Sergei Witte in the 1890's, as vigorously courting foreign investors and promoting industrialization. That picture finds absolutely no confirmation in the Singer experience. Nor do Singer records suggest any significant problem with official venality, another common theme in histories of the period. The internal logic of Singer's marketing strategy and its remarkable success in expanding Russian sales, rather than governmental encouragement, drove the decision to manufacture at Podolsk.

The second great multinational company active in Russia at the time was International Harvester. Its principal predecessor, McCormick Harvesting Machine Company, had developed strong overseas sales but had not developed any overseas manufacturing capacity at the time of the 1902 merger that created International Harvester. Believing the American market to be largely saturated, the new company gave particular attention to developing foreign markets. By 1906, in response to the strength of some European competitors and the difficulty in competing effectively from a North American base, International Harvester had bought an old factory in Norrköping, Sweden. It soon followed that with factory acquisitions in France, Germany, and Russia. As with Singer, concerns about tariffs, licensing, and other issues sometimes helped focus attention on the question of the appropriateness of local manufacturing, but the fundamental reason that drove development of local factories in Russia and elsewhere was the necessity of providing adequate quantities of goods to meet rapidly growing sales.

Unlike Singer, International Harvester did get deeply involved with the Russian

government when it decided that it ought to develop manufacturing capacity in Russia. The prospect of government bounties for the manufacture of complex modern harvesting equipment and the possibility of facing stiff duties on imported machines led senior managers at International Harvester to open negotiations with top Russian officials. The company ultimately reaped no benefits from these negotiations; in fact, they distracted management from the critically important supervision that was needed to make the Russian factory a success. Ultimately, International Harvester's experience in Russia confirmed the lessons of Singer's history there: There was very little the Russian government would or even could do for a market-oriented investor. The challenge was to manage the marketing organization and its supporting manufacturing plant with skill and insight.

Bibliography

Carstensen, Fred V. *American Enterprise in Foreign Markets: Studies of Singer and International Harvester in Imperial Russia.* Chapel Hill: University of North Carolina Press, 1984. Detailed case studies of Singer and International Harvester (and its principal predecessor, McCormick Harvesting Machine Company) in Russia. Based on rich archival sources. Good analysis of how these two transnational corporations developed. Particularly strong on marketing.

Chandler, Alfred D. *The Visible Hand: The Managerial Revolution in American Business.* Cambridge, Mass.: Belknap Press, 1977. The authoritative, award-winning history of the rise of hierarchical corporate management in American firms between 1850 and 1920. Provides excellent context for understanding processes at Singer and International Harvester.

Davies, Robert B. *Peacefully Working to Conquer the World: Singer Sewing Machines in Foreign Markets, 1854-1920.* New York: Arno Press, 1976. A good general description of Singer's overseas development, including materials on Singer in Japan, China, India, South America, and Europe. Weak on the critical marketing developments of the 1870's.

McKay, John. *Pioneers for Profit: Foreign Entrepreneurship and Russian Industrialization, 1885-1913.* Chicago: University of Chicago Press, 1970. The best summary of foreign enterprises active in Russia.

Wilkins, Mira. *The Emergence of Multinational Enterprise: American Business Abroad from the Colonial Era to 1914.* Cambridge, Mass.: Harvard University Press, 1970. The authoritative and comprehensive survey of American transnational companies operating prior to World War I.

Fred V. Carstensen

Cross-References

International Harvester Company Is Founded (1902), p. 52; Lever Acquires Land Concessions in the Belgian Congo (1911), p. 201; Hoover Signs the Smoot-Hawley Tariff (1930), p. 591; The Bretton Woods Agreement Encourages Free Trade (1944), p. 851; Fiat Plans to Build a Factory in the Soviet Union (1966), p. 1293.

THE SUPREME COURT UPHOLDS PROSECUTION OF THE BEEF TRUST

Category of event: Monopolies and cartels
Time: January 30, 1905
Locale: Washington, D.C.

The federal government's successful prosecution of the beef trust represented an early and notable antitrust victory from which sprang an important new legal concept concerning interstate commerce

Principal personages:

THEODORE ROOSEVELT (1858-1919), the first president to aggressively press prosecutions under the Sherman Act

GUSTAVUS F. SWIFT (1839-1903), a leading meatpacker, a defendant in prosecution of the beef trust

PHILIP DANFORTH ARMOUR (1832-1901), a meatpacker whose company fell under attack

OLIVER WENDELL HOLMES, JR. (1841-1935), the Supreme Court justice who delivered the Swift decision

UPTON SINCLAIR (1878-1968), a novelist who exposed conditions in the meat-packing industry

PHILANDER CHASE KNOX (1853-1921), a U.S. attorney general who investigated and prosecuted the beef trust

Summary of Event

Still new in his presidency, Theodore Roosevelt wrote to a U.S. senator in 1902 that he was fully aware that the American people were "very bitter" about operations of the "beef trust." Roosevelt was accurate. Independent butchers, businesspeople, farmers, and consumers had complained since the 1880's that the large packing houses led by Gustavus F. Swift, Nelson Morris, Philip Danforth, Armour, Jonathan Ogden Armour, and the Cudahy family were preserving their meats with poisons. In the decade following passage of the Sherman Antitrust Act of 1890, two federal indictments had been brought against the "pooling" arrangements of meat exchanges, commission dealers, and stockyard operators. Each indictment was overruled by the U.S. Supreme Court on grounds that "pooling"—businesses striking agreements not to compete—comported with current business philosophy and that since stockyard transactions were local they formed no part of interstate commerce. Although the Supreme Court had ruled against legal arguments of federal attorneys, those rulings had neither resulted in a slackening of press campaigns against the beef trust nor allayed the public's disquiet about prospects of a monopoly or exercise of monopoly power.

From his service in the Spanish-American War, Roosevelt had firsthand knowledge of the scandal about the "embalmed beef" supplied to American forces. Complaints

from businesses and consumers continued to pour into the office of Philander Chase Knox, Roosevelt's attorney general, about the rising prices of beef trust products and about the big packers' collusions with railroads. More directly, Knox was bombarded by influential members of the House of Representatives to reveal the government's intentions in regard to actions against this trust.

By 1902, therefore, upon Roosevelt's initiative, Knox launched antitrust inquiries concerning activities in the meat-packing industry. The evidence subsequently amassed showed the six leading ("big six") meatpackers to be engaged in price fixing, conspiracies to divide markets in regard to purchases of livestock and meat sales, blacklisting of competitors or of businesses failing to conform to trust practices, false bidding in dealings with public institutions, and acceptance of rebates from railroads. The six companies brought under federal scrutiny were Swift, Armour, Morris, Cudahy, Wilson, and Schwartzchild, all of which consorted in pooling agreements.

Together the big six controlled about half of the American beef-packing industry, a percentage that rose in the eastern United States to as much as 60 percent of the beef business in Pittsburgh and Philadelphia to 75 percent in New York City and to 85 percent in Boston. The overall industrial reach was far more extensive, and the industrial importance of these meatpackers was much greater than their substantial trade in beef because in addition they handled calves, hogs, and sheep. They drew significant parts of their $700 million yearly business from the purchase, storage, and sales of dairy and poultry products. Furthermore, in most major cities they owned packing plants, stockyards, and elevators. They all had subsidiaries that dealt in or manufactured byproducts such as hides, fats, animal foods, fertilizers, glue, soap, and canned fruits, and they owned refrigeration plants as well as railroad refrigerator cars for transporting their wares.

Capitalized in the aggregate at $93 million in 1903, these industry leaders could boast impressive achievements for their firms as well as for consumers. Philip Armour, originally based in Milwaukee, Wisconsin, and Nelson Morris, nearby in Chicago, Illinois, had profited from government Civil War contracts. With the postwar projection of railways into the prairies, they had stimulated the great cattle drives from Texas to the transcontinental railroads. In so doing, they contributed to the existence and prosperity of many prairie communities. Gustavus Swift, arriving in Chicago from Massachusetts in 1875, revolutionized the industry by the regular employment of refrigerator cars and by efforts, soon followed by other packers, to attain the efficiencies of vertical integration. He played a large part in making Chicago famous as the world's greatest meat-packing and processing center. The meatpackers' out-raged response to government action, typified by Jonathan Ogden Armour's *Saturday Evening Post* articles defending his industry, was predictable if not commendably accurate.

Saddled with Sherman Act injunctions in May, 1902, for pooling agreements and for taking railroad rebates, Gustavus Swift, Jonathan Armour, and Edward Norris abolished their pool, destroyed its records, and contracted to merge their firms into one. Cudahy and Schwartzchild quickly consented to join, and many other meat-

packing companies were rapidly purchased by these three companies. Failing to secure adequate financing from Wall Street to expand their merger, they formed the National Packing Company in 1903. National's leaders were the same figures who had dominated the previous pool, and they continued meeting to regulate their trade. In response, federal injunctions were made permanent. The government's equity proceeding was heard by the U.S. Supreme Court in 1905, shortly after the Roosevelt Administration's much-heralded victory in the Northern Securities case of 1904. The Court's decision in that case had broadened the meaning of interstate commerce and provided a favorable context for a decision against the beef trust.

In *Swift & Co. v. United States* (196 U.S. 375), Oliver Wendell Holmes, Jr., spoke for the Court. Holmes took his cues from the narrow interpretation of interstate commerce propounded in *United States v. E. C. Knight Company* (1895) as modified by the Northern Securities decision. He broadened the concept of interstate commerce. Granting that many sales and transactions by the enjoined meatpackers occurred as local ones, Holmes emphasized the steady movement of animals and meat products in and out of stockyards and localities to and from all parts of the nation. The reality was that they were actually a part of the "stream of commerce." Having concluded that this was true, Holmes asserted that activities of the beef trust fell under federal jurisdiction, as did all matters pertaining to interstate commerce, and were therefore in violation of the Sherman Act. The Supreme Court's decision was unanimous.

Impact of Event

The Swift decision had several ramifications. The Roosevelt Administration clearly had won a political victory against an unpopular trust, even though the trust's leaders were heavy Republican contributors. Roosevelt, who was basically a moderate conservative, earned respectful enmity in corporate circles while gaining repute as an ardent reformer in many other quarters. His action in the beef trust prosecution, strengthened by forty more antitrust suits during his tenure in office, also contributed to public impressions that the federal government was becoming an effective umpire of the nation's economic affairs. Roosevelt's position on trusts, which constituted a significant step toward a stronger, more interventionist federal government, helped establish precedents for later presidencies.

The Supreme Court also contributed to foundations of the modern state in advancing Holmes's "stream of commerce" doctrine. In the short run, this doctrine encouraged the federal government to pursue other antitrust cases, many of which were prosecuted successfully. Over the long term, the "stream of commerce" doctrine became a working concept basic to expanded understandings of the federal government's control of commerce. During the late 1930's, judicial applications of the doctrine served to break down earlier Court decisions that had isolated manufacturing from commerce. In so doing, they allowed federal authorities to initiate a vast array of economic legislation and a broad spectrum of social programs.

The focus of government prosecution of the beef trust centered on its business

practices, their effects upon competition, and restraints of trade. Health and working conditions within the industry lay beyond the scope of these government inquiries. Such limitations, however, did not inhibit journalists ("muckrakers") and writers whose attention was directed to the beef trust by government injunctions or by judicial decisions. A series of articles written by Charles Edward Russell, appearing in *Everybody's Magazine* during 1904 and 1905, condemned the trust as greedy while impugning a number of public officials as its dupes. More impressive and influential was novelist Upton Sinclair's dramatic exposé of specific sanitary and working conditions in Chicago packing plants contained in his 1906 book *The Jungle*. Forced to take account of the public alarm generated by Sinclair's novel, government officials characterized its depictions as misleading and false. The result of these and similar exposures of practices of the meat-packing industry led to passage of both the Pure Food and Drug Act and the Meat Inspection Act in 1906. Each act greatly augmented federal inspection powers, and each came to be ranked, less for immediate effectiveness than for precedents set, among the memorable legislation of Theodore Roosevelt's presidency.

Because its products were items of daily consumption in the nation's households, the meat-packing industry remained under government investigation and attack long after the Swift decision had been rendered and reform legislation had been passed. Federal criminal and civil charges, for example, were filed against officials of the National Packing Company and additional companies in 1910. Charges ranged from rigged agreements on livestock purchases to use of uniform accounting practices and the establishment of market quotas by trust members. National's officers won acquittal, but they were defeated by the firm's own inefficiencies and dissolved it in 1912.

A Federal Trade Commission (FTC) report on the meat-packing industry, initiated by President Woodrow Wilson in 1917, gathered a mass of evidence on unfair competition and recommended government ownership. By 1920, after their purchase of thirty-one smaller companies, the industry's leaders were confronted once more by FTC and Justice Department charges that they had violated antitrust provisions of the Sherman Act and Clayton Act. Responding to what became a famous antitrust consent decree, the companies disposed of substantial holdings in stockyard companies, stockyard railroads, and trade newspapers. They also agreed to abandon dealing in 114 nonmeat and dairy products as well as to give up their retail outlets. Authorities on the industry, in concert with its spokespeople, later acknowledged that these federal antitrust measures had redounded to the ultimate benefit of the industry.

The principal result of the FTC's investigation and the consent decree was the passage of the Packers and Stockyards Act of 1921, which brought the meat-packing and related industries under federal regulation. The act placed stockyard markets and those operating with them under federal rules and supervision by the secretary of agriculture. In effect, the industry could thereafter be perceived as a kind of public utility. The act also comprehensively forbade anyone manufacturing or preparing meats to engage in price fixing, price discrimination, or the apportionment of markets. On balance, the federal investigations and antitrust suits, and the judicial decisions

arising from them, left the meat-packing industry with an oligopolistic concentration of leading firms but with access to the industry much more open to smaller competing firms. Antitrust proceedings beginning in 1902 destroyed the industry leaders' pool and helped prevent the evolution of such agreements into something approximating a genuine monopoly.

Bibliography

Crunden, Robert M. *Ministers of Reform: The Progressives' Achievement in American Civilization, 1889-1920*. New York: Basic Books, 1982. Clear, informative reading. Chapter 6 is excellent on muckraking journalists and especially on Upton Sinclair and his influence on the Pure Food and Drug Act. Brief bibliographical essays for chapters. Good index.

Purdy, Harry L., Martin L. Lindahl, and William A. Carter. *Corporate Concentration and Public Policy*. New York: Prentice-Hall, 1942. Good survey filled with specifics. Chapter 23 deals with the meat industry, with good background material. Balanced account that takes note of this industry's problems. Ample page notes replace a bibliography.

Sinclair, Upton. *The Jungle*. New York: New American Library, 1906. A classic of literary realism. Sinclair had firsthand experience in Chicago packing plants. The novel is stronger on conditions than on character development. A graphic and engaging read.

Thorelli, Hans. *The Federal Antitrust Policy*. Baltimore: The Johns Hopkins University Press, 1955. Scholarly and dense but very valuable. Chapter 7 is excellent on the development of Theodore Roosevelt as a trust buster and his decision to pursue the beef trust. Many page notes, bibliography, table of cases, and good index. Good for context on the antitrust movement in general.

Whitney, Simon N. *Antitrust Policies: American Experience in Twenty Industries*. 2 vols. New York: Twentieth Century Fund, 1958. Written by a scholar and FTC official. Clear and authoritative. Concentrates on meat-packing in chapter 1. Superb on post-1920 developments. Page notes supplant a bibliography. Table of cases.

Wiebe, Robert H. *The Search for Order, 1877-1920*. New York: Hill & Wang, 1967. A fine interpretive history, well written and informative. Offers perspectives on the antitrust and antimonopoly movement throughout. Excellent for concepts and context on trusts. Bibliographical essay for each chapter. Index.

Clifton K. Yearley

Cross-References

The Supreme Court Rules Against Northern Securities (1904), p. 91; Congress Passes the Pure Food and Drug Act (1906), p. 128; The Supreme Court Decides to Break Up Standard Oil (1911), p. 206; The Supreme Court Breaks Up the American Tobacco Company (1911), p. 212; Congress Passes the Clayton Antitrust Act (1914), p. 275; The Robinson-Patman Act Restricts Price Discrimination (1936), p. 746.

THE SUPREME COURT STRIKES DOWN A MAXIMUM HOURS LAW

Category of event: Labor
Time: April 17, 1905
Locale: Washington, D.C.

By ruling that maximum hours laws were unconstitutional, the Supreme Court upheld the freedom of contract and severely limited the ability of states to enact reform legislation

Principal personages:
RUFUS WHEELER PECKHAM (1838-1909), an associate justice of the Supreme Court, 1895-1909, who wrote the majority opinion in *Lochner v. New York*
OLIVER WENDELL HOLMES, JR. (1841-1935), an associate justice of the Supreme Court, 1902-1932
JOHN MARSHALL HARLAN (1833-1911), an associate justice of the Supreme Court, 1877-1911
HERBERT SPENCER (1820-1903), an influential scientist and philosopher who championed the theory of social Darwinism

Summary of Event

On April 17, 1905, the Supreme Court ruled five to four in the case of *Lochner v. New York* that maximum hour laws were an unreasonable interference with the liberty of contract. The Court ruled that the power of the state to regulate did not outweigh the freedom of contract. The ruling struck down an 1895 New York statute that had limited the number of work hours for any employee in any bakery or confectionery establishment to no more than ten hours in a day or sixty hours in a week. New York's labor law was an example of the aggressive interventionist and experimental policies that several states had begun pursuing around the turn of the century. The Court held that New York's experiment had been a "meddlesome interference" and an undue infringement on the right of free contract and thus of the private rights of the employer. In a powerful and eloquent dissent, Justice Oliver Wendell Holmes, Jr., held that the states had the authority to pursue their own social experiments and enact reform legislation.

New York's Bakeshop Act had been enacted in an effort to regulate and improve the often dreadful working and health conditions in the state's cramped bakeshops, establishments that often employed only a handful of workers and were often located in the basements of tenement buildings. Passed as an act to regulate the manufacture of flour and meal food products, the Bakeshop Act established maximum hours and required that bakeries be drained and plumbed; that products be stored in dry and airy rooms; that walls and floors be plastered, tiled, or otherwise finished; and that inspections be carried out.

The law was not the first attempt to set limits on hours worked. Among the earliest efforts to regulate hours of work was an executive order signed by Martin Van Buren in 1840 that limited the daily hours of labor in government Navy yards to ten. Most early efforts to set limits on hours of labor concerned the employment of women and children. Massachusetts and Connecticut each passed laws limiting the number of hours for children employed in manufacturing establishments as early as 1842. By the late nineteenth century, laws limiting hours for women, children, or both had been passed in New Hampshire, Maine, Pennsylvania, New Jersey, Rhode Island, Ohio, Illinois, Missouri, and Wisconsin. The arguments in support of limiting the hours of work included enhancing the efficiency or productivity of labor and improving public health. Proponents of maximum hours legislation argued that limits on the length of daily labor would lead to qualitative as well as quantitative improvements. Clearly, any bakeshop laborer who toiled long hours in cramped sweatshop conditions stood to gain some benefit, but proponents argued that there were also potential benefits for the consumers of baked goods. The principal arguments against such legislation were simply that it was an overextension of the police powers of the state and that it infringed on the right of freedom of contract. Moreover, theories of social Darwinism and laissez-faire economics insisted that such government intervention was an unjustified and inefficient disruption of the free market.

Joseph Lochner owned and operated a small bread bakery in Utica, New York. After being twice found guilty of violating New York's Bakeshop Act, he was fined $50. He appealed his conviction to the New York Supreme Court and the New York Court of Appeals, losing each time. His case ultimately made its way to the Supreme Court. Why this case emerged as the test case for a host of reform legislation is unclear; Lochner's bakery was a small and relatively obscure establishment. An ongoing clash between Lochner and the Utica branch of the journeyman bakers' union may have led to his fine and kept this case alive on appeal.

The majority opinion in *Lochner* was written by Associate Justice Rufus Peckham. Peckham was known for his staunch support of laissez-faire policies and his contempt for government regulation, beliefs that would lead others to link Peckham with the writings of Herbert Spencer, one of the most outspoken and best-known champions of social Darwinism. In an 1897 ruling in *Allgeyer v. Louisiana*, Peckham had written the opinion that held a law unconstitutional for depriving a person of liberty of contract. Any contract suitable to the operation of a lawful business was thus afforded protection under the Fourteenth Amendment. The doctrine of liberty of contract, established in *Allgeyer*, was advanced in *Lochner*.

In *Lochner*, Peckham held that there was no reasonable ground for interfering with the liberty of a person or the right of free contract by determining the hours of labor in this particular case. Although he acknowledged the power of states to protect the health and morals of citizens in specific situations, he questioned the need for protection of bakers. Laboring long hours in a bakery, though perhaps unpleasant and posing some health risks, was neither as arduous nor as unsafe as working at many other occupations. By restricting the freedom of contract, New York's Bakeshop Act

had violated the due process clause of the Fourteenth Amendment and as such was unconstitutional. Since the connection between bakeries and health remained shadowy, the states were not free to exercise police or regulatory powers under the guise of conserving morals, health, or safety.

In a dissenting opinion, Associate Justice John Marshall Harlan held that New York's Bakeshop Act was not in conflict with the Fourteenth Amendment and that the states had the "power to guard the health and safety of their citizens by such regulations as they in their wisdom deem best." Justice Harlan held that it was clearly within the discretionary power of the states to enact laws regarding health conditions and that such statutes should be enforced unless they could be demonstrated to have plainly violated the "fundamental law of the Constitution." In Harlan's opinion, the use of the Fourteenth Amendment to invalidate New York's statute would in effect cripple the abilities of the states to care for the well-being of their citizens.

In a forceful and eloquent dissent, Associate Justice Oliver Wendell Holmes, Jr., held that the majority decision in *Lochner* was based upon an economic theory rather than law and that a "constitution is not intended to embody a particular economic theory." In this well-known dissent, Justice Holmes criticized the majority extending the doctrine of liberty of contract and for defining too narrowly the states' police power. Holmes went on to write that a constitution is written for people of fundamentally differing views and that the "Fourteenth Amendment does not enact Mr. Herbert Spencer's Social Statics."

Impact of Event

The immediate impact of the Court's decision in *Lochner* was to restrict, or at least postpone, the ability of states to regulate such economic issues as maximum hours and minimum wages. Exactly how the Supreme Court would define the regulatory role of the states was an issue of great interest to reform-minded legislatures as well as to employers and their employees. The use of legislative reform was becoming more common, but such legislation often faced hostile review by the generally conservative courts.

Within a matter of a few years, the movement for shorter hours appeared to have won, lost, and then won again in significant cases before the Supreme Court. In 1898, the Court upheld a limitation on hours for Utah miners and smelters in *Holden v. Hardy*. In 1905, it reversed Joseph Lochner's conviction as an illegal and unwarranted interference with the liberty of contract, but in 1908 it upheld an Oregon law limiting hours for women in factories and laundries in *Muller v. Oregon*.

The Court's majority apparently viewed *Lochner* differently from the other two cases because its members saw no good reason that bakers should be singled out; if bakers' hours were regulated, then regulations on others would follow. Exceptions could be made for inherently dangerous occupations or in the case of women and children, but a general limitation on hours was not yet to be accepted. A 1917 ruling, in *Bunting v. Oregon*, accepted a ten-hour day for men and women on the grounds of preserving the health and safety of workers but only because the legislation did not

apply to all workers, only those workers in certain inherently dangerous industries. The implications of the Court's ruling in *Lochner* obviously extend far beyond Joseph Lochner and the treatment of bakers in Utica bakeshops. The Court's decision signified an ardent acceptance by the Court majority of the doctrine of laissez-faire capitalism and a belief that reform legislation and the regulatory movement could be suspended by the courts. By ruling against the state of New York, the Court sent a clear message of hostility to any reform-minded legislative body. Liberty of contract, in this case the right of Joseph Lochner to make his own contracts and control his property, took precedence over the right of the state to exercise its police powers.

Up until the economic crisis of the Great Depression, the mostly conservative justices of the Supreme Court used the doctrine of liberty of contract to limit the ability of states to enact reform legislation. Specific contracts could always be struck down, but only in those cases with narrowly defined public purposes. A notable example of prevailing judicial temperament can be seen in the 1908 case that outlawed "yellow dog contracts," *Adair v. United States.* A law protecting union members by prohibiting yellow dog contracts, under which employees promised not to join a union, was judged by the Court to be an unreasonable invasion of personal liberty and property rights. This reliance upon liberty of contract and devotion to laissez-faire economic doctrines remained a marked feature of the Court for some years. Not all scholars agree that the Court was as hostile to regulatory legislation and as antilabor as a few of these decisions might imply.

The decision in *Lochner* ranks among the most famous of all Supreme Court rulings, but for dubious reasons. Many consider it now, as Justice Holmes considered it then, an insensible ruling that ignored the hardships of sweatshop labor and launched a misguided assault on reform legislation. The premise of the decision later came into question. Rather than remove labor relations from the domain of politics, most people came to accept the notion that public debate and legislative action on economic issues is an appropriate use of police powers.

Social change is often a difficult and lengthy process. The necessary adjustments of an emerging industrial and increasingly urban society, with its resulting conflicts in labor relations, raised perplexing issues. Progressive reformers, and later New Dealers, who sought change through legislative enactments found, as in *Lochner*, that the courts were often unsympathetic. The realities and the pressures of the Great Depression led to a pervasive revision of judicial, political, and economic philosophies. New and inventive attempts were made to revitalize the economy, and legislatures were generally given more freedom to exercise regulatory powers.

Bibliography

Hall, Kermit L., ed. *The Oxford Companion to the Supreme Court of the United States.* New York: Oxford University Press, 1992. Contains a detailed and useful outline of the history of the Court, major decisions and doctrines that have guided and influenced Court rulings dating back to 1789, and brief biographies of every justice who served on the Court and other historically significant characters. Concise but

detailed entries help to make landmark cases and legal terms accessible to a variety of users.

Kens, Paul. *Judicial Power and Reform Politics: The Anatomy of Lochner v. New York.* Lawrence: University Press of Kansas, 1990. Presents a well-written and well-documented analysis of the issues surrounding the Lochner case, turn of the century bakeries, the politics of reform legislation, and the ramifications of the Court's decision.

Nichols, Egbert Ray, and Joseph H. Baccus, eds. *Selected Articles on Minimum Wages and Maximum Hours.* New York: H. W. Wilson, 1936. Outlines and defines the debate over whether Congress has the power to fix minimum wages and maximum hours for workers. Reprints of editorials and comments offer a variety of legal, political, and economic interpretations.

Siegan, Bernard H. *Economic Liberties and the Constitution.* Chicago: University of Chicago Press, 1980. An examination of changing judicial policy and the Court's review of economic legislation. Offers an explanation of alternative views of substantive due process and the protection of economic liberties.

Ziegler, Benjamin M., ed. *The Supreme Court and American Economic Life.* Evanston, Ill.: Row, Peterson, 1962. One of many books outlining the decisions in important Supreme Court cases. Despite being dated, this collection has the advantage of listing only cases with compelling economic themes.

Timothy E. Sullivan

Cross-References

Champion v. Ames Upholds Federal Powers to Regulate Commerce (1903), p. 63; A Supreme Court Ruling Allows "Yellow Dog" Labor Contracts (1908), p. 140; The Supreme Court Rules Against Minimum Wage Laws (1923), p. 426; The National Industrial Recovery Act Is Found Unconstitutional (1935), p. 701; Roosevelt Signs the Fair Labor Standards Act (1938), p. 792.

THE FIRST NICKELODEON FILM THEATER OPENS

Category of event: New products
Time: June, 1905
Locale: Pittsburgh, Pennsylvania

The proliferation of storefront theaters created a revolution in film exhibition and provided the foundation for an entertainment industry based on motion pictures

> *Principal personages:*
> THOMAS ALVA EDISON (1847-1931), an inventor and businessman who created motion picture technology and attempted to keep the business under his control
> CARL LAEMMLE (1867-1939), a nickelodeon operator who led film exhibitors out of the film trust and established an integrated film company
> ADOLPH ZUKOR (1873-1976), an entrepreneur who moved from running a nickelodeon to creating a film studio
> WILLIAM FOX (Wilhelm Fried, 1879-1952), an independent exhibitor and distributor of films

Summary of Event

The American public was introduced to the wonders of moving pictures in peep show machines installed in penny arcades. The kinetoscope, developed by inventor Thomas Alva Edison, was introduced around 1893 and soon became commonplace in large cities. The invention of the film projector at the end of the 1890's sent technology in a different direction and disrupted Edison's plans to keep motion picture exhibition within the framework of individual machines for public places or the home. The projector enabled businesses to entertain larger groups of people. Operators of penny arcades and music halls adopted film projectors, as did traveling shows.

In June, 1905, businessmen Harry Davis and John P. Harris opened a storefront theater in Pittsburgh, Pennsylvania to show projected motion pictures. Their "store show" had about two hundred seats. Admission cost five cents, leading to the name "nickelodeon." This was not the first time that motion pictures had been shown in one place, but the theater concentrated on film exclusively, rather than mixing it with other forms of entertainment. Davis and Harris offered continuous exhibition of films and frequent changes of programs, directing their services to the working classes.

Under the management of Harry Cohen, the Davis and Harris nickelodeon achieved astounding success. The show started at 8 A.M. and ran to full houses until midnight. The operation was estimated to be making a profit of nearly a thousand dollars a week. Soon there were hundreds of nickelodeons in the Pittsburgh area, as storefronts and penny arcades were converted into film theaters.

The nickelodeon started in cities of the Midwest, where there were plenty of well-paid blue-collar workers, and spread to other cities in the Northeast and West.

After two years of "nickel madness," most American cities had at least one film theater, and big cities typically had twenty or thirty. By 1910, there were more than nine thousand film theaters in the United States. This number grew to almost thirteen thousand in 1912, with about thirty million tickets sold each week. The nickelodeon had created a large business in film exhibition.

The nickelodeon also created the moviegoer, a customer for motion pictures who did not view them in other venues such as vaudeville shows or amusement parks. The moviegoer was devoted to the motion picture and expected a constant flow of new films at the nickelodeon. He or she soon became more experienced and consequently more critical in the viewing of films. Expectations for narrative plots, professional acting, and convincing settings increased. Film producers had to make longer films with strong story lines to keep the customers of the nickelodeons happy.

With motion pictures now a form of mass entertainment, filmmakers had to increase production to meet the new levels of demand created by the success of the nickelodeon. They began to build larger studios and organize production facilities to maintain a constant output of films. Custom-built studios were constructed to film more than one scene at a time and to bring all the elements of film production under one roof. The system of production in which the cameraman did all the nonacting work was replaced by a division of labor that established the director in overall charge of making the film, with filming and lighting carried out by specialized workers.

Edison's invention of the motion picture camera gave him a strong patent position, which his company exploited to drive competition from the field. This policy was part of a common strategy in American business, that of achieving a monopoly based on control of patents. During the 1890's, Edison's lawyers had attempted to eliminate smaller film producers, but they met with limited success. Companies such as Biograph and American Vitagraph obtained their own patents and fought back. Extensive litigation in the 1890's brought constant disruptions to film production and discouraged entrepreneurs from entering the field or investing in it. Film production was dominated by a few large companies with strong patent positions, such as the Edison and Biograph organizations, and numerous small operations who operated outside the law. Their inability to meet the demand for films encouraged foreign film producers to enter the American market.

With motion pictures now a large and profitable business, Edison set out to organize manufacturers around his patents. An agreement was reached in 1907 to offer manufacturing licenses to the largest film producers: Biograph, Vitagraph, Lubin, Selig, Pathé, Méliès, and Kalem. Biograph refused the offer and did not become part of the Association of Edison Licensees. The continuing warfare between Edison and Biograph maintained an atmosphere of uncertainty in film production, because an adverse court decision might invalidate patents. It was clear that peace was the key to stability and prosperity. George Kleine of Kalem took charge of the negotiations that finally brought the warring companies together and led to the creation of the Motion Picture Patents Company (MPPC) in 1908.

The MPPC organized film producers under the pooled patents of Edison, Biograph,

and Vitagraph. It gave licenses to nine producers: the original members of the Association of Edison Licensees (minus Méliès) Biograph, and the Kleine Optical Company, and the Edison concern. Interlocking agreements were made with Eastman Kodak (the main supplier of film stock), projector manufacturers, film importers, and film exchanges and exhibitors. The film trust, as it was called, created a monopoly of film production and established minimum prices that ensured healthy profits. As in numerous other trusts formed at this time, power over a whole industry fell into the hands of a few large concerns.

The MPPC also took the lead in self-regulation of the industry to ensure that motion pictures would provide respectable entertainment. This was intended to head off growing criticism against the low moral tone of films. The MPPC also took the responsibility of policing the nickelodeons to reduce fire and safety hazards in film theaters.

The formation of the MPPC opened a period of rapid growth and high profits in the film industry. Film producers established a schedule of regular releases to ensure that exhibitors would be able to change programs regularly.

Impact of Event

Like the phonograph before it, the motion picture projector created a large entertainment industry within twenty years of its invention. The explosive growth of nickelodeon theaters signaled to the business community that there was a great opportunity in film exhibition. The success of the nickelodeon idea brought many entrepreneurs into the business. Until 1905, most attention in the fledgling film industry had been on the process of filmmaking. Many of the people who would later figure prominently in the history of motion pictures got their start in film exhibition. Adolph Zukor, a successful Chicago furrier, invested $3,000 in a penny arcade in New York in 1903 and took advantage of the "nickel madness" to turn it into a nickelodeon in 1906. In that same year, Carl Laemmle opened his store theater in Chicago and William Fox acquired a storefront arcade in Brooklyn with a nickelodeon over it for about $1,000. Each of these three men went on to create powerful film studios: Universal (Laemmle), Paramount (Zukor), and Twentieth Century-Fox.

The nickelodeon brought immediate profits to film exhibitors and many changes to the business. The increased demand for films supported film exchanges, which rented reels of film to exhibitors. This replaced the expensive practice of buying films and made it possible for nickelodeon operators to offer greater selections of films. In many cases, the exchanges were established by entrepreneurs who already owned nickelodeons, such as Carl Laemmle and William Fox, who started exchanges to serve their strings of theaters.

At the same time that film producers were banding together, exhibitors and film exchanges also organized themselves into trade groups to protect their interests. They wanted to eliminate price cutting and stop the practice of "duping," or unauthorized copying, of films. The renters of films organized themselves into the Film Service Association (FSA) in 1907 and agreed to acquire film from Edison Licensees only.

They committed to buying a certain amount of film per week at a fixed price, providing the producers with a secure and predictable market. Both sides agreed only to do business with one another; in that way an independent filmmaker could not sell his product to a member of the FSA and the Edison licensees promised to sell their output exclusively to FSA exhibitors. This made it very difficult for an independent concern to operate in the motion picture industry, but many did.

The process of consolidation among both producers and exhibitors had the immediate effect of eliminating smaller, unaligned concerns from the business. The number of companies making or renting films decreased, and those that remained in business grew larger. Although the nickelodeons received better prints under the new system, their costs were higher, and many increased the admission charge to ten cents.

The formation of the MPPC accelerated consolidation and gave film producers more power over exhibitors. Each group obtained a license from the MPPC to use film cameras or projectors. The MPPC held all the important patents for film projectors, and under the new system the exhibitors had to pay $2 royalty fees each week. This caused dissension and led to the first defections. Carl Laemmle announced his withdrawal from the MPPC in 1909. He was followed by several other film exchanges, which began buying films from independent producers. The MPPC issued injunctions against patent infringers but was powerless to prevent all of them from operating, especially those that left the New York City area—the center of the film industry—and moved to Southern California.

The independent film exchanges provided more business to the independent film producers, but uncertain supply and low quality of films pushed exhibitors and renters into making their own films. Carl Laemmle in 1909 was again a pioneer, this time in the backward integration of film exhibitors into film production. He was followed by Zukor, who launched the Famous Players Film Company in 1911.

It was clear to exhibitors and renters that the film producers had both the means and the ambition to move into their business. The MPPC-licensed film producers in 1910 created their own film exchange, the General Film Company, which quickly took over other renters, including George Kleine. By 1912, the company had acquired fifty-seven of the largest licensed exchanges in the country. Film renters that refused to sell out to the General Film Company found that their licenses were revoked by the MPPC. William Fox was one renter who refused to sell. He successfully fought the General Film Company in the courts.

The monopolistic practices of the General Film Company and its parent, the MPPC, were well documented and resulted in the U.S. government bringing an antitrust suit against them in 1912. In 1915, the courts found the General Film Company guilty of violations of antitrust laws. This was followed by an even more damaging defeat in 1917, when the U.S. Supreme Court held that the MPPC could not enforce the use of licensed film on patented projectors in theaters. This was clearly the end of the film trust, but it did not end the conflict between producers and exhibitors. One important consequence of the failed attempt to create a monopoly in the film industry was the policy of integration, in which one organization was set up to manufacture, distribute,

and exhibit films. Many of the powerful film studios that dominated Hollywood in the first half of the twentieth century traced their origins to the nickelodeon.

Bibliography

Balio, Tino, ed. *The American Film Industry.* Madison: University of Wisconsin Press, 1976. A collection of scholarly articles about the film industry, written by experts in the field. Contains sections on nickelodeons and the Motion Picture Patents Company.

Bowser, Eileen. *The Transformation of Cinema: 1908-1915.* Vol. 2 in *A History of the American Cinema.* New York: Macmillan, 1990. This volume covers the history of the film business from the nickelodeon era to the construction of the first "picture palaces," the large and ornate film theaters. Describes the emergence of the studio and star systems.

Musser, Charles. *Before the Nickelodeon.* Berkeley: University of California Press, 1991. The definitive account of the early years of the film industry. Covers filmmaking and exhibition up to 1915. Profusely illustrated and exhaustively researched, this book provides a wealth of information. There is no better analysis of the content of films and the response of audiences.

_____ . *The Emergence of Cinema: The American Screen to 1907.* Vol. 1 in *A History of the American Cinema.* New York: Macmillan, 1990. The first volume of what will become the authoritative history of American cinema, this book provides a detailed and thoroughly researched account of the formation of the film industry. The author is the leading authority on early American film.

Ramsaye, Terry. *A Million and One Nights.* 1926. Reprint. New York: Simon & Schuster, 1986. An entertaining account of the film industry. The author worked from firsthand accounts and primary sources, and his book was approved by Thomas Edison. Although somewhat unreliable and biased in Edison's favor, this book captures the essence of the early days of film production and exhibition.

Sklar, Robert. *Movie-Made America: A Cultural History of American Movies.* New York: Random House, 1975. A concise and perceptive general history of the motion picture business that places it within the context of culture and entertainment. The leading short overview of the American film industry by one of its most respected scholars.

Andre Millard

Cross-References

The Jazz Singer Opens (1927), p. 545; The BBC Begins Television Broadcasting (1936), p. 758; The 1939 World's Fair Introduces Regular U.S. Television Service (1939), p. 803; Antitrust Rulings Force Film Studios to Divest Theaters (1948), p. 937; Video Rental Outlets Gain Popularity (1980's), p.1745; The Fox Television Network Goes on the Air (1986), p. 1928.

IVY LEE SETS A PRECEDENT FOR PUBLIC RELATIONS

Category of event: Business practices
Time: 1906
Locale: Pennsylvania

By cooperating with the press during a labor dispute with the Anthracite Coal Roads and Mines Company in 1906, Ivy Lee established open disclosure as a public relations philosophy

> *Principal personages:*
> IVY LEDBETTER LEE (1877-1934), the founding father of modern public relations
> GEORGE F. BAER (1842-1914), the leader of the anthracite coal mine operators and the Philadelphia and Reading Railway
> JOHN MITCHELL (1870-1919), the leader of the United Mine Workers
> THEODORE ROOSEVELT (1858-1919), the president of the United States, 1901-1909
> GEORGE F. PARKER (1847-1928), a cofounder of the Parker and Lee publicity agency in 1904 and an early influence on Lee's career
> ALEXANDER J. CASSATT (1839-1906), the president of the Pennsylvania Railroad

Summary of Event

In 1906, as a second major strike in four years threatened to paralyze mining operations and further encourage federal regulation, George F. Baer and his coal mining associates (all affiliated with J. P. Morgan's financial empire) retained an up-and-coming young publicist named Ivy Ledbetter Lee to help manage the potentially explosive situation. Instead of following standard corporate procedures and suppressing information flows to the public, Lee adopted what was then a radical approach. He candidly announced that he was a publicity consultant who had been hired by the anthracite coal mine management to handle publicity, then invited the press to ask questions. Lee actively distributed information via press releases that were written according to the standard style guidelines followed by journalists of the time. This too was not the normal procedure for corporations. His open disclosure and dissemination of information in an easily used form effectively promoted his client as cooperative, open, and honest.

Grasping the moment, Lee sent his now-legendary "Declaration of Principles" to appropriate newspaper editors. These principles set the tone for the practice of modern public relations and still serve as the standard for ethics in the industry. Lee stated:

This is not a secret press bureau. All our work is done in the open. We aim to supply news. This is not an advertising agency; if you think any of our matter ought properly to

go to your business office, do not use it. Our matter is accurate. Further details on any subject treated will be supplied promptly, and any editor will be assisted most cheerfully in verifying directly any statement of fact. Upon inquiry, full information will be given to any editor concerning those on whose behalf an article is sent out. In brief, our plan is, frankly and openly, on behalf of the business concerns and public institutions, to supply to the press and public of the United States prompt and accurate information concerning subjects which it is of value and interest to the public to know about.

A Princeton graduate, Lee had been a newspaper journalist from 1899 to 1903, when he began taking on clients as a publicist. In 1904, Lee and George F. Parker formed Parker and Lee, one of the nation's first publicity agencies. Contrary to Lee, Parker was somewhat of a traditionalist in the field. He was much older and more experienced, however, and had a number of important connections in the business and political arenas, with such men as George Westinghouse and Thomas Fortune Ryan. Parker's contacts resulted in work that enabled Lee to establish his reputation. Although Parker and Lee held together for less than four years, the firm was a major springboard from which Lee launched his illustrious and often controversial career.

The late 1800's and early 1900's were an era of social consciousness, with which big business and government was ill equipped to deal. The Populist political party grew from distrust of capitalist power brokers and corrupt government officials. Muckraking investigative journalists made a living exposing corruption in business and government. Articles and books published during this period by authors such as Lincoln Steffens, Frank Norris, Ida Tarbell, and Upton Sinclair resulted in legislation that still influences American society, such as the Pure Food and Drug Act of 1906.

President Theodore Roosevelt strongly believed that the federal government had a responsibility to protect the public's welfare when conflicts arose among management, labor, and consumers. A master of publicity himself, Roosevelt maintained a high profile in the popular press and used it to effectively pursue his policies. Although a Republican, Roosevelt was progressive minded. He successfully challenged huge corporations such as Northern Securities Company, Pennsylvania Railroad, Standard Oil, and U.S. Steel through use of the Sherman Antitrust Act of 1890 and impeded their attempts to concentrate economic power. His well-publicized conservation policies saved many American resources from excessive exploitation.

Business leaders reacted by trying to use the same weapons to their own advantage. They turned in increasing numbers to publicity to help defeat what they considered to be harsh and unfair regulatory attempts. The hiring of Ivy Lee in 1906 by George Baer was one such attempt to use publicity, though one arrived at with difficulty. As coal mining operations had consolidated into a few huge organizations during the 1890's, the United Mine Workers (UMW) union had expanded as well. In 1902, the UMW's 150,000 members went out on strike in the anthracite coal regions of Pennsylvania. This spectacular strike lasted from May until October and threatened the nation's major source of heating fuel as winter approached.

President Roosevelt was determined to halt the dispute and threatened to operate the mines under the supervision of federal troops. Management did a poor job of

handling the situation, remaining aloof and seemingly unconcerned about Roosevelt, worker demands, and the public's fear of freezing to death with winter coming on. George Baer made only one statement to the press during the entire ordeal. When published, it angered the American people. He essentially told the press that labor rights were the responsibility of the men to whom God had seen fit to give control of the nation's property interests, and not the responsibility of labor agitators.

On the other hand, John Mitchell, the head of the UMW, demonstrated model press relations during the turmoil. He treated reporters with respect, providing them with trustworthy information concerning the UMW's point of view. Some accused the press of showing a pro-union bias in coverage of the strike. Mitchell made complete statements to reporters, whereas the mine operators maintained silence; thus, it was primarily the UMW's perspective that appeared in print. As a result of this one-sided communication flow and the disastrous statement made by Baer, the public was influenced to sympathize with labor rather than with management. With public opinion turned against the coal mine operators and President Roosevelt threatening to send in federal troops, management was forced to compromise. Labor won a shorter work day, a 10 percent pay increase, and other union rights.

By 1906, another major UMW strike was imminent, but this time the anthracite coal operators seemed to understand that their response must be different from that given four years before under similar circumstances. They retained Lee, who immediately announced to all newspapers that the coal mine operators realized the public's interest in the situation and would supply the press with all information possible. The statements released by Lee during the period that followed were sent as signed notes from the men he represented, the Coal Operators' Committee of Seven, which included George F. Baer, W. H. Truesdale, J. B. Kerr, E. B. Thomas, J. L. Cake, David Willcox, and Morris Williams.

Lee's activities on behalf of the Coal Operators' Committee of Seven represented a radical departure from the behavior exhibited by these men in the past. Instead of attempting to prevent journalists from gathering information, Lee saw to it that their work on the coal strike story was simplified. Reporters were given advance notice when a press conference was being held, including its place, time, and topic. A complete summary of the proceedings was distributed to the press within a short time after the meeting had adjourned.

Lee knew what was newsworthy as well as the proper format in which to write his releases, so he was able to get many news articles published concerning positive aspects of the coal trust. Press officials were relieved to have such cooperation and welcomed input from the coal operators. As a result, the public received a more balanced treatment of the issues involved than in the 1902 strike. The situation was worked out more equitably and rationally than in 1902.

Impact of Event

Lee's success in getting favorable press coverage for the anthracite coal operators led to the retention of Parker & Lee by Alexander J. Cassatt, president of the

Pennsylvania Railroad, in the summer of 1906. Lee immediately reinforced the direction he had established for the practice of public relations by boldly transforming the railroad's policy of secrecy. Accidents coincidentally occurred at about the same time on a Pennsylvania Railroad line and a New York Central route. Lee arranged for reporters to travel to the scene of the Pennsylvania mishap at railroad expense, then helped them to take photographs and write their stories. Meanwhile, proceeding as usual, the New York Central line attempted to minimize reportage. As a result, the Pennsylvania Railroad management received enthusiastic praise for its handling of the situation, whereas the competition foundered in a wave of public criticism. The Pennsylvania Railroad was the acknowledged management leader in its industry at that time, much the same as General Motors would become in the 1950's, and Lee's position with such a prestigious and respected firm was highly visible. His unquestioned success in dealing with the accident was an important stride not only for his own career but also for the future of the public relations profession.

Lee came to view his job as not only interpreting the organization to the public but also as interpreting the public to the organization. He wrote that the Pennsylvania Railroad management was pursuing a broad policy of common sense, which entailed doing as much for the public as possible because if it did so, the public would reward the firm with its loyalty. Lee attempted to humanize the company by relating many human interest stories about company officials to the public through the use of pamphlets, press releases, and speeches. These stories told of the Pennsylvania Railroad's contributions to agricultural education, college scholarships, the Young Men's Christian Association (YMCA), and pension plans. He portrayed the company as one big happy family.

Other firms realized the efficacy of Lee's methods. International Harvester gave him the opportunity to prove his philosophy in the face of a Senate resolution to investigate the company for its alleged monopolistic practices. Lee wrote that International Harvester's management welcomed such an investigation because it had done no wrong and that company officials would facilitate the proceedings in every manner possible. By expressing confidence in itself, the firm gained the goodwill of the public and government personnel.

Lee soon had many imitators. Newspaper reporters looking to change careers realized that they had the skills necessary to recognize newsworthy events and report them clearly and objectively, and these individuals realized that business and governmental organizations needed such skills to promote themselves effectively. As a result, the modern practice of public relations was born and grew. It is interesting to note that Lee did not use the term "public relations" during this period to refer to his work; he used the term "publicity" instead. It was not until the mid-1910's at the earliest that Lee began to refer to the tasks he performed as "public relations."

According to Ray E. Hiebert, a Lee biographer, Lee depended heavily on the works of others such as Andrew Carnegie, Woodrow Wilson, and Walter Lippmann and was not a great original thinker. He did possess, however, a unique ability to put the ideas of many others together and use the collection in original ways. Although Lee was not

alone in establishing the field of public relations, he was the first to practice in it as an independent agent. Most important, Lee was the first to attempt to explain his occupation to the public.

The anthracite coal mine strike in 1906 was the first in a series of highly publicized events that gave Lee the opportunity to set good examples for a fledgling profession to follow. His success not only defined sound public relations practice but also illustrated its worth to management. Lee knew that a favorable public opinion toward a firm must be rooted in that firm's ethical behavior. The result of his ability to successfully communicate this fact to corporate management is a more socially responsible business environment.

Bibliography

Cutlip, Scott M., Allen H. Center, and Glen M. Broom. *Effective Public Relations.* 6th ed. Englewood Cliffs, N.J.: Prentice-Hall, 1985. This textbook is one of the most widely used in public relations education. Provides accurate and comprehensive coverage of the profession.

Henry, Kenneth. "Social History and Significance of Public Relations." In *Defenders and Shapers of the Corporate Image.* New Haven, Conn.: College & University Press, 1972. Discusses the historical development of public relations in the United States.

Hiebert, Ray E. *Courtier to the Crowd: The Story of Ivy Lee and the Development of Public Relations.* Ames: Iowa State University Press, 1966. The major biographical work concerning Lee. Detailed treatment of the subject, primarily focused on Lee's career instead of his private life.

—————. "Myths About Ivy Lee." In *Perspectives in Public Relations*, edited by Raymond Simon. Norman: University of Oklahoma Press, 1966. Dispels myths about Lee and analyzes the important contributions he made to the practice of public relations.

Seitel, Fraser P. *The Practice of Public Relations.* 5th ed. New York: Macmillan, 1992. A good public relations textbook, written from the practitioner's perspective. Widely used, with a "real-world" business orientation.

Tedlow, Richard S. *Keeping the Corporate Image: Public Relations and Business, 1900-1950.* Vol. 3 in *Industrial Development and the Social Fabric*, edited by John P. McKay. Greenwich, Conn: JAI Press, 1979. Probably the most complete history of corporate public relations for the period covered. Those interested in the topic should read this reference first.

William T. Neese

Cross-References

The Supreme Court Rules Against Northern Securities (1904), p. 91; Congress Passes the Pure Food and Drug Act (1906), p. 128; The Supreme Court Decides to Break Up Standard Oil (1911), p. 206; Labor Unions Win Exemption from Antitrust

Laws (1914), p. 282; The Railway Labor Act Provides for Mediation of Labor Disputes (1926), p. 516; Roosevelt Signs the Fair Labor Standards Act (1938), p. 792; General Motors and the UAW Introduce the COLA Clause (1948), p. 943; Seven People Die After Taking Cyanide-Laced Tylenol (1982), p. 1837.

CONGRESS PASSES THE PURE FOOD AND DRUG ACT

Category of event: Consumer affairs
Time: June 30, 1906
Locale: Washington, D.C.

The Pure Food and Drug Act of 1906 established the first federal standards for food and drug regulation, reflecting a commitment to consumer protection advocated by social reformers as well as some bureaucrats, businesspeople, and scientists

Principal personages:
HARVEY W. WILEY (1844-1930), the chief chemist with the United States Department of Agriculture, author of the Pure Food and Drug Act of 1906
THEODORE ROOSEVELT (1858-1919), the president of the United States, 1901-1909
UPTON SINCLAIR (1878-1968), a socialist, journalist, and author of *The Jungle* (1906), an exposé of the Chicago meatpacking industry

Summary of Event

The passage of the Pure Food and Drug Act by Congress in 1906 marked the culmination of a long struggle by an assortment of groups to enact federal legislation controlling the quality of foods and drugs widely available to consumers. Although many local and state authorities had attempted to guard against the sale of contaminated, or even harmful, food and medicinal products for several years prior to 1906, a variety of critics had charged that those regulations were ineffectual at best. Particularly as a result of the rapid growth of rail systems that could transport products between regions and states, dangerous or adulterated products were becoming threats not only in local markets but also for consumers across the nation.

Scientific and medical experts offered crucial support for the passage of the 1906 act. Advocacy for federal pure food and drug regulation by physicians' groups, notably the American Medical Association, came rather late in the process of securing passage in comparison with state and local efforts by physicians, research scientists, and even agriculture commissioners interested in scientific farming. Those scientific proponents had been quite active in some states and localities, such as Massachusetts and New York City, beginning in the decades immediately following the Civil War. The careful investigations and calm presentations of researchers such as E. F. Ladd, food commissioner of North Dakota, began to receive notice beyond that of fellow specialists in the early years of the twentieth century. Ladd's findings were stated in such an accessible manner in a paper on food adulteration he read in St. Louis in 1904 that they were published in popular periodicals such as the *Ladies' Home Journal*. They caused a sensation among middle-class readers. In Ladd's testing of cider vinegars, for example, it had been impossible to detect apple juice, a supposed

ingredient. Products labeled as "potted chicken" and "potted turkey" contained no chicken or turkey that he could isolate. Cocoa shell and other foreign matter accounted for 70 percent of the substances found in his samples from chocolate and cocoa mixtures.

Congress had heard such allegations much earlier, for example when the Committee on Epidemic Diseases of the Forty-Sixth Congress published a report recommending the establishment of a commission to study contamination in food and drugs. Congressional committee members listened in 1880 to the precise testimony of such experts as George T. Angell of Boston, who already had argued successfully for stricter local regulations on the food trade. In 1899 and 1900, a Senate investigation focused on the manufacture of contaminated food.

The most consistent advocate for federal food and drug regulation was Harvey W. Wiley, the chief chemist for the United States Department of Agriculture (USDA). Wiley had been working at the USDA since 1883, when he published his findings on the adulteration of cane and beet sugars, milk, and butter. Ironically, the purpose of Wiley's research had not been to uncover massive adulteration in the food industry. He had been trying to develop better analytical methods for the Bureau of Chemistry. He continued to write about his investigations in a methodical series of USDA bulletins in the 1880's and 1890's. When he realized the impact of his research, however, he began to advocate delving more thoroughly into food and drug adulteration. Wiley rapidly became convinced of the necessity of federal government action and went so far as to sanction unorthodox methods of demonstrating the dangers of substances. The "poison squads" of the USDA, for example, were a dramatic device. Chemists used themselves as guinea pigs to test the human effects of potentially adulterated or toxic substances.

In the early twentieth century, no consumer lobby at the national level existed that could press for a national law providing interstate regulation of food and drug manufacture, distribution, and advertisement. Definitive congressional action was blocked repeatedly in several ways: openly by legislators closely tied to food or drug interests, or more subtly on constitutional grounds that federal regulation would be an intrusion on states' rights. Between 1879 and 1906, at least 190 bills concerning food and drug regulation were considered and defeated. Wiley's careful efforts gradually began to convince some members of Congress and the public that a federal agency could be effective in detection, yet until early 1906, federal pure food and drug legislation seemed stymied.

The spark for passage of an act that had been introduced in December, 1905, came as a result of the publication of Upton Sinclair's shocking exposé of life among meatpackers in Chicago. That book, *The Jungle* (1906), had been intended by Sinclair more as a socialist condemnation of America's treatment of immigrant workers than as an indictment of a particular noxious industry. Sinclair later commented that he had aimed for the heart of the public but had hit readers in the stomach.

Certain images left in the minds of readers of *The Jungle* were indelible. The makers of processed meats such as sausages found themselves years later still fighting

Sinclair's allegations that the brutal machinery inside packinghouses sliced off workers' fingers, which then were ground into meats. However uncommon such incidents were, especially in contrast with more usual contaminations, such as the presence of rat droppings in processing rooms, they captured some American consumers' distrust of the large-scale meatpackers. Other muckraking books of the era, such as Joseph Lincoln Steffens' *The Shame of the Cities* (1904) and Jacob Riis's *How the Other Half Lives: Studies Among the Tenements of New York* (1890), could be written off by members of the public as condemnations of conditions in specific urban areas, conditions that could be overlooked if one simply stayed away from the areas of blight. Food contamination as described in *The Jungle* clearly was a problem too far-reaching to avoid.

Sinclair's vivid descriptions of the conditions under which meat was processed raised alarm not only among the public in general but also among key players in Washington, notably President Theodore Roosevelt, who ordered his secretary of agriculture, James Wilson, to investigate the validity of Sinclair's book. Roosevelt, spurred on by his personal outrage, played a key role in ensuring passage of the act and in preventing its being watered down in committee.

The Pure Food and Drug Act, along with a meat inspection bill passed in tandem with it, outlawed the shipment, interstate or abroad, of food that was judged to be "unsound" or "unwholesome." The legislation gave new vigor to the inspection powers already exercised by several federal authorities, especially the Department of Agriculture, along with the Departments of Commerce, Labor, and the Treasury. The new laws expanded inspections already required for exported meats to make similar inspections mandatory for foods destined for American tables. Products that passed inspection were to be marked with a USDA stamp; unsuitable foods were to be destroyed in the sight of an inspector. The laws provided for truth in labeling, prohibiting false or deceitful advertising of food and drug products, known at the time as "misbranding." The penalties for violation of pure food and drug laws included fines starting at $200, up to one year of imprisonment, and seizure of contaminated goods.

Impact of Event

With its complex provisions regulating the manufacture, sale, and advertisement of a vast range of food products and popular medicines, the Pure Food and Drug Act promised difficulties in enforcement and engendered hostility from several quarters when it went into effect on January 1, 1907. Many manufacturers had opposed its passage and continued to resent its requirements. Even members of Congress openly grumbled that the measure was an unwarranted intrusion on the right of individual states to regulate the health and welfare of their own citizens.

Theodore Roosevelt was one of many individuals and groups who celebrated the achievement of the passage of the Pure Food and Drug Act. The act was the product of a series of delicate compromises between Roosevelt, Department of Agriculture investigators, and key members of Congress. In ironing out differences between a

Senate and a House version of the act, a congressional conference committee produced a bill with somewhat more teeth than either house's version, although certain provisions for which its sponsors had fought doggedly were abandoned, such as the placing of the date of canning on canned meats.

For Roosevelt, passage of the legislation was evidence of his skill at political maneuvering and an example of a personal commitment to good health, both his own and the public's. In Roosevelt's mind, efforts to clean up packinghouses and to ensure high-quality consumer goods meshed well with his goals to expand his role as chief executive and to enhance the role of the national government. Biographers of Roosevelt have noted that Roosevelt's part in the passage of the Pure Food and Drug Act, along with his advocacy of the Hepburn Act (passed in June, 1906, boosting the power of the Interstate Commerce Commission to examine railroad operations) marked his determination to provide decisive leadership in the wake of his convincing 1904 presidential election victory.

Although Roosevelt's support of the Pure Food and Drug Act was important to its eventual passage as "progressive" legislation, and although he was accused by some conservative Republicans of moving too far toward the left, he resisted easy categorization as a liberal or a follower of fads. For example, he characteristically announced his distrust of scientists' warnings about saccharin as a food additive, declaring that he used saccharin daily with the approval of his own physician and obviously was in excellent health.

In the aftermath of the passage of the Pure Food and Drug Act, the writers of editorials as well as lawmakers themselves sensed that several watersheds had been achieved in terms of the authority of the federal government, the regulation of big business, and the protection of the public's health by Congress. Those achievements came at a political price. Roosevelt had created or intensified divisions within the Republican Party. Most criticism of those developments, however, remained beneath the surface for a few years. Roosevelt's prestige as an international figure seemed to increase the confidence of the public and Congress that his leadership in domestic affairs was worthy of trust.

The furor surrounding publication of *The Jungle*, as well as intense political scrutiny of food production, was felt by manufacturers of consumer goods. One estimate put the drop in meat sales in the wake of *The Jungle* at 50 percent. The controversy made food processors and drug makers aware of the need to assure the public as well as potential regulators of the quality of their output. A number of producers of foods and drugs actually supported the Pure Food and Drug Act, on the grounds that regulation of their industry would reassure the public and increase consumption, both domestically and on world markets.

The Pure Food and Drug Act did not stem the tide of product injury lawsuits. It may have created more such suits by raising expectations by consumers that products would be produced carefully and that if they were not, a governmental entity would catch the mistake. In a legal sense, therefore, federal food and drug legislation helped dispel any lingering notion that it was solely the buyer's responsibility to beware of

dangerous food and drug products. The act of 1906 also reflected the ideas that the collective protection of consumers was an appropriate function of the federal government and that federal food and drug regulation could be a more effective and scientific approach than were individual caution, local circumspection, or industry self-policing.

Bibliography

Anderson, Oscar E. *The Health of a Nation: Harvey W. Wiley and the Fight for Pure Food*. Chicago: University of Chicago Press, 1958. Emphasizes the role of Wiley, the importance of scientific investigations, and the publication of those investigations in technical and specialists' journals, especially in the 1880's and 1890's, in bringing about medical and expert calls for national food and drug regulation. Supplemented by James Harvey Young's 1989 study of the passage of the 1906 act.
Burrow, James G. *Organized Medicine in the Progressive Era*. Baltimore: The Johns Hopkins University Press, 1977. Stresses the medical community's efforts at professionalization, its success with public relations strategies, its alliances with state authorities, and its links with progressive reformers who wished to apply scientific findings to address social problems.
Gould, Lewis. *The Presidency of Theodore Roosevelt*. Lawrence: University Press of Kansas, 1991. A balanced treatment of Roosevelt as a politician, showing his practical methods of operation in conjunction with Congress. Draws judiciously upon earlier biographies by William H. Harbaugh and John Morton Blum, and on Gould's own examination of Roosevelt's political style contained in earlier publications. Contains a detailed bibliographic essay.
Wiebe, Robert. *Businessmen and Reform*. Cambridge, Mass.: Harvard University Press, 1962. Along with Wiebe's *The Search for Order* (Westport, Conn.: Greenwood Press, 1980), provides an influential explanation of various reasons why businessmen supported or opposed progressive reforms, with emphasis on the desire by entrepreneurs to promote efficiency and predictability through governmental action. Utilizes in great detail the records of national business groups such as the National Civic Foundation as well as chamber of commerce publications.
Young, James Harvey. *Pure Food: Securing the Federal Pure Food and Drug Act of 1906*. Princeton, N.J.: Princeton University Press, 1989. Examines passage of the act in detail, sorting out Roosevelt's and Senator Albert Beveridge's behind-the-scenes pressuring of the Senate against the lobbying of meatpacking interests. Illustrates the process of publicizing the findings of governmental and scientific investigators.

Elisabeth A. Cawthon

Cross-References

The Wheeler-Lea Act Broadens FTC Control over Advertising (1938), p. 775; Congress Requires Premarket Clearance for Products (1938), p. 787; Congress Sets

Standards for Chemical Additives in Food (1958), p. 1097; Nader's *Unsafe at Any Speed* Launches a Consumer Movement (1965), p. 1270; The Wholesome Poultry Products Act Is Passed (1968), p. 1369; The U.S. Government Bans Cigarette Ads on Broadcast Media (1970), p. 1443.

A FINANCIAL PANIC RESULTS FROM A RUN
ON THE KNICKERBOCKER TRUST

Category of event: Finance
Time: October and November, 1907
Locale: The United States

A run on the Knickerbocker Trust Company caused a general financial panic in the United States, precipitating intervention by a team of powerful New York bankers led by J. P. Morgan

Principal personages:
> J. P. MORGAN (1837-1913), the senior partner of J. P. Morgan & Company, a private international investment bank
> JAMES STILLMAN (1850-1918), the president of National City Bank
> GEORGE BAKER (1840-1931), the president of First National Bank of New York
> THEODORE ROOSEVELT (1858-1919), the president of the United States, 1901-1909
> F. AUGUSTUS HEINZE (1869-1914), a copper speculator
> CHARLES W. MORSE (1856-1933), a financial speculator and banker
> BENJAMIN STRONG (1872-1928), a secretary of Bankers Trust and a chief Morgan investigator during the 1907 panic

Summary of Event

Coming on the heels of an international liquidity crisis, a run on some of the most prominent trust companies in New York City in October, 1907, sent shock waves through the American economy. J. P. Morgan responded by setting up a syndicate of the most powerful banks in New York. For three weeks, his syndicate acted like a central bank by providing liquidity (ready cash) to affected trust companies. When the crisis cooled in mid-November, the financial community credited Morgan with saving the nation, even as many people criticized the power wielded by Morgan. Almost all Americans had been shaken by the panic and demanded reforms of the financial system.

The seeds of the 1907 panic can be found in the world's growing credit crunch after 1900. Sharp increases in the rate of economic growth, the number of government security issues, and the amount of stock market speculation strained the existing supply of capital, bidding up interest rates in most countries. By 1907, there were major bank failures in Tokyo, Hamburg, Alexandria, Genoa, and Santiago. Most countries also witnessed declines in their stocks of gold, average stock prices, and money supplies as the year wore on. In some countries, including Great Britain and France, rapid central bank intervention counteracted the impending crisis by increasing liquidity, boosting the sagging confidence of their investment communities. In

other countries, such as Germany, financial regulation dampened speculative activity and thus eased pressures on the money supply.

The United States, in contrast, had no central bank. More important, financial regulation was irregular or nonexistent. This was especially true in terms of the trust companies that had increasingly moved into general banking business since 1900. Banks generally faced high reserve requirements, stipulations on the amount of cash they had to keep available to meet demands for withdrawals. Trust companies did not face these high reserve requirements. Since they had to keep less cash on hand, cash that did not pay a return, they could offer higher rates of interest to depositors, attracting them away from banks. The trust companies then loaned these deposits out. Many borrowers used securities (stocks and bonds) as collateral for loans, which in turn were used to buy even more securities. In this way, the trust companies increased the supply of money, but on the unstable basis of financial speculation. When stock prices began to fall in early 1907 in response to international conditions, credit automatically contracted, and trust companies were forced to call their more speculative loans, leading to further falls in the money supply.

This instability made it possible for one incident to break investor confidence and cause a major run on deposits in banks and, more significant, in the trust companies involved in speculative ventures. The incident was F. Augustus Heinze's failed attempt to corner the copper market. Before 1906, Heinze was the owner of a copper smelter in Montana. He sold out as a millionaire, moved to New York City, and teamed up with Charles W. Morse, a bank proprietor with a notorious reputation for speculative dealing. By using their funds to buy a controlling interest in commercial banks such as the Mercantile National, Heinze and Morse gained access to large amounts of deposit funds. They used these, in turn, to gain control of trust companies unfettered by reserve and loan restrictions. This pyramidal financial structure gave Heinze and Morse control over a vast sum of funds that they used for speculative investments, the most important of which was their scheme to corner the copper market. When their scheme backfired in mid-October, the resulting decline in copper share prices prompted depositors to withdraw their funds. These "runs" occurred not only on banks and trust companies associated with Heinze and Morse but also on other institutions. Their main bank, Mercantile National, was saved through the intervention of the New York Clearing House. Trust companies, however, were not eligible for clearinghouse assistance, and their customers were more easily frightened into demanding the return of their deposits.

By Friday, October 18, a run had begun at New York's third largest trust, the Knickerbocker Trust Company. All of Wall Street was aware of the fact that the trust was connected to Heinze and Morse through its president, Charles Barney. J. P. Morgan was in Richmond, Virginia, attending the Triennial Episcopal Convention when he received word about Knickerbocker Trust's difficulties. Concerned about the possibility of runs spreading to other banks and trust companies, Morgan returned to New York one day ahead of schedule. His arrival ushered in a series of meetings, during which he put together a rescue team that included two of the nation's most

powerful bankers: George Baker, Morgan's longtime financial ally and president of the First National Bank, and James Stillman, Morgan's sometime rival and president of the National City Bank (later Citibank). The purpose of the rescue team was to lend money to otherwise solvent institutions suffering runs on deposits. To determine solvency, Morgan, Baker, and Stillman put together an investigative staff led by Benjamin Strong, then secretary of Bankers Trust.

On Monday, October 21, the run continued at Knickerbocker Trust, and Morgan's rescue team was asked for help. Strong was sent in to assess whether Knickerbocker was worth saving. It was bled dry of deposits before his investigation could be completed. Knickerbocker's failure set off runs at other trust companies, which were forced to call in their loans, many of which had been issued to brokers for speculative purposes. One indication of the extent of problems is that when Charles Barney asked for Morgan's help two weeks later and Morgan refused to see him, Barney shot himself. Morgan's rescue team stepped in to assist the Trust Company of America after Strong had judged it worthy, but others were not so lucky. As a consequence, money became so difficult to come by on Wall Street that the call (very short term) interest rate escalated to 150 percent by Thursday, October 24. Many brokers were on the edge of bankruptcy, and trading had virtually ceased on the New York Stock Exchange. Morgan brought together a large syndicate of commercial banks that immediately made $18.95 million available for call loans at interest rates as low as 10 percent. The next day, the loans were renewed, and the syndicate issued a further $9.7 million of liquidity to Wall Street.

Morgan, Baker, and Stillman, along with their newly created banking and trust committees, then worked all weekend trying to shore up all possible defenses. Morgan even called in the city's religious leaders and asked them to reassure churchgoers on Sunday. On Monday, October 28, however, the unexpected struck. The City of New York was not able to find buyers for its warrants abroad because Europeans were withdrawing their money from American investments. The city needed an immediate loan of $30 million to avoid default by the end of the week. Morgan came up with an ingenious solution. Since issuing bonds through normal channels was impossible, he arranged for Baker and Stillman each to take a portion of the bonds and turn them over to the New York Clearing House, which paid for them with certificates credited to the city's accounts at the First National and National City banks, controlled by Baker and Stillman.

The next week saw more trust companies and brokerage firms in trouble, including Moore and Schley, a prominent Wall Street investment house that owed $25 million. Morgan agreed to help Moore and Schley if he received something in return. The firm owned a majority of the stock of the Tennessee Coal Iron and Railroad Company (TCI&R). Morgan wanted United States Steel, the company he had set up in 1901, to gain control by exchanging its gold bonds for the majority stock of TCI&R held by Moore and Schley. Arguing that Moore and Schley's failure would result in further brokerage house and trust company bankruptcies, Morgan agreed to have United States Steel buy TCI&R's shares if the trust companies set up their own trust rescue

fund. He then sent his United States Steel emissaries to Washington to tell President Theodore Roosevelt that the Moore and Schley bailout and the trust company rescue fund were contingent on a promise by the U.S. government not to launch an antitrust suit against United States Steel. Roosevelt agreed not to interfere, and the deal went through. The trust company rescue fund helped restore confidence, and Wall Street began a gradual recovery.

Impact of Event

Although the financial distress of 1907 was a worldwide phenomenon, it led to a financial panic of immense proportions only in the United States. When measured in terms of the degree of decline in credit, share prices, and output growth, as well as the number of bank and trust company failures, the United States fared far worse than did other countries. This resulted from a number of factors, including the lack of trust company and securities regulation, the lack of deposit insurance, and the absence of a central bank that could take timely preventive measures.

Reactions to the Morgan-led rescue efforts were polarized. On Wall Street, Morgan, Baker, and Stillman were seen as heroes who had saved the country from imminent financial collapse. Morgan, the financial community believed, had acted like a one-man central bank. Nevertheless, Wall Street and the wider financial community realized that some reforms would be needed to prevent similar panics in the future. Congress responded almost immediately by passing the Aldrich-Vreeland Act, a temporary compromise intended to make more credit available in future emergencies, and by setting up the National Monetary Commission, with a mandate to study the defects of the existing system of finance and propose permanent solutions.

Many Americans outside the financial community, however, were concerned about both the amount of power held by Morgan, Baker, and Stillman and the manner in which they used that power. Beginning in March, 1908, Senator Robert M. La Follette began a series of speeches against what he called the "money trust." He and other Progressive politicians began to call for an investigation of the money trust and the ways in which it had abused its tremendous power. In particular, they were upset about United States Steel's acquisition of TCI&R and how Morgan had personally profited from what they now called the "Bankers' Panic." The government, already pursuing John D. Rockefeller's Standard Oil trust, came under increasing pressure to attack the Morgan trusts. It would take another four years, but eventually the government reacted by launching an antitrust suit against United States Steel.

The speculative side of the 1907 financial panic caused Americans to reassess Wall Street and spurred Populists and Progressives across the United States to turn to political action. In 1911, Kansas was the first state to pass a "blue sky law" creating a state commission that determined which securities could be sold or traded within the state. Twenty-five states soon followed Kansas' lead in an attempt to prevent speculative activity in securities, the root cause of the 1907 financial panic, according to many observers at the time.

In February, 1912, the House Banking and Currency Committee began an investi-

gation into the "money trust" that would become known as the Pujo Inquiry. Hearings began later in the year. The alleged members of the inner core of the money trust—Morgan, Baker, Stillman, and their respective financial institutions—were identified in large part because of their actions during the preceding panic. The highlight of the hearings was Morgan's testimony and his explanation of the rescue party's actions during the panic.

The most permanent legacy of the 1907 panic was the proposal for a decentralized central banking system by the National Monetary Commission. This proposal would eventually be adopted, though with many amendments, in the Federal Reserve Act of 1913. As the governor of the powerful Federal Reserve Bank of New York, Benjamin Strong, who investigated banks during the 1907 panic, would be the dominant voice in the direction of the new system until his death in 1928.

Bibliography

Carosso, Vincent P. *The Morgans: Private International Bankers, 1854-1913*. Cambridge, Mass.: Harvard University Press, 1987. The most scholarly work on J. P. Morgan's investment banking activities. Contains a detailed and reliable account of Morgan's activities during the 1907 financial panic.

Chernow, Ron. *The House of Morgan*. New York: Atlantic Monthly Press, 1990. A broader and more accessible account of the Morgan dynasty, from the creation of the investment bank until 1990. Less scholarly than Carosso's account and more critical of J. P. Morgan's actions. Devotes one short chapter to the 1907 panic.

Cowing, Cedric. *Populists, Plungers, and Progressives*. Princeton, N.J.: Princeton University Press, 1965. Provides a general intellectual history of the opposition to Morgan, Wall Street, and the increasing concentration of economic power. Provides an insightful guide to the Populist and Progressive critiques of American finance capitalism.

Kindleberger, Charles P. *Manias, Panics, and Crashes: A History of Financial Crises*. Rev. ed. New York: Basic Books, 1989. A general survey of financial speculation and monetary crises from the eighteenth century to the 1980's. Also provides a general theory of the boom-and-bust nature of economic development. Contains an interesting chapter on the 1907 financial crisis in Italy.

Sobel, Robert. *Panic on Wall Street*. New York: Truman Talley Books/Dutton, 1988. An accessible history of financial disasters in the United States, written in an entertaining style. Devotes one complete chapter to the 1907 financial panic.

Sprague, O. M. W. *History of Crises Under the National Banking System*. Washington, D.C.: Government Printing Office, 1910. Issued as a book, this is the report of the National Monetary Commission, created as a direct result of the 1907 panic. Remains the most detailed account and analysis of the panic. Can be found in many university libraries.

White, Eugene Nelson. *The Regulation and Reform of the American Banking System, 1900-1929*. Princeton, N.J.: Princeton University Press, 1983. Deals with the 1907 financial panic as a backdrop to the issue of banking reform in the United States.

Contains a wealth of information on the American banking system before passage of the Federal Reserve Act in 1913.

Gregory P. Marchildon

Cross-References

Morgan Assembles the World's Largest Corporation (1901), p. 29; The Federal Reserve Act Creates a U.S. Central Bank (1913), p. 240; The Supreme Court Rules in the U.S. Steel Antitrust Case (1920), p. 346; The U.S. Stock Market Crashes on Black Tuesday (1929), p. 574; The Credit-Anstalt Bank of Austria Fails (1931), p. 613; The Banking Act of 1933 Reorganizes the American Banking System (1933), p. 656; The Banking Act of 1935 Centralizes U.S. Monetary Control (1935), p. 717; The U.S. Government Bails Out Continental Illinois Bank (1984), p. 1870; Bush Responds to the Savings and Loan Crisis (1989), p. 1991.

A SUPREME COURT RULING ALLOWS "YELLOW DOG" LABOR CONTRACTS

Category of event: Labor
Time: January 27, 1908
Locale: Washington, D.C.

In Adair v. United States, *the Supreme Court declared unconstitutional a provision of the 1898 Erdman Act that prohibited "yellow dog" contracts*

Principal personages:
CONSTANTINE JACOB ERDMAN (1846-1911), a member of the House of Representatives, 1893-1897; principal sponsor of the Erdman Act
JOHN MARSHALL HARLAN (1833-1911), an associate justice of the Supreme Court, author of the majority opinion
OLIVER WENDELL HOLMES, JR. (1841-1935), as associate justice of the Supreme Court, author of one of the dissenting opinions
JOSEPH MCKENNA (1843-1926), an associate justice of the Supreme Court, author of one of the dissenting opinions

Summary of Event

To fully grasp the importance of *Adair v. United States* in the evolution of labor relations, one must understand the nature of the employment relationship examined in that case. "Yellow dog" contracts were agreements between an employer and a prospective employee that the employee did not belong to and would not join a labor union. The employer was then able to make this promise not to join a union a condition of employment, effectively barring unions from the workplace. These contracts might be arrived at individually between a worker and the employer or they might take the form of collective agreements between the employer and groups of workers.

The earliest collective agreements in the printing trades in 1795 and in the iron industry in 1866 were little more than wage scales, but over time the subject matter of agreements extended to cover other aspects of the employer-employee relation, including provisions precluding union membership or union organizing activity. Yellow dog contracts increased in frequency in response to the growing use of the strike by unions in the railroad industry, use that culminated in the Pullman Strike of 1894, one of the most violent of the period. The Erdman Act of 1898 attempted to strengthen the ability of the employer and employees to resolve conflicts between themselves, but it also provided for federal mediation and conciliation. It outlawed discrimination against employees by virtue of union membership, in effect rendering yellow dog contracts illegal. In addition, many states passed legislation making it illegal for an employer to force workers to agree not to join a union as a condition of employment.

These issues came to the attention of the Supreme Court in October, 1907, when

Adair v. United States (208 U.S. 161) was argued. William Adair was a supervisor for the Louisville and Nashville Railroad when O. B. Coppage, a member of the Order of Locomotive Firemen, was discharged. The only apparent reason for the discharge was his union membership. The majority opinion of the Supreme Court, issued on January 27, 1908, affirmed the discharge of Coppage. The Court, in the majority opinion written by John Marshall Harlan, concluded that the prohibition of yellow dog contracts was a violation of the property right of the employer to hire and fire, a right protected by the Fifth Amendment of the Constitution. Adair had a responsibility to prescribe conditions of employment that were in the best interests of his business. As long as those conditions were not injurious to the public interest, the Court ruled, legislation should not interfere with individual freedom. Two additional points were made. First, there had been no stated or implied length of employment agreed to between the employer and the employee, so that the dismissal was not a breach of contract. In addition, although Congress had the right to regulate interstate commerce, that right extended only to those aspects of the employer-employee relation that affected interstate commerce. Membership in a labor organization had nothing substantive to do with how commerce was conducted or with the ability of workers to perform their function. Congress did not have the right to prescribe conditions of union membership, since such a prescription would not fall within its constitutional powers to regulate commerce among the states. In the same way that a worker may choose whether to accept a job, an employer has a reciprocal right to specify the terms and conditions of employment.

This decision was a significant blow against unions on two fronts. First, it made organizing workers more difficult, since the very fact of union membership might lead to dismissal. Second, it greatly diminished the bargaining power of the union by lessening effectiveness of the strike. Striking workers could be replaced with workers who would agree not to join the union. In workplaces that were unionized, the employer could, by precipitating a strike, effectively eliminate the union by replacing the striking union workers with nonunion workers.

There were two dissenting opinions in *Adair v. United States*. Joseph McKenna expressed the view that the intent of the Erdman Act was to resolve industrial conflict in the workplace. This end could be served better by having the employer deal with members of a labor organization rather than with separate individuals. The potential gains to society from the law thus overrode any losses of individual freedom to the employer. The second dissenting opinion was expressed by Oliver Wendell Holmes. Holmes saw the outlawing of yellow dog contracts as a means of protecting workers, usually the weaker party in employment contracts, from the potentially discriminatory exercise of power by the employer. The rights of the employer are not without bound, and the interest of the public welfare takes precedence over that of the employer. Foreshadowing future events, Holmes concluded that even if the only outcome of the Erdman Act was to promote the growth of organized labor in railroads, that would be sufficient justification for passage. A strong union was in the best interests of the individual workers, the railroad industry, and society as a whole.

The Court in 1915 found illegal a state statute prohibiting yellow dog contracts, in *Coppage v. Kansas* (236 U.S. 1). In this case, the Court held that the state statute violated the due process clause of the Fourteenth Amendment. Although the individual had the right to join or not join a union, the employer was not obligated to hire or to continue to employ a union member. In the same way that the individual does not have the right to join the union without the consent of the union organization, the individual does not have the right to be employed without the consent of the employer.

Impact of Event

In the early 1900's, the United States faced a question that would shape its political and social structure. The issue was whether workers should have the right to bargain collectively. In the laissez-faire world of the eighteenth and nineteenth centuries, employers bargained individually with workers. The rights of the employer were relatively unbounded, though workers did have access to the court system when they believed they had been wronged. The technological advances accompanying the Industrial Revolution brought workers together in factories, where the same terms and conditions of employment affected many people. These common concerns inevitably led to collective mechanisms to resolve conflicts with employers. Previously, an employee's main recourse was to quit if conditions were unacceptable; now there was the possibility of groups of employees having a voice. Unions offered the possibility of affecting the terms and conditions of employment, and the threat of the strike gave unions bargaining power. Social acceptance of the right of unions to bargain collectively implied a jurisprudence in the workplace separate from that in the courts. Although the right of the employer to bargain with individual employees over the preconditions of employment may be acceptable in the abstract, it may not hold universally. In other words, private contracting may not be in the public's best interest because it denies workers the right to a voice; it denies them democracy in the workplace. The yellow dog contract might be in the interests of the employer and possibly even of the worker directly involved, but it was not in the best interests of society.

Adair v. United States set the stage for a dramatic change in legislation concerning unions. The yellow dog contract served as an effective tool for employers to keep out unions and in the event of a strike to replace union workers with workers who promised not to join a union. The idea of "employment at the will of the employer," however, was being slowly circumscribed. The majority and dissenting opinions in this case, especially that of Holmes, highlight the complexity of the issue.

The right to bargain over the terms and conditions of employment was assured by the Fifth Amendment. In that context, yellow dog contracts can be viewed in two quite different ways. On one hand, their prohibition by Congress ensured that employers, assumed to have the greater power in the bargaining context, would not be allowed to use that power to exploit an individual worker and indirectly all workers or the labor movement. Since the prohibition of union membership was not essential to the performance of the job and did not alter the worker's productivity, it should not be

permitted and in fact was discriminatory since it was unrelated to job performance. Yellow dog contracts would be illegal because they were coercive on the part of the employer or because such subject matter was beyond the scope of legitimate contracts. The alternative view was that Congress was interfering with the rights of individuals to engage in potentially mutually advantageous trades. The private property rights of the employer made union membership a legitimate matter for contracting, while the right of the prospective employee to refuse the job offer precluded coercion. This right of the employer was affirmed in the 1917 Supreme Court case of *Hitchman Coal and Coke Co. v. Mitchell* (245 U.S. 229). A yellow dog contract was in effect when union agents attempted to organize the employees and become their exclusive bargaining agent. The Court determined that the employer could seek injunctive relief against the union. Justice Mahlon Pitney asserted that the right of the employer to make union membership a condition of employment is as sacrosanct as the right of the employee to join the union and that these rights derive from the constitutional rights of private property and individual freedom. In another 1917 case, *Eagle Glass Mfg. Co. v. Rowe* (245 U.S. 275), the Court ruled that the employer could enjoin the officers and members of the union from conspiring to induce employees to violate such a preemployment contract.

At the federal level, the change in public attitude toward unions is symbolized by the Railway Labor Act of 1926. It forbade the use of yellow dog contracts by employers and rendered invalid any such existing contracts. The constitutionality of the act was affirmed in Texas in the 1930 Supreme Court case of *N.O.R. Co. v. Brotherhood of Ry. S.S. Clerks* (281 U.S. 548). The Court sustained a decision of a lower court that workers discharged because of union membership be reinstated. The Court reconciled its decision in this case with those in *Adair v. United States* and related cases by making a subtle distinction. The employer's right to hire whom it wanted was not being interfered with. The employees, however, had a right to be represented by individuals of their own choosing. The law was not limiting the right of the employer but was ensuring the right of employees to choose their own representatives. The employer does not have a constitutional right to limit the right of workers to choose their representatives.

The opinion in *Adair v. United States* stated that the worker and the employer were equal parties in the contracting process, that unions inhibited individual rights, and that unions were in some cases conspiracies in restraint of trade that could be enjoined. These legal ramifications were changed by the Norris-LaGuardia Act (the Anti-Injunction Act) of 1932. The main focus of the act was to prevent employers from seeking injunctive relief against striking unions, but it also acknowledged the helplessness of individual workers in bargaining with employers. Section 3 of the Norris-LaGuardia Act made yellow dog contracts nonenforceable and not subject to injunctive relief. The prohibition of the use of the injunction was extended to railroads the next year.

In 1933, Congress amended the Bankruptcy Act to prevent railroad carriers in bankruptcy from using yellow dog contracts to circumvent unions. This prohibition

was extended and reinforced in the Emergency Railroad Transportation Act of 1933 and in the 1934 amendments to the Railway Labor Act. The change in the public attitude toward unions from one of tolerance to one of encouragement culminated in the passage of the National Labor Relations Act (Wagner Act) in 1935.

The opinions articulated in *Adair v. United States* defined the terms in the debate concerning the role of organized labor in the American economy. The decision of the Court represents one of the last times that the rights of the employer to freedom and to private property were ruled to dominate the rights of the worker. In *Adair v. United States*, the role of the union was seen as negatively affecting private rights without consideration of the public good. Implicit was the eighteenth century view that the private good was compatible with the social good. This attitude of individual rights was challenged in Holmes's minority opinion, in which he stated that in the interest of the public good and the collective social well-being, the unilateral right of the employer must be limited. The unrestricted right of the employer limits the right of the employee and is not in the best interests of society. Once this view was accepted, the institution of unionism could no longer be seen as an obstructionist conspiracy contrary to the Constitution. Unions instead became recognized as vehicles to safeguard individual rights.

Bibliography

Commerce Clearing House. *Labor Law Course.* 24th ed. New York: Author, 1976. A complete summary of the law governing labor relations. Both topic and legal case indexes are provided. Major legislation and court opinions are presented and cross-referenced.

Herman, E. Edward, and Gordon S. Skinner. *Labor Law: Cases, Text, and Legislation.* New York: Random House, 1972. An introduction to labor law. Each major topic is summarized. The principal legislation is presented, and the most important legal cases are excerpted.

Myers, A. Howard, and David P. Twomey. *Labor Law and Legislation.* 5th ed. Cincinnati: South-Western, 1975. Both essays and legal cases are used to trace the evolution of societal views on labor relations, beginning with British common law.

Taft, Phillip. *Organized Labor in American History.* New York: Harper & Row, 1964. One of the best descriptions of the role of unions in the United States prior to 1960. Analyzes the influence of yellow dog contracts and labor legislation on union growth.

"William Adair v. United States." In *United States Supreme Court Reports.* Vol. 208. Rochester N.Y.: Lawyers Co-Operative Publishing Co., 1926. Reports the decisions of the Supreme Court along with the dissenting opinions. The specific reference for *Adair v. United States* is 208 U.S. 161 (1908).

John F. O'Connell

Cross-References

Labor Unions Win Exemption from Antitrust Laws (1914), p. 282; The Railway Labor Act Provides for Mediation of Labor Disputes (1926), p. 516; The Norris-LaGuardia Act Adds Strength to Labor Organizations (1932), p. 635; The Wagner Act Promotes Union Organization (1935), p. 706; Air Traffic Controllers of PATCO Declare a Strike (1981), p. 1803.

THE DANBURY HATTERS DECISION CONSTRAINS SECONDARY BOYCOTTS

Category of event: Labor
Time: February 3, 1908
Locale: Danbury, Connecticut, and Washington, D.C.

The U.S. Supreme Court's decision subjecting a trade union's secondary boycott to prosecution under the Sherman Antitrust Act imperiled the existence of all labor unions

Principal personages:

MELVILLE WESTON FULLER (1833-1910), the Chief Justice of the United States who rendered the Loewe v. Lawlor decision

SAMUEL GOMPERS (1850-1924), the president of the American Federation of Labor

WILLIAM HOWARD TAFT (1857-1930), the Chief Justice of the United States who reexamined the Danbury Hatters decision

THEODORE ROOSEVELT (1858-1919), the president whose administration helped set the tone for the Danbury Hatters decision

FRANKLIN D. ROOSEVELT (1882-1945), the president who backed the Norris-LaGuardia Act

Summary of Event

On February 3, 1908, Chief Justice Melville Weston Fuller, a lifelong Democrat and President Grover Cleveland's appointee to the U.S. Supreme Court, delivered the Court's unanimous opinion in the case of *Loewe v. Lawlor* (208 U.S. 274), soon dubbed the Danbury Hatters' case. Along with all other American labor leaders, Samuel Gompers, president of the American Federation of Labor (AFL), the nation's largest trade union, awaited the Court's ruling with apprehension. Organized labor was under widespread assault from the business community and had already suffered reversals in several lower federal court rulings. Union leaders consequently anticipated that any Supreme Court decision would be significant. The Danbury Hatters ruling was epochal, but it also realized all of their fears. The Court declared illegal a secondary boycott mounted by the Danbury, Connecticut, United Hatters of North America against nonunion hat manufacturers. The Court did so by bringing trade unions under provisions of the Sherman Antitrust Act of 1890.

The Sherman Act was a response to public reactions against the proliferation of trusts and monopolies spawned by the unprecedented expansion of industrial and finance capitalism after 1880. In effect federalizing legislation previously enacted in many states, the Sherman Act sought to maintain competition in the marketplace by prosecuting conspiracies that were judged to be in restraint of trade or commerce. Until the administration of President Theodore Roosevelt (1901-1909), the act,

appearing toothless, was seldom employed. Roosevelt sensationalized the act by launching and winning several major trust prosecutions, but the act's first eighteen years passed with the Supreme Court limiting its jurisdiction to cases involving business or industrial combinations.

Never, until 1908, had the Court indicated that the act also applied to the country's trade unions, though lower courts had invoked it to justify injunctions issued in the celebrated case involving labor leader Eugene Debs in 1895. Unions feared that if they were subjected to the Sherman Act and exposed to charges that they conspired to restrain trade, then the full gamut of trade union weaponry—propaganda, organizing campaigns, picketing, walkouts, strikes, and boycotts—could be cast aside as illegal. It was a reasonable presumption in these circumstances that America's organized labor movement faced extinction.

The Danbury Hatters' Union was interested in one kind of restraint of trade. The union asserted jurisdiction over the country's eighty-two major felt hat manufacturers. By 1908, in some instances through collusion with manufacturers themselves, the Danbury Hatters had unionized seventy of these firms. In the course of trying to bring the closed shop—a workplace that could hire only union members—to the holdout companies, the Hatters had initiated a series of strikes, one of them in 1901 against Dietrich E. Loewe's Danbury hat factory.

When the Loewe strike eventually failed, the union tried another tack. With additional assistance from the AFL, its affiliates, and a number of local unions, the Hatters called upon members and the general public to boycott Loewe's products, the bulk of which were shipped out of Connecticut to twenty-eight other states. The union branded Loewe's firm as "unfair," urging merchants and the public to cease purchasing Loewe hats. To lend substance to their campaign, the Hatters likewise threatened similar boycotts—called secondary boycotts—against dealers who refused to aid them in their fight against Loewe.

The union's nationwide boycott succeeded in reducing Loewe's sales significantly. In 1903, having meanwhile secured the covert aid of the business-funded American Anti-Boycott Association, Loewe filed two suits against individual members of the Hatters' Union, including Martin Lawlor. Filing suit against individuals rather than the union was a legal innovation. Both suits sought redress for Loewe under the Sherman Antitrust Act. One claimed the triple damages the act allowed, amounting to $240,000. The other charged union members with engaging in a criminal common law conspiracy to interfere, by means of their secondary boycott, with interstate commerce. Loewe claimed losses as a consequence of interference with his shipments of goods from as well as into Connecticut. This involvement of interstate commerce allowed the Court to find jurisdiction under the commerce clause of the federal Constitution and authority to apply the Sherman Act.

Whether the Sherman Act applied to organized labor had been debated since its enactment. Seven cases invoking the Sherman Act against labor, each prosecuted by railroad companies, had been heard by lower federal courts by 1895. It was in one of these cases that the Supreme Court found its precedent for doing likewise. It therefore

accepted Loewe's contention that the stoppage of his orders outside Connecticut, in addition to union interference with his ability to fill orders within the state, constituted a restraint of trade or commerce under the meaning of Section 1 of the Sherman Act. On this basis, the Court declared the Hatters' boycott illegal while simultaneously awarding Loewe his damages. Secondary boycotts would remain illegal for the next six decades.

Impact of Event

Controversial even in 1908, the Supreme Court's decision to subject the Danbury Hatters' Union to the Sherman Act has remained so among legal scholars. Few would deny the court's power to employ the act, but most would agree that in so doing the justices engaged in their own brand of legal artistry. The intent of Congress, as made clear in congressional discussions and debates, was that the Sherman Act be aimed at the practices of then-much-feared industrial combinations rather than at labor unions. Industrial combinations continued to be targeted by antitrust prosecutions into the 1990's.

It appears to most legal scholars that common law prohibitions against restraint of trade and commerce were applied erroneously by the Court in the Danbury Hatters' case. The language of the Sherman Act is broad, but legal authorities generally agree that the act's phraseology was not intended by Congress to apply to interference with interstate commerce. In effect, the Court arrogated virtual powers of legislation and in so doing exercised judicial interference with the development of the nation's economic policy.

Gompers and other labor leaders, shocked and dismayed by the decision, broke with their traditions of political nonpartisanship. After a series of national conferences, they decided to organize politically to reward politicians who favored them and punish those who did not. American labor leaders in this respect were borrowing from the actions of their British counterparts. Following the discriminatory Taff Vale railway decision (like the Danbury ruling, it had subjected unions to charge of conspiracy and combination), workers formed a Labour Representation Committee that soon elected fifty members of Parliament. American labor found ample incentive to follow suit, as the Danbury Hatters decision came almost simultaneously with other foreboding judicial news. In 1905 alone, for example, the Massachusetts Supreme Court rendered an opinion that could have doomed the union shop, a Cincinnati, Ohio, court decision appeared to declare that employers had rights regarding workers similar to rights regarding property, the U.S. Supreme Court ruled in the famous *Lochner v. New York* case (198 U.S. 45) that New York State's legislative limits on hours of labor were illegal, and a judge in Chicago, Illinois, prevented peaceful picketing or any moral suasion on the part of Typographical Union strikers to bring nonunion workers into their fold.

The Supreme Court, a little more than a week before ruling on *Loewe v. Lawlor*, negated the Erdman Act of 1898 in its decision in *Adair v. United States*. The Adair decision allowed railroad companies to discriminate against their workers because of

their union membership. Meanwhile, the nation's courts continued employing blanket injunctions against labor's use of its principal weapons: picketing, striking, propagandizing, and boycotting. President Roosevelt publicly proclaimed it unwise to inhibit the judiciary's authority in this regard.

Organized labor's subsequent efforts and, just as important, the inauguration of President Woodrow Wilson's sweeping reform administration contributed to passage of the Clayton Act of 1914, hailed as labor's Magna Carta. The Clayton Act was designed in part to amend the Sherman Act by acknowledging the right of unions to exist, with federal recognition of their additional right to picket or strike peacefully. Secondary boycotts remained illegal. Although union leadership hailed the Clayton Act as exempting unions from the force of the Sherman Act, the amending act changed little. The Supreme Court demonstrated this in 1921 in *Duplex Printing Company v. Deering* (254 U.S. 443) by confirming a lower court restraining order against Duplex strikers, as well as by limiting the strike to Duplex's Michigan plant, thereby condemning sympathetic strikes or threats of strikes or boycotts by unionists in New York State.

Disappointing as the Danbury Hatters decision was to labor leaders, they established by the early 1920's that trade unions were one of the tenacious realities of industrial life. It is therefore of interest that a lifelong Republican and conservative former U.S. president, William Howard Taft, delivered an opinion as Chief Justice of the United States in the *United Mine Workers v. Coronado Coal Company* (259 U.S. 344) case of 1922. The decision offered labor distant hope by skirting allegations that a mine workers' strike had so interfered with interstate commerce as to subject them to the Sherman Act. Taft implicitly acknowledged that by the 1920's nearly all union actions affected interstate commerce, and that to decide against unions on this basis would strip them entirely of their weaponry. Neither socially nor politically was this a viable course. The Court's determination that there had been only an indirect restraint of interstate commerce, restraint insufficient for the Court to apply the Sherman Act, strengthened the cause of labor, although the Court condemned use of the boycott. Congress confirmed the swing in attitude in favor of labor with the reforms embodied in the Norris-LaGuardia Act of 1932 and the National Labor Relations Act of 1935. Continuing in heated legal and political debate, however, was the issue of whether the nation's antitrust laws ought to apply, and if so in what ways, to organize labor.

Bibliography

Foner, Philip S. *The Policies and Practices of the American Federation of Labor 1900-1909*. Vol. 3 in *History of the Labor Movement in the United States*. New York: International Press, 1964. Scholarly and substantive, with a strong prolabor bias. Provides an excellent understanding of organized labor's views of the Sherman Act as used by employers and the federal government. Extremely interesting and informative on the Danbury Hatters decision and its context. Extensive end notes replace bibliography. Splendid index.

Gregory, Charles O. *Labor and the Law*. New York: W. W. Norton, 1946. Intelligently interpretive synthesis by a noted law professor. Good pithy reading with appropriate insertions of Gregory's views on the Danbury Hatters' case and related decisions involving applications of the Sherman Act to labor. Contains two appendices, reference notes, a table of authorities (list of cases cited), and an adequate index. A fine read not yet out of date on basic issues.

Millis, Harry A., and Royal E. Montgomery. *Organized Labor*. New York: McGraw-Hill, 1945. Continues to stand the test of time. The authors were outstanding economists and public servants. Rich in overviews and detail. Abundant informative notes in lieu of bibliography. Fine index. Excellent on the Danbury Hatters' case and others under the Sherman Act.

Seager, Henry R., and Charles A. Gulick, Jr. *Big Business: Economic Power in a Free Society*. New York: Harper & Brothers, 1929. Authoritative and detailed account, excellent on applications of the Sherman Act. Notes, bibliography, and index are all very extensive. Good reading.

Thorelli, Hans B. *The Federal Antitrust Policy: Origination of an American Tradition*. Baltimore: The Johns Hopkins University Press, 1955. The most detailed work on the subject. Best used selectively. Essential but dense reading that reflects confusions of antitrust policies themselves. Extensive notes, seven appendices, exhaustive bibliography, lengthy table of cases, and detailed index.

Wilcox, Clair. *Public Policy Toward Business*. Homewood, Ill.: Richard D. Irwin, 1966. The finest synthesis of its kind. Wonderful context for the Sherman Act's applications to business and labor. Ample notes replace bibliography. Index of cases, names, and subjects are all excellent. Wilcox is unafraid of giving interpretations of his materials.

Clifton K. Yearley

Cross-References

The Supreme Court Strikes Down a Maximum Hours Law (1905), p. 112; A Supreme Court Ruling Allows "Yellow Dog" Labor Contracts (1908), p. 140; Labor Unions Win Exemption from Antitrust Laws (1914), p. 282; The Railway Labor Act Provides for Mediation of Labor Disputes (1926), p. 516; The Norris-LaGuardia Act Adds Strength to Labor Organizations (1932), p. 635; The Wagner Act Promotes Union Organization (1935), p. 706; Roosevelt Signs the Fair Labor Standards Act (1938), p. 792; The Landrum-Griffin Act Targets Union Corruption (1959), p. 1122.

CADILLAC DEMONSTRATES INTERCHANGEABLE PARTS

Category of event: Manufacturing
Time: February 29, 1908
Locale: Brooklands, England

Henry M. Leland, a master of precision techniques, introduced automobile manufacturers to the use of interchangeable parts, providing a key element necessary to the implementation of mass production

Principal personages:

HENRY M. LELAND (1843-1932), the president of Cadillac Motor Car Company in 1908, known as a master of precision

FREDERICK BENNETT, the British agent for Cadillac Motor Car Company who convinced the Royal Automobile Club to run the standardization test at Brooklands, England

HENRY FORD (1863-1947), the founder of Ford Motor Company who introduced the moving assembly line into the automobile industry in 1913

Summary of Event

Mass production is a twentieth century methodology that for the most part is a result of nineteenth century ideas. It is a phenomenon that, although its origins were mostly American, has consequently changed the entire world. The use of interchangeable parts, the feasibility of which was demonstrated by the Cadillac Motor Car Company in 1908, was instrumental in making mass production possible.

The British phase of the Industrial Revolution saw the application of division of labor, the first principle of industrialization, to capitalist-directed manufacturing processes. Centralized power sources were connected through shafts, pulleys, and belts to machines housed in factories. Even after these dramatic changes, the British preferred to produce unique, handcrafted products formed one step at a time using general-purpose machine tools. Seldom did they make separate components to be assembled into standardized products.

Stories about American products that were assembled from fully interchangeable parts began to reach Great Britain. In 1851, the British public saw a few of these products on display at an exhibition in London's Crystal Palace. In 1854, they were informed by one of their own investigative commissions that American manufacturers were building military weapons and a number of consumer products with separately made parts that could be easily assembled, with little filing and fitting, by semiskilled workers.

English industrialists had probably heard as much as they ever wanted to about this so-called "American system of manufacturing" by the first decade of the twentieth century, when word came that American companies were building automobiles with

parts manufactured so precisely that they were interchangeable.

During the fall of 1907, Frederick Bennett, an Englishman who served as the British agent for the Cadillac Motor Car Company, paid a visit to the company's Detroit, Michigan factory and was amazed at what he saw. He later described the assembling of the relatively inexpensive Cadillac vehicles as a demonstration of the beauty and practicality of precision. He was convinced that if his countrymen could see what he had seen they would also be impressed.

Most automobile builders at the time claimed that their vehicles were built with handcrafted quality, yet at the same time they advertised that they could supply repair parts that would fit perfectly. In actuality, machining and filing were almost always required when parts were replaced, and only shops with proper equipment could do the job.

Upon his return to London, Bennett convinced the Royal Automobile Club to sponsor a test of the precision of automobile parts. A standardization test was set to begin on February 29, 1908, and all of the companies then selling automobiles were invited to participate. Only the company that Bennett represented, Cadillac, was willing to enter the contest.

Three one-cylinder Cadillacs, each painted a different color, were taken from stock at the company's warehouse in London to a garage near the Brooklands race track. The cars were first driven around the track ten times to prove that they were operable. British mechanics then dismantled the vehicles, placing their parts in piles in the center of the garage, making sure that there was no way of identifying from which car each internal piece came. Then, as a further test, eighty-nine randomly selected parts were removed from the piles and replaced with new ones straight from Cadillac's storeroom in London. The mechanics then proceeded to reassemble the automobiles, using only screwdrivers and wrenches.

After the reconstruction, which took two weeks, the cars were driven from the garage. They were a motley looking trio, with fenders, doors, hoods, and wheels of mixed colors. All three were then driven five hundred miles around the Brooklands track. The British were amazed. Cadillac was awarded the club's prestigious Dewar Trophy, considered in the young automobile industry to be almost the equivalent of a Nobel Prize. A number of European and American automobile manufacturers began to consider the promise of interchangeable parts and the assembly line system.

Cadillac's precision-built automobiles were the result of a lifetime of experience of Henry M. Leland, an American engineer. Known in Detroit at the turn of the century as a master of precision, Leland became the primary connection between a series of nineteenth century attempts to make interchangeable parts and the large-scale use of precision parts in mass production manufacturing during the twentieth century.

The first American use of truly interchangeable parts had occurred in the military, nearly three-quarters of a century before the test at Brooklands. Thomas Jefferson had written from France about a demonstration of uniform parts for musket locks in 1785. A few years later, Eli Whitney attempted to make muskets for the American military by producing separate parts for assembly using specialized machines. He was never

able to produce the precision necessary for truly interchangeable parts, but he promoted the idea intensely. It was in 1822 at the Harpers Ferry Armory in Virginia, and then a few years later at the Springfield Armory in Massachusetts, that the necessary accuracy in machining was finally achieved on a relatively large scale.

Leland began his career at the Springfield Armory in 1863, at the age of nineteen. He worked as a tool builder during the Civil War years and soon became an advocate of precision manufacturing. In 1890, Leland moved to Detroit, where he began a firm, Leland & Faulconer, that would become internationally known for precision machining. His company did well supplying parts to the bicycle industry and internal combustion engines and transmissions to early automobile makers. In 1899, Leland & Faulconer became the primary supplier of engines to the first of the major automobile producers, the Olds Motor Works.

In 1902, the directors of another Detroit firm, the Henry Ford Company, found themselves in a desperate situation. Henry Ford, the company founder and chief engineer, had resigned after a disagreement with the firm's key owner, William Murphy. Leland was asked to take over the reorganization of the company. Because it could no longer use Ford's name, the business was renamed in memory of the French explorer who had founded Detroit two hundred years earlier, Antoine de la Mothe Cadillac.

Leland was appointed president of the Cadillac Motor Car Company. The company, under his influence, soon became known for its precision manufacturing. He disciplined its suppliers, rejecting anything that did not meet his specifications, and insisted on precision machining for all parts. By 1906, Cadillac was outselling all of its competitors, including Oldsmobile and Ford's new venture, the Ford Motor Company. After the Brooklands demonstration in 1908, Cadillac became recognized worldwide for quality and interchangeability at a reasonable price.

Impact of Event

The Brooklands demonstration went a long way in proving that mass-produced goods could be durable and of relatively high quality. It showed that standardized products, although often less costly to make, were not necessarily cheap substitutes for handcrafted and painstakingly fitted products. It also demonstrated that, through the use of interchangeable parts, the job of repairing such complex machines as automobiles could be made comparatively simple, moving maintenance and repair work from the well-equipped machine shop to the neighborhood garage or even to the home.

Because of the international publicity Cadillac received, Leland's methods began to be emulated by others in the automobile industry. His precision manufacturing, as his daughter-in-law would later write in his biography, "laid the foundation for the future American [automobile] industry." The successes of automobile manufacturers quickly led to the introduction of mass production methods, and strategies designed to promote their necessary corollary mass consumption, in many other American businesses.

In 1909, Cadillac was acquired by William Crapo Durant as the flagship company of his new holding company, which he labeled General Motors. Leland continued to improve his production methods, while also influencing his colleagues in the other General Motors companies to implement many of his techniques. By the mid-1920's, General Motors had become the world's largest manufacturer of automobiles. Much of its success resulted from extensions of Leland's ideas. The company began offering a number of brand name vehicles in a variety of price ranges for marketing purposes, while still keeping the costs of production down by including in each design a large number of commonly used, highly standardized components.

Henry Leland resigned from Cadillac during World War I after trying to convince Durant that General Motors should play an important part in the war effort by contracting to build Liberty aircraft engines for the military. He formed his own firm, named after his favorite president, Abraham Lincoln, and went on to build about four thousand aircraft engines in 1917 and 1918. In 1919, ready to make automobiles again, Leland converted the Lincoln Motor Company into a car manufacturer. Again he influenced the industry by setting high standards for precision, but in 1921 an economic recession forced his new venture into receivership. Ironically, Lincoln was purchased at auction by Henry Ford. Leland retired, his name overshadowed by those of individuals to whom he had taught the importance of precision and interchangeable parts. Ford, as one example, went on to become one of America's industrial legends by applying the standardized parts concept.

In 1913, Henry Ford, relying on the ease of fit made possible through the use of machined and stamped interchangeable parts, introduced the moving assembly line to the automobile industry. He had begun production of the Model T in 1908 using stationary assembly methods, bringing parts to assemblers. After having learned how to increase component production significantly, through experiments with inter-changeable parts and moving assembly methods in the magneto department, he began to apply this same concept to final assembly. In the spring of 1913, Ford workers began dragging car frames past stockpiles of parts for assembly. Soon a power source was attached to the cars through a chain drive, and the vehicles were pulled past the stockpiles at a constant rate.

From this time on, the pace of tasks performed by assemblers would be controlled by the rhythm of the moving line. As demand for the Model T increased, the number of employees along the line was increased and the jobs were broken into smaller and simpler tasks. With stationary assembly methods, the time required to assemble a Model T had averaged twelve and one-half person-hours. Dragging the chassis to the parts cut the time to six hours per vehicle, and the power-driven, constant-rate line produced a Model T with only ninety-three minutes of labor time. Because of these amazing increases in productivity, Ford was able to lower the selling price of the basic model from $900 in 1910 to $260 in 1925. He had revolutionized automobile manufacturing: The average family could now afford an automobile.

Soon the average family would also be able to afford many of the other new products they had seen in magazines and newspapers. At the turn of the century, there

were many new household appliances, farm machines, ready-made fashions, and prepackaged food products on the market, but only the wealthier class could afford most of these items. Major consumer goods retailers such as Sears, Roebuck and Company, Montgomery Ward, and the Great Atlantic and Pacific Tea Company were anxious to find lower-priced versions of these products to sell to a growing middle-class constituency. The methods of mass production that Henry Ford had popularized seemed to carry promise for these products as well. During the 1920's, by working with such key manufacturers as Whirlpool, Hoover, General Electric, and Westing-house, these large distributors helped introduce mass production methods into a large number of consumer product industries. They changed class markets into mass markets.

The movement toward precision also led to the birth of a separate industry based on the manufacture of machine tools. A general purpose lathe, milling machine, or grinder could be used for a number of operations, but mass production industries called for narrow-purpose machines designed for high-speed use in performing one specialized step in the production process. Many more machines were now required, one at each step in the production process. Each machine had to be simpler to operate, with more automatic features, because of an increased dependence on unskilled workers. The machine tool industry became the foundation of modern production.

The miracle of mass production that followed, in products as diverse as airplanes, communication systems, and hamburgers, would not have been possible without the precision insisted upon by Henry Leland in the first decade of the twentieth century. It would not have come about without the lessons learned by Henry Ford in the use of specialized machines and assembly methods, and it would not have occurred without the growth of the machine tool industry. Cadillac's demonstration at Brooklands in 1908 proved the practicality of precision manufacturing and interchangeable parts to the world. It inspired American manufacturers to continue to develop these ideas; it convinced Europeans that such production was possible; and, for better or for worse, it played a major part in changing the world.

Bibliography

Hill, Frank Ernest. *The Automobile: How It Came, Grew, and Has Changed Our Lives.* New York: Dodd, Mead, 1967. Tells the story of the automobile industry and its growth. Includes a number of discussions of Leland's work. Provides details on the Brooklands demonstration and discusses its consequences.

Hounshell, David A. *From the American System to Mass Production, 1800-1932.* Baltimore: The Johns Hopkins University Press, 1984. Discusses Leland's early life, his work at the Springfield Armory, and his management of Brown and Sharpe's sewing machine department. Provides an excellent picture of how Leland became enamored with the idea of precision manufacturing.

Leland, Ottilie M., and Minnie Dubbs Millbrook. *Master of Precision: Henry M. Leland.* Detroit: Wayne State University Press, 1966. The primary biography of Henry Leland, coauthored by his son's widow. Tells the story of one of America's

most important industrial entrepreneurs, an individual who played a pivotal role in the development of mass production by teaching the automobile industry the importance of interchangeable parts.

Marcus, Alan I., and Howard P. Segal. *Technology in America: A Brief History*. New York: Harcourt Brace Jovanovich, 1989. Discusses the importance of interchangeable parts in the evolution of mass production processes in the automobile, home appliance, and agricultural implement industries.

Nevins, Allan, and Frank Ernest Hill. *The Times, the Man, the Company*. Vol. 1 in *Ford*. New York: Charles Scribner's Sons, 1954. Discusses Leland's various relationships with Henry Ford, the Henry Ford Company, and Ford Motor Company. Briefly discusses the Brooklands demonstration.

Robert G. Lynch

Cross-References

Catalog Shopping by Mail Proliferates (1900's), p. 6; Hashimoto Forms the Roots of Nissan Motor Company (1911), p. 185; Ford Implements Assembly Line Production (1913), p. 234; The Hawthorne Studies Examine Factors in Human Productivity (1924-1932), p. 437; The Number of U.S. Automakers Falls to Forty-four (1927), p. 533.

HARVARD UNIVERSITY FOUNDS A BUSINESS SCHOOL

Category of event: Management
Time: April 8, 1908
Locale: Cambridge, Massachusetts

The Harvard Business School's innovative instructional methods helped professionalize management and the way managers are educated

Principal personages:

EDWIN F. GAY (1867-1946), the founding dean of the Harvard Business School

ARCH W. SHAW (1876-1962), a noted publisher and lecturer on business policy at Harvard

MELVIN T. COPELAND (1884-1975), a distinguished professor of business administration and historian of the Harvard Business School

CHARLES WILLIAM ELIOT (1834-1926), the president of Harvard University who suggested the establishment of a school of diplomacy and government

A. LAWRENCE LOWELL (1856-1943), a distinguished Boston lawyer and lecturer on government at Harvard, later its president

FRANK W. TAUSSIG (1859-1940), a professor at Harvard who drafted a detailed plan for the Harvard Business School

GEORGE F. BAKER (1840-1931), a president of the First National Bank in New York and a major financial contributor to the Harvard Business School

Summary of Event

The emergence of the multiunit form, a vision that institutions of higher education could serve a utilitarian purpose, and a popular desire to professionalize most occupations encouraged the development of collegiate business education in the late nineteenth century. An early participant in this exciting experiment in higher learning was the Harvard Business School, founded in 1908. Although preceded by the Wharton School at the University of Pennsylvania and the Amos Tuck School at Dartmouth, the Harvard Business School inaugurated a change in the education of professional managers through its innovative instructional methods and the high priority it placed on business research.

An emphasis on framing business problems, class discussion, written case analysis, and a climate that encouraged confident decision making were seen from the outset as vital to the development of top managers. It soon became apparent, however, that a rather large breach existed between the school's educational aspirations and its ability to achieve them. There were few teachers trained in business administration, and scholarship in the form of published works was almost nonexistent. In fact, course

offerings, materials, and textbooks were sparse until the 1920's.

Early professors of business administration both at Harvard and elsewhere were drawn from a wide variety of academic disciplines. Economists such as Simon N. Patten were influential teachers and scholars at the Wharton School. The economics department also dominated academic life at the Amos Tuck School at Dartmouth. Business educators in this nascent stage of development were also drawn from less closely allied fields. Of the two accounting courses offered at Wharton, for example, one was taught by a professor of journalism who also instructed in business practices and banking. The other course was taught by a political scientist.

The recruitment of faculty proved to be the most challenging aspect of running the fledgling Harvard Business School for its first dean, Edwin F. Gay. Determined that the education of professional managers required a unique approach, he eschewed teachers from undergraduate business programs and scholars from the traditional social science disciplines. This represented a departure from accepted practice. The business school, in fact, had been envisioned as a school of diplomacy and government by Harvard University president Charles William Eliot. Gay quickly set out to establish a core faculty and to recruit practicing managers from New York, Boston, and Philadelphia. William Morse Cole and Oliver Mitchell Sprague joined the regular faculty to teach accounting and banking, respectively. Paul Terry Cherington, who would make seminal contributions in the field of marketing education through his work *Advertising as a Business Force: A Compilation of Experience Records* (1913), joined the faculty from the Philadelphia Commercial Museum. Lincoln Frederick Schaub became the school's first full-time instructor of commercial law. These individuals, along with two part-time instructors, eight part-time lecturers, and fifty-five outside (guest) lecturers, composed the school's first teaching staff. Over the next decade, the permanent faculty grew, and as the case method became more widely used, the need for outside lecturers waned.

Initial courses at Harvard were analogous to those provided at the older business schools. Required first-year coursework in accounting, commercial contracts, and economic resources of the United States (later marketing) were augmented by electives in industrial organization, corporate insurance, and banking. These traditional courses were seen as essential prerequisites for a career with a multiunit firm. Second-year courses examined the intricacies of management in specialized industries such as railroading, foreign trade, banking, and insurance.

The school made a marked advance toward achieving its unique mission of educating professional managers through a "problems" or "case method" approach with the addition of Arch W. Shaw to its faculty. Shaw was the energetic publisher of *System*, a journal that crusaded for more efficient business practices. Upon his appointment to the faculty at Harvard, he turned his energies to developing a course in business policy using the case approach. His use of "real life" cases animated his classes, and in time his course became the capstone for the school. His book *An Approach to Business Problems* (1916), along with colleague Melvin T. Copeland's *Problems in Marketing* (1920), did much to advance their respective specialties and

advance business education in the United States.

These textbooks, along with other seminal contributions to the business literature by Cherington, Charles Edward Russel, Bruce Wyman, and Walter Dill Scott, became required reading in every business school and program soon after publication. Despite these works, however, there was a dearth of business information and research material needed for the development of cases and advanced coursework. The development of the marketing discipline, perhaps more than any other in the business curriculum, was constrained as a result of meager "real life" data. Even the trade journals of the day gave scarce attention to selling or marketing problems.

The collection of business information and data for course materials, cases, and textbooks proceeded in an ad hoc fashion through individual professors and in a more organized manner through bureaus of business research. J. E. Hagerty, an early marketing professor at Ohio State University, for example, was frustrated by the paucity of textual material in his discipline and attempted to fill this breach by interviewing local businesspeople. He discovered that these individuals gave freely of their time and information because of their curiosity about his research effort. They wondered why anyone would want to learn about their organizations, methods, procedures, and business problems.

The Harvard Bureau of Business Research was begun at the urging of Arch W. Shaw shortly after the founding of the school. Although its principal mission was to gather data to aid instruction in the school, especially in marketing, it was hoped that research results would prove beneficial to students and teachers in other schools and to individuals in the wider business community. Its first study, of the shoe industry, received wide distribution in trade papers and other business publications and aroused interest in the activities of the school. Soon, studies of the operating expenses of grocers, department stores, and variety chains were produced. Later, scholarly investigations of labor unions, the distribution of textiles, cotton mill hedging practices, and interstate power transmission not only provided a wealth of teaching material but also encouraged further exploratory work in other business schools throughout the United States.

Impact of Event

The founding and the early success of the Harvard Business School had a significant effect on the professionalization of management, which in turn had consequences for the education of managers. The bold and innovative instructional methodologies and the scholarly climate at Harvard in the early twentieth century became a model for all other business schools to follow. It soon became common for business careers to begin after formal education in business administration. General education would precede professional coursework. Students would take a core of business subjects that gave coherence and content to their professional studies. This core included business law, statistics, marketing, accounting, money and banking, and corporate finance. The problem approach would supersede rote memorization of formulas and data. Written and oral communication were stressed for future business leaders. The discovery of

new business knowledge through research and investigation of active organizations would be attempted and encouraged. Classroom instruction and theoretical knowledge would be augmented and tested with internship experiences in business. The formal education of managers would not necessarily terminate in the nascence of their careers, as professional education for practicing managers was introduced.

Each of these innovations was a bold step. Each served to convince prospective students as well as academic and business leaders that the business site and academe could be connected through a business school or program. Within two decades of the opening of the business school at Harvard, numerous major public and private universities established similar ventures. Business schools were established at Ohio State (1916); Alabama, Minnesota, and North Carolina (1919); Virginia (1920); Indiana (1921); and Kansas and Michigan (1924). Columbia (1916) and Stanford (1925) were private institutions that established business schools during this period. In addition, it would not be long before an even larger number of public and private institutions established business programs "in town" to educate future business leaders living and working in large metropolitan areas.

The revolutionary changes in the education of future managers were the result of a courageous decision to foster the development of an educational experience free of the intellectual control of other long-established academic disciplines. Gay believed that the aims of a graduate school of business should be instillation of a rational method of attacking business problems and development of intellectual respect for the management profession. This also entailed appreciation for the social, cultural, and ethical dimensions of the field. Harvard's early commitment to developing a business administration paradigm that could stand on its own energized stakeholders to find new ways and means of educating a new profession, that of management. The case method, with its attendant vigorous analysis and discussion of companywide problems together with scholarly investigation of living organizations, was an important part of this philosophy of education.

Case studies adopting the companywide problems approach benefited students, teachers, and practitioners alike. Students benefited by seeing that rational decision-making processes could be applied to problems encountered in a wide variety of business settings. Professors gained because cases gave flexibility as well as content and depth to their courses. Well-researched and well-written cases provided a wealth of information about industry practices and technical matters in the process of teaching problem-solving skills. Perhaps most important, practicing managers benefited from their training in the case method. As business school graduates, they enjoyed a common basis for communication and a better understanding of mutual problems. In short, managers trained in this analytical method could relate better to their peers.

Business research, like the case method, can trace its origins to the first years of the school. It reached its full instructional potential some years later. Harvard's pioneering Bureau of Business Research had substantial pedagogical value to the academic community in the school and elsewhere while also providing strategic information to

managers in industry. The work of the bureau helped make class discussions and teaching materials more interesting and relevant for the first students in the school and, in time, became the foundation for instruction conducted there. The style and method of research carried out in the early days of the business school also had important consequences for the conduct of business research in general. The bureau, with its strategy of focusing its efforts on a small area of business and studying it thoroughly to achieve notable results in a brief period, its refusal to be commercialized, and its aspiration to be at a level equal to Harvard's other schools, became a model for other researchers and institutions to imitate.

Bibliography

Chandler, Alfred D. *The Visible Hand: The Managerial Revolution in American Business.* Cambridge, Mass.: The Belknap Press of Harvard University Press, 1977. This seminal work by a distinguished historian of business examines the rise of modern business enterprise and its managers during the formative years of modern capitalism, from the 1850's until the 1920's. A superb book for anyone interested in the profession of management.

Copeland, Melvin T. *And Mark an Era: The Story of the Harvard Business School.* Boston: Little, Brown, 1958. An important study of the founding and development of the Harvard Business School through its first half century. Written by a distinguished member of the school's faculty during the period studied. An essential work for understanding the development of collegiate business education in the United States.

Heaton, Herbert. *A Scholar in Action: Edwin F. Gay.* New York: Greenwood Press, 1968. A biography of the bold, imaginative, and scholarly first dean of the Harvard Business School. Provides interesting background information about this educational administrator whose early advocacy for the problem approach and business research aided the development of the profession of management.

Pierson, Frank C., et al. *The Education of American Businessmen.* New York: McGraw-Hill, 1959. Chapter 3 provides in a concise manner excellent historical information about American business schools from their origins through the early 1950's. Valuable as an overview while also providing interesting insights into the origin and growth—and often decline—of early American collegiate business schools.

Veysey, Lawrence R. *The Emergence of the American University.* Chicago: University of Chicago Press, 1965. An authoritative study of the social and cultural forces that helped transform the American university into a modern institution at the beginning of the twentieth century. An important work for those interested in placing business education in a larger cultural and intellectual context. Can be enjoyed by both serious scholars and generalists.

S. A. Marino

Cross-References

Walter Dill Scott Publishes *The Theory of Advertising* (1903), p. 80; Donham Promotes the Case Study Teaching Method at Harvard (1920's), p. 335; Sloan Develops a Structural Plan for General Motors (1920), p. 368; The American Management Association Is Established (1923), p. 419; Barnard Publishes *The Functions of the Executive* (1938), p. 770.

CONGRESS UPDATES COPYRIGHT LAW IN 1909

Category of event: Business practices
Time: March 4, 1909
Locale: Washington, D.C.

The Copyright Act of 1909 was the end product of hundreds of years of common and statutory copyright law

Principal personages:
> WILLIAM MURRAY MANSFIELD (1705-1793), a British jurist and member of the House of Lords who argued for copyright protection and monetary reward for authors
> JOSEPH STORY (1779-1845), an American jurist whose decisions formed precedent for the fair use doctrine
> OLIVER WENDELL HOLMES, JR. (1841-1935), an American jurist whose opinions influenced future opinions on the nature of originality of works
> LEARNED HAND (1872-1961), an American jurist whose decisions shaped future definitions of copyright infringement

Summary of Event

Under copyright law in general, authors or creators of original works have the exclusive right to reproduce (or authorize others to reproduce) these works and are protected against unlawful copying, known as plagiarism or piracy. "Original" does not mean "unique." Original works are those created by the author's own intellectual or creative effort, as opposed to having been copied. Copying all or part of a work without permission of the author (or any agency the author has authorized for copying) constitutes copyright infringement. Willful unauthorized copying for the purpose of making a profit is a criminal offense punishable by fine or imprisonment. When authors suspect infringement but have no grounds for charging criminal intent, they can bring civil action against the alleged offender. Under certain circumstances, parts of authors' works can be copied without permission according to what is known as the fair use doctrine.

Works are protected by copyright for a specific length of time. At the end of that time, a work is said to be in the public domain and can be copied without permission. Ever since the concept of the right to copy was established and codified, copyright has existed under both common and statutory law. Common law is unwritten law, based on tradition and precedent. Statutory law is written law passed by a legislative body, such as the British Parliament or the United States Congress.

In general, common law protects a work before it is published and statutory law protects it after it is published. In both common and statutory law, it is assumed that what is written or created is property. The creator of a work has sole ownership of the

work and the right to dispose of it as one would any other type of property; that is, to sell it, lease it, transfer it, or leave it in a will. Upon publication of the work, the author gives up some of the ownership rights granted by common law but is given monetary rewards for doing so. The law is based on two sometimes conflicting principles: authors should be rewarded for their labors and knowledge should be made readily available to the pubic for the good of society as a whole. Much of the history of copyright law is concerned with attempts to reconcile these two principles.

The concept and fundamental issues of copyright date back at least as far as the fifteenth century. With the invention of printing, copies of both ancient and contemporary works began to proliferate and become readily available to the public. Early English copyright law began to address the questions of what should be printed, who ultimately owned the works and for how long, how the owners should be compensated for them, and who should be authorized to copy them.

Throughout Europe, by the sixteenth century printing had developed from an unregulated cottage industry of craftsmen to a full-fledged profession and a thriving large-scale industry. Usually, the printers of books were also the vendors of them. In England, the printing and selling of books was done by a monopoly called the Stationers' Company. Copyright at this time was a license given to the Stationers' Company by royal decree. The decree gave the company exclusive rights to print all works the government deemed proper to print. The law was for the benefit of publishers and booksellers more than for authors. Furthermore, since the license to publish was granted on the basis of what the government decided could or could not be published, it was actually a form of censorship. It bore little resemblance to the laws that followed but did recognize that what was written in a book was as much property as was the book itself. Authors, who had hitherto been supported by wealthy, interested patrons rather than by sale of their work, could now earn money (although hardly a living wage) apart from patronage by selling their manuscripts to printers, who paid them a lump sum. It was generally accepted that once the manuscript was sold, the work was no longer the property of the author. Copyright infringement, which frequently consisted of printing unauthorized works outside the Stationers' monopoly, was more an offense against the publisher, or those who licensed the publisher, than against the author.

By the late seventeenth century, the English press was generally liberated from the dictates of the authorities. There was much less censorship, and licenses to the Stationers' Company were no longer renewed. Freedom of the press destroyed the Stationers' monopoly, for now anyone could print virtually anything. An unfettered press also meant a lack of protection for authors from piracy and plagiarism. Literary piracy long had been considered an outrage, if not actually a criminal offense, and was supposed to be prevented by common law, but there were few means of enforcing common law. Both authors and booksellers pressured Parliament for legislation that would protect authors from piracy and provide booksellers with enough security to allow them to stay in business. In 1710, Parliament responded with the Statute of Anne, named for the reigning queen. The Statute of Anne established time limits, with

renewals, on how long a published work would be protected before it went into the public domain and outlined penalties for copyright infringement. The law was not clear, however, on how long an unpublished work was protected by common law or whether common law was superseded by statutory law after a work was published. It did not answer whether an author gave up all rights to a work after it was published. There were many cases in which publishers freely copied works for which the statutory term of protection had expired. When the authors of the works complained that this free copying was a violation of their common law rights, the English courts decided that once a work had been published and the term of protection had expired, common law rights no longer applied. This conflict sparked long and heated debates over ownership and the balance between authors' rights and the public good. These debates continued through the twentieth century.

Limited and controversial as it was, the Statute of Anne became the pattern for all subsequent copyright legislation in both England and the United States. Twelve of the thirteen original states adopted copyright statutes before the federal Constitution was drawn up. These statutes were summarized in article 1, section 8 of the federal Constitution, which says: "Congress shall have power . . . to promote the progress of science and useful arts by securing for limited times to authors and inventors the exclusive right to their respective writings and discoveries." The first federal copyright law, enacted in 1790, was revised in 1831 and 1879. On March 4, 1909, Congress passed a copyright law that remained in effect until revisions were made in 1976.

The 1909 law states that the purpose of copyright is "not primarily for the benefit of the author, but primarily for the benefit of the public." Although unpublished works were still held to be covered by common law, publication was necessary in order for a work to be covered by statutory law, and an author's rights under statutory law were substantially different from what they were under common law. Under the 1909 law, there was no general protection of unpublished works. Omission of or serious error in a copyright notice or failure to deposit a copy in the Copyright Office resulted in loss or forfeit of copyright.

The Copyright Office, located in the Library of Congress in Washington, D.C., was established by the 1909 law to keep records and register works. The law outlined procedures for registration of copyright, detailed circumstances of and penalties for infringement, and listed fourteen categories of works that could be copyrighted. It codified the standard of copyrightability of a work as being original by the author and not copied from other work. It also lengthened the duration of copyright to twenty-eight years, renewable for twenty-eight more.

Impact of Event

Just as the Statute of Anne had responded to the implications of the new technology of the printing press, so the law of 1909 tried to respond to the new technology of the early twentieth century. The 1909 law grew out of centuries of political upheaval, factional controversy, technological development, and legislative compromise. As English government swung from monarchy to republic and back to monarchy again,

up to the early eighteenth century, written work was first strictly censored and then liberated to the point of anarchy. Printing had made works of all kinds widely available, and once the press was liberated in England, the rights of publishers, authors, and the public came into sharp conflict. Some of the conflicts were resolved by the Statute of Anne, which served as a pattern for American copyright law.

In the spirit of the original state laws and the federal copyright law of 1790, the 1909 law stated its purpose as being "primarily for the public," thus favoring the rights of the public over the rights of authors but allowing for reward to authors in order to encourage them to continue producing. In this way, the conflicting principles of rewards to creators and the "promotion of progress in science and useful arts" for the common good seemed to be reconciled. By extending the term of copyright coverage, it gave more protection to authors than previous legislation had. It provided no protection, however, for unpublished work, and it tended to supersede common law, since publication was a necessary condition for copyright. Nor did it address the special issues of copyright involved for writers as employees or contractors, such as newspaper reporters and freelance writers, who do what is known as "work for hire."

The fair use doctrine had been applied even in early copyright law and was based on the constitutional principle of public benefit from authors' works. In 1961, while the 1909 law was still in effect, the Copyright Office listed what could be copied without permission and for what purpose. Research, instruction, and literary review, for example, were given fairly broad rights to copy. Fair use was not codified until the copyright law revision of 1976.

As technology improved and became more varied, the 1909 law lagged in its provisions. In describing the classes of works that were copyrightable, the language of the 1909 law indicated that it was still largely based on the technology of the printing press. It protected the "writings" of an author, whereas later law protects "original works of authorship," thus broadening the definition of "author" and lengthening the list of what can be considered to be authors' works. Although the 1909 law listed motion pictures and sound recordings among the classes of copyrightable works, it made inadequate provision for the protection of what was disseminated via these new technologies and no provision at all for infringement issues arising from the use of photocopy machines, television, videotapes, computers, or cable and satellite communications.

Beginning in 1955, there were several attempts to revise the law, but it was not extensively revised until 1976 (effective in 1978). The most significant impact of the 1909 copyright law on the writing and publishing world and on society in general, as beneficiary of authors' work, is that it was specific, whereas prior legislation had been general. By establishing a Copyright Office, listing the kinds of works that could be copyrighted, and outlining how they could be protected, it sought to resolve the ongoing conflict between rewarding creators and benefiting their audiences.

Bibliography

Bunnin, Brad, and Peter Beren. "What Is Copyright?" In *The Writer's Legal Compan-*

ion. Reading, Mass.: Addison-Wesley, 1988. Contains practical legal advice for writers. Compares the constitutional foundation of copyright with current law and compares the 1909 and 1978 laws in outline form.

Dible, Donald M., ed. *What Everybody Should Know About Patents, Trademarks, and Copyrights.* Fairfield, Calif.: Entrepreneur Press, 1978. Provides a lengthy historical background to copyright and practical guidelines to what copyright is and how it is obtained. Contains the full text of the 1978 law.

Goldfarb, Ronald L., and Gail E. Ross. "What Every Writer Should Know About Copyright." In *The Writer's Lawyer.* New York: Times Books, 1989. Contains only brief historical background to copyright but provides important information on later developments in copyright law.

Johnston, Donald F. *Copyright Handbook.* 2d ed. New York: R. R. Bowker, 1982. Describes and interprets every element of copyright law in detail. Includes the full texts of both the 1909 and the 1978 laws.

Kaplan, Benjamin. *An Unhurried View of Copyright.* New York: Columbia University Press, 1967. Three lectures analyzing judicial decisions regarding copyright issues from the fifteenth century through the 1960's.

Moore, Waldo. "Ten Questions About the New Copyright Law." In *Law and the Writer,* edited by Kirk Polking and Leonard S. Meranus. Cincinnati, Ohio: Writer's Digest Books, 1978. Explains the 1976 revisions by comparing some of their elements to the 1909 law.

Wincor, Richard, and Irving Mandell. "Historical Background—Copyright Law." In *Copyright, Patents, and Trademarks.* Dobbs Ferry, N.Y.: Oceana Publications, 1980. Provides a concise, thorough, and extremely readable history of copyright from its origins to the status of the law in the 1970's.

Christina Ashton

Cross-References

ASCAP Forms to Protect Writers and Publishers of Music (1914), p. 252; Penguin Develops a Line of Paperback Books (1935), p. 696; The 1976 Copyright Act Reflects Technological Change (1976), p. 1626; Patent Protection Is Granted on Genetically Engineered Mice (1988), p. 1970; U.S. Courts Restrict Rights to Photocopy Anthologies (1991), p. 2040.

THE TARIFF ACT OF 1909 LIMITS CORPORATE PRIVACY

Category of event: Government and business
Time: August 5, 1909
Locale: Washington, D.C.

The Tariff Act of 1909 forced corporations, for the first time, to open their books to the United States government for inspection and audit

Principal personages:
WILLIAM HOWARD TAFT (1857-1930), the president of the United States who signed the Tariff Act of 1909 into law
WILLIAM RUFUS DAY (1849-1923), the Supreme Court justice who wrote the opinion declaring the corporate excise tax constitutional
NELSON W. ALDRICH (1841-1915), an influential United States senator who coauthored the Tariff Act of 1909
SERENO ELISHA PAYNE (1843-1914), a United States senator who co-authored the Tariff Act of 1909
JOSEPH CANNON (1836-1926), the speaker of the House of Representatives, an influential supporter of the Tariff Act

Summary of Event

The Tariff Act of 1909 (HR 1438), also known as the Payne-Aldrich Tariff Act, can be characterized as one part of a growing progressive movement against rapid concentrations of wealth during the late nineteenth and early twentieth centuries. Social forces were driven by sentiment against those business tycoons perceived as reaping exorbitant profits at the expense of the masses of laborers. In the meantime, political figures, determined to address the concerns of their constituents, were also challenged by growing federal deficits. The need to finance and eradicate the national debt while circumventing the appearance of imposing an income tax, declared unconstitutional by the Supreme Court, was imperative. The direct result was an excise tax on corporate forms of businesses. An indirect result was the authorization for the Internal Revenue Service to audit corporate records with respect to enforcing compliance with the excise tax. The invasion into corporate records and accounting practices, which were until that time considered highly guarded secrets, was as traumatic to business as was the tax itself.

Section 38 of the Tariff Act of 1909 authorized a special excise tax on net incomes of domestic corporations, joint stock companies, associations organized for profit and having capital stock represented by shares, insurance companies, and foreign corporations operating in the United States or United States territories. The tax was 1 percent of net incomes in excess of $5,000 after allowing deductions for ordinary and necessary operating expenses, losses, depreciation charges, interest and taxes paid, and dividends received from organizations subject to this new tax. All taxable incomes

were assessed on a calendar-year basis, with tax returns due on March 1 of the following year.

Penalties were determined for fraud, failure to file, and late returns. Fraud carried a corporate penalty of 100 percent of the tax due and a fine with a minimum of $1,000 and a maximum of $10,000. Individuals responsible for fraud were subject to fines of up to $1,000, imprisonment of up to one year, or both. Failure to file a return carried a corporate penalty of 150 percent of the tax due and a fine with a minimum of $1,000 and a maximum of $10,000. Responsible individuals were subject to the same fines and imprisonment terms as set forth for fraud. Corporations were assessed a penalty of 5 percent of the tax due plus 1 percent interest, per month, of the tax due for late returns.

The period from the late 1800's to the early 1900's was one in which the United States experienced an economic transition from an agricultural society to an industrial society. This transition caused a population shift from the country to cities. Wealth became concentrated among the few fortunate enough to own businesses. The business climate was ripe for increases in wealth for going concerns, as business was favored by cheap immigrant labor and raw materials, an expanding market, and high protective tariffs against imports, such as those imposed by the Dingley Tariff Act of 1897. Andrew Carnegie, J. P. Morgan, and John D. Rockefeller reached their financial zeniths during this time period in the steel, banking, and railroad industries, among others.

The recessions of 1893 and 1907 also contributed to wealth concentration, as they allowed or encouraged large corporations to buy out smaller firms unable to weather the financial storms. For example, the Morgan family bought the Morse shipping interests, a competitor to the Morgan New Haven Railroad. Morgan's United States Steel Corporation bought the troubled Tennessee Coal, Iron and Railroad Company.

Monopolies or highly concentrated markets were formed as a result of this financial concentration. For example, 95 percent of the railroad track in the United States was owned by six investment groups by 1900. The Sherman Antitrust Act of 1890 was designed to defuse monopoly power by breaking large monopolies into smaller, diversely owned entities. The Sherman Act was loosely enforced by the government, however, and corporations often appeared to have more wealth and political power than did the government. Industrialists circumvented antitrust law by breaking up their consolidated corporations and creating holding companies, which evaded antitrust legislation but in substance were essentially the same form of entities.

On the labor side, the experiences of the 1880's and 1890's brought a maturity to organized labor, which became strong enough to begin challenging corporate sovereignty. The oppression of labor through low wages, poor working conditions, and long hours encouraged the formation of labor unions. The American Federation of Labor (AFL) grew to a membership of approximately half a million by 1898 and more than 1.6 million by 1906, accounting for more than three-fifths of all trade-union workers.

The unity of labor, demonstrated by strikes, caused industrialists to become conciliatory toward labor, and corporate concessions were made. For example, the United

Mine Workers of America (UMW) won an unprecedented victory in 1897 when the conditions of 100,000 striking mine workers were met, including a 20 percent pay increase, the eight-hour day, abolition of company stores, recognition of the union, and a provision for annual joint conferences with the mine operators. This newfound success encouraged labor to move toward a socialist philosophy, not to abolish capitalism but to share in corporate profits.

States also began exercising power over corporations by passing prolabor legislation in the early 1900's. Child protection laws were passed in all states, and many states passed laws to protect laborers, particularly women, from unsafe working conditions. Workers' compensation laws were passed in Maryland (1902), Montana (1909), Massachusetts (1909), and New York (1910). These laws were declared unconstitutional shortly thereafter but were constitutionally reinstated before 1920. Finally, the federal government saw the mood as right to challenge the power of corporate America.

The convergence of social, political, and legal sentiment against large corporations led to the Tariff Act of 1909. The act was sponsored by senators Sereno Elisha Payne and Nelson W. Aldrich. Aldrich was a particularly powerful senator who wished to mitigate or repeal certain tariffs contained in the Dingley Tariff Act of 1897 pertaining to favored special interest groups. To offset the revenue reductions, however, new taxes had to be imposed to meet the $100 million federal deficit. Opposed to an income tax, Aldrich included an inheritance tax in his act. A coalition of Republican Party dissidents demanded that an income tax be included. To prevent a split within the Republican Party, President William Howard Taft stepped in and worked out a compromise. The result was the Tariff Act of 1909, authorizing an excise tax on the privilege of operating corporate forms of business with the excise based on corporate net incomes.

Impact of Event

The immediate, and most significant, impact of the Tariff Act of 1909 was the intrusion of government into corporate financial affairs. Government had established an implicit control of corporations, at least in principle. The Internal Revenue Service was authorized to audit corporate records if it had reason to believe returns were incorrect or not filed as required. Authorization was also given to use the courts to force compliance.

Looking more like an income tax than an excise tax, the special tax was challenged in *Flint v. Stone Tracy Company* in 1911. It was affirmed by the Supreme Court as constitutional. The Court ruled that this tax was an indirect tax, not a direct tax, on individuals through stock ownership and therefore was not subject to apportionment according to the population. The Court expounded that there were distinct advantages to operating in the corporate form of entity and that Congress had the right to tax that privilege with an excise tax. The tax could be based on any component of the corporation that Congress saw fit, including its income.

The 1911 decision made it apparent that corporations had no further recourse. For

the first time in history, records of U.S. corporations were open to outside inspection. Laissez-faire no longer applied. Furthermore, the requirement to report corporate incomes on standardized government forms set in motion a standardization of accounting principles and an accountability to shareholders virtually nonexistent before.

Prior to 1909, corporate records were guarded closely by the few principal corporate owners. Most investment bankers and stockholders were uninformed regarding the financial position and operations of corporations. They relied on the reports of the principals, sometimes to their detriment. Moreover, investors were generally unsophisticated in financial matters and were therefore willing to accept the reports in blind faith. When investment bankers asked for audited financial statements, some corporations would refuse to sell securities through those individuals.

Reporting behavior changed as a result of the excise tax. It was not uncommon for corporations to keep two sets of records, one for tax reporting and one for reporting to stockholders and other users of financial statements. Lower, and probably more accurate, earnings were reported to the government. Despite this new accountability to the government, shareholders had no protection from securities fraud until the Securities Acts of 1933 and 1934.

Depreciation policy received greater attention as a result of the act because this was the only expense deductible against income that could be based on estimates rather than determined on a cash basis. Before the Tariff Act of 1909, no method of depreciation allocation was prescribed, and accordingly, a multitude of methods was used. For example, Standard Oil Company applied depreciation rates of 6 to 35 percent around 1905, depending on the equipment, but the rates were not necessarily applied in proportion to the normal lives of the assets. John D. Rockefeller, the company's principal owner, thought that the company assets were undervalued around the time of the Tariff Act. Consequently, the public records of Standard Oil show "depreciation restored." It is uncertain whether this short-lived practice was used to recapitalize asset values for later tax deductions. Although the Tariff Act of 1909 required no standard method of depreciation, later tariff acts narrowed the methods acceptable for reporting purposes.

The corporate excise tax became a corporate income tax in 1913 with the passage of the Sixteenth Amendment, which allowed for direct taxation not apportioned according to population. The difference between the income tax of 1913 and the excise tax before 1913 was in name only. The reporting requirements remained the same. As later tariff acts refined income and expense reporting requirements, tax planning became an important corporate management function. When the Securities Acts of 1933 and 1934 created the Securities and Exchange Commission to regulate the accounting of corporations that publicly traded securities, many of the accounting methods established by the tariff acts, such as depreciation methods and inventory costing methods, were adopted by the commission. The Tariff Act of 1909 thus formed a basis for generally accepted accounting principles to be used by publicly owned corporations.

Bibliography

Anderson, Donald F. *William Howard Taft: A Conservative's Conception of the Presidency.* Ithaca N.Y.: Cornell University Press, 1973. This book is devoted to all aspects of the presidency of Taft. Chapter 4 discusses the political bargaining used by Taft to secure passage of the Tariff Act, particularly the instrumental support gained from Speaker of the House Joseph Cannon and from Senator Nelson W. Aldrich, who opposed corporate income taxation.

Beth, Loren P. *The Development of the American Constitution: 1877-1917.* New York: Harper & Row, 1971. Provides insight into the political, economic, and social events surrounding constitutional reform in the late nineteenth and early twentieth centuries. Chapter 5 sheds light on the mood of the Supreme Court toward business in the areas of labor relations and taxation.

Carson, Gerald. *The Golden Egg.* Boston: Houghton Mifflin, 1977. Chronicles the political events surrounding and perpetuating income taxation. Primarily concerned with the income taxation of individuals, but chapters 4 through 7 provide insight into the politics leading to the corporate excise tax. Entertaining reading for those interested in political behavior.

Degler, Carl N. *Out of Our Past: The Forces That Shaped Modern America.* New York: Harper & Row, 1970. Presents a descriptive account of the beliefs, assumptions, and values that shaped America in the mid-nineteenth century. Provides indirect evidence of social forces influencing and leading to the Tariff Act, with accounts of attitudes and events during the late 1800's and early 1900's.

Faulkner, Harold U. *The Decline of Laissez Faire, 1897-1917.* New York: Rinehart, 1951. Provides a comprehensive history of economic, business, and technological progress during this period. Entire chapters are devoted to manufacturing, railroads, and agriculture. Illustrations and photographs.

_____. *The Quest for Social Justice, 1898-1914.* New York: Macmillan, 1931. Gives a history of social thought and attitudes around this time period. Dynamics of attitudes and practices of business and labor are expounded, with many examples. A good source for names, dates, and events.

Ratner, Sidney. *Taxation and Democracy in America.* New York: John Wiley, 1967. Probably the best in this bibliography for the social, political, and economic history of taxation in the United States up to World War II. Chapters 12 and 13 provide excellent coverage of the Tariff Act of 1909.

Seligman, Edwin. *The Income Tax: A Study of the History, Theory, and Practice of Income Taxation at Home and Abroad.* 2d ed. New York: Macmillan, 1914. More general in nature than the other citations, giving the reader a theoretical perspective on the history of taxation.

Paul A. Shoemaker

Cross-References

Delaware Begins Revising Laws for Incorporation (1903), p. 69; The United States

Establishes a Permanent Tariff Commission (1916), p. 297; Wartime Tax Laws Impose an Excess Profits Tax (1917), p. 319; U.S. Tax Laws Allow Accelerated Depreciation (1954), p. 1030; Value-Added Taxes Bring a More Efficient Tax System to Europe (1954), p. 1035; Congress Gives Tax Breaks to Financiers of Small Businesses (1958), p. 1107; The Kennedy-Johnson Tax Cuts Stimulate the U.S. Economy (1964), p. 1218.

THE CANADA CEMENT AFFAIR PROMPTS
LEGISLATIVE REFORM

Categories of event: Mergers and acquisitions; government and business
Time: October, 1909
Locale: Canada

The formation of the Canada Cement Company began the first great merger wave in the country and precipitated a financial and political scandal that reached its peak during the 1991 election

Principal personages:
> WILLIAM MAXWELL AITKEN (later LORD BEAVERBROOK, 1879-1964), the president of the Royal Securities Corporation and the chief promotor behind the Canada Cement merger
> SIR SANDFORD FLEMING (1827-1915), a director of the Canadian Pacific Railway; president and chief shareholder of the Western Canada Cement and Coal Company
> SIR EDWARD SEABORNE CLOUSTON (1849-1912), the general manager and vice president of the Bank of Montreal, Canada's largest and most powerful bank
> SIR WILFRID LAURIER (1841-1919), the prime minister of Canada, 1896-1911
> WILLIAM LYON MACKENZIE KING (1874-1950), Laurier's labor minister and author of the Combines Investigation Act
> SIR ROBERT LAIRD BORDEN (1854-1937), a Conservative leader who defeated Laurier in the 1911 election

Summary of Event

Consolidated in October, 1909, the Canada Cement Company was formed through one of the first of about forty major industrial mergers that swept the country during a four-year period. Its size and the alleged monopoly power it created made the merger the most publicized of the era. Canada Cement's promoter, William Maxwell Aitken (later Lord Beaverbrook), would be lionized in the establishment press as a financial wizard and pilloried in the populist press as a maker of trusts. Sentiment against Canada Cement and other mergers ran so high that Sir Wilfrid Laurier's government was pressured into passing an antitrust law targeting mergers. When the general public became aware of a business dispute between Aitken and Sir Sandford Fleming, a prominent and respected member of Canadian society, their struggle became part of the intense political campaign then being waged over a prospective free trade agreement between Canada and the United States.

As in the case of Great Britain's Associated Portland Cement Manufacturers merger in 1900, the origins of Canada Cement lay in the technological revolution sweeping

the portland cement industry at the turn of the century. Large rotary kilns fired by pulverized coal produced better and cheaper cement (and thus concrete), which was rapidly becoming the building material of choice throughout the advanced industrial world. This technological change, coupled with the unparalleled economic growth experienced by Canada during the first decade of the twentieth century, resulted in the establishment of dozens of new portland cement plants throughout the country to supply the booming construction industry.

This new mass production technology, however, created a glut of cement during the industrial downturn that followed the financial panic of 1907. Operations that were just coming on stream in 1908 were hardest hit. One of these companies, the Western Canada Cement and Coal Company, with its plant at Exshaw, Alberta, found that the only way to prevent bankruptcy was to dilute its debt in a merger with a number of other, more solvent, cement companies. After consulting with Sir Edward Seaborne Clouston, the general manager and vice president of the Bank of Montreal, Canada's largest and most powerful financial institution, Western Canada Cement's board members called upon Max Aitken, a young Montreal investment banker, to lead the merger syndicate. Clouston, whose own bank was owed hundreds of thousands of dollars by Western Canada Cement, believed that Aitken was the man to properly execute the merger and thereby protect the Bank of Montreal's interest. He thought so highly of Aitken that he had been a regular member of Aitken's underwriting syndicates and had become a shareholder in Aitken's investment bank, the Royal Securities Corporation.

Aitken started work on the merger negotiations in April, 1909, and by the summer he had convinced the owners of every modern plant in the country, as well as some older but larger cement producers, to join his consolidation. He hoped that the resulting company would be able to eliminate overproduction and prevent the price of cement from falling any further. Although the chief shareholders of the companies joining the merger were enthusiastic supporters of Aitken's strategy, some were forced to accept less than what they thought their companies were worth. Aitken was particularly hard on Sir Sandford Fleming, the president of two companies entering the merger, who not only had to accept less for his International Portland Cement Company shares but also had to reduce the debt load carried by his Western Canada Cement Company before it would be allowed to join the merger. This reorganization proved difficult and, by the time of Aitken's deadline of February, 1910, Western Canada Cement found that the majority of its bondholders in Great Britain were unwilling to reduce the value of their securities. At this point, Fleming began to pressure Canada Cement into accepting his plant on easier terms.

As honorary president and one of the original incorporators of the newly merged company, Fleming should have been in a strong position to extract some concession from Canada Cement, but Aitken, working behind the scenes with other Canada Cement directors and his own lawyers, argued against this course of action. Facing an unexpected wall of opposition, Fleming tried to pressure his fellow directors into settling with Western Canada Cement by alleging that Canada Cement had overissued

$12 million worth of securities to Aitken as remuneration for his promoting services. Fleming threatened to go public with his allegations.

In an effort to prevent the damage that such bad publicity would inflict on Canada Cement, the company's board gave Fleming more time to reorganize Western Canada Cement's debts and agreed to order an investigation into Aitken's promotion of the company, allowing Fleming's lawyer to act as one of the two investigators. Their report, submitted in July, 1910, revealed that Canada Cement had not been "robbed" by Aitken, as Fleming had alleged. Fleming did not accept the report, however; nor did he attempt to write down Western Canada Cement's debt in order to meet his new deadline. Instead, he presented a proposal to Western Canada Cement's English bondholders to allow him to reorganize the company and run it as a rival to the new merger. Meanwhile, Aitken, who had just moved to London, met directly with the bondholders and convinced them that they would be better off selling their interest in Fleming's company at a discount to Canada Cement. The sale took place in January, 1911, forcing the liquidation of Western Canada Cement and its transfer to Canada Cement for the bargain price of less than $1.5 million.

Fleming vowed revenge, as the sale had left him out in the cold. He sent out a circular criticizing the actions of both Aitken and Canada Cement and publicly resigned from his position as honorary president of the company. He then petitioned the prime minister of Canada, demanding a government inquiry into the affair. Prime Minister Laurier met with Fleming but stalled on ordering an inquiry because of the presence of influential members of his own party on the Canada Cement board.

The Bank of Montreal had also lost money on the Western Canada Cement sale. Determined to recoup at least a portion of the bank's debt, Sir Edward Clouston sued Fleming and members of his family on the basis of personal guarantees they had given the bank for loans to Western Canada Cement. Clouston's position in the lawsuit was complicated, however, by his involvement as an underwriter and part owner of the investment bank promoting Canada Cement as well as by his role in bringing two other Bank of Montreal officers into the promotional syndicate. If this conflict of interest were revealed, the Bank of Montreal's reputation as a pillar of financial respectability would be destroyed in a scandal sure to rock the normally sedate and conservative business establishment.

Impact of Event

Fleming's allegations set off a storm of popular protest against mergers and monopolies in general, and Canada Cement and Aitken in particular. Populists and other opponents of big business and finance came out in favor of Sir Wilfrid Laurier's proposed reciprocal free trade agreement between the United States and Canada. They had pressured his Liberal government into acting against trusts the previous year, when Laurier had called upon Minister of Labour William Lyon Mackenzie King to design a piece of legislation that could be used against mergers. King's response was the Combines Investigation Act, a complex antitrust law that used publicity as its main sanction against monopoly behavior. Weaker than American antitrust laws, however,

King's legislation did not satisfy the populists who wanted to see Canada Cement prosecuted in the same way that the U.S. government had prosecuted the Standard Oil trust.

In the summer of 1910, Laurier visited western Canada, where he was met by a wave of populist and antimonopoly sentiment. King's antitrust legislation had not satisfied Laurier's western constituents. Since the populists viewed the tariff as the chief cause of trusts, Laurier began secret negotiations with the United States to lower some of the Canadian tariffs preventing American exports to Canada. Ironically, at the same time, farm activists organized a protest in which hundreds of their representatives traveled east by train and then swarmed into the House of Commons in what they would call the "Siege of Ottawa." For one day, Laurier was forced to listen to petition after petition about the evils of the "eastern trusts." He did not reveal that the tariff negotiations were going better than expected.

To his surprise, Laurier found the United States eager to negotiate a comprehensive free trade agreement with Canada. To protect Canadian manufacturers and his political support in central Canada, however, Laurier restricted the agreement to predominantly natural goods. When this proposal, known as the reciprocity agreement, was presented in Parliament in January, 1911, Laurier thought he had a perfect deal. The removal of dozens of tariffs would dampen the antimonopoly sentiment of the western populists, while the exemption of manufactured goods would satisfy the manufacturers of central and eastern Canada.

Laurier soon found, however, that most Canadian businesspeople opposed the proposed trade deal. The Canadian Manufacturers Association in particular feared that an agreement on natural goods would be the thin edge of the wedge and that they eventually would be subjected to manufactured goods streaming north as a result of a comprehensive free trade agreement between the two countries. These sentiments were heartily supported by Conservative Party leader Robert Laird Borden, who led a crusade against the reciprocity agreement, and Max Aitken, who had opposed the dismantling of the Canadian tariff since 1909 by publishing antireciprocity and anti-American propaganda in his weekly magazine, *Canadian Century*. Aitken threatened to enter the political fray by becoming one of Borden's chief election managers, much to Laurier's chagrin.

In December of 1910, Aitken had been elected a Unionist (pro-Imperialist) member of Great Britain's Parliament, but he continued to keep in touch with Borden. In April, 1911, Borden wrote to Aitken telling him that an election on reciprocity was imminent and that he expected Aitken to return to Canada and help him defeat Laurier by organizing the Conservative campaign in Nova Scotia and New Brunswick.

To prevent Aitken from returning, Laurier gave the impression that he might order the public inquiry into Canada Cement that Sir Sandford Fleming demanded. Aitken himself wanted to explain his side of the story in public to defend his own reputation, but many of his business associates, some closely connected to Clouston and the Bank of Montreal, urged him not to do so. They reached a compromise in which Aitken would remain in Great Britain on the condition that Laurier would agree to prevent a

government inquiry into the Canada Cement affair. They urged Aitken to accept the deal, arguing that the press campaign being waged against him would last only a few days and never do permanent harm to his reputation. Aitken reluctantly agreed, mainly to protect Clouston, to whom he felt great loyalty for past support.

As a consequence, the nature of Canadian finance capitalism in general and Max Aitken's activities in particular were never subjected to government investigation. Nevertheless, newspaper coverage of the affair permanently scarred Aitken's reputation. Aitken would never be able to dispel the prevalent image of himself as a crook, despite the fact that he had not taken even one-fifth of what Fleming alleged as his profit for promoting Canada Cement. Clouston, along with the two Bank of Montreal officers involved in the Canada Cement promotion, resigned and devoted more of their time and energy to their investments in the Royal Securities Corporation. Clouston died of a heart attack in the offices of the Royal Securities Corporation the following year, while talking to Arthur Doble, his old executive secretary at the bank and now general manager of Royal Securities in Canada.

Despite Laurier's best efforts, he lost the election of September, 1911, to the Conservative Party under Borden. As a result of reciprocity's defeat, free trade between Canada and the United States remained a political impossibility until 1988. During the interwar years, the polarization and western alienation evident during the merger wave of 1909-1913 resulted in new forces of opposition to the "eastern" monopolies and financiers. These forces included western political parties, such as the Progressive Party, the Cooperative Commonwealth Federation (CCF), and the Social Credit Party, that would challenge the hegemony of the established parties. Throughout it all, the Canada Cement affair remained the central focus of popular criticism against the Canadian business and financial establishment.

Bibliography

Bliss, Michael. *Northern Enterprise: Five Centuries of Canadian Business*. Toronto: McClelland and Stewart, 1987. This survey of the history of Canadian enterprise puts the first Canadian merger movement into historical perspective and briefly deals with Max Aitken and the Royal Securities Corporation.

Chisholm, Anne, and Michael Davie. *Beaverbrook: A Life*. London: Hutchinson, 1992. The most objective and well-written biography of Beaverbrook to date, providing a brief summary of his Canadian financial career and a sixteen-page appendix on the Canada Cement affair.

Creighton, Donald. *A History of Canada*. Boston: Houghton Mifflin, 1958. A lengthy history of Canada that focuses on significant events. Useful for context and a broader understanding of Canadian history.

Lamoreaux, Naomi R. *The Great Merger Movement in American Business, 1895-1904*. New York: Cambridge University Press, 1985. Although the Canada merger movement and Canada Cement are not the subject of this book, Lamoreaux provides a good example of how capital-intensive production processes and rapid growth around the turn of the century resulted in overproduction and declining

prices, helping to create the first great merger wave in the United States.
Naylor, R. T. *The History of Canadian Business, 1867-1914.* 2 vols. Toronto: J. Lorimer, 1975. Takes a largely negative view of Max Aitken, Canada Cement, and the impact of the merger movement on Canadian business and society.

Gregory P. Marchildon

Cross-References

Cement Manufacturers Agree to Cooperate on Pricing (1902), p. 35; A Financial Panic Results from a Run on the Knickerbocker Trust (1907), p. 134; The Supreme Court Decides to Break Up Standard Oil (1911), p. 206; The United States Establishes a Permanent Tariff Commission (1916), p. 297; Canada Passes Tariffs to Ease the Great Depression (1930), p. 597; Canada Seeks Preferential Trade Status from Great Britain (1932), p. 624; The North American Free Trade Agreement Goes into Effect (1994), p. 2072.

THE FIRST MORRIS PLAN BANK OPENS

Category of event: Finance
Time: April 5, 1910
Locale: Norfolk, Virginia

By fulfilling a need of wage earners for small loans at a reasonable rate of interest, Morris Plan banks democratized the banking industry

Principal personages:
ARTHUR J. MORRIS (1881-1973), an attorney, originator of Morris Plan banks
FERGUS REID (1862-1941), a Norfolk cotton merchant and financier; an early supporter of the Morris Plan instrumental in obtaining financial support
ELGIN R. L. GOULD (1860-1915), the president of City and Suburban Homes Company of New York and first president of Industrial Finance Corporation

Summary of Event

On April 5, 1910, the first Morris Plan bank, the Fidelity Savings and Trust Company, was opened in Norfolk, Virginia, with $20,000 in capital. Its modest quarters on the sixth floor of an office building were the law offices of its founder, Arthur J. Morris, an enterprising attorney in his late twenties. As a member of the law firm of Morris, Garnett, and Cotten of Norfolk, Morris specialized in banking and corporate law. Morris was well acquainted with the bankers of the area and was surprised to learn, when asked by a railroad employee for help in securing a personal loan to pay for surgery required for his wife, that no bank was interested in making such a loan. This was despite the fact that the employee was steadily employed, earning a good salary, and would now be considered an excellent credit risk. Morris got the loan for the railroad employee by agreeing to be a surety on the loan. Other requests for assistance followed. Within two years, Morris personally had guaranteed forty-two loans for a total of $26,000. These experiences inspired Morris to investigate the lending sources available to wage earners who lacked the necessary collateral to secure loans.

After extensive investigation, Morris found that 80 percent of the American people had no access to bank credit. Other than a few charitable organizations that would make small loans to "worthy" individuals, the sources of small loans for wage earners were almost exclusively limited to family and friends, pawnbrokers, or loan sharks. Commercial banks covered the borrowing needs only of businesspeople and some affluent depositors. Having determined that there was a demand for unsecured small loans from banks or other mainstream lending institutions, Morris began to study how the demands for such loans could be met. He found that several European countries

already had a solution. In Germany, several hundred banks known as *Schulze-Delitzsch* were in operation. These banks served industrial and agricultural workers by making small loans and accepting small deposits. Similar banks were thriving in Austria-Hungary, Belgium, France, and especially Italy, where the equivalent of millions of dollars was loaned annually by the "People's Bank."

After spending some time in Europe investigating the operation of these small-loan banks, Morris returned to the United States and attempted to interest his banker friends in the personal loan plan he had formulated, later to be known as the Morris Plan. Unable to convince bankers of the feasibility of his plan, he turned to the general business community. He secured the support of several prominent Norfolk citizens who lent their financial and moral support to the incorporation of the Fidelity Savings and Trust Company, the first Morris Plan bank.

A typical Morris Plan loan required two cosigners. It was discounted at the rate of 6 percent, and an additional 2 percent loan fee was charged. Thus on a loan of $100 the borrower would sign a note for $100 but receive only $92. The sum of $100 would be repaid in weekly installments of two dollars each over a period of fifty weeks. Instead of repaying the loan directly, however, the borrower would be making installment payments on an investment certificate. When the payments on an investment certificate equaled the amount of the loan, the loan could be canceled or a new loan made, at the option of the borrower. Another method of lending was to sell an investment certificate in a given amount on the installation plan. The investment certificate, when issued, paid interest at a higher rate than passbook savings in a conventional bank. The proceeds from the sale of these certificates helped to finance the lending activity. Holders of these certificates could obtain loans without cosigners by pledging the certificates as collateral. In both cases, a penalty of 5 percent per week was charged for delinquent payments.

These cumbersome loan arrangements were necessary to circumvent the usury laws in most states, which limited the amount of interest that could be charged, typically at 6 or 8 percent per annum. Although the nominal (stated) rate on a Morris Plan loan was 6 percent, the effective rate (actually charged) on outstanding balances was about 19 percent. The reason is that the debtor did not receive the full face amount of the loan, since it was discounted. Furthermore, the debtor did not have the use of the money for the full term of the loan, since it had to be paid back in weekly installments. Although the spirit of the usury law was violated, the Morris Plan made small loans available to the average person at a charge that was reasonable considering the administrative costs involved in handling small installment payments.

Credit insurance was also pioneered by Arthur J. Morris and the Morris Plan banks. In 1917, the Morris Plan Insurance Society was established. During the next two decades, credit insurance developed into its present form, promising repayment of a loan should the borrower became unable to make payments. Credit insurance appealed to borrowers, as it protected the cosigners in the event of the borrower's death. The lender was also given additional protection by the insurance.

The Morris Plan soon became part of a chain operation through the establishment

of Morris Plan companies in Baltimore and Atlanta. By 1912, additional offices were opened in Washington, D.C., Memphis, and Richmond. The average amount per loan was $123.50, and credit losses amounted to less than .1 percent. In less than 2 percent of the loans did cosigners have to make a payment.

Morris interested Wall Street in his idea through a friend, Fergus Reid, a prominent Norfolk financier. In February, 1914, the Industrial Finance Corporation was formed. This corporation acquired all the assets of Fidelity Savings and Trust Company together with controlling interest in fourteen Morris Plan offices located throughout the United States. Eglin R. L. Gould became the first president of the Industrial Finance Corporation, which included among the members of its first board of directors such notables as Andrew Carnegie, Julius Rosenwald, Vincent Astor, and Nicholas Murray Butler. In furnishing the capital and moral support for the corporation, their motive was primarily philanthropic: to provide people of limited finances the means to obtain small loans without pledging collateral or resorting to loan sharks. Fearing that their philanthropic motives would be questioned if the corporation was run as a purely business venture, control of the corporation was allowed to pass to the Morris group of investors. Gould and the other philanthropists quietly withdrew from the board of directors.

The Morris Plan Corporation of America was incorporated in 1925 as a holding company for Morris Plan institutions. By 1937, the number of Morris Plan companies had increased to 121. More than $4.5 billion had been loaned to more than twenty million Americans. The number of bad loans was still less than .1 percent. In 1956, the Morris Plan Corporation of America changed its name to Finance General Corporation. The Morris Plan was operational until the 1960's, when rising interest rates together with changing banking and small-loan laws made it obsolete.

Impact of Event

Arthur J. Morris, through his Morris Plan concept, made it possible for the average wage earner to borrow money on the basis of steady income and good character, without having to pledge collateral or pay an exorbitant rate of interest. The availability of small loans through the Morris plan deprived many loan sharks of their prey. It was reported that in the city of St. Louis the establishment of a Morris Plan bank drove fifteen loan sharks out of business within a period of less than a year. This effect was foretold in a study made by the Russell Sage Foundation in 1907 and 1908 of small-loan conditions and practices. The study concluded that the most effective way of combating abuses in the small-loan business would be to attract reputable lenders. This could be done by making the small-loan business profitable. Abuses were to be avoided by strict state licensing requirements and regulation.

Complicating the spread of Morris Plan companies was the lack of uniformity in state laws. In 1916, the Russell Sage Foundation, in cooperation with a money-lending group, drafted what has become known as the Uniform Small Loan Law. Under this law as enacted in many states, a Morris Plan company had the option of incorporating as a small-loan company. Thus in some states, Morris Plan companies

were incorporated voluntarily as loan companies rather than as banks. In some other states, they were required to incorporate as loan companies rather than as banks in order to make loans under the Morris Plan.

Paralleling the spread of the Morris Plan bank, or industrial bank as it was generically termed, was the spread of credit unions. The first credit union in the United States was formed in 1909 in New Hampshire. Within a few years, more than one hundred credit unions were operating in six states. Morris Plan banks and credit unions performed the same functions of making small loans to those of limited means and accepting savings deposits. Credit unions, however, are cooperative associations, and their services are restricted to members of the affiliated group.

During the 1920's, strong competition developed from the growth of finance companies, which made small loans and financed consumer purchases of automobiles, home appliances, and other household goods. Morris Plan companies pioneered in the field in automobile financing in 1919 with an arrangement with the Studebaker Corporation. During the 1930's, the Morris Plan companies charged ahead in the consumer finance field. The percentage of unsecured personal loans dropped from 87 percent of the companies' loan portfolios in 1932 to 60 percent in 1936.

Most commercial banks had looked askance at the small-loan business, but the lean Depression years of the 1930's, coupled with the low returns on government securities, caused commercial banks to open commercial loan departments. In 1935, the Bank of America, which had pioneered in offering low-cost loans since its founding in 1904, announced its willingness to finance automobiles. By 1940, commercial banks held fifteen times more consumer credit than they had in 1930.

When Morris Plan banks were initiated in 1910, few wage earners could obtain loans from commercial banks; by the end of the twentieth century, few wage earners would be refused a loan. Arthur J. Morris always stressed that the industrial supremacy of the United States depended on mass production, and for mass production, there must be mass consumption. Mass consumption could only come about through mass credit. Morris made consumer credit his life's work, as he saw credit as the lever for realization of human hope. His efforts brought on the forces that democratized credit and the banking industry.

Bibliography

Cole, Robert H. *Consumer and Commercial Credit Management*. Homewood, Ill.: Richard D. Irwin, 1980. A comprehensive textbook of consumer and business credit. Useful in understanding the development of consumer credit and changing attitudes of consumers, retailers, and lenders.

Grant, James. *Money of the Mind: Borrowing and Lending in America from the Civil War to Michael Milken*. New York: Farrar, Straus, Giroux, 1992. A Wall Street analyst with street sense traces the long cycle of relaxation of credit practices that brought about the democratization of credit and the socialization of credit risk. Must reading for anyone who wants to probe the inner mysteries of money, credit, and banking.

Harold, Gilbert. "Industrial Banks." *Annals of the American Academy of Political and Social Science* 196 (March, 1938): 142-148. A concise treatise on Morris Plan institutions, referred to generically as industrial banks. Although quite short, the article is perhaps the most particular and definitive treatment of the subject matter of industrial banking accessible at most college and public libraries.

Klebaner, Benjamin J. *American Commercial Banking.* Evolution of American Business Series 5. Boston: Twayne, 1990. Traces the evolution of commercial banking in the United States. The historical perspective greatly assists an understanding of the contemporary scene.

Mayer, Martin. *The Bankers.* New York: Weybright and Talley, 1974. Interesting journey into the world of banking by a best-selling author of similar books about law, Wall Street, and Madison Avenue. The dynamic writing makes this book on banking read like an adventure story.

Gilbert T. Cave

Cross-References

The Federal Reserve Act Creates a U.S. Central Bank (1913), p. 240; The Banking Act of 1933 Reorganizes the American Banking System (1933), p. 656; Congress Passes the Federal Credit Union Act (1934), p. 690; The Negotiable Certificate of Deposit Is Introduced (1961), p. 1159; Congress Deregulates Banks and Savings and Loans (1980-1982), p. 1757.

HASHIMOTO FORMS THE ROOTS OF NISSAN MOTOR COMPANY

Category of event: Foundings and dissolutions
Time: 1911
Locale: Japan

Nissan, one of the oldest Japanese automobile companies, had its roots in a company formed in 1911 and became one of Japan's and the world's leading automobile manufacturers

Principal personages:
MASUJIRO HASHIMOTO, a machinist who in 1911 founded Kwaishinsha Motor Car Works
YOSHISUKE AIKAWA (1880-1967), the founder of Tobata Casting Company, a component of what became Nissan Motor Company
KATSUJI KAWAMATA (1905), the chief executive officer of Nissan in the 1950's

Summary of Event

Before World War II, the Japanese automobile industry was quite small. Most of the country's few cars had been produced from kits sent from the United States and the United Kingdom. A handful of Japanese companies in the early twentieth century had attempted to produce low-priced vehicles, but these were far outnumbered by the rickshaws and carts that were the main means of transportation. In 1924, for example, when American companies produced 3.1 million cars and U.S automobile registrations totaled almost 18 million, Japanese passenger car registrations came to 17,939, while there were 105,000 registered rickshaws, 3.7 million bicycles, and 374,200 ox- and horse-drawn wagons. In those years, military contracts for trucks accounted for most motorized vehicle sales.

Masujiro Hashimoto was one of the handful of mechanics who attempted to enter the automotive manufacturing field. He traveled to the United States in 1902 to study the manufacture of internal combustion engines and returned home in 1911 to found the Kwaishinsha Motor Car Works. His new company manufactured a twelve-horse power engine that powered a small passenger car. For the car's name, he used "DAT," the first letters of the surnames of three associates, Den, Aoyama, and Takeuchi. He then added "son" to the car's name, but since the sound "son" in Japanese is similar to that of "bankruptcy," he changed the name to Datsun.

The hand-crafted Datsuns were well received, which in this period meant that Hashimoto was able to sell between ten and twenty of them each year. The company's factory was destroyed in a 1923 earthquake, forcing it to merge in 1926 with Jidosha Seizo Company Ltd. in order to survive.

In 1932, the company was renamed DAT Jidosha Seizo. It came out with a car with

a 500 cubic centimeter engine. Although the company was still small by American standards, it was one of the larger Japanese auto firms of the period. In 1932, the entire Japanese industry turned out 880 units, none of which were exported.

Most of the Japanese companies manufactured cars by imitating American and European models. Tokyo Gas and Electric, a manufacturer of home appliances, and Mitsubishi Shipbuilding, part of the Mitsubishi *zaibatsu* (industrial group), produced some trucks for the Army. For the most part, however, the *zaibatsus* showed little interest in motor vehicles. The military distrusted the *zaibatsus* and preferred to buy supplies elsewhere. The Mitsui Bank, part of the Mitsui *zaibatsu*, financed the Ishikawajima Shipbuilding Company's foray into automobiles in 1919.

Yoshisuke Aikawa, who had been graduated from the Tokyo Imperial University in 1904 and then went to the United States to study manufacturing, formed the Tobata Casting Company in 1910. It became a major supplier of parts for several companies within the automobile industry. Although he agreed with the prevailing opinion that military requirements would shape the industry in the short run, he believed that in time the Japanese people would take to passenger cars. Aikawa organized a corporate shell that he called Motor Vehicle Industries, which then approached DAT with a takeover bid. DAT, which in 1931 produced ten vehicles, was receptive. Tobata and another of Aikawa's companies, Nippon Industries, purchased DAT in 1932, then acquired the automobile operations of Ishikawajima. In 1933, Tobata and Nippon spun off the motor vehicle unit into a new company, which Aikawa named the Nissan Motor Company. Most histories list this year as the one in which Nissan was founded, but as can be seen, its origins are complex.

Impact of Event

Nissan and Toyota dominated the small Japanese automobile industry before and during World War II. Nissan's growth resulted in large part from an arrangement with Graham-Paige, an American firm that provided it with technical assistance and machinery as well as helping it to create a modern automobile factory. In 1941, total Japanese automobile production came to 46,648 vehicles, of which 19,688 came from Nissan and 14,611 from Toyota.

Nissan made other overtures to companies based in the United States. In 1939, Aikawa proposed a joint venture with General Motors Japan that was rejected. He then approached Ford Motors Japan, suggesting a merger of Nissan into Ford. This offer also was declined.

The same year, Nissan's automobile production was shifted to Manchuria, and the firm was renamed Manchurian Motor Company. The parent company, which became Nissan Heavy Industries, turned out aircraft engines and other military products. When the war ended, Manchurian Motor Company was seized by the Soviet Union and the Japanese parent was taken over by American occupiers.

After the war, Nissan and Toyota petitioned General Douglas MacArthur for permission to resume production, which was granted with some restrictions. In 1946, Nissan turned out a few trucks, with passenger cars following in 1948. In 1949, the

company once again took the name Nissan Motor Company.

In the late 1940's, most of Japan's cars still were imported from the United States. In 1948, Japanese companies produced 28,700 four-wheeled vehicles, of which 381 were passenger cars. All restrictions on the industry were removed the following year, when Japan manufactured 1,070 passenger cars.

During the Korean War, Japanese industry received massive stimulation from American orders for trucks. During the first nine months of 1951, Nissan sold 4,325 cars and trucks to the American military. A wealthier Japanese population also started buying cars and trucks.

In 1952, Nissan formed a partnership with Great Britain's Austin Motors, under which it would manufacture Austins in Japan. By mid-decade, Nissan had become Japan's leading automobile manufacturer. Its leader, Katsuji Kawamata, embarked upon a major expansion effort.

In 1958, 50,600 Japanese cars were produced, most by Nissan and Toyota, and in the following year, 78,598 were turned out. Even then, sales of small, inexpensive, three-wheeled vehicles approximately doubled those of cars.

Nissan and Toyota decided to test the American market, believing that the domestic market for passenger cars was saturated. They received no encouragement from the government, which saw the United States as a reliable source for inexpensive, well-made cars. With this source available, the government saw no need to develop a large domestic industry.

Nissan sponsored two studies of the American market. As a result of them, it came to several conclusions. Americans would not buy cars backed by weak service organizations; no Japanese car could compete with the popular Volkswagen Beetle, which by then was solidly entrenched; there was a sizable potential market for small, well-constructed, inexpensive imported cars; and in order to convince American drivers that Japanese cars were quality products, extended warranties would have to be offered.

The key figure in the Japanese incursion into the American market was Yutaka Katayama, who had started his career at Nissan in advertising. Katayama had visited the United States several times and had a keen knowledge of promotion. His plan was to select franchisees with great care and not to start operations until sufficient parts and trained personnel were in place to guarantee superior service. Sales outlets would be selected on the East and West Coasts, where Volkswagen had blazed the way and where foreign cars were popular. For the time being, Katayama would bypass the South and Midwest. Woolverton Motors of North Hollywood was the West Coast dealer, and Luby Chevrolet of New York had the East Coast.

In 1957, Nissan sent one of its small sedans, the Cedric, to the Los Angeles Automobile Show, where it met with indifference. The Cedric was the company's top-of-the-line model, but it was unsuited to American roads and stodgy in design. The following year, Americans purchased 83 Cedrics. Sales for 1959 came to 1,131. Encouraged, Nissan organized Nissan Motor Corporation U.S.A. and planned for many more franchisees. Sales rose for a while but then declined. Nissan, along with

Toyota, which had the same experience with its Toyopet, withdrew to study the situation.

Late in 1959, the company exported the Datsun 200 series to the United States to an indifferent reception. The following year it sent the 310 series, led by the Bluebird, which might be considered the first Japanese car with meaningful appeal. Even so, sales were hardly spectacular. In 1962, Nissan and Toyota sold fewer than three thousand cars between them in the American market. That year, Volkswagen sold 240,143 cars in the United States, and even Jaguar sold 4,442 cars in America.

Nissan soon accomplished its goal of creating and marketing what was, to all intents and purposes, a small American car. Datsun dealerships sprouted throughout the country, numbering 640 by the end of the 1970's. Datsuns seemed to combine aspects of the Beetle and the Chevrolet, and in so doing they obtained an increasing share of the market.

Nissan displayed a sensitivity to the American market that European companies, Volkswagen included, lacked. The company produced a wide range of cars for Japanese customers, ranging from minis to luxurious limousines, but in the 1970's sent to the United States only a handful of low-priced and intermediate models, finding a niche and not moving out of it until its position was solid. In the mid-1960's, the mid-range Bluebird, priced between the Chevrolet and the Volkswagen, was a major seller. As American tastes shifted to compact cars, Nissan sent the lower-priced PL 600 series, which proved even more popular. Flexibility in planning, integrity in manufacturing, excellence in service, and shrewdness in marketing were hallmarks at Nissan.

Almost 19,000 Datsuns were sold in 1965, placing the company sixth in terms of American imports, ahead of Simca and Renault but behind Volkswagen and Volvo. A veritable Japanese car mania then developed among buyers. In 1970, 703,672 Japanese cars were sold in the United States. Toyota provided 184,898 of them, second in import sales behind Volkswagen. Nissan was in third place, selling 100,541 Datsuns.

It appeared that sales had reached a plateau. This was a result of several factors, one of the more important being the growing strength of the yen, which caused prices of Japanese imports to rise. By 1972, the Datsun 1200 sold for $1,976, against $1,960 for the Ford Pinto.

In 1973, the world was struck by the soaring price of oil. Gasoline rose sharply in price and for a while was hard to come by. Large American "gas guzzlers" lost popularity, while fuel-efficient Japanese cars were in demand. This situation ended with the easing of the gasoline supply. Datsun sold 319,000 cars in America in 1973; the 1974 figure was 245,000.

As Americans became accustomed to paying more for Japanese cars than for American, sales rose again, hitting 488,217 in 1977. American customers gave Japanese cars high marks for reliability, justifying the higher prices. By then, Nissan was the world's third largest car manufacturer, behind General Motors and Toyota but ahead of Ford and Chrysler. Toyota was ahead of Volkswagen in the American market, while Nissan was neck-to-neck with the fading German company.

In the late 1970's, Nissan successfully entered the higher end of the American automobile market. In 1978, it exported the 810, soon to be renamed the Maxima. The Maxima and Toyota's similarly targeted Cressida did poorly at first, as Americans accustomed to seeing Japanese cars compete with Chevrolets and Fords had to be convinced that these models were the equals of Buicks and Chryslers. In the 1980's, however, the cars proved to be successful, and more luxury models appeared.

In 1982, Nissan made two significant announcements. It would faze out the Datsun nameplate and market cars as Nissans, this being done to harmonize world strategies. More concretely, it intended to assemble trucks at a $320 million facility to be erected in Smyrna, Tennessee. Later, cars would be produced there. By the early 1990's Nissans from Smyrna were close to qualifying as domestic cars and so were not covered by quota arrangements worked out by the Japanese and American governments. Toyota and Honda followed a similar strategy with their Camrys and Accords.

Nissan also obtained a European foothold, through the purchase of an equity interest in Motor Iberica, a Spanish manufacturer of trucks, vans, and buses. Nissan also formed an alliance with Alfa Romeo, an Italian specialty car manufacturer, to build small cars at an Alfa Romeo plant. Nissan also conducted negotiations for a similar arrangement with Volkswagen. Eighty years after its beginnings, the company was poised to succeed throughout the world marketplace.

Bibliography

Chang, C. S. *The Japanese Auto Industry and the U.S. Market*. New York: Praeger, 1981. A short work that appears to have had its origins as a Ph.D. dissertation. Good for the early history of Nissan.

Cole, Robert E., ed. *The Japanese Automotive Industry: Model and Challenge for the Future?*. Ann Arbor: Center for Japanese Studies, University of Michigan Press, 1981. Several of the essays in this collection deal with Nissan's history.

Duncan, William. *U.S.-Japan Automobile Diplomacy: A Study in Economic Confrontation*. Cambridge, Mass.: Ballinger, 1973. This short work deals with attempts on the part of American manufacturers to limit Japanese access to the domestic market.

Rae, John. *Nissan/Datsun: A History of Nissan Motor Corporation in U.S.A., 1960-1980*. New York: McGraw-Hill, 1982. Written with company cooperation, this work contains a short history of the parent company but concentrates on Nissan in the American market.

Sobel, Robert. *Car Wars: The Untold Story*. New York: Dutton, 1984. Contains several chapters on Japanese automobile history but concentrates on Japanese success in the American market.

United States Strategic Bombing Survey. Military Supplies Division. *Japanese Motor Vehicle Industry*. Washington, D.C.: Government Printing Office, 1946. An excellent study of the pre-World War II Japanese automobile industry.

Robert Sobel

Cross-References

Ford Implements Assembly Line Production (1913), p. 234; Studebaker Announces Plans to Abandon U.S. Auto Production (1963), p. 1190; Ford Introduces the Mustang (1964), p. 1224; Volkswagen Opens the First Foreign-Owned U.S. Auto Plant (1978), p. 1664; Japan Becomes the World's Largest Automobile Producer (1980), p. 1751; Yugo Begins Selling Cars in the United States (1985), p.1898.

THE TRIANGLE SHIRTWAIST FACTORY FIRE
PROMPTS LABOR REFORMS

Category of event: Labor
Time: March 25, 1911
Locale: New York, New York

Public outrage following the Triangle Shirtwaist Factory fire led to immediate fire safety legislation and reform demonstrations, but substantial labor reform did not come until years later

Principal personages:

ROSE SCHNEIDERMAN (1882-1972), an influential member and later president of the Women's Trade Union League

ALFRED E. SMITH (1873-1944), a New York State legislator who conducted investigations and made recommendations for fire safety legislation

ROBERT WAGNER (1877-1953), a New York State senator who conducted investigations

MAX BLANCK, a co-owner of the Triangle Shirtwaist Factory

ISSAC HARRIS, a co-owner of the Triangle Shirtwaist Factory

Summary of Event

Prior to the Triangle Shirtwaist Factory fire of 1911, garment workers had begun to organize and make known their desires for reform. In 1900, the International Ladies Garment Workers Union (ILGWU) was formed. In 1903, the Women's Trade Union League (WTUL) was established for the purpose of bringing more women into the trade unions. The Triangle Shirtwaist Factory was the site of one of the first demonstrations, a 1909 event that grew into a general strike of garment workers known as the "Uprising of the 20,000." The Triangle workers were locked out during that strike but were encouraged by the ILGWU and the WTUL to picket. Factory owners Max Blanck and Issac Harris hired replacement workers and called in thugs to break the pickets. Throughout the year-long series of strikes that followed, other factories agreed to various reforms. Although not meeting all demands, most shirtwaist makers agreed to shorter hours, collective bargaining, and safety improvements. The Triangle Shirt-waist Factory, however, retained its fifty-nine-hour workweek and refused to make safety improvements.

Like many other plants of its kind during the first decades of the twentieth century, the Triangle Shirtwaist Factory was a loft factory, occupying the top three floors of an office building. Meeting the increased demand for tailored blouses for the growing number of female clerical workers during that era, Triangle was one of the most successful garment factories in New York City. It employed one thousand workers, mostly immigrant women who knew little or no English. They worked long hours in

hazardous and unhealthful conditions for pennies a day.

Workers were jammed elbow to elbow and back to back at rows of tables. Scraps of the highly flammable fabric they worked with were scattered on the floor or stored tightly in bins. Cutting machines were fueled by gasoline. The few safety regulations were ignored. Smoking was prohibited, but workers commonly smoked while supervisors looked the other way. Water barrels with buckets for extinguishing fires were not always full. There was one rotting fire hose, attached to a rusted valve. In general, conditions were ideal for fire to break out and spread at any time.

Escape in case of fire was difficult or impossible. The only interior exit from the work room was down a hall so narrow that people had to walk single file. There were four elevators, but usually only one was functional. The stairway was as narrow as the hall. Of the two doors leading from the building, one was permanently locked from the outside, and the other opened inward.

On March 25, 1911, the day of the fire, the offices below the factory were closed for the weekend. About half of the Triangle work force was in the factory on that Saturday. The flames spread far too quickly to be extinguished by the meager water supply in the barrels, and the fire hose did not work. In the stampede to get down the narrow passages and stairways to the doors, peopled were trampled. Some tried to break through the locked door. Other surged to the other door and were crushed as they tried to pull it inward. As people crowded into the elevators, others tried to ride down on the tops of the cars, hanging onto the cables. Soon there were so many bodies in the shafts that the one functioning elevator could no longer be used. The women, girls, and few men trapped in the workroom threw themselves out of the windows and were dashed to death on the pavement. Others tried to use the fire escape. Already too flimsy to hold much weight, the fire escape soon melted in the heat and twisted into wreckage. Only twenty women managed to escape by it.

Fire fighters arrived at the scene quickly but nevertheless too late. Once they arrived, several factors inhibited their efforts. Many of the women who jumped from the windows landed on the fire hoses. Their bodies had to be removed before the hoses could function. The nets and blankets that the firefighters spread to catch the jumping women tore, and the women crashed through to die on the pavement. The fire engine ladder reached no further than the seventh floor, one story short of the workroom. Those who escaped did so by being first out the door or down the elevator, or by climbing from the top floor onto the roofs of other buildings.

The death toll was 146, including 13 men. Several of the bodies were so badly charred that they could not be identified, even as to sex. The cause of the fire was never discovered. Given the number of fire hazards that were present, it was speculated that the cause might have been a match, a lighted cigarette, or a spark from a cutting machine igniting gasoline or the combustible fabric scattered on the floor and packed in bins.

On the evidence of the locked door, factory owners Blanck and Harris were indicted for first- and second-degree manslaughter. They claimed that they did not know the door was locked and were acquitted.

Impact of Event

The Triangle Shirtwaist Factory disaster was a terrible object lesson in the need for reforms in fire prevention in particular and labor reform in general. It also illustrated the need for solidarity among the organizations and labor groups working for reform.

Public outrage at the 146 deaths and the miserable conditions under which the victims had worked formed the basis for future legislation on factory safety. The New York state legislature appointed investigative commissions to examine factories statewide, and thirty ordinances in New York City were enacted to enforce fire prevention measures. One of the earliest was the Sullivan-Hoey Fire Prevention Law of October, 1911, which streamlined six separate agencies into one fire commission with a fire prevention division that required the installation of sprinkler systems in factories.

Significant labor reform for garment workers took longer to achieve. Although they had gained only small victories compared to what they had demanded, the ILGWU and WTUL had demonstrated in the 1909 strike that workers could be organized and could be depended upon to fight with strength and determination. Immigrant women, who had to battle not only inhumane working conditions and language barriers but also a general hostility to their entering labor unions, had demonstrated a surprising show of force. The Triangle fire was a tragic example of how much more reform was still needed. At a memorial service held at New York's Metropolitan Opera House, Rose Schneiderman, an influential member of the WTUL and later its president, gave a scathing speech pointing out how the Triangle tragedy indicated that alleged reform was not taking place. She called the crowd of workers, public officials, and interested citizens of all classes to join a working-class movement for reform. This speech, along with tens of thousands of New Yorkers marching in tribute to those killed in the Triangle fire, strenghtened the resolve of reformers, inspired the labor unions to get legislative support for their demands, and stimulated reforms of social ills directly related to poor labor practices. Those ills included lack of education, which was encouraged by the employment of child labor.

State senator Robert Wagner and state legislator Alfred E. Smith began a series of investigations and recommendations to improve factory safety. Women connected with the unions and other reform organizations took to the streets to inform workers of the benefits to which they were entitled and encourage them to fight for those benefits when they were denied. Organizers conducted legislators on tours through factories, revealing the abuses that existed in them.

Progress continued to be slow. It was not until 1913 that the investigations, recommendations, and resolutions resulted in effective labor legislation. In that year, the fifty-four-hour workweek became law. That same year, Max Blanck, who owned a new Triangle Shirtwaist Factory, was fined for keeping his doors locked and received a court injunction against using a counterfeit ILGWU fair-practice label he had been using to sell more shirtwaists.

The Triangle fire acted as a catalyst to consolidate reforms in different sectors of society. Suffragists joined forces with the unions in their efforts to gain equal rights

for women. Education reformers worked with the WTUL to teach immigrants English and to inform them about social issues and trade union practices. Women of the middle and upper classes held fund-raisers for the nearly empty coffers of the labor organizations. This sort of work was done nationwide, and its organizers had international counterparts.

The ILGWU tightened its organization and gained the power to negotiate contracts better than those of other unions. It was particularly effective in negotiating the right to strike. During the years of World War I, a period of full employment and high production, the ILGWU managed to maintain union contract standards under the pressures of increased production demands. At the same time, the union began a new drive for a shorter workweek and established a thriving union health center, the first of its kind in the United States, to provide preventive medical service.

Progress in labor reform continued to be slow and uneven, however, as it would be for decades to come. By 1915, management had increased efforts to reassert control over labor. This provoked a series of wildcat strikes, which provoked conflicts between conservative and more militant unions. Later, rank-and-file conflict with union leadership weakened union power further.

On the other hand, the ILGWU continued to increase its power. By 1916, five years after the Triangle Shirtwaist Factory fire, the union had enough power both to withstand a lockout in New York City that affected twenty thousand workers and to win in a fourteen-week general strike by two thousand shops employing sixty thousand members.

The immediate impact of the Triangle Shirtwaist Factory disaster on labor reform was that it provoked enough public outrage to establish stricter fire codes and inspire new and inexperienced labor organizations to press for supportive legislation. Response to the tragedy was part of the beginning of a long struggle for fair labor practices for all workers, equal treatment of women, and safe plants in which to work.

Bibliography

Butler, Hal. "New York's Triangle Tragedy." In *Inferno! Fourteen Fiery Tragedies of Our Time*. Chicago: Henry Regnery, 1975. Citing eyewitness reports, the author describes the Triangle fire in vivid detail. The article is part of a collection on disastrous fires in the United States.

Garrison, Webb. "Triangle Shirt Waist Fire." In *Disasters That Made History*. Nashville, Tenn.: Abingdon Press, 1973. The author gives detailed reports on the significance of twenty-three disasters. The report on the Triangle fire includes specific details on the sociopolitical and economic conditions surrounding the fire and its aftermath as well as on the incident itself.

Green, James R. "The Struggle for Control in the Progressive Era." In *The World of the Worker: Labor in Twentieth-Century America*. New York: Hill & Wang, 1980. The author places the Triangle fire as a significant incident in the American labor movement as well as in the social and cultural history of the nation as a whole.

Schneiderman, Rose. *All for One*. New York: Paul S. Eriksson, 1967. Written with

editor Lucy Goldthwaite, this is the author's own story of her fifty years in the labor movement. Chapter 10 details the Triangle fire and its aftermath.

Wertheimer, Barbara Mayer. "Working Women in the National Women's Trade Union League: 1903-1914" and "The Rise of the Woman Garment Worker: 1909-1910." In *We Were There: The Story of Working Women in America.* New York: Pantheon Books, 1977. The volume is a narrative history of American working women from precolonial times to the mid-twentieth century. Contains valuable material on the significant developments in the labor movement and the influential women connected with it. Many illustrations, extensive notes, and an annotated bibliography.

Christina Ashton

Cross-References

The Supreme Court Strikes Down a Maximum Hours Law (1905), p. 112; The Supreme Court Rules Against Minimum Wage Laws (1923), p. 426; Congress Restricts Immigration with 1924 Legislation (1924), p. 459; Congress Passes the Equal Pay Act (1963), p. 1185; The Civil Rights Act Prohibits Discrimination in Employment (1964), p. 1229; The United States Announces Plans for Immigration Reform (1965), p. 1259; Nixon Signs the Occupational Safety and Health Act (1970), p. 1466; The Immigration Reform and Control Act Is Signed into Law (1986), p. 1933.

THE BARO-KANO RAILROAD EXPANDS NIGERIAN GROUNDNUT EXPORTS

Categories of event: Transportation; international business and commerce
Time: March 28, 1911
Locale: Kano, British protectorate of Northern Nigeria

The Baro-Kano railroad provided access to the hinterland and expanded colonial trade in commodities and raw materials

Principal personages:
 SIR FREDERICK LUGARD (1858-1945), the high commissioner of Northern Nigeria, 1900-1907; governor-general in 1914
 SIR E. P. C. GIROUARD (b. 1867), a railroad expert who supervised the Baro-Kano railroad
 MICHAEL IMOUDU (1906-), a labor leader
 T. L. N. MORLAND (1865-1925), the commander of the colonial force that bombarded and conquered Kano in 1903
 MACGREGOR LAIRD (1808-1861), an explorer, shipbuilder, and trader who pioneered steamer transportation to the Niger River
 JOHN BEECROFT(1790-1854), the first British consultant to Nigeria

Summary of Event

Baro is a railway terminus on the northern bank of the Niger River. The city of Kano, farther north, is landlocked. Prior to the completion of the Baro-Kano railroad in 1911, access to the interior of what later became Nigeria was limited. The Baro-Kano line promptly opened up a vast hinterland to colonial trade.

The need for a railroad to Kano was cardinal in the colonial scheme. For centuries, in the old trans-Saharan trade network, Kano had exported woven textile and leather goods to distant markets in North and West Africa by animal caravan. The merchants of Kano also traded southward to the banks of the Niger and Benue rivers. By 1854, owing to the advent of steamers, European merchants had joined in the river trade. The trade with the hinterland, however, still depended on animals and human porters.

As the colonial impulse quickened in the last quarter of the nineteenth century, the rivalry among European traders heightened in the Niger area. The merger of four United Kingdom firms in 1879 secured for them an advantage over their German and French rivals. Owing to the manual transport system, however, and to the fact that private initiatives in 1878 to build a railroad had failed, trade expansion to the interior had to wait. Railroad construction finally began in Lagos in 1898, after years of hesitation, with funds from the Imperial Treasury. The hasty inception of the project coincided with the consolidation of colonial rule in Nigeria. On January 1, 1900, the British Colonial Office proclaimed protectorates in northern and southern Nigeria. Shortly afterward, the Lagos-Ibadan railroad, consisting of 120 miles of track across

western farmlands, was completed and opened to traffic.

The success of the colonial enterprise depended on cheap and reliable access to raw materials. Unlike the coastal southern region, the landlocked northern portion of the Nigerian protectorate depended on imperial grants-in-aid for support. The system of direct tax in the North allowed for payments in kind rather than in cash. Kano, as the principal collection point of the northern protectorate, needed a cheaper and reliable outlet to the sea so that these crops could be sold.

Sir Frederick Lugard, the North's influential high commissioner, stressed to the Colonial Office the importance of railroads to the viability of his administration and the entire colonial enterprise. Lugard wanted the shortest link to the Atlantic seaport of Lagos as well as a share of the customs revenue. The coast, he argued, must support the interior and must be connected with it for military and logistical reasons. Before leaving for Hong Kong to assume duties as governor, Lugard had established a basis for the railroad. Sir E. P. C. Girouard succeeded Lugard in 1907. Girouard, former railroad executive in South Africa, Egypt, and the Sudan, recommended that the northern railroad exploit the commercial advantages offered by the Niger River. In Girouard's opinion, the inland waterways were potential resources for the North's development.

Approval for construction of the Baro-Kano railroad was granted by the secretary of state for the colonies in August, 1907. A team of royal engineers, whose salaries were charged to the railway budget, arrived shortly afterward. The capital appropriation came from the southern area while interest payments were met from the North's share of southern contributions to customs revenue. The South also secured permission from the secretary for a northward extension of the Lagos-Ibadan rail line, the intention being for the latter to link up with the Baro-Kano line at Minna.

Two rival railroad systems thus had emerged, separated only by the Niger River. The two railroads promoted the different goals of the North and South. In 1909, the Lagos-Ibadan line reached Jebba, on the bank of the Niger River. The North-South rivalry would eventually lead to the amalgamation of the two dependencies. The immediate controversy, however, concerned the territorial control and operational policy of the Lagos-Kano line. Would policy and control issue from the North or from the South? The answer seemed to lie in the unification of the two sections, which finally occurred on October 3, 1912, when the systems were merged as the Nigerian Railway.

The Baro-Kano project set an example for future construction, particularly because of its low cost and timely completion. The railroad was opened to traffic on March 28, 1911, after forty-four months of work. The line, constructed at an estimated cost of £1,480 per mile, had 356 miles of track. Unlike the earlier Lagos-Ibadan line, the Baro-Kano project was locally supervised by public works officials such as Girouard and John Eaglesome. The latter later became the director of railways and works. Under the system used for the Lagos-Ibadan line, procurement and supervisory details were preset abroad by crown agents and consulting engineers, then passed down to a resident engineer who was not accountable to local officials.

The Nigerian railroad was profitable, like most colonial systems. The system was built with loans and appropriations from the colonial revenue and reserves. The total cost of railroad construction amounted to £8,670,145 by 1918. Despite the interest on capital and payments to the sinking fund, the railroad profitably paid its way. As Lugard observed, Nigeria was colonized at no cost to the British taxpayer. Critics of the colonial enterprise, however, speak in terms of the exploitation of Africa.

Impact of Event

The Baro-Kano railroad expanded the existing channels of transportation and became a profitable link in the network of colonial trade. The improvement in transportation facilitated the large-scale procurement, marketing, and distribution of goods from the hinterland. The railroad increased the volume and value of transactions, particularly, in the commodities trade. The tonnage export of groundnuts, which were second to palm produce in overseas shipment, increased by a factor of eighty-seven between 1911 and 1928. In 1900, the year Kano came under a protectorate government, Nigeria exported only 599 long tons of groundnuts. The volume of trade increased from 1,179 tons in 1911 to 103,161 tons in 1928. By 1946, groundnut exports exceeded a quarter of a million tons. Railroad transportation also increased the scope and frequency of trade and communication. Prior to completion of the Niger bridge, cargo trains from the northern hinterland were ferried across the Niger River. By 1929, more than fourteen thousand miles of telegraph wire ran in connection with the railroads.

The domestic economy, however, increasingly became subject to the vicissitudes of war, worldwide instability, and price fluctuations abroad. Between 1914 and 1915, partly as a result of diversion of steamships to the war effort, groundnut exports dropped by nearly 50 percent. In 1915, Nigeria exported 8,910 tons of the produce, in dramatic contrast to the 50,368 tons exported in 1916. Crises in the European oils and fats industries in the interwar years also affected domestic Nigerian trade. In 1926, for example, Nigeria exported 126,799 tons of groundnuts, 427 tons less than it exported in 1925 and 36,026 tons more than it exported in 1927. During World War II, as during World War I, pricing controls of the colonial government fixed the terms of trade in commodities as well as fixing farmers' incomes.

The impact of the railroad on industry was significant. The railroad allowed greater production and sales in agriculture and mining, but the incomes of producers in these sectors went toward purchase of imported consumer goods and the payment of colonial taxes. Little was left for saving or reinvestment, so industry grew slowly. The Women's Riots of 1929 were a revolt against the taxing policy of the government and the monopolistic terms of trade in produce. Some business historians have argued that the colonial cash-crop policy, which depended on the railroads, turned skilled craft workers into farmers and miners who fed raw materials to factories overseas. The railroad project, they maintain, stultified the manufacturing base and suffocated infant industries.

Hundreds of miles of track passed through farmlands acquired by the government

on the basis of eminent domain, or the right of the government to claim land. Rural populations eventually drifted to the railway towns, which had become trading centers. The population of Kano, for example, grew from one million in 1903 to three million in 1959, even though the town did not offer such amenities as an adequate supply of pipe-borne water. Generally, colonial railroads in Africa were uncoordinated, except to the extent that they linked the sources of raw materials with the sea.

Because trade, banking, and finance were controlled and dominated by British firms, whose directors resided overseas, business policies and practices did not coincide with local business aspirations and growth. In a report submitted to the British parliament in December, 1919, Lugard condemned a system in which British merchants, who depended on the colony for their wealth, perceived little responsibility to the colony and its inhabitants.

The railroad projects affected the economy in other ways. In the absence of a comprehensive banking system, railroad construction workers became unofficial agents for the circulation of money in remote areas. Thus the workers aided government authorities in retiring the existing money, which in some areas included seashells, and replacing it with new money.

The colonialists in Nigeria have been criticized for employing "political labor" in railroad projects, as was also the case in German, French, Portuguese, Italian, and Belgian colonies. The system involved conscription of workers, with the aid of local chieftains. Conscripts walked hundreds of miles in several months, and, as in the Kano project, were typically paid an average daily wage of six pence after tax. A junior clerk in the southern civil service received an average monthly wage of £2 (1,200 pence) in 1912 and belonged to the Civil Service Union. The "political laborer" was far removed from the seeming luxury of clerical service and regular employment. Several thousand forced laborers died all over Africa in the colonial era from accidents, starvation, and other perils. Forced labor was much loathed because of its brutal and enslaving form and the separation it caused for family units.

Railway workers, including clerks and mechanics, sowed the seeds of activist unionism in Nigeria. Under the leadership of Michael Imoudu, the workers' union, after a decade of conflict with management, successfully resisted an hourly wage system introduced in 1931.

A miners' strike over conditions of work resulted in the death of twenty-one miners in Iva Valley on November 18, 1949. In Northern Rhodesia, colonial troops killed six miners and wounded twenty-two others in 1935. In 1940, in the same colony, seventeen Africans died and sixty-four others were wounded in a miners' riot.

European appropriation of land, labor, and raw materials in the colonial era is often blamed as the continuing cause of underdevelopment in Africa. Business historians have described the colonial enterprise, including railroads, as exploitive and as the originating cause of economic nationalism in contemporary Africa.

Bibliography

Burns, A. C. *History of Nigeria*. London: George Allen and Unwin, 1929. An account

by a former deputy secretary to the colonial government of Nigeria. Well written despite the author's narrow understanding of the Nigerian society.

Ekundare, R. O. *An Economic History of Nigeria, 1860-1960*. London: Methuen, 1973. A business and economic analysis of Nigeria's experience from the colonial era to independence. Useful statistical and comparative data.

Lugard, Frederick J. O. *The Dual Mandate in British Tropical Africa*. London: Frank Cass, 1965. Chapter 5 discusses principles of colonial administration, particularly in relation to the amalgamation of the Nigerian dependencies.

——————————. *Lugard and the Amalgamation of Nigeria: A Documentary Record*. London: Frank Cass, 1968. A reprint of the report by Lugard on the amalgamation of northern and southern Nigeria, presented to Parliament in December, 1919. Also includes previously unpublished materials on the amalgamation and administration of Nigeria. Excellent compilation.

Martin, Susan M. *Palm Oil and Protest*. New York: Cambridge University Press, 1988. Presents an economic history of southeastern Nigeria from 1800 to 1980.

Olanrewaju, S. A. "The Infrastructure of Exploitation: Transport, Monetary Changes, Banking." *In Britain and Nigeria: Exploitation or Development?* edited by Toyin Falola. London: Zed Books, 1987. The entire book is informative regarding what the contributors interpret as a pattern of managed exploitation.

Orr, Charles. *The Making of Northern Nigeria*. London: Frank Cass, 1965. Chapter 10 discusses the politics of the railroad.

Wogu, Ananaba. *The Trade Union Movement in Nigeria*. New York: Africana, 1970. Gives interesting insights into the origin and nature of labor unionism in Nigeria. Chapter 3 examines the emergence of Imoudu as a railway labor leader.

Satch Ejike

Cross-References

Tobacco Companies Unite to Split World Markets (1902), p. 57; Lever Acquires Land Concessions in the Belgian Congo (1911), p. 201; Oil Companies Cooperate in a Cartel Covering the Middle East (1928), p. 551; Truman Orders the Seizure of Railways (1946), p. 880; The Economic Community of West African States Forms (1975), p. 1589.

LEVER ACQUIRES LAND CONCESSIONS IN THE BELGIAN CONGO

Category of event: International business and commerce
Time: April 14, 1911
Locale: The Belgian Congo

William Lever's concessions in the Belgian Congo set an example of multinational corporate responsibility in a developing economy

Principal personages:
WILLIAM HESKETH LEVER (1851-1925), an entrepreneur in international business
FRANCIS D'ARCY COOPER (1882-1941), the chairman of Lever Brothers after the death of William Hesketh Lever
ANTON JURGENS (1867-1945), a joint chairman, with Francis Cooper, of Unilever
SIMON KIMBANGU (1889-1951), a nationalist and leader of a movement to fight colonialism
PATRICE LUMUMBA (1925-1961), a leader of the Congolese National Movement; the first prime minister of Zaire

Summary of Event

An agreement signed on April 4, 1911, by William Lever and the Belgian colonial government in Brussels invested in Lever Brothers, Ltd., extensive proprietary rights and responsibilities for the development of business and society in the Bas-Zaire region of the Congo. Lever's interest in Africa began early in the 1900's, following the poor performance of his Pacific islands ventures. Lever looked to the British colonies as sources of raw materials, but policy concerning lands in the tropical dependencies did not foster extensive concessions to business or the development of a plantation enterprise. The British government, only a few years earlier, had revoked the charter concessions of the Royal Niger Company in northern and southern Nigeria and was not about to grant another concession.

Lever's search for raw materials necessarily shifted to other areas. A combination of events gave Lever the opportunity he wanted. Mounting African resistance to the murderous and brutal regime of Belgium's King Leopold II in the Congo Free State was firm and unmistakable. Beginning in 1902, world opinion, especially in England, condemned the murderous system of forced native labor in the corporate plantations of the Congo.

The idea of corporate respect and responsibility to colonized peoples had been a valued part of British policy since the eighteenth century, even though its enforcement by resident officials did not always reflect the seriousness with which the Home Office in London viewed the policy. Every attempt was made by British colonialists,

however, to respect local customs and laws, except in cases in which local traditions conflicted with British notions of equity and good conscience.

The physical abuses meted to the people of the Congo by the concessionary firms in the Free State offended the minimum standards of equity. By 1908, it was clear that Leopold's Congo government was on the brink of a collapse. The Congo Reform Association, vocally led by journalist Edmond Dene Morel, and the Aborigines Protection Society publicized the abuses in England. This publicity finally led to an international inquiry. A depression in the world rubber market soon eroded whatever clout and protective support Leopold enjoyed from rubber-importing nations.

The pressure was such that in November, 1908, Leopold turned over his Congo Free State to the Belgian government. Questions arose, however, as to the legal validity of the annexation, and international recognition of the transfer ultimately depended on Belgium's promise to reform the defunct system in the Congo. Thus, upon Leopold's death on December 7, 1909, neither King Albert, Leopold's uncle and successor, nor the government could afford to continue the old system in the Congo.

Responding to hints of opportunity and encouragement from other industrialists, and after preliminary investigations, Lever took up the challenge to secure a foothold in the Congo. On April 14, 1911, Lever, on behalf of himself and Lever Brothers, Ltd., entered into a convention with the colonial administration of the Congo, represented by Jules Renkin. As a newcomer to the colonial enterprise and eager to secure corporate participation in the process, the Belgian parliament hastily approved the concession.

By the terms of the agreement, Lever Brothers, through a newly formed subsidiary, accepted far-reaching responsibilities that went beyond the ordinary scope of a firm's business obligations. These obligations were designed to satisfy the international insistence on reform in the Congo. The mere fact of a concession being granted that included social and political responsibilities was not a novelty. The British East Africa Company, the Royal Niger Company, the British South Africa Company, the Portuguese Mozambique Company, and many others before Lever Brothers had been chartered with mandated political and social responsibilities in the colonized areas. The uniqueness of the Lever concession rested on the specificity of the mandates. In addition to provisions requiring the company to develop agricultural and oil-processing facilities within a given period, Lever Brothers was required to comply with minimum standards of community responsibility set by the convention, including the construction and staffing of a school and a hospital in each of the localities in the concession. The concession required the company to pay minimum and fair wages for local labor and to respect local traditions. The injunction was significant given the fact that in the neighboring Moyen Congo, the French were increasingly subjecting the local population to forced labor and were pursuing a system of cultural orientation designed to "evolve" or reform the Congolese into French persons.

The concession also imposed certain commercial conditions for the benefit of the Belgian economy. The company was required to buy about one-third of its industrial input from Belgian sources. This condition was waivable if such items were locally

produced by the company. The agreement, however, anticipated that the company would maintain a minimum volume of purchases from Belgium. A clause in the concession enjoined the company to ship specified quantities of palm oil to Belgium directly from the colony, while another prescribed the Belgian flag and registry for the company's ships. Belgian workers secured the right to reside and work in the concession areas. The agreement required that at least half of the company's work force be Belgian citizens. The five concessions in Lusanga, Basongo, Ingende, Bumba, and Barumbu were intended by the grant to become pivotal points of development in the colony.

Thus, the grant carefully qualified the present and future interests of the company. It was required to establish an oil-processing plant in each of the districts within six years of the grant, after which it would be in a position to exercise leasehold options. The company would not take freehold interest in the lands before 1945. With the influx of European firms and speculators in the post-World War I era, the concessional limitations were watered down.

Impact of Event

The concession of 1911, as contracted, placed on Lever Brothers a fundamental responsibility to introduce a moral quality to the conduct of colonial commerce and trade. The concession thus represented the prospect of a new beginning for the Congo's people in their relationships and contacts with foreign firms and held out the promise of equity and fair play in business. The gulf between promise and practice, however, would limit the full impact of the concessional stipulation.

The concession, apart from enabling Belgium to find and consolidate its colonial foothold in Africa, reinforced the erstwhile system of large long-term grants to foreigners under Leopold. Nevertheless the Belgian government, by granting the concession to Lever Brothers showed a seeming disposition to reform and in effect softened England's opposition to the 1908 annexation of the Congo.

By the terms of the grant, the Lever Brothers subsidiary had to ensure that forced labor was replaced with a system of voluntary labor. Outside the palm oil concession areas, however, the production or processing of rubber, ivory, copper, uranium, diamonds, and gold continued to rely on veiled forced labor. In the Katanga copper mines, forced labor took subtle forms, including the imposition of various taxes and resort to migrant and temporary workers from Northern Rhodesia. Following the expansion of mining activity in Northern Rhodesia in the 1920's and the resulting shortage of migrant laborers, Union Minière mildly upgraded its employment practices. In 1925, the colony exported 85,323 tons of copper produced essentially by migrant and underpaid native laborers. By 1959, mining accounted for 60 percent of the domestic exports.

Critics have argued that Lever Brothers merely upgraded the status of native labor to indentured servitude. By 1925, the company had more than twenty-four thousand African employees in the region.

The company's need for local labor expanded shortly after production began. By

the end of the first quarter of 1912, the company had shipped produce to Belgium. In that year, the company produced 384 tons of palm oil and 118 tons of palm kernels. Despite the interruptions of World War I, expansion continued. By 1918, the output of palm oil and kernels reached 4,491 tons and 2,206 tons, respectively.

In the context of the colonial economy, African labor remained concentrated in the primary industries of agriculture, mining, and processing. The shortage of African labor, which increased significantly during and after World War I, caused the colonial government to introduce a "full employment" policy, under which able-bodied Congolese were required to seek employment. As in Kenya and other European plantation colonies, the Congolese were effectively edged out of cash-crop production and marketing by foreign operators.

Congolese farmers, having lost their lands to mining and plantation interests, accepted positions as wage earners. The situation in the Belgian Congo did not show any significant departure from the situations in the neighboring colonies of Angola, Kenya, and Rhodesia, where European plantations and mining monopolies dominated. By 1959, shortly before independence, there were more than a million native employees and laborers in the various industrial sectors of the Belgian Congo. In the period following World War II, native labor increasingly moved into manufacturing, construction, transportation, commerce, and clerical services.

The contractual commitment of Lever Brothers to the concession hamstrung the firm's competitiveness in the Congo. Lever Brothers, through its subsidiary, was saddled with undertaking the social transformation of the Congo. Some historians have argued that Lever Brothers did not necessarily seek to be ahead of its time and was merely the victim of a cosmetic colonial policy symbolized by the convention of 1911. Whatever the case, social services improved in the concession districts as well as in the outlying territory. Within its concessionary domain, the company contributed to the infrastructural development of the colony. By the mid-1950's, the colony had 3,214 miles of railroads, 90,253 miles of motor roads, and improved seaports at Matadi and Boma. In 1911, the Matadi railroad had hardly been able to bear the weight of equipment for the Lever Brothers subsidiary.

Lever Brothers took advantage of the concession to integrate the company's oils and fats operations along vertical lines, controlling the entire process of production from the palm fields and oil mills of the Congo to the soap shops of Brussels. The concession of 1911, short of enabling Lever Brothers to achieve a perfect integration of the oils and fats enterprise, prepared the way for the firm to undertake the challenges of British corporate multinationalism in tropical Africa.

Although William Lever's palm oil and kernel production in the Congo was not immediately profitable, partly because of competition from trading companies and capital investments in the erection of the mandatory mills, he was able to retain a sizable share of the market by diversifying investments. The latter effort led to the acquisition of trading companies and shipping lines. Lever's most fulfilling venture was his expansion into Africa. The concession afforded his company a unique opportunity to show exemplary conduct of multinational business in a dependent and

developing environment, but pressures for cheap labor and profit suffocated an otherwise noble purpose.

Bibliography

Ake, Claude. *A Political Economy of Africa*. Harlow, Essex; England: Longman, 1981. Discusses in provocative ways what he sees as the disarticulation of African economies by colonial and postcolonial interests.

Coquery-Vidrovitch, C. "The Colonial Economy of the Former French, Belgian, and Portuguese Zones, 1914-1935." In *Africa Under Colonial Domination, 1880-1935*. Vol. 3 in *General History of Africa*, edited by A. Adu Boahen. Berkeley: University of California Press, 1985. Excellent summaries and data.

Fieldhouse, D. K. *Unilever Overseas: The Anatomy of a Multinational, 1895-1965*. Stanford, Calif.: The Hoover Institution Press, 1978. Offers insights into the strategy and structure of a multinational firm.

Gran, Guy, ed. *Zaire: The Political Economy of Underdevelopment*. New York: Praeger, 1979. A collection of studies analyzing the internal and external variables that have conditioned the history and development of modern Zaire, formerly the Belgian Congo. Contains an interesting discussion of a concession in 1976 by President Mobutu Sese Seko to a German firm for a satellite pad.

Stopford, John M. "The Origins of British-Based Multinational Enterprise." *Business History Review* 48 (Autumn, 1974): 319-335. Interesting analysis of the growth, maturation, and expansion of family enterprises into overseas markets.

Wilson, Charles. *History of Unilever: A Study in Economic Growth and Social Change*. 2 vols. New York: Praeger, 1968. A comprehensive and well-documented institutional history, describing the quality of enterprise that shaped the institution.

Young, Crawford. "Zaire: The Unending Crisis." *Foreign Affairs* 57 (Fall, 1978): 169-185. A critical and balanced analysis of Zaire's continuing search for stability and its dependence on foreign support.

Satch Ejike

Cross-References

Tobacco Companies Unite to Split World Markets (1902), p. 57; The Baro-Kano Railroad Expands Nigerian Groundnut Exports (1911), p. 196; Sloan Develops a Structural Plan for General Motors (1920), p. 368; Oil Companies Cooperate in a Cartel Covering the Middle East (1928), p. 551.

THE SUPREME COURT DECIDES TO
BREAK UP STANDARD OIL

Category of event: Monopolies and cartels
Time: May 15, 1911
Locale: Washington, D.C.

In its decision to break up the Standard Oil Company, the Supreme Court established the principle of the "rule of reason" in deciding whether companies were in violation of antitrust laws

Principal personages:
JOHN D. ROCKEFELLER (1839-1937), the president of Standard Oil Company, 1870-1911
JOHN SHERMAN (1823-1900), a senator from Ohio, 1885-1897, author of the Sherman Antitrust Act of 1890
EDWARD WHITE (1845-1921), the chief justice of the United States, 1910-1921

Summary of Event

Founded in 1870, Standard Oil Company became one of the largest companies in the United States by the end of the nineteenth century. In *Standard Oil v. United States* (221 U.S. 1), decided on May 15, 1911, the Supreme Court found the company guilty of violating the Sherman Antitrust Act of 1890 based on alleged "unreasonable" restraints of trade, including buying out small independent oil companies and cutting prices in selected areas to force out rivals. The case resulted in the separating of the parent Standard Oil from its thirty-three affiliates.

Eleven years after the historic oil discovery in Titusville, Pennsylvania, that marked the beginning of the modern oil refining industry, the Standard Oil Company was incorporated by John D. Rockefeller in Cleveland, Ohio, on January 10, 1870. At the time of the company's formation, the oil refining industry was decentralized. Standard Oil's share of refined oil production in the United States was less than 4 percent, and Rockefeller had to compete with more than 250 other independent refineries.

During the last quarter of the nineteenth century, deflation and oversupply of oil brought down oil prices, causing fierce competition among oil refineries. The price for refined oil fell from more than 30 cents a gallon in 1870 to 10 cents a gallon in 1874 and to 8 cents in 1885. Compared with other oil refineries, Standard Oil was managed efficiently under Rockefeller and his associates, allowing it to survive while many competitors failed.

During the post-Civil War deflationary period, the railroad industry became very competitive. Rockefeller took advantage of Standard Oil's increasing size to secure secret rebates from shipping companies, thus reducing transportation costs and overall operating costs. Rockefeller further reduced Standard Oil's operating costs by verti-

cally integrating the company, acquiring oil wells, railroads, pipelines, tank cars, and retail outlets. Vertical integration gave more control at all stages of production.

Meanwhile, because of declining market conditions, many small and nonintegrated oil companies that were unable to reduce their operating costs became unprofitable to operate. In addition, the method of destructive distillation introduced in 1875 increased the minimum efficient size of a refinery to more than one thousand barrels per day, making smaller companies even less competitive. Rockefeller began to take advantage of the situation, buying out many of the independent refineries in Pittsburgh, Philadelphia, New York, and New Jersey at low prices, often below their original cost. Standard Oil soon refined about 25 percent of the U.S. industry output. In 1882, Rockefeller and his associates formed the Standard Oil Trust in New York, the first major "trust" form of business combination in U.S. history. The company held "in trust" all assets of the many regional Standard Oil subsidiary companies, one of which was Standard Oil of New Jersey, the third largest U.S. refinery in the 1880's. Despite the substantial drop in oil prices, Standard Oil was able to increase its profits by reducing costs from about 3 cents per gallon in 1870 to less than .5 cents in 1885. By 1900, the oil trust controlled more than 90 percent of the petroleum refining capacity in the United States.

The size and power of Standard Oil led to public hostility against it and against monopolies in general, prompting passage of the Sherman Antitrust Act in 1890. During the same year, immediately after New York State's action against the "sugar trust," the state of Ohio brought a lawsuit against Standard Oil for illegal monopolization of the oil industry. On March 2, 1892, the Ohio Supreme Court convicted Standard Oil of violating the Sherman Act by forming a holding company and forbade the company to operate Standard Oil of Ohio in that state.

The court decision led to dissolution of the Standard Oil trust back into its independent parts. The New Jersey unit took advantage of favorable state laws to become the Standard Oil Company of New Jersey, now known as Jersey Standard, as the trust's parent holding company. Rockefeller remained president, and management of the trust was consolidated through interlocking directorates of the more than thirty subsidiary companies. The supposedly separate companies thus were able to act as a single entity.

In 1901, the discovery of the Spindletop oil field created a boom in oil production on the Gulf Coast of Texas. The formation of new oil companies, such as Texaco and Gulf, increased the competition faced by Standard Oil. Standard Oil responded by continuing to buy out independent oil refineries. The Standard Oil trust's market share in the oil industry continued to expand.

Meanwhile, the commissioner of the Bureau of Corporations, James R. Garfield, investigated the oil company for violations of antitrust law. As a result of his studies, the government, led by Attorney General George Wickersham, brought charges in November, 1906, in the Federal Circuit Court of the Eastern District of Missouri against Standard Oil for monopoly and restraint of trade in violation of the Sherman Antitrust Act.

In 1909, the Missouri court found Jersey Standard guilty of violating section 1 of the Sherman Act by forming a holding company and of violating section 2 by restraining competition among merged firms by fixing transportation rates, supply costs, and output prices. Standard Oil appealed the decision to the U.S. Supreme Court. The Supreme Court upheld the Missouri decision on May 15, 1911, and later entered a dissolution decree to dismember the Standard Oil trust and divest the parent holding company, Jersey Standard, of its thirty-three major subsidiaries. Many of its offspring still bore the name Standard Oil. These new companies included the Standard Oil Company of Indiana (later American), the Standard Oil Company (Ohio), Standard Oil Company of California (later Chevron), Standard Oil of New Jersey (later Exxon), and Standard Oil of New York (later Mobil).

The Standard Oil case marked the beginning of a new direction in U.S. antitrust legislation and prosecution. Along with the decision in the American Tobacco case in 1911, the ruling of the Supreme Court, led by Chief Justice Edward White, departed from earlier cases. The new interpretation of section 2 of the Sherman Act was that only "unreasonable", instead of all, restraints of trade were illegal. The Standard Oil decision, followed closely by the American Tobacco case, gave birth to a new doctrine in U.S. antitrust policy called the rule of reason.

The allegedly "unreasonable" practices by Standard Oil that were ruled illegal under sections 1 and 2 of the Sherman Act included forcing smaller independent companies to be bought on unfavorable terms and selectively cutting prices in market areas were rivals operated, with the intent of bankrupting those rivals, while maintaining higher prices in other markets. Chief Justice White maintained that it was mainly Standard Oil's merger practices in an attempt to monopolize the oil refining industry that constituted illegal restraint of trade.

Impact of Event

The Standard Oil case of 1911 significantly altered the course of American business history as well as the development of U.S. antitrust laws. The victory of the government against a powerful trust provided an important lesson in the early history of antitrust. The dissolution of Standard Oil into many independent companies effectively increased competition in the oil industry. In addition, the case provides a classic study of the development of American big business at the beginning of the twentieth century.

The first major antitrust law was the Sherman Antitrust Act of 1890, which emerged largely from public dissatisfaction with the monopoly power gained by Standard Oil in the oil refining market. The Sherman Act prohibits conspiracies or combinations in restraint of trade (section 1), and any attempts to create them, known as monopolization (section 2). The limits of the law regarding what constitute unlawful practices were not precisely defined, leading to different judicial interpretations of the act.

In the decade following passage of the Sherman Act, only sixteen cases were brought to court. Even though the courts began to establish that actions such as formal agreements to fix prices or limit output were definitely illegal, court judges were

equivocal in their treatments of the existing large trusts in industries such as oil (Standard Oil), tobacco (American Tobacco), and steel (United States Steel).

The Supreme Court's decision against Standard Oil marked the beginning of a new era in antitrust legislation and prosecution. It established the "rule of reason" approach, by which Chief Justice White maintained that it was not the history or the relative size of a monopoly such as Standard Oil in its market that was an offense against the law, but rather its "unreasonable" business practices. This new doctrine set a precedent for cases involving antitrust laws that was not broken until the Alcoa case in 1945.

The Supreme Court decision in the Standard Oil case highlighted the need for additional legislation to define specific business practices that constituted "unreasonable," and thus illegal, conduct. That need led to passage of the Clayton Antitrust Act and the Federal Trade Commission Act in 1914. The Clayton Act declared illegal specific "unfair" business practices including price discrimination, exclusive dealing and tying contracts, acquisitions of competing firms, and interlocking directorates. The Federal Trade Commission Act gave birth to a new government authority, the Federal Trade Commission, to enforce compliance of the modified antitrust law.

The victory in the government's prosecution of Standard Oil, together with passage of the Clayton Act, led to more vigorous enforcement of the antitrust laws. The U.S. Justice Department filed suit in the 1910's and early 1920's against many trusts in other industries, including American Can Company (tin cans), United Shoe Machinery Company (shoe machinery), International Harvester (farm machinery), and United States Steel Corporation (steel). The Supreme Court decision against Standard Oil also signified the government's attitude toward mergers. Mergers and acquisitions subsided briefly, until the government's failure in prosecuting the merger practices of the United States Steel Corporation in 1920.

The dissolution of the oil monopoly, Standard Oil, effectively changed the structure of the oil industry. On one hand, its successor companies, particularly the New Jersey unit, maintained considerable market power in their regional territories. The retail price of gasoline increased sharply in 1915, leading to government investigation of the extent of competition in the oil industry. On the other hand, the government apparently succeeded in enforcing competition among the separated units. As a result of the dissolution, Standard Oil's successor companies were allowed to operate only in the oil refining business. They began to confront competition from other companies, such as Shell, Gulf, and Sun, which operated with the advantage of vertical integration.

In an attempt to battle the rising competition, two of Standard Oil's successor companies, Standard Oil of New York and the Vacuum Oil Company, proposed a merger in 1930. The government filed suit in federal district court against their merger, as violating the 1911 decree. The court's decision in favor of the merger began a new era of merger movement in the oil industry. Through mergers, the original thirty-four successor companies combined into nineteen companies during the 1930's.

In the 1920's, Standard Oil's successor companies began to expand their oil

exploration overseas, particularly in the Middle East and Europe. That exploration continued as American resources were exhausted. Increased imports of oil, notably from the Organization of Petroleum Exporting Countries (OPEC) after its formation in 1960, intensified competition in the U.S. oil market and reduced American companies' market shares. The oil refining industry developed into one with companies operating worldwide, many of them large relative to the industry as a whole but none with the power formerly held by Standard Oil.

Bibliography

Adams, Walter, ed. *The Structure of American Industry.* 7th ed. New York: Macmillan, 1986. Chapter 2 provides good coverage of the background and historical development of the petroleum industry as well as discussions of the industry's structure, price behavior, and performance. Valuable for undergraduate and graduate students in industrial organization.

Armentano, Dominick T. *Antitrust and Monopoly: Anatomy of a Policy Failure.* New York: John Wiley & sons, 1982. Covers major antitrust lawsuits since the Sherman Act and the development of antitrust legislation. Covers the Standard Oil case in chapter 4. Includes an appendix of relevant sections of antitrust laws. Written for undergraduate business and economics students.

Destler, Chester McArthur. *Roger Sherman and the Independent Oil Men.* Ithaca, N.Y.: Cornell University Press, 1967. A biographical study of the person who fought for small independent oil refineries against the monopolization of the industry by Standard Oil in the northeastern region. Easy to read.

Gibb, George Sweet, and Evelyn H. Knowlton. *The Resurgent Years, 1911-1927.* Vol. 2 in *History of Standard Oil Company (New Jersey),* edited by Henrietta M. Larson. New York: Harper & Brothers, 1956. Deals with the evolutionary development of the New Jersey unit following the Standard Oil case in 1911, including operations overseas, increased competition with other Standard Oil successors, and labor relations.

Hidy, Ralph W., and Muriel E. Hidy. Pioneering in Big Business, 1882-1911. Vol. 1 in History of Standard Oil Company (New Jersey), edited by Henrietta M. Larson. New York: Harper & Brothers, 1955. Comprehensive documentation of the company's early history, particularly its administration and vertically integrated operations in the oil business. Good discussion of the dynamic development of a big corporation from business administration and business history perspectives. Valuable for business students.

McGee, John. "Predatory Price Cutting: The Standard Oil (N.J.) Case." Journal of Law and Economics 1 (October, 1958): 137-169. McGee's controversial article provides arguments and evidence against accusations of predatory pricing practices by Standard Oil. His critique led to debates about the profitability of predatory price cutting and its violation of antitrust law.

Whitney, Simon N. *Antitrust Policies: American Experience in Twenty Industries.* 2 vols. New York: Twentieth Century Fund, 1958. Chapter 3 of volume 2 provides a

case study of the petroleum industry until 1950. Good economic analysis of the impacts of the antitrust suit on development of the industry. Other chapters are case studies of other major industries. The appendix contains critiques of the studies of economists and government officials.

Jim Lee

Cross-References

Discovery of Oil at Spindletop Transforms the Oil Industry (1901), p. 24; The Supreme Court Breaks Up the American Tobacco Company (1911), p. 212; The Federal Trade Commission Is Organized (1914), p. 269; Congress Passes the Clayton Antitrust Act (1914), p. 275; The Supreme Court Rules in the U.S. Steel Antitrust Case (1920), p. 346; Oil Companies Cooperate in a Cartel Covering the Middle East (1928), p. 551; Alcoa Is Found in Violation of the Sherman Antitrust Act (1945), p. 869; OPEC Meets for the First Time (1960), p. 1154.

THE SUPREME COURT BREAKS UP THE AMERICAN TOBACCO COMPANY

Category of event: Monopolies and cartels
Time: May 29, 1911
Locale: Washington, D.C.

The Supreme Court ruled against the American Tobacco Company on the basis of its unreasonable anticompetitive business practices, leading to its dissolution

Principal personages:
JAMES DUKE (1856-1925), the founder and president of the American Tobacco Company
JOHN SHERMAN (1823-1900), a senator from Ohio, 1885-1897, and the author of the Sherman Antitrust Act of 1890.
EDWARD WHITE (1845-1921), the chief justice of the United States, 1910-1921
RICHARD REYNOLDS II (1906-1964), the founder of R. J. Reynolds Tobacco Company

Summary of Event

Founded in 1890, the American Tobacco Company became one of the largest holding companies in the United States before its forced dissolution in 1911. In *United States v. American Tobacco Co.* (221 U.S. 106), the company was found guilty under the Sherman Antitrust Act of 1890 of monopolizing the cigarette industry through "unreasonable" business practices, including buying out rivals, excluding rivals from access to wholesalers, and predatory pricing.

The market for tobacco products includes smoking tobacco, chewing tobacco, cigars, snuff, and cigarettes. Developments in the cigarette market have had significant effects on other branches of trade. Early in the 1880's, the cigarette industry experienced increasing competition in prices. Innovations in production technology, including Bonsack cigarette-making machines, which replaced hand labor, caused oversupply in the market. James Buchanan Duke, who first adopted the Bonsack machine for full-scale production, began to revolutionize the tobacco industry.

Duke entered the cigarette business in 1881 with his father, Washington Duke, in W. Duke Sons and Company, a smoking tobacco manufacturer near Durham, North Carolina. When the government reduced the tax on cigarettes by two-thirds, he cut the price of his cigarettes by half. In addition to price cutting, he launched an extensive advertising and promotion campaign for his Duke of Durham and Cameo brands, using huge newspaper ads and billboard displays. By 1889, advertising and promotion outlays amounted to about 20 percent of sales, an unusually high level within the tobacco industry.

In 1884, Duke began to operate a new factory in New York and to control the

northern and western parts of the U.S. market. Price cuts and competitive advertising intensified among his and four other major cigarette manufacturers: Allen & Ginter, Kinney Tobacco Company, William S. Kimball & Company, and Goodwin & Company. In 1890, Duke took advantage of the New Jersey incorporation law of 1889 to organize a merger with those other four major cigarette manufacturers to form the American Tobacco Company. With $25 million in capital, the new company immediately became one of the biggest "trust" or holding companies in the United States. It controlled nearly 90 percent of all domestic cigarette sales.

American Tobacco continued to expand its spending on cigarette advertising, with expenditures exceeding $4 million in 1910. Its competitive prices were the result of Duke's efficient management, which kept operating costs substantially below those of most competitors. Duke's cost-cutting practices included hiring nonunion labor at a wage rate lower than its union counterpart; an exclusive contract with the Bonsack Company for its cigarette-making machines, which cut production costs by fifteen to twenty-five cents per thousand cigarettes; vertical integration through forming extensive networks to perform all functions from purchasing leaf tobacco to warehouse storage to marketing cigarettes through its tobacco product retail chain, the United Cigar Store (which replaced the old industry method of using traveling salespersons); and discontinuing less profitable brands and closing less efficient factories.

By 1900, American Tobacco's profits had risen to be more than half of sales. As public tastes switched to Turkish tobacco, however, American Tobacco's cigarettes declined in popularity. Duke fought back with his own Turkish brands, regaining a market share of 85 percent of cigarette sales by 1910. Market shares for the company's smoking and chewing tobacco also increased, to more than 75 percent of the U.S. market.

American Tobacco bought out about 250 of its competitors before its dissolution in 1911. In 1898, Duke had organized a combination of tobacco plug manufacturers, the Continental Tobacco Company. In 1901, the American and Continental companies were consolidated into the Consolidated Tobacco Company, a holding company that was soon dissolved and reorganized under the original name of the American Tobacco Company. In 1901, it stretched its market power overseas to England by buying Ogden's Limited of Liverpool, a leading British cigarette manufacturer. One year later, Duke negotiated with the Imperial Tobacco Company to form the British-American Tobacco Company to operate in overseas markets.

The success of American Tobacco in the cigarette market did not prevent Duke from diversifying into other tobacco-related products. He waged the so-called "Plug Wars" by acquiring plug and smoking tobacco manufacturers including Liggett & Myers Tobacco Company and R. J. Reynolds Tobacco Company. In conjunction with its massive advertising campaign, it deliberately sold various "fighting brands" at prices below cost in order to bankrupt competitors. As American Tobacco became the monopoly in the market, advertising intensity subsided to less than 10 percent of sales.

Before American Tobacco was dissolved by order of the Supreme Court, the company had acquired approximately 95 percent of sales of snuff, 85 percent of

chewing tobacco and cigarettes, and 75 percent of smoking tobacco. By the end of the nineteenth century, the growth and practices of large trusts, especially those in the oil, sugar, and tobacco industries, had brought the attention of the U.S. Department of Justice, which sought to restore competition in the marketplace.

In 1890, the first major U.S. antitrust legislation, the Sherman Antitrust Act, written by Senator John Sherman, was passed. It outlawed any restraints of trade (section 1) and attempts or conspiracy among competitors to monopolize a market (section 2). The antitrust campaign was intensified by President Theodore Roosevelt. On July 19, 1907, after one of American Tobacco's subsidiaries was indicted for price fixing in District Court for the Southern District of New York, the Justice Department filed a petition against the entire tobacco trust for violating sections 1 and 2 of the Sherman Act.

In November, 1908, American Tobacco was ruled guilty in a three-to-one vote. The decision was not finalized until May 29, 1911, when the Supreme Court sustained the lower court's verdict. Supreme Court Chief Justice Edward White, following logic developed in the ruling against Standard Oil two weeks earlier, used the "rule of reason" principle to find American Tobacco guilty of monopolizing the cigarette industry. The "rule of reason" stated that monopolies were not necessarily unlawful; they violated the law only by acting "unreasonably." White expressed his opinion that the "undisputed" evidence of "unreasonable" business practices was overwhelming. This evidence included the original formation of the tobacco trust by buying out its competitors, the use of the trust's power to further monopolize the trade in tobacco and the plug and snuff business using below-cost pricing, its attempt to conceal its practices through secret agreements and creation of brands falsely promoted as independent, its practice of vertical integration with wholesalers and leaf tobacco suppliers to blockade the entry of others into the tobacco trade, and price fixing with some formerly independent tobacco companies.

The case resulted in a dissolution decree, issued in November, 1911. The circuit court was directed to form a plan to dissolve the trust and form a new decentralized market structure. As a result, American Tobacco was split into sixteen successor companies, including a new American Tobacco Company, Liggett & Myers Tobacco Company, P. Lorillard Company, R. J. Reynolds Company, and the American Snuff Company. It was dissolved from its purchasing subsidiaries and separated from Imperial Tobacco, its overseas subsidiary.

Impact of Event

Along with the Standard Oil case in the same year, the American Tobacco case significantly altered the course of both the U.S. history of big business and the development of antitrust law. The victory of the U.S. government in these two cases highlighted its efforts to promote competition in U.S. markets.

As for the tobacco industry, however, American Tobacco's successor companies continued to have considerable market power. The dissolution decree gave the new American Tobacco, Liggett & Myers, Lorillard, and Reynolds a combined 80 percent

of the smoking and chewing tobacco facilities of that time. Despite declining profits, the successor companies continued to increase advertising spending, which exceeded $10 million in 1912. Their total sales increased from the old American Tobacco's $6.9 billion in 1910 to $11.8 billion in 1912.

In October, 1912, in response to declining market shares, four of the independent companies formed Tobacco Products Corporation. The new trust soon was joined by six more independents. Because the government concentrated its attention on American Tobacco's successor companies after the dissolution decree, the case actually gave birth to other industrial combinations. The next few decades witnessed the rise of Brown & Williamson Tobacco Company and Philip Morris Company, the latter of which grew to become the biggest U.S. tobacco manufacturer by 1990.

In the 1911 Supreme Court decision against American Tobacco, Chief Justice White explained his interpretation and application of the Sherman Act, arguing that not all restraints of trade were violations of the antitrust law, only the "unreasonable" ones. White emphasized that it was not the mere size of American Tobacco in relation to its market that the court condemned but the evidence of its "unreasonable" restraints of trade. The new doctrine, known as the "rule of reason," set a precedent for a new antitrust era of Court decisions. The rule of reason stayed in force until the Alcoa case in 1945.

The Supreme court ruling illustrated the need for additional legislation that would define specific business practices that were "unreasonable" and thus illegal. That need led to passage of the Clayton Act and the Federal Trade Commission Act in 1914, which respectively declared specific business practices, including attempts to monopolize through mergers and acquisitions, to be "unfair" and gave birth to the Federal Trade Commission as an agency to enforce compliance with the modified antitrust law. In 1938, the Wheeler-Lea Amendment to the Federal Trade Commission Act was passed to give the Federal Trade Commission authority over consumer protection matters.

The dissolution of American Tobacco transformed the structure of the U.S. tobacco industry from a near monopoly to an oligopolistic structure with a few large companies. That character prevailed until the end of the century. The dissolution of American Tobacco immediately resulted in increased competition among its successor companies. Product variety and advertising and promotional efforts increased in attempts to increase brand loyalty. The average advertising expenses in the tobacco industry doubled in the two years following the dissolution. In 1913, Richard Reynolds II of R. J. Reynolds Tobacco Company introduced a new brand of cigarettes, Camel. Lorillard responded with its Tiger brand in 1915 and Old Gold in 1926, American Tobacco with Lucky Strike in 1916, and Liggett & Myers with Chesterfield in 1920.

The American Tobacco case, along with the Standard Oil case, signified the government's negative attitude toward merger and acquisition activities. Mergers appeared to level off until the government's failure in prosecuting the merger practices of U.S. Steel in 1920. As for the tobacco industry, even though competition increased with the rise of Brown & Williamson Tobacco Company and Philip Morris Tobacco

Company, the biggest three successor companies to American Tobacco—the new American Tobacco, Reynolds, and Liggett & Myers—still maintained considerable market power, as a group controlling between 65 and 90 percent of the U.S. tobacco product sales during the next two decades. Such a market without major entry became the main evidence used by the Supreme Court to convict the largest three successor companies of conspiracy in monopolization and restraint of trade in 1946.

The practices of the American Tobacco Company contributed important lessons not only in the development of antitrust law but also in the role of marketing and advertising in business practices. Tactics innovated by James Duke and later by American Tobacco's successor companies, including heavy use of advertising, disseminated to other markets for nearly identical products, such as the market for gasoline. Consequently, in 1938, the government stepped in with passage of the Wheeler-Lea Act, which gave the Federal Trade Commission jurisdiction to regulate advertising and promotional activities.

Bibliography

Adams, Walter, ed. *The Structure of American Industry.* 7th ed. New York: Macmillan, 1986. Chapter 9 provides a good coverage of the development of the tobacco industry as well as discussions of the industry's structure, price behavior, and performance. Valuable for undergraduate and graduate students in industrial organization.

Armentano, Dominick T. *Antitrust and Monopoly: Anatomy of a Policy Failure.* New York: John Wiley & Sons, 1982. Covers major antitrust lawsuits since the Sherman Act. Discusses their relationship to economic theory and the development of antitrust legislation. Covers the American Tobacco case in Chapter 4. Includes an appendix of relevant sections of antitrust laws. Written for undergraduate business and economics students.

Cox, Reavis. *Competition in the American Tobacco Industry, 1911-1932.* New York: Columbia University Press, 1933. A good study of the performance and competition among the major tobacco companies.

Nicholls, William H. *Price Policies in the Cigarette Industry.* Nashville, Tenn.: Vanderbilt University Press, 1951. Contains valuable comparative price and sales statistics of major cigarette manufacturing companies.

Porter, Patrick G. "Origins of the American Tobacco Company." *Business History Review* 43 (Spring, 1969): 59-76. A concise historical study of the tobacco company until its dissolution in 1911. Porter draws comparisons with the oil industry.

Tennant, Richard B. *The American Cigarette Industry* New Haven, Conn.: Yale University Press, 1950. A detailed history of the cigarette industry through the 1940's. Includes analysis of market behavior using economic models and statistical regression analysis. An excellent business or economics case study for the undergraduate level.

U.S. Bureau of Corporations. *Report of the Commissioner of Corporations on the Tobacco Industry.* Washington D. C., Government Printing Office, 1908-1909.

Reports on a government investigation of the tobacco industry, particularly the American Tobacco Company.

Whitney, Simon N. *Antitrust Policies: American Experience in Twenty Industries.* 2 vols. New York: Twentieth Century Fund, 1958. Chapter 11 of volume 2 provides in-depth discussion of the tobacco industry from different perspectives, including its price and product competition and its performance that resulted in the second antitrust lawsuit. Other chapters are case studies of other major industries. The appendix contains critiques of the studies by economists and government officials.

Jim Lee

Cross-References

Tobacco Companies Unite to Split World Markets (1902), p. 57; The Supreme Court Decides to Break Up Standard Oil (1911), p. 206; The Federal Trade Commission Is Organized (1914), p. 269; Congress Passes the Clayton Antitrust Act (1914), p. 275; The Supreme Court Rules in the U.S. Steel Antitrust Case (1920), p. 346; The Wheeler-Lea Act Broadens FTC Control over Advertising (1938), p. 775; The U.S. Government Bans Cigarette Ads on Broadcast Media (1970), p. 1443; R. J. Reynolds Introduces Premier, a Smokeless Cigarette (1988), p. 1976.

PARLIAMENT NATIONALIZES THE BRITISH TELEPHONE SYSTEM

Category of event: Government and business
Time: December 31, 1911
Locale: London, England

After many decades of rancorous discussion, Parliament nationalized the telephone service in the United Kingdom, putting its administration under the Post Office

Principal personages:

HENRY FAWCETT (1833-1884), the postmaster general, 1880-1884

GEORGE HERBERT MURRAY (1849-1936), the secretary to the Post Office, appointed in 1899

MICHAEL EDWARD HICKS BEACH (1837-1916), the chancellor of the exchequer, 1895-1902

AUSTEN CHAMBERLAIN (1863-1937), the postmaster general, 1902, and chancellor of the exchequer, 1903-1905

DAVID LLOYD GEORGE (1863-1945), the chancellor of the exchequer, 1908-1915

HERBERT SAMUEL (1870-1963), the postmaster general, 1910-1911

HENRY BABINGTON SMITH (1863-1923), the secretary to the Post Office, 1903-1909

GEORGE EVELYN MURRAY (1880-1947), the secretary to the Post Office, 1914-1934

Summary of Event

At the end of 1911, after years of debate, discussion, and argument, the British Post Office was given the responsibility for operating the national telephone system. Beginning in 1912, with minor exceptions, a single government institution provided all the telephone service for Great Britain.

Some hoped that this change from private to government ownership and control would result in more efficient and extensive service and increased technical modernization. Some predicted that the cost to consumers would decrease. Others hoped that business would benefit. Even many of those who favored nationalization, however, were not convinced that any significant improvement would suddenly take place. Instead, they saw no alternative, given the past failures of the existing system of telephone service in the United Kingdom in comparison to other countries.

The nationalization of telephone service in 1911 was not a sudden or radical departure. The telephone was introduced into the United Kingdom in the 1870's, shortly after the first successful transmission by Alexander Graham Bell in 1876. Much publicity resulted, and even Queen Victoria wished to make use of the new technology.

Government takeover of telephone service had antecedents in the nationalization of the several privately owned telegraph companies, which had been placed under the auspices of the Post Office. In spite of the prevailing laissez-faire liberalism of the time, by the 1860's many politicians in both major parties supported government ownership of the telegraph. The reasons were varied. A government-operated monopoly could benefit from economies of scale. Some Post Office officials were inspired by their success with mail delivery and wished to venture into new areas such as the telegraph. Others claimed that lower and uniform rates for business and consumer users would come with government ownership. Still others noted the success of state-owned systems, such as those in Belgium and Switzerland. To many, it seemed obvious that the kingdom should have a unified telegraph system. The importance of such a system was made apparent in the American Civil War and the Austro-Prussian War. The spark that led to nationalization was an increase in rates by the private companies that resulted in considerable public outrage. Parliament enthusiastically supported nationalization in 1869, not because the members approved of state ownership and control in principle but because it was the solution to the particular issues associated with the telegraph.

By the end of the 1870's, the Post Office was concerned about the implications of the new telephone technology and its potential impact upon revenues, particularly if it began to replace the telegraph. Private firms soon entered the field, some cooperating with the Post Office and some not. By 1879, it was decided to allow private development of the telephone under Post Office license. When several private companies objected to obtaining licenses, the government filed suit, winning a judgment in 1880 confirming that the telephone fell within the scope of the 1869 law establishing government ownership and operation of the telegraph. This would later be the basis for public ownership of the wireless (radio) and television.

Post Office officials saw the advantages of telephone development but differed in opinion regarding whether the initiative should remain solely in private hands, the Post Office should compete with business, or the new technology should be nationalized, as the telegraph system had been only a few years earlier. These three alternatives were discussed for decades. In 1880, the licensing system was adopted, with licenses to run for thirty-one years, with a clause allowing the government to cancel the licenses before that date. The issue of whether the Post Office should compete with the private companies was another matter. The decision was something of a muddle, with a small Post Office telephone operation and various private telephone companies all providing service.

One of the justifications for allowing business to take the lead was the belief that government operations were costly and not as efficient as private enterprise. Competition among numerous private firms was expected to advance the progress of the telephone, both in use and technology. The hoped-for developments through government licensing did not occur. The companies resented paying royalties to the government. In addition, private competition soon gave way to a private monopoly when a number of companies were brought together in the National Telephone Company

(NTC). Some critics predicted that with no competition there would be no improvement. The options were competition from the Post Office in order to spur the NTC into greater progress and the creation of a government-owned monopoly. A parliamentary proposal to nationalize the telephone was defeated in 1892 by a vote of 205 to 147, but much of the opposition to nationalization was based less on philosophy and principle than on the financial cost, particularly if nationalization occurred before the licenses expired in 1911.

In the 1890's, a new factor complicated the situation. Certain municipalities wanted to establish their own telephone systems, relying neither on the private NTC system nor on the possibility of a government monopoly run by the Post Office. Critics of these plans argued that local development would never result in an efficient national system, which could come about only through a monopoly, either public or private. Inasmuch as many critics claimed that the NTC was failing to provide adequate service, nationalization seemed to be the inevitable alternative to either private monopoly or municipal control.

There was no great enthusiasm for government ownership and operation. In the 1860's, British optimism saw the nationalization of the telegraph as a great step forward in progress. By the beginning of the twentieth century, many feared that Great Britain was falling behind in technology as Germany and the United States advanced. This widespread pessimism led some critics to argue that there was no rational choice except nationalization, because the existing private monopoly was not working and something had to be done.

In 1902, in a compromise measure, the government agreed to take over the NTC's London operations when the license expired in 1911. In the interim, the Post Office and the NTC would cooperate in meeting London's telephone needs. The final step was taken in 1905, when it was decided that the government would nationalize the National Telephone Company when its license expired at the end of 1911.

That decision was made not in any hope or expectation that there would be great improvement and rapid development of the telephone in Great Britain. There simply seemed to be no satisfactory alternative. The NTC was failing to provide the minimum service necessary, even in the eyes of the numerous critics who saw little future in the telephone except as a novelty for the upper classes. The agreement was ratified by the House of Commons in August, 1905, by a vote of 187 to 110. On the last day of 1911, the Post Office was given control of telephones throughout the United Kingdom.

Impact of Event

Government ownership and control of telephone facilities, beginning in 1912, led to little change. Some critics of the NTC had hoped that quick progress would result, benefiting both business users and those using the telephone for personal matters. Most people who favored and who had urged the nationalization of telephone service had not envisioned a radical departure from the past. They saw nationalization as a necessity brought about because the existing system was inadequate, not because of any utopian transformation expected to occur.

Many politicians still saw the telephone as a novelty rather than as a necessity. There was little of the enthusiasm that had existed when the telegraph was nationalized, concerning the benefits that would accrue to all social classes, how economic prosperity would result, or how the telephone could further unify the country. Some business organizations hoped for an expansion of telephone service and a reduction in rates, but most Post Office officials and their political colleagues in Parliament lacked the vision to see the crucial significance of the telephone, and were more concerned about the costs to the government than about the benefits to business. Members of Parliament often represented rural interests and were themselves members of old landed families; business and trade were still suspect in the British ruling class.

Critics frequently complained about the slow progress made after nationalization, pointing out that the system was failing to assist commerce and contrasting the British system, which had changed little after 1911, with the telephone facilities available in the United States. The telephone systems in America were largely private, but the issues for most critics involved not public versus private ownership and operation but service, efficiency, and development.

The problems facing the Post Office after nationalization were formidable. The prevailing attitude among politicians and Post Office administrators was caution, not boldness. The most notable change was financial. The costs involved in the takeover of the National Telephone Company were significant, not so much for payment for the resources of the NTC but for wages. When former NTC workers transferred to the Post Office, their salaries increased, fulfilling a prediction by some opponents of nationalization. In addition, most of the facilities bought from the NTC were outmoded or in need of replacement.

World War I delayed telephone development in the United Kingdom. The war emergency did not allow planning of telephone facilities, and thirteen thousand telephone workers joined the military. There was little concerted progress even after the war ended. Secretary to the Post Office George Evelyn Murray, the director of the system, saw the responsibility of the Post Office as merely meeting existing needs, not pursuing developmental opportunities. The result was that by 1921 there was only one telephone for every forty-seven persons in the United Kingdom, in contrast to one for every eight persons in the United States.

The policy of drift continued throughout the 1920's. Politicians and other critics frequently discussed the continuing inadequacies in telephone service and development, but to little avail. In 1932, twenty years after nationalization, Viscount R. C. P. Wolmer, a member of Parliament, noted that the history of the telephone system under government ownership "has been one of sedate development," with increasingly slower rates of growth. He blamed inefficient management by the Post Office, a complaint similar to many made about the National Telephone Company in the era before telephone service was nationalized.

Little changed in Great Britain as the result of the 1911 nationalization. The British example had little impact elsewhere, particularly in the United States, where the use

of the telephone was more widespread and the service more extensive, both for business and for private individuals. There was little support for nationalization in the United States. The progressive movement was at its apogee when the British Post Office took over telephone service in the United Kingdom, but neither of the liberal reform presidents, Theodore Roosevelt and Woodrow Wilson, was enticed by public ownership. Roosevelt's New Nationalism favored strict government regulation of business, and Wilson's New Freedom looked to antitrust laws to make business responsive to the needs of the public. In 1913, the Wilson Administration forced the gigantic American Telephone and Telegraph Company to agree not to acquire any existing telephone companies or facilities, thus placing some limits on its monopoly status. In retrospect, the nationalization of the telephone system in Great Britain offered some promise but had few consequences. It stands as an example and case study of nationalization, showing neither great harms nor great benefits, calming debates about other nationalization worldwide.

Bibliography

Baldwin, F. G. C. *The History of the Telephone in the United Kingdom*. London: Chapman & Hall, 1925. This exhaustive work, written by a Post Office engineer, is a comprehensive study of the development of the telephone in Great Britain from the perspective of an insider. Although dated, it is nevertheless a useful volume.

Crutchley, E. T. *G.P.O.* Cambridge, England: Cambridge University Press, 1938. This volume was one in a series on "English institutions." Relating the story of the General Post Office from even before its inception in the nineteenth century, the author includes a discussion of the development of the telephone within the wider context of the Post Office.

Link, Arthur S. *Woodrow Wilson and the Progressive Era, 1910-1917*. New York: Harper, 1954. This important work in the prestigious "The New American Nation Series" tells the story of an important reform era in America. The reform movement did not use nationalization as a tool of government policy.

Mowry, George E. *The Era of Theodore Roosevelt, 1900-1912*. New York: Harper, 1958. Another volume in "The New American Nation Series," this work covers the presidency of Theodore Roosevelt and includes a discussion of Roosevelt's attitudes and practices regarding business monopoly. Again, nationalization was considered as a realistic alternative.

Murray, George Evelyn Pemberton, Sir. *The Post Office*. London: G. P. Putnam's Sons, 1927. Murray, secretary to the Post Office from 1914 to 1934, was the chief administrator under the postmaster general. In his discussion of the telephone, he focuses on the years after nationalization, defending the accomplishments made during a difficult era.

Perry, C. R. *The Victorian Post Office: The Growth of a Bureaucracy*. Rochester, N.Y.: Boydell Press, 1992. This illuminating work indicates how most decisions concerning the nationalization of the telegraph and telephone were internal matters relatively unaffected by outside pressures.

Robertson, J. H. *The Story of the Telephone*. London: Scientific Book Club, 1948. This brief and readable history of the telecommunications industry in Great Britain carries the story of the telephone and its significance through World War II.

Wolmer, R. C. P. *Post Office Reform: Its Importance and Practicability*. London: Ivor Nicholson & Watson, 1932. Wolmer is extremely critical of Post Office operations, including the telephone system. He primarily blames the bureaucracy for the failure of the British telephone system to meet the standards and accomplishments of foreign systems, including those in the United States.

Eugene Larson

Cross-References

The BBC Begins Television Broadcasting (1936), p. 758; A British Labour Party Victory Leads to Takeovers of Industry (1945), p. 857; Great Britain Passes the National Health Service Act (1946), p. 885; AT&T Is Ordered to Reduce Charges (1967), p. 1325; Great Britain Announces Plans to Privatize British Telecom (1982), p. 1831.

THE FULLER BRUSH COMPANY IS INCORPORATED

Categories of event: Foundings and dissolutions; marketing
Time: 1913
Locale: Hartford, Connecticut

Guided by the moral principles of its founder, the Fuller Brush Company transformed the image of house-to-house salespeople and introduced new selling techniques to the business world

> *Principal personages:*
> ALFRED CARL FULLER (1885-1973), the founder and first president of the Fuller Brush Company
> HOWARD FULLER (1913-1959), the elder son of Alfred Fuller and second president of the company
> AVARD E. FULLER (1918-1992), the younger son of Alfred Fuller and third president of the company
> MARY BAKER EDDY (1821-1910), the founder of the Church of Christ, Scientist, whose writings on Christian Science had a profound influence on Alfred Fuller's life and business practices

Summary of Event

Alfred Fuller's life story would have made a satisfactory plot for one of Horatio Alger's rags-to-riches novels. Fuller was a shy, awkward, uneducated young man reared on a subsistence farm in Nova Scotia. He failed at several jobs before discovering that he had a talent for making and selling brushes.

Fuller estimated that the typical household in the early part of the twentieth century used as many as eighty brushes, including toothbrushes, nail brushes, hair brushes, clothes brushes, shoe brushes, brushes for scrubbing pots and pans, brushes for currying horses and grooming other animals, brushes for basting, brushes for scrubbing potatoes and other vegetables, and brushes for cleaning up the kitchen and the rest of the house. He conceived of the idea of a business concentrating solely on brushes, an early example of the principle of specialization refined to a considerable extent by American entrepreneurs.

Fuller was reared by strict parents who taught their children the importance of integrity, self-discipline, industry, and religious faith. At an early age, he became acquainted with the teachings of Mary Baker Eddy and remained a devout Christian Scientist throughout his life. He applied strict moral standards to every aspect of his business, demanding the same qualities from his subordinates.

Door-to-door salespeople, historically called peddlers and drummers, had a bad reputation in the United States because so many had victimized the public by selling shoddy merchandise ever since the days of the original English colonies. Many peddlers were outright scoundrels looking for opportunities to commit burglaries,

rapes, and other crimes. Alfred Fuller's high moral standards, more than any managerial feature, were responsible for the success of the Fuller Brush Company, as he imposed the same standards on his sales force. Many American women who would have nothing to do with other house-to-house salespeople would welcome the "Fuller Brush man" (salespeople were all male) into their homes because they regarded him as a trustworthy neighbor who sold the most reliable products of their kind.

When the business was still in its infancy and Fuller was still making his own brushes in his little shop in Hartford, Connecticut, he had the idea of advertising in a national magazine to recruit sales personnel. This proved to be the best merchandising idea he ever had. He was astonished by the response. "That little ad changed the whole thing from a one-man effort to a company operating nation-wide," he said. Practically overnight, and with virtually no capital, he built up a network of dealers. The dealers were not employees but instead independent operators assigned exclusive rights to specific territories, so Fuller did not have to worry about payroll expenses for them. It was not until Fuller received the huge response to his recruiting ads that he decided to incorporate as the Fuller Brush Company in 1913.

The Fuller Brush men bought their merchandise from the company and sold it at company-authorized prices to the people within their own territories, averaging a 30 percent profit. The representatives had an agreement with the company to sell nothing but Fuller products, and in turn the company guaranteed the quality of each item and gave dealers the benefits of national advertising. This was one of the earliest examples of the idea of franchising, which has since been applied to countless other types of enterprises.

Fuller's success nearly overwhelmed him. He suddenly had more orders for his brushes than he was able to fill. Many of his representatives earned more money than they had at any other job. The typical Fuller Brush man was an ambitious individualist who liked being his own boss and being compensated in proportion to his efforts.

In order to keep control of his rapidly growing business, Fuller had to employ people to supervise the twin aspects of his enterprise, production and sales. In addition to supervising and motivating the far-flung army of sales representatives, his executives worked hard to improve manufacturing methods. They strived to provide better products at lower prices as well as to create new kinds of brushes to fit every conceivable need. The fact that the Fuller Brush man was always able to show new items when he called on his regular rounds made for more enthusiastic reception. Fuller was one of the earliest American entrepreneurs to understand the importance of giving "news value" to familiar products. The company eventually added such products as waxes and polishes, and in 1948 it began employing women, called "Fullerettes," who offered a line of cosmetics.

Alfred Fuller also conceived the brilliant idea of overcoming sales resistance and circumventing the many local antipeddler laws by having his representatives give housewives free gifts every time they called. This "giveaway" idea has been imitated widely and is still effective in generating sales and goodwill.

The company remained in business but was absorbed as a subsidiary of the Sara

Lee Corporation. Although its glory days are over, the Fuller Brush Company remains a legend in the world of business and commerce for its innovative methods and phenomenal success.

Impact of Event

The Fuller Brush Company, under the leadership of Alfred C. Fuller and his two sons, Howard and Avard, who succeeded him as presidents of the company, contributed many important ideas to American business. Perhaps the most important was the idea of specialization. Not only did the company specialize in selling brushes, but it also devoted intense effort to developing new kinds of brushes for every conceivable purpose. Modern consumers are offered a nearly infinite variety of highly specialized tools, appliances, and other gadgets, and more are being invented and marketed every year. The Fuller Brush Company set an early example of achieving success through understanding its customers' needs and using ingenuity to satisfy them.

The Fuller Brush Company was one of the first business firms to utilize the concept of franchising. Its representatives were not employees but independent dealers who were assigned specific territories in which they had the exclusive right to sell Fuller products. Franchising revolutionized American business and changed the American business landscape. McDonald's fast food restaurants provide an excellent example of the power of franchising, with their familiar logo and golden arches in every corner of the land. People patronize these establishments because they can depend on getting the same quality of food and service wherever they go. There are franchise real estate dealers, franchise barbershops, franchise hardware stores, and many other types of franchise businesses, all independently owned but operating under the same name and following operating guidelines laid down by the parent company.

The Fuller management realized that strict control of far-flung franchises was essential to maintaining the company's reputation for quality and integrity. The company pioneered in the art of maintaining communication with its representatives, teaching them improved selling techniques and offering frequent motivational talks to ensure continued high performance. This was done through literature and directly through regional sales representatives.

Similar motivational techniques and ongoing sales education programs can be observed in many of America's largest corporations. Motivational speakers still refer to the Fuller Brush man as an outstanding example of the professional salesperson who knew how to be aggressive without becoming obnoxious, who believed in what he was selling, who took pride in his profession, who believed in the principles of the American free enterprise system, and who was willing to work hard for his legitimate rewards.

The Fuller Brush Company pioneered in studying and teaching sales psychology. Fuller Brush men are still legendary in the business world for their ability to achieve success in selling from house to house, an occupation that historically has a huge turnover rate because only rare individuals are strong enough to put up with barking dogs and doors being slammed in their faces. The company developed a sophisticated

recruitment and training program because management discovered that only two out of seven new dealers had the necessary qualities to prosper in the field. The company also pioneered in establishing rigid ethical and performance standards for its representatives through a system of field managers and district supervisors.

Alfred Fuller himself remains an inspiration to American business because he was able to rise to wealth and social prominence with little education, almost no capital, and few social connections. Fuller had worked as a door-to-door salesman himself and understood what his representatives were up against. He never forgot what he owed to the men on the "firing line." He and his managerial staff developed dozens of new techniques for gaining entrance to people's homes, for winning confidence, for coping with sales resistance, and for maintaining courage and confidence in the face of rudeness and rejection.

The idea of giving free gifts on every visit was a stroke of genius on the part of the company's founder. Although door-to-door selling has declined in importance as a method of selling merchandise, the concept of free gifts has been imitated by many types of businesses. Promotional calendars and keychains, trading stamps, and various kinds of coupons are common examples. Fuller taught American businesspeople the importance of building a friendly company image in order to generate repeat sales.

The company gradually declined in importance in the decades following World War II. A number of factors contributed to its demise, including the proliferation of supermarkets, the appearance of more efficient competitors such as the Avon Company, the abundance of inexpensive automobiles that gave housewives more mobility, and the development of other forms of marketing such as direct-mail selling, home shopping services, and discount stores. Another important reason for the company's decline was the entrance of millions of women into the labor market, leaving no one at home to answer the door. Although the Fuller Brush Company was still in business eighty years after its founding, it had been taken over by the Sara Lee Corporation in 1968, and no member of the Fuller family was involved in its operation.

Bibliography

Bainbridge, John. "May I Just Step Inside." *The New Yorker* 24 (November 13, 1948): 36-48. An in-depth profile of Alfred C. Fuller. Contains shrewd insights into the personalities of Fuller and other company executives. Offers an overview of the Fuller Brush Company from its inception to its peak period in the late 1940's.

Carnegie, Dale. *How to Win Friends and Influence People.* Rev. ed. New York: Simon and Schuster, 1981. The most famous book ever written on the subject of using an understanding of human psychology in order to achieve success. Incorporates many of the ideas originally developed by the Fuller Brush Company. The book has had an enormous influence on American entrepreneurs and professionals.

Carson, Gerald. "The Fuller Brush Man." *American Heritage* 37 (August/September, 1986): 26-31. A retrospective article about the days when the Fuller Brush Company was a nationally famous institution and its dealers were the subject of many cartoons satirizing their notorious persistence and the incredible variety of oddly

shaped brushes they had to offer. Contains much valuable information about the company and its golden era.

Fuller, Alfred Carl, as told to Hartzell Spence. *A Foot in the Door: The Life Appraisal of the Original Fuller Brush Man.* New York: McGraw-Hill, 1960. The life story of the man who founded the Fuller Brush Company, told in an interesting conversational manner and full of anecdotes about Fuller's own experiences as well as information on general business conditions during the first half of the twentieth century. Fuller offers much valuable practical advice to young people entering the business world. The best available book about the Fuller Brush Company.

"The Fuller Brush Company." *Fortune* 18 (October, 1938): 69-73, 100-104. Attempts to explain the phenomenal success of the Fuller Brush Company. Covers such aspects of management as motivation, compensating for employee attrition, and teaching door-to-door selling techniques. Publicity of this type inspired emulation by other businesspeople.

Lifskey, Earl. *Door-to-Door Selling: The Factual Story of a Little Known but Rapidly Growing $7 Billion Industry.* New York: Fairchild, 1948. Reprints of feature articles that originally appeared in *Retailing Daily* in the 1940's. Recognizes the growing importance of door-to-door selling in the rapidly expanding American economy. Discusses the techniques used by Fuller Brush dealers to overcome sales resistance and enhance the image of the Fuller Brush line of products.

"Never Say Quit to Charlie Tucker or He's Likely to Give You the Brush." *People Weekly* 32 (July 10, 1989): 106-107. A brief, nostalgic profile of the oldest living Fuller Brush salesman, who at ninety years of age was still selling brushes from door to door. Tucker exemplifies the aggressive, optimistic spirit that characterized Fuller Brush men in the company's heyday.

Bill Delaney

Cross-References

Walter Dill Scott Publishes *The Theory of Advertising* (1903), p. 80; Invention of the Slug Rejector Spreads Use of Vending Machines (1930's), p. 579; Kroc Agrees to Franchise McDonald's (1954), p. 1025; Drive-Through Services Proliferate (1970's), p. 1406; Price Club Introduces the Warehouse Club Concept (1976), p. 1621; Video Rental Outlets Gain Popularity (1980's), p.1745; A Home Shopping Service Is Offered on Cable Television (1985), p.1909.

ADVERTISERS ADOPT A TRUTH IN ADVERTISING CODE

Category of event: Advertising
Time: August, 1913
Locale: Baltimore, Maryland

The Associated Advertising Clubs of America adopted "A Business Creed" in the hope that other organizations would adhere to similar high standards

Principal personages:
JOSEPH SWAGAR SHERLEY (1871-1941), a congressman from Kentucky who introduced a measure to amend the Pure Food and Drug Act
JAMES ROBERT MANN (1856-1922), a congressman from Illinois who made significant contributions to modifying Sherley's amendment
JOSEPH HAMPTON MOORE (1864-1950), a congressman active in development of the Sherley Amendment

Summary of Event

Adoption of a truth in advertising code by the Associated Advertising Clubs of America in 1913 was prompted by passage of the Sherley Amendment to the Pure Food and Drug Act of 1906. To better understand the significance of that 1912 amendment, it is necessary to review how the original act came into being. The purpose of the original act was to prevent the manufacture, sale, or transportation of adulterated, misbranded, or deleterious foods, drugs, medicines, and liquors. The act also intended to regulate traffic in foods, drugs, and medicine.

In section 8 of the 1906 Pure Food and Drug Act, the term "misbranded" applied to all drugs, articles of food, or individual contents as well as packages or labels that bore any statement, design, or device regarding the ingredients or contents. The term "misbranded" also referred to any imitation or substitution. An item would be identified as "misbranded" if its label failed to state the quantity or proportion of any alcohol, morphine, opium, cocaine, heroin, alpha or beta eucaine, chloroform, cannabis indica, chloral hydrate, or acetanilide, or any derivative or preparation of such substances. In addition, if a package did not list the proper weight and measure of the contents, it was considered to be misbranded. A package could not be false or misleading in any way. Section 8 of this act further stated that ingredients could not be imitations or substitutes for the stated contents.

Debate over House Resolution 11877 to amend the 1906 Pure Food and Drug Act took place on August 19, 1912. Congressman Joseph Hampton Moore of Pennsylvania suggested that one more addition be made to Congressman Joseph Swagar Sherley's amendment regarding statements of contents in packages. He noted that in cases of nostrums and patent medicines, the statement in regard to the ingredients or therapeutic properties usually appeared on the inside of the cover of the package or bottle. Congressman James Robert Mann from Illinois stated that the effect of

Sherley's proposed amendment was not to keep drugs off the market but to keep sellers from making false claims about the curative powers of those drugs. The Sherley Amendment to section 8 of the Pure Food and Drug Act was approved on August 23, 1912. The amendment contained a clause stating that no package should make false or fraudulent claims pertaining to curative or therapeutic effects. A further amendment was approved on March 3, 1913, to state that reasonable variations would be allowed in regard to weight, measure, and numerical count.

In August, 1913, "A Business Creed" was published by the Associated Advertising Clubs of America (AACA). The creed stated belief in the continued and persistent education of the press and public in regard to fraudulent advertising. Members of the AACA further stated a belief that each and every member owed a duty to the association of enforcing the code of morals based on truth in advertising as well as truth and integrity in all functions pertaining to the creed. The AACA creed also endorsed the work of the National Vigilance Committee, a group similar to a commission of the Associated Advertising Clubs, in its belief in the continued education of the press and public in regard to fraudulent advertising. The AACA also encouraged every advertising interest to submit problems concerning questionable advertising and to uphold the code of morals based on truth in advertising. At the date of publication of this creed, few businesses or associations had formal codes of conduct of the same sort, but many people endeavored to make business more profitable while exerting pressure to keep business activity on a higher plane than it had been.

The adoption of a truth in advertising creed following on the heels of the Sherley Amendment was timely in its intent to promote the credibility of the AACA. At the time, magazines and other advertising media contained much material of dubious truth. Business suffered from mistrust by the buying public. Buyers often were taken in by false claims, some of which carried the potential for harm, as claims of cures or other benefits were made. The public was tired of throwing money away on false hopes, and this attitude was bad for business, as the members of the AACA well knew.

Impact of Event

Recognition of advertising as a viable means of widespread communication came around the beginning of the nineteenth century. The Industrial Revolution gave rise to the need to promote the abundant manufactured goods then being produced. Advertising as a profession developed in response to this need. As the profession grew into an industry, advertising practitioners became concerned with maintenance of high business standards. Advertising professionals saw the need to join together to protect and promote their trade. Across the United States, local organizations were formed to uphold industry standards. The aims of these associations were primarily education and self-regulation.

In 1911, the Advertising Federation of America formed a national vigilance committee and launched the truth in advertising movement, a forerunner to the Better Business Bureaus. The Advertising Association of the West entered the movement a year later. These groups worked in cooperation with each other over the years. In

1962, they held a joint convention to discuss a merger that became a reality in 1967. The new group was named the American Advertising Federation (AAF), headquartered in Washington, D.C. The AAF is dedicated to serving its members by promoting, protecting, and advancing advertising interests, including the freedom to truthfully advertise legal products. Its actions and goals rely heavily on the AACA creed as a basis.

The goals of the AAF include professional development, public education to promote awareness and understanding of how advertising contributes to the economy and society, fostering high standards of ethical conduct including truth in advertising, encouraging use of the advertising process for the public good, and recognizing and honoring excellence in advertising. The AAF upholds the high standards of the industry, including truth in advertising. It also opposes bans or restrictions on truthful, nondeceptive advertisements for legal products and services. It therefore opposed bans and restrictions on advertisements for tobacco products and alcoholic beverages.

Some consumer goods fall under the scrutiny of the Food and Drug Administration (FDA). Vitamin supplements and herbal remedies, for example, are types of products at which the Pure Food and Drug Act was aimed. Most of these products comply with "truth in advertising" to the extent that no claims are made on the labels, other than warnings. Some products, for example, warn that use can contribute to a rise in blood pressure. Labeling thus made no false claims and few claims of any sort. Information about benefits of the products must come from other sources.

A more subtle example of questionable advertising lies in the visual portrayal or image of a product. The Marlboro Man, for example, portrayed to impressionable audiences the idea that smoking is an activity undertaken by tough, masculine men. Another example is the slogan for Pepsi, "Be young, be happy, drink Pepsi." The slogan does not directly imply that drinking Pepsi will make one young and happy, but the suggestion is there. A final example comes from the young models typically used in advertisements for wrinkle cream. Such models may use the product for prevention of wrinkles; the implication of the ads, however, is that use of the product will make anyone look as young as the models. The premise of truth in advertising does not cover such subtleties. Consumer advocates also criticize packaging claims that are truthful but leave out important facts. Some food packages, for example, contain claims of having fewer calories; the fact is that the calorie reduction comes from the simple fact that there is less food in the container.

Grocery shoppers are well advised to be wary because, although there is definitely truth in advertising as far as listings of ingredients, those listings often contain chemicals that are unfamiliar to all but the most informed shoppers. The FDA has banned certain food colorings as harmful. Other ingredients, however, can cause reactions in some people but not in others. Common reactions include rashes, digestive upset, and even heart palpitations. Many people have discovered a sensitivity to monosodium glutamate (MSG), but many packaged foods as well as certain sausage preparations still contain MSG. Consumers therefore must know their own situations. Labels will identify ingredients, but full truth does not extend as far as providing a

warning that "this product may induce digestive upset." It is up to the consumer to know.

Truth in advertising codes and laws have extended to other sectors. A law firm in California was found guilty of false advertising, and an exterminating company honored a government order to produce scientific evidence for health and safety claims. One vacuum cleaner manufacturer filed suit against another to stop a campaign promoting its new cleaning effectiveness rating, which may have been misleading. It is evident that federal agencies, consumers, and the advertising profession are keeping watch to ensure that truth in advertising comes as close as possible to becoming a reality.

Bibliography

"A Business Creed." *The World's Work*, (August, 1913): 384. The Business Creed was adopted by the Associated Advertising Clubs of America in an effort to keep business and advertising on a higher plane than previously. This is the text of the creed.

Pridgen, Dee. *Consumer Protection and the Law*. New York: Clark Boardman, 1986-1990. A comprehensive account of the history of consumer protection laws. Covers relevant court decisions. Topics include seller misrepresentation and the doctrine of *caveat emptor*.

Reid, Margaret G. *Consumers and the Market*. New York: F. S. Crofts, 1938. A summary of the problems then facing consumers in such areas as labeling, product quality, advertising, and price setting. Includes specific examples and historical references.

Sullivan, Mark. "The Crusade for Pure Food." In *America Finding Herself*. Vol. 2 in *Our Times: The United States, 1900-1925*. New York: Charles Scribner's Sons, 1927-1935. An account of the personalities and controversies that led to the 1906 Pure Food and Drug Act. Sullivan consulted with many of the people involved in passage of the law.

U.S. Department of Agriculture. Office of the General Counsel. *Food and Drugs Act June 30, 1906, and Amendments of August 23, 1912 and March 3, 1913 with the Rules and Regulations for the Enforcement of the Act, Food Inspection Decisions, Selected Court Decisions, Digest of Decisions, Opinions of the Attorney General and Appendix*. Washington, D.C.: Government Printing Office, 1914. A government report detailing the passage of the Pure Food and Drug Act and its amendments.

Young, James Harvey. *Pure Food: Securing the Federal Food and Drugs Act of 1906*. Princeton, N.J.: Princeton University Press, 1989. An authority on the history of medical misconduct presents a study of the evolution of the Food and Drug Administration and development of the Pure Food and Drug Act.

Corinne Elliott

Cross-References

Walter Dill Scott Publishes *The Theory of Advertising* (1903), p. 80; The Federal Trade Commission Is Organized (1914), p. 269; The Wheeler-Lea Act Broadens FTC Control over Advertising (1938), p. 775; The U.S. Advertising Industry Organizes Self-Regulation (1971), p. 1501; The FTC Conducts Hearings on Ads Aimed at Children (1978), p. 1658.

FORD IMPLEMENTS ASSEMBLY LINE PRODUCTION

Category of event: Manufacturing
Time: October, 1913
Locale: Highland Park, Michigan

The Ford Motor Company began use of mass-production techniques to reduce costs and prices, thereby becoming the industry leader in automobile sales for a decade

Principal personages:
HENRY FORD (1863-1947), the owner of Ford Motor Company
WILLIAM S. KNUDSEN (1879-1948), the factory manager for Ford Motor Company and General Motors
CHARLES E. SORENSEN (1881-1965), the production manager for Ford Motor Company
CLARENCE AVERY (1893-1943), the time study expert for Ford Motor Company
JAMES COUZENS (1872-1947), the business manager of Ford Motor Company

Summary of Event

Introduction of the sturdy, high-wheeled Model T Ford in 1908 was followed by immediate success. Six thousand of the cars were sold in its first year. In 1910, 32,000 were sold; in 1911, 70,000; and in 1912, 170,000. Henry Ford had made a pledge to reduce the price of the car as the success of his company was realized, and he reduced the 1908 price of $850 to $600 in 1912. This made the machine competitive with the low-cost Buicks, which were priced at $850 in 1908.

In 1908, Ford's business manager James Couzens performed a market study that indicated that a price of $600 would ensure a strong competitive situation for Ford's new Model T. At the same time, his best estimate of the price that could be offered with the current production methods was $850. In order to make the new car profitable, Ford had to find ways to cut costs. Couzens enlisted the aid of Clarence Avery, a time study expert, and Charles Sorensen, the production manager at Ford, in making a study of the practices then in use, with the intention of converting to mass-production methods.

Avery made exhaustive time studies to determine the labor costs of the various subassembly steps as well as the final assembly. At the same time, Sorensen conducted mock-up tests, simulating final assembly of the Model N car, another in the Ford line, as the chassis was pushed along on skids past the points at which components were fed in.

Several things were needed to realize mass production. First, parts and subassemblies had to be reliably supplied and interchangeable. In 1908, Cadillac had demonstrated that car parts could be made with such precision that three cars could be disassembled, have their parts mixed, and then be reassembled into working vehicles

that made a successful five-hundred mile test run.

Mass production had been long practiced in firearms manufacture and in clock manufacture, as well as for other small assembled goods. Although automobiles had many more individual parts, most were not as complex nor as highly stressed as those in firearms, and they were not as dependent upon precision as those in timepieces. Ford believed that through better control of his sources for parts, including bringing many subassemblies into his works, he could satisfy requirements for precision and timely delivery.

As early as 1800, pulley blocks for the Royal Navy were produced and assembled with specialized machinery designed by Henry Maudslay. The work that specialized machinery could accomplish grew ever more complex. In 1881, cigarettes were made at the rate of 120,000 per day on a machine invented by James Bonsack. Diamond Match in 1881 had machines capable of making and packing matches automatically. In 1884, George Eastman invented a continuous-process system for coating photographic materials. By 1880, flour mills were built to move the grist from incoming bins to shipping containers in continuous-flow processes that required no human handling of the materials. In some cases, the grain processing became so inexpensive that breakfast cereals were invented to sell the surplus.

The next steps in reducing the cost of automobile manufacturing was much more difficult. Although standardized parts were available and the specialized machines to produce them had been invented, there was a need for a machine to aid in final assembly. Buick had experimented with the assembly line approach to automobile chassis assembly, moving cars along rude wooden tracks by hand. This innovation increased the production of Buicks from forty-five to two hundred per day, but it was not integrated with subassembly manufacture, nor was there any mechanical assistance to transport materials.

In the spring of 1913, William C. Klann, who was in charge of engine assembly, introduced moving belt assembly, first to assembly of the flywheel-mounted magneto, then to engine and transmission production. The moving belt system proved to be workable, but only in a one-dimensional system in which parts were fed to a single line that carried the assembled product to completion. A two-dimensional system would be needed to make mass assembly of an automobile possible; branches of subassembly lines would feed into a trunk line for the auto chassis.

To make this possible, Ford had to ensure that the "tree" would not wither for lack of parts along one "limb." He negotiated supply contracts with his subassembly suppliers based on a time-required basis. Those suppliers that he believed were unable to satisfy these requirements he purchased or replaced with subassembly shops of his own. By 1914, the company had bought more than fifteen thousand special-purpose machine tools to produce parts in Ford's own shops. In this way, Ford gradually acquired subassembly manufacturing capability for parts of his cars, beginning in some cases with raw material supply.

The first Ford automobile assembled on a moving line was built in October, 1913. The chassis was pulled along the line by a windlass and ropes. In January, 1914, the

power was switched to an endless chain drive. On February 27, Ford integrated the system into a fully conveyorized assembly line, utilizing rails to guide and support the cars, which moved past workers at a convenient height at the rate of six feet per minute.

This new line demonstrated another innovation, the desirability of which was obvious once it had been tried. Raising the assembly line to about the level of a worker's waist eliminated the need for workers to bend or squat, greatly reducing worker fatigue. Each feeder line was located at a level enabling a worker to swing or slide a part into place. Nothing ever came to rest, and nothing was lifted or carried except by machinery.

Impact of Event

Introduction of the assembly line reduced the labor time required to build a Model T from twelve hours to one and one-half. As the cost of manufacture fell, so could the price. Although sales of the car were temporarily stifled as a result of a patent infringement suit filed by George Selden, who demanded royalties for use of his engine design, sales rose from the few thousands before 1910 to millions, and the price fell from $850 in 1908 to $290 in 1926. During this period, the profits of the company rose steadily. In 1909, the company earned slightly less than $2 million. By 1913, profits exceeded $11 million. As the effects of the moving assembly process were realized, profits rose more steeply.

Ford began to encourage his workers to be part of the market for his cars. On January 4, 1914, he and Sorensen met with other executives to discuss a general wage increase. At the time, workers received a starting wage of $2 a day, and the average wage was $2.20 per day. Ford made an executive decision that wages would start at $5 a day, about double the industry average. This decision had the desired effects on morale, labor turnover, and quality of work. In addition, it made it possible for a worker to buy a Ford car in 1914 for four month's wages, thus making a potent case for the Model T being "everyman's car."

Other automobile manufacturers were shocked that Ford would take such a huge step without consulting them. In order to compete for the semiskilled labor available in the Detroit area, they had to make similar wage adjustments, but from weaker financial positions. Ford remained the industry's wage leader.

Ford's progress in reducing costs followed a learning curve of surprising regularity considering the early date at which mass production was introduced. From 1909 through 1923, the curve of price versus cumulative units sold followed a smooth slope as production increased by a factor of more than a thousand. The fact that the curve continued smoothly through the later stages of development of the Model T shows that there was continual refinement of the mass-production process. Much of this resulted from Ford expanding his business to include the earliest stages of supply, such as mining of raw materials. These acquisitions ensured a reliable supply of materials to allow mass assembly to continue without interruption. It set the style for later development of mass-produced products such as home appliances.

An important effect of mass assembly was the change in the type of labor needed. When automobiles were assembled at a single staging area, a limited number of workers could work simultaneously at each site. Each performed several tasks and brought multiple skills to the job, including the ability to correct or mend defects in the parts being assembled. As production levels rose, the necessity of accepting laborers of lesser skill levels made greater supervision necessary. Even the one-dimensional system in which a car was moved from station to station still required clusters of semiskilled workers performing multiple tasks.

The two-dimensional system meant that tasks could be separated along the line. The division of labor was limited only by the number of work stations that would fit along a production line of practical length. As each worker had fewer tasks to perform and parts became more uniform, requiring no "fitting" tasks to mount them, necessary skill levels fell. Workers could be trained quickly to perform a limited number of tasks. With this came a concomitant drop in the technical skill of supervisors, until the task of the "gang boss" shrank to mere social and time-keeping functions, allowing supervisors to oversee larger groups. In 1913, 5 percent of Ford Motor Company's labor was salaried (management); by 1921 this had fallen to 2 percent.

The division of labor into simple tasks facilitated training, since new workers needed to be taught to perform only the single tasks for which they were needed. Retraining would be necessary as the mix of tasks changed, but this would then involve seasoned workers, making the training process simpler.

A large economic effect of the new production methods was a decrease in the "residence time," the time that an automobile was in the factory under construction. Before mass assembly methods were introduced, residence time was twenty-one days for the Ford Model T. This fell to four days as the gains in efficiency of the mass assembly system were realized. This meant that the firm had less money lying idle in the form of expensive, partially completed products. This freed the company's capital for factory expansion and other improvements.

The introduction of mass assembly methods forced a change in manufacturing culture in the auto industry. In the heyday of the Model T, many cars were "assembly cars," built under the name of the factory owner from parts, and even major subassemblies such as bodies, purchased from firms not related to the assembler. There were hundreds of brand names. Outside the town where a company's factory was located, an automobile owner was vulnerable unless he or she could repair the car or find a general mechanic to do so. Mass manufacture meant that precise and interchangeable Ford parts could be shipped anywhere. Repair often meant simple replacement.

With the availability of cheap, repairable, rugged automobiles came popular travel away from cities, with their mass transit systems. With that came pressures for better roads that was so intense that the federal government was forced to take an active role in their construction and maintenance. To stimulate interest, a private organization, the Lincoln Highway Association, was formed to plan for and provide an all-weather road from coast to coast. In 1916, the Road Aid Act was passed by Congress to provide

federal funds to assist the state in improving rural roads. This was followed in 1921 by a more comprehensive federal highway act.

Bibliography

Abernathy, William, Kim Clark, and Alan Kantrow. *Industrial Renaissance.* New York: Basic Books, 1983. A compact treatise on the rise of industry in the United States, using the automobile industry as an illustration. It studies the economics of the industry from its birth and projects economic progress based on continued technological improvements.

Bruchey, Stuart. *Enterprise: The Dynamic Economy of a Free People.* Cambridge, Mass.: Harvard University Press, 1990. Bruchey presents a history of industrial enterprise from colonial times until the present, showing the effects on the American economy and culture of domestic and foreign influences. Contains much demographic and economic data in tabular form.

Chandler, Alfred. *The Visible Hand.* Cambridge, Mass.: Belknap Press, 1977. A study of the changing role of management in the burgeoning American manufacturing industry. Contains a concise history of manufacturing methods and projections of future changes in various industries as a consequence of continued changes in technical and managerial methods.

Crabb, Richard. *Birth of a Giant.* Philadelphia: Chilton, 1969. A history of the American automobile as it was affected by the talents and personalities of the men who created it. There are anecdotes, some possibly apocryphal, about the principals as well as illuminating vignettes showing their flaws and foibles. Of interest are many clear photos of early auto manufacturing and testing.

Flink, James. *The Car Culture.* Cambridge, Mass.: MIT Press, 1975. Flink presents a complete history of the manufacture of the American automobile, including design, management, financing, and marketing. Of particular interest is a thorough treatment of the effects of large-scale auto manufacture and widespread ownership upon the American culture.

Hayes, Robert. *Restoring Our Competitive Edge.* New York: Wiley, 1984. A comprehensive treatment of economic competition in manufacturing as it arises from production planning, improved processes, and technological innovation. Contains case studies of mass-production facilities and the effects of various hardware and managerial factors.

Piore, Michael. *The Second Industrial Divide.* New York: Basic Books, 1984. A study of the rise of productivity in America resulting from technological innovation. Selected corporations are studied to illustrate various elements of industrial growth. Mass production is treated separately as affecting large-scale manufacture.

Rae, John. *The American Automobile.* Chicago: University of Chicago Press, 1965. A brief, popularized history of the American automobile from its origins until the 1950's. It focuses strongly on the pioneers in the industry and their interactions.

Loring Emery

Cross-References

Tobacco Companies Unite to Split World Markets (1902), p. 57; Cadillac Demonstrates Interchangeable Parts (1908), p. 151; Sloan Develops a Structural Plan for General Motors (1920), p. 368; The Number of U.S. Automakers Falls to Forty-four (1927), p. 533; General Motors and the UAW Introduce the COLA Clause (1948) , p. 943; Sara Lee Opens an Automated Factory (1964), p. 1202; Ford Buys Jaguar (1989), p. 2007.

THE FEDERAL RESERVE ACT CREATES A U.S. CENTRAL BANK

Category of event: Finance
Time: December 23, 1913
Locale: Washington, D.C.

By establishing the Federal Reserve System, the Federal Reserve Act of 1913 provided a central banking arrangement with the potential to improve the functioning of the American economy's financial sector

Principal personages:
CARTER GLASS (1858-1946), the chairman of the House Banking Subcommittee, which formulated the act
HENRY PARKER WILLIS (1874-1937), a banking expert who assisted Glass in drafting the law; secretary of the Federal Reserve Board, 1914-1918
ROBERT LATHAM OWEN (1856-1947), the chairman of the Senate Banking Committee; coauthor of the Federal Reserve Act
PAUL MORITZ WARBURG (1868-1932), a partner in the investment bank of Kuhn, Loeb & Company; a member of the Federal Reserve Board, 1914-1918

Summary of Event

In the wake of the severe financial panic of 1907, the Aldrich-Vreeland Act of May 30, 1908, authorized emergency currency issues and established a National Monetary Commission to study the issue of permanent reform. The commission supported the Aldrich bill of 1911, calling for a banker-controlled single central bank with branches, but public opinion weighed against it. Although the Aldrich bill was not passed, it outlined the basis for the Federal Reserve Act, enacted into law on December 13, 1913. The act represented the culmination of two decades of debate on how to remedy deficiencies in the American banking system.

The preamble to the 1913 law enumerates its goals: to provide for the establishment of Federal Reserve Banks, to supply currency in amounts appropriate to the needs of the economy, to afford means of rediscounting commercial paper, and to establish more effective supervision of banking in the United States. The preamble did not mention discretionary central bank intervention intended to stabilize the economy countercyclically, but this type of intervention became commonplace. The twelve branches of the central bank were expected to operate fairly automatically. Changes in gold reserves would lead to corresponding movements in currency and credit under the rules of the international gold standard then in effect. Federal Reserve bank note and deposit liabilities would automatically expand and contract according to the volume of U.S. business activity.

Under the law, banks that were members of the Federal Reserve System would own the Federal Reserve Banks, as they would be required to purchase shares. The member banks would elect six of the nine directors of the system. The Federal Reserve Board, appointed by the president of the United States, would exercise general supervision of the system and implement policy. President Woodrow Wilson would not agree to putting full control of the system in the hands of bankers. Instead, the Federal Advisory Council would make recommendations regarding the operations of the Federal Reserve Board and the Federal Reserve Banks. The council was to be composed of twelve members, with the board of directors of each Federal Reserve Bank electing one member. All national banks, numbering about seventy-five hundred at the time, were required to join the system. Some national banks converted to state charters to avoid joining the system. State-chartered banks were permitted to join, but were not required to do so. At first, very few chose to join, but amendments to the Federal Reserve Act in 1916 made membership more attractive. In response to the amendments and to President Wilson's appeal to join the system out of patriotism, about nine hundred of the nineteen thousand state-charted banks joined by the end of 1918.

Carter Glass, chairman of the House Banking Subcommittee and a key sponsor of the act, never tired of insisting that the Federal Reserve System was not a central bank. The decentralized nature of the system, with twelve separate banks, came as a response to a deep-rooted suspicion of concentrated financial power and hostility to Wall Street financial interests. Central banking had been tried twice before in the United States with mixed success. The Federal Reserve Banks were expected to loosely supervise, rather than strictly control, the monetary system of the United States.

The boundaries of the twelve Federal Reserve Bank districts reflected convenience and how business was conducted at the time. District boundaries split twelve states. Most of Pennsylvania, for example, was in the third district, headquartered in Phila-delphia, but the western counties were in the Cleveland district. The Boston district comprised all six New England states, except for Fairfield County, Connecticut, which was part of the New York City district.

The system as a whole was under the supervision of the seven-member Federal Reserve Board, appointed by the president. It included the secretary of the treasury and the comptroller of the currency as *ex officio* members. Two of the five other members were to have experience in finance. That requirement was eliminated in 1922, when the number of freely appointed members was increased to six, so that an "agriculturalist" could be added to the board.

Charles S. Hamlin, a Boston lawyer, was the first governor, or head, of the Federal Reserve Board. Frederic Delano, a Chicago railway executive, was the first vice governor. The other appointed members were Paul Moritz Warburg, a partner in the investment banking firm of Kuhn, Loeb & Company; W. P. G. Harding, president of the First National Bank of Birmingham, Alabama; and Adolph C. Miller, professor of economics at the University of California. Miller and Hamlin remained on the board

until it was reorganized in 1936.

The amount of national bank notes issued previously had depended on the profitability of national bank ownership of government securities. By 1865, a congressional resolution had recognized the need for a paper currency that could change in its amount circulated according to the requirements of legitimate business. The Federal Reserve Act represented a shift from a bond-based to an asset-based currency reflecting the volume of commercial transactions. The amount of currency would expand and contract automatically to meet the needs of trade. To satisfy the followers of William Jennings Bryan, who opposed a strict gold standard, Federal Reserve notes were made obligations of the U.S. Treasury, though they were not given the status of legal tender until 1933. To assure an appropriate volume of currency for each district, each Federal Reserve Bank was responsible for issuing its own notes.

Banks that were members of the Federal Reserve System had the right to "rediscount" loans that they had issued, using them in effect as collateral against loans from the Federal Reserve Bank in their district. To simplify this procedure, a 1916 amendment to the Federal Reserve Act permitted advances to member banks secured by this type of collateral or by U.S. government securities. The district reserve banks established the interest rate charged for discounts and advances "with a view of accommodating commerce and business," according to the words of the law. In the early years of the system, discount rates varied among the districts, with the rate structure adapting to local conditions. After 1917, the rates tended to uniformity.

Loans that were eligible to be discounted, or used as security for loans from the Federal Reserve Banks, were defined elaborately in the law. That definition relied heavily on the commercial loan theory, also known as the real bills doctrine. Loans eligible for discounting were to be self-liquidating; that is, they were not to be speculative but instead were to finance carrying, production, or marketing costs for products that already had been contracted for sale. In order to encourage development of a market in bankers' acceptances, a source of credit to finance international transactions, the Federal Reserve System stood ready to rediscount them at favorable rates.

Member banks were required to keep reserves against withdrawals by depositors as a safety measure. Mandatory reserves of member banks were lower than previously required of national banks and could be kept as vault cash or deposits at a Federal Reserve Bank. The reduction in required reserves was deemed appropriate in view of the centralization of reserves within the Federal Reserve System and the availability of rediscounting at the Federal Reserve Banks, through which member banks could get cash to meet withdrawals. The 1913 law also distinguished between demand deposits and time (including savings) deposits, requiring a much lower percentage of the latter to be set aside as reserves. Under a June, 1917, amendment, all required reserves had to be in the form of deposits at a Federal Reserve Bank. Vault cash no longer counted, but the percentages of deposits that had to be held as reserves declined dramatically. Later, vault cash would again be counted against the reserve requirement.

Impact of Event

With the opening in November, 1914, of check-clearing facilities of the twelve Federal Reserve Banks came significant improvements in the payments mechanism. Circuitous, time-consuming arrangements to collect payment on out-of-town checks were no longer needed. Member banks were required to pay the face value of checks drawn against them when those checks were presented for collection at a Federal Reserve Bank. The Federal Reserve System had a goal of making payment of checks at face value, or "par," universal. That goal was abandoned under pressure from Congress after the Supreme Court declared in 1923 that state laws protecting nonpar payments were constitutional. By the end of 1928, almost four thousand state banks that were not members of the Federal Reserve System chose to be "nonpar banks." Ineligible because of this choice to clear checks through the Federal Reserve System, these banks turned to large "correspondent" banks in financial centers to collect out-of-town checks and for other services. Many banks eligible for clearing services through the Federal Reserve System also found it more convenient to use correspondent banks. Member banks, in addition to keeping legal reserves with their local Federal Reserve Bank, continued to keep active balances with correspondent banks. Private banks thus did not abandon their prior relationships to take full advantage of what the Federal Reserve System had to offer.

The federal government itself made little use of the Federal Reserve Banks before World War I. The Treasury continued to use national banks as depositories, but beginning in 1916 it increasingly did business through the Federal Reserve Banks. The role of the Federal Reserve System as fiscal agent of the government was enhanced when subtreasuries, an arrangement in effect since 1846, were discontinued in 1921.

An amendment to the Federal Reserve Act in September, 1916, allowed advances by Federal Reserve Banks to member banks to be secured by the member banks' holdings of U.S. government securities. At the time, the federal debt was declining, and most of it served to secure national bank notes. That situation changed radically within a few months as the United States entered World War I. The U.S. Treasury used the Federal Reserve System to finance a swelling national debt on easy terms. Reserve Banks made loans at preferential rates to member banks that in turn made loans to purchasers of war bonds. The Federal Reserve did not regain its freedom to raise the rates it charged on loans to member banks (the discount rate) until November, 1919, after installment payments on the Victory Loan of April, 1919, had been completed.

In the face of a severe postwar recession in 1920-1921, the discount rate was not reduced until May, 1921, a year after the index of wholesale prices had peaked. The Federal Reserve Act allowed for open market operations (purchases and sales of government securities by the Federal Reserve System) as a device to make the discount rate effective and to control interest rates in the open market. In 1922, the Federal Reserve System bought $400 million in securities, partly as a means of obtaining earnings so that it could pay the dividends to member banks that were required by law. In 1923, open market operations began to be used as a major

instrument to control credit conditions.

During the economic downturn between May, 1923, and July, 1924, the Federal Reserve System cut the discount rate and the Open Market Committee authorized purchases of government securities as a means of providing banks with reserves that they could then lend out. Similar measures were taken in response to the more mild recession between October, 1926, and November, 1927.

The Federal Reserve Banks were expected to act as a "lender of last resort" to member banks, providing loans to financially sound member banks that could not get loans elsewhere. This provision was expected to prevent financial panics, as depositors did not have to worry about banks running short of cash to meet withdrawals as long as those banks were financially sound. The banks could simply discount some of their loans at the local Federal Reserve Bank if they temporarily came up short of cash.

The stock market boom of the late 1920's led Federal Reserve System officials to worry about speculation in the market absorbing excessive amounts of credit. They therefore increased the discount rate in January, 1928, in an attempt to slow speculative lending. They reversed direction and eased credit slightly when stock prices collapsed in the fall of 1929. The system largely stood by, however, as the means of payment (currency plus demand deposits) declined by about one-fourth between 1929 and 1933 and as the American banking system collapsed in the early 1930's. When banks failed, many depositors lost most or all of their money.

Bank runs and losses inflicted on small depositors by bank failures prompted passage of the Banking Act of 1933, which established the Federal Deposit Insurance Corporation (FDIC). Through the FDIC, deposits were insured against bank failure. In 1935, Congress reorganized and significantly strengthened the Federal Reserve System, giving it more centralized control over the American banking system in the hope that greater control could be used to avoid a recurrence of the disaster of the early 1930's.

Bibliography

Beckhart, Benjamin Haggott. *Federal Reserve System.* New York: American Institute of Banking, 1972. A clearly written survey of the structure, functions, and history of domestic and international policies of the Federal Reserve System since its founding.

Board of Governors of the Federal Reserve System. *The Federal Reserve System: Purposes and Functions.* 7th ed. Author, 1984. An official exposition for the general public. Periodically updated.

Burgess, Warren Randolph. *The Reserve Banks and the Money Market.* Rev. ed. New York: Harper & Brothers, 1936. Overview featuring the impact of monetary policy actions on financial markets, written by an expert who was with the Federal Reserve Bank of New York from 1920 to 1938.

Goldenweiser, Emanuel Alexander. *American Monetary Policy.* New York: McGraw-Hill, 1951. A presentation in straightforward prose by an economist who was director of research and statistics for the Federal Reserve Board from 1926 to 1945.

Kemmerer, Edwin Walter. *The ABC of the Federal Reserve System.* 12th ed. New York: Harper, 1950. A posthumous edition. The core of this lucid, brief exposition was first published in 1918.

Laughlin, James Laurence. *The Federal Reserve Act: Its Origins and Problems.* New York: Macmillan, 1933. A comprehensive investigation presenting a distinctive position in the scholarly controversies surrounding the subject.

Moore, Carl H. *The Federal Reserve System: A History of the First Seventy-five Years.* Jefferson, N. C.: McFarland, 1990. Concise, clear, and interestingly written by an economist associated for thirty-two years with the Federal Reserve Bank of Dallas.

Warburg, Paul Moritz. *The Federal Reserve System: Its Origin and Growth.* 2 vols. New York: Macmillan, 1930. A collection of writings by the German-born banker who labored indefatigably for central bank reform and sound practice.

West, Robert Craig. *Banking Reform and the Federal Reserve, 1863-1923.* Ithaca, N.Y.: Cornell University Press, 1977. A scholarly monograph on the intellectual background to the Federal Reserve Act.

Willis, Henry Parker. *The Federal Reserve System.* New York: Ronald Press, 1923. An insider's in-depth view. Willis helped draft the Federal Reserve Act.

Benjamin J. Klebaner

Cross-References

A Financial Panic Results from a Run on the Knickerbocker Trust (1907), p. 134; The U.S. Stock Market Crashes on Black Tuesday (1929), p. 574; The Bank of United States Fails (1930), p. 603; The Reconstruction Finance Corporation Is Created (1932), p. 630; The Banking Act of 1933 Reorganizes the American Banking System (1933), p. 656; The Banking Act of 1935 Centralizes U.S. Monetary Control (1935), p. 717; Congress Deregulates Banks and Savings and Loans (1980-1982), p. 1757; Bush Responds to the Savings and Loan Crisis (1989), p. 1991.

THE U.S. GOVERNMENT BEGINS USING COST-PLUS CONTRACTS

Categories of event: Government and business; business practices
Time: 1914
Locale: Washington, D.C.

By offering cost-plus contracts to business firms, the government ensured that high-quality war materials were delivered to war agencies on time during World War I

Principal personages:

BERNARD M. BARUCH (1870-1965), a Wall Street speculator, chairman of the War Industries Board

GEORGE O. MAY (1875-1961), an accounting scholar, author, and vice president of the American Institute of Accountants, 1917-1918

ROBERT H. MONTGOMERY (1872-1953), a special adviser to the War Industries Board and the president of the American Association of Public Accountants, 1912-1914

WOODROW WILSON (1856-1924), the president of the United States, 1913-1921

ROBERT D. MARSHALL, a brigadier general in the U.S. Army and chief of the construction division, War Department, 1917-1919

Summary of Event

During World War I, the usual method of awarding government contracts on competitive bids was changed for some contracts because it was found to be inexpedient as a result of factors related to the urgency of wartime demands. Cost-plus contracts were formally legalized by the National Defense Act of 1916, though they had been in limited use for several years. The major feature of cost-plus contracts is that contractors are reimbursed for all costs plus a profit, either fixed or a percentage of cost, by the government. Since profits were guaranteed, the contractors could deliver war materials on time, in sufficient quantities, without having to worry that speeding up an order would cost more.

Markets for materials and labor were in a state of uncertainty during the war period, making it difficult for business firms to bid for contracts on the basis of a fixed price. Contractors argued that the government should assume the risk of wide fluctuations in wages and material prices and that it should guarantee profits to manufacturers in the form of cost-plus agreements. Production of war materials was new to many firms. Experimentation with production in untried fields made it difficult for them to estimate costs. Cost-plus contracts therefore made sense for goods that the government needed urgently.

Cost-plus contracts had some major drawbacks. On one hand, critics claimed that costs were excessive. Because the government reimbursed all costs plus a profit, there

were no incentives for contractors to control costs. Maintenance of enormous cost accounting systems was required to figure out actual costs, for example calculation of overhead or research expenses, and there were disputes regarding the calculation of costs. Producers who lowered costs also lowered profits on contracts with profits calculated as a percentage of costs. Thus, there was a premium on inefficiency. On the other hand, contractors were unhappy that the profit percentages were small. Some businesses not awarded contracts complained of favoritism.

Responding to these criticisms, Congress prohibited the use of cost-plus contracts for housing facilities in May, 1918. In July, 1918, the purchase of all standard articles required by the five main War Department bureaus was consolidated under one purchase division. As a result of this reorganization, all cost-plus contracts were rejected. By then businesses were able to forecast costs, and they preferred bidding to having their products commandeered. The Poindexter Bill of May, 1919, prohibited cost-plus contracts in any government contracting. That law applied only to contracts with profits calculated as a percentage of costs and not to cost-plus contracts with fixed profits.

Cost-plus contracts basically take two forms, paying costs plus a fixed fee or costs plus a percentage. Fixed fee types provide that the buyer will reimburse the contractor all costs actually incurred to perform a job in accordance with the contractual terms, and in addition will pay a fixed fee to the contractor. The contractor's fee remains the same whether the final actual cost of the work turns out to be lower or higher than what was expected by both parties when the contractual agreement was signed. The buyer pays all costs. Only when there is a change in the scope of the work (for example, an increase in the square footage of a building being constructed) can the fee be changed.

Cost-plus-percentage-fee contracts provide that the buyer will reimburse the contractor for all costs actually incurred to perform the job in accordance with the contractual terms, and in addition pay a specific percentage of cost, as a fee to the contractor. The contractor's fee changes in direct proportion to the actual costs incurred.

One of the earliest known uses of cost-plus contracts was made by the U.S. Navy a few years before the United States became involved in World War I. It was difficult to estimate the cost of production for experimental projects in naval gunnery. When production requires experiments, cost-plus contracting is attractive to both the manufacturer and the government. If the manufacturing firms were honest and reputable and if they adopted sound cost accounting systems, cost-plus contracts did not result in wasteful and expensive public contracts. Although this method of contracting requires an assumption that contractors behave with integrity, it is useful for experimental projects during war periods, when costs of materials and wages are unpredictable.

A major use of cost-plus contracts was made by the construction division of the quartermaster general's corps of the U.S. Army. The Army construction program included 250 contracts in 1917, with an outlay of about $300 million. In awarding

these cost-plus contracts, the government carried the risk and tried to select contractors with experience, integrity, and the ability to complete large construction projects. The government agreed with business leaders that in times of war the hazards of the emergency conditions should be assumed by the government. Construction engineers of high repute recognized cost-plus contracting as a proven method of compensation for emergency work. It saved time and allowed big construction companies to start work quickly without waiting for detailed plans, and it allowed the selection of contractors based on reliability and experience rather than awarding contracts to the lowest bidders, who might be incompetent. It also allowed the contractor to be free from worries about profit and instead concentrate on speedy execution of quality work under wartime conditions.

The ordnance department of the U.S. Army entered into cost-plus contracts for a large portion of the total amount contracted out, which was $1.75 billion in 1917. Naval construction contracts were awarded to the five largest private shipyards for lighter vessels such as submarine chasers, destroyers, and mine sweepers to be built in 1918. These contracts were for costs plus a fixed profit. In the summer of 1917, orders for twenty-two thousand Liberty motors, used in aircraft, were placed with six different companies under cost-plus-fixed-profit contracts. Cost-plus contracts thus were freely used during World War I by various government agencies.

Impact of Event

One of the major impacts of the use of cost-plus contracts was the increased cooperation between the government and private enterprise. Traditionally, the relationship between the two has been one of distrust and antagonism. War contracting taught the government the importance of working with business. The government also recognized the contributions of large businesses in economic development. War contracting resulted in the government receiving voluntary cooperation from the three major professions of engineering, accounting, and law. These professions rendered exemplary service in the final settlement, liquidation, and cancellation of these cost-plus contracts.

During this era of war contracting, many business people became millionaires thanks to cost-plus contracts. At the same time, wages of millions of workers rose rapidly. This huge increase in purchasing power fueled economic expansion. Because of war needs, many commercial organizations were not free to make commercial goods, reducing the supply of both necessary and luxury products and increasing the profit margins of manufacturers. In some cases, the government had to use its commandeering authority to keep prices under control. The government had to resort to price fixing to protect the public and the war effort. The price fixing committee of the War Industries Board was in charge of fixing prices for such goods as iron, steel, copper, and other metals; chemicals; medical supplies; textiles; leather; rubber; and machinery and tools. One of the greatest impacts of the war contracting experience as a whole was the evolution of price control mechanisms to keep the supplies of food, fuel, and other war materials allocated during war time.

Another impact of cost-plus pricing during World War I was the increased stature of accounting as a science and a profession. Accounting services were required to establish costs, monitor business practices, and settle claims. Cost accounting methods and practices gained importance, and contracts between industry and the government attained more precision and a scientific character. Another impact of war contracting was the introduction of standardization in the manufacturing process. The formal specifications contained in the contracts introduced precise technical measurements into production processes. This standardization of production processes often led to reductions in costs. When the war was over, industrial organizations were able to use these standardization techniques in commercial production as well.

Because of the impact of cost-plus contracting during World War I, it was realized that accounting is not just bookkeeping. Accounting is sometimes viewed as entirely academic, but cost accounting reports can be used for efficient administration of large manufacturing plants. During World War I, the Navy used cost accounting reports as a guide to the distribution of labor in large manufacturing plants. These cost accounting reports were useful in controlling costs, eliminating inefficiencies, and securing greater output. War contracts led to the development of industrial cost accounting, which became vital to industrial management.

Cost-plus pricing also had many adverse impacts. When contractors are reimbursed for all costs of production plus a fixed fee or a variable fee based on full costs, they have no incentive to control costs. A major problem with cost-plus pricing is prevention of wasteful and inflated costs. In fixed-price contracts, there is an incentive for contractors to reduce costs so that they can increase their profits. In cost-plus contracts, that incentive to reduce costs is eliminated. Cost accountants played a large role in the determination of correct unit costs, and better cost accounting systems were designed, but no satisfactory solution was found for this vexing problem of wasteful costs and inefficiency.

There are several problems inherent in cost-plus contracts. When contractors are paid full costs plus a fee, the fee can be either too low or too high when measured as a percentage of investment in plant, inventories, and working capital. For example, a 5 percent fee on full costs can generate a higher annualized return on investment than a 10 percent fee if the project is completed much more rapidly. A related problem in cost determination is allowance for depreciation. If replacement or current costs, rather than the purchase price of an item, are used to calculate depreciation, that can inflate production costs to a great extent. The Navy insisted on using historical costs to compute depreciation allowances. Both of these problems illustrate issues of the time value of capital; that is, that value may depend on when something is used.

Another impact of cost-plus contracting relates to the extraordinary profits made by manufacturers and the excess profits tax imposed by the federal government. The Revenue Act of 1917 provided for graduated income taxes and excess profits tax. It was specifically written into these cost-plus contracts that federal income taxes and excess profit taxes were not to be considered part of manufacturing costs and hence would not be reimbursed by the government. It was considered that an indirect refund

of taxes would be against public policy and beyond the powers of various war agencies of the government.

For all of its problems, cost-plus contracting became a regular part of government procurement. After World War II, various defense projects and those involved in space research came under cost-plus contracting, as firms were unwilling to take the risk of costs that could be much higher than anticipated. Examples of seemingly wasteful expenditures proliferated, such as hammers and toilet seats costing hundreds of dollars each, but the system did make many projects feasible and worthwhile for private contractors.

Bibliography

Aljian, George W., ed. *Purchasing Handbook.* New York: McGraw-Hill, 1958. Provides useful information for purchasing agents in government and private industry. Chapter 16 gives a good summary of various types of cost-plus contracts. Easy to read.

Baruch, Bernard M. *American Industry in the War.* New York: Prentice-Hall, 1941. Describes the various facets of the industrial mobilization for war and the experience of the United States War Industries Board of 1917 and 1918. Chapter 6 gives a good summary of the price fixing activities of the board, which followed the principle of cost plus reasonable profits.

Crowell, Franklin J. *Government War Contracts.* New York: Oxford University Press, 1920. Provides a discussion of contractual relations between the government and private firms during World War I. Chapters 2-4 describe the evolution of cost-plus contracts. A readable, reasonably concise history of contractual accounting and government contracting. Useful for researchers.

Cuff, Robert D. *The War Industries Board: Business-Government Relations During World War I.* Baltimore: The Johns Hopkins University Press, 1973. Describes the motives and methods of businesspeople in government work and the nature of the relationship between business and government during World War I. Chapter 8 details the price fixing process and describes how fair prices were arrived at for various commodities. Excellent references.

Farquhar, Francis P. "Accounting for Cost of Naval Vessels Under Cost-Plus-Profit Contracts." *The Journal of Accountancy* 29 (July, 1919): 180-189. Describes shortcomings with cost-plus-percentage contracts and traces the evolution of cost-plus-fixed-profit contracts. Useful for researchers.

Kelley, Arthur C. "Cost Analysis of a Cost-Plus Contract." *The Accounting Review* 17 (October, 1942): 370-376. An in-depth analysis of the problems involved in administering a cost-plus contract program. Suggests a system for cost control and unit cost determination. Very readable.

Miranti, Paul J., Jr. *Accountancy Comes of Age: The Development of an American Profession, 1886-1940.* Chapel Hill: University of North Carolina Press, 1990. Highlights major events in the history of the accounting profession in the United States.

Shillinglaw, Gordon. *Managerial Cost Accounting.* 5th ed. Homewood, Ill.: Richard D. Irwin, 1982. Chapter 21 provides the theoretical rationale for cost-plus contracts by government with defense contractors.

Srinivasan Ragothaman

Cross-References

The Federal Trade Commission Is Organized (1914), p. 269; Accountants Form a New Professional Association (1916), p. 308; Wartime Tax Laws Impose an Excess Profits Tax (1917), p. 319; The Ultramares Case Establishes Liability for Auditors (1931), p. 608; The Securities Exchange Act Establishes the SEC (1934), p. 679; U.S. Tax Laws Allow Accelerated Depreciation (1954), p. 1030; Congress Begins Hearings on Cost Overruns for the C-5A Galaxy (1969), p. 1384; Congress Passes the RICO Act (1970), p. 1449.

ASCAP FORMS TO PROTECT WRITERS AND PUBLISHERS OF MUSIC

Categories of event: Business practices; foundings and dissolutions
Time: February 13, 1914
Locale: New York, New York

The American Society of Composers, Authors, and Publishers (ASCAP) became the primary organization collecting fees and royalties for the performance of copyrighted music

Principal personages:

STANLEY ADAMS (1907-), the president of ASCAP, 1953-1956 and 1959-1980

NATHAN BURKAN (d. 1936), a founder of ASCAP and its first general counsel

VICTOR HERBERT (1859-1924), an influential founding member of ASCAP and popular composer of light opera

RAYMOND HUBBELL (1879-1928), a founder of ASCAP

GEORGE MAXWELL (d. 1931), a founder of ASCAP and its first president

Summary of Event

The copyright laws of the United States changed over the years in response to new uses for copyrighted materials such as literary work and musical compositions. In 1897, Congress added performance rights to the copyright statute. In 1909, Congress furthered coverage to include mechanical reproductions such as piano rolls. This addition helped to set the stage for the development of the American Society of Composers, Authors, and Publishers (ASCAP).

In 1913, three friends gathered to establish a group to protect the writers and publishers of musical compositions. The three—Raymond Hubbell, a composer from Ohio; George Maxwell, an American subpublisher for the Italian firm G. Ricordi; and Nathan Burkan, a New York attorney—wanted to form an organization that could enforce the payment of fees for the performance of copyrighted music.

The three realized that in order to draw attention to their organization, to add credibility, and to bring in members, they needed an important leader. They contacted Victor Herbert, a composer of the light operas popular at the time. Herbert quickly gathered support among his friends and associates within the music industry by stressing the importance of protecting one's work.

The four scheduled an initial meeting at Luchow's Restaurant in New York City. As a result of bad weather, only five additional people showed up: Silvio Hein, Louis A. Hirsch, Glen MacDonough, Jay Witmark, and Gustave Kerker. These nine became founding members and scheduled a second meeting for February 13, 1914, at the Hotel Claridge in Manhattan. More than one hundred people attended this meeting,

at which ASCAP was officially created.

The group elected George Maxwell as its first president and Nathan Burkan as the first general counsel. An office was rented at the Fulton Theater Building on the corner of Forty-sixth Street and Broadway in New York City. From this scantily furnished office, the society set out to protect the musical compositions of its members, who paid $10 in dues for membership as writers and $50 as publishers. These fees remained constant for the next eighty years. Performance fees for works protected by ASCAP were to be collected based on adjusted gross receipts (after license fees and operating expenses were deducted) of a production or performance, and revenues were to be shared equally between the writer and the publisher. In its first year, ASCAP added the power to license foreign music through an agreement with the British Performing Right Society, also created in 1914.

Relying on the strength of the federal copyright laws, which specified that copyrighted musical works could not be performed publicly without permission of the copyright owner, ASCAP set out to license the public businesses where music was performed. The group first set its sights on restaurants and hotels. It issued its first blanket license (covering all ASCAP-protected music) to Rectors, a restaurant on Broadway, for an annual fee of $180. During that first year, the organization licensed an additional eighty-four hotels and restaurants in New York City.

ASCAP's movement to license came under harsh opposition from hotels and restaurants. Lawsuits ensued between Victor Herbert and Shanley's Restaurant as well as between John Philip Sousa and the Vanderbilt Hotel. In each case, the business profited from performances of the composer's work without prior permission. The cases went to the Supreme Court. In 1917, Justice Oliver Wendell Holmes ruled "If music did not pay, it would be given up. . . . Whether it pays or not, the purpose of employing it is profit, and that is enough." In essence, this decision gave ASCAP the right to exist and the right to license.

By 1921, the society had grown tremendously, as writers and publishers were quick to sign on as members. That year, ASCAP made its first distribution of royalties. The organization was truly operational.

Impact of Event

Because of its ability to protect its members' rights and to police public performances of music, ASCAP included some of the most influential members of the music industry. Early members included George and Ira Gershwin, Richard Rodgers, Oscar Hammerstein II, Cole Porter, and Duke Ellington. Even as other groups formed to compete with ASCAP, significant composers and publishers such as Aaron Copeland, Igor Stravinsky, and Leonard Bernstein joined the organization. Eventually, the new genres of pop music and rock and roll added Henry Mancini, Burt Bacharach, Stevie Wonder, Smokey Robinson, Bruce Springsteen, and Lionel Richie, among many others, to ASCAP's rosters.

In order to keep up with this growing membership, the society opened its first general licensing office, based in Charlotte, North Carolina, in 1933. This office

oversaw the licensing of businesses within its district as well as checking on possible nonlicensed performances. ASCAP had expanded to twenty-two district offices across the United States by 1993. District offices helped to compile information on members. That information was published in 1948 in the society's first biographical directory, which contained more than eighteen hundred entries.

As ASCAP membership grew and the society tried to license more businesses, several problems arose. Radio broadcasting entered the picture during the 1920's. ASCAP found its first major challenge in keeping up with the newest technology. Radio stations resisted licensing attempts by ASCAP, which wanted to prevent radio broadcasts of copyrighted music without payment. Again ASCAP went to the courts, which deemed radio broadcasts to be public performances and therefore subject to licensing. In February, 1923, station KFI in Los Angeles became the first radio station licensed by ASCAP.

As radio networks and independent stations spread across the country, policing music performances became more difficult. ASCAP set up a sampling system wherein programs were recorded and analyzed for infringements without prior notice to the station. This system resulted in a tremendous amount of data that needed to be processed. ASCAP responded by creating a tabulation department during the 1940's.

Although it had won early court battles, the society was plagued by lawsuits in the 1940's concerning radio broadcasting. Starting in the 1940's, ASCAP faced several antitrust cases. Court decrees in 1941 and 1950 required ASCAP to offer businesses either a blanket or per-program license. Blanket licenses, most commonly used by radio stations, required the licensee to pay a percentage of total revenues plus a fixed sum for the right to use music on unsponsored programs. On the other hand, per-program licenses, more prevalent among television stations, required a higher percentage of revenues but applied only to programs using ASCAP music.

Also in 1941, ASCAP signed a consent decree stating that it would no longer act as the exclusive agency for its members. Fees would be collected only for the ASCAP songs played and only from the originating station. This was especially valuable to radio networks that broadcast the same program across the country via affiliate stations. ASCAP had tried to collect fees for each station airing the program, not just from the originating station.

ASCAP remained the only U.S. licensing and collection organization for several years. This ended in 1937, with the creation of the American Composer Alliance (ACA), started by Aaron Copeland, who later became an ASCAP member. ACA became the chief organization for "serious" composers. The creation of Broadcast Music, Inc. (BMI) in 1939, however, affected ASCAP to a much greater degree.

BMI started as an attempt by radio broadcasters to gain more control over their stations. In 1940, the contract between ASCAP and the National Association of Broadcasters expired. Radio networks across the United States dropped the ASCAP catalog of 1.5 million songs in favor of music that was in the public domain, carrying no copyright, in addition to new songs produced for BMI. This experiment lasted almost a year and resulted in increased popularity of such copyright-free tunes as

"Jeanie With the Light Brown Hair." ASCAP found itself forced into a corner. A 1945 court decision ruling that collaborative works could be licensed by either group furthered the competition between ASCAP and BMI.

The film industry also had its complaints about ASCAP licensing. In 1942, owners of film theaters filed suit against ASCAP for misusing its power by requiring film exhibitors to carry licenses. Because ASCAP carried rights to nearly all the music available, the theater owners had no options. Six years later, the courts ruled this licensing practice to be illegal. The ruling led the government to file more antitrust suits against the society for monopolizing music performance rights in a worldwide cartel. A 1950 court decision effectively ended ASCAP's monopoly on the licensing of foreign music and opened the door for BMI. The same year, another court required ASCAP to offer single licenses for film or television producers for all the music performed within a film or television broadcast.

In 1949, the society began offering licenses to television stations. Although television greatly expanded the avenues available for music composers, it created problems concerning performance monitoring, as radio had done decades earlier. Television broadcasters resisted licensing. In the late 1960's, the Columbia Broadcasting System (CBS), which wanted a per-program license, gave ASCAP its biggest fight over television licensing. ASCAP wanted to issue a blanket license to CBS at a fee of $12,500 a month, with additional fees for ASCAP music performances. The debate raged concerning blanket licenses versus per-program licenses, even though earlier court decrees in 1941 and 1950 had required ASCAP to offer both. Early court rulings favored CBS; however, in the early 1980's, the Supreme Court upheld ASCAP's right to blanket license. Other lawsuits concerning licensing were filed after this ruling, and it appeared as though ASCAP faced a long battle over this issue.

The long court case with CBS occurred during the ASCAP presidency of Stanley Adams, who held the office of president from 1953 to 1956 and from 1959 to 1980. He helped ASCAP to enjoy a period of tremendous success. New genres such as pop music and rock and roll found a youthful market, while the rise of country music called attention to the need for a Nashville district office, which was established in 1963. The television industry expanded rapidly and offered new avenues for composers in the form of commercial and theme or background music. Adams' efforts brought ASCAP into the modern age. The society introduced computers and other new technology to better police the music industry.

At the end of Adams' presidency in 1980, ASCAP faced new challenges, including the licensing of the video market and cable television. The organization was successful in reaching a license agreement with the cable leader, Home Box Office (HBO), and the newest powerhouse in music, the Music Television (MTV) network. What seemed clear was ASCAP's commitment to keeping up with the latest technologies and their use of music. If the technologies used copyrighted themes, tunes, or other musical work, ASCAP would seek to license it.

Even with all the controversy and court cases, ASCAP had its proud moments. Members won numerous awards through the years, including several firsts. Con

Conrad and Herb Magidson won the first Oscar for Best Song for "The Continental," from *The Gay Divorcée*, in 1934. Ira Gershwin became the first songwriter to receive a Pulitzer Prize in theater, for *Of Thee I Sing* in 1932. Cole Porter won the first Tony award, for *Kiss Me Kate* in 1949. Other notable awards include the first Emmy awarded for music, which went to Walter Schumann for the theme to *Dragnet* in 1954, and the first Grammy awarded for Song of the Year, which went to Domenico Modugno for *Volare* in 1958. In 1959, gold records were established. ASCAP members Lee Pockriss and Paul Vance were the first to receive the honor, for *Catch a Falling Star* (sung by Perry Como for RCA Records).

Other accomplishments reflected a commitment by ASCAP to its members. The society helped struggling writers and publishers to get through hard times with financial help. The group had a constant mission of promoting interest in and growth of the music industry. During the 1970's, the society increased commitment to that growth through scholarships and grants given by the ASCAP Foundation. These were possible as the result of a donation by the widow of Jack Norworth, the composer of the popular songs *Take Me Out to the Ball Game* and *Shine on, Harvest Moon*. Mrs. Norworth gave the rights to the songs to the society, and all future royalties from the songs went to ASCAP.

The society itself has also been honored. The U.S. Postal Service issued a special commemorative stamp honoring ASCAP. In 1985, the New York Public Library at Lincoln Center established the permanent archives of ASCAP and opened the organization's history to all those interested. The archives contained a wide range of items, including Irving Berlin's piano, John Philip Sousa's baton, Victor Herbert's membership application, ASCAP's first licenses, and photographs of influential members.

Despite opposition to its efforts, ASCAP struggled to become the primary licensing and collection organization for the performance of copyrighted music. Without the efforts of its founders and early leaders, the composers, authors, and publishers of music likely would have lost control over their own work as the radio, film, and television industries expanded.

Bibliography

Finkelstein, Herman. *Public Performance Rights in Music and Performance Right Societies*. Rev. ed. Chicago: Commerce Clearing House, 1952. A detailed description of copyright laws as they pertain to music and public performances. Includes information on how these laws affect ASCAP.

Fornatale, Peter, and Joshua E. Mills. *Radio in the Television Age*. Woodstock, N.Y.: Overlook Press, 1980. A concise examination of how the radio industry responded to challenges posed by the development of television. Covers new formats that emerged in the 1950's and early 1960's.

Meyer, Hazel. *The Gold in Tin Pan Alley*. Philadelphia: J. B. Lippincott, 1958. Traces the development of the music industry during the first half of the twentieth century. Includes a chapter on ASCAP and BMI titled "They're Playing Our Songs."

Shemel, Sidney, and M. William Krasilovsky. *This Business of Music*. New York:

Billboard Publications, 1977. A comprehensive look at the music industry. Contains three sections covering recording companies and artists, music publishers and writers, and general music industry aspects. Also discusses copyright regulations as they pertain to the publishing and performance of musical compositions.

Sterling, Christopher H. *Stay Tuned: A Concise History of American Broadcasting.* Belmont, Calif.: Wadsworth, 1978. A detailed look at the broadcasting industries. Good coverage of the development of television.

Jennifer Davis

Cross-References

Congress Updates Copyright Law in 1909 (1909), p. 163; George O. Squier Founds Muzak (1934), p. 674; Radio's Payola Scandal Leads to Congressional Action (1960), p. 1148; The 1976 Copyright Act Reflects Technological Change (1976), p. 1626; Compact Discs Reach the Market (1983), p. 1848.

LILLIAN GILBRETH PUBLISHES
THE PSYCHOLOGY OF MANAGEMENT

Category of event: Management
Time: March, 1914
Locale: New York, New York

Gilbreth discussed the psychological impact of using various management approaches, thereby highlighting the importance of understanding psychology to the effective practice of management

Principal personages:
LILLIAN EVELYN GILBRETH (1878-1972), an author and efficiency expert
FRANK BUNKER GILBRETH (1868-1924), the author of several books developing and promoting Taylorism
HUGO MÜNSTERBERG (1863-1916), the "Father of Industrial Psychology"
FREDERICK WINSLOW TAYLOR (1856-1915), the "Father of Scientific Management"

Summary of Event

The Psychology of Management: The Function of the Mind in Determining, Teaching, and Installing Methods of Least Waste, written by Lillian Gilbreth, was first published in 1914 by Sturgis and Walton of New York. This text, which examined management from a psychological perspective, earlier had been published in serial form by *Industrial Engineering* in 1912 and 1913. The work was significant because of its attempt to extend management theory to include psychological factors. The initial purpose of the work was to fulfill the thesis requirement for Gilbreth's doctoral studies in psychology at the University of California. Although the thesis itself was found acceptable by Gilbreth's faculty committee members, they were unwilling to grant her the Ph.D. because of her failure to fulfill a one-year residency requirement, which she had expected to be waived. As a consequence, Lillian's husband, Frank B. Gilbreth, was angered enough to pursue publication of the thesis and thus prove the merit of his wife's work. Ultimately, Gilbreth was allowed to complete her residency requirement at Brown University and was granted the doctorate in 1915. It is quite possible that the work would not have gained the attention that it did or had the same impact if the degree had been granted as expected by the Gilbreths.

The context of this work is worthy of mention. First, it should be noted that Lillian Gilbreth was the wife of Frank Gilbreth, a proponent of scientific management who was well known for his developmental work in the area of motion study. Second, the field of management was itself in its embryonic stages, with considerable debate occurring as to whether management could be taught and learned or was instead an innate art. Third, the field of psychology was not well developed and, as Lillian

Gilbreth noted, had focused primarily on the "psychology of the crowd" and had developed very limited insights into the psychology of the individual. Industrial psychology, in particular, was a new field of inquiry championed by Hugo Münsterberg. Münsterberg's seminal work was based on experiments in his laboratory at Harvard University. This work, *Psychologie und Wirtschaftleben*, was published in 1912 and translated to English for publication as *Psychology and Industrial Efficiency* (1913). Fourth, scientific management and its founder, Frederick Winslow Taylor, were being subjected to extremely severe criticism, including congressional inquiry, at the time Gilbreth was writing her doctoral thesis.

By no means was *The Psychology of Management* intended to be a break with Taylorism and scientific management. The chief aims of the book were to introduce readers to psychology and to management, to suggest the relationship between the two, and to promote further investigation. The first chapter of the text is primarily introductory. In addition to giving an explanation for the organization of the book, the author goes to considerable lengths to define the terms "psychology," "management," and "psychology of management."

Gilbreth defined psychology as "the study of the mind." The author notes that psychology was then viewed as a "culture subject," included in the studies of philosophy and education students but not included in the studies of scientific or engineering students. According to Gilbreth, "it was not recognized that every man going out into the world needs all the knowledge that he can get as to the working of the human mind in order not only to give, but to receive information with the least waste and expenditure of energy, nor was it recognized that in the industrial, as well as the academic world, almost every man is a teacher."

Management was defined as "the art of directing activity." Gilbreth contended that most individuals of her day failed to recognize that management involved more than the "managing part of the organization" and included the "best interests of the managed." She argued that the importance of management was magnified by realization that it involved structuring the relationship between the managing and managed individuals. Further, Gilbreth distinguished between three approaches to management: the traditional approach, the transitory approach, and the ultimate approach. The traditional approach placed managerial power in the hands of a single manager with clear, fixed lines of authority. Transitory management referred to all forms of management that were "passing into Scientific Management." Thus any management environment in which at least one, but not all, of the principles of scientific management had been applied would be classified as transitory. The third type of management was pure scientific management. According to Gilbreth, this differed from the prior two types in that "it is a definite plan of management synthesized from scientific analysis of the data of management."

The psychology of management was defined as "the effect of the mind that is directing work upon that work which is directed, and the effect of this undirected and directed work upon the mind of the worker." Gilbreth believed that scientific management would enlighten people to the value of studying the psychology of management.

She argued that "efficiency is best secured by placing the emphasis on the man, and modifying the equipment, materials and methods to make the most of the man."

The Psychology of Management was organized around the underlying ideas and divisions of scientific management. These underlying ideas were individuality, functionalization, measurement, analysis and synthesis, standardization, records and programs, teaching, incentives, and welfare. Through this organization, Gilbreth was able to illuminate the underlying principles of scientific management, compare scientific management to other types of management that she had identified, and discuss the psychological factors influencing each principle of scientific management. For example, in discussing the scientific management principle of "individuality," Gilbreth noted that the traditional form of management seldom recognized it, as evidenced by an absence of individual rewards and measurement of individual output, limited individual teaching, and few attempts to study the individuals applying for work through a defined selection process. She noted that the principle was recognized, though not fully pursued, in the transitory form of management. Finally, she noted that individuality was a fundamental principle of scientific management and elaborated on the ways in which recognition of individuality provided superior results to the absence of such recognition.

Included in the discussion of each principle of scientific management is an underlying theme of the need for further discovery. Gilbreth clearly suggested that scientific management was superior to other forms of management extant in her day, but she also indicated a need to learn more about the relationship between psychology and management in order to further develop and improve scientific management.

Each of the twenty conclusions Gilbreth reached were favorable to scientific management. Among these conclusions, the following three paid particular attention to the psychological aspects of her discussions. First, she concluded that the psychological element of scientific management was its most important element. Second, since scientific management was "psychologically right," it was the ultimate form of management. Third, the psychological study of scientific management should especially emphasize its teaching features.

Impact of Event

Gilbreth's thesis was submitted in 1912, thus predating the 1913 publication of Münsterberg's seminal work. It was published in serial form in 1912 and 1913 and in book form in 1914. The fact that the field of industrial psychology gained acceptance and became an area of ongoing study must, at least partially, be attributed to these publications. Gilbreth's book brought the required initial credibility to the field, developed awareness, and provided the context, rationale, and objectives for development of the field. Had an individual of stature similar to that of Gilbreth's within the scientific management movement not endorsed industrial psychology, the field could very well have been met with strong resistance in its early period. The field would likely have developed more slowly, and the course of the development may have been altered. It is unrealistic, however, to suggest that Gilbreth's thesis made

significant theoretical contributions to the field of industrial psychology. These contributions were made by Münsterberg and others who followed. This viewpoint is consistent with Gilbreth's stated objectives for the work.

Although the pioneering work of Lillian Gilbreth may have had limited impact on the field of industrial psychology, it did contribute significantly to the development of the field of management. First, this work suggested an area of content in which managerial expertise could clearly be developed, taught, and learned. This work thus helped resolve the controversy as to whether management could and should be taught, in favor of establishing programs of managerial education. Second, this work focused attention on the managed as well as the managers. Third, *The Psychology of Management* was followed by extensive studies of human fatigue and its elimination, worker selection processes, vocational guidance, worker relations, and worker training. Gilbreth's call for investigation of the psychology of management thus was effective.

An unstated objective of this work appears to have been to present evidence from the field of psychology that scientific management was the ideal approach to management. The book promoted and justified the Taylor system and apparently had some success in this regard between 1913 and the late 1920's. Evidence of this success includes the fact that the early development of industrial psychology was clearly rooted in scientific management and grew out of it. Further evidence of this success is the fact that the book was published by three separate publishers on three separate occasions. After the 1920's, however, the industrial gestalt of scientific management began to be superseded by the disciplines of labor relations, personnel management, and industrial sociology. Ironically, the work that Gilbreth designed to defend and promote scientific management contained the seminal arguments of theories that would displace scientific management in the preeminent role with regard to managerial theory and practice.

Hugo Münsterberg, not Lillian Gilbreth, is the acclaimed "Father of Industrial Psychology." The new field had its roots in scientific management yet sought to extend scientific management into the realm of human thought processes. Münsterberg noted that although scientifically structured attention was given to machines and methods of production, the management of workers was left to managers who had limited scientific understanding. A scientific understanding of individual worker psychology was sought so that work might be designed scientifically for the attainment of ideal levels of efficiency.

The focus on development of an understanding of individual worker behavior provided a basis for discovery of the importance of group factors in individual behavior. Taylor described this group influence as worker "soldiering," an element of individual behavior that scientific management sought to overcome through design of work and establishment of individual-based measurement and incentive systems. Out of industrial psychology and the work of management theorists such as Max Weber, Emile Durkheim, Vilfredo Pareto, and Whiting Williams, the field of industrial sociology came into being. This was a counterbalancing field for scientific management that sought to develop structured and scientifically valid constructs of the

influence of human interactions on the performance of work-related tasks.

A growing union movement in the early twentieth century, along with the development of scientific theories in industrial psychology and industrial sociology, ultimately led to the development of fields of managerial practice such as labor relations and personnel management. Practitioners in these fields were the human performance experts who had been absent in the scientific management era. Industrial psychology, labor relations, personnel management, and industrial sociology are all fields of endeavor that, to one degree or another, were anticipated by Gilbreth's dissertation. The somewhat ironic conclusion, therefore, must be that *The Psychology of Management*, a work Gilbreth designed to defend and promote scientific management, contained the seminal arguments of theories that would displace scientific management.

Bibliography

George, Claude S., Jr. *The History of Management Thought.* Englewood Cliffs, N.J.: Prentice-Hall, 1968. A comprehensive treatment of the history of management thought from prehistoric times through the 1960's. Contains a timeline of critical events.

Gilbreth, Lillian. *The Psychology of Management: The Function of the Mind in Determining, Teaching, and Installing Methods of Least Waste.* New York: Macmillan, 1921. Discusses scientific management from the psychological perspective, defends scientific management, and calls for study and inquiry into the field of the psychology of management. One of several editions.

Korman, Abraham K. *Industrial and Organizational Psychology.* Englewood Cliffs, N.J.: Prentice-Hall, 1971. A textbook with a succinct yet complete description of the development of industrial and organizational psychology in its introductory chapter. Presents a thorough review, geared toward college students of the subject, of the psychological theory and research relating to industrial and organizational psychology.

Rose, Michael. *Industrial Behaviour: Theoretical Development Since Taylor.* London: Allen Lane, 1975. This book is divided chronologically into five parts. Written from a British perspective, particularly noticeable in the last two sections.

Wren, Daniel A. *The Evolution of Management Thought.* 2d ed. New York: John Wiley and Sons, 1979. This text provides a definitive treatment of the development of early management thought, the scientific management era, the "social man" era, and the modern era. An extensive bibliography of works pertinent to each of these eras is provided at the end of the text.

Mark D. Hanna

Cross-References

The U.S. Government Creates the Department of Commerce and Labor (1903), p. 86; The Supreme Court Strikes Down a Maximum Hours Law (1905), p. 112;

Harvard University Founds a Business School (1908), p. 157; Ford Implements Assembly Line Production (1913), p. 234; Labor Unions Win Exemption from Antitrust Laws (1914), p. 282; The Supreme Court Rules Against Minimum Wage Laws (1923), p. 426; The Hawthorne Studies Examine Factors in Human Productivity (1924-1932), p. 437.

THE PANAMA CANAL OPENS

Category of event: Transportation
Time: August 15, 1914
Locale: Panama

The completion and opening of the Panama Canal significantly lowered shipping costs and improved transit time

Principal personages:
ULYSSES S. GRANT (1822-1885), the president of the United States, 1869-1877; initiated exploration in Panama
GEORGE WASHINGTON GOETHALS (1858-1928), the director of the Panama Canal project
FERDINAND DE LESSEPS (1805-1894), a French pioneer of the canal project
THEODORE ROOSEVELT (1858-1919), the president of the United States, 1901-1909

Summary of Event

Early maps were based as much on belief as on facts. When Christopher Columbus searched for a new route to the Orient, he happened to land first in the West Indies. The people there told him stories about a strait through which one might sail westward into waters that led directly to the land he sought. He believed in these stories and sought that strait, in the process coming closer and closer to the North American continent. His belief in the secret strait is reflected in a map inspired by him, though not published until two years after his death. The map has no isthmus of Panama, showing in its place a strait permitting direct passage from Europe to India.

Vasco Nunez de Balboa followed Columbus with exploration of the isthmus, ultimately discovering the Pacific Ocean. Even at that time, the legend of the strait persisted. Native people told Balboa that a newly discovered isthmus provided a connection between the oceans. Balboa also believed the story. Many explorers and geographers accepted the existence of this unseen strait, leading to exploration up and down the coast. Explorers never found the mysterious strait, but their work spawned the idea of digging a waterway to connect the two oceans. The Panama Canal therefore is not entirely a project of the nineteenth and twentieth centuries. Its conception falls back to a much earlier time, in particular to a proposal given to Charles V of Spain in 1523. It was, in fact, Hernán Cortés, the Spanish conqueror of Mexico, who first proposed constructing this great waterway. When Cortés failed to find the legendary strait, he proposed constructing an artificial waterway.

The creation of the Panama Canal thus represents a historical legacy as well as an unprecedented feat of engineering and design. It became a major transportation link, facilitating direct trade and changing the face of the political and economic world. It

has critical historic dimensions, as it represented the largest, most costly single effort attempted in modern times. The canal's construction held much of the world's attention over a span of forty years, affecting the lives of tens of thousands of people at almost every level of society and of many races and nationalities. The nations involved were much affected by the process. The Republic of Panama was born; Colombia lost its prize possession, the Isthmus of Panama; and Nicaragua was left to wait for some future chance to participate in such a venture.

The Panama Canal marked significant advances in engineering, in government planning, and in labor relations. Planning focused on the construction of an enduring wonder, a canal of unprecedented length and breadth. Its construction and operation would require considerable government planning and direction as well as an unheralded organization of large numbers of laborers. The canal was born of the conviction that sea power would become the political and economic base for the future. It was judged to be the greatest enterprise of the Victorian era and the first significant demonstration of American power at the dawn of the new century. Its completion in 1914 marked the conclusion of a dream as old as the voyages of Columbus.

The cost of the canal was enormous. Dollar expenditures totaled $352 million, including $10 million paid to Panama for land rights and $40 million paid to the French company involved in the original canal project. The cost was more than four times that of the Suez Canal and much higher than the cost of anything previously built by the United States government. Except for wars, the only remotely comparable federal expenditures up to the year 1914 had been for acquisition of new territories. The price for all acquisitions as of that date—the Louisiana Territory, Florida, California, New Mexico, and other western lands acquired from Mexico, Alaska, and the Philippines—was $75 million, or only about one-fifth of the amount spent on the canal. French companies earlier had been involved in the canal project, beginning in 1880. Taken together, French and American expenditures came to almost $639 million.

The canal also involved nonmonetary costs. According to hospital records, more than 5,600 lives were lost to disease and accidents during the canal's construction. Approximately 4,000 deaths were those of black workers, with only 350 white Americans dying in the process. If one includes earlier French efforts, the total loss of human lives may have been as high as 25,000.

Unlike most government projects, the canal cost less in dollars than was projected. The final price was $25 million below what had been estimated in 1907, despite a change in the width of the canal and the building of fortifications. Had these additional expenses been calculated into original budgets, Congress might not have approved the project. The Spooner Act of 1902 approved a $40 million payment to the French company involved in the original canal project, but Colombia, which controlled Panama, stood in the way of further construction. Panama declared its independence from Colombia on November 3, 1903. Construction of the canal by the U.S. team began in 1904.

Even though it was completed at a cost below that estimated at mid-project, the

canal was opened six months ahead of schedule. The final product came amazingly close to precise engineering targets as to location, structure, and operation. There were no signs of graft, kickbacks, payroll padding, or other corruption in the process. Successful completion of such a vast project is noteworthy, since most previous and subsequent projects had shortcomings in the dimensions mentioned above. Much of the project's success resulted from the management and expertise of the director of the project. George Washington Goethals exhibited considerable insight in the design of the project, considerable influence in coordinating the various constituencies affected by and involved in the project, and unusual management control techniques used to monitor expenditures and progress. No excessive profits were registered by the thousands of firms involved with a project under the auspices of the Interstate Commerce Commission.

Impact of Event

Much of the history of the world is based on the quest for improved transportation, particularly the discovery of and building of all-water routes connecting bodies of water. With the completion of the canal came direct and lower-cost transportation from the Atlantic Ocean to the Pacific Ocean. Savings came in terms of both dollar outlays and time. The cost savings that resulted from the canal encouraged businesspeople to explore new markets that now appeared to be profitable.

World War I kept the traffic flow through the canal low, with only four or five ships passing through per day, on average. It was not until July, 1919, that the vision of President Theodore Roosevelt came true by virtue of the transit of an American armada of thirty-three ships through the canal. The first thirty made it through in only two days. This was an astounding feat given the rigors of the previous route around the tip of South America.

About ten years after it opened, the canal was handling more than five thousand ships a year, traffic approximately equal to that of the Suez Canal. Even then, large British and U.S. carriers squeezed through the locks with only feet to spare. By the late 1930's, annual traffic exceeded seven thousand ships. Following World War II, that figure more than doubled. Channel lighting was installed in 1966, allowing nighttime transit, and ships were going through the canal at the rate of more than one an hour, twenty-four hours a day, every day of the year. Many of them were giant container and bulk carriers of a size never imagined when the canal was designed and built. The 950-foot *Tokyo Bay* was the largest container ship in the world at the time it made its first Panama Canal transit in 1972. By the 1970's, traffic reached fifteen thousand ships a year, with annual tonnage well beyond 100 million tons, twenty times that of 1915. Clearly, shippers were taking advantage of the improvement in transport speed made possible by the canal. The canal made feasible the opening of Far Eastern markets to the East Coast of the United States. It can be argued that the facilitation of trade allowed by the canal markedly altered the configuration of world industrial patterns.

The *Queen Mary*, launched in 1934, was the first ship too large for the locks. Many

others followed, even though the builders realized at the time of construction that ships of more than 1,000 feet in length and beams of 150 feet could not pass through the canal. Proposals to find an alternate route or to build a larger canal were considered. Attention was once again given to Nicaragua and a route through that nation. Earlier proposals for an isthmus canal had considered Nicaragua.

Tolls collected in 1915 reached only $4 million. In 1970, they exceeded $100 million, even though rates remained unchanged. In 1973, the Panama Canal Company recorded its first loss, largely as a result of mounting costs of operation. In 1974, tolls were raised for the first time, from $0.90 per cargo ton to $1.08. The *Queen Elizabeth II* locked through the canal in 1975 and paid a record toll of $42,077.88. The average toll per ship was approximately $10,000, approximately one-tenth of the cost of sailing around Cape Horn as an alternate direct all-water route. The lowest toll on record was paid by Richard Halliburton, a world traveler who in the 1920's swam the length of the canal in installments. Although he was not the first to swim the canal, he was the first to persuade authorities to allow him through the locks.

In design matters, some changes were made in the canal over time. Parts were widened by up to 500 feet; a storage dam was built across the Chagres; and the original towing locomotive was retired and replaced by more powerful models. The fundamental characteristics of the canal remained unchanged. Only two issues of design received significant criticisms. It has been argued that the two sets of locks should have been replaced by a single unit at Miraflores, and Goethals seemed to have underestimated the impact of slides. The canal has been influenced by slides on many occasions. In 1914, a slide at East Culebra caused blockage of the entire channel. Slides have posed a continuing problem.

As ships grew in size, the canal handled a lower proportion of the world's sea traffic. By provisions of the 1977 Panama Canal Treaty, the canal itself was scheduled to be turned over to the Panamanian government. The Canal Zone was abolished, and all U.S. troops were to be removed by Dec. 31, 1999, when the Panamanian government would take over the canal.

The all-water passage across Panama is a supreme achievement. It completed a dream held through hundreds of years. Its impact has been enhanced East-West trade, shorter times in transit, a dedication to technological improvement in transportation, and a unification of political and economic interests in the Eastern and Western worlds.

Bibliography

Gause, Frank Ales, and Charles Carl Carr. *The Story of Panama.* 1912 Reprint. New York: Arno Press, 1970. A comprehensive analysis of the development of the Panama Canal, drawn from materials prepared at the time.

Harmon, George M., ed. *Transportation: The Nation's Lifelines.* Rev. ed. Washington, D.C.: Industrial College of the Armed Forces, 1968. Some general comments about the developing role of the transportation infrastructure, including the Panama Canal.

Kemble, John H. *The Panama Route: 1848-1869*. Berkeley: University of California Press, 1943. Covers the entirety of the construction and operation process.

McCullough, David. *The Path Between the Seas*. New York: Simon & Schuster, 1977. A readable and comprehensive coverage of the building of the canal, including many interesting statistics and helpful perspectives.

Marlowe, John. *The World Ditch*. New York: Macmillan, 1964. A readable coverage of the canal and its impacts.

Theodore O. Wallin

Cross-References

The Baro-Kano Railroad Expands Nigerian Groundnut Exports (1911), p. 196; The Air Commerce Act Creates a Federal Airways System (1926), p. 499; Supertankers Begin Transporting Oil (1968), p. 1336; The Alaskan Oil Pipeline Opens (1977), p. 1653.

THE FEDERAL TRADE COMMISSION IS ORGANIZED

Category of event: Government and business
Time: September 26, 1914
Locale: Washington, D.C.

Creation of the Federal Trade Commission (FTC) empowered an agency of the federal government to protect competition and proactively deter potential monopolies

Principal personages:

THEODORE ROOSEVELT (1858-1919), the president of the United States, 1901-1909

WOODROW WILSON (1856-1924), the president of the United States, 1913-1921

LOUIS D. BRANDEIS (1856-1941), an economic adviser to President Wilson

GEORGE RUBLEE (1868-1957), an attorney who assisted in drafting the FTC bill

Summary of Event

The establishment of the Federal Trade Commission (FTC) in 1914 signaled a dramatic change in the relationship between government and business. No longer would the courts and the executive branch be the only interpreters of antitrust legislation; instead, the independent regulatory commission was empowered to define "unfair competition" and was also granted the requisite discretionary authority to apply the standard of unfairness.

Although enacted in 1914, the Federal Trade Commission Act can trace its roots to the late nineteenth century. It was the exercise of corporate economic power in that period by men such as John D. Rockefeller, J. P. Morgan, and Cornelius Vanderbilt that seemed to galvanize an antibusiness sentiment among small business owners, labor unions, and the middle class. These groups would become the core of the Progressive movement.

The turn of the century witnessed the beginning of the Progressive Era, characterized by the use of social, economic, and political reform movements aimed at creating a society organized for collective action in the public interest. In 1901, Theodore Roosevelt advocated the supremacy of the "public interest" over business when he assumed the presidency. In 1903, the newly created Department of Commerce contained a Bureau of Corporations with a function of investigating corporate practices and publicizing unethical competitive methods of businesses. A series of informal agreements evolved between big business and the bureau, under which firms granted the government access to their records and the bureau approved mergers when it found them to be in the public interest.

During the Progressive Era, there developed a clear sense of obligations of business

to society. The role of the state started to evolve from laissez-faire to the belief that it had a moral obligation to provide for the general welfare. It was during the first administration of Woodrow Wilson that the Bureau of Corporations was transformed into the FTC.

Wilson and the Democrats swept the country on election day in November of 1912. A key component of the winning party platform was a program Wilson called the New Freedom, aimed at the destruction and prevention of industrial and financial monopoly. Wilson proposed to accomplish this goal by reducing tariffs, reforming the banking and currency systems, and strengthening the Sherman Antitrust Act. A tariff reduction bill was quickly passed, and the Federal Reserve System was created in 1913. The last major item on the New Freedom agenda was the creation of legislation to strengthen the Sherman Act.

The Sherman Act of 1890 to this point was the sole federal antitrust legislation. It did not enumerate specific monopolistic behaviors, instead declaring as illegal any contracts, combinations, and conspiracies in restraint of trade. The act's vagueness ultimately left determination of the meaning of its prohibitions to the courts. The attorneys general of the 1890's were reluctant to exercise their discretionary authority to initiate prosecutions under the act's provisions. The act was further weakened by the Supreme Court's promulgation of the "rule of reason" in the Standard Oil and American Tobacco cases of 1911. The Court held that only "unreasonable" restraints of trade were illegal.

The first response in an attempt to strengthen the Sherman Act was the Clayton bill. Drafted by Representative Henry Clayton, it attempted to overcome the vagueness of the Sherman Act and the rule of reason by enumerating specific illegal business practices. Prohibited acts included discriminatory pricing, tie-in selling, exclusive dealing, and interlocking directorates. These acts were deemed illegal per se, regardless of their reasonableness. The political compromises necessary to obtain passage of the bill led to an act with provisions that were easily circumvented. The act was signed into law three weeks after the Federal Trade Commission Act, on October 15, 1914. President Wilson described the Clayton Act as "so weak you cannot tell it from water." A major cause of concern was that the primary responsibility for enforcement remained with the Department of Justice and the judicial system.

Originally, neither Wilson nor his primary economic adviser, Louis D. Brandeis, supported the concept of a strong trade commission. Wilson at first proposed the creation of an agency that would moderate but not unduly restrict business. In keeping with this philosophy, the administration supported a bill introduced by Representative James Covington that envisioned a commission that would secure and publish information, conduct investigations as requested by Congress, and support methods of improving business practices and antitrust enforcement.

This proposal submitted to Congress, to create an advisory commission, was transformed into an act creating a powerful commission with broad regulatory powers. This metamorphosis can be attributed to the inability to pass a strong version of the Clayton Act and the pragmatic difficulty of specifying all unlawful trade practices.

Faced with these difficulties, Wilson, in consultation with congressional leaders, decided on a new strategy that would abandon a legislative solution for an administrative one. The new strategy was greatly influenced by George Rublee, and former member of the Progressive party called in by Wilson to assist in the drafting of antitrust legislation when Brandeis was occupied by an Interstate Commerce Commission rate case. Rublee's intervention and the deadlock over the Clayton bill were primary factors in the creation of a regulatory agency as the primary method of restraining the activities of business. The FTC Act was signed into law on September 26, 1914.

The newly created commission had two major duties: to see that unfair methods of completion were prevented and to keep the public and Congress informed as to developments within an industry that threatened competition. This mission would be carried out by the utilization of the agency's three major powers: the cease and desist order, the stipulation, and the trade practice conference. The FTC was structured as an independent regulatory commission with five members (no more than three from the same political party) serving staggered seven-year terms, appointed by the president and confirmed by the Senate. Creating a bipartisan, independent commission with broad discretionary authority was viewed as a radical step in the government's attempts to control and regulate business. The FTC was to become perhaps the most controversial of the independent regulatory commissions, and its broad discretionary powers the primary source of the controversy.

Impact of Event

In assessing the impact of the FTC, it is necessary to analyze both the political and pragmatic consequences associated with its creation. Politically, the FTC represented the institutionalization of the widespread public opinion that competition was beneficial and an integral part of the American economy. It further inexorably altered the relationship between the federal government and the private sector. The commission represented a continuing repudiation of the laissez-faire doctrine, which commenced with the creation of the Interstate Commerce Commission in 1887.

The FTC was a permanent administrative apparatus, granted broad statutory powers, discretionary authority, and a jurisdiction not limited to a specific industry. These delegations of authority created an agency that could attack economic and societal problems without reliance on the judicial or executive branches of government to initiate antitrust actions. As an independent regulatory commission, the FTC combined the functions of policy-making, administration, and adjudication. The agency set precedents for the evolution of the administrative state in America. Starting in the late nineteenth century and continuing into the 1970's, the federal government became increasingly involved in regulating industries and activities.

The creation of the FTC was surrounded by great controversy, and the commission is one of the most studied of federal agencies. The major source of the controversy is the FTC's broad legislative delegation of authority. Section 5 of the FTC Act defines the commission's primary reponsibilities as identifying and preventing "unfair meth-

ods of competition" by issuing enforceable cease and desist orders. Section 6 outlines eight additional powers: to investigate corporations, to request reports from corporations, to investigate compliance with antitrust decrees, to conduct investigations for the president or Congress, to recommend business adjustments to comply with law, to make public the information obtained, to classify corporations, and to investigate conditions in foreign countries that affect trade. The Wheeler-Lea Act (1938) amended the FTC Act to empower the agency to protect the consumer as well as to promote competition. A 1974 amendment expanded the commission's jurisdiction from "methods, acts, practices in commerce" to " methods, acts, practices affecting commerce."

The discretionary authority granted the FTC proved to be a double-edged sword. Discretion theoretically allowed action in numerous areas with various tools, but it also allowed the agency to choose to take no action. It is the perceived failure of the FTC to exercise its discretion in the form of action that has been the source of much criticism.

The commission has been accused of misallocating its resources toward minor issues and failing to take action on substantial matters. Critics argue that the cases investigated involved minor matters with only minimal impact on the economy or the public interest. The agency's broad mandate has contributed to its inability to articulate definite goals, objectives, and standards of performance. The absence of direction left the commission rudderless in a complex environment.

The FTC has also been accused of failing to detect violations, since its primary means of detecting deceptive practices is to wait for a businessperson to inform on practices of competitors. The failure to establish priorities led to the commission handling too many cases, the vast majority having little impact on the public interest. The FTC has been accused of failing to exercise enforcement powers, all too often relying on voluntary correction of behavior. The agency was also accused of allowing its power to dissipate by allowing unreasonable time lapses from investigation to final decision. During the period of investigation, the FTC has no punitive power to discourage illegal behavior, and many firms continued their behavior until actual sanctions were imminent. Delay also undermines a major goal of the FTC, that of preventing unfair practices. The delay in starting agency proceedings is primarily a function of poor staff work, raising the issue of the efficacy of FTC personnel. Critics question the ability of staff and cite the high turnover rate among FTC personnel.

The FTC was born of political compromise, with no consensus as to the agency's mission, and as such it has been exposed to shifting political winds. The FTC was created as an independent, bipartisan regulatory commission, but too often the FTC employs or promotes the politically well connected and allocates resources to marginal issues solely because of requests by members of Congress.

The FTC is not without its advocates, who are as vigorous as its critics. Criticisms of personnel and actions, they argue, should have produced significant reform if valid. Defenders of the FTC counter that incompetence is asserted but not proven. Allegations that the absence of precise standards has led the commission to concentrate on

smaller firms is rebutted by citing incidents in which the commission has been both innovative and courageous. Proponents of the FTC further state that its activities are severely hampered by the lack of financial resources in comparison to the vast array of tasks allocated to the FTC. The speed at which the commission resolves cases is defended by reminding critics that the FTC is bound by procedures of due process.

In the final analysis, the evaluation of the impact of the FTC on the American economy, society, and public interest is probably a function of one's expectations of the commission and perceptions of the optimal level of governmental involvement in the private sector. FTC advocates demand greater involvement in reaction to evils of business, while critics view any action as tampering with the market system.

Bibliography

Blackford, Mansel G., and Austin K. Kerr. *Business Enterprise in American History.* 2d ed. Boston: Houghton Mifflin, 1990. Provides a concise coverage of the history of the American business firm and the evolution of government-business relations, from colonial times to the present.

Clements, Kendrick A. *The Presidency of Woodrow Wilson.* Lawrence: University Press of Kansas, 1992. Provides a brief coverage of the Wilson presidency. Valuable for highlighting major issues in a direct and concise manner. The coverage of major domestic issues (chapter 3) is especially pertinent.

Cox, Edward, Robert C. Fellmeth, and John E. Schulz. *The Nader Report on the Federal Trade Commission.* New York: Richard W. Baron, 1969. Represents a scathing criticism of the Federal Trade Commission's operations, highlighting its failures, politicization, and attempts to mask inefficiency.

Green, Mark J. *The Closed Enterprise System.* New York: Grossman Press, 1972. Analyzes the impact of the FTC on American antitrust policy.

Link, Arthur. *Woodrow Wilson and the Progressive Era, 1910-1917.* New York: Harper, 1954. Addresses that political and diplomatic history of the United States from the disruption of the Republican Party in 1910 to the entrance of the United States into World War I. Provides excellent coverage of America's transitionary reform period and the increasing role of government in society.

Stone, Alan. *Economic Regulation and the Public Interest.* Ithaca, N.Y.: Cornell University Press, 1977. Presents an analysis of the Federal Trade Commission in theory and practice, and provides an objective analysis of the agency's strengths and weaknesses.

Wilson, James Q., ed. *The Politics of Regulation.* New York: Basic Books, 1980. Wilson and other contributors analyze the politics of the major regulatory agencies. Of special interest is Robert A. Katzmann's chapter on the FTC, which presents an unconventional explanation of the agency's political behavior.

Eugene Garaventa

Cross-References

Congress Passes the Clayton Antitrust Act (1914), p. 275; The Wheeler-Lea Act Broadens FTC Control over Advertising (1938), p. 775; The Supreme Court Rules Against a Procter & Gamble Merger (1967), p. 1309; The Federal Trade Commission Endorses Comparative Advertising (1970's), p. 1410; Congress Passes the Magnuson-Moss Warranty Act (1975), p. 1584; Sears Agrees to an FTC Order Banning Bait-and-Switch Tactics (1976), p. 1631; The FTC Conducts Hearings on Ads Aimed at Children (1978), p. 1658.

CONGRESS PASSES THE CLAYTON ANTITRUST ACT

Categories of event: Monopolies and cartels; government and business
Time: October 15, 1914
Locale: Washington, D.C.

With the passage of the Clayton Antitrust Act in 1914, the federal government further codified the prohibitions against unlawful restraints of trade and monopolies

Principal personages:
 WOODROW WILSON (1856-1924, the president of the United States, 1913-1921
 LOUIS D. BRANDEIS (1856-1941), a well-known public advocate who influenced Wilson's antitrust policy
 HENRY D. CLAYTON (1857-1929), the U.S. representative from Alabama who proposed the Clayton antitrust bill
 THEODORE ROOSEVELT (1858-1919), the president of the United States, 1901-1909, and presidential candidate in 1912
 ARSÈNE PUJO (1861-1939), a U.S. representative from Louisiana who chaired the House subcommittee on the "Money Trust"

Summary of Event

On October 15, 1914, Congress passed and President Woodrow Wilson signed the Clayton Antitrust Act (H.R. 15657). This law was designed to strengthen the Sherman Antitrust Act of 1890 by fully codifying specific illegal antitrust activities. The Clayton Act forbade a corporation from purchasing stock in a competitive firm, outlawed contracts based on the condition that the purchaser would do no business with the seller's competitors, and made interlocking stockholdings and directorates illegal. It also contained provisions designed to make corporate officers personally responsible for antitrust violations. The Clayton Act also declared that labor unions were not conspiracies in restraint of trade, thus exempting them from provisions of the bill. To carry out and enforce the Clayton Act and the Sherman Act, Congress created the Federal Trade Commission in a related measure.

For more than a decade after its passage, the Sherman Antitrust Act of 1890 had very little effect upon corporations in the United States. President Theodore Roosevelt, however, pushed enforcement of the Sherman Act. In 1902, the Roosevelt Administration brought suit against the giants of the railroad industry and the "Beef Trust." The Supreme Court ordered dissolution of the Morgan-Hill-Harriman railroad holding company in the Northern Securities case (1904); in the case of *Swift & Company v. United States* (1905), the Supreme Court enjoined the "Beef Trust" from engaging in collusive price fixing activities. In 1906 and 1907, Roosevelt had the Justice Department bring suit against the American Tobacco Company, the E.I. Du Pont Chemical Corporation, the New Haven Railroad, and the Standard Oil

Company. The Supreme Court ordered the dissolution of the American Tobacco (1910) and Standard Oil (1911) companies. Between 1890 and 1905, the Department of Justice brought twenty-four antitrust suits; the Roosevelt Administration brought suit against fifty-four companies. The single administration of William Howard Taft later prosecuted ninety antitrust cases.

Despite this increase in federal antitrust regulation and prosection, the trend toward large corporations grew. The economic concentration that had increased dramatically in the late nineteenth century continued to increase in the early twentieth century. The greatest period of business mergers in the United States occurred during the William McKinley Administration, from 1897 to 1901. Between 1896 and 1900, there were approximately two thousand mergers, with nearly twelve hundred mergers occurring in 1899. Business consolidations took place in phases after that. Between 1904 and 1906, there were roughly four hundred mergers; between 1909 and 1913, there were more than five hundred mergers.

During this time of increasing economic concentration, interlocking directorates increased. An interlocking set of directorates involves individuals serving on the boards of directors of several corporations, particularly within the same industry. By 1909, 1 percent of the industrial firms in the United States produced nearly half of its manufactured goods. By 1913, two financial groups, the investment banking firm of J. P. Morgan and the interests of John D. Rockefeller, held 341 directorships in 112 corporations with an aggregate capitalization of more than $22 billion. These facts and many others were made public by the House of Representatives subcommittee on the "Money Trust" in the summer of 1912. Led by Representative Arsène Pujo (D-Louisiana), the hearings heightened existing public fears about economic concentration and intensified the political debate over the trust issue during the presidential campaign of 1912.

Louis Brandeis, a Boston attorney who had developed a reputation for being the "people's lawyer," greatly influenced Democratic presidential candidate Woodrow Wilson's policies on business trusts and government regulation. Brandeis often represented small and medium-sized manufacturers, retailers, and wholesalers and had developed a philosophy he believed would protect them against the actions of their larger competitors. Brandeis met Wilson in the summer of 1912, and later advised Wilson on matters of banking reform, monopoly and antitrust policy, and a trade commission to enforce existing antitrust laws.

Brandeis also publicized his regulatory philosophy in a series of articles appearing in *Harper's Weekly* entitled "Other People's Money and How the Bankers Use It." Coming in the wake of the Pujo Committee hearings, these articles further directed public attention to the issues of banking reform, antitrust, and economic concentration. Brandeis denounced combinations and trusts of all kinds, including interlocking directorates.

In the 1912 presidential campaign, Theodore Roosevelt, in his attempt to regain the presidency, proposed an increase in governmental agencies to regulate large corporations. Agencies would police certain corporate actions rather than focusing on corpo-

rate size. Roosevelt believed that large corporations could be more efficient than smaller businesses and that unlimited competition could be devastating to corporations and ultimately to the economy. His Progressive/Bull Moose Party platform advocated a trade commission to begin a cooperative regulatory approach. Wilson, influenced by Brandeis and to some extent by former Populist/Democratic presidential candidate William Jennings Bryan, opposed bigness in general, both in business and in government. Wilson favored dissolutions such as those of Standard Oil and American Tobacco. He believed that such large corporate monopolies squeezed economic opportunity away from smaller or medium-sized businesses. For much of the 1912 campaign, Wilson failed to propose an antitrust agency or trade commission, as Roosevelt did. Toward the end of the campaign, and certainly once in office, Wilson came to support positions on the issues of antitrust and a trade commission that were closer to those of Roosevelt.

The general public wanted increased regulation of large corporations, but businesses of all sizes wanted a clarification and further codification of the Sherman Antitrust Act. Both small and large businesses wanted a clear line between legality and illegality to be embodied in legislation and enforced by a trade commission that would work with the private sector. What the business community opposed was being subject to the unpredictable policies of the Justice Department and the shifting jurisprudence of the Supreme Court. That court had clouded the already vague standards and definitions of antitrust with its decisions in the Standard Oil and American Tobacco cases. In those cases, the Supreme Court ruled that not every restraint of trade was illegal in terms of the Sherman Act. The Supreme Court had ruled in the Standard Oil case that it would determine whether combinations restrained trade rather than using size alone as a criterion of noncompetitive behavior. Firms would be within the law, through the "rule of reason," no matter how large they were, if they did not engage in "unreasonable" behavior. The main objectives of additional antitrust legislation were thus clear: to obtain statutory specifics on antitrust prohibitions, to make monopolistic price-fixing agreements and price discrimination illegal, and to eliminate interlocking directorates.

After obtaining legislation on tariff and banking reform in 1913, Wilson turned his attention to antitrust in 1914. In his message to Congress of January 20, 1914, Wilson stated that although further antitrust legislation would make a number of activities illegal, the main purpose was to help businesses remain within the bounds of legality. "Nothing hampers business like uncertainty," said Wilson. "The best informed men of the business world condemn the methods and processes and consequences of monopoly as we condemn them." With this presidential support, two days later Representative Henry D. Clayton (D-Alabama) introduced four bills in the House to amend the Sherman Act. Proposed antitrust bills and trade commission bills developed from February through June as the House Judiciary Committee and the Senate Interstate Commerce Committee held hearings.

Although businesses wanted antitrust clarification, some provisions of the developing Clayton bill alarmed smaller and "peripheral" businesses, which often engaged

in trade or associational activities and price agreements initially prohibited by the bill. Businesses such as merchants, grocers, small manufacturers, and retailers desired prosection of "unfair price competition" engaged in by larger firms. Conversely, these peripheral businesses feared government prosecution of trade association activities that included "fair-price agreements" designed to ensure profitability.

Smaller businesses had been hit especially hard by federal antitrust policies in the past. From 1905 to 1915, seventy-two antitrust cases had been against these peripheral businesses; fewer than thirty had involved the largest firms. Under pressure from business groups such as the U.S. Chamber of Commerce, the Chicago Chamber of Commerce, and the National Association of Manufacturers, Congress amended the bill. The Clayton Act illegalized price discrimination but attached amendments that gave businesses considerable allowances and exemptions.

Other amendments undermined the strength of the bill. The prohibition against corporate mergers in the Clayton Act was modified to apply only in those cases in which merger tended to decrease competition, a vague standard open to judicial interpretation. The exemption of labor unions under the Clayton Act was equivocal and subject to judicial review. It was in fact the intention of Congress and the Wilson Administration to allow the courts to settle the ambiguity of the new antitrust law. As a consequence, federal courts often ruled that the Clayton Act was inapplicable to business mergers, and labor unions found that they had no more protection under the Clayton Act than they had before.

In its final form, the Clayton Act prohibited a corporation from discriminating in price between purchasers, engaging in exclusive sales, and tying purchases of one good to purchases of another if the effect of any of these actions was "to substantially lessen competition or tend to create a monopoly," a standard open to broad judicial interpretation. Executives, directors, and officers of a corporation were made personally liable for corporate antitrust violations. The Clayton Act also prohibited one corporation acquiring the stock of a competitor or a holding company acquiring the stock of two competitors if such acquisition would substantially lessen competition, restrain commerce, or tend to create a monopoly; these were again standards open to judicial review. The Federal Trade Commission Act, also passed in 1914, transferred the functions of the United States Bureau of Corporations to the Federal Trade Commission (FTC) and authorized the FTC, among other duties, to issue cease-and-desist orders enjoining "unfair methods of competition and commerce."

Impact of Event

The Clayton Act proved to be an enduring piece of legislation, and it has been strengthened a number of times since its passage. Just after its passage, however, the antitrust movement began to fade away. The great period of antitrust activity in the United States began in the McKinley Administration and peaked under President Taft. The Wilson Administration brought fewer antitrust suits than did either the Roosevelt or the Taft administrations. Late in 1914, Wilson stated that he believed federal regulation had gone far enough. The president viewed the Clayton Act as the conclud-

ing act in the antitrust movement. "The reconstructive legislation which for the last two decades the opinion of the country has demanded," stated Wilson, "has now been enacted."

At least as important, however, was the fact that foreign policy and World War I increasingly demanded Wilson's attention. Many historians have contended that although the antitrust movement had reached a natural decline, World War I further undermined it. War mobilization required the coordinated efforts of leaders of each industry. Economic concentration and collusive efforts were necessary and accepted for the war effort. For example, in early 1918 the Fuel Administration, a wartime agency, suppressed an attempt by the Federal Trade Commission to begin litigation against Standard Oil of Indiana for violation of the Clayton Antitrust Act.

Some economic historians contend that the Clayton Act actually promoted economic concentration. The Clayton Act clarified illegal actions, thereby helping to eliminate some monopolistic activities, but in so doing it allowed business combinations and trusts to engage in collusive activities not specifically prohibited. By codifying illegal behavior, Congress tacitly sanctioned other collusive activities designed to reduce chaotic competition and ensure stability. Large corporations such as General Motors and the Du Pont Chemical Company grew much larger just immediately after the Clayton Act and especially during the war effort.

Desire for further antitrust reform was rekindled, briefly, by the federal New Deal response to the Great Depression of the 1930's. The Public Utilities Holding Company Act of 1935 prohibited public utility systems with more than three tiers of companies and designated the Securities and Exchange Commission to regulate their size and finances. The Robinson-Patman Act of 1936 and the Miller-Tydings Act of 1937 both supplemented the Clayton Act by attempting to protect small business from wholesalers that practiced price discrimination and by establishing "fair trade" price floors on numerous items. In 1938, Congress created the Temporary National Economic Committee to hold hearings on the issue of antitrust. Attorney general Thurman Arnold reinvigorated federal antitrust prosecution. Arnold brought a number of antitrust suits, notably against General Electric and the Aluminum Company of America. Like the earlier antitrust effort of the Progressive Era, this campaign lost its strength and direction as a result of foreign policy concerns and economic mobilization for a war effort.

There have been some important antitrust cases since World War II. In 1945, the Aluminum Company of America was found to be in violation of the Sherman Antitrust Act. In 1948, the federal government forced a number of major U.S. film studios to divest themselves of studio-owned theaters. In 1961, the Supreme Court ordered the Du Pont Company to divest itself of its holdings in General Motors Company. In 1967, the Federal Communications Commission ordered the American Telephone and Telegraph Company (AT&T) to lower its rates. In 1982, after eight years of battling a private antitrust suit in federal court, AT&T agreed to be broken up, and a number of rival long-distance communication companies came in to challenge AT&T's control over the market.

In 1950, the Celler-Kefauver Act extended the Clayton Act by tightening prohibitions on business mergers that lessen competition and lead to monopoly. In 1976, Congress passed the Hart-Scott-Rodino Act, or Concentrated Industries Act. This was a mild reform law that attempted to strengthen provisions of existing antitrust laws. Clearly, monopolistic behavior remained a fact of American economic life, but federal prosecution of anticompetitive mergers and acquisitions had become rare.

Bibliography

Blum, John Morton. "Woodrow Wilson and the Ambiguities of Reform." In *The Progressive Presidents: Theodore Roosevelt, Woodrow Wilson, Franklin D. Roosevelt, Lyndon Johnson.* New York: W. W. Norton, 1980. Good for an introduction to progressive policies and politics, as well as foreign policies, of Roosevelt and Wilson. Has a concise section on the development of Wilson's legislative reform efforts, especially the Clayton Act and the Federal Trade Commission.

Clark, John D. *The Federal Anti-Trust Policy.* Baltimore: The Johns Hopkins University Press, 1931. This work is analytical, detailed, and still brief enough to be of use both to those seeking an introduction to the topic of antitrust at the federal level and to those with some familiarity with the topic. Contains the varying economic analyses of the time and a chapter on the Clayton and Federal Trade Commission acts.

Kolko, Gabriel. *The Triumph of Conservatism: A Re-interpretation of American History, 1900-1916.* New York: Free Press of Glencoe, 1963. Presents an interpretation challenging the standard view of progressive regulation and business-government relationships in the early twentieth century by showing the ways in which businesses desired and influenced regulatory legislation as a means to achieving their own goal of ending cutthroat competition and stabilizing industries. Contains a lengthy section on the development of the Federal Trade Commission and the Clayton Act in this vein.

Link, Arthur S. *Wilson: The New Freedom.* Princeton, N.J.: Princeton University Press, 1956. Part of a series on Wilson, this work is the best on Wilson's "New Freedom" progressive reforms. Detailed section on the development of the Clayton and Federal Trade Commission bills in Congress, along with Wilson's role with them.

McCraw, Thomas. *Prophets of Regulation: Charles Francis Adams, Louis D. Brandeis, James M. Landis, Alfred E. Kahn.* Cambridge, Mass.: Harvard University Press, 1984. An excellent study of business-govesrnment relations in U.S. history. Uses the efforts of these prominent individuals to assess the success and failure of regulation. Focuses more upon Brandeis and the development of the FTC than on the Clayton Antitrust Act, although it contains a good analysis of the problems of the Clayton Act. Very readable.

Thorelli, Hans B. *The Federal Antitrust Policy: Origination of an American Tradition.* Baltimore: The Johns Hopkins University Press, 1955. A comprehensive and in-depth treatment of antitrust policy in U.S. history. Covers economic, social, and

political formation of the antitrust movement in the legislative, executive, and judicial branches of government in the late nineteenth and early twentieth centuries. For those seeking a highly sophisticated and detailed treatment of U.S. antitrust policy.

Bruce Andre Beaubouef

Cross-References

The Supreme Court Upholds Prosecution of the Beef Trust (1905), p. 107; The Supreme Court Decides to Break Up Standard Oil (1911), p. 206; The Supreme Court Breaks Up the American Tobacco Company (1911), p. 212; The Federal Trade Commission Is Organized (1914), p. 269; The Supreme Court Rules in the U.S. Steel Antitrust Case (1920), p. 346; The Robinson-Patman Act Restricts Price Discrimination (1936), p. 746; The Miller-Tydings Act Legalizes Retail Price Maintenance (1937), p. 764; Antitrust Rulings Force Film Studios to Divest Theaters (1948), p. 937; The Celler-Kefauver Act Amends Antitrust Legislation (1950), p. 970.

LABOR UNIONS WIN EXEMPTION
FROM ANTITRUST LAWS

Category of event: Labor
Time: October 15, 1914
Locale: Washington, D.C.

Provisions of the Clayton Antitrust Act sought to exempt unions from prosecutions under the Sherman Antitrust Act of 1890 and under the Clayton Act itself

Principal personages:
WOODROW WILSON (1856-1924), a Democratic reform president who supported the Clayton Act
LOUIS D. BRANDEIS (1856-1941), a controversial reform lawyer and Supreme Court justice
HARRY DAUGHERTY (1860-1941), a conservative U.S. attorney general who favored antilabor injunctions

Summary of Event

Labor reforms embodied in provisions of the Clayton Act of 1914 had been decades in coming to realization. American labor legislation in the mid-nineteenth century had been as advanced in some regards as any in the world. The famed decision of the Massachusetts Supreme Court in *Commonwealth v. Hunt* in 1842 exemplified wide public acknowledgment that efforts by labor combinations to raise wages did not constitute a "conspiracy" and that laborers were justified in striking to win a closed, or all-union, shop. Half a century later, however, this tolerance of labor's right to organize in its own self-interest had altered drastically in the public mind and therefore had changed the character and interpretations of labor legislation.

The unprecedented industrialization of the United States and the attendant political ascendancy of the business classes were reflected in judicial decisions relevant to labor organizations and their methods. By the 1880's, the nation's courts were stipulating that labor's right to combine and to strike were subject to serious legal restrictions.

The judiciary's antilabor bias was attributable in part to the violence that had marked labor protests, notably in an 1877 national railroad strike and in the Haymarket Square bombing in 1886. The judiciary's hostility to many of the tactics associated with the growing labor movement was explained only in part as a reaction to labor violence. More basically, judges' antilabor decisions mirrored fresh interpretations about the nature of property and the presumptive rights of business. That is, during the last quarter of the nineteenth century, the right to do business became a "property." However troublesome they were, strikes against employers' physical properties usually could be dealt with by police, by troops, or through criminal law. Labor's picketing and boycotts, however, disrupted employers' claimed right to have access

to their markets. Beginning in the 1880's, this perspective brought court injunctions into play as a preferred weapon of business against labor. Injunctions first won general public attention in 1894, when they were issued under provisions of the Sherman Antitrust Act of 1890 against labor organizer Eugene Debs.

Injunctions were one cause of labor's cries for national legislative reform. What turned such cries into screams were injunctions with provisions that led to the assessment of damages against unions resulting from boycotts that prevented employers from doing business. The U.S. Supreme Court's decision in the Danbury Hatters' Case in 1908 (*Loewe v. Lawlor*) not only gave specificity to this menace to labor but also, by subjecting labor organizations and their members to damages under antitrust law, threatened trade unions with extinction.

Labor's salvation, if there were to be any, appeared in 1913 with the inauguration of President Woodrow Wilson. Wilson, taking a positive view of his office under the banner of his New Freedom, sponsored or supported a whirlwind of reform legislation. These measures affected tariffs, banking, the hours and conditions of labor, the protection of seamen, income taxation, popular election of U.S. senators, aid to agriculture, and, by way of strengthening the Sherman Act, the regulation of business trusts. It was from this latter step toward improved trust regulation that the Clayton Act emerged.

Three bills that had been drafted by the chairman of the House Judiciary Committee, Henry D. Clayton (D-Alabama), were subsequently combined into one. In its original form, the bill left the proclaimed needs of labor unaddressed. Primarily, the bill sought to abolish the trusts' characteristic unfair trade practices, including price discrimination, tying contracts, and interlocking directorates and stockholdings.

The bill was assailed immediately by representatives of big business, but the most vociferous of its critics were representatives of organized labor, led by a founder and the president of the American Federation of Labor (AFL), Samuel Gompers. Anticipating Wilsonian reform, Gompers had broken AFL tradition by throwing the group's political support behind Wilson's election campaign. Nothing in the initial Clayton bill removed labor from the purview of Sherman Act antitrust injunctions and prosecutions. Vowing that he would lead the AFL into Republican arms against Wilson's antitrust reforms, Gompers declared publicly that "without further delay the citizens of the United States must decide whether they wish to outlaw organized labor."

President Wilson remained adamant, but pressure from Gompers produced a congressional compromise. It was engineered by North Carolina's Representative E. Y. Webb, who believed, as did many others, that the Sherman Act was never intended to apply to labor unions. The compromise therefore incorporated labor provisions in a bill otherwise aimed at eliminating restraint-of-trade strategies employed by trusts. Affirmed by an overwhelmingly favorable vote, the Clayton bill cleared the House of Representatives on June 5, 1914. After its Senate passage, it was signed into law on October 15, 1914.

Because of the Clayton Act's sections 6 and 20, Gompers instantly hailed it as providing basic but important rights. On its face, the act appeared to confirm this

appraisal. Section 6 asserted that human labor was neither a commodity nor an article of commerce and further declared that nothing in federal antitrust laws forbade the existence of labor and agricultural unions or their lawful activities. Section 20 prohibited federal courts from issuing injunctions in labor disputes, except when irreparable damage to property might result and when there was no legal remedy for the dispute. More specifically, section 20 forbade federal injunctions prohibiting the encouragement of strikes, primary boycotts, peaceful assembly, and any other labor activities that were lawful otherwise under federal statutes.

Impact of Event

With passage of the Clayton Act, organized labor had its day in Congress, but it had not had its day in the nation's judicial system. Outside labor circles, many experts agreed that the act in no sense gave labor organizations immunity from antitrust prosecution. Evidence indicates that Wilson himself opposed such exemption. Sharp critics of the act's provisions further noted that the original bill had been so diluted in debate that its final version was an anemic sop to labor.

As swift and brilliant as President Wilson's reform legislation had been, its momentum was halted by America's preparation for and participation in World War I. At war's end, the public soon wearied of ideological and partisan battles over Wilson's foreign policy and became disillusioned with reformist exuberance. The 1920's witnessed a revival and strengthening of traditional conservative probusiness politics.

Taking advantage of the nation's postwar lassitude, fears generated by violence attending postwar strikes, and antipathy toward Communists, who were said to be leaders of the labor movement, employers again went on the offensive against labor. They created thousands of company-sponsored unions and again resorted to hiring armed company guards and strikebreakers. Capitalizing on antilabor sentiments, employers drew upon local and state authorities to deploy police and troops to harass and arrest union organizers. Yellow dog contracts (threatening workers with dismissal should they join a union) became commonplace and, chiefly under the auspices of the National Association of Manufacturers, antilabor propaganda was circulated widely and systematically in favor of open shops, which allow nonunion workers to be employed even though a union may have organized the workplace.

The fabric of protective legislation that Gompers and his fellow labor leaders presumed to be embodied in the Clayton Act's labor provisions was shredded by a U.S. Supreme Court decision in 1921. This seminal case was *Duplex Printing Press Company v. Deering*. It represented the Court's interpretation of the Sherman and Clayton acts as protecting employers from labor violence, from secondary boycotts, and from the use of other labor tactics that could be construed as unlawful interference with interstate commerce. The Duplex case involved attempts by a Michigan union in 1919 to organize the Duplex Company, one of only four such companies manufacturing printing presses and the only one remaining unorganized. To this end, the Michigan union persuaded workers and their employers in New York to boycott Duplex products; that is, to impose a secondary boycott.

Speaking for a conservative Court, Justice Mahlon Pitney held that certain union tactics constituted unlawful interference with interstate commerce and therefore were subject to antitrust laws. Secondary boycotts fell under antitrust laws as restraints of interstate trade and conspiracies. Section 6 of the Clayton Act, Pitney asserted, protected unions solely in regard to their lawful pursuit of legitimate objectives. Since in the Court's view secondary boycotts were unlawful, unions that instituted them were deprived of protection by the Clayton Act. The act's provisions in section 20 shielded unions from the issuance of injunctions against them, but injunctions were prohibited, Pitney noted, only in regard to the employees of an offending employer, the immediate parties to a labor dispute. The act thus did not prohibit an injunction against the New York workers and employers secondarily involved in the dispute.

By holding unions accountable under antitrust laws for anything the Court deemed to be other than normal and legitimate union activity, the Court effectively nullified the Clayton Act's labor provisions. As experts observed, the only remaining union actions that fell under protection of the Clayton Act were those considered lawful before passage of the act. This narrow judicial interpretation of sections 6 and 20 effectively negated the intent of a reform Congress and made it almost impossible for unions to organize workers in nonunion companies.

It scarcely mattered in the short run that Supreme Court Justice Louis D. Brandeis, one of the architects of Wilson's New Freedom, defended labor's right to push its struggle to the limits of its self-interest through encouraging sympathetic strikes. Employers benefited from judicial protection, a fact seemingly confirmed in a 1922 decision that confirmed the possibility of prosecution of unions as trusts. That same year, U.S. Attorney General Harry Daugherty invoked a wholesale issuance of court injunctions, nearly three hundred of them, against striking railway workers. Final hearings on these injunctions were repeatedly postponed until union battles against employers had failed. The wide latitude allowed to courts by the Duplex decision meant not only a denial of jury trials but the use of injunctions against payment of strike benefits and even against the public's feeding of strikers' families.

Relief from what labor and most liberals regarded as the blatant injustices of a probusiness and ultraconservative decade seemed possible by the end of the 1920's. In 1928, the planks of both major political parties featured anti-injunction proposals. The public pressures that resulted in enactment of the prolabor Norris-LaGuardia Act in 1932 and passage of the seminal National Labor Relations Act (Wagner Act) three years later were mounting. The New Deal administrations of Franklin D. Roosevelt ushered in an era rich in labor reform.

Bibliography

Brooks, Thomas R. *Toil and Trouble: A History of American Labor*. 2d ed. New York: Delacorte Press, 1971. A colorful and not uncritical prolabor account. Solid and informative. Chapters 11 and 12 are especially relevant.

Gregory, Charles O. *Labor and the Law*. New York: W. W. Norton & Company, 1946. A law professor's pithy and straightforward account. Excellent on labor, injunc-

tions, and antitrust problems in chapters 7 and 8. Includes a list of cases.

Link, Arthur S. *Woodrow Wilson and the Progressive Era, 1910-1917.* New York: Harper & Brothers, 1954. Authoritative survey by the leading Wilson scholar. Reads easily. Chapter 3 is excellent on Wilson, Congress, labor, and the Clayton Act. A fine introduction to the topic.

Northrup, Herbert R., and Gordon F. Bloom. *Government and Labor.* Homewood, Ill.: Richard D. Irwin, 1963. Authoritative, detailed, and clear reading. Balanced and outstanding. Includes a table of cases.

Taft, Philip. *The A. F. of L. in the Time of Gompers.* New York: Harper & Brothers, 1957. Dry, dense narrative, but an authoritative study. Invaluable for Gompers' views on and politics involving the Sherman and Clayton acts and injunctions.

Wilcox, Clair. *Public Policies Toward Business.* 3d ed. Homewood, Ill.: Richard D. Irwin, 1966. Splendid analysis of the subject. Balances the interests and motives of government, business, and labor in regard to antitrust regulations. Chapters 1 through 5 are pertinent. Table of cases.

Clifton K. Yearley

Cross-References

A Supreme Court Ruling Allows "Yellow Dog" Labor Contracts (1908), p. 140; The Danbury Hatters Decision Constrains Secondary Boycotts (1908), p. 146; The Federal Trade Commission Is Organized (1914), p. 269; Congress Passes the Clayton Antitrust Act (1914), p. 275; The Norris-LaGuardia Act Adds Strength to Labor Organizations (1932), p. 635; The Wagner Act Promotes Union Organization (1935), p. 706; Roosevelt Signs the Fair Labor Standards Act (1938), p. 792.

FAYOL PUBLISHES *ADMINISTRATION INDUSTRIELLE ET GÉNÉRALE*

Category of event: Management
Time: July, 1916
Locale: Paris, France

Henri Fayol provided the beginnings of a general theory of management based on his fifty-eight years of successful administrative experience

Principal personages:
HENRI FAYOL (1841-1925), a French mining engineer, founder of the process school of management thought
FREDERICK WINSLOW TAYLOR (1856-1915), an American industrial engineer, management consultant, and founder of the scientific school of management thought
HENRY FORD (1863-1947), the American industrialist who introduced the world to mass production and popularized the moving assembly line

Summary of Event

Henri Fayol was born in 1841 to a family of the French lower middle class. He was educated at the National School of Mines at St. Etienne, and at the age of nineteen was graduated as a mining engineer. In 1860, he accepted a job in the mines of the Commentary-Fourchambault Company (Comambault). He stayed with the same employer until his retirement in 1918.

During his years with Comambault, Fayol pursued three different career stages. During the first twelve years, he worked on technical issues, especially the problem of overcoming explosions and fires in the coal mines. From 1872 to 1888, he served as director of operations for a group of mines in the company's coal business. His intellectual efforts during this second stage were centered on geological questions, and his thoughts on this subject were published in three technical monographs.

Beginning in 1888, Fayol took on the greatest challenge of his industrial career. He was appointed director general of Comambault, becoming chief executive of a firm that was on the verge of bankruptcy. "The success with which he carried out those duties," according to Lyndall Urwick, author of a foreword to Fayol's *General and Industrial Management* (1949), "is one of the romances of French industrial history." Fayol became known across Europe for his success in turning the firm around. When Fayol retired in 1918, Comambault was financially strong and among the largest industrial combines of Europe.

The practical knowledge Fayol gained through his legendary industrial success led him to a fourth career after retirement. Fayol became an advocate of management studies in the schools, and in the process of promoting this belief he gained even more

notability as the founder of a revolutionary new approach to management thought.

In two papers written prior to his retirement, he began to express his views on management and on the methods he had used successfully at Comambault. In 1900, he argued that management should be considered a necessary skill of organizational life, a skill that is separate and apart from any technical knowledge. His point was that every individual at work and at home carries out administrative functions to a certain degree each and every day, no matter what title or position the person holds. He had become convinced of the universality of administrative processes, and from this belief he argued that society in general would benefit from the study of management fundamentals at all educational levels. In private enterprise and in public administration, the development of effective managers would be speeded if young trainees were first given a theoretical foundation and then matured through experience. In the home, the church, and social organizations, improved administrative abilities would lead to more efficient uses of personal and societal resources.

In his second preretirement paper, "Discourse on the General Principles of Administration," presented in 1908, Fayol began to identify some of the methods that he thought had led to his successes at Comambault. He was searching for a theory of management to act as a foundation for the practices he had discovered through experience. In this paper he also began to argue that a firm's technical expertise (tactical actions) were of little benefit if its administrators were "defective" in their managerial duties (strategic actions). Good administrative talent was, according to Fayol, more important to the success of an organization than was technical expertise.

His most important written work was a monograph entitled "Administration Industrielle et Générale," which first appeared in the *Bulletin of the Societe de L'Industrie Minerale* in 1916. This monograph merged his thoughts from the two previous papers and expanded on a set of principles and concepts that he considered to be "lighthouses" that would lead to a theory of administration. In 1925, the monograph was published in book form in France, and in 1929 it was translated for the first time into English and published in Great Britain.

Known to many management scholars in English-speaking countries by the title *General and Industrial Management*—a translation of the original title for a 1949 publication of the work—it became a milestone in the history of management thought. So much of contemporary management theory and practice is built upon Fayol's ideas and terminology that it has become difficult to find anything that appears to be unique in his writings. His ideas, however, were certainly revolutionary in the early decades of the twentieth century.

After repeating his arguments for the teaching of management in the schools, Fayol directed his attention to finding a starting point for the educational process by detailing those ideas and principles that he had discovered through practice. His theory, therefore, is based on experience. He first segregated industrial undertakings into activities, so that the place of administration could be better understood. Duties within the enterprise, he proposed, could be divided into six categories: technical activities, including production and manufacture; commercial activities of buying,

selling, and exchange; financial activities of finding and using capital; security activities of protecting property and persons; accounting activities of inventory control and calculation of balance sheets, costs, and statistics; and managerial activities involving foresight, organization, coordination, and control. Fayol pointed out that each of the first five activities required specialized learning to carry out its particular tasks, but that managerial capability was generally applied. It was necessary in each of the first five activities, and it was needed to provide high-level overall direction to the enterprise.

Fayol also sought to spell out the personal characteristics of a good manager. He listed six qualities to look for in determining administrative potential: physical qualities of health and vigor; mental qualities including the ability to understand and learn, judgment, mental vigor, and adaptability; moral qualities of energy, firmness, willingness to accept responsibility, initiative, loyalty, tact, and dignity; general education; special knowledge peculiar to any technical, commercial, financial, or managerial function to be performed; and experience. He understood that the importance of each of these characteristics varied with the level in the hierarchy of the position to be filled. He attempted to establish the relative importance of each of these abilities by graphically plotting their relationship to each of his six industrial activities.

The primary obstacle to offering management courses in the schools, Fayol determined, was the lack of something to teach. There was an absence of theory, and without theory the only method of developing managerial capabilities was on-the-job experience. Fayol attempted in part 2 of *Administration Industrielle et Générale* to build a foundation for a theory of management. His fourteen principles of good management, taken from his fifty-eight years of experience, were in his view the beginnings of the development of a theoretical basis for organizational administration. These fourteen principles included division of work into specialized tasks; authority and responsibility, or the right to give orders and the power to exact obedience; discipline, or clear agreements between management and labor regarding rules and the judicious use of sanctions; unity of command, by which an employee should have only one superior; unity of direction, with only one head and one plan for a group of activities having the same objective; subordination of interests, with individuals subordinating their personal interests to the firm's; fair and reasonable pay; centralization; a clear hierarchy of authority; a place for everything and everything in its place; equity, with kindness and justice in employee relations; stability of tenure of personnel, with orderly personnel planning and provisions to replace human resources; initiative, with promotion of zeal and energy on the job; and a spirit of teamwork.

To provide structure to this study of management, Fayol suggested that a school's curriculum be designed around the functions performed by a manager. He broke the managerial process into five basic elements: forecasting and planning; organizing; commanding; coordinating; and controlling. From his experience, these were the managerial activities carried out in directing the parts or the whole of an organization.

Impact of Event

During the nineteenth century, business firms in the United States and Europe grew in size beyond anything ever seen before, and many were profitable because they were the first to apply some newly discovered operational or marketing strategy. Efficiency, however, was neglected, and the potential for tactical improvements was quite high. New methods of organizing the production process would turn out to be the keys to success for the first two decades of the twentieth century.

Henry Ford revolutionized the manufacturing process by achieving great increases in productivity through the use of the moving assembly line. His specialized machines, interchangeable parts, and standardized products became the definition of American mass production. The tremendous success of the Ford Motor Company earned the attention of managers worldwide.

Frederick Winslow Taylor, an American industrial engineer, began to study work itself by examining the actual steps taken by workers on the shop floor. He applied science to the improvement of the work process and by so doing introduced the world to time study and other scientific management ideas. Taylor and his disciples began a "cult of efficiency" that spread across American industry.

Taylorism was popularized in Europe through the successful use of his scientific management techniques to meet military needs during World War I. Americans demonstrated its potential in building docks, roads, and bridges, and in setting up communication lines. After the war, Henry-Louis Le Châtelier and Charles de Freminville promoted Taylorism in France. Its popularity overshadowed Fayol's efforts until the last few years of his life.

Immediately after his retirement in 1918, Fayol founded and presided over the Center of Administrative Studies, an organization he used to promote the concepts of what would become known as Fayolism. For most of the years after the publication of *Administration Industrielle et Générale* and before Fayol's death in 1925, the disciples of Taylor and the followers of Fayol competed with each other for the attention of French managers. Fayol had always contended, however, that the two approaches were in fact complementary. In 1924, others began to agree with his assessment of the situation, and the Center of Administrative Studies merged with Le Châtelier-de Freminville to form the Comité National de l'Organization Française.

The approaches taken by Taylor and Fayol were simply different paths to the same general goal. They both sought to improve the practice of management through the application of scientific methods. Taylor had begun his career on the shop floor, and his approach came from these beginnings. His methods were mostly tactical and were centered on production processes and accounting procedures. His view was primarily from the bottom up. Fayol, on the other hand, discovered his principles and processes while at the top of a large mining organization. His concepts were mostly strategic, taking the top executive's view and attempting to integrate the whole from the top down.

Although Fayol's writings were not translated into English until 1929, and even then were not well distributed in book form outside of France, his ideas began to be

disseminated in the United States somewhat earlier through the debates that became rather common between Taylorites and Fayolites on the European continent. His major influence on American management, however, came after World War II with the publication of his book under the title *General and Industrial Management* (1949), with translation by Constance Storrs. His functional approach to the study of management became known in the literature as the process school of management thought. By the 1950's chapters of most management textbooks were structured around his functional areas of planning, organizing, commanding, coordinating, and controlling. His work provided the important theoretical foundation needed to prepare students to enter the practice of management.

Bibliography

Archer, Earnest R. "Toward a Revival of the Principles of Management." *Industrial Management* 32 (January/February, 1990): 19-22. An analysis of how Japanese management methods are related to Fayol's classic principles. Argues that the Japanese have applied Fayol's principles and that the United States should return to these basic ideas. An excellent comparison of the classical approach and the precepts that have brought success to the Japanese.

Breeze, John D. "Harvest from the Archives: The Search for Fayol and Carlioz." *Journal of Management* 11 (Spring, 1985): 43-47. A discussion of the management ideas of Fayol as applied by one of his top management assistants. Carlioz directed Comambault's commercial department and was in charge of purchasing and selling. His application of Fayol's methods brings practicality to the theory.

Fayol, Henri. *General and Industrial Management.* Translated by Constance Storrs: London: Sir Isaac Pitman & Sons, 1949. Consists of the first two sections of *Administration Industrielle et Générale*. Includes his arguments for teaching management in the schools, his discussion of the six industrial activities, details of his management principles, and a discussion of the functions included in the administrative apparatus. The foreword to this book is by Lyndall Urwick and provides an excellent overview of Fayol's accomplishments.

George, Claude S., Jr. *The History of Management Thought.* Englewood Cliffs, N.J.: Prentice-Hall, 1972. George includes Fayol among six early contributors to the science of management in his classic history of management. Each of Fayol's principles and his functions of the manager are discussed briefly.

Urwick, Lyndall. *The Elements of Administration.* New York: Harper & Bros., 1944. Uses the work of Fayol as the framework for a study of several key management scholars. Consolidates the principles and ideas of each scholar. A key resource for those studying Fayol, but somewhat difficult to find.

Wren, Daniel. "The Emergence of Management and Organizational Theory." In *The Evolution of Management Thought.* New York: John Wiley & Sons, 1987. An eleven-page discussion of Fayol's career and his key contributions to management theory. Discusses his arguments for teaching management in schools, lists and discusses his principles, and spells out clearly and concisely the processes of

planning, organizing, commanding, coordinating, and controlling. Well written and well researched.

Robert G. Lynch

Cross-References

Walter Dill Scott Publishes *The Theory of Advertising* (1903), p. 80; Cadillac Demonstrates Interchangeable Parts (1908), p. 151; Harvard University Founds a Business School (1908), p. 157; Ford Implements Assembly Line Production (1913), p. 234; Lillian Gilbreth Publishes *The Psychology of Management* (1914), p. 258.

THE HINDENBURG PROGRAM MILITARIZES THE GERMAN ECONOMY

Category of event: Government and business
Time: August, 1916
Locale: Germany

The Hindenburg Program of 1916 attempted to more effectively organize the German economy for war once it became clear that a quick victory was not in sight

Principal personages:
PAUL VON HINDENBURG (1847-1934), a general and national hero
ERICH LUDENDORFF (1865-1937), a general, Hindenburg's aide
WILLIAM II (1859-1941), the German emperor
THEOBALD VON BETHMANN HOLLWEG (1856-1921), the German chancellor from 1909 to 1917
ERICH VON FALKENHAYN (1861-1922), a general and Prussian minister of war
MAX BAUER (1869-1929), the artillery expert on the general staff, with close ties to industry
WILHELM GROENER (1867-1939), a general, head of the railways section of the general staff at the beginning of the war

Summary of Event

The Hindenburg Program is the name given to a series of initiatives that attempted to reorganize Germany's war effort around the concept of total war. The program reversed previous policies regarding munitions and manpower, seeking to produce a vastly increased amount of weapons and munitions in a fixed amount of time. The results were mixed. There was some increase in weapons production, but at the expense of major disruptions in coal production and transportation, accompanied by heightened social tensions and strikes.

For all of its aggressive activity and rhetoric prior to 1914, Germany entered World War I only minimally prepared to mobilize its enormous industrial potential behind the war effort. This lack of preparation was the result of German military planners' belief that any war would be short. On August 13, 1914, the War Raw Materials Department (Kriegsrohstoffabteilung, or KRA) was established within the Prussian War Ministry. The KRA fixed maximum prices, allocated raw materials, and was charged with developing substitutes for scarce materials. Special, privately held, war raw materials corporations under business leadership were set up to control the acquisition and distribution of individual strategic materials. The War Ministry and the KRA centered all war production goals on the production of powder, based on the appreciation that weapons required munitions and munitions required powder. They also held war materials producers to higher standards and lower profit margins than those producers desired.

An importer of food, industrial raw materials, and labor, the German economy was peculiarly dependent upon international markets and could ill afford a long war. When the Schlieffen Plan went awry in September, 1914, the German war economy was left in a perilous situation. Any policies carried out by Chief of Staff Erich von Falkenhayn, the War Ministry, and the KRA were sure to come under criticism. Businesspeople claimed that they could produce more and better weapons if the War Ministry got out of the way. They were supported and pushed on by individuals on the general staff such as Colonel Max Bauer, who wanted to wrest power from the War Ministry. Other staffers, such as Wilhelm Groener, thought that a more efficient mechanism than the KRA could be found. These individuals found an ally in Erich Ludendorff, who advocated an all-out offensive on "his" front, that in Russia. All agreed for their own reasons that some sort of dictator or strongman was necessary. Chancellor Theobald von Bethmann Hollweg wanted to use the prestige of the hero of the East, Paul von Hindenburg, as a shield behind which he could negotiate a compromise peace. Only in August, 1916, did this strange, divided coalition succeed in convincing Emperor William II to replace Falkenhayn with Hindenburg. William was reluctant to make this move, for he knew that the lionized Hindenburg could easily eclipse him in popularity. Moreover, he despised Ludendorff, the true genius behind Hindenburg's success. Little as William cared for civilian servants such as Bethmann Hollweg, he reckoned that although they shared some power with the military, he as emperor was not out of the picture.

The Hindenburg Program developed in stages. In November, a Supreme War Office (Oberstes Kriegsamt, or OK) was created under the leadership of Wilhelm Groener. Theoretically, the OK functioned as part of the War Ministry, but in reality it was the domain of the Army High Command. It was put in charge of both the KRA and the Arms and Munitions Procurement Office, both formerly the province of the War Ministry. The OK set new, high goals for the production of weapons and munitions. Price and quality became less significant, and waves of high-priced contracts were let out. Transportation bottlenecks developed. Coal production failed to keep pace with industry's increased demand, which incidentally diverted warmth from people's homes. Their coffers overflowing with marks fresh off the government's printing press, industrialists competed to attract skilled workers who had returned from the war or were exempt from service.

This latter development led to the second aspect of the Hindenburg Program, an attempt to mobilize and control labor resources known as the Auxiliary Service Law of December 5, 1916. Before 1914, Germany had been a labor importing country. With traditional supplies of foreign labor disrupted and several million men in service at the front, the labor shortage had become acute by the second year of the war. Workers in the weapons industry had responded by exercising greater mobility in search of higher wages or better conditions. According to the Auxiliary Service Law, all men between seventeen and sixty years of age were drafted into work deemed necessary to the war economy. At the same time, restrictions were placed on their mobility. In return, workers' committees were introduced in all firms with more than

fifty employees. These committees, elected by and representative of the workers, were legally recognized as equal partners with the employers in negotiations over wages and working conditions.

Impact of Event

During the course of 1917, the goals of the Hindenburg Program had to be continually scaled back. The program experienced the sorts of bottlenecks and dislocations that Falkenhayn, the War Ministry, and the KRA had with some success managed to avoid before August, 1916. As a plan to concentrate on war production, the Hindenburg Program was partially successful. It is estimated that production in the consumer goods sector shrunk by half. The program, however, failed to produce weapons and munitions sufficient to turn the tide of the war in Germany's favor.

Whatever increase in war production was realized, it was at the expense of social cohesion. The policy of financing the war by printing money, in tandem with the program's weapons-at-any-price procurement policy, resulted in the creation of a wealthy class of "war profiteers" who were able to live extravagantly while others suffered from shortages and overwork. The government's food policies, which favored producers to the detriment of consumers, heightened social tensions as well. Aware of growing disquiet among the population at large, the civilian government tried to offer the hope of future social reform as a means of staving off social unrest. In his Easter Speech of April, 1917, the emperor promised postwar political reform and the abolition of Prussia's inequitable suffrage laws. None of this sat well with the militarists and expansionists coalesced around Ludendorff and the High Command, nor was it sufficient to prevent the outbreak of strikes in Berlin and Leipzig the same month. These strikes at first concerned food and working hours, but later strikers began to issue political demands.

The immediate result of the Hindenburg Program was thus a minimal, strategically insufficient increase in war production achieved at high economic and social cost. It failed to provide Germany with the weapons needed to win the war. Moreover, it helped to sharpen social and political antagonisms between interests and classes and by doing so ensured the fall of the monarchy, which occurred in November, 1918.

The Hindenburg Program had two important medium-term effects. The Auxiliary Service Law established the terrain on which many of the domestic political disputes of the 1920's would be fought. The workers committees established under the law, for example, provided the basis upon which collective bargaining was based. The industrialists of the Weimar Republic bitterly resented the increased power of their workers represented by collective bargaining and the forty-hour week; they made a diminution of these workers' gains a condition of their participation in government after 1923. Perhaps of even greater significance, the policy of purchasing war materiel with unsupported paper currency laid the groundwork for Germany's postwar hyperinflation. The inflation, in turn, probably did more to discredit the new republican regime in the popular mind than any other fact.

The Hindenburg Program's long-term effects were similarly pernicious. The pro-

gram's authors were never really brought to task for their role in unleashing social and political chaos or in losing the war. Instead, other scapegoats, including politicians, socialists, and the Jews were found. Hindenburg's popularity never diminished. In 1925, he was elected the second president of the republic by a coalition of conservative, nationalist, and monarchist parties. In 1930, he appointed a chancellor to rule without a parliamentary majority, and three years later he accepted Adolf Hitler as the last chancellor of the Weimar Republic. Hitler, for his part, learned little from the failure of Ludendorff's eastern expansionism or from the failed experiment with "war socialism." Although Hitler and his cronies would claim to enter World War II with a realistic economic plan in place, the competing fiefdoms made a full utilization of resources for the war effort impossible. The regime only opted for "total war" in 1942. If armaments czar Albert Speer did a better job than Ludendorff, Groener, and Bauer, it was not because he had learned from their mistakes.

Bibliography

Feldman, Gerald D. *Army, Industry, and Labor in Germany, 1914-1918.* Princeton, N.J.: Princeton University Press, 1966. The standard text on the Hindenburg Program. Feldman wrote a new preface for the 1992 edition, in which he describes the research done between 1964 and 1992 on German domestic policy during the war and suggests how his own views have changed in the intervening years.

_____. *The Great Disorder: Politics, Economics, and Society in the German Inflation, 1914-1924.* New York: Oxford University Press, 1993. Feldman's much-awaited work on the German hyperinflation.

Hardach, Gerd. *The First World War, 1914-1918.* Translated by Peter and Betty Ross. London: Allen Lane, 1977. A good overview text on the war, with attention to the German internal situation.

Kocka, Jürgen. *Facing Total War: German Society, 1914-1918.* Translated by Barbara Weinberger. Cambridge, Mass.: Harvard University Press, 1984. The standard text on the domestic policies of the German government during the war.

Vincent, C. Paul. *The Politics of Hunger: The Allied Blockade of Germany, 1915-1919.* Athens: Ohio University Press, 1985. Concerns how the nutritional requirements of Germans were met and the effects of the Hindenburg Program on provision of food.

George Vascik

Cross-References

The U.S. Government Begins Using Cost-Plus Contracts (1914), p. 246; Wartime Tax Laws Impose an Excess Profits Tax (1917), p. 319; Germans Barter for Goods in Response to Hyperinflation (1923), p. 406; Stalin Introduces Central Planning in the Soviet Union (1929), p. 563; France Nationalizes Its Banking and Industrial Sectors (1936-1946), p. 735.

THE UNITED STATES ESTABLISHES A PERMANENT TARIFF COMMISSION

Category of event: International business and commerce
Time: September 8, 1916
Locale: Washington, D.C.

Seeking to restructure and reform America's tariffs along "scientific" lines, the administration of President Woodrow Wilson created the Federal Tariff Commission

Principal personages:
WOODROW WILSON (1856-1924), the president of the United States, 1913-1921
FRANK WILLIAM TAUSSIG (1859-1940), an economist, tariff expert, and proponent of moderate tariffs
OSCAR WILDER UNDERWOOD (1862-1929), a tariff reformer and congressional leader
THEODORE ROOSEVELT (1858-1919), the president who originally proposed a permanent tariff commission
ROBERT JOHN WALKER (1801-1869), a treasury secretary who laid the basis for tariffs as a source of revenue

Summary of Event

Establishment of the independent Federal Tariff Commission in 1916 represented a turning point in reformers' half-century struggle against the politics of protectionism. Tariffs are schedules of duties levied by government fiat upon imports, and sometimes on exports. Since 1789 and the levying of the first such American duties, tariffs had been the subject of debate and often of passionate controversy. Debates concerned the levels of tariffs and their uses, such as promoting free trade; protecting and subsidizing "infant industries" (those in the process of development and therefore unable to compete in international markets), sectional interests, and politically powerful farmers and manufacturers; providing a source of federal revenues; and acting as weapons of trade policy and foreign policy. Such questions have surrounded the tariff issue in many local elections and in nearly every presidential campaign from the founding of the United States into the 1990's. In pre-Civil War years, while Southern and Western agricultural interests held sway in Washington, the tendency of the Democratic administrations representing them to maintain low tariffs became an article of faith. With the ascendance of Northern and Western Republicanism from the 1860's to the early 1900's, and again in the 1920's, the political allegiance of the dominant party shifted to protectionism and high tariffs.

Reform impulses of the Progressive Era emerged during a fifty-year period of high, at times exclusionary, Republican-made tariffs. Rarely did political pronouncements of the dominant Republicans discuss the virtues of liberalizing foreign trade. The

momentum of reform, which cut across party lines, did encompass tariff rates. Convictions about tariff issues thus became a simplistic touchstone of whether individuals were identified as conservative champions of economic privilege or were marked as liberals eager to relieve consumers of tariff-raised prices and to restore a competitive marketplace.

Without publicly abandoning their support of high tariffs, Republican administrations beginning early in the 1880's nevertheless negotiated a series of short-term reciprocal trade treaties that in principle modified their protectionism. Even a paragon of Republican conservatism such as President William McKinley had concluded privately by 1897 that, as the world's major industrial power, the United States had outgrown the need to isolate and safeguard its economy behind high tariff walls. America's productivity and attendant surpluses of goods, its new international interests, its growing imperial commitments, and its increasingly restive antitariff forces all indicated that prosperity was no longer tied exclusively to the domestic market. Consequently, under McKinley's presidential successor, Theodore Roosevelt, there were signs of tariff moderation and of lowered rates, including passage of the Payne-Aldrich Tariff of 1909.

President Woodrow Wilson an eloquent advocate of reforms and a learned exponent of "positive government," engineered or supported the largest packet of American reform legislation in history, most of it during his first term in office. Tariff reform was ranked foremost on his legislative agenda and proved in 1913 to be the earliest of his political tests before Congress.

Wilson chose the Underwood bill, vetoed by his predecessor, William Howard Taft, as the vehicle to affirm his commitment to making American business and agriculture genuinely competitive through a restructuring of tariffs. After his inauguration, Wilson consulted with the bill's author, Oscar Wilder Underwood, an Alabama Democrat who chaired the House of Representatives' powerful Ways and Means Committee. The bill stung hordes of lobbyists into action and was debated hotly. Wilson's personal appearance before Congress to urge its passage was almost unprecedented and constituted a daring gamble with his party stature and his executive authority.

Successfully enacted in 1913, the Underwood Tariff was described appropriately as the most revolutionary tariff reduction and revision in more than half a century, matched only by Treasury Secretary Robert John Walker's classic enunciation in 1846 of principles of low tariffs, to be used only for revenue and not for protectionism. The Underwood Tariff specifically invested wide discretionary authority in the secretary of the treasury to examine the books of importers suspected of dishonesty, to strengthen the power of collectors, and to improve the assemblage of accurate trade and tariff statistics. These were all subtle extensions of federal authority. Of more lasting significance, the Underwood Tariff carried provisions for an income tax to compensate for the $100 million in revenues expected to be lost from tariff reduction, a tax soon institutionalized by the Sixteenth Amendment to the Constitution.

The Federal Tariff Commission, created in 1916 as one of the first independent

federal agencies, was designed as a keystone to this lengthy and often tortuous process of tariff reform. The immediate aims of the commission were to winnow the morass of often-unreliable information on which previous tariffs had been based and to collect accurate data that would inform the structuring of "scientific" tariffs. The Wilson Administration hoped to depoliticize the tariff-setting process, removing it from insidious lobbying and favoritism that generally had marred it in the past. It was hoped that future Congresses and presidents could be informed by the unbiased advice of experts. The six members of the commission, among them the distinguished Harvard economist and tariff historian Frank William Taussig, were presidential appointees. Members were three from each party, serving six-year terms upon their Senate confirmations.

Neither political party was enthused about establishing the commission. Wilson's demonstration of his presidential authority alone carried it into being. Wilson was clear about wanting to depoliticize the process of setting tariffs, about eliminating the special privileges masked behind earlier tariffs, and about listening to the complaints of small businesses and reformers. Wilson was not an unbridled advocate of free trade. He described himself as a "rational protectionist" and had insisted in campaign speeches on "a competitive tariff," a position close in practice to the Republican call for tariffs designed to equalize domestic costs of production with the costs of imported goods. The fate of the commission and the services it might be called upon to perform depended on presidential perceptions about the objectives to be sought in the formulation of national policies.

Impact of Event

Tariff exports and economists such as Taussig were aware of the inherent limitations imposed upon the Federal Tariff Commission at its inception. They saw as illusory the hope among reformers that the commission could help the enactment of scientific tariffs. As Taussig wrote dismissively in this connection, "there are no scientific laws applicable to economic problems." Later, Nobel Prize-winning economist Paul Samuelson described pleas for a scientific tariff as "the most vicious" argument for a tariff, one that for generations had ignorantly informed federal policy and reflected adversely upon the "economic literacy" of the American people.

Many of the justifications advanced by Wilson and other Progressives in the battle to establish a tariff commission were fallacious. Reformers hoped to make the tariff scientific by making it "competitive," and Republican conservatives insisted on a tariff that "equalized the costs of production at home and abroad." In practice, these were nearly identical positions. The unsoundness of them rests on the fact that trade is based on differences in costs and advantages among individuals and nations. Contrary to this, a so-called "scientific tariff" gave sanction to the prejudices that all industries were equally worth having; that when cost differences between nations grew, duties accordingly should rise; and that every industry, regardless of the quality of its products and its adaptation to America's natural resources, should enjoy the equalizing protection of the tariff.

The fallacious reasoning was part of politics and not of economics, but its prevalence highlighted the political limitations that weighed on the Federal Tariff Commission. The commission was an administrative agency and as such was incapable of significantly influencing national policy-making. Moreover, as friendly observers of the commission noted during its first years of operation, even if it were to be charged with preparing a tariff or elaborating a tariff bill, it was ill-equipped to do so. The experience of the Tariff Commission of 1882 and the Tariff Board of 1910 (both temporary organizations) indicated that the time required for requisite investigations of costs and conditions at home and abroad, as well as for reviews and the actual formulation of tariff schedules, would prove much too lengthy for such work to be of service to Congress.

Exactly how contingent the work of the Federal Tariff Commission was upon the varying degrees of enlightenment that characterized national politics was manifested by a renascence from 1921 to 1934 of high protectionism. Wilson's Emergency Tariff (1921) raised import levies on most agricultural products and reversed the pronounced downward trend of the Underwood Tariff. This reversal was followed swiftly by the Fordney-McCumber Tariff in 1922, which elevated levies imposed on manufactured imports and farm products substantially above the Payne-Aldrich levels of 1909. Presidential selection of tariff commission members, moreover, ran to the mediocre. Then, in the midst of economic crisis at the onset of the Great Depression and against the advice of more than a thousand economists, the administration of President Herbert Hoover enacted the Smoot-Hawley Tariff in 1930, imposing the highest protective tariffs in the nation's history. Tariff commissioners could draw some comfort from changes in the law that allowed presidents, after receiving the commission's recommendations, to alter individual tariff rates by half of those set by Congress.

When President Franklin D. Roosevelt's first New Deal administration shifted from economic isolationism to the initiation of long-term tariff reductions by means of reciprocal trade agreements in 1934, vitality was infused into the commission's functions by the perceived mandates of a new trade era. After 1934, and continuing almost unabated into the 1990's, protectionism was repudiated as national policy. That change was reflected in the Federal Tariff Commission's redesignation in 1974 as the U.S. International Trade Commission (ITC). The ITC, in conjunction with advising presidents, Congress, and other governmental agencies on a wide array of trade and tariff questions, has exercised important investigatory and reporting functions in regard to the fiscal and industrial effects of American customs laws. These encompass relationships between duties on raw materials and finished products, the impact of customs laws on national revenues as well as upon industry and labor, the trade and tariff relations between the United States and other countries, economic alliances, commercial treaties, multilateral trade negotiations, and the effects of foreign competition with American industries. Its data analysts monitor the impacts of hundreds of categories of imports on the domestic economy. As always, the utility and effectiveness of such agencies remained determined by the nation's political course.

Bibliography

Leech, Margaret. *In the Days of McKinley*. New York: Harper & Brothers, 1959. McKinley's career was closely identified with protectionism. Insightful on changes in his views. Fine background to an understanding of why reformers wanted a permanent commission. Chapters 2 and 6 are especially relevant.

Link, Arthur S. *Woodrow Wilson and the Progressive Era, 1910-1917*. New York: Harper & Brothers, 1954. Authoritative synthesis by the leading Wilson scholar. Excellent on tariff issues and the commission. Photos, ample footnotes, essay on sources, excellent index. Invaluable for context and specifics.

Lyon, L. Leverett S., and Victor Abramson. *Government and Economic Life*. Vol. 2. Washington, D.C.: The Brookings Institution, 1940. Authoritative and easy to read. Chapter 20 is a superb summary of tariff history and the tariff commission. Updates and condenses Taussig's works.

Taussig, Frank W. *Free Trade, the Tariff, and Reciprocity*. New York: Macmillan, 1920. Taussig remains the chief authority on tariff history through 1930. His work is clear, is easy to read, and reflects his interactions with working government as well as his academic specialization. Chapters 5, 6, 9, and 10 are especially relevant.

——————————. *The Tariff History of the United States*. 1892. Reprint. New York: A. M. Kelley, 1967. Still an essential, authoritative, easy-to-read survey. Chapters 8 through 11 are relevant on the commission's evolution and functions. Few notes and no bibliography, but a useful index.

Clifton K. Yearley

Cross-References

Hoover Signs the Smoot-Hawley Tariff (1930), p. 591; The Bretton Woods Agreement Encourages Free Trade (1944), p. 851; The General Agreement on Tariffs and Trade Is Signed (1947), p. 914; Eisenhower Begins the Food for Peace Program (1954), p. 1052; The European Market Unifies (1992), p. 2051; The North American Free Trade Agreement Goes into Effect (1994), p. 2072.

CLARENCE SAUNDERS INTRODUCES
THE SELF-SERVICE GROCERY

Category of event: Retailing
Time: September 11, 1916
Locale: Memphis, Tennessee

Clarence Saunders' Piggly Wiggly grocery store introduced self-service in 1916 and established the basis for the supermarket

Principal personages:
CLARENCE SAUNDERS (1881-1953), the grocer who founded Piggly Wiggly, the first self-service grocery store chain in the United States
MICHAEL CULLEN (1884-1936), a grocer whose self-service, low-prices stores sparked the rise of the supermarket during the 1930's
JOHN A. HARTFORD (1872-1951), a grocer who made the decision to shift the chain of Great Atlantic and Pacific Tea Company stores to a supermarket format

Summary of Event

On September 11, 1916, Clarence Saunders opened his first retail outlet, which he named King Piggly Wiggly. This store and others that followed incorporated Saunders' ideas on organizing, selling, and advertising grocery products. Unlike virtually every other store in the trade, Saunders' Piggly Wiggly featured self-service, which enabled him to dispense with many of the clerks who served customers in more traditional grocery stores. His was the first chain of stores to incorporate self-service.

A native of Amherst County, Virginia, Saunders acquired his early experiences in the grocery trade while a young man in Clarksville, Tennessee. Saunders moved in 1900 to Memphis, Tennessee, where he worked as a clerk in a local grocery store. In 1904, Saunders assumed the position of salesman for Shanks-Phillips, a Memphis company. He spent a number of years learning the grocery business. By 1915, Saunders had moved from salesman to the head of a grocery cooperative and finally owner of a wholesale grocery business, the Saunders-Blackburn Company. Having seen the industry from every angle, Saunders concluded that the methods of delivering food and beverages demanded significant rethinking, especially because of the combination of high operating costs and excessive credit so widespread among grocery outlets.

Saunders' understanding of the grocery business encouraged him to move beyond self-service in organizing his stores. He mandated that each shelf item in his stores display a clearly marked price. This eliminated haggling over prices, quickening the pace of customer shopping. Saunders introduced a new type of store design that compelled each patron to walk down every aisle and pass every type of grocery product before leaving the store. Saunders hoped this exposure would spark impulse

buying and boost his sales. To encourage this buying, Saunders demanded that shelves be within easy reaching distance of customers and always fully stocked. Products appeared on shelves according to type and brand, facilitating the patron's search for a specific product. Upon finishing shopping, the customer entered a turnstile, pioneered by Saunders, where a single clerk totaled the prices for all the items and packaged the goods. Finally, Saunders ordered all of his stores to be painted in blue, brown, and yellow, with the name Piggly Wiggly appearing in white. The standard design increased customer recognition.

Saunders understood the growing popularity of nationally produced brand-name goods and the widespread knowledge made available to customers through the national advertising of large-scale producers. By the 1910's, national manufacturers had built up substantial levels of trust among customers through aggressive promotional campaigns that often made their products more appealing than locally manufactured brands. Saunders' stores capitalized on the free advertising provided by these manufacturers to lure customers into the store and to reassure them of the quality of the products featured in Piggly Wiggly outlets. He complemented this strategy with advertisements composed in his own unique prose. Saunders also decorated his stores with thoughtfully crafted and patented fixtures and fittings that gave a modern appearance to all of his outlets.

Saunders' concern for detail also appeared in his dealings with employees. He insisted that no clerk handle merchandise or render assistance to a customer in choosing a grocery product, both longstanding traditions in the grocery trade. To reinforce customer confidence, Saunders ordered that clerks on duty wear sanitary uniforms provided by the company. The store manual that governed appropriate conduct for all Piggly Wiggly employees noted that each clerk had an assigned task and should work at that task exclusively.

Saunders even hired experts who used the time and motion approach, made famous among large-scale corporations by Frederick W. Taylor, to study his employees and the ways they carried out tasks. These efficiency experts intended to remove all unnecessary motions and create the most time-effective means of accomplishing a specific task. Saunders and his management team planned almost all aspects of operation, from handling of customer-damaged goods to the number of keys allocated to each outlet. Devices used in the operation of the store, such as weights, occupied sites that allowed clerks to handle products only once before they were transferred to the customer. These techniques dictated practices throughout his growing Piggly Wiggly self-service chain, which he formally incorporated in 1919.

In developing these methods, Saunders jettisoned time-honored practices that had marked the grocery business. Credit, which grocers made available to the majority of their customers, and delivery of orders had no place in a self-service system. Practices such as assisting customers in selecting goods also conflicted with guidelines that dictated the behavior of all employees. Individual attention had been the rule in the traditional grocery store; Saunders' approach left customers alone and let them do much of the work performed by clerks in other stores.

The benefits quickly appeared in the company's balance sheets. In the first six months of operation, Saunders' first store generated $114,000 in business. His eye for detail and efficiency reduced operating costs $300 a month from those of the previous owners, who had conducted a grocery business in the same store. Saunders accomplished this feat with many of the same employees, whom he kept on and retrained. By 1922, the Piggly Wiggly chain had grown to twelve hundred stores operating in twenty-nine states.

Saunders' control of the Piggly Wiggly chain failed to survive an attack on his stock by hostile Wall Street interests. These speculators sought to make money by manipulating Piggly Wiggly's stock price. In an effort to defend his company, Saunders secured $10 million in loans to do battle with these speculators. Despite his best efforts, the founder of Piggly Wiggly lost his grip on the grocery chain and faced economic ruin.

Saunders then made a spectacular appeal to the Memphis community for financial backing to repay the borrowed money. Saunders argued that his personal failure would place a black mark on Memphis and its businesses. With powerful backing from the press, Saunders attempted to sell fifty thousand shares to the citizens of Memphis. Open declarations of support from civic groups such as the Chamber of Commerce and the American Legion seemed to promise a way out of his dilemma. Growing suspicions about his handling of Piggly Wiggly affairs, however, undermined this bid for community support and convinced Saunders to step down as head of the Piggly Wiggly chain. Before the end of 1924, Saunders had sunk into bankruptcy.

By 1928, local backing in Memphis enabled him to open another chain, Clarence Saunders'—Sole Owner of My Name, which proved unable to withstand the impact of the Great Depression. Saunders tried again with a new grocery store, the Keedoozle. This store mechanized grocery shopping by introducing mechanical means of selecting and packing food and beverages. Despite years of effort, mechanical difficulties prevented the store from ever operating as anticipated. Never despairing, Saunders prepared in the early 1950's to open the "foodelectric," another venture into automated shopping. Saunders suffered a heart attack in October, 1953, and died before he had completed work on his new design.

Impact of Event

Clarence Saunders' self-service idea foretold sweeping changes in the grocery business. As a forerunner of the supermarket, Piggly Wiggly challenged the practices of established chains such as the Great Atlantic and Pacific Tea Company (A&P). The grocery business included both small independent outlets and chain stores that pursued a strategy of multiple, low-inventory stores scattered over an area. Such outlets depended on a daily neighborhood trade, which later diminished in the age of the automobile and the refrigerator.

In both the independent retailer and the chain store, distribution retained its traditional character well into the 1930's. Clerks dealt with each customer on an individual basis, including extending credit and delivering orders placed by tele-

phone. Buyers never handled any of the grocery items situated behind counters. Clerks usually filled an order on an item-by-item basis, often suggesting a related product to a customer as a way of boosting sales. Once the patron finished ordering, clerks wrapped and packaged the groceries and totaled the bill, which the customer promptly settled or had recorded in a credit ledger. Speed and turnover played no role in the thinking of these grocery store owners.

The small-scale independents relied on high prices and high margins to generate their profits, as their volume of business was lower than that of chain stores. The independents usually anchored their grocery trade among a network of friends and neighbors. In contrast, chain stores pursued a strategy of volume sales, numerous outlets, and low prices to spur their profits. By 1914, the A&P had introduced the Economy Store, which dispensed with most services commonly associated with grocery outlets. All business relied strictly on a cash and carry basis. This approach precipitated a sharp drop in prices and boosted sales among cost-conscious customers.

Still, neither the chains nor the independents had adopted self-service for their operations. Saunders combined the advantages of the chains with the notion of unhindered customer choice. Self-service encouraged impulse buying on the part of the consumer and stimulated volume, crucial in a growing chain that depended on low prices, high sales, and rapid turnover. Saunders' ruthless standardization further reduced costs and made Piggly Wiggly one of the most efficient and rapidly growing grocery chains in the country. Saunders' decision to embrace the notions of scientific management as the basis of his operations contrasted sharply with the practices of many independents, who even ignored sales slips as a means of checking turnover among grocery products.

By the mid-1920's, Piggly Wiggly's success had spawned a number of smaller self-service chains such as Handy Andy Stores, but Saunders' ideas about store operation had yet to dominate thinking about grocery store organization. Only in the 1930's, with the appearance of Michael Cullen's King Kullen Stores, would the supermarket begin to achieve dominance in grocery distribution.

Cullen had operated an outlet in Herrin, Illinois, for the Kroger grocery chain in the 1920's. He fruitlessly appealed to the vice president of the Kroger chain to enlist the company's funds for his idea of a supermarket. Cullen finally persuaded Harry Socoloff, vice president of Sweet Life Foods Corporation, to contribute half of the start-up capital. With this backing, Cullen opened a self-service store on Long Island in August, 1930, the date marked as the beginning of the supermarket by the grocery industry.

His stores featured low prices, minimal help, no services, only national brands, and well-stocked shelves, all notions that had made the Piggly Wiggly chain so successful. Unlike Saunders, Cullen chose to place his stores in low-rent districts, often in abandoned buildings with abundant floor space. He minimized store decoration and concentrated on lowering costs. The supermarkets benefited from the widespread use of the refrigerator, which allowed customers to make large purchases and stock up. Increasing ownership of automobiles also facilitated supermarket shopping. Finally,

almost every home had a radio, opening possibilities for advertising. The radio also enhanced the aggressive promotional campaigns of national brand manufacturers. Brand names became widely known, working to the advantage of the supermarket chains that featured brand-name products.

By 1936, more than a thousand supermarkets had appeared, exerting market pressure on chains such as A&P, that still relied on numerous small stores. A&P faced substantial competition from the rapidly spreading supermarkets. By the end of the decade, John A. Hartford, son of the A&P founder George Hartford, had persuaded his father that only a supermarket strategy would enable the mammoth A&P operation to survive and maintain its status as a leader in a competitive business. This decision ultimately made the A&P the second-largest industrial corporation in the United States as measured by sales. By the 1950's, the supermarket dominated food and beverage distribution in America.

Bibliography

Brooks, John Nixon. "Annals of Finance." *The New Yorker* 35 (June 6, 1959): 128-150. Contains a thorough description of Clarence Saunders' efforts to protect Piggly Wiggly against attacks by stock market speculators. Includes a brief description of Saunders' personal life.

Charvat, Frank. *Supermarketing*. New York: Macmillan, 1961. The first chapter outlines the history of the supermarket. The author discusses the founding of Piggly Wiggly and the ideas behind Saunders' decision to open a self-service store. The chapter also describes the King Kullen and Big Bear stores, which firmly established the supermarket in the grocery business.

Hayward, Walter S., and Percival White. *Chain Stores: Their Management and Operation*. 3d ed. New York: McGraw-Hill, 1928. The first chapter provides a good analysis of the organization of a Piggly Wiggly store and the advantages gained from following Saunders' ideas about store layout, self-service, and monitoring costs. The authors provide the contemporary reactions of chain stores to the role of Piggly Wiggly in changing patterns of food distribution.

Nystrom, Paul H. *Economics of Retailing: Retail Institutions and Trends*. 3d ed. 2 vols. New York: The Ronald Press Company, 1930. Volume 1 contains a description of chain stores in the grocery trade and their history. Also included is an account of Piggly Wiggly and its impact on the trade.

Strasser, Susan. *Satisfaction Guaranteed: The Making of the American Mass Market*. New York: Pantheon Books, 1989. Chapter 7 describes changes in retailing that occurred in the early twentieth century. Includes a first-rate analysis of the grocery trade and Piggly Wiggly's place in the new patterns of food distribution. Also included is a picture of an aisle in a Piggly Wiggly Store in which goods, their manufacturers, and price tags are identifiable.

Tedlow, Richard. *New and Improved: The Story of Mass Marketing in America*. New York: Basic Books, 1990. Chapter 4 focuses on the rise and fall of the Great Atlantic and Pacific Tea Company. An insightful analysis of food distribution from the late

nineteenth century through the 1950's. Discusses Piggly Wiggly and the impact of the supermarket on the market strategies of A&P.

Zimmerman, M. M. *The Supermarket: A Revolution in Distribution*. New York: McGraw-Hill, 1955. Gives a succinct and effective description of grocery store practices through the early 1950's. Particularly insightful on the early history of the supermarket, including Piggly Wiggly. As editor and publisher of the trade journal *Super Market Merchandising*, the author brings the perspective and knowledge of an insider.

Edward J. Davies II

Cross-References

Procter & Gamble Begins Selling Directly to Retailers (1919-1920), p. 330; The First Major U.S. Shopping Center Opens (1922), p. 380; Sears, Roebuck Opens Its First Retail Outlet (1925), p. 487; The First Two-Story, Fully Enclosed Shopping Mall Opens (1956), p. 1070; Retailers Begin Using High Technology to Control Shrinkage (1970's), p. 1421.

308

ACCOUNTANTS FORM A NEW
PROFESSIONAL ASSOCIATION

Category of event: Business practices
Time: September 19, 1916
Locale: Washington, D.C.

By offering a national qualifying examination and an ethics code, the IAUSA (later AIA) assured businesspeople that the accounting profession has competence and integrity

Principal personages:

ELIJAH W. SELLS (1858-1924), the founder of a large public accounting firm and the president of the American Association of Public Accountants, 1906-1908

GEORGE O. MAY (1875-1961), an accounting scholar and a vice president of the American Institute of Accountants

SANDERS W. DAVIES (1862-1940), the first president of the Institute of Accountants in the United States of America

ROBERT H. MONTGOMERY (1872-1953), a prolific writer and author, president of the American Association of Public Accountants, 1912-1914

JAMES T. ANYON (1851-1929), an author and one of the founders of the American Association of Public Accountants

ERIC L. KOHLER (1892-1976), the editor of *The Accounting Review* for fifteen years; a president of the American Accounting Association

Summary of Event

The American Association of Public Accountants (AAPA) was established in 1887 in New York as the first organized body of professional accountants in the United States. In 1896, the AAPA prompted passage of the first state law pertaining to certified public accountants. Soon several states followed suit. By 1915, thirty-nine states had granted legal recognition to the accountancy profession. Thus there was a gradually growing need to bring practicing accountants in various states together. The AAPA responded to this need by admitting members not only directly as individuals but also indirectly as members of state societies.

This practice of dual membership continued from 1896 through 1915. By then, it was obvious that the dual membership practice was not satisfactory, especially when it came to disciplining members for bringing the profession into disrepute by their acts of omission or commission. It was also widely believed by then that the profession should set its own standards of competency and hold rigorous national qualifying examinations. At its meeting held on September 19, 1916, the AAPA approved its own merger with the newly created Institute of Accountants in the United States of

America (IAUSA), a society composed of individual members. There were 1,150 charter members. In January, 1917, the words "in the United States of America" were dropped from IAUSA for the sake of brevity, and a new name, the American Institute of Accountants (AIA), was adopted.

Accountancy as a profession was relatively unknown in the United States in the 1870's, but it flourished as a respected profession in Great Britain at the same time. Two years after incorporation of the AAPA, its membership stood at thirty-two. Many attempts were made by the AAPA to elevate the status of the profession through collegiate instruction in accounting. For example, the University of Pennsylvania started the Wharton School of Finance and Economy and included accounting in its curriculum. The AAPA also obtained a two-year charter from the Regents of New York University and established a "college of accounts" with degree-conferring powers. This effort soon failed. The School of Commerce, Accounts and Finance was established at New York University in 1900. In 1906, the Pace Institute of Accountancy was founded. Overall, these attempts in collegiate education were largely unsuccessful. Seeing that accountancy would not gain recognition quickly through university degrees in the field, the AAPA started advocating public accountancy legislation so that accountants could gain status.

Leading public accountants were of the opinion that federal regulation and recognition would help the accounting profession. This argument is based on the fact that accounting was to a great extent interstate. Most of the major accounting firms practiced in more than one state, and some practiced in foreign countries. A federal license would be recognized in all states and hence was very desirable from the accounting firms' viewpoint. The attempts made by the AAPA to get Congress to take legislative action were unsuccessful. Several large states, including New York, California, Pennsylvania, Florida, Illinois, Michigan, and Maryland, had legislation pertaining to certified public accountants (CPAs) in force, and Congress was reluctant to intrude on states' rights to regulate. The AAPA was eager to help other states in obtaining state accountancy laws and held out the New York CPA law as the model. The AAPA was dominated by New York accountants at this time. State CPA laws were passed in Georgia, Connecticut, Ohio, Louisiana, and Rhode Island in 1908; in Nebraska, Minnesota, Missouri, Massachusetts, and Montana in 1909; and in Virginia in 1910. By 1924, all states had CPA laws, though they varied in their definition of the CPA title.

A major event in the history of the AAPA was the First International Congress of Accountants, held in St. Louis, Missouri, in 1904. More than one hundred fifty accountants from England, Canada, Holland, and the United States attended the congress, a large number for those days. George Wilkinson, president of the Illinois Society of Public Accountants, was elected secretary of the congress, and as such he organized and directed the meeting. The program of the 1904 congress included mostly technical accounting papers. The papers and discussions were subsequently published as proceedings of the congress. This proceedings volume became the most important professional accounting publication thus far in the United States. In many

respects, this congress was a huge success and greatly contributed to the progress of the accountancy profession in the following years.

In 1906, the AAPA included fifteen state societies, whose members were automatically AAPA members through their membership in state societies. Of these fifteen, only eight were societies of certified public accountants. Thus the dual membership policy allowed the admission of both CPAs and non-CPAs as members of the AAPA. Even among CPAs, there were differences in the examinations they had taken to qualify for the CPA designation. Some states had rigorous standards, while standards were thought to be lax in other states. There was no national standard of qualification and no national test for public accountants.

The AAPA advanced two mechanisms for standardization: the model CPA law and the model state society bylaws. Neither mechanism was adopted widely. Some states required high-school education, while others did not. Many required practice for licensure, but Illinois, Vermont, and Washington did not. Many states were reluctant to grant reciprocity to qualified accountants from other states. State licensing board appointments were sometimes made as a result of political considerations rather than on the basis of candidate qualifications. There was no uniformity in the examinations administered by different states. Generally speaking, the minimum educational standards were not very high, and they varied from state to state.

In 1915, the national leaders of the AAPA appointed a Special Committee on the Form of the Organization of the Association comprising Sanders W. Davies, Elijah W. Sells, Carl Nau, and Waldron Rand. This committee submitted a report in 1916 suggesting that the profession should be represented and controlled by a national organization and that only individuals should be admitted as members. State societies would not be members of the new national institute. It was envisioned that this national organization would establish uniform admission standards and offer national qualifying examinations. At the meeting held on September 19, 1916, the AAPA approved its own merger with the newly created IAUSA, a society of individual membership. The IAUSA was incorporated under the laws of the District of Columbia, which had provisions for incorporating educational and scientific bodies.

Impact of Event

One of the major impacts of the formation of the AIA came through its successful efforts to raise qualification standards. Because the state CPA examinations were not uniformly rigorous, one of the first acts of the AIA was to set up a board of examiners in 1916. The first national CPA examination under the auspices of the AIA was offered on June 15, 1917. This examination was used by California, Colorado, Florida, Michigan, Missouri, Nebraska, New Hampshire, New Jersey, and Tennessee. This examination was given in the fields of accounting theory and practice, auditing, and commercial law. By 1929, a majority of state licensing boards adopted the uniform CPA examination offered by the AIA. The AIA also strongly pushed states to adopt stringent practice requirements for certification.

Another impact of the newly formed AIA was in the area of professional ethics. In

1918, the AIA set up the Special Committee on Ethical Publicity to make recommendations about advertising and solicitation of clients by public accountants. In 1919, the AIA passed a resolution, proposed by George May, that disapproved of circular letters that promised prospective clients substantial tax savings. In 1921, the AIA passed stringent ethical rules prohibiting such activities as advertising and direct solicitation of clients. This infuriated some practitioners. The AIA was thought to be controlled by big national firms and by the elite from the East. Many local practitioners rebelled against these rules, which were thought to be useful for large firms to consolidate their practices. A rival accounting association, the American Society of Certified Public Accountants (ASCPA), was started in December, 1921. The AIA and the ASCPA coexisted until 1937, when these two organizations merged, retaining the AIA name.

An important achievement of the AIA was the creation of a world-class accounting library. In 1917, George May and his partners at the accounting firm of Price Waterhouse donated $25,000 to the Library Endowment Fund. Elijah W. Sells subscribed $15,000, and by 1919 $150,000 had been collected. The AIA library began its operations with eleven hundred bound books and thirteen hundred unbound books and pamphlets. A singular achievement of the librarians at the AIA library was the publication of the *Accountants' Index* in 1921. This volume listed all articles and books on accounting published until that time. In 1926, the AIA also established a Bureau of Research, which existed for some twenty-five years.

Leaders of the accounting profession perceived a need to disseminate technical accounting information to educators and practitioners who could not attend annual meetings and special congresses. In 1905, the AAPA made arrangements to take over a magazine titled *The Auditor*, launched by the Illinois Society of Accountants. The name of this magazine was changed to the *Journal of Accountancy*. The first issue appeared in 1905, and thereafter the journal has been continuously published by the AIA and successor organizations. This journal freed American accountants from relying on the British journal, *The Accountant*. By 1909, circulation of the *Journal of Accountancy* had reached nearly two thousand. Five years later, the journal had a circulation of nearly five thousand. It had become the principal medium through which educators and practitioners throughout the nation exchanged information, ideas, and opinions.

During the years of World War I, the AIA offered its services to the Naval Consulting Board and the Council of National Defense. An AIA committee conferred with both these bodies. The *Journal of Accountancy* published many articles on topics such as wartime taxes, construction records and accounts, Navy Yard cost accounting, and the determination of costs for contract purposes. Accountants were needed for audits of costs and other accounting work. Many AIA members were appointed as division auditors. They drew up manuals for audits and generally supervised accounting for the Army. Joseph Strett served as the vice chairman of the Excess-Profits-Tax Review Board. Lieutenant Colonel Robert Montgomery served as the representative of the War Department on the Price-Fixing Committee of the War Industries Board.

Arthur Teele served on a committee appointed by the quartermaster's department to consider the determination of property accountability. The AIA took justified pride in its war activities. Friendships formed with important people in Washington, D.C., during the war years brought the institute access to government leaders later on.

Bibliography

Academy of Accounting Historians. *Working Paper Series.* Edited by Edward N. Coffman. Richmond, Va.: Author, 1979. Contains twenty research papers on accounting history. Useful for researchers.

Carey, John L. *The Rise of the Accounting Profession: From Technician to Professional, 1896-1936.* New York: American Institute of Certified Public Accountants, 1969. Describes the first forty years of the accounting profession in the United States from the viewpoint of the AICPA. Useful for understanding the background of the AICPA. Easy to read.

Chatfield, Michael, ed. *Contemporary Studies in the Evolution of Accounting Thought.* Belmont, Calif.: Dickenson, 1968. A collection of thirty-one articles with a focus on accounting history. Chapter 16, "Some Significant Developments of Public Accounting in the United States," gives a good summary of factors contributing to the growth of the American accounting profession. The book also contains an excellent annotated bibliography on accounting history.

Edwards, James D. *History of Public Accounting in the United States.* East Lansing: Bureau of Business and Economic Research, Graduate School of Business Administration, Michigan State University, 1960. Provides a discussion of the European antecedents of American accounting practices and describes the evolution of the educational, legal, and organizational aspects of the profession. A readable, reasonably concise history of the accounting profession.

Miranti, Paul J., Jr. *Accountancy Comes of Age: The Development of an American Profession, 1886-1940.* Chapel Hill: University of North Carolina Press, 1990. Highlights major events in the history of the accounting profession in the United States between 1886 and 1940. Chapter 6 covers the time period between 1916 and 1923, which includes the formation of the American Institute of Accountants (AIA) to absorb the American Association of Public Accountants (AAPA).

Previts, Gary J., and Barbara D. Merino. *A History of Accounting in America.* New York: Ronald/Wiley, 1979. Chapter 5, "The Formation of an Accounting Profession," gives a detailed history of the accounting profession between 1890 and 1920.

Zeff, Stephen A., ed. *The U.S. Accounting Profession in the 1890s and Early 1900s.* New York: Garland, 1988. A collection of eighteen papers by eminent scholars that portray the early decades of the accounting profession in the United States. Three kinds of papers are included: historical studies, contemporary accounts, and recollections. Useful for researchers.

Srinivasan Ragothaman

Cross-References

The U.S. Government Begins Using Cost-Plus Contracts (1914), p. 246; The Federal Trade Commission Is Organized (1914), p. 269; Wartime Tax Laws Impose an Excess Profits Tax (1917), p. 319; The Ultramares Case Establishes Liability for Auditors (1931), p. 608; The Securities Exchange Act Establishes the SEC (1934), p. 679; U.S. Tax Laws Allow Accelerated Depreciation (1954), p. 1030; Congress Passes the RICO Act (1970), p. 1449.

FORBES MAGAZINE IS FOUNDED

Categories of event: Foundings and dissolutions; management
Time: September 15, 1917
Locale: New York, New York

Forbes *became the voice of the investing public, reporting, interpreting, and commenting on the accomplishments and failures of American business leaders and their companies*

Principal personages:
> BERTIE CHARLES (B. C.) FORBES (1880-1954), an author on business topics and founder of *Forbes*
> MALCOLM FORBES (1919-1990), a politician, author, and owner and editor-in-chief of *Forbes*
> BRUCE FORBES (1916-1964), a son of B. C. Forbes who managed the magazine
> JAMES MICHAELS (1921-), an editor of *Forbes* who emphasized investigative reporting and sought to make the magazine more controversial and outspoken on behalf of investors
> MALCOLM STEVENSON (STEVE) FORBES, JR. (1947-), an editor-in-chief of *Forbes*

Summary of Event

Professional managers, investors, and others interested in knowing how business events help shape their lives turn to business periodicals for both information and entertainment. Although there are dozens of important magazines and journals devoted to satisfying the demands of this special readership, as of the early 1990's, three— *Forbes, Business Week,* and *Fortune*—owned the lion's share of the market. The oldest of these, *Forbes,* was launched in 1917, more than a decade earlier than either of its two major competitors.

Bertie Charles (B. C.) Forbes founded the magazine that bears his name. A man possessed of many talents, interests, and ambitions, he at first wished to name his periodical *Doers and Doings* because that name reflected his philosophy that individuals make companies and markets. This worldview was a product of his experience as an apprentice printer's devil in his native Scotland and later as a reporter on Johannesburg, South Africa's, *Rand Daily Mail.* After his arrival in the United States, B. C. Forbes quickly rose to prominence in the investment and journalism communities through his syndicated columns for the *Journal of Commerce* and subsequently for the daily *New York American. Forbes* was an outgrowth of his fecundity in both newspaper and magazine journalism.

The American business press has a long and distinguished record of achievement, consistently and successfully identifying and adapting to changes in the economy,

commerce, industry, and the workplace. The earliest publications were known as price-currents. Edited by commodity brokers and commission merchants, they provided businesspeople with wholesale commodity prices and basic shipping information. In the early nineteenth century, they evolved into publications that reported intricate commodity and maritime data and offered commentaries on market conditions and occasional analyses of commercial problems.

The growing role of financial capital in the mid-nineteenth century was met with an increased interest in news about banking and investment matters. Two premier financial papers founded during this era were *The Wall Street Journal* and *The Commercial and Financial Chronicle*. It was in this milieu that B. C. Forbes both cut his journalistic teeth and learned the requisite business lessons to launch and develop an important new magazine. In time, his magazine would serve as a model for business journalism in the twentieth century.

As a reporter for the *Journal of Commerce* and other daily newspapers, B. C. Forbes recognized that the business press was characterized by good writing and strong news gathering, analysis, and interpretation. As a gifted writer, he brought talent in these areas to the new venture. He also noted, however, that many business leaders of the day were excessively secretive in their commercial dealings, resulting in little of the most important information about individual companies and their dealings finding its way into print. Cognizant of this, many potential readers found the business press of almost no value beyond the statistical data they reported. As both a journalist and an entrepreneur, B. C. Forbes knew that for his magazine to prosper, he would need to bring the knowledge and insights of leading investment bankers and businesspeople to bear in each article. Inside sources of information; crisp writing, formatting, and presentation; a view of the human side of each enterprise; a willingness to make predictions; and a desire to represent stockholders' interests blended into the formula that provided *Forbes* with its early, and lasting, success. The approach would be successfully emulated by dozens of other periodicals.

The initial success of *Forbes* and many of its early rivals in the business press can be traced to economic and cultural factors present in early twentieth century America. Among the more notable were revolutionary changes in distribution and manufacturing processes, new inventions, and the scientific management movement. As a disseminator and interpreter of information about changes in American industry, the business press served as an invisible classroom and the editors as teachers for a population hungry for information on how to advance in their careers and make prudent choices about investments and life-styles.

As an entrepreneur and journalist, B. C. Forbes recognized that he could make an important contribution in this exciting era by using his prodigious writing talent and his many sources in the investment banking community to report on the achievements, failings, and foibles of business leaders. He recognized that businesses often neglected stockholder interests, and he was concerned with reporting such disregard. From the outset, the *Forbes* publishing formula combined popular folk wisdom that sought to harmonize the managerial process with a tough, biting, investigatory

approach that often upbraided poorly performing companies and their managers. This approach characterized the editorial policies of the magazine through three generations of family management and found favor within the journalistic community. An important illustration of the *Forbes* publishing style could be found in each issue's "fact and comment" section. This opinion piece frequently was acerbic, written in the free-spirited style that characterized the lives of the publishers.

B. C. Forbes's contributions to the business press extended far beyond his important achievements on the editorial side of journalism. His many innovations as a publisher were also of seminal value. His early experiences made him painfully aware that failing to make significant changes on the "business side" of publishing would have dire consequences not only for his new venture but also for the entire arena of business journalism. He knew that even though business periodicals of the era had lives far in excess of popular magazines, those lives were still painfully short. Many of the periodicals lacked a specific purpose: Their editors and publishers were not truly in touch with their audience. Magazines depended too heavily on subscriptions as a source of revenue, and subscription prices were excessive. Advertising was negligible. Advertisers could not be expected to promote products to an ill-defined audience. These conditions, along with faulty distribution processes, especially through the post office, discouraged entry into the field.

Although B. C. Forbes could not remedy all these ills, he made significant inroads. One of his most enduring accomplishments was defining his audience and ensuring that its interests were represented in each issue of the magazine. This strategy of carving out a market niche of prosperous, well-educated readers served to increase circulation and advertising revenues and placed the magazine on a path of dynamic growth. He also improved production and distribution processes, but major advances in this area were left to his son Bruce. Later, his son Malcolm, through extensive promotional efforts and effective reporting, turned the magazine into the "Capitalist Tool" it claimed to be, as well as a model for modern business magazines.

Impact of Event

The Depression years were not kind to B. C. Forbes and his founding copartner, Walter Drey. Their magazine's fortunes ebbed in direct proportion to the number of individuals interested in investment matters during this bleak period. For a time, *Forbes* employees worked one week each month without remuneration. B. C. Forbes himself did not draw a paycheck for much of this era. Subscriptions fell to sixty thousand. Like the competitor *Fortune* magazine, many issues of *Forbes* were devoted to bolstering the sagging spirits of American business leaders.

In the years following World War II, B. C. Forbes's sons Bruce and Malcolm ascended to senior leadership positions within the organization. The congenial Bruce Forbes made important advances in strengthening operating and marketing functions. In the nearly ten years that he was at the helm, the magazine's circulation almost doubled. The editorial side was enriched with the addition of Byron (Dave) Mack and James Michaels.

Although much of Malcolm Forbes's time was devoted to winning political office, two of his strategic ideas altered the future of the magazine. First, in an effort to bring more consistent quality and focus to the magazine, he suggested replacing free-lance writers with a permanent editorial staff. Second, as a way of increasing January advertising revenue and competing more directly with *Fortune*, he proposed an issue that would rank corporations not only by revenue (as in the Fortune 500) but also by such measures as profitability and return on equity. This early fascination with lists continued. Later, *Forbes*'s rankings of the four hundred richest Americans catapulted the magazine to new heights of popular recognition and acceptance.

Upon Bruce Forbes's death in 1964, Malcolm, who was functioning as editor-in-chief, assumed complete operating control of the magazine. Known for enjoying considerable promotional skills, Malcolm Forbes is also remembered for his dynamic leadership on the editorial side. During his tenure, *Forbes* became an even greater proponent of shareholder interests. Toughly worded commentaries, in-depth investigations, and incisive reporting often lambasted business leaders for their ineptitude and general neglect of the true owners of their corporations, the stockholders. His efforts helped form the magazine into the "Capitalist Tool" that it claimed to be in its advertising. By 1983, *Forbes* had tripled its advertising revenue, ranking it eighth among *Ad Week*'s leading magazines. The Magazine Publishers Association named Malcolm Forbes publisher of the year in 1984. This recognition came at a plateau in the magazine's history; soon, *Forbes* would lose market share to competitor *Business Week*.

Malcolm Stevenson (Steve) Forbes, Jr., took over his father's position. His many talents and interests served the magazine well and continued to place it among the leading business periodicals.

Forbes earns high marks when evaluated by most measures of organizational success. The magazine survived when others failed, brought enormous financial rewards to its owners, and enjoyed almost universal recognition and public acclaim. The magazine's many imitators and the robust health of business journalism are testimony to the accomplishments of *Forbes*. *Forbes*'s impact, however, extends well beyond the magazine's institutional boundaries. Its significance lies in its contribution to enlarging and enriching the public debate on matters of vital economic and financial interest. The depth and detail of its articles, its willingness to take the risks of prediction and to take positions that could be damaging to itself, and a professional approach to publishing earned the magazine its preeminent position in the world of communications.

Bibliography

Forbes, Malcolm S. *Fact and Comment.* New York: Knopf, 1974. An excellent resource for readers interested in examining the writings of the magazine's long-time owner and editor-in-chief, Malcolm S. Forbes. The columns written over a twenty-five-year period illustrate how the magazine reacted to and attempted to influence important events of the day.

——————— . *More than I Dreamed*. Edited by Tony Clark. New York: Simon and Schuster, 1989. An autobiography that reveals the many talents and interests of Malcolm Forbes. Chapter 1 provides an invaluable brief history of the early days of *Forbes* and the life of B. C. Forbes.

Forsyth, David P. *The Business Press in America*. Philadelphia, Pa.: Chilton Books, 1964. Although the 1750-1865 period covered in this scholarly work predates *Forbes*'s launching, the book is an indispensable tool for understanding the early business press and, more specifically, the financial periodicals extant before World War I.

Kohlmeier, Louis M., Jon G. Udell, and Laird B. Anderson, eds. *Reporting on Business and the Economy*. Englewood Cliffs, N.J.: Prentice-Hall, 1981. James W. Michaels' chapter on business magazines provides insights into the workings of the editorial side of *Forbes* and other important business journals. Michaels was a *Forbes* editor.

Tebbel, John, and Mary Ellen Zuckerman. *The Magazine in America, 1741-1990*. New York: Oxford University Press, 1991. A thoroughly researched and well-written book that will appeal to both scholars and general readers.

Winans, Christopher. *Malcolm Forbes: The Man Who Had Everything*. New York: St. Martin's Press, 1990. An entertaining and thoroughly researched work about the life of the man most responsible for the growth and development of *Forbes*. Valuable information about B. C. Forbes is presented in chapter 2.

S. A. Marino

Cross-References

Reader's Digest Is Founded (1922), p. 390; Henry Luce Founds *Time* Magazine (1923), p. 412; The American Management Association Is Established (1923), p. 419; Henry Luce Founds *Fortune* Magazine (1930), p. 585; *The Saturday Evening Post* Publishes Its Final Issue (1969), p. 1379.

WARTIME TAX LAWS IMPOSE AN EXCESS PROFITS TAX

Category of event: Government and business
Time: October 3, 1917
Locale: Washington, D.C.

By significantly increasing corporate tax rates and the complexity of tax laws, Congress virtually mandated the services of professional tax consulting, providing the catalyst to promote the development of the emerging profession of public accountancy in the United States

Principal personages:

THOMAS S. ADAMS (1873-1933), an economist and chairperson of a key Treasury committee that made the income tax laws workable

ROBERT H. MONTGOMERY (1872-1953), a certified public accountant and influential member of the American Association of Public Accountants

ARTHUR E. ANDERSEN (1885-1947), a certified public accountant and head of the accounting department of Northwestern University of Chicago, 1912-1922

JOSEPH E. STERRETT (1870-1934), a prominent public accountant and steadfast supporter and promoter of the accounting profession

Summary of Event

The War Revenue Act (H.R. 4280), passed into law on October 3, 1917, significantly modified the existing corporate tax structure through the enactment of an excess profits tax. Tax rates were increased from 1 to 12 percent with the avowed intention of raising revenue to defray costs associated with conducting World War I. Prior to this act, business income taxation had been so insignificant in amount that it was considered, for all intents and purposes, a nonexistent factor in the United States business environment.

Although this tax legislation affected all people in the United States, its most important consequences were reserved for management, shareholders, and the emerging profession of public accountancy. For the first time, it was abundantly evident that Congress would utilize its new powers under the Sixteenth Amendment to the Constitution of the United States (which had been ratified in 1913) to enact extensive tax statutes to raise substantial funds for the operation of the federal government. The passage of this act foreshadowed income taxation, in partnership with tax advice, as an important factor in the successful operation of businesses in the future.

The history of income tax law in the United States, and the genesis of the War Revenue Act of 1917, can be traced to the Revenue Act of July 4, 1861. This statute, the first serious congressional attempt to tax income, was also associated with hostilities. Congress convened an extraordinary session pursuant to the outbreak of the Civil War. The intent was to enact a system of internal taxation to finance this historic confrontation. Subsequent sessions of Congress held between July 4, 1861,

and August 5, 1861, evoked considerable discussion of the proposed revenue bill. Members of Congress, perhaps realizing the immense ramifications of a comprehensive income tax bill, displayed concern and reluctance to enact such a measure. Faced with preserving survival of the union, Congress opted to enact the forefather of the present system of taxation. This seminal legislation embraced a cash receipts/disbursements approach to earnings determination, essentially an income statement, a method in direct opposition to the economic value approach advocated and used by most businesspeople at that time.

A major obstacle to development of a far-reaching income tax during the later half of the nineteenth century and the first two decades of the twentieth century was the Constitution of the United States. The Constitution did not provide for an income tax without a proper apportionment of the tax burden among the states with respect to their populations. Such an apportionment would be extremely difficult, if not impossible. Congress, however, chose to overlook questions of constitutionality and enacted numerous tax provisions between 1870 and 1894. With each law, the judicial branch of government came into play. Ultimately, in *Pollock v. the Farmers Loan and Trust Company* (157 U.S. 429, 1894), the Supreme Court declared income taxation without apportionment invalid.

The Sixteenth Amendment to the Constitution of the United States was ratified on February 25, 1913. Congress was given the constitutional power to lay and collect taxes on income, from whatever source derived, without any apportionment among the individual states. On October 3, 1913, the first constitutionally valid income tax, based on the cash receipts/disbursements concept as originally articulated in 1861, was enacted in the Revenue Act of 1913. These tax provisions were made retroactive to March 1, 1913, and scheduled to expire on February 28, 1914. They provided a limited degree of complexity and minimal tax rates, ranging from 1 to 7 percent, on a progressive scale of taxable income. Although this legislation represented a significant historical event, the limited complexity and low rates of taxation coupled with reasonable levels of income progression were such that the overall burden was quite small for most people. As a result, the tax did not command a high level of concern among businesspeople.

Yearly revenue-raising measures were enacted between 1914 and 1917 to replace the respective tax provisions as each expired. None was more complex or significant than the Revenue Act of 1913. These acts provided little evidence that Congress had more than a transitory and minimal interest in income taxation. It was widely believed that an insignificant tax bill would be enacted each year and that ultimately the necessity to raise revenue for the government would disappear, bringing an end to the income tax.

This simplistic, naïve belief and hope collapsed with the entry of the United States into World War I. Rapidly expanding business activity accompanied the war effort, leading to a dramatic increase in corporate profitability. Concurrently, the leaders of the United States were faced with a mandate to raise substantial sums of revenue in support of the war effort. The obvious course of action, given the relatively new

congressional powers to tax income, was to enact a scheme of corporate income taxation. Thus, with two objectives in mind, dampening corporate profitability and financing the military effort, Congress enacted the War Revenue Act of 1917, forever changing the business environment in the United States.

Impact of Event

Passage of the excess profits tax legislation had two critical effects on virtually every business in the United States. First, the corporate tax burden was, for the first time, increased to significant levels. Required payments to the government substantially decreased the profitability of many businesses and diminished the funds available for distribution to managers and shareholders in the form of salaries and dividends. Second, a copious level of complexity and regulation was added to the already complex nature of American commerce. Dependable, verifiable data on earnings were needed to comply with the provisions of this legislation and to satisfy the accountability demands of the revenue service. Further, of paramount importance to business managers and shareholders, expert knowledge and assistance were needed to ensure that a business did not pay too much in income tax. Therefore, the most immediate and far-reaching impact on business and commerce was to focus attention on the evolving need for competent professionals schooled in the fundamentals of income determination and the complexities of tax law. The question became: Who would fill this void?

The practice of public accountancy in the United States in the early 1900's was evidenced by a limited usefulness to businesses. Public accountants were seldom sought out for advice except in the case of fraud detection. Businesses were characterized by either common ownership and management or limited outside ownership with majority stockholders as management. The financial information desired by these parties was primarily directed at net worth calculations and not at measuring yearly performance. Accounting data were developed, as deemed necessary, by management and bookkeepers inside the company. Secrecy was the hallmark of the day, with little, if any, operational or financial information being supplied by anyone outside the management circle. When information was supplied to outside parties, it was of questionable value, as no mandated set of financial statements had been agreed upon. To further exacerbate the situation, what was published was best described as lacking in conformity to any accounting standards of consistency or comparability. No rules of taxation or generally accepted accounting principles existed to guide the process.

Into this unregulated environment came the War Revenue Act of 1917, containing significant tax provisions that demanded proper accounting and reporting of taxable income in accordance with a detailed set of rules. A determination and assessment would be made concerning a required, perhaps significant, payment to the government based on the contents of a self-prepared tax return. The net effect was to force businesspeople to direct attention to the income statement (tax return) and the proper determination of net income (taxable income). Management and owners were spurred

to keep better internal accounting records; to keep such records in a consistent fashion in accordance with tax rules; to take an active interest in providing an accurate and proper accounting to the taxing authorities; and, most important to the emerging profession of accountancy, to seek competent advice from external tax professionals to ensure accuracy and to mitigate the substantial effects of these tax provisions.

The adoption of the cash receipts/disbursements concept for tax reporting was of paramount importance. This approach required a specific set of rules for determining taxable income, rules based on sound accounting principles. Such a methodology placed public accountants, who were really master bookkeepers, in a preferred position because they alone possessed the necessary training and skills to successfully respond to the businesspeople's immediate need for reliable tax information. These skills also enabled them to respond to the changing tax environment of the future. The service potential was apparent, and the profession was quick to respond. Leaders among the practitioners of the day were able to convince the business public, through exceptional service, that public accountants possessed the intelligence and initiative to cope with this legislation. Norman L. McLaren in "The Influence of Federal Taxation upon Accountancy" (1937), suggested that the War Revenue Act was the greatest single factor responsible for elevating the status of public accountants from master bookkeepers to members of an honored profession. He estimated that less than 10 percent of the businesses in the United States regularly used the services of a public accountant prior to this historic event.

Corporate tax returns opened wide and profitable avenues for service, providing an impetus for the development of public accountancy in the United States. Educators such as Arthur E. Andersen of Northwestern University recognized that a system of formal education was a fundamental ingredient for the successful emergence of the profession. He had prepared a textbook for publication in 1917, perhaps the first such available, entitled *Complete Accounting Course*. During the 1917-1918 academic year, Andersen expanded his curriculum by offering a course of six lectures on the wartime and excess profits taxes. The lectures were well attended by prominent service professionals and business executives. Other universities throughout the country, envisioning the instrumental part public accountants would be expected to play in the modern business world, reorganized their course offerings to provide intensive training in accountancy and taxation. Authors responded by publishing an array of books aimed at accountants in school and already in practice. Robert H. Montgomery, a prominent public accountant, wrote a tax treatise that, through yearly updates, would become the standard for accounting education and a must for the professional library of all practitioners.

The single most important long-term outcome of the War Revenue Act of 1917 was its demonstrated ability to raise significant amounts of revenue. It became clear to Congress that a readily available source of funds existed. New and expansive tax laws were developed and enacted in yearly revenue acts over the next two decades. This litany led to the permanent codification of the income tax system with passage of the Internal Revenue Code of 1939 (recodified in 1954 and 1986). For businesspeople,

shareholders, and professional accountants, the income tax had become a persistent feature in the business environment, a presence that elevated public accountants to positions of prominence as valuable members of the management team.

Bibliography

Arthur Andersen & Company. *The First Fifty Years, 1913-1963*. Chicago: Author, 1963. This historical account summarizes the development of one of the largest accounting firms in the world. A chapter is included on the time period from 1913 to 1920, with a section describing the impact that federal income tax law had on the advancement of the profession of accountancy. Articulates the significant contributions and accomplishments of Andersen as a university professor.

Brundage, Percival F. "Milestones on the Path of Accounting." *Harvard Business Review* 29 (July, 1951): 71-81. An excellent overview of the growth of the accounting profession in the United States prior to 1950. A section assesses the impact of war and taxes on the profession, identifying World War I as the third milestone.

Chatfield, Michael. "The Accounting Role in Income Taxation." In *A History of Accounting Thought*. Hinsdale, Ill.: The Dryden Press, 1974. Contains three major sections, covering the earliest development of accounting methods, the industrial era, and concepts of accounting theory. Chapter 15 concentrates on income taxation in the United States. Provides an excellent overview concerning the temporal evolution of revenue statutes and their importance to the development of accounting as a profession.

Edwards, James Don. "Public Accounting in the United States, 1913-1928." In *History of Public Accounting in the United States*. East Lansing: Michigan State University Press, 1960. Offers a comprehensive analysis of the significant historical developments in public accountancy, emphasizing the growth and development of the profession in the United States. Chapter 6 concentrates on the period from 1913 to 1928, inclusive of the early years of income taxation. Extremely informative and readable. An excellent source for students at all levels.

McLaren, Norman L. "The Influence of Federal Taxation upon Accountancy." *Journal of Accountancy* 44 (December, 1937): 426-439. A lighthearted, thoroughly enjoyable depiction of the development of the accounting profession specifically addressing the significance of the income tax. Helpful and entertaining to anyone interested in the history of accounting.

Robert E. Rosacker

Cross-References

The Tariff Act of 1909 Limits Corporate Privacy (1909), p. 168; Accountants Form a New Professional Association (1916), p. 308; The U.S. Stock Market Crashes on Black Tuesday (1929), p. 574; The Ultramares Case Establishes Liability for Auditors (1931), p. 608; The Securities Exchange Act Establishes the SEC (1934), p. 679; Congress Passes the RICO Act (1970), p. 1449.

CHARLES PONZI CHEATS THOUSANDS
IN AN INVESTMENT SCHEME

Categories of event: Business practices and finance
Time: 1919-1920
Locale: Boston, Massachusetts

Charles Ponzi and his imitators raised millions of dollars in fraudulent investment schemes, prompting regulation of the securities industry

Principal personages:
 CHARLES PONZI (188?-1949), a creative promoter who participated in many of the major investment frauds of the 1920's
 RICHARD GROZIER (1887-1946), the *Boston Post* publisher whose efforts in unmasking Ponzi earned a Pulitzer Prize
 CLARENCE W. BARRON (1855-1928), the founder of *Barron's Weekly* and a chief Ponzi critic

Summary of Event

Charles Ponzi achieved immense but short-lived success marketing investments of dubious merit to the public in the 1920's. These "Ponzi schemes," initiated by other swindlers, attracted gullible investors by promising high yields over short periods of time. In general, Ponzi scheme promoters develop an ever-widening circle of customers for a nonexistent investment by paying interest and dividends from the client's own funds or from contributions of subsequent investors. The schemes involve paying early investors with money received from later investors; the promoter can then point to high dividend payments to encourage new investors. Ponzi's most notorious and successful scheme involved taking advantage of exchange rate disparities in the trading of international reply coupons, which are negotiable postage stamps used to facilitate international correspondence. He managed to attract thousands of investors from all the social and economic strata of Boston in 1920.

Ponzi was born Carlo Ponsi in Parma, Italy, in the 1880's. Ponzi failed to meet the expectations of his wealthy family and spent much of his youth in aimless pursuits. Hoping he would find success in the New World, Ponzi's family gave him a thousand lire (about two hundred dollars) and a one-way ticket to the United States in 1902. Ponzi spent the next fourteen years holding an assortment of odd jobs as he traveled throughout the United States and Canada. In 1917, he settled in Boston, where he worked with his father-in-law as a fruit dealer.

Ponzi received a business letter from Spain in 1919 that contained an international reply coupon that had cost the sender the equivalent of one cent in Spain. The Universal Postal Union issued international reply coupons to enable the sender to prepay reply postage. Immigrants in the United States often sent them in letters to European relatives. The coupon could be exchanged at any U.S. post office for a six-cent stamp, enough to send a letter back to Spain.

Ponzi discovered that the pricing disparity existed in several European countries and that the profit potential was theoretically enormous. He began a speaking tour of the Boston area in August of 1919, giving investment seminars designed to raise capital for the Securities Exchange Company, a firm he created to perform the international reply coupon transactions.

Advertising a 50 percent return in forty-five days, he initially attracted small sums from Boston's Italian immigrants. Word of the phenomenal promised returns reached the elite of Boston society, and Ponzi was soon collecting hundreds of thousands of dollars daily. Potential investors either waited for hours in long lines outside his School Street office or simply mailed him cash. His clerks were forced to store cash in baskets and in closets as contributions flooded Ponzi's rented offices.

Ponzi used some of the proceeds to gain control of several Boston businesses, including area banks that had made loans to him. Ponzi quickly adopted a lavish life-style and became a hero to the immigrant community and small investors. His success inevitably attracted the attention of Boston's legal authorities. Police Commissioner Edwin U. Curtis sent three investigators to Ponzi's office in the summer of 1920. Two of them bought shares in the scheme after speaking with Ponzi. Postal inspectors, the district attorney's office, and federal attorneys paid visits to Ponzi's operation. No evidence of illegal activities was uncovered and Ponzi, a public relations genius, used these official pronouncements to mitigate any suspicions potential investors might have held. Ponzi had collected nearly $15 million by August of 1920.

Richard Grozier, publisher of the *Boston Post*, doubted Ponzi's claims and set out to prove that Ponzi was engaged in a massive fraud. Grozier interviewed Clarence W. Barron, founder of *Barron's Weekly*, about Ponzi's operation for a July 25 article. The article iterated Barron's opinion that it would be impossible to turn over more than a few thousand dollars worth of coupons in the manner described by Ponzi.

The article resulted in a run on the Securities Exchange Company that Ponzi stemmed by offering a full refund to anyone who requested it. Ponzi admitted that the coupon scheme was simply a ruse to cover an even more inventive plan he had developed that he sought to keep secret from Wall Street speculators. These developments, to Grozier's chagrin, only caused more investors to entrust Ponzi with their money; Grozier had unwittingly promoted Ponzi's operation. Grozier ordered his staff to widen the investigation of the immigrant millionaire.

The *Boston Post*, exploring an anonymous tip, discovered that Ponzi had been convicted of forgery in Canada in 1908 for activities strikingly similar to the reply coupon enterprise. Publication of these allegations on August 11 prompted federal postal inspectors to focus attention on Ponzi's activities. He was arrested by a U.S. marshal on August 13 and charged with mail fraud. Six Boston banks that were closely tied to Ponzi failed, including Hanover Bank and the Tremont Trust. Investigators soon discovered that Ponzi had also been convicted of smuggling illegal aliens into the United States from Canada after being released from Canadian prison.

Ponzi was tried and convicted in Boston's federal court and was sentenced to five

years in prison. Because federal facilities were unavailable, Ponzi was incarcerated in the Plymouth County Jail and was paroled after serving forty months of the sentence. Massachusetts then tried him on state charges; with twenty-two counts of conspiracy and larceny against him. Ponzi was sentenced to seven to nine years in prison in February of 1925. He escaped while free on bail.

Ponzi resurfaced in Florida in 1926, selling swampland for ten dollars an acre to naïve investors. He was convicted of fraud and sentenced by a Florida court but again escaped while on bail. He was arrested in New Orleans in 1927 and was returned to Boston to serve his sentence. Ponzi was released in 1934 and deported to Italy, where he had achieved celebrity status.

Italian dictator Benito Mussolini asked Ponzi to manage the Brazilian offices of Italy's new airline. He was fired in 1942 after allegations surfaced that he was involved with currency smuggling. He retired to a pauper's life that was interrupted briefly by efforts at finding renewed glory. He reportedly tried to swindle the Soviet Union in a gold smuggling operation in the late 1940's. Ponzi died of a stroke in a Rio de Janeiro hospital's charity ward on January 18, 1949, leaving an estate of $75 that was used to cover burial expenses.

Impact of Event

Few concrete steps were taken in the 1920's to stem the proliferation of investment scams that helped define the decade. Although the more outrageous schemes received intense press coverage, victims found little recourse at the federal level. It is ironic that, like Ponzi before them, many promoters experienced increased demand for their securities as the level of media coverage intensified, regardless of whether the reporting was salutary or critical.

The 1920's was a decade of rapid income growth coupled with amazing returns for holders of stocks of both established and new corporations. Given these conditions, a novice investor could rationalize looking past risk in the hope that a token investment could be parlayed into a fortune. The speculative fever that infected the United States in the 1920's has been attributed by some social historians to consequences stemming from World War I. Consumer demand was suppressed throughout the war by a comprehensive rationing system, despite impressive growth in real personal income throughout the war and into the early 1920's. As a result, the savings rate reached levels not seen again until late in World War II. A large portion of wartime savings had been accomplished through the purchase of war bonds. Americans began the 1920's with stockpiles of these long-term securities paying yields of 3.5 to 4.5 percent, which seemed paltry when compared to the returns generated by stocks and other risky investments in the war's aftermath. Savvy promoters seized on this dissatisfaction and allowed investors to exchange the bonds at par for investments in the promoters' schemes.

Ponzi's success spawned countless imitators who profited throughout the 1920's. For example, hundreds of itinerant Russian immigrants invested $500,000 in a fictitious gold and platinum mine on the Hudson River. Brazen Chicago swindlers

sold shares in the League of Nations. Midwestern investors purchased uninspected wetlands under the Mississippi River, land that was advertised as already having running water. Countless investors contributed millions of dollars to fraudulent oil well ventures. Hundreds of entrepreneurs sold Florida real estate at seminars held in cities throughout the eastern half of the United States.

Few in government had the inclination or power to stop Ponzi and his imitators. Beginning with Kansas in 1911, states passed laws that attempted to regulate investment sales. New York's Martin Act stood out because it provided for criminal proceedings against fraud. The laws of most states, especially the "blue-sky" laws, regulating stock and other investment sales, of Texas and other states were cosmetic or were not enforced. In the case of Ponzi, only the Pulitzer Prize-winning efforts of the *Boston Post* forced state authorities to belatedly intervene. The Commonwealth of Massachusetts was forced to prosecute Ponzi under arcane "common and notorious thief" statutes.

Federal investigative units had the greatest success prosecuting investment fraud cases in the 1920's. Postal inspectors successfully collected evidence for local prosecuting attorneys and had the power to stop the flow of mail to operators of investment scams. Postal investigations, however, typically consumed a year or more before completion, and federal prosecutors often took months or years to press charges against the promoters once they received evidence. Even when promoters were convicted, prison terms were generally short and fines were small. Large fines often went unpaid.

State and local efforts at interdiction generally stopped at political borders. It was a relatively simple matter for an investment scheme operator to move to a new community when local authorities responded to complaints and initiated investigations. The lack of a national tracking system ensured that a criminal's past was easily buried with each relocation.

The newly created Federal Trade Commission (FTC) investigated a handful of investment fraud cases on the premises that crooked schemes unfairly competed with honest ones and were thus a restraint of free trade. The FTC was thought to be so incompetent that *The New York Times* described it as the "fragile sword."

The speculative boom of the 1920's died with the 1929 stock market crash. Thus, the legal impact of Ponzi's international reply coupon swindle was not immediate. It took many other investment frauds, a stock market crash, and the near collapse of the banking system before Congress acted in the early 1930's and passed the Securities Act of 1933 and Securities Exchange Act of 1934. The latter law required registration with the newly created Securities and Exchange Commission (SEC) before securities could be offered or sold. The Securities Exchange Act of 1934, the Investment Company Act of 1940, and the Investment Advisors Act of 1940 placed licensing and activity limitations on individuals engaged in security sales or distribution.

The SEC is an independent bipartisan administrative agency that enforces compliance with laws against false and misleading investment disclosures and unethical securities sales practices. Learning from the difficulties Massachusetts had in convict-

ing Ponzi of fraud, the SEC found it easier to derail Ponzi schemes by citing technical violations of SEC regulations instead of focusing on fraud allegations.

Ponzi schemes continue to surface on a regular basis, despite increased investor sophistication and enhanced legal weapons for prosecution. Recent instances include the Moses Lake commodity futures scheme, the J. David currency trading scandal, the ZZZZ Best penny stock scam, and the Memory Metals affair. Each of these plans paid interest or dividends to investors from the capital of later investors. Many investment industry observers attribute the continued success of Ponzi scheme promoters to the SEC's tendency to concentrate on "big fish" (for example, insider traders who victimize a small circle of investors for large sums) instead of scams that defraud a large number of investors of relatively small amounts. The fact that Ponzi schemes systematically surface can more likely be attributed to the fact that they tend to bring out the worst in both the promoter and the investor, who loses sight of economic reality when faced with prospects of immediate wealth.

Bibliography

Dunn, Donald H. *Ponzi!* New York: McGraw-Hill, 1975. The authoritative biography of Charles Ponzi. Highlights major events in his life and gives the reader an idea why Ponzi was driven to succeed. Easy to read.

Evans, D. Morier. *Facts, Failures, and Fraud.* Reprint. New York: Augustus M. Kelley, 1968. The surprisingly readable volume is a case history of financial fraud in Victorian England. The book is a reminder that Ponzi's scheme was innovative but not original.

Kahn, Ely J. *Fraud.* New York: Harper and Row, 1973. A comprehensive and entertaining account of the long history of the Postal Inspection Service. Major United States Postal Inspection Service fraud investigations from the 1700's to the present are covered in a case format. Unfortunately, the cases are not presented in chronological order and are somewhat difficult to find.

Olien, Roger M., and Diana Davids Olien. *Easy Money.* Chapel Hill: University of North Carolina Press, 1990. Examines investment schemes of the 1920's, with a particular emphasis on oil promoters. Provides an interesting psychological perspective on the Jazz Age and presents theories on why so many investors were duped. A glossary is provided to assist readers.

Russell, Francis. "Bubble, Bubble—No Toil, No Trouble." *American Heritage* 24 (February, 1973): 74-80. Provides a historian's perspective on Ponzi's impact on Boston. Political and social tensions are tied together in examining Ponzi's rise and fall. Contains several photographs and political cartoons reprinted from the defunct *Boston Post.* The writing is lively and not altogether unsympathetic to Ponzi.

Shapiro, Susan P. *Wayward Capitalists.* New Haven: Conn.: Yale University Press, 1984. Provides detailed information on how the Securities and Exchange Commission detects securities violations and prosecutes offenders. The scholarly book is thoroughly documented, with excellent references and footnotes.

Robert A. Nagy

Cross-References

The Federal Trade Commission Is Organized (1914), p. 269; The U. S. Stock Market Crashes on Black Tuesday (1929), p. 574; The Securities Exchange Act Establishes the SEC (1934), p. 679; Insider Trading Scandals Mar the Emerging Junk Bond Market (1986), p. 1921; Drexel and Michael Milken Are Charged with Insider Trading (1988), p. 1958.

PROCTER & GAMBLE BEGINS SELLING DIRECTLY TO RETAILERS

Category of event: Marketing
Time: 1919-1920
Locale: Cincinnati, Ohio

By implementing a plan for direct selling to retailers, Procter & Gamble assumed control of its distribution function from jobbers, enabling steady production, quick assessment of marketing efforts, guaranteed employment, and increased market presence

Principal personages:

WILLIAM COOPER PROCTER (1862-1934), the president of the company and principal architect of the direct selling plan

RICHARD R. DEUPREE (1885-1974), the general sales manager who implemented and refined the plan

JOHN J. BURCHENAL (1861-1926), the vice president and general manager in charge of coordinating production for the plan

RALPH F. ROGAN (1875-1955), the advertising manager who devised promotional strategies for direct retail sales

Summary of Event

Facing industrywide marketing pressures, Procter & Gamble initiated direct selling to retailers in the early 1920's. This change enabled the company to exert greater control over wholesale grocers, whose actions previously had made it difficult to rationalize production and labor costs. By implementing direct sales, the company stabilized its distribution methods to meet a steady consumer demand rather than satisfying the sporadic purchasing cycles of wholesalers.

Focusing on the retail grocer, the company developed a support structure that included economic forecasting, cost/benefit analysis of advertising, and specialized marketing support services geared to the retail trade. Procter & Gamble also devised sophisticated analytical tools to gain a better understanding of its markets, which, in turn, led to the development of consumer marketing, advertising, and research expertise unequaled in the consumer products industry. Additionally, the production stability that the direct selling plan enabled allowed the company to guarantee full-time employment to its factory workers in 1923.

Procter & Gamble's direct selling strategy was primarily a response to the practices of wholesale grocers. Their large-scale speculative purchasing of consumer goods such as soaps and shortenings wreaked havoc with production schedules. Peak order periods strained the company's factories and forced it to maintain excess capacity as well as paying expensive overtime. Between the peaks, capital equipment lay idle, and employees faced layoffs. Procter & Gamble had no control over when large orders

would come in, and these orders were difficult to predict.

Company president William Cooper Procter had long recognized that consumer demand for his company's products remained steady throughout the year. He hoped to devise a means to link production with true demand, as the sporadic purchasing patterns of wholesale grocers infuriated him. Wholesalers often bunched their orders in anticipation of a price change or to entice the company to lower prices. Procter & Gamble first attempted to deal with this issue in 1913, and its experience served as a precursor to the direct selling plan.

To achieve fair competition among retailers, the company stipulated in its contracts with wholesalers that they sell the company's goods to retailers at the list price. If management suspected a wholesale firm of price cutting, it refused to deal with the alleged offender. The Supreme Court in 1913 declared such a contractual arrangement to be an unconstitutional restraint of trade. In response, many wholesaler grocers, led primarily by New York City firms, initiated a price war. When some wholesalers appealed to Procter & Gamble for discounts, the company refused. The company decided in March, 1913, to try direct selling to retailers in the New York City area.

To its delight, the company found that retail orders varied little from week to week, giving production managers greater flexibility in scheduling labor and raw material purchases. Additionally, direct selling provided company salespeople with valuable firsthand contact with those most familiar with the buying habits of the company's ultimate consumers. Point-of-sale contact enabled salespeople to assist retailers with the display of goods and also provided a forum for a crucial exchange of information about the most effective means of selling Procter & Gamble's products. Management realized that this information was crucial in assessing the impact of advertising and arranged for the systematic collection and analysis of "consumer perceptions."

Although the benefits of direct selling in the New York City area seemed clear, implementing direct sales nationwide proved too great a challenge in 1913. Such a move would require a complete overhaul of the sales function, including a massive expansion of the sales force, new training programs, and a system of regional warehouses to accommodate the new distribution system. The outbreak of World War I also delayed efforts, forcing Procter & Gamble to focus on supply and production problems instead.

After the war, however, the company moved quickly. Procter assigned the task of devising and implementing a nationwide plan to Richard R. Deupree, the general sales manager. In 1919, Deupree reorganized the sales department, expanding the sales force from 150 to more than 800 employees. He also implemented a new training program tailored to the demands of retail sales and service. Formal notice of the nationwide direct sales plan was dispatched to the trade in July, 1920.

The company expected, and found, significant resistance from wholesalers. They correctly interpreted Procter & Gamble's direct selling plan as a serious challenge to their economic power. After canceling longstanding orders with the company, whole-sale grocers, through their trade association, launched a campaign in the press to rally the industry against Procter & Gamble. Many retail grocers also protested. Accus-

tomed to dealing with wholesalers, they resented company salespeople and resisted the policy of requiring individual stores to purchase larger orders than they had through wholesalers, a necessary step to make direct selling economically feasible.

Although initial opposition caused Procter & Gamble great concern, by March, 1921, more than 75 percent of the nation's grocers had agreed to purchase the company's products on a direct basis. Many wholesalers, responding to a new pricing structure and unwilling to abandon a popular product line, also returned to the fold. Procter & Gamble remained flexible in implementation of the plan and returned to jobbing arrangements through wholesalers in remote locations where direct selling proved uneconomical. The overall success of the move enabled the company to reduce the cost of selling its products by half during the first five years of the direct selling plan.

Impact of Event

For Procter & Gamble, marketing expertise was the most significant and enduring benefit of direct selling. By cutting out the intermediaries, the company moved closer to its customers and developed formal procedures to assess the effectiveness of its marketing and service functions. Close contact with retailers forced the company to understand the needs and desires of its customers as well as to establish a pattern of mutual cooperation between the company and retail grocers. Salespeople were instructed to value the opinions of retailers regarding company products and to be flexible in devising marketing strategies tailored to the differing economic environments of retail grocers. Point-of-sale contact placed the company in a position to gain valuable insight into consumer preferences. That opportunity was exploited in a variety of marketing and advertising plans.

Exposed to a wealth of new information about perceptions of its products on the retail level, Procter & Gamble created a formal research department in 1922 in an attempt to understand and predict market behavior. Since the basic intention of the direct selling plan had been to align production with consumer demand, an accurate assessment of the external influences on demand was essential. The company used economic forecasting for such factors as the market potential of each product line, the effects of industry competition, and the impact of advertising and promotion. Research on general and local business conditions aided in estimating demand and scheduling production.

Additionally, Procter & Gamble began to analyze marketing effectiveness and market potential for each product line. This foreshadowed the implementation of brand management, a concept that treated each product as produced by an individual company within the company. Eventually, each product would compete against all others for corporate resources and consumer loyalty.

The production stability gained as a result of the direct selling plan enabled Procter & Gamble to achieve many economies. With a better understanding of consumer demand, the company exercised greater control over manufacturing costs. Systematic scheduling of raw material purchases, labor requirements, warehouse facilities, and

transportation resulted in significant savings. The peaks and troughs of producing for the wholesale trade would never again plague the firm.

Procter & Gamble's confidence in the continued success of direct selling was best reflected in the guarantee of full-time employment to its fifty-five hundred factory employees in 1923, an unprecedented move for a manufacturer of its size. The stabilization of production enabled such a guarantee. It further benefited the company by reducing turnover and increasing production efficiency. Procter & Gamble also received much favorable publicity that in turn increased its reputation among American consumers.

The successful implementation of direct selling and the numerous benefits it provided to the company did not go unnoticed by other firms in the consumer products industry. By 1939, more than 90 percent of soap produced in the United States was distributed directly to retailers as competitors copied Procter & Gamble.

Gaining control over the channels of distribution was an important trend in American business during the late nineteenth and early twentieth centuries. Firms such as Procter & Gamble mastered continuous process production technology, which enabled them to produce vast quantities of goods at lower costs. This, in turn, forced firms to devise new techniques for mass distribution. Gradually, they seized control of the distribution function from wholesalers and took responsibility for marketing their products.

Sales departments in competing firms grew larger as they assumed responsibility for implementing new methods of distribution. Influencing demand through promotion and advertising, then assessing and predicting the impact of their efforts through research and analysis, became key functions of sales departments. Procter & Gamble itself became one of the largest corporate advertisers in terms of dollars spent.

Greater control over marketing also enabled firms to rely on the sales department to coordinate the flow of goods from production facilities to the ultimate consumer. As Procter & Gamble found, this eliminated the instability involved in producing for wholesalers and resulted in significant savings in all phases of the manufacturing and distribution process.

As Procter & Gamble's primary competitors in the consumer products industry adopted direct selling plans, they also developed sophisticated marketing techniques and support functions. With the pathway to the consumer more clearly defined, competitive battle lines were drawn. Because demand for most mass-produced consumer goods was inelastic or unresponsive to price, firms sought to increase market share not by reducing prices but by increasing advertising. Over the years, they became more sophisticated in their techniques and made the industry one of the most effective and influential users of marketing and promotional strategies in the United States and around the world.

Bibliography

Deupree, Richard R. *William Cooper Procter (1862-1934): Industrial Statesman.* New York: Newcomen Society, 1951. This brief pamphlet is a transcription of a

speech by Procter & Gamble chairman Richard Deupree. Provides personal recollections about Procter and remembrances of important events in the company's history.

Editors of *Advertising Age*. *Procter & Gamble: The House That Ivory Built*. Lincolnwood, Ill.: NTC Business Books, 1988. A corporate history written outside the company. More extensive than the other corporate histories cited.

Lief, Alfred. *"It Floats": The Story of Procter & Gamble* New York: Rinehart & Company, 1958. This company-sponsored history, while not a scholarly presentation, provides useful information on corporate strategy and influences on decision makers. Well organized and clearly written, it provides the starting point for historical research on the company.

Procter & Gamble Company. *Into a Second Century with Procter & Gamble*. Cincinnati, Ohio: Author, 1944. A short corporate history produced by the company.

Schisgall, Oscar. *Eyes on Tomorrow: The Evolution of Procter & Gamble*. Chicago: J. G. Ferguson, 1981. A company-sponsored history. An informal but useful chronicle of Procter & Gamble's growth. Makes extensive use of anecdotes and remembrances to personalize corporate development. Especially strong on the post-World War II era.

Douglas Knerr

Cross-References

The Federal Trade Commission Is Organized (1914), p. 269; Clarence Saunders Introduces the Self-Service Grocery (1916), p. 302; The Supreme Court Rules Against a Procter & Gamble Merger (1967), p. 1309; Price Club Introduces the Warehouse Club Concept (1976), p. 1621.

DONHAM PROMOTES THE CASE STUDY
TEACHING METHOD AT HARVARD

Category of event: Management
Time: The 1920's
Locale: Cambridge, Massachusetts

Wallace B. Donham, dean of the Harvard Business School, introduced the case history teaching method to improve students' management skills and knowledge of the business world

Principal personages:

WALLACE B. DONHAM (1877-1954), the dean of the Harvard Business School, 1919-1942

N. S. B. GRAS (1884-1956), the professor chosen by Donham to initiate a case history program at Harvard

HENRIETTA M. LARSON (1894-1983), a developer, with Gras, of case histories

EDWIN F. GAY (1867-1946), the first editor of the *Journal of Economic and Business History*

Summary of Event

Virtually all management-related textbooks for business classes include case histories. There was a time, however, when such books contained nothing but theory. Wallace B. Donham, who was appointed to his position as dean of the Harvard Business School in 1919, changed that. He introduced an innovative element to the teaching of business, the case history. In so doing, he changed the way business subjects were taught at colleges and universities and improved the quality of graduates entering the business world. Both educators and business executives owe Donham a large debt of gratitude as a result.

Donham began his business career as a banker. After Harvard appointed him to the position of dean of the business school in 1919, Donham sought to introduce a major change into the curriculum: the inclusion of actual business histories to supplement the theory on which teachers relied so heavily. He hired N. S. B. Gras, a professor at the University of Minnesota, to implement the teaching, research, and writing program designed to introduce the case history method.

Gras began at once to develop the case histories Donham so ardently wanted. He enlisted the help of several associates, primarily Henrietta M. Larson, to develop cases for his courses. Gras also teamed with Edwin F. Gay, a professor at Harvard, to publish the *Journal of Economic and Business History*. Gay edited the publication, and Gras acted as the managing editor. The first issue appeared in November, 1928. The Great Depression forced them to cease publication in 1932, although Gras and Gay had parted ways a year earlier following disagreements over editorial policies. Six years

later, the school resumed publication of the journal under a new name, *The Bulletin of the Business Historical Society*, which was renamed the *Business History Review* in 1954. The journals kept alive Donham's idea of the case history approach and provide evidence of the longevity of his ideas.

Donham was named dean of the Harvard Business School at a time when people were beginning to look at business as a profession. Owen D. Young, the industrialist largely responsible for the rise of the General Electric Company, discussed the new importance of business in a speech he delivered on June 4, 1927, at the dedication of the George F. Baker Foundation of the Harvard Graduate School. He noted that until then, business largely had been conducted within the community and on a small scale. Consequently, the community disciplined the individual businessperson effectively. As the 1920's came to a close, however, business was becoming bigger, and its local flavor was fading. Businesspeople and educators saw a need for a new approach to teaching business. Donham was one of these people.

Colleges did not place business education, especially at the graduate level, among their highest priorities in the early part of the twentieth century. For example, only two universities in the United States, Harvard and Stanford, sponsored schools that dedicated themselves entirely to graduate students of business. The Wharton School of Finance, the first collegiate school of business established in the United States, concentrated on undergraduate training. Many businesspeople saw the lack of concentration at the graduate level as a severe deficiency in the educational system. Some business executives sought to remedy that situation. Young's speech was part of the ceremonies celebrating the donation of a multimillion-dollar gift to business education from the noted New York banker, George F. Baker. Donham connected the donation with his vision of the new profession of business, which included a social consciousness with the objective of a sound evolutionary progress of civilization.

Donham believed that education at the college level is a powerful accelerator of social change. He advocated a balance between scientific and liberal arts education, if for no better reason than to advance the study of business. He believed fervently that business is the main instrument through which science brings social change.

Donham emphasized that more college graduates were finding careers in business than in any other field. He also noted that an increasing number of engineering school graduates were becoming business administrators instead of engineers. He concluded therefore that educators should concentrate on providing a well-rounded business curriculum to students. He emphasized that education should not be strictly theoretical and that training should not necessarily be restricted to colleges.

In his own experience, Donham had learned that business administration in a technical and immediate sense was often relatively weak in its overall public relations and in its handling of human problems. He determined to correct this deficiency by widening students' overall knowledge of business theory and its practical application. Donham explained that the mission of the Harvard Business School was not so much to train specialists as it was to develop students' capacity to examine as many of the constantly changing facts and forces surrounding administrative situations in business

as they could bring effectively into their thinking. They would then use these facts imaginatively in determining current policies and action. The method he favored as a way of developing students' capacities was the case history. Donham suggested that case histories would illustrate how problems actually came to the attention of business managers and show the background material actually used to solve those problems. As he noted, case histories developed students' essential habits, skills, and ability to form judgments based on diverse factual situations.

Impact of Event

Donham soon reported that the Harvard Business School had experienced success with the case history method. The experience had been so positive, in fact, that he suggested that the method be included in substantial parts of the curriculum in general education. He stressed that schools should not, however, place complete reliance on the case history method. In his view, there was still a need for a large amount of theoretical reading if students were to gain the necessary background in their fields of specialization. The case history approach did offer a number of benefits to students in a variety of fields.

In his 1944 book, *Education for Responsible Living: The Opportunity for Liberal-Arts Colleges*, Donham presented a brief history of the impact of case histories on the curriculum at Harvard. Originally, the business faculty implemented the method on an experimental basis. The professors had seen how well case histories had worked in the law school and wanted to apply the method in business education. They hoped that it would do the same thing it had in the teaching of law, stimulating both student initiative and student interest. From the onset, it accomplished these results so satisfactorily that its use spread rapidly.

The implementation process did not go smoothly. At first, there existed no books of finished business case histories that students could purchase. Therefore, Harvard professors had to go out into the field to collect data on which to base their own case histories. This practice was fraught with problems. Donham reported that most of the graduate business professors were economists with little experience in gathering and analyzing business data of the type needed for general case histories. For example, they often omitted essential facts of cases, leaving students with gaping holes in the data being analyzed. Students were therefore unable to arrive at decisions of general policy.

Donham and his associates worked diligently to iron out the kinks in the case history method. They made some startling discoveries. For example, many of the generalizations they thought of as established principles did not stand the tests imposed by changing facts, and many established theories did not stand the test of practice. Out of this experience, Donham and his cohorts learned that factual situations, realistically reported, are more than a basis for improved pedagogy.

One of the school's concerns in the early stages of the process was monetary. As the procedure for gathering data for cases became better refined, the case reporting was turned over to young graduates of the school of business who were paid entry-

level salaries for their efforts. The process helped these young graduates immeasurably as a part of their education, whether they were going into business or into teaching. In addition, it sharpened the professors' skills. As Donham explained, the data gatherers needed considerable supervision from the professors under whom they worked and for whom they were reporting cases. Everyone involved in the process realized that the quality of supervision could be improved if the professors went through the data-gathering process themselves. This, combined with consulting work performed by the professors, which gave them the opportunity to work directly with businesses, upgraded the professors' teaching abilities.

Donham concluded that the results improved the business schools' status in everyone's eyes. Students learned more about the realities of business principles, rather than only the perceptions. Professors became more adept at integrating practical application and theory in their presentations. Businesspeople derived benefits from hiring newly graduated students with a broader knowledge of actual business practices.

Donham noted that the faculty's teaching became more realistic and satisfactory to students. Professors could imagine themselves in the surroundings of a case with sufficient accuracy without an actual site visit. This realistic touch spread to their teaching of cases collected by their assistants. Donham continually extolled the virtues of the case history method. He added that professors were freed from the feeling that they were amateurs looking in from the outside. Their classroom experience and repeated experience of discovering that they could hold their own in business conferences at which business problems and policy were discussed confirmed this. In effect, Donham believed that the case history approach broke down the fence between theory and practice.

Donham also was careful to point out that problems remained in using the case history method. He cited the lack of cases to use as teaching materials, the costs of gathering data, heavy teaching loads, and the sense of insecurity that afflicts many teachers when, with their background as specialists, they themselves face the necessity of formulating policy judgments on the basis of complex shifting facts. Business administration teachers frequently commented to Donham that they were unable to establish direct contacts with business because of lack of funds or heavy teaching loads. Therefore, they found it difficult to use cases as a teaching tool. Donham encouraged business administration teachers to overcome these obstacles as best they could, lest they be shown up by students who knew more than they did because of their familiarity with case histories. He advised them that the extra work they had to put in to integrate cases into their classes would be well worth the effort.

Not everyone agreed with Donham's assessment. Some detractors of the case method expressed fears that it would result in uniformity. Donham argued that the exact opposite was true. He recalled that in his experience, the only two uniformities running through instruction by the case method were the greater reliance on discussion in which students took part and the fact that every discussion started, as the students knew, from some honestly reported segment of concrete reality that called for a decision or a judgment. In Donham's mind, there were no other fixed formulas.

Donham concluded that the case system was radically different from the project method used in the extreme progressive schools and from the use of problems as isolated bits of student research. He stressed that emphasis should always be placed on systematic development of a subject. Furthermore, he noted, the choice of things important for study was always the teacher's choice. He also pointed out that the case method involved group work, much as true business management does. Donham thus discussed a group philosophy of work and study years before it became popular.

Donham conceded that the case history method might not please everyone or be useful in all situations. Its use did point out the necessity in any reorganization of general education of preventing the repetition year after year, to unreceptive students, of disassociated unused facts and inert knowledge. Instruction, he said, must tie itself into life and develop the habits and skills required to make imaginative judgments. That message had a major impact on business educators as more schools started adopting the case method.

By the end of the twentieth century, almost no business textbook was published that did not include several case histories. They had become vital components of business teaching. Decades of experience showed that case problems bring reality to business subjects, improve students' analytical abilities, and increase their learning. They also stimulate students' interest in acquiring more knowledge about management. That was exactly the message that Donham succeeded in getting across to business teachers. His tenure as dean of the Harvard Business School revolutionized the teaching of business.

Bibliography

Bursk, Edward C., et al., eds. *The World of Business*. Vol. 3. New York: Simon and Schuster, 1962. A compendium of major contributors to business history. Includes mentions of Donham and his approach and verifies the significance of the case history method.

Cruickshank, Henry M., and Keith Davis. *Cases in Management*. Homewood, Ill.: Richard D. Irwin, 1954. Discusses the use of case histories in education, giving examples to acquaint teachers and readers with the approach.

Donham, Wallace B. *Business Adrift*. New York: McGraw-Hill, 1931. Discusses how business had departed from the classical operating style of the past and offers suggestions on how management styles can be improved. Many of the ideas are applicable to business today, despite the book's age. Also lays out a method of treating complex domestic and worldwide social problems.

——————— . *Education for Responsible Living: The Opportunity for Liberal-Arts Colleges*. Cambridge, Mass.: Harvard University Press, 1944. Donham uses his experience as a businessperson and educator to offer suggestions to educators on how they can better prepare students for careers in the business world.

Gilbert, Horace N., and Charles I. Gragg. *An Introduction to Business: A Case Book*. 2d ed. New York: McGraw-Hill, 1933. This collection of case histories is a prime example of the contemporary impact Donham's method had on teaching business

courses. The authors acknowledge Donham's influence in their preface.

Gras, N. S. B., and Henrietta M. Larson. *Casebook in American Business History.* New York: Appleton-Century-Crofts, 1939. This collection of case histories was among the first of such volumes to be published; the authors mistakenly claimed that it was the first. It contains forty-three cases taken from American and business history. The cases are excellent examples of those touted by Donham as invaluable teaching tools.

Arthur G. Sharp

Cross-References

Harvard University Founds a Business School (1908), p. 157; The American Management Association Is Established (1923), p. 419; Barnard Publishes *The Functions of the Executive* (1938), p. 770; Drucker Examines Managerial Roles (1954), p. 1020.

THE YANKEES ACQUIRE BABE RUTH

Category of event: Business practices
Time: 1920
Locale: New York, New York

The New York Yankees' acquisition of Babe Ruth coincided with the emergence of the home run as baseball's new weapon, enormously increasing the sport's popularity and marking a new approach to franchise operations

Principal personages:
GEORGE HERMAN "BABE" RUTH (1895-1948), the star outfielder who was at the forefront of baseball's revolution
JACOB "JAKE" RUPPERT (1867-1939), the owner of the Yankees and an independently wealthy brewery magnate
JOSEPH JEFFERSON "SHOELESS JOE" JACKSON (1887-1951), a legendary pioneer in the development of the power swing in hitting
KENESAW MOUNTAIN LANDIS (1866-1944), the first commissioner of baseball
EDWARD GRANT BARROW (1868-1953), the Yankees' general manager from 1921 to 1939

Summary of Event

The New York Yankees' purchase of Babe Ruth's contract from the Boston Red Sox in 1920 was more than a simple baseball business transaction. The appearance of Ruth in a Yankee uniform was significant in the transformation of how baseball was played on the field and, on a different level, had a profound effect on how management devised strategies for the overall operation of professional sports franchises. Ruth, the premier home-run hitter of the era, was also the key to the Yankees' financial success. His contract was available after the 1919 season because Harry Frazee, the owner of the Red Sox, needed cash to handle debts and legal problems. The Red Sox, though financially strapped, were a traditionally strong team that had won four World Series championships in the preceding eight years; in contrast, Yankees' owner Jake Ruppert had ample personal monetary resources but owned a team that had never finished higher than second place in the American League. In an effort to bring fans into the Polo Grounds (the Yankees' home field until the opening of Yankee Stadium in 1923), Ruppert identified Ruth as a player of immense potential and purchased his contract from the Red Sox for $125,000 and a loan of $300,000—unprecedented amounts in player transactions of the time. By comparison, Ruppert and his partner had paid $450,000 for the entire ball club in 1915.

The arrival of Ruth in New York and the rise of the Yankee dynasty came at a time of crisis in professional baseball. Many franchises had heavy financial burdens from the brief but costly rivalry with the upstart Federal League, which in 1914 and 1915 had signed more than eighty major-league players and had drawn a large number of

fans. The settlement with the Federal League may have cost American and National League owners as much as five million dollars. In 1918, moreover, more than two hundred major-league ballplayers entered the armed forces to serve in World War I. Fan interest dropped sharply, the playing season ended a month early, and club incomes declined. Finally, the 1919 World Series ended under the shadow of rumors that eventually resulted in open charges that the Chicago White Sox, including star outfielder Shoeless Joe Jackson, had accepted bribes from gamblers to lose the contest on purpose. In September, 1920, after several months of owner coverups, extensive coverage of the "Black Sox" scandal appeared in the press. This scandal threatened to deepen the game's financial woes, since skeptical fans were not likely to pay admission to root for teams that may have sold out to gamblers.

Even before the full extent of the 1919 World Series scandal became public knowledge, Babe Ruth and the Yankees set out in a more positive direction. Ruth came to personify changes in batting techniques that, in the space of three years, revolutionized the way in which the game was played. Ruth's main weapon was a long, thin-handled bat, and his method was a mighty, body-wrenching swing. One result was a swing and a miss. He struck out often. He was also exceptionally gifted in driving the heavy part of the bat directly into the pitch. The result was, for both players and spectators, nothing less than phenomenal. Ruth's claim to baseball immortality was the home run—not the typical extra-base hit of the day, which was usually a line drive that skipped between converging outfields to find the far reaches of a ballpark, but a towering fly ball that traced a huge arc as it went into the stands or, in some cases, entirely out of the park. This style of hitting, based on a powerful swing with both arms fully extended, a slight uppercut motion with the bat, and the violent pivoting of the hitter's body, was unlike the prevailing style of "punch" or "slap" hitting, in which the batter met the pitch with a short-armed swing.

Ruth's performance in Boston had given an indication of what was to become his forte in New York. In 1918, although he was used primarily as a pitcher and played in fewer than two-thirds of his team's games, he tied for the American League leadership in home runs, with eleven. Converted into a full-time everyday player for his final season with the Red Sox, he hit twenty-nine, nineteen more than the second-place figure. This record-setting feat stimulated interest among fans, but the 1919 season was only a prelude to what was to become a turning point in baseball history. After a slow start with the Yankees in April, 1920, Ruth found his form. On May 1, he hit a tremendous home run that cleared the right-field stands of the Polo Grounds and landed on a recreation field nearby. Before the end of the month, he had added ten more home runs, and by the end of the season Ruth had a total of fifty-four—approximately five times the number needed for league leadership during the previous two decades.

The effect of this extraordinary performance on ticket sales and team income was dramatic. Owner Ruppert was delighted to see the Yankees set attendance records in the Polo Grounds and also in other ballparks in the American League as fans flocked in to see Ruth. Although the Yankees finished third in 1920, their home attendance led

the league at 1,289,432, a record that stood until 1946. The first-place Cleveland Indians drew the second-largest number at 912,834.

Impact of Event

Jake Ruppert had found a formula for popular and financial success in baseball. The unprecedented payment for Ruth's contract, which had appeared to be a substantial risk in early 1920, had become a solid investment by the end of the season. Ruth's home runs inspired respect and fear among other players, and awe and excitement among knowledgeable baseball fans. These mighty blasts also attracted the attention of people who rarely had any interest in baseball. Ruth's appearance at a local ballpark brought a large cross-section of the community into the stands. In 1919, he was a superior ballplayer, but by the middle of the 1920 season, he was a national celebrity. The Yankees' income for 1920 provided Ruppert with a firm financial base to use in signing other talented players and to begin the construction of Yankee Stadium.

Babe Ruth also cut a path for himself as an athlete who achieved media celebrity for profit. He rose to national prominence at an opportune moment in the city where the national print media had their headquarters. New York was the hub for the nation's press associations and had thirteen daily newspapers of its own. The public relations and advertising industries expanded their nationwide operations from their offices along Madison Avenue. Ruth's fame and fortune rose on a tide of media coverage that he received not only as baseball's "Sultan of Swat" but also as a colorful, uninhibited, sometimes irresponsible personality who also caused excitement off the field.

Some of Ruth's non-baseball activity brought anxiety to the Yankees' management and to the new commissioner of baseball, Kenesaw Mountain Landis, who had been charged with restoring the public trust in baseball in the wake of the 1919 World Series scandal. Ruth complicated Landis' job. In spite of Landis' concerns about the public image of ballplayers, Ruth consumed alcoholic beverages during a time of national prohibition, drove automobiles with reckless abandon, and pursued female companionship with equally reckless disregard for mainstream morality. Despite these foibles, however, Ruth managed to get good publicity. His running conflict with Landis became the subject of much press coverage and, in some circles, the source of considerable humor that included Ruth's popular 1921 vaudeville act. He also starred in a silent film and joined forces with Christy Walsh, a sportswriter and promoter, who supervised a syndicated newspaper column under the byline "Babe Ruth." As was customary, Ruth did not write the column (several other sports stars, including Rogers Hornsby and Knute Rockne, had similar arrangements), but Walsh was careful to direct the content toward entertainment rather than journalism. Ruth received ample compensation for the use of his name—about $15,000 in 1921, the column's first full year.

This public image tended to obscure the baseball revolution that Ruth led. It was not his revolution alone, however, as he often admitted. Ruth shaped his swing after that of Shoeless Joe Jackson, who ironically was banished from baseball in 1920. Baseball statistics, however, do support the notion that Ruth was ahead of other power

hitters in the period from 1919 to 1921. In 1920, for example, Ruth's fifty-four home runs surpassed second-place George Sisler's total by thirty-five. Even more remarkably, Ruth by himself hit more home runs than any entire team (other than his own) in the American League. As the months passed, batters adjusted their swings to follow the Jackson-Ruth form. Although other factors may have played a part, the aggressive blow of the power hitter ushered in an era of high-scoring games. From 1901 to 1918, the average number of home runs per season in the American League was less than 200. In 1920, American League hitters accounted for 370. In 1921, they hit 477, and from 1922 to 1941, the average number of home runs per season rose to more than 600. The National League followed a similar pattern.

To handle his expanding franchise operations, Yankees' owner Ruppert hired Ed Barrow as general manager at the end of the 1920 season. Barrow, an iron-willed, authoritarian type, proceeded to build a baseball dynasty founded on power hitting. Lou Gehrig joined the Yankee organization in 1923, and by the middle of the decade, the Ruppert-Barrow teams began to dominate the American League. Yankee management continued to sign sluggers: Joe DiMaggio roamed the outfield from 1936 to 1951, Yogi Berra was a power-hitting catcher in the late 1940's and 1950's, and Mickey Mantle's homers of the 1950's and 1960's reminded many of the handiwork of Ruth. In 1961, another Yankee slugger, Roger Maris, broke Ruth's longstanding record for home runs in a single season.

The Yankee approach spread throughout baseball, but it was most successful in large cities with big stadiums that could accommodate heavy ticket sales. For example, the Philadelphia Athletics assembled the mighty bats of Mickey Cochrane, Al Simmons, and Jimmy Foxx to challenge the Yankees in the late 1920's and early 1930's. In smaller cities, this formula did not work as well, probably because limited populations and smaller stadiums did not generate enough revenue. Branch Rickey, an innovative executive, devised another operational strategy for the St. Louis Cardinals. He organized a "farm" system of about thirty minor-league teams that would develop talented young players. This system worked well and lifted St. Louis into the upper echelons of the National League through the 1940's, providing the Cardinals with the likes of pitching sensation Dizzy Dean and, later, slugger Stan Musial.

In spite of their imitators and challengers, however, the Yankees remained baseball's premier organization from the 1920's into the 1960's. The open green field surrounded by the massive stands of Yankee Stadium symbolized baseball's merger of the nation's rural past with the modern industrial city. Ruth himself seemed to represent a somewhat undisciplined version of heroic individualism while attracting millions of loyal fans for the smoothly run corporate organization headed by Barrow and Ruppert. The Ruth phenomenon of the 1920's connected an organization's financial success with the performance of an individual star, a development in professional sports that had rough parallels with Hollywood films and popular music, as film studios and record companies discovered that stars such as Rudolph Valentino, Greta Garbo, Bing Crosby, and Frank Sinatra were necessary to hold public attention and to command a large paying audience.

Bibliography

Alexander, Charles. *Our Game: An American Baseball History*. New York: Henry Holt, 1991. A veteran historian's skillful summation of baseball history, including two chapters on the revolution in batting. Useful annotated bibliography.

Creamer, Robert. *Babe: The Legend Comes to Life*. New York: Simon & Schuster, 1974. A lively biography that focuses on Ruth in Boston and his early years in New York. Limited by absence of bibliography and footnotes.

Curran, William. *Big Sticks: The Batting Revolution of the Twenties*. New York: William Morrow, 1990. Highly readable discussion of the spread of the home-run revolution through the major leagues. Gives appropriate emphasis to Ruth but pays also much-needed attention to lesser-known sluggers. Also has a chapter on the home-run revolution in the minors.

Parrish, Michael. *Anxious Decades: America in Prosperity and Depression, 1920-1941*. New York: W. W. Norton, 1992. A well-written historical survey that explains the economic, social, and cultural context in which Ruth, Ruppert, and Barrow revolutionized baseball. Lengthy annotated bibliography provides guidance to more specialized historical works on the era.

Rader, Benjamin. *Baseball: A History of America's Game*. Urbana: University of Illinois Press, 1992. An outstanding one-volume history of baseball. Chapters 8 through 10 provide a readable synthesis of recent research on Ruth's impact. Effective use of statistics to support the thesis that the owners did not order the use of a livelier ball. Rader, like Curran, emphasizes the Jackson-Ruth swing.

Robinson, Ray. *Iron Horse: Lou Gehrig in His Time*. New York: W. W. Norton, 1990. A competent biography of Ruth's teammate and sometime rival. Based on interviews of Gehrig's contemporaries, including Frank Crosetti, Jimmy Reese, and Ben Chapman.

Seymour, Harold. *Baseball: The Golden Age*. New York: Oxford University Press, 1989. Comprehensive study of baseball from 1903 to around 1930, with balanced coverage of the game on the field and business operations off the field. Detailed information on the workings of franchises and on league policies and politics.

Smelser, Marshall. *The Life That Ruth Built*. New York: Quadrangle, 1974. Well-researched biography, with considerable attention to Ruth's contracts, other financial arrangements, and ventures into show business and public relations as well as his work on the field. Footnotes and bibliography add depth for the researcher.

John A. Britton

Cross-References

Station KDKA Introduces Commercial Radio Broadcasting (1920), p. 363; *The Jazz Singer* Opens (1927), p. 545; The Brooklyn Dodgers Move to Los Angeles (1957-1958), p. 1076; The NFL-AFL Merger Creates a Sports-Industry Giant (1966), p. 1298; Curt Flood Tests Baseball's Reserve Clause (1970), p. 1437; The Boston Celtics Sell Shares in the Team (1986), p. 1939.

THE SUPREME COURT RULES IN THE U.S. STEEL ANTITRUST CASE

Category of event: Monopolies and cartels
Time: March 1, 1920
Locale: Washington, D.C.

The United States v. United States Steel Corporation *case was dismissed by the Supreme Court because the defendant had not committed conduct in violation of antitrust laws despite its large share of the steel industry*

Principal personages:

JOSEPH MCKENNA (1843-1926), a justice of the Supreme Court, 1895-1925

JOSEPH BUFFINGTON (1855-1938), a district judge of the Third Circuit Court, 1906-1938

ELBERT HENRY GARY (1846-1927), a Chicago corporate attorney who became the chief executive officer of the United States Steel Corporation

CHARLES M. SCHWAB (1862-1939), the president of the United States Steel Corporation, 1901-1903

J. P. MORGAN (1837-1913), a financier and the founder of the United States Steel Corporation

Summary of Event

The United States Steel Corporation (U.S. Steel) was founded in 1901 as the world's first billion-dollar company. It immediately became the dominant firm in the steel industry. A decade after its formation, its relative size and leadership in industry pricing were challenged by the government as violating the Sherman Antitrust Act. After ten years of litigation, *United States v. United States Steel Corporation* (251 U.S. 417) was dismissed by the Supreme Court in 1920. The Court decision reduced the market power of U.S. Steel by encouraging other mergers within the steel industry.

Until the mid-nineteenth century, the iron and steel industry was competitive and decentralized. In the 1870's, adoption of the Bessemer process of steelmaking, discovered in England, led to large-scale production that gradually changed the development of the structure of the steel industry. In contrast to a rapid increase in steel output, the depression of 1893-1896 resulted in a reduction of demand for steel. Consequently, the price of steel rail dropped from more than $100 a ton in 1870 to $17 a ton in 1898. A wave of merger movement in the industry took place in an attempt to reduce competition among firms.

One of the biggest mergers was organized by J. P. Morgan, who bought three major steel producers: Federal Steel, National Steel, and Carnegie Steel. In 1901, the United States Steel Corporation was formed as trust, or holding company, of these operating firms in addition to ore mines, railroads, and ore-carrying ships. Charles M. Schwab

of Carnegie Steel was made president of the company. The new trust immediately accounted for 44 percent of the nation's ingot capacity and 66 percent of steel casting production.

An economic recession in 1907 reduced the demand for steel. Rather than cutting prices in response to the declining market, U.S. Steel's chairman of the board, Elbert Henry Gary, attempted to stabilize prices through cooperation with competitors. Through a series of well-publicized meetings, known as the Gary dinners, with many steel producers between 1907 and 1911, Gary promoted a policy of cooperation rather than competition among companies.

Gary developed a new pattern of pricing generally followed by other producers. The new policy was a basing point system, known as the Pittsburgh plus system. U.S. Steel began to quote steel product prices in all market areas on the basis of the Pittsburgh price plus the railroad freight rate from Pittsburgh to the market, regardless of where the products were made. U.S. Steel's policy was disseminated during the Gary dinners, and other steel producers gradually adopted the Pittsburgh plus system. Other firms also followed U.S. Steel's list of "extras" and price charges quoted to customers.

Despite its cooperative practices with other steel producers, U.S. Steel continued to expand, by acquiring seven more companies between 1902 and 1908 and through construction of the world's largest steel mill at a city in Indiana named for Gary. The company's expansionary and cooperative actions soon brought public attention, notably from newspaper journalists and labor unions.

In the early 1900's, following formation of U.S. Steel, the government began to prosecute trusts in sugar, oil, and tobacco for illegal monopolization. The relationship between Gary and President Theodore Roosevelt prevented an antitrust suit in 1907, when the president granted advance approval of U.S. Steel's acquisition of the Tennessee Coal, Iron, and Railroad Company. In 1911, as a result of extensive investigations of the steel industry conducted by the United States Bureau of Corporations and the Stanley Committee of the House of Representatives, the long-expected antitrust suit could not be avoided. Attorney General George Woodward Wickersham filed suit against U.S. Steel in October, 1911, and asked for divestiture of the corporation. In the *U.S. Steel Corporation v. United States* (223 Federal Reporters 55) case, the Department of Justice filed suit against U.S. Steel, charging monopolization through acquisition of competing firms and price fixing with competitors, both of which constituted unreasonable restraints of trade in the steel industry and violations of the Sherman Act.

Meanwhile, the success of the government's prosecution in the early 1910's against other major trusts, including Standard Oil and American Tobacco, for violating antitrust law encouraged the government to wage a war against more trusts and big corporations. The passage of the Clayton Act and the formation of the Federal Trade Commission in 1914 further strengthened the enforcement of antitrust laws. The Clayton Act forbade specific "unfair" business practices, including price discrimination and acquisition of competing companies in order to reduce market competition.

On June 3, 1915, the U.S. Steel case was dismissed in the District Court of New Jersey in a 4-3 decision. District Judge Joseph Buffington explained the decision, ruling that there was no acceptable evidence of a monopoly, unfair pricing, or monopolization by U.S. Steel in the steel market. In fact, U.S. Steel's share in the iron and steel markets had declined to about 50 percent between 1901 and 1910, while many competitors, such as Bethlehem Steel, Inland Steel, and LaBelle Steel, had grown rapidly during the period. There were more than eighty competitive steel manufacturers in the industry, hardly evidence of a monopoly.

Furthermore, the court did not find any evidence that the defendant attempted to control iron ore supply, as its major competitors all had sufficient iron ore supplies. Judge Buffington found the above evidence contrary to claims of monopolization and trade restraints. Furthermore, the Gary dinners, which might have constituted evidence of illegal practices as conspiracy to monopolize among firms, were discontinued before the suit. No competitors of U.S. Steel testified against the defendant's allegedly unreasonable business practices. Nevertheless, the decision was appealed to the Supreme Court.

On March 1, 1920, the Supreme Court reaffirmed the district court decision in a 4-3 vote. Chief Justice Joseph McKenna delivered the majority opinion, similar to that of Buffington. He explained that U.S. Steel was not formed with the intent to monopolize or restrain trade or to restrict competition, and that the formation of the steel trust was a natural result of the existing industrial technology, which made mass production efficient. Despite its gigantic size, the corporation did not abuse its market power to increase profits by reducing the wages of its employees or lowering product quality or output. Furthermore, McKenna did not find any evidence of unfair practices or trade restraints. The corporation had no power of its own, and its power to fix prices and maintain price stability arose from the cooperation of its competitors.

Unlike the American Tobacco (1911) and Standard Oil (1911) cases, both the district court and the Supreme Court found that the size of U.S. Steel itself was not an offense against the Sherman Antitrust Act, as it was not accompanied by "unreasonable" business practices. The failure of the government in prosecuting U.S. Steel signified the Court's tolerance of "good trusts."

Impact of Event

The U.S. Steel case contributed much to the early development of antitrust laws and the course of American industries. It represents the government's early efforts to maintain market competition in the face of mergers. Following government victories in the Standard Oil (1911) and American Tobacco (1911) suits, the case accounted for the first major failure in prosecuting a big corporation.

Both the district court and the Supreme Court decisions in favor of U.S. Steel were based on the "rule of reason" principle established in the Standard Oil and American Tobacco cases. McKenna reinforced the "rule of reason" that corporate size alone was no offense against the antitrust laws if not accompanied by anticompetitive conduct. The Supreme Court's confirmation of the "rule of reason" signified its tolerance of

big corporations. Its ruling immediately initiated a new merger movement in the steel industry as well as in other American industries over the next two decades. In addition, the U.S. Steel case set the tone for the government's defeat in the Alcoa antitrust suit in 1924.

After the 1920 case, U.S. Steel ceased its expansion, hoping to avoid another antitrust lawsuit. Its share in steel production continued to decline while competitors, particularly Bethlehem Steel and Republic Steel, began to grow through mergers. Only two years after U.S. Steel's victory over the government, several major steel companies (Midvale, Ordnance, Republic, Inland, Bethlehem, and Lackawanna) proposed the formation of the North American Steel Company, with a size only slightly smaller than that of U.S. Steel. The proposed merger eventually was broken into two parts and approved by the Justice Department, which hoped to add to the competitive forces acting on U.S. Steel. The Federal Trade Commission filed complaint against both mergers as constituting unfair competition under section 5 of the Federal Trade Commission Act. Although the Midvale-Republic-Inland proposed merger was dropped voluntarily, Bethlehem successfully merged with Lackawanna and Midvale when the Supreme Court dismissed the Federal Trade Commission's charges in 1927. Steel mergers continued successfully without challenge from the government until 1935, when Republic acquired Corrigan, McKinney Steel. A suit filed by the Justice Department against the merger was decided by the Northern Ohio District Court in favor of the industry.

In the U.S. Steel antitrust case, the Supreme Court did not find the defendant's cooperative Pittsburgh plus pricing system to be an illegal type of price fixing. The Clayton and Federal Trade Commission acts, however, explicitly ruled price discrimination illegal. In April, 1921, the Federal Trade Commission filed a complaint that U.S. Steel's Pittsburgh plus pricing practice constituted price discrimination against western consumers and was an unfair business practice. U.S. Steel obeyed the commission's cease-and-desist order in 1924 and abandoned the pricing policy. Meanwhile, the basing point policy had spread to industries such as cement despite the Federal Trade Commission's unsuccessful challenge against this industry in 1925. The basing point system continued to be used until explicitly banned by the government in 1948.

The U.S. Steel victory over the government encouraged mergers and use of basing point pricing practices, leading to the government's increased efforts in regulating these practices. As for the steel industry, the case marked the end of U.S. Steel's dominance and the rise of its competitors, setting the tone for the oligopolistic market structure that developed.

Within the steel industry, the U.S. Steel case marked the end of that corporation's dominance and of cooperative pricing practices among firms. It also led to elimination of the practice of price discrimination. The failure of the government's prosecution of U.S. Steel initiated a merger wave in the steel industry in the following decades. As of 1990, even though the steel industry was still very concentrated, U.S. Steel controlled less than 35 percent of the market.

Bibliography

Armentano, Dominick T. *Antitrust and Monopoly: Anatomy of a Policy Failure.* New York: John Wiley, 1982. Covers major antitrust lawsuits since the Sherman Act, discussing their relationship to economic theory and the development of antitrust legislation. Covers the U.S. Steel case in chapter 4. Includes an appendix of relevant sections of antitrust laws. Written for an undergraduate audience.

Schroeder, Gertrude. *The Growth of Major Steel Companies, 1900-1950.* Johns Hopkins Studies in Historical and Political Science, 71st series, no. 2. Baltimore: The Johns Hopkins University Press, 1952. Detailed historical study of the leading steel companies, written for a general audience.

Tarbell, Ida. *The Life of Elbert H. Gary: The Story of Steel.* New York: D. Appleton, 1925. In-depth look at the corporate life of the president of U.S. Steel as well as the early development of the company. Also includes Gary's relationships with President Theodore Roosevelt and with organized labor.

U.S. Steel Corporation. *United States Steel Corporation: T.N.E.C. Papers.* 3 vols. New York: Author, 1940. Contains economic and statistical studies, charts, and illustrations submitted by U.S. Steel to the Temporary National Economic Committee during the court hearings on the steel industry in 1939 and 1940.

Weiss, Leonard. *Economics and American Industry.* New York: John Wiley, 1961. Chapter 7 provides good coverage of the integration in steel production and market concentration in the early years of the industry. Explores pricing policy, including oligopoly and basing point systems, with economic models. Valuable for undergraduate economics students.

Whitney, Simon N. *Antitrust Policies: American Experience in Twenty Industries.* 2 vols. New York: Twentieth Century Fund, 1958. Chapter 5 of volume 1 provides historical and legal case studies of the steel industry and U.S. Steel in the first half of the twentieth century. Economic analysis includes changes in market concentration, forms of interindustry competition, and industry performance. Also discusses antitrust laws from an economic perspective. A good end-of-chapter summary of historical events. Other chapters are case studies of other major industries.

Jim Lee

Cross-References

Morgan Assembles the World's Largest Corporation (1901), p. 29; The Supreme Court Decides to Break Up Standard Oil (1911), p. 206; The Supreme Court Breaks Up the American Tobacco Company (1911), p. 212; The Federal Trade Commission Is Organized (1914), p. 269; Congress Passes the Clayton Antitrust Act (1914), p. 275; Truman Orders Seizure of Steel Plants (1952), p. 997.

GREAT BRITAIN AND FRANCE SIGN THE SAN REMO AGREEMENT

Category of event: International business and commerce
Time: April 26, 1920
Locale: San Remo, Italy

Meeting in San Remo, the Allied leaders of Great Britain, France, and Italy divided up the Turkish possessions of the Middle East, with Great Britain and France dividing Middle Eastern oil

Principal personages:
DAVID LLOYD GEORGE (1863-1945), the British prime minister, 1916-1922
GEORGES CLEMENCEAU (1841-1929), the French premier, 1906-1909 and 1917-1920
SIR MARK SYKES (1879-1919), the British negotiator of the Sykes-Picot Agreement in 1916
PHILIPPE BERTHELOT (1866-1934), the director of the Political and Commercial Department, French Foreign Office
HUSAYN IBN 'ALĪ (c.1854-1931), the amir of Mecca (1908-1916), king of the Hejaz (1916-1924)
SIR HENRY MCMAHON (1862-1949), the British high commissioner in Egypt, 1914-1916
JOHN CADMAN (1877-1941), the director of the British Petroleum Department and director of the Anglo-Iranian Oil Company and the Iraq Petroleum Company
ARTHUR JAMES BALFOUR (1848-1930), British foreign secretary, 1916-1919
HENRI BERENGER (1867-1952), a senator representing Guadaloupe, 1912-1940

Summary of Event

The map of the Middle East in the late twentieth century was the product of political decisions made during World War I (1914-1918). These decisions in their turn were the product of wartime exigencies confirmed in the peace settlement of Versailles, including arrangements made elsewhere and enshrined in the peace treaties among the belligerents, such as the San Remo Agreement. The decisions made by the Allied leaders who met at San Remo in April, 1920, laid out the lines of the political settlement of the Middle East.

The San Remo Agreement has several antecedents. First, a commitment made in 1915 by the British high commissioner in Egypt, Sir Henry McMahon, to Husayn ibn 'Alī, the amir of Mecca, promised British support of a movement for Arab inde-

pendence from Turkish control. Second, in May of 1916, Great Britain and France signed the Sykes-Picot Agreement. Under this agreement, Russian territorial expansion east of the Black Sea, at the expense of Turkey, was recognized. A very large Syria, including Lebanon, was to go to France. Great Britain was to receive southern Mesopotamia in addition to the Mediterranean coastal ports of Haifa and Akka. Both Syria and Mesopotamia were to be made into Arab states, under the control of the two European powers. The Holy Places were to be placed under international control.

The contradictions between the Sykes-Picot Agreement and the promises made to Husayn on behalf of Arab independence were evident, and the British and French tried to keep the Sykes-Picot Agreement secret. When the Russian Communists seized power in November, 1917, however, they found the agreement in the Russian archives and published it in *Izvestia*. The Sykes-Picot Agreement proved to be a difficult obstacle for Great Britain to overcome, and it caused even greater problems for France.

The postwar situation in the Middle East was made even more complex by the issuance of the Balfour Declaration, a declaration made to the leaders of Zionism that the British government looked with favor on the establishment of a Jewish "national home" in Palestine. The declaration took the form of a letter to Lord Rothschild, head of the British Zionist Committee, on November 2, 1917. The letter reserved the rights of the indigenous population.

With the end of World War I clearly imminent, on November 7, 1918, the British and French issued a joint declaration in which they promised freedom to the various peoples subjected by the Turks, with the right to set up governments of their own choosing. The Arabs interpreted this statement to mean that the British and French did not intend to impose the settlement outlined in the Sykes-Picot Agreement. In fact, the British were prepared to modify the agreement and insisted upon some modification to reflect the fact that British arms, not French, had liberated the Middle East from the Turks. British Prime Minister David Lloyd George insisted upon a modification reflecting this fact when he met with French Premier Georges Clemenceau in London in December of 1918.

Matters were further complicated by the arrival in Paris of the American delegation to the peace conference, headed by President Woodrow Wilson. Wilson refused to be bound by the Sykes-Picot Agreement and demanded that an investigative commission be sent to the Middle East to determine local sentiment. The British were prepared to cooperate, but France refused; out of a sense of loyalty to France, Great Britain then declined to participate. Accordingly, the commission went to the Middle East staffed only by Americans.

Meanwhile, the British and the French continued negotiating. It was at this point that oil entered the picture. It was strongly suspected that substantial oil deposits existed in the region around Mosul. This area had originally been incorporated in the "greater Syria" promised to France in the Sykes-Picot Agreement. Great Britain, which in 1919 had full military command of the area, demanded that the Mosul area be attached to Mesopotamia and included in the portion of the former Ottoman

Empire assigned to Great Britain. France proved willing to concede the point provided that France gained some access to the potential oil profits of the area. This proved possible because the exploration rights around Mosul had been granted by the Ottoman government, though in a somewhat informal matter, to the Turkish Petroleum Company in the summer of 1914. British interests owned 75 percent of the Turkish Petroleum Company; German interests owned the rest. The German interest had been confiscated at the outbreak of war by Great Britain, where the company was incorporated. Great Britain offered to turn over to France the German interest in the Turkish Petroleum Company.

The negotiations over the disposition of the Mosul area and the rights to its oil were formalized in the Long-Berenger Agreement of April 18, 1919. With some modifications, the results of the negotiations were also incorporated in the San Remo Agreement of April 26, 1920.

The political provisions of the San Remo conference laid down many of the boundary lines that prevailed in the Middle East into the 1990's. Syria and Lebanon were destined for France as mandates under the League of Nations, though the mandate system had yet to be set up by the League. Mesopotamia and Palestine were to go to Great Britain. As a corollary, and as the price Great Britain had to pay to get the whole of Mesopotamia, including the district around Mosul, the British and French signed the Cadman-Berthelot Agreement on April 24, 1920. It was confirmed the following day by Lloyd George and Alexandre Millerand, Clemenceau's successor as premier of France.

The Cadman-Berthelot Agreement, otherwise known as the San Remo Oil Agreement, gave to France the former German interest in the Turkish Petroleum Company. This assured France of 25 percent of the profits from the Mosul oil field and from any other oil found in Mesopotamia. Other provisions assured both signatories equal access to oil resources in Romania and the Soviet Union should these become available for private exploitation.

The agreement also looked forward to the construction of a pipeline to the Mediterranean coastline, to facilitate shipment of Mosul oil to Europe. The parallel construction of railroads from the oil producing region to the Mediterranean was also foreshadowed in the agreement. France agreed to facilitate these projects so far as they passed through French-controlled territory in Syria. Should pipelines and a railroad be built from the oil producing regions to the Persian Gulf, Great Britain promised equal facilitation of the projects.

Impact of Event

The immediate impact of the event was to spark a revolt among the Arabs living in interior Syria. The Syrian Arabs had already proclaimed Faisal I as king. The San Remo Agreement was seen as a betrayal of promises made by Great Britain, then seemingly confirmed by France in November of 1918, that the Arabs of the Middle East would be allowed to form an independent Arab state (or states) in the Middle East. Although the San Remo Agreement technically provided for Arab states, these

were to be under the tutelage of Great Britain or France through the system of mandates.

The French, who had substantial forces in western Syria, defeated the Arabs in July, 1920. They dethroned Faisal I, who fled. Although the French were unpopular in Syria and Lebanon, they proceeded to organize the governments of both areas. The French maintained a military presence in Syria and Lebanon that ensured their control.

Meanwhile, the British had taken control of Mesopotamia. A revolt of the Arabs followed; it was finally brought under control by October of 1920. The British decided that the best policy was to organize an Arab government and to invite Faisal I to become king of Iraq, subject to approval by the populace. A referendum showed 96 percent approval, and in August of 1921, Faisal I was installed in power. Meanwhile, a constituent assembly, organized by British High Commissioner Sir Percy Cox, had designed a constitution for Iraq. Confirming this state of affairs, Great Britain converted Iraq's status from a mandate territory, entering into a treaty relationship with the kingdom of Iraq in 1922; at the same time, a special military agreement gave the British a substantial degree of control. During the 1920's and 1930's, the British military presence in Iraq was steadily reduced.

The most important consequence of the San Remo Agreement was that it opened the Middle East up to development of its oil resources. Prior to World War I, only Iranian oil had been developed to any significant extent. The Iranian oil fields had been discovered just after the turn of the century by English interests and had been substantially developed by the outbreak of the war. The Anglo-Persian Oil Company was organized in 1908 to exploit a concession originally designed to last sixty years, granted in 1901 to the British exploration group. Anglo-Persian acquired Abadan Island in 1909, then built a pipeline from the oil field to the island and a refinery on the island between 1910 and 1913. Production began in 1912 and rose rapidly to 273,000 tons by 1914.

Exploitation of the oil potential in Iraq did not occur until the late 1920's. The legal situation continued to be murky after the end of World War I. The Turkish Petroleum Company, a British company with a 25 percent French interest, was the owner of the concession made by the Ottoman government in the summer of 1914. The collapse of the Ottoman government, and its effective displacement after World War I by the native Turkish government of Kemal Ataturk, left the status of the concession uncertain. Until 1922, the Ankara Turks continued to demand the return of the Mosul area to Turkish control, and the issue was finally submitted to the League of Nations. In 1925, the League ruled that the area was properly part of the kingdom of Iraq but that Turkey was to receive 10 percent of any oil revenues derived from the Mosul province.

This determination in turn made it possible for the Turkish Petroleum Company to renegotiate the concession for Mosul. The Iraqi government gave the Turkish Petroleum Company permission to explore for oil in the Mosul province, and in 1927 an immense oil field was struck in the vicinity of Kirkuk. Meanwhile, the ownership of the Turkish Petroleum Company was being protested by the Americans, who favored

an "open door" policy for the exploration and development of Middle Eastern oil. A compromise was reached in 1925, under which some of the shares of the Turkish Petroleum Company that were owned by Anglo-Persian Oil would be made available to a consortium of American oil companies, provided they accepted a proviso that they would not seek other oil development properties in the area controlled by the Turkish Petroleum Company. Originally, the American consortium consisted of most of the major American oil firms of that time, but by the time the agreement was formalized in 1928, it consisted of only two companies, Standard Oil Company of New Jersey (later Esso) and Socony-Vacuum Oil Company (later Mobil). These two firms formed a new company, the Near East Development Corporation, that became the owner of 23.75 percent of the shares of the old Turkish Petroleum Company, which was now renamed the Iraq Petroleum Company.

In addition, there was a special agreement, signed by all the participating firms in the Iraq Petroleum Company, that they would not seek oil concessions elsewhere in the Middle East except with the approval of the British government. This agreement was known as the Red Line Agreement. It was later challenged in court by American oil companies not party to it and was nullified after World War II.

The discovery of the major oil field in the vicinity of Kirkuk made the construction of a pipeline essential. The pipeline was constructed in a wishbone shape, with two terminals, one at Tripoli, Lebanon, the other at Haifa, in Palestine. This pipeline construction was foreshadowed in the San Remo Agreement. The pipeline opened in 1935. The decision by the Allied leaders at San Remo that the mandate for Palestine should go to Great Britain was of importance for the pipeline, because one of its terminals on the Mediterranean coast was located at Haifa. The British endeavored to fulfill their commitments to both the Arabs and the Jews by allowing limited immigration into Palestine by Jews and by creating the kingdom of Transjordan (which became Jordan) and placing on its throne a brother of the king of Iraq.

During the 1920's, Ibn Saʻūd secured for himself the kingdom of Saudi Arabia in the Arabian desert, technically independent but closely linked to the British. He was not bound by the Red Line Agreement and so was able to negotiate oil concessions with American oil companies, notably Standard Oil of California and Texaco. These two companies created Aramco to carry out exploration in Saudi Arabia as well as development of the oil resource.

It is clear that although the extent of Middle Eastern oil resources was not known at the time of the San Remo Agreement, experts had a suspicion. This suspicion became reality between the two world wars. Between 1920 and 1940, Middle Eastern oil rose from a mere 1 percent of world oil production to 5.5 percent. The full import of Middle Eastern oil resources was, however, realized only after World War II.

Bibliography

American Association for International Conciliation. *International Conciliation.* No. 166. New York: Author, 1921. This bulletin, part of a series published by the American Association for International Conciliation in the period immediately

after World War I, contains the full text of the San Remo oil agreement.

Dockrill, Michael L., and J. Douglas Goold. *Peace Without Promise: Britain and the Peace Conferences, 1919-1923*. Hamden, Conn.: Archon, 1981. A retrospective view of the peace conference, from the perspective of half a century. The book contains one chapter on the Middle East settlement and some useful maps.

Lenczowski, George. *Oil and State in the Middle East*. Ithaca, N.Y.: Cornell University Press, 1960. Although the book is focused on the post-World War II period, the introductory chapters contain useful background material in more compressed form than in Longrigg's book.

Longrigg, Stephen Hemsley. *Oil in the Middle East: Its Discovery and Development*. 3d ed. London: Oxford University Press, 1968. Longrigg, himself a participant in many of the events he describes as an employee of Anglo-Persian Oil, has written the ultimate account of the development of Middle Eastern oil. The first hundred pages deal with the period prior to World War II.

Temperley, Harold W. V., ed. *A History of the Peace Conference of Paris*. 6 vols. London: Henry Frowe and Hodder & Stoughton, 1920-1924. Volume 6 of this exhaustive account of the Paris peace settlements deals with San Remo. All the intricacies of the negotiations are revealed. Because the book was written immediately after the conclusion of the peace conference, it does not have the benefit of historical perspective.

Nancy M. Gordon

Cross-References

The Supreme Court Decides to Break Up Standard Oil (1911), p. 206; Oil Companies Cooperate in a Cartel Covering the Middle East (1928), p. 551; OPEC Meets for the First Time (1960), p. 1154; Iran Announces Nationalization of Foreign Oil Interests (1973), p. 1533; Arab Oil Producers Curtail Oil Shipments to Industrial States (1973), p. 1544.

THE POST OFFICE BEGINS TRANSCONTINENTAL AIRMAIL DELIVERY

Category of event: Transportation
Time: September 8, 1920
Locale: The United States

Initiation of transcontinental airmail service gained widespread public acceptance and led to enhanced congressional support for airmail service in general

Principal personages:
OTTO PRAEGER (1871-1948), the second assistant postmaster general under Woodrow Wilson
MORRIS (SAM) SHEPPARD (1875-1941), a Texas senator
ALBERT S. BURLESON (1863-1937), the postmaster general under Woodrow Wilson
WOODROW WILSON (1856-1924), the president of the United States, 1913-1921
WARREN G. HARDING (1865-1923), the president of the United States, 1921-1923
WILL HAYS (1879-1954), the postmaster general under Warren G. Harding
PAUL HENDERSON (1884-1951), a second assistant postmaster general under Calvin Coolidge

Summary of Event

Through the efforts of the Post Office Department, primarily the efforts of Otto Praeger, the second assistant postmaster general during Woodrow Wilson's administration, Congress in 1917 was persuaded to fund a formal experiment to determine the feasibility of scheduled airmail service. This test, the first since about thirty earlier experiments in 1911-1912, called for Army pilots and planes to carry mail between New York City and Washington, D.C., with an intermediate stop in Philadelphia. Under Congress's funding conditions, the Post Office Department would administer the program. Senator Morris (Sam) Sheppard of Texas, who had long argued for airmail service, was to prove instrumental in obtaining airmail appropriations, the first of which was authorized in 1916 from the Post Office Department's Steamboat or Other Powerboat Service line item.

The war situation in Europe delayed any chance of experimentation until President Woodrow Wilson's intervention in 1918. Realizing that airmail service might provide some advantages to the business sector, Wilson directed the secretary of war to supply Army pilots and airplanes for an experimental operation. This air mail experiment began on May 15, 1918, and proved successful enough that the Post Office Department on August 12 assumed responsibility for the entire operation, including pilots and aircraft. During the airmail service's first year of operation, 1,208 flights were

completed, with 90 others aborted, because of weather or mechanical problems. Even with this admirable performance, the Post Office's primary goal remained that of establishing an airmail system rather than earning profits. Moreover, postal officials began at this early date to remind Congress and the public that the Post Office did not consider itself to be an operating agency, and that the department had no intention of remaining indefinitely in the transportation business.

One year after its inauguration of airmail service, and under the forceful leadership of Otto Praeger, the Post Office Department began service between Chicago and Cleveland, the first of its transcontinental route segments. Six weeks later, airmail service was extended eastward from Cleveland to New York City. During 1919, with three routes in operation (including the original New York-Washington, D.C. route), eight Post Office airplanes were being flown 1,900 miles daily by the department's pilots, with a 95 percent completion rate.

The next major transcontinental route segment became operational on May 15, 1920, when service was extended westward from Chicago to Omaha, Nebraska. Four months later, on September 8, 1920, the final link was added, connecting Omaha to San Francisco. The lack of suitable air-to-ground communications and navigation equipment, as well as the rather primitive aircraft instrumentation then available, made night operations impossible. Mail sacks had to be transferred to trains for carriage overnight, a problem that hampered further improvement in service until Congress decided to appropriate funds in fiscal year 1922 to establish an experimental lighted airway between Chicago and Cheyenne, Wyoming.

Urging this appropriation, ironically enough, was Warren G. Harding, who had publicly proclaimed during his 1920 presidential campaign that airmail service, was a waste of money. The candidate's public pronouncement became especially troubling for the Post Office Department when Harding won the election. Faced with an incoming president whose public stance opposed airmail service. Postmaster General Albert S. Burleson and Second Assistant Postmaster General Otto Praeger decided to rush the development of an overnight airmail service in a bold attempt to capture media attention and public acclaim to a degree that might cause Harding to rethink his stance. This strategy led to the first attempt at overnight service being conducted in February, not an ideal time, weatherwise, for a first try at night operations.

With considerable fanfare, two planes set out from each coast at daybreak on February 22. The two westbound flights were grounded in Chicago because of blizzard conditions, causing the airmail to be transferred to a train, much to the chagrin of Burleson and Praeger. The Chicago-area weather also grounded one of the relief pilots who had been en route to Omaha. Of the two eastbound flights, one crashed near Elko, Nevada, killing the pilot W. F. Lewis, while the other continued on to North Platte, Nebraska, where pilot Jack Knight took over. Knight, flying in worsening weather conditions, found no relief pilot waiting in Omaha and immediately departed for Des Moines, where snow accumulation precluded his landing for fuel. He continued to Iowa City, where a night watchman, hearing an unexpected airplane, lit a flare that allowed Knight to land. Although never having flown the route

east of Omaha, Knight continued to Chicago, arriving at 8:40 after flying 830 miles through dangerous winter weather conditions. The airmail continued on its eastbound journey, arriving late that afternoon in New York City. The mail had been carried 2,660 miles in an elapsed time of 33 hours and 20 minutes; by train, 108 hours would have been needed.

Overnight, Jack Knight's heroism captured the public's imagination. Media coverage and the public's positive reaction to transcontinental airmail service caused Harding to recant his earlier remarks, and he urged Congress to support the new service. As a result, annual appropriations for both the transcontinental airmail route and its night operations first became available in late 1921, Harding's first year in office, with $1.3 million to be used to expand airmail service and develop lighting for airways and airports. Over the next six years, these two separate appropriations would average a combined annual total of approximately $2.5 million.

The Post Office Department's first lighted airway was installed between Chicago and Cheyenne, Wyoming, and became fully operational in the spring of 1923. Over the next twelve months, more route miles were equipped with navigational beacon lights, until finally, on July 1, 1924, the last segment was lighted. Following a thirty-day test period, true round-the-clock transcontinental airmail service was inaugurated.

Impact of Event

Although not expecting a profit from its new service, by the end of the first year of operation the Post Office Department had realized postal revenues of $162,000, an excess of $19,000 over the operation's cost of $143,000 or $64.80 per flight hour. The service's early success led Praeger to concentrate Post Office efforts on developing a transcontinental route that could serve as the foundation for a gradually expanding airmail system with connecting flights extending outward to the north and south. The first of these routes connected St. Louis with Chicago in August, 1920.

By the end of 1921, ninety-eight airmail planes were in service, half of which were surplus and virtually obsolete deHavilland DH-4's, obtained from the Army and refurbished by the Post Office for $2,000 per plane. These were the only airplanes available, since at the time there was no incentive for aircraft companies to develop commercial airplanes. A need for larger aircraft capable of carrying a few passengers in addition to mail would come about only after passage of the 1925 Air Mail Act, which authorized the Post Office to contract with private operators for the carriage of air mail.

The Post Office Department's successful airmail operation was publicly recognized in both 1922 and 1923, when the Air Mail Service received the coveted Collier Trophy, awarded annually for the greatest achievement in aviation in the United States. By the end of the first six years of airmail service, Post Office pilots had flown 6.9 million miles and carried 255 million letters. Almost fifteen thousand of the flights were made in fog or storms, and the Post Office proudly pointed to the service's average operating efficiency of almost 92 percent over the six-year period.

Upon completion of navigational beacons on the transcontinental route in July, 1924, round-the-clock cross-country airmail service became a reality. Westbound airmail took 34 hours, and eastbound airmail took 29 hours. One year later, businesses in New York and Chicago were benefiting from overnight airmail service. Airmail postage on the transcontinental route was set at eight cents per ounce for transit in each of three zones: New York-Chicago; Chicago-Rock Springs, Wyoming; and Rock Springs-San Francisco.

To support its coast-to-coast operation, the Post Office Department established 17 weather-reporting stations linked by radio, installed 289 flashing beacons along the route, equipped and lighted emergency landing fields an average of thirty miles apart, and installed radios at all of its main stations. Airmail service needs, especially those of the transcontinental operation, brought about the development of night and instrument flying, federal airways, air-to-ground communications, multiengine aircraft, hard-surface runways, and the weather service.

In late 1925, Harry F. Guggenheim, in an address at the newly established School of Aeronautics of New York University, hailed the U.S. Air Mail Service as the only brilliant achievement in commercial aviation in this country. He stated that with this one notable exception, the United States lagged far behind Europe in commercial aviation.

Airmail volume on the transcontinental route grew rapidly, with widespread public acceptance of the service and recognition, particularly by the business community, of the distinct advantages that coast-to-coast airmail service offered. During the fiscal year that ended on June 30, 1924, Post Office pilots on the transcontinental route flew slightly more than two million miles with a completion rate of 96 percent. In the following year, 9.3 million first-class letters were carried, providing the Post Office with revenues that exceeded costs by $600,000. In July, 1925, alone, excess postage amounted to $60,434. The actual cost of transporting mail by air was 21 cents per mile. When overhead costs were included, the cost was only 50 cents per mile.

It was in 1925 that Congress passed the Kelly Air Mail Act, which came about in response to urging by the Post Office Department. It authorized the awarding of contracts to private operators for the carriage of airmail. In effect, the Post Office would phase itself out of airmail transport. By mid-1926, private carriers were operating the twelve original routes, all of which were feeders that linked with the transcontinental route still being operated by the Post Office Department.

In mid-1927, the transcontinental route was divided at Chicago into two segments, with Boeing Air Transport successfully bidding for the western portion and National Air Transport the eastern segment. Mail volume on the coast-to-coast route continued to grow rapidly, to the point that in February, 1928, Boeing Air Transport carried 32 percent of all airmail in the United States just on its Chicago-San Francisco route.

During 1927, the Post Office continued to phase itself out of airmail operations as more and more routes were transferred to private operators. The final Post Office flight was conducted on September 9 of that year, ending one noteworthy era while ushering in another, one that would be dominated by the rapidly developing airline

industry. The obvious success of the Post Office's efforts, particularly on its transcontinental route, led to continued expansion of airmail service as well as the inception of passenger service. More important, it had convinced Congress that the time had arrived for private operators to carry the mail. It was from this group of original private carriers that America's airline industry evolved.

The Post Office's achievements, laudable as they were, had a cost beyond that of the annual congressional appropriations. In the nine years and four months of government-operated airmail service, forty-three Post Office pilots were killed and twenty-three suffered serious injury, with most accidents occurring on the transcontinental route segment across the Allegheny Mountains in Pennsylvania, a section that became known in the press as the "Hell Stretch" and "Graveyard of the Air Mail." In that same time, twenty-five thousand miles of government-improved airways came into existence, almost 60 percent of which were lighted, and rotating beacons were installed at approximately one thousand airports. The Post Office's airmail service had cost the government $17.5 million, but partially offsetting this was $5 million in postal revenue. By the end of 1928, all forty-eight states had airmail service, every branch post office had a box marked "air mail," transcontinental passenger air service was being offered, and the fledgling airline industry had established a foothold—quite a bargain for the $12.5 million the Post Office Department lost on airmail.

Bibliography

Christy, Joe, with Alexander Wells. *American Aviation: An Illustrated History*. Blue Ridge Summit, Pa.: TAB Books, 1987. A panoramic view of the evolution of American aviation. Although primary emphasis is on the military, contains some interesting material on early airmail service and the beginnings of the airline system.

Johnson, Robert E. *Airway One*. Chicago, Ill.: Lakeside Press, 1974. Authorized by a member of United Air Lines' top management (1929-1972), this is one of the better corporate narratives. Includes a fascinating look at United's developmental years, together with its predecessors that began operating after the Kelly Act.

Kane, Robert M. *Air Transportation*. 10th ed. Dubuque, Iowa: Kendall/Hunt, 1990. Although an undergraduate textbook, a section on history includes excellent coverage of the early airmail days and the Kelly Act's ramifications. Material on subsequent aviation legislation nicely supplements earlier coverage.

Loening, Grover. *Takeoff into Greatness*. New York: G. P. Putnam's Sons, 1968. A fascinating autobiography by one of the Wright Brothers' pupils who established himself as one of the leaders in aircraft design and manufacture during the 1920's. Interesting recollections of the early airmail operations, with details, some technical, on the first group of private airmail carriers.

Wells, Alexander T. *Air Transportation: A Management Perspective*. 2d ed. Belmont, Calif.: Wadsworth, 1989. Written primarily as an undergraduate textbook, it includes a brief, but rather thorough, discussion of contract airmail service and the original twelve contract airmail routes.

James D. Matthews

Cross-References

Congress Authorizes Private Carriers for Airmail (1925), p. 493; The Air Commerce Act Creates a Federal Airways System (1926), p. 499; Congress Centralizes Regulation of U.S. Commercial Air Traffic (1940), p. 815; An Independent Agency Takes Over U.S. Postal Service (1971), p. 1506; Federal Express Begins Operations (1973), p. 1538.

STATION KDKA INTRODUCES COMMERCIAL RADIO BROADCASTING

Categories of event: New products and advertising
Time: November 2, 1920
Locale: Pittsburgh, Pennsylvania

The first commercial radio broadcast demonstrated radio broadcasting's potential both as a source of communication and as a source of advertising revenue

Principal personages:
DAVID SARNOFF (1891-1971), a young wireless operator for American Marconi, later president of RCA
WILLIAM S. PALEY (1901-1990), the owner of CBS
FRANK CONRAD (1874-1941), an amateur radio station operator and engineer with Westinghouse
GUGLIELMO MARCONI (1874-1937), the inventor who first popularized wireless communication
REGINALD FESSENDEN (1866-1932), an inventor who presented the first known voice broadcast
OWEN D. YOUNG (1874-1962), the board chair of GE and RCA

Summary of Event

On November 2, 1920, station KDKA of Pittsburgh, Pennsylvania, broadcast the results of the Warren G. Harding-James Cox presidential election. This presentation is generally considered to be the first commercial radio broadcast. Although the event is more a milestone than an indication of innovation, it was the demonstration that finally pushed the wireless industry into the realm of big business.

The KDKA broadcast was the culmination of efforts begun in the late nineteenth century. The idea of wireless communication began to take shape in 1873, when physicist James Clark Maxwell theorized the existence of electromagnetic waves. Maxwell's theory was proven by Heinrich Hertz, and a young Italian inventor, Guglielmo Marconi, experimented with and improved upon the ideas of Hertz. Others would make contributions, including Reginald Fessenden, who arranged what many refer to as the first public broadcast. On Christmas Eve, 1906, Fessenden successfully broadcast music and voice messages to ships at sea. This was the first time that wireless communication had been used for anything other than Morse code or coded messages.

In its early development, wireless communication was a fairly specialized endeavor. Initially it was used only when existing telephone and telegraph applications were impossible, as in ship-to-shore communications. It was of particular interest to private shippers and to the military.

Controversies over patent rights and alleged infringements threatened to strangle the development of wireless communication. World War I pushed the development

forward. When the United States entered the war, the Navy took control of wireless operations, suspending amateur licenses and controlling key facilities. It also called for a moratorium on patent suits, asking all manufacturers to pool their resources for the war effort. The resulting cooperation not only sped up the development of wireless communication but also served as a precedent for cooperation in the 1920's.

After the war, reprivatization meant that once again competing companies each held important pieces of the radio puzzle. After complex negotiations, General Electric (GE), the Radio Corporation of America (RCA), American Telephone and Telegraph Company (AT&T), and Westinghouse signed a patent pooling agreement on July 1, 1920. This agreement seemed to make good economic sense to all the new partners. GE and Westinghouse would manufacture radio receivers, which would be sold by RCA. AT&T would manufacture transmitters and would also hold the rights to "radio telephony" operations. RCA, because it was jointly owned by GE, Westinghouse, and AT&T, became the common ground for the pooling of information and cooperation. The agreement was effective only for a short time, in large part because it had not taken into account a new use for radio telephony, that of radio broadcasting.

The evolution of station KDKA is a good example of the swift changes in the industry. KDKA began as an amateur experimental station (8XK) licensed to Frank Conrad, a Westinghouse engineer. Shortly after World War I, Conrad resumed his private broadcasts. On October 17, 1919, he became an instant celebrity when he placed his microphone in front of a phonographic machine to broadcast prerecorded sound. Conrad's broadcasts proved so popular that a Pittsburgh department store began selling amateur receivers designed to pick up Conrad's signal. This activity caught the attention of Westinghouse vice president H. P. Davis, who suggested to Westinghouse executives that the company could both boost sales of its receivers and promote its own name by building its own station. In October of 1920, the company filed an application. Its station KDKA became the first governmentally licensed radio station. On November 2, the station inaugurated its broadcasting with the results of the presidential election.

Impact of Event

Although station KDKA broadcast a number of program types later to become standard radio fare, it did not run commercials or paid advertisements. Its owner, Westinghouse, financed the operation as a means of selling its own products. RCA and GE also began to fund broadcasting facilities, each with the purpose of encouraging the sale of radio receivers.

A different philosophy was expressed by AT&T, which started station WEAF in New York City in 1922. AT&T planned to lease its broadcasting facility, just as it leased its long-distance telephone wires, charging a "toll" for advertising. Although the WEAF experiment was not an immediate success, the concept would ultimately prove to be the answer to a question that had baffled broadcasters for years, that of how broadcasting could pay its own way. It would also be the catalyst for renewed conflict in the industry.

In 1926, a new set of agreements was reached that effectively redefined radio broadcasting. AT&T maintained a monopoly on providing connections between stations (forming "networks") and in return sold WEAF and agreed not to buy any other station for at least eight years. RCA, with newly purchased WEAF as its flagship station, formed a new subsidiary to oversee its network operations. This new enterprise, the National Broadcasting Company (NBC), became the first company organized solely to operate a network. Some two dozen stations, most of them independently owned, carried NBC's first network program on November 15, 1926. This set of stations became the basis of NBC's "Red Network." RCA's station WJZ in New York City served as the anchor for NBC's second group of stations, the "Blue Network." By operating two networks, NBC controlled two stations in most major markets, creating a formidable economic enterprise.

The Columbia Broadcasting System (CBS) emerged from the merger of the United Independent Broadcasters and the Columbia Phonograph Corporation. The Columbia Phonographic Broadcasting System began in 1927 but would struggle until controlling interest was purchased by William S. Paley, then an executive with the Congress Cigar Company. Under Paley's leadership, CBS expanded from seventeen affiliates in 1928 to ninety-one affiliates in 1933. Although all three networks were still heavily dependent on their owned and operated stations for income, by 1933 the basis for modern network practices was in place.

The first commercial radio broadcast by KDKA, followed in 1922 by the airing of the first paid radio advertisement on WEAF, demonstrated the potential of radio broadcasting both as a communication source and as a vehicle for economic gain. Once the "toll broadcasting" idea took root, a new mass medium was created.

An important element in the development of radio broadcasting, one that differentiated the United States from other countries, was that broadcasting was essentially privately owned and commercially supported. Initially, stations were built by manufacturers as a means of selling radio receivers. Other stations were started as publicity gimmicks, or even on a whim. In the early 1920's, most stations expected to reap indirect values such as future sales or good will rather than direct revenues. By the late 1920's, however, the need for increased power, better equipment, and more sophisticated programming (in order to attract and maintain an audience) meant that radio could no longer be supported as a "hobby." Station owners began to look for ways to make radio pay its own way. To this end, the "toll experiment" of WEAF was closely monitored.

In the late 1920's, radio stations still did not have the production and programming skills necessary to meet the increasing demand for entertainment. Filling this void, advertising agencies began to take over part of the programming role, expanding the notion of program sponsorship. During the "Golden Age" of network radio in the 1930's and early 1940's, most major entertainment programs were produced by advertising agencies for their clients. The agencies sometimes charged the usual 15 percent commission rate both to the station and to their clients.

Network radio would literally change the way advertising was bought and sold. For

the first time, radio advertisers were able to send their messages to every part of the country via one purchase. The first truly mass medium was born. By the end of World War II, networks accounted for the vast majority of the radio audience.

Radio was one of the few industries to survive, and even grow, during the Depression. Unlike other media, radio was free to its audience. The periodic interruption of programming for commercials was a small price to pay for a populace desperate for any sort of escape from daily reality.

Advertising revenues increased dramatically after the advent of networks. In 1926, the estimated total sale of commercial time was $200,000. This rose to $4,820,000 in 1927, the first complete year of network operations. Revenues almost tripled in 1928, then almost doubled again in 1929, to $26.8 million. By the end of the decade, radio had clearly proved itself as an effective advertising medium.

The KDKA broadcast demonstrated that commercial broadcasting was possible, and the WEAF experiment in "toll" broadcasting identified a means of economic survival. The formation of radio networks created the first real opportunity for national advertising, an opportunity that would forever change the way goods and services were marketed.

Bibliography

Barnouw, Erik. *A Tower in Babel: To 1933*. Vol. 1. In *A History of Broadcasting in the United States*. New York: Oxford University Press, 1966. A detailed chronology of the history of broadcasting. Emphasizes the important individuals and their contributions. Later volumes continue the research. An important work.

Douglas, George H. *The Early Days of Radio Broadcasting*. Jefferson, N.C.: McFarland, 1987. An informal history of the early years of radio broadcasting, paying particular attention to the 1920's. Focuses on political, financial, manufacturing, and entertainment developments.

Head, Sydney W., and Christopher H. Sterling. *Broadcasting in America: A Survey of Electronic Media*. Boston: Houghton Mifflin, 1987. A detailed and analytical look at the electronic media. An excellent resource, one of the most popular textbooks in the field.

Keith, Michael C., and Joseph M. Krause. *The Radio Station*. Boston: Focal Press, 1986. Combines an overview of the history of radio broadcasting with detailed explanations of commercial station operations. Useful primarily as a means of understanding how a contemporary station works.

Sterling, Christopher H., and John M. Kittross. *Stay Tuned: A Concise History of American Broadcasting*. Belmont, Calif.: Wadsworth, 1978. A good overview of radio and television, organized both chronologically and by topic. Does an effective job of blending events with explanations of their significance. A popular textbook.

Summers, Robert E., and Harrison B. Summers. *Broadcasting and the Public*. Belmont, Calif.: Wadsworth, 1966. Looks at the history of broadcasting both as a social force and as a business. A useful background source.

William J. Wallace

Cross-References

WEAF Airs the First Paid Radio Commercial (1922), p. 396; The National Broadcasting Company Is Founded (1926), p. 522; Antitrust Prosecution Forces RCA to Restructure (1932), p. 640; Congress Establishes the Federal Communications Commission (1934), p. 685; NBC Is Ordered to Divest Itself of a Radio Network (1941), p. 827.

SLOAN DEVELOPS A STRUCTURAL PLAN
FOR GENERAL MOTORS

Category of event: Management
Time: December 29, 1920
Locale: New York, New York

Alfred P. Sloan developed a decentralized, multidivisional organizational structure for General Motors that became a model for large-scale enterprise

Principal personages:
ALFRED P. SLOAN (1875-1966), a corporate executive
WILLIAM CRAPO DURANT (1861-1947), the founder of General Motors
PIERRE DU PONT (1870-1954), the chairman of the board and president of General Motors
IRÉNÉE DU PONT (1876-1963), the president of Du Pont, 1911-1926
JOHN J. RASKOB (1879-1950), the treasurer of Du Pont and later a member of the General Motors Finance Committee

Summary of Event

On December 29, 1920, the General Motors (GM) board of directors approved the recommendation of Pierre Du Pont, company president, that the corporation adopt Alfred P. Sloan's plan for a decentralized, multidivisional organization. This scheme set up autonomous operating divisions, to be assisted by a corporate advisory staff that would provide specialized services. The staff also acted as a liaison with the central office, which established company policies and coordinated the activities of the various divisions. Pierre Du Pont also presided over the installation of financial and statistical controls that enabled the company to monitor the operating divisions, chiefly through short-term and long-term forecasts. These enhanced GM's capacity to respond quickly to market changes.

The origins of this structure grew out of the policies of GM's founder, William Crapo Durant. A successful salesman who turned a carriage-making operation into a national business through an effective distribution network, Durant moved into the infant automobile business in 1904, when he purchased a floundering Buick Company. Excited by the potential in this market, Durant relied on his distribution network to sell the cars produced by his retooled carriage operation. He also purchased companies necessary for manufacturing parts and accessories. On September 8, 1908, Durant brought these operations together under the legal name General Motors.

Durant's continued success in this new industry depended on a constantly expanding market to justify his own increasingly larger capacity. The flourishing sales of GM cars appeared to sustain this faith in consumer demand and the absence of any sizable cash reserves at GM. The company faced a sharp economic downturn in 1912 without sufficient resources to meet the immediate financial crisis sparked by the brief

recession. To meet the cash demands, Durant agreed to a $15 million loan from a combination of Boston and New York bankers in exchange for his effective departure from the operations of GM.

By 1916, Durant had parlayed the financial strength of the Chevrolet Company, formed by Durant and Louis Chevrolet in 1911, to take control of more than half of the GM stock. With the reluctant support of Pierre Du Pont, chairman of GM's board of directors since September, 1915, Durant won overwhelming controlling interest in the automaker and forced out the coalition of bankers.

During the years from 1916 to 1920, Durant engaged in a massive expansion program. In May, 1916, he acquired the Hyatt Roller Bearing Company and New Departure Manufacturing, both of which he placed under the United Motors Corporation (UMC), a holding company. Durant appointed Alfred P. Sloan, the capable head of the Hyatt operation, as president of UMC. Durant added numerous other companies to UMC. Concerned about this costly expansion, Pierre Du Pont asked John J. Raskob, his confidant and partner, to serve as financial adviser to Durant, insisting that the financial committee come under the control of the Du Pont company so that Durant's spending could be monitored. Du Pont soon discovered that the financial committee lacked the statistical capacity to restrain Durant's excessive spending.

After the end of World War I, Durant renewed his expansion through vertical integration. With Pierre Du Pont's blessing, Durant bought the Fisher Body Corporation, a longtime supplier without which GM could barely survive. The GM founder also acquired the Dayton Engineering Laboratories Company (Delco), chiefly to secure the services of owner Charles Kettering, a leading figure in the industry. Durant made these purchases in part through a $50 million Du Pont loan, but his strategy flew in the face of the caution urged by Pierre Du Pont.

In 1920, a sharp drop in the automobile industry brought GM close to bankruptcy. Durant personally owed creditors almost $30 million, for which he had used GM stock as collateral. Its rapidly shrinking value forced Durant to sell his shares to the Du Pont organization and J. P. Morgan and Company to meet his financial obligations. In the wake of Durant's departure, Pierre Du Pont assumed the presidency of GM.

In one of his first acts, Du Pont adopted Alfred P. Sloan's plan as the basis of GM's structure. Sloan had acquired a keen understanding as head of UMC. In that role, he sold to most of GM's subsidiaries and came to grasp the inherent dangers in a company of this type that lacked any integrated system of organization. In his scheme, Sloan proposed autonomous divisions independent of executive intrusion but responsible for their financial performance and subject to the general policies of the corporation. Eventually, he placed the automobile division in five price brackets, with Cadillac the most expensive and lowest in volume and Chevrolet with the lowest price and highest volume. Through this arrangement, Sloan hoped to end the competition among GM models that prevailed under Durant. Last, Sloan brought together the numerous parts and accessory units, scattered among GM subsidiaries, and placed them in two separate divisions. Sloan's general office left untouched the model set up by Pierre Du Pont in his effort to build controls at GM before Durant's departure.

The general office consisted of the finance and executive committees, both designed to establish companywide policies and explicitly avoid routine matters left to the divisions. Sloan expected the members of these committees to be generalists. The financial committee's jurisdiction included salaries of GM's top executives, dividend rates, and capital requests of more than $300,000. All corporate financial policies came under its authority. The executive committee concentrated its energies on evaluating GM divisions, determining the prices for company products, and formulating long-term plans. Sloan invested the company president with the authority to enforce policies created by these committees. In this task, the top executive was assisted by his personal staff as well as the appropriations committee, led by Pierre Du Pont's trusted adviser, John Lee Pratt.

One of Sloan's chief contributions, the advisory staff, played a crucial role in integrating the constituent parts of the giant enterprise. These consisted of engineering, research, manufacturing, and plant layout sections; the legal and patent offices; and plant engineering, personnel, real estate, purchasing, and sales sections. The staff provided data to the central office, to be used to evaluate the performance of GM's divisions. The staff also facilitated the tasks of the divisional managers by supplying them with technical information.

Sloan also introduced interdivisional committees, which facilitated contact among GM's executives. These committees, headed by representatives from the executive committee, relied on their own staffs. The interdivisional committees assumed responsibilities for key corporate issues from developing new products to sales and advertising.

Du Pont realized that GM needed some means of monitoring production and market demand. To accomplish this end, he recruited personnel from the Du Pont Corporation to develop a system of forecasting that depended on three-month projections, estimated monthly by each division. These estimates served as the basis for purchases of everything from raw materials to manpower. Reallocations were made every thirty days, depending on current performance and projections. This scheme gave GM a flexible budget system, unheard of among large-scale companies, and allowed it to avert any threat comparable to that of 1920. By 1925, GM had achieved notoriety as one of the most innovative and best-organized companies in American industry.

Impact of Event

The innovations pioneered at GM were implemented throughout American industry from the 1920's through the 1950's. The central office, the advisory staff, and the multidivisional structure pioneered at GM slowly acquired a permanence in much of large-scale industry. Word of these changes spread through business via the speeches and writings of Sloan and others involved in the transition. The motivation to adopt this scheme varied depending on the market, the product, and the internal makeup of the company.

Corporations in the chemical and electrical industries provide examples of these

variations. The largest chemical operation, Du Pont, developed its new multidivisional structure at the same time as GM implemented Sloan's decentralized plan. In 1917, Du Pont embraced a strategy of product diversification. The company expanded from explosives to plastics, paints, dyestuffs, and other products. This decision transformed Du Pont into a multi-industry company and made obsolete the old centralized structure organized around functions, such as marketing and manufacturing. In 1920, the president of the Du Pont corporation, Irénée Du Pont, decided that the company's range of products had far outstripped the technical capacity of its executives and introduced a multidivisional structure. This decision accommodated the new strategy and set up autonomous divisions, each handling one product type. The company also established an executive committee free of the daily routine and dedicated to coordinating the activities of the corporation's divisions and determining corporate policy. The new organizational scheme also included a service department, which acted in an advisory capacity to both the central office and the divisions.

Unlike Du Pont, which coped with a multiplicity of new products, Union Carbide confronted the demand for an effective central office, much like the demand facing GM. In 1917, four large companies—Carbide, Prest-o-lite, Linde, and National Carbon—merged to form Union Carbide. During the 1920's, the new firm purchased smaller chemical companies and created a range of new products through research and development. The company consciously adopted the multidivisional scheme to meet the organizational strain of the merger and expansion. It grouped its more than twenty divisions into four autonomous sections, each under a vice president. It also established a service department, which acted in an advisory capacity. At the same time, the company created an executive committee that assumed overall direction of the company.

By the 1950's, the leading corporations in the electrical industry had moved to the multidivisional structure developed at GM and Du Pont. General Electric (GE) shifted into household appliances during the 1920's. By the 1950's, GE had put in place seven groups based on product types, which ranged from appliances to lamps. The company had also set up eleven service divisions that replaced the old staff departments (engineering, manufacturing, research, and sales). The earlier departments actually exercised authority, whereas the new service divisions acted only in an advisory capacity. GE also established a central office comparable to GM's. Not all companies immediately moved in the direction of GM and Du Pont. Henry Ford, for example, rejected any notions of decentralization and clung to the old centralized system, with its managerial hierarchy and vertical integration. The Ford Motor Company ranked as one of the ten largest corporations in the world during the early 1920's, while the Model T remained unchallenged. By 1927, Ford had lost out in competition with GM and other auto manufacturers, forcing a retrenchment and leading to design and production of the Model A. During that period, competitors made serious inroads into Ford's 55 percent share of the market.

The Ford Motor Company continued to lose ground in the market. Badly managed and poorly organized, it simply lacked the capacity to dominate the auto industry.

Only the departure of Henry Ford and the arrival of his grandson, Henry Ford II, brought change to the company. Henry Ford II recognized the problems inherited from his grandfather and set about repairing them. Although he lacked any technical education, he knew the automobile business. He fired ineffective top managers and recruited personnel from GM to introduce its multidivisional structure and uniform accounting system to Ford. By the 1960's, the Ford had recovered from near collapse.

From 1920 through the 1950's, much of large-scale American industry underwent a massive reorganization that produced companies with greater flexibility and an enhanced capacity to respond to market changes and demands. The motivation for this reorganization varied: Multi-industry companies needed the multidivisional scheme for more effective autonomous production; loosely federated enterprises such as GM demanded better coordination. Flexibility and coordination became the hallmarks of American industry by the 1950's.

Bibliography

Chandler, Alfred. "Management Decentralization: An Historical Analysis." *The Business History Review* 30 (June, 1956): 111-174. Provides an overview of the spread of the decentralized model of corporate structure throughout key industries. Chandler explains variations in the adoption of this scheme. Provides an effective starting point for understanding the key issues in this process of corporate restructuring.

——————. *Strategy and Structure: Chapters in the History of the American Industrial Enterprise*. Cambridge, Mass.: MIT Press, 1962. The key work on the organization of the American corporation. Includes a discussion of the centralized structure, product diversification, and decentralization. Chapters include extensive analyses of Du Pont, General Motors, Standard Oil, and Sears, Roebuck and Company. Chapter 7 reviews the spread of the multidivisional structure throughout American industry. Anyone seeking to understand this process should begin with this book.

——————. *The Visible Hand: The Managerial Revolution in American Business*. Cambridge, Mass.: The Belknap Press, 1977. The best discussion of the evolution of the corporate enterprise and management in America from the 1840's through the early twentieth century. Chapter 14, "The Maturing of the Modern Business Enterprise," deals with the spread of the multidivisional organization throughout American industry. Includes a discussion of the professionalization of management after 1900.

——————, and Stephen Salisbury. *Pierre S. Du Pont and the Making of the Modern Corporation*. New York: Harper & Row, 1971. In section 4, the authors carefully analyze the role of Pierre Du Pont in adapting financial methods from the Du Pont company to General Motors and in creating a central office comparable to that developed at Du Pont. Explains Pierre Du Pont's role in adopting Sloan's decentralized structure at General Motors.

Johnson, H. Thomas. "Management Accounting in an Early Multidivisional Organi-

zation: General Motors in the 1920s." In *Managing Big Business: Essays from the Business History Review*, edited by Richard S. Tedlow and Richard R. John, Jr. Boston: Harvard Business School Press, 1986. This essay provides the most effective description of the accounting techniques developed for GM. It is especially effective on the use of forecasting. The author analyzes the price study, the yearly company forecast, and the standard volume, an estimate of capacity that played a key role in forecasting and evaluating the performance of divisions. Also reviews Sloan's Ten Day Sales Report and the flexible budgets used at GM.

Livesay, Harold C. "Entrepreneurial Persistence Through the Bureaucratic Age." In *Managing Big Business: Essays from the Business History Review*, edited by Richard S. Tedlow and Richard R. John, Jr. Boston: Harvard Business School Press, 1986. Near the end of this piece, the author includes an insightful discussion of Henry Ford II and his direction of Ford Motor Company from near bankruptcy at the end of World War II to recovery and prosperity by 1960. The article also investigates the extensive overseas activities of Ford under Henry Ford II.

Sloan, Alfred P. *My Years with General Motors*. Edited by John McDonald with Catherine Stevens. Garden City, N.Y.: Doubleday & Company, 1972. Provides the clearest expression of Sloan's ideas on structuring General Motors and the motivation for this move. Also has good background information on Sloan. Gives an incisive description, from Sloan's viewpoint, of many issues involved in operating the central office and instituting financial controls. Indispensable for understanding the changes at General Motors.

Edward J. Davies

Cross-References

Ford Implements Assembly Line Production (1913), p. 234; The Number of U.S. Automakers Falls to Forty-four (1927), p. 533; Barnard Publishes *The Functions of the Executive* (1938), p. 770; Drucker Examines Managerial Roles (1954), p. 1020; Ford Introduces the Edsel (1957), p. 1087; The Supreme Court Orders Du Pont to Disburse GM Holdings (1961), p. 1164; Tom Peters Gains Prominence as a Writer on Management (1982), p. 1815.

LENIN ANNOUNCES THE NEW ECONOMIC POLICY

Category of event: Government and business
Time: March, 1921
Locale: The Soviet Union

The New Economic Policy changed the implementation of communism, allowing more private entrepreneurship and giving greater incentives to individual farmers and businesspeople

Principal personages:
> VLADIMIR ILICH LENIN (1870-1924), the leader of the 1917 Russian Revolution and founder of the Soviet Union
> JOSEPH STALIN (1879-1953), the general secretary of the Soviet Communist party, 1922-1953
> NIKOLAI IVANOVICH BUKHARIN (1888-1938), a Soviet theorist and political leader who supported Lenin's New Economic Policy
> GRIGORY ZINOVYEV (1883-1936), a Bolshevik leader who supported Lenin's New Economic Policy
> MIKHAIL TOMSKY (1880-1936), the chairman of the trade union organization

Summary of Event

In early 1921, the Soviet economy was in a deep crisis. Forced collection of grain and centralized control of the economy helped the Red Army fight its enemy, but such tough measures led to widespread discontent among peasants, workers, and soldiers. Bolshevik leader Vladimir Ilich Lenin was forced to reject what was known as war communism. Lenin persuaded his colleagues Joseph Stalin, Nikolai Ivanovich Bukharin, Grigory Zinovyev, and others to adopt the New Economic Policy. The New Economic Policy was a retreat from radical policy and an attempt to stabilize the economy and to consolidate the Soviet regime. The New Economic Policy reduced centralized control of the economy and gave farmers and small businesses access to the market. As a result, it helped Soviet economic recovery following the civil war. The New Economic Policy lasted for about seven years. It was finally rejected by Stalin in 1928, when he imposed an authoritarian central planning system.

In the early twentieth century, the Russian economy was predominantly agricultural rather than industrial. Treatment of peasants was thus a vital issue for any regime. When the Bolsheviks seized power after the October Revolution (1917), they had few specific plans concerning direction of the economy. Early economic measures amounted to little more than recognition of de facto developments. Nationalization of the land, the first measure, in effect recognized real peasant possession. The decree on workers' control similarly accepted that many factories had been taken over by workers.

In December, 1917, the Supreme Economic Council was created, marking a

significant step in establishing central control over the economy. The land decree became law in January, 1918. Under its provisions, land was to be in possession of those who used it. This was not a socialist measure but one recognizing the customary peasant concept of ownership.

The seizure of power in the capital by the Bolsheviks was relatively peaceful, but the consolidation of power was a violent and difficult process. Civil war broke out in 1918 and lasted until 1921. The period of the civil war ushered in a new form of economic organization that became the precedent for a command economy. The demands of war gradually called forth more and more central control. Nationalization was extended to all industrial enterprises, trade became outlawed, and money virtually ceased to have value. Market mechanisms were replaced by administrative orders. The main problem was securing food supplies for towns and for the army. A state grain monopoly had been introduced in February, 1918. This proved unworkable, since the money paid to peasants in return for their produce was virtually useless.

In May, 1918, a decree on grain control was issued with urgency. This decree called for compulsory delivery of all surpluses, over and above subsistence needs and seed, to the state. Any concealment could lead to seizure without payment. Specific provision was made in the decree for the use of armed force if necessary. The Soviet government clearly was attacking the peasantry, though the attack was nominally only against rich peasants and black marketeers. Armed workers and political police became involved in collection of grain.

The basis of war communism was the compulsory seizure of foodstuffs and their distribution without the market mechanism. The policy perhaps helped to win the war by keeping the army fed at least minimally, but it had negative consequences. Peasants reduced their planting to meet only their consumption needs, did their utmost to conceal their reserves from the requisitioning authorities, and occasionally responded to seizures with violent attacks on food collectors. Not only were peasants alienated by this policy but a sharp decline in production also ensued.

Agricultural production fell by about 40 percent. Sown area was reduced, in passive response to grain seizure, by 34 percent from 1917 to 1920. Compared with production in 1913, yields of the major grains had fallen by more than 25 percent by 1920. Industrial production fell by 70 percent between 1913 and 1921, and that of heavy industry by nearly 80 percent. Coal extraction fell by 77 percent between 1913 and 1920.

The results were serious famine and supply shortages. Revolt was threatened in the countryside, workers rioted in the streets of Petrograd, and sailors at Kronstadt mutinied in March, 1921. There was urgent need for reform. In the same month as the Kronstadt rebellion, the Tenth Party Congress approved the ending of war communism. By the winter of 1920-1921, the civil war had essentially ended, and perhaps for this reason resentment of the workers and peasants about the standard of living became stronger. The countryside witnessed a swelling tide of sporadic peasant uprisings, numbering 118 in February, 1921, by police count. More significantly, in March, 1921, the major naval base at Kronstadt revolted. The sailors called for

economic reform and political change.

At the Tenth Party Congress in March, 1921, Lenin announced a series of measures that collectively became known as the New Economic Policy. The most important reversal of policy was the abandonment of forced requisitions in favor of a tax in kind that left peasants free to dispose of any surpluses that remained after the tax assessment had been met. The tax in kind represented a determined effort to win back the favor of the peasantry. In order to persuade peasants to part with their surpluses, incentives had to be provided in the form of increased supplies of consumer goods. This made a revival of industrial production imperative.

Over the following months, the regime moved to restore private trade and to permit the establishment of small private industries and industrial cooperatives, in the hope that they could readily increase the flow of consumer goods. New enterprises were promised freedom from nationalization. Small enterprises that had been nationalized were leased to their former owners or industrial producers' cooperatives for fixed terms, with the provision that rents were to be paid in the form of a definite proportion of the output of the enterprise. In 1922, Lenin further allowed operation of small private farms as a means of adding to food production. Peasants were permitted to lease land and hire labor, although the purchase and sale of land were still prohibited.

Impact of Event

The most important impact of the New Economic Policy was the transformation of state-market and state-society relations. Specifically, the Soviet state no longer saw all market relations as negative. The main features of the New Economic Policy were the abandonment of forced requisitions in agriculture and the substitution for them of a tax in kind, the toleration of private ownership in trade and small-scale industry, and the attempt to entice foreign capitalists into the Soviet Union in order to acquire their badly needed skills and capital. Replacing the policy of forced acquisition of grain with the tax in kind enabled farmers to sell their surplus food, giving a degree of market freedom to farmers. By allowing the operation of small private farms, the Soviet regime sought reconciliation with the peasantry. The period of the New Economic Policy (1921-1928) has been seen by many scholars as a relatively free period for agricultural and business activities under the Soviet government.

In 1921, the economy of the Soviet Union lay in ruins. Seven years of war and civil war had produced catastrophe. Industrial production stood at 13 percent of prewar volume. The grain harvest had fallen from 74 million tons in 1916 to 30 million tons in 1919 and continued to decline.

Under the New Economic Policy, nearly twenty-five million peasants were permitted to farm their holdings on legally nationalized land and sell their produce after paying a tax to the state. Small-scale entrepreneurs were given a free hand in light industry and in the service trades. Small traders carried on the functions of buying and selling, sometimes through private trading concerns of their own, sometimes concealed as cooperatives, and not infrequently as official agents of the state trading organizations themselves.

Although the food tax was prompted by basically political motives, it initiated the revival of the economy. The law provided that a peasant must pay the government a tax in kind consisting of a certain percentage, varying somewhat from region to region, of farm production. The peasant could then dispose of the remainder on the free market. In 1922, the tax was fixed at a standard 10 percent.

By the Fundamental Law on the Exploitation of Land by the Workers, enacted in May, 1922, the government guaranteed peasants freedom of choice of land tenure. Land could be held individually, communally, or in other ways. Villagers thus were permitted, within rather broad limits, to manage their own economic lives as they saw fit.

Most of the land taken during the Revolution was redistributed through peasant communes. The 1922 land code recognized the legal position of the land society, which in nearly all cases was the same as the traditional village commune. The land society was a community of households, usually within the same village, that performed an administrative function, exercised control over land use, and generally governed the farming program. The commune or land society organization became more extensive in the New Economic Policy period. Land formerly the property of the Czarist state was for the most part taken over by land societies. In 1926, 83.4 percent of such land in the central industrial region and 61.7 percent in the central agricultural region was in land societies.

Under the New Economic Policy, private enterprise was encouraged, within set limitations, in the areas of agriculture, domestic trade, light industries, and public services. The state, however, retained its monopoly over the so-called "commanding heights": banking, heavy industries, transportation and communication, and foreign trade. Small businesses were granted a measure of economic freedom. Entrepreneurs were permitted to resume management of smaller concerns, to hire labor, and to trade more or less freely with the goods produced. The new class of small urban capitalists, however, suffered social pressures from which the peasants were exempt. It was difficult for them to obtain credit at banks, the rents on their apartments were often higher than their neighbors', and their children had to pay higher tuition fees at schools. Many of them expressed their suspicion that their situation was precarious and temporary by free spending and high living, taking advantage of liberties while they existed.

The new era of "free enterprise" benefited not only the peasants and small businesspeople but also individual workers. Trade unions, organized under the leadership of Mikhail Tomsky, were permitted to strike against the private capitalists. It was thought necessary that they be allowed to strike against state enterprises as well, even though they were urged not to do so and were reminded that by doing so they were by definition striking against themselves.

Under the new dispensation, the economy began to revive. Lenin told rank-and-file Communists to "master trade." State industries and state farms were commanded to show a profit and to operate on commercial principles. Financial stability was slowly recovered. By the end of 1922, a third of government revenue was coming from the

food tax, another third from a variety of direct money taxes, and the final third from the issuance of bank notes.

The New Economic Policy restored a considerable measure of capitalism to the Soviet economy, particularly in agriculture and trade. Lenin's idea was that by this strategic retreat the Communist Party could keep control of the country but stimulate its recovery from the destruction and disorganization of the war years. Once the pressing problem of getting the economy functioning again was solved, the Party could then resume its advance toward socialism.

Internal trade was conducted by state trading organs, which were relatively few, private traders, and cooperatives. Cooperative trading bodies were actively encouraged by the government and became relatively successful in the sale of consumer goods in rural areas. State-controlled trade was confined primarily to wholesale trade in urban areas. In Moscow in 1922, 83 percent of retail trade was in private hands and only 7 percent in state hands, whereas 77 percent of wholesale trade was handled by the state.

In the New Economic Policy period, agriculture developed along capitalistic lines. The peasants paid taxes that, with the passage of time, became more and more monetary taxes rather than taxes in kind. The land belonged to the state, but the peasants did what they saw fit with it. In seven years, agriculture reached levels unsurpassed in prerevolutionary Russian history and never again to be reached under the Soviet system.

Bibliography

Campbell, Robert. *Soviet Economic Power*. 2d ed. Boston: Houghton Mifflin, 1966. Provides a concise introduction to the Soviet economy, with critical analysis.

Davies, R. W. *The Socialist Offensive: The Collectivization of Soviet Agriculture, 1929-30*. Cambridge, Mass.: Harvard University Press, 1980. The authoritative study of the sources, process, and consequences of Soviet agricultural collectivization.

Fitzpatrick, Sheila, Alexander Robinowitch, and Richard Stites, eds. *Russia in the Era of NEP: Explorations in Soviet Society and Culture*. Bloomington: Indiana University Press, 1991. Examines the social and cultural background of the New Economic Policy.

Hosking, Geoffrey. *The First Socialist Society: A History of the Soviet Union from Within*. Cambridge, Mass.: Harvard University Press 1985. Highlights major events in the history of the Soviet Union.

Hough, Jerry F., and Merle Fainsod. *How the Soviet Union Is Governed*. Cambridge, Mass.: Harvard University Press, 1979. This influential text examines the development of the Soviet political and economic system, with an emphasis on the policy process.

Hutchings, Raymond. *Soviet Economic Development*. 2d ed. Oxford, England: Basil Blackwell, 1982. A comprehensive introduction to the Soviet economy and the forces that promoted or retarded its development until the late 1960's.

Nove, Alec. *The Soviet Economic System*. London: George Allen & Unwin, 1977. An authoritative examination of the origins, nature, and process of the Soviet economic system, by one of the world's leading experts on the Soviet economy.

Treadgold, Donald W. *Twentieth Century Russia*. 6th ed. Boulder, Colo.: Westview Press, 1987. Provides essential historical background for understanding the Soviet economy and society.

Guoli Liu

Cross-References

The Hindenburg Program Militarizes the German Economy (1916), p. 293; Stalin Introduces Central Planning in the Soviet Union (1929), p. 563; China Begins Its First Five-Year Plan (1953), p. 1003; The Soviet Parliament Allows Private Ownership (1990), p. 2022.

THE FIRST MAJOR U.S. SHOPPING CENTER OPENS

Category of event: Retailing
Time: 1922
Locale: Kansas City, Missouri

The development of shopping centers provided customers with ease of access to consumer goods and retailers with growth opportunities

Principal personages:
J. C. Nichols (1880-1950), the real estate developer of Country Club Plaza, the first major shopping center in the United States
Melvin Simon (1926-), the developer of the Mall of America
Howard Van Doren Shaw (1869-1926), the designer of the first planned shopping center in the United States, called Market Square

Summary of Event

The development of the shopping center concept in the mid-twentieth century in the United States was a result of life-style and environmental changes. New forms of transportation affected both the life-style of the American people and the environment of the country. The widespread ownership of automobiles allowed city workers to live in suburbia. Increased automobile traffic led to city congestion, making it difficult for customers to shop in leisure and comfort inside the city. Aviation and the introduction of bus lines also promoted the growth of shopping centers in outlying areas of cities. The rise of housing developments, large apartment complexes, family hotels, and restaurants on the perimeters of cities also drew people into suburbia. Professionals such as doctors and accountants moved their practices to the suburbs. As Americans moved to the suburbs, they demanded shopping facilities that were conveniently located. The shopping centers that developed in response had their roots in the early twentieth century.

Early developers of shopping centers based their ideas on the concept of buying a variety of products in one location. The early American trading post and general store were forerunners of the shopping center and provided experience to support the underlying concept of shopping center development. Bazaars of the Middle East and arcades that rose up in nineteenth century America supported also this concept and provided developers with insights into retailing.

Even though shopping centers were built as early as 1907, when Roland Park Shopping Center was established outside Baltimore, Maryland, the detailed planning of centers did not occur until later. Solo ventures into suburbia by retailers were the general rule. The National Historic Records list Market Square of Lake Forest, Illinois, as the first planned shopping center in the United States. The plans designed by Howard Van Doren Shaw in 1916 included a landscaped plaza, stores behind an arcade walkway, apartments on the second floor, and a commuter train station across the street.

Integrated shopping centers, with a variety of large and small tenants under one landlord and with affordable off-street parking, did not exist until 1922. In that year, the J. C. Nichols Company built Country Club Plaza, the first planned, fully integrated shopping center in the United States. Country Club Plaza was located on a forty-acre site five miles south of downtown Kansas City, Missouri. The extensive plans called for patterns for the flow of traffic and road width, parking arrangements for customers and employees, delivery systems, pedestrian walkways, display window location and control of other advertisement forms, interior and exterior building design, store location according to merchandise line, landscaped plazas, and proximity of other shopping facilities. The Country Club Plaza featured Spanish architecture with detailed ornamental corners and towers. The uniform height of the buildings, lack of overhead wires, and attention give to architectural details provided the shopping center with a distinctive and harmonious appearance.

Another important occurrence that influenced shopping center development was the Beeler Organization survey of female shoppers of New York and Chicago in 1926. This widely publicized survey revealed both the changing habits of shoppers and the need to give more attention to the planning of shopping centers. Shoppers were reducing the number of shopping trips, were shopping more hurriedly, and preferred shopping nearer their homes and using their own automobiles instead of public transit facilities, though they often were forced to take public transportation because of traffic congestion. Harold Dunn, an engineer for the Beeler Organization, stated that off-street or garage parking should be included in shopping center planning and could be used as a feature in advertisements for shopping centers.

By the end of the 1920's, city planners and shopping center developers recognized the need to plan integrated shopping centers. The July, 1929, edition of *American City* stated that allowances for growth must be included when planning a center. The location and type of the center should be based on market research of the target area. In addition, a call was made for city planners and developers to give attention to both the general layout of the centers and their architectural details and controls. In the same edition of *American City*, Country Club Plaza, the first major shopping center in America, was recognized as a model of shopping center development.

Impact of Event

One of the most important effects of the development of the shopping center was that consumer goods could be purchased nearer to homes and away from business and manufacturing districts. Customers began to see shopping as a pleasurable and social event, and not only as a necessary duty.

At the close of World War II, mushrooming housing developments throughout the United States created a tremendous stimulus for development of shopping centers. The type of shopping center built in a particular locale depended on the size of the population and the available space. Neighborhood shopping centers, or strip centers as they are sometimes called, carry a limited line of convenience merchandise and serve a trading population of up to forty thousand. Community shopping centers,

which serve approximately ten thousand families and occupy ten to twenty acres, are located close to heavily populated suburban towns and villages. Community shopping centers carry a fairly complete line of goods. Regional shopping centers, the largest of the three types of centers, serve a trading population of one hundred and fifty thousand, are typically located in high-traffic areas, and offer a variety of goods and services. An example of the complexity of a regional shopping center is the River Park Regional Shopping Center, built in the early 1950's on ninety acres near Philadelphia, Pennsylvania. On this site were located a shopping center containing more than seventy retail shops and eating facilities; a 770-unit, twelve-story, three-building apartment complex; a twelve-story hotel; a twelve-story office building; a medical center, including a drug store; and a fifteen-acre parking area. By the end of the 1980's, the United States had an estimated thirty-three thousand shopping centers.

Evolution in the design of shopping centers has had large effects on where, when, and how consumers shop in the United States. The shopping centers of the 1940's and 1950's, designed as neighborhood or strip centers where each shop had an outside entrance, were seen as the ultimate answer to the needs of consumers living in the suburbs. These centers fostered the growth of small department and specialty stores as well as supermarkets and convenience stores. Discount stores such as Kmart and Wal-Mart have always done business in strip centers. In 1956, the first enclosed shopping center, commonly referred to as a mall, was built in Edina, Minnesota. Necessity was the force behind this evolutionary design. Edina, a suburb of Minneapolis, typically has more than a hundred days each year of subfreezing temperatures. Enclosed malls attracted medium- to higher-scaled department and specialty stores; few discounters have located in enclosed malls. Hypermarkets, or superstores, and outlet malls sprang up in the 1980's and 1990's. These were operated by some of the major discounters, grocery chains, and manufacturers and were similar to enclosed malls except that the facilities, merchandise, services, and operations are controlled by one company.

Innovations in the design of enclosed malls continued as they were built throughout the United States. In the 1960's, the Thomas Mall, built in Phoenix, Arizona, featured the first usage of utilities and duct work on the roof. This design feature, shielded from view by decorative screens and accessible by special stairs, saved space for merchants inside the mall while allowing for ease of service and relocation of utilities without disrupting business. Another 1960's innovation in mall design was the elimination of street display windows. Since the entrance to each business was from an interior walkway, the display windows were relocated to inside the mall. Another design change was the inclusion of areas for displays, live shows, demonstrations, and community meetings.

The expansion of goods and services that appeared within the shopping center from the 1950's on seemed limitless. The early neighborhood shopping centers provided a broad mix of merchandise and perhaps a film theater. Sometimes a professional service, such as dry cleaning or optometry, would locate in the center. Often a grocery store and a convenience store would be built near the center. With the enclosed mall

came an even greater variety of services, beginning with food courts and film theaters. Other expansions in enclosed malls included elegant dining facilities, banks, child care centers, multiplex cinemas, bars with live music, lawn and garden centers, and full-scale amusement parks. The Mall of America, opened in 1992 in Bloomington, Minnesota, best exemplified what shopping centers could include. A 300,000-square-foot entertainment park was built in the center of the mall, surrounded by more than eight hundred stores. The Knott's Camp Snoopy theme park offered sixteen rides, including a full-scale carousel, a roller coaster, a seventy-foot mountain with a water flume ride, arcades, and live entertainment featuring Charles Schulz's Peanuts characters. The mall also included a two-story food court. One restaurant provided a large-screen television for patrons to watch sporting events. Terry Van Gorder, president and chief executive officer of Knott's Berry Farm, summarized well what was happening inside shopping centers, stating that malls had become much more than places to shop. They had become places for people to visit as centers of community life. Great strides have been made in youth-oriented attractions in malls; at the same time, malls needed to provide older consumers with a variety of special events and attractions geared to their needs. One problem connected with attractions, especially youth-oriented ones, was liability. Unlike video arcades, which could be strictly supervised, rides and other amusement attractions were difficult to supervise.

Shopping center development has a great impact on the surrounding communities. In the 1920's, city planners and shopping center develops were concerned about the center's appearance and customer facilities such as parking. In the 1950's, city planners advocated a "look before you leap" philosophy in the construction of centers, suggesting that they should be built only after thorough studies by market analysts, traffic and land planning engineers, real estate brokers, merchandising consultants, architects, landscape artists, and community planners. In the 1980's and 1990's, environmental regulations such as those covering wetlands and storm water runoff made it more difficult to build centers. Because of these and other concerns, such as fewer markets and greater costs, the emphasis in shopping center development was likely to become smaller regional centers loaded with amenities and with mixed uses.

A change in use of existing shopping centers occurred in the 1980's and 1990's. Demand for retail space dropped as a result of slower population growth and over-building. The 1980's saw 10 percent growth in population and a 50 percent growth in leasable area in shopping centers. Innovative uses for centers included conversion to museums, schools, office space for professionals, and townhouses and accompanying parking facilities.

Many center city areas were refurbished as part of urban renewal enterprises during the same period. These enterprises often included shopping centers for the convenience of the inner-city traffic, as well as to entice people to come into the city to shop. Trump Towers, an outstanding example of urban enterprise, contained some of the most prestigious fashion stores in the world, located around a six-floor atrium. Shopping centers were thus reversing their original purpose by bringing people into cities.

Bibliography

Bohlinger, Maryanne Smith. *Merchandise Buying*. 4th ed. Boston: Allyn and Bacon, 1993. Chapter 1 describes the evolution of retailing. The tremendous growth in shopping malls throughout the United States and Canada is emphasized.

Jarnow, Jeannette, and Miriam Guerreiro. *Inside the Fashion Business*. 5th ed. New York: Macmillan, 1991. This textbook, which includes readings, provides coverage on shopping centers as retailers of fashion. Discusses the circumstances and period of their origin, the part they have played in the business of fashion, and how they are changing.

Larson, Carl, Robert Weigand, and John Wright. *Basic Retailing*. Englewood Cliffs, N.J.: Prentice-Hall, 1976. An excellent review of the retailer response to change through store locations. The classification of shopping centers is thoroughly covered. Includes a line of drawing of a regional shopping center.

Mason, J. Barry, Morris L. Mayer, and J. B. Wilkinson. *Modern Retailing*. Homewood, Ill.: Irwin, 1993. Discusses retailing in the 1990's in detail. Good coverage of site evaluation for centers. An interesting retailing capsule is entitled "Shopping Malls: The Unlikely Battleground for Free Speech."

Morgenstein, Melvin, and Harriet Strongin. *Modern Retailing*. New York: John Wiley and Sons, 1983. Excellent coverage on store location and types of shopping centers. Sales promotions and public relations ideas for retailing—including shopping centers—are suggested.

Sue Bailey

Cross-References

Ford Implements Assembly Line Production (1913), p. 234; Clarence Saunders Introduces the Self-Service Grocery (1916), p. 302; Invention of the Slug Rejector Spreads Use of Vending Machines (1930's), p. 579; The First Two-Story, Fully Enclosed Shopping Mall Opens (1956), p. 1070; Drive-Through Services Proliferate (1970's), p. 1406; A Home Shopping Service Is Offered on Cable Television (1985), p. 1909; Vons Opens Its First Tianguis Marketplace (1987), p. 1943.

OIL IS DISCOVERED IN VENEZUELA

Category of event: International business and commerce
Time: 1922
Locale: Venezuela, near Lake Maracaibo

Discovery of oil near Lake Maracaibo in Venezuela altered the world energy market and eventually changed the nature of Venezuela's economy, propelling Venezuela into a leading position among oil-producing and -exporting states

Principal personages:

ROMANO BETANCOURT (1908-1981), the president of Venezuela during the crucial 1945-1948 period

JUAN VINCENTE GOMEZ (1857-1935), the dictator of interwar Venezuela

JUAN PABLO PÉREZ ALFONZO (1904-1979), the Venezuelan government's central spokesman for oil

WALLACE PRATT, a geologist who negotiated the 50-50 agreement to retain Standard Oil's security of operations in Venezuela

GEORGE REYNOLDS, a Shell manager whose work resulted in the discovery of oil near Lake Maracaibo

Summary of Event

By any measurement, Venezuela is an old oil-producing area. Spanish explorers returned to Europe in precolonial days with tales of its oil being used by primitive tribes. Significant foreign exploration and development ventures, however, did not begin there until after World War I, when Western security needs arising from the conversion of fleets to oil, growing consumer needs for oil, and fears of shortages in the market produced a sharp, general increase in exploratory efforts abroad. By 1918, Venezuela was already exporting limited amounts of oil. Still, as late as the early 1920's, exploration in Venezuela did not appear to be particularly promising. The discovery of oil at Lake Maracaibo in 1922 changed that picture abruptly. By the end of the decade, oil had become Venezuela's principal export, and Venezuela had become the world's largest exporter of oil and a major voice in the world's oil business, a role it would retain for the next half century.

Petroleum exploration and development ventures in Latin America initially concentrated on Mexico. Had the Mexican government not become politically unreliable by declaring in its 1917 constitution that the mineral resources of Mexico belonged to the Mexican people rather than those who developed them, exploratory interest in Venezuela would probably have been much later in developing. As a result of the Mexican Revolution, however, Venezuela appeared as a particularly promising haven for the foreign capital rapidly fleeing the petroleum business in Mexico. Perversely, Venezuela's appeal was primarily the stable, though repressive, nature of the regime there.

Venezuela's undisputed ruler, General Juan Vincente Gomez, coveted the wealth that oil operations in Venezuela would bring him. To lure foreign investment, Gomez was willing to accept a series of administrative arrangements that proferred grantees of petroleum concessions in his country a high level of stability in enjoying those concessions. Companies responded to the incentives.

From the outset, the most important of these was the Royal Dutch/Shell corporation. Its initial geological tests were encouraging, and it began exploratory drilling in the Lake Maracaibo area as early as 1913. By the time World War I had ended, it had been joined there by Standard Oil of New Jersey, the industry leader in the Latin American market. For all, however, the exploratory conditions were difficult. Jungles had to be breached; disease, contaminated water, and poisonous snakes all posed problems; and many of the more promising areas were under water rather than on land. Nevertheless, at the insistence of George Reynolds, its local manager and a man with a major reputation in the field, Royal Dutch/Shell persevered with its operations in the La Rosa area of the Lake Maracaibo Basin. In 1922, a major gusher rewarded this tenacity. Venezuela's petroleum industry was off and running, much of it based on fixed drilling platforms located on the lake itself. Additional companies applied for concessions, and the drilling ventures quickly multiplied. By 1929, Venezuela was producing more oil than any country in the world except the United States, drawing half of its revenue and three-fourths of its export earnings from oil.

The global depression of 1929-1933 caused a collapse in the demand for oil at approximately the same time that major finds in Oklahoma and Texas were combining with improvements in the efficiency of refining petroleum to curtail America's import needs. For the Venezuelan petroleum industry, these developments proved to be extraordinarily costly. Of all the countries then exporting oil, Venezuela was the hardest hit during the depression. Its rate of unemployment soared as nearly half the oil workers had to be dismissed. Government income was sliced by two-thirds between 1929 and 1932 as the price of oil dropped from $1.05 to $.24 per barrel. Full and rapid recovery was unlikely. Venezuela had been sending more than half of its total production to the United States throughout the 1920's, but in 1932 America enacted a tariff system in order to protect its domestic industry. The system drastically dampened America's demand for imported oil and, as a result, Venezuela was forced to reorient its industry to a broader, world market. It would eventually manage the feat so successfully that by the eve of World War II it was supplying 40 percent of British petroleum needs; however, the prolonged adjustment process left a growing number of nationalists in Venezuela with a profound—and soon to be important—distrust of outside consumers, particularly the United States.

Impact of Event

The discovery of substantial petroleum reserves in Venezuela ultimately had a significant impact on the development of industry-host country relationships throughout the oil producing world, the global evolution of the international petroleum industry, and the social, economic, and political development of Venezuela. General

Gomez's death in 1935 ignited considerable jockeying for influence among various factions in the country. Many of these, including the *Accion Democrática* party, were spurred by their recent memory of the unreliability of foreign oil buyers and what they saw as the scandalous failure of the petroleum wealth of their country to improve the standard of living of most Venezuelans. As these factions acquired political influence, Venezuela's political agenda shifted dramatically from that of the wealth- and power-hungry days of General Gomez. Meanwhile, rapid changes in the international environment during the late 1930's and early 1940's greatly enhanced their bargaining position in the international petroleum industry. In particular, Europe was drifting toward war, and the United States was evincing a renewed interest in security of petroleum supply arrangements in the Western Hemisphere. As a consequence, the United States government, as well as far-seeing oilmen such as Standard Oil of New Jersey's Wallace Pratt, soon came to back Venezuela's reformers in their attempts to negotiate a more beneficial arrangement with the multinational oil corporations operating in their country.

The product of these negotiations was the 50-50 agreement, obligating the companies to split their net profit evenly with the host government in Venezuela. Officially passed as the Petroleum Law by the Venezuelan legislature in March, 1943, this agreement rapidly replaced the old concession system in defining company-host government relationships throughout the oil-producing and -exporting world during the immediate postwar period.

Even this agreement did not completely satisfy nationalist politicians such as Juan Pablo Alfonzo, President Romano Betancourt's minister for development and *Accion Democrática*'s oil spokesman. He regarded it instead as a useful step toward his long-term goal of assisting oil exporting countries to secure full control over their natural resources. He pursued this goal throughout the remainder of his political career, tightening Venezuela's tax laws in order to ensure that Standard Oil, Shell, and the other multinational companies in Venezuela would truly pay the obligated 50 percent share of their net profits. He was one of the founding fathers of the Organization of Petroleum Exporting Countries (OPEC) in 1960.

The story of the impact of the oil industry on Venezuela lacks a tidy, happy ending. There is no doubt that the production of oil in Venezuela generated tremendous wealth and led to a general modernization of the country. On the other hand, evidence suggests that in modernizing the country, the petroleum industry also left Venezuela's economy excessively dependent on oil. At crucial moments when its governments might have otherwise restructured and diversified Venezuela's economy, the vast profits from the petroleum industry provided an alternative, a lubricant capable of keeping those governments going by the easier means of creating clients and purchasing the support necessary to remain in power.

As a result of the Petroleum Law and subsequent revisions to it, the government's income from oil increased sixfold between 1942 and 1948. From that point onward, difficult economic reforms were often tabled, with the result that for more than half a century, the country continued to depend on oil for most of its foreign earnings, a giant

share of government income, and a large part of its economy, allowing for the hotels, restaurants, and other service sector industries developing like satellites around the oil industry. That dependence, in turn, left Venezuela vulnerable to influence by the actions of others, especially the United States. The deleterious effects of America's 1932 tariff laws on Venezuela were echoed later, when the United States adopted a quota system in 1958 to protect its domestic producers from foreign exporters by limiting American oil imports to 12 percent of its petroleum needs. The same dependence likewise left Venezuela's economy vulnerable to disruption by changing conditions in the petroleum market, as occurred during the mid-1980's with the general collapse in the price of oil on the world market. OPEC had begun to lose power, leaving the Venezuelan oil industry and economy with few economic weapons.

Bibliography

Choucri, Nazli. *Energy and Development in Latin America: Perspectives for Public Policy.* Lexington, Mass.: Lexington Books, 1982. A comprehensive study of the relationship between energy and development in the oil producing states of Latin America. The relationship between governments and the state petroleum companies is extensively discussed.

Coronel, Gustavo. *The Nationalization of the Venezuelan Oil Industry from Technocratic Success to Political Failure.* Lexington, Mass.: Lexington Books, 1983. Basically a historical account of the development of the Venezuelan oil industry between 1878 and 1970 and of the declining power of the international oil cartel to control that industry.

Gibb, George S., and E. H. Knowlton. *The Resurgent Years, 1911-1927.* Vol. 2 in *History of Standard Oil.* New York: Harper, 1956. For details on the history of the twentieth century's largest and most important oil company, nothing surpasses the Business History Foundation series. This book, the second in the series, covers the period of the company's emergence as the leader of the international oil industry.

Klapp, Merrie Gilbert. *The Sovereign Entrepreneur: Oil Policies in Advanced and Less Developed Capitalist Countries.* Ithaca, N.Y.: Cornell University Press, 1987. A scholarly treatment of the conflict over time among host countries, multinational corporations, and domestic oil companies. Discusses policy options open to the states and oil companies in these conflicts.

Lax, Howard L. *States and Companies: Political Risks in the International Oil Industry.* New York: Praeger, 1988. Lax focuses on the relationship between host countries and multinational corporations and on the tension resulting from the different goals of the two. Especially good in discussing the companies' decreasing bargaining position over time.

Philip, George D. E. *Oil and Politics in Latin America: Nationalist Movements and State Companies.* New York: Cambridge University Press, 1982. Good background reading on the development of the oil industry in the oil producing states of Latin America from 1890 to the oil shocks of the 1970's as well as on the industry's impact on the politics of these states.

Tugwell, Franklin. *The Politics of Oil in Venezuela*. Stanford, Calif.: Stanford University Press, 1975. Chronologically organized, Tugwell's study of Venezuela's relationship with the major multinational oil companies contains numerous insights on such topics as the distorting effect the petroleum industry can have on a developing country's economy. The emphasis is on the 1958-1973 period.

Willrich, Mason, et al. *Energy and World Politics*. New York: Free Press, 1975. Basic introductory reading for anyone working in the area of energy politics. Published after the first energy crisis, this volume provides an exceedingly solid and readable overview of energy and international politics.

Wirth, John D., ed. *Latin American Oil Companies and the Politics of Energy*. Lincoln: University of Nebraska Press, 1985. An excellent analysis of the development of state oil companies in Latin America, with particular attention to events in the key states of Venezuela, Mexico, Brazil, and Argentina. The emphasis is on the formative years.

Yergin, Daniel. *The Prize: The Epic Quest for Oil, Money, and Power*. New York: Simon and Schuster, 1991. A massive study of the development of the international oil industry, with as much attention to the personalities and politics involved as to historical events. Several excellent sections on Venezuela's role in the story.

Joseph R. Rudolph, Jr.

Cross-References

The Supreme Court Decides to Break Up Standard Oil (1911), p. 206; Oil Companies Cooperate in a Cartel Covering the Middle East (1928), p. 551; OPEC Meets for the First Time (1960), p. 1154; Atlantic Richfield Discovers Oil at Prudhoe Bay, Alaska (1967), p. 1331; Arab Oil Producers Curtail Oil Shipments to Industrial States (1973), p. 1544; The Alaskan Oil Pipeline Opens (1977), p. 1653.

READER'S DIGEST IS FOUNDED

Category of event: Foundings and dissolutions
Time: February, 1922
Locale: New York, New York

By condensing high-quality articles and information from a variety of sources, Reader's Digest carved a niche in the highly competitive media market and became the world's most-read periodical

> *Principal personages:*
> DEWITT WALLACE (1889-1981), a cofounder of *Reader's Digest*
> LILA BELL ACHESON (1889-1984), a cofounder of *Reader's Digest* and the wife of DeWitt Wallace
> BARCLAY ACHESON (1887-1957), the chairman of *Reader's Digest* international editions
> HOBART L. LEWIS, the first president and editor-in-chief of *Reader's Digest*

Summary of Event

Several quality magazines and newspapers existed prior to World War I, but the majority of Americans lacked the time to read and the money to purchase the wide variety of publications available to them each month. In addition, a number of magazines were unavailable to the general public, as they were obtainable only in libraries. Believing that American readers could benefit from scaled-down versions of such publications, DeWitt Wallace and his wife, Lila Bell Acheson, founded *Reader's Digest*, a magazine that grew to become the world's most widely read publication.

Wallace began a hobby of clipping and editing (or "digesting") from magazines while in college. He would read through numerous publications looking for interesting articles and then edit the material down to highlight the main points. He found that the theme or main point could be maintained while details were eliminated. After college, he entered the publishing business at the Webb Publishing Company in St. Paul, Minnesota.

World War I cut short any plans for pursuing a career. While recovering from shrapnel wounds incurred in France, he dove into his dream. Wallace wanted to start a monthly magazine designed to highlight, in condensed, digested form, the wealth of information available to readers. He used his time in the hospital to select and edit articles from the numerous works available to him. He was aided by the fact that many publishers provided free copies of magazines to soldiers. He looked for inspiration and constructive content in articles, reflecting his Presbyterian background, and selected those that contained elements of "lasting interest."

Upon his return to the United States, Wallace devoted himself to finding a publisher

for his digest, hoping to find one that would keep him on as editor. Wallace created a dummy issue of *Reader's Digest* dated January, 1920, that included articles from *Woman's Home Companion*, *The New Republic*, and *Vanity Fair*, then canvassed the publishing industry. Only one positive comment came in, that the magazine might make a profit of $5,000 per year. No publisher, however, would back his efforts.

Undaunted by the lack of support, Wallace continued to digest articles and look for means to get his idea out to the public. He compiled numerous mailing lists and sent circulars to teachers, nurses, friends, and others hoping to receive charter subscriptions for his time-saving and economical magazine. He targeted working women because he believed they could appreciate the time-saving quality of the magazine. On October 15, 1921, he married Lila Bell Acheson. In a last effort to launch the magazine, they mailed more than a thousand circulars on their wedding day. They returned from their honeymoon to find fifteen hundred charter subscriptions at $3 each. *Reader's Digest* was born.

Volume 1, Number 1, was dated February, 1922. It opened with "How to Keep Young Mentally" and contained, as it stated, "An article a day from leading magazines in condensed, permanent booklet form." Printed on cheap paper, it had no color, no illustrations, and no advertisements. Subscription holders became charter members of The Reader's Digest Association, with the magazine provided as a "service" to them. Wallace and Acheson headed the publication as cofounders, coeditors, and co-owners. Lila kept her maiden name on the masthead until 1938.

The magazine grew dramatically. Continued mailings of circulars and word-of-mouth publicity increased the demand for the magazine throughout its early years. Wallace worked at the New York Public Library to save money on the magazines that provided material. The couple lived and worked from a small apartment over a garage in Greenwich Village. By the end of 1922, the magazine had become too big for their apartment, and the Wallaces moved to Pleasantville, about forty miles north of New York City.

Wallace remained aware that his magazine relied on material being produced in other publications. He wrote to publishers and editors asking for permission to reprint from their magazines. Many publishers saw the publicity benefits of reprints and gladly gave their permission. One reluctant voice came from George Horace Lorimer of *The Saturday Evening Post*, which had a standing order that reprint permission was not given for more than five hundred words. Wallace, undaunted by the challenge, made a personal visit to see Lorimer. The publisher was impressed with the young man and made an exception to the rule. *Reader's Digest* was able to grow and profit because of the generosity of the editors and publishers who allowed Wallace to condense their works free of charge. He never forgot that generosity. By the 1930's, as the magazine began to show a profit, he started sending money to surprised editors for the articles he used.

This friendly relationship with other publications stemmed from the fact that *Reader's Digest* was available only through subscriptions sold as a service to members; the source magazines were not in direct newsstand competition with it. Increased

competition in the industry, however, led Wallace to arrange for S-M News Company to sell single copies at retail outlets beginning in 1929. This led to resistance by some magazines to having their contents reprinted. Wallace quickly turned the situation around by emphasizing the publicity given to the source magazines. His efforts resulted in exclusive reprint rights from thirty-five leading American magazines.

Impact of Event

Following World War I, numerous new publications started a flood of information across the country. Magazines such as *Time*, *Newsweek*, and *Fortune*, for example, started soon after the war. It was during this period of growth that *Reader's Digest* was founded. By the 1930's, the digest was well established.

The magazine's circulation grew to almost 2.5 million by 1937. The early editorial staff came from a variety of disciplines. It was not until 1930 that the first professional editors came on board. After that time, editors would include Ivy League graduates and former editors of such publications as *American Mercury* and *The New Republic*. Original articles, rather than condensed versions of previously published articles, began to appear in 1933. At the same time, special departments, which later became regular features, developed from reader materials. These included "Life in These United States" and "Drama in Everyday Life." The Wallaces expanded the magazine to 128 pages and added condensed books a year later. By 1939, the magazine had grown to fill a new $1.5 million office building in Chappaqua, New York.

The successful digest format used by the Wallaces was imitated throughout the 1940's and 1950's. Titles such as *Negro Digest*, *Catholic Digest*, and *Children's Digest* appeared. *Reader's Digest* set the standard for editing, and these other magazines found success by targeting their articles to specific groups.

In addition to setting a standard within the publishing industry, the *Reader's Digest* also set standards as an employer. Writers received a monthly stipend to keep them on retainer, and editors were consulted about the future of the magazine. Employees were paid well and received good benefits such as vacation time, profit sharing, and medical insurance. Retirement programs were a key benefit. Added compensation in these forms was unusual in a country facing the Great Depression. The Wallaces, however, sought to create a positive working environment, in terms of both benefits and aesthetics. Lila Wallace decorated the grounds to be soothing to the eye, and corporate offices featured artworks by the masters.

The editorial policy that Wallace had established for himself when first choosing articles had remained intact as the magazine grew. Articles for consideration should be quotable, applicable, and "of lasting interest" to readers. Material was edited to be read by the average reader, not a specialized audience. Jokes, at first used only as filler, became an integral part of the publication. Although the digest contained no editorial page, within its covers attacks were waged on expansive government, big business, and advertising. Wallace, although an avid smoker himself, recognized the importance of public awareness concerning the dangers of cigarette smoking. *Reader's Digest* therefore spoke against the practice. The digest also had the power to positively

persuade. An article about a Connecticut housewife and her baking helped Pepperidge Farms to enter into the food market.

Perhaps the most phenomenal effect ever brought about by a magazine occurred with the August, 1935, issue. J. C. Furnas wrote an original piece for *Reader's Digest* titled "—And Sudden Death." This graphic and realistic depiction of highway accidents spoke to American readers. The article was reprinted in whole or in part in virtually every large U.S. newspaper. Radio programs and civic groups devoted entire events to the topic, and a short motion picture was made concerning highway safety. A comic strip geared toward young drivers appeared, and reprints of the article were given to motorists at toll booths and at license bureaus. Most important, transportation agencies established task forces and committees to work for improved highway conditions. How Americans drove was brought to their attention; one study concluded that accidents fell by 13 percent soon after the article appeared in print. Within three months, the article went through more than four million reprints. This article began the *Reader's Digest*'s reputation for public service. Later articles on medical and employment issues, among others, also called for action.

Taking the American success of *Reader's Digest* to other countries and into other languages proved to be another important move for the publication. Barclay Acheson, Lila's brother, guided *Reader's Digest* as head of the international editions until his death in 1957. He helped move the magazine beyond the American borders as foreign editions developed. A British version of the digest appearing in 1938 was the first foreign edition. In 1940, a Spanish-language edition was published. Other editions followed in French, German, Italian, Arabic, and Chinese. By the 1980's, more than 160 countries and sixteen languages were represented by various editions. These editions stimulated the economies in the foreign countries, through editorial and printing facilities, while also serving as an interpreter of American life. Through its pages, *Reader's Digest* opened the morality, hopes, and concerns of the American public to the rest of the world as an unofficial ambassador. In addition, Braille editions (the first in 1928) and talking records opened its pages to the blind and sight-impaired.

Despite their successes, the Wallaces were forced to work within the publishing industry and to face its problems. During the 1940's, circulation had climbed to more than nine million, with the cover price still at 25 cents, the 1922 cost. Paper, printing, and postal costs, however, had skyrocketed. In 1954, the Wallaces faced a deficit of more than a million dollars. Options were to increase the cover price or to accept advertising. Wallace took the debate to his "members," the readers. More than 81 percent of the readers favored the acceptance of advertising. In April, 1955, *Reader's Digest* opened itself to thirty-two pages of advertising, with strict guidelines against ads for liquor, tobacco, and medical remedies. Charging $31,000 for a full-color page, the highest ad rate of any magazine, the Wallaces expected marginal sales. Instead, several million dollars worth of ad space was sold, proving that the magazine could maintain its integrity concerning certain practices. As a result, the magazine expanded to 216 pages and included full-color, glossy paper.

The Wallaces were not content to work solely on the monthly publication and

expanded their business throughout the 1950's and 1960's, even as other publications such as *Collier's* and *The Saturday Evening Post* succumbed to competition. In 1950, the Condensed Book Club opened, drawing more than five million subscribers. Records, textbooks, and school readers as well as dictionaries and almanacs with the *Reader's Digest* name also appeared in the 1950's. A complete history and geography, *These United States*, came out in 1968 after The Reader's Digest Association purchased Funk and Wagnalls in 1965. The 1960's also saw the introduction of the successful Reader's Digest Sweepstakes. Other publications earned money by selling their subscription lists for promotions. The Wallaces had maintained strict control over their lists and used them only for internal purposes and promotions. This stemmed from their initial belief that subscribers were members of their association and that the digest was a service to them.

By the late 1960's, the Wallaces turned their attention to the coming decades. Advanced age left them with the task of finding a successor to oversee their successful publication. In 1964, Wallace created an office of the president. Hobart D. Lewis filled the position and later became the first editor-in-chief, in 1969. The Wallaces left the publication in the early 1970's, turning it over to his direction. DeWitt and Lila Wallace maintained their ties to *Reader's Digest* throughout their later years, however, and continued to work as philanthropists for education and the arts, especially New York City's Metropolitan Museum.

Reader's Digest maintained its position as the most-read magazine in the world. By the early 1990's, more than nineteen million copies came off the presses each month. International editions increased the total to more than twenty-eight million. Only *TV Guide* and *Parade*, two weekly publications, had monthly totals that were higher. Each month, the reader can expect to find personal anecdotes, funny yet biting jokes, and inspirational as well as educational information. Readers are loyal, with a renewal rate that has fluctuated from 64 to 80 percent, almost double the industry averages. Unlike the majority of American magazines, which relied on a specific readership base, *Reader's Digest* cut across socioeconomic boundaries for its success. Historians have referred to *Reader's Digest* as the "common denominator" of American life.

Bibliography

Peterson, Theodore. *Magazines in the Twentieth Century*. 2d ed. Urbana: University of Illinois Press, 1964. The standard history of U.S. magazines. A well-researched and detailed look at the popular magazines on the market. An excellent reference work.

Taft, William H. *American Magazines for the 1980s*. New York: Hastings House, 1982. A well-researched look at the magazine industry as it entered the 1980's and faced increased competition from other media. Categorizes magazine titles by interest and genre as well as looking at the entire industry's advertising, publishing, and distribution networks.

Tebbel, John, and Mary Ellen Zuckerman. *The Magazine in America, 1741-1990*. New York: Oxford University Press, 1991. Provides a good understanding of the

effect the magazine industry has had on the American public. Discusses how magazines have changed with the times and why some have succeeded in the competitive market.

Wood, James Playsted. *Magazines in the United States*. 3d ed. New York: The Ronald Press, 1971. Considered to be one of the definitive studies of the magazine industry. Provides social and economic information on magazines and follows the industry's leaders. Chapter 18, "Common Denominator," gives a detailed history of *Reader's Digest*. The author leaves little doubt concerning his admiration for the Wallaces and their publication.

_____ . *Of Lasting Interest*. Rev. ed. Garden City, N.Y.: Doubleday, 1967. The history of *Reader's Digest*. Provides a detailed look at the founders and the publication. Also discusses the impact of the magazine on the world.

Jennifer Davis

Cross-References

Forbes Magazine Is Founded (1917), p. 314; Henry Luce Founds *Time* Magazine (1923), p. 412; Mail-Order Clubs Revolutionize Book Sales (1926), p. 504; Henry Luce Founds *Fortune* Magazine (1930), p. 585; *The Saturday Evening Post* Publishes Its Final Issue (1969), p. 1379.

WEAF AIRS THE FIRST PAID RADIO COMMERCIAL

Category of event: Advertising
Time: August 28, 1922
Locale: New York, New York

Station WEAF's sale of air time began the movement of radio toward being a new advertising medium instead of paying its way through sales of radio receivers

Principal personages:

VISCHER A. RANDALL, the announcer who introduced the first radio commercial

MR. BLACKWELL, an employee of the Queensboro Corporation who delivered the first radio commercial

HARRY B. THAYER (1858-1936), the president of AT&T at the time of the first radio commercial

WILLIAM H. RANKIN (1878-1957), the head of the advertising agency that first used commercials on radio

MARION DAVIES (1897-1961), the actress who did the first celebrity commercial on radio

OWEN D. YOUNG (1874-1962), the General Electric executive who negotiated the sale of American Marconi and the creation of the Radio Corporation of America

DAVID SARNOFF (1891-1971), the president of Radio Corporation of America and founder of the National Broadcasting Company

HERBERT HOOVER (1874-1964), the secretary of commerce when the Commerce Department was the regulator of radio

FRANKLIN D. ROOSEVELT (1882-1945), the assistant secretary of the Navy during World War I, instrumental in achieving the pooling of radio patents

Summary of Event

Radio station WEAF in New York City, owned by the American Telephone and Telegraph Company (AT&T), broadcast what is usually considered to be the first paid radio commercial at 5 P.M. on August 28, 1922. The commercial consisted of a ten-minute lecture that was an extended description and philosophical discussion of life in the country and a new apartment complex in New York's Jackson Heights, away from the hustle and bustle of city life. The Queensboro Corporation had named the tenant-owned dwellings Hawthorne Court after Nathaniel Hawthorne, the famous American author and nature lover.

A Queensboro Corporation employee identified only as Mr. Blackwell delivered this first commercial. The speaker was introduced by WEAF announcer Vischer A. Randall. The charge for the air time for the electronic media's first commercial was $50. Within two months, WEAF had sold three hours of time and billed a total of $550.

After a year of offering the service, WEAF had about thirty advertisers. The first leasers of radio time used the medium to present talks related to their product or service. The idea of sponsors providing entertainment came later.

Several radio pioneers had foreseen radio receivers as entertainment centers in the home. The most successful of these was David Sarnoff, who had achieved some fame as the wireless operator instrumental in saving lives and relaying information about the sinking of the Titanic. In 1916, Sarnoff sent a memo to his superiors at the American Marconi Company suggesting the potential of a "radio music box" in each home. Little heed was paid to his insight. Soon after Westinghouse started broadcasting from its KDKA station in Pittsburgh, Pennsylvania, in November of 1920, however, Sarnoff became the general manager of Radio Corporation of America (RCA).

KDKA was the first "commercially licensed" radio station on the air. It sold no commercials. The station did, however, give announcements acknowledging those who had supplied records and services for the station. The initial function of KDKA was to create programming that people would want to listen to, thus encouraging them to buy radio receivers.

Prior to World War I, it was almost impossible to manufacture a radio set for sale in the United States without infringing on a patent because so many different entities owned key patents. When the United States got into the war, Assistant Secretary of the Navy Franklin D. Roosevelt was able to get American patents pooled "for the duration." Radio telegraphy had become a basic naval communications medium, and the nation needed to produce radio equipment for the war effort.

American Marconi, a British-owned corporation, had gained a near monopoly on wireless communication in the United States prior to World War I. After the war, the U.S. government was unwilling to have one of America's military communication systems owned by foreign interests, even friendly ones. In 1919, with tacit congressional approval, Owen D. Young of General Electric (GE) negotiated the purchase of American Marconi's radio holdings.

A new corporation was formed to take over the Marconi facilities and patents. AT&T, General Electric, Westinghouse, and the United Fruit Company became major stockholders in this new corporation, Radio Corporation of America (RCA). United Fruit held patents and had a radio manufacturing division at the time. The major RCA stockholders had accumulated rights to most of the important United States radio patents. The new corporation was in a position to make a patent pool agreement under which the various radio manufacturing and sales functions in the United States were split among the major RCA stockholders. GE and Westinghouse were to manufacture radio sets and RCA was to do the marketing. AT&T's Western Electric division was given the franchise to produce radio transmitters. The agreement gave AT&T rights to all radio telephony functions, whether via wire or wireless.

AT&T envisioned radio as another form of common carrier. Under AT&T's concept of "toll" broadcasting, the customer would lease a broadcast facility and supply a message, as with a telephone or with the postal service. The first of the toll stations

was WEAF. AT&T president Harry B. Thayer and others foresaw a nationwide network of something akin to "radio telephone booths."

AT&T saw toll broadcasting as an extension of the function of its long lines division. "Long lines" sales efforts proved to be unsuccessful, so broadcasting was moved to the miscellaneous division of the company.

Impact of Event

After the first broadcast commercial, the Queensboro Corporation bought five additional spots on successive days. Four were in the 5 P.M. slot at $50 each, and one was later in the evening, at a cost of $100. According to the manager of Queensboro Corporation, Edgar Felix, sales of more than $125,000 resulted from the first commercials on WEAF.

Other advertisers were slow in appearing. Tidewater Oil Company and American Express were the first after Queensboro. William H. Rankin of the Rankin Advertising Agency decided that he would try the new medium before recommending it to any of his clients. He gave a short speech on advertising and received more than twenty letters in response. The speech attracted a new client, Mineralava beauty products. Rankin engaged the famous actress Marion Davies to appear for Mineralava on WEAF. Davies described her film makeup and offered autographed photographs. The response was phenomenal. Hundreds of people wrote to request photographs. Rankin subsequently signed up the Goodrich Tire Company. WEAF insisted on paying Rankin a 15 percent commission, as was the custom with print media, thus encouraging advertising agency participation in promoting WEAF "programming."

As more advertisers appeared, WEAF imposed rules to try to prevent criticism of the station. Advertisers were limited to the mention of their brand name, with no sales pitch or mention of price. Secretary of Commerce Herbert Hoover repeatedly and emphatically expressed his belief that a medium as powerful and important as radio should not be denigrated by the crass insertion of advertising.

Under AT&T's interpretation of the patent pool agreements, only AT&T stations were permitted to air commercials, so only the AT&T station had a direct income. Other stations provided programming to create a demand for radio sets. Organizations from department stores to churches saw ownership of a radio station as a way of informing the public about their particular offerings.

Many people assumed that those who wanted to promote a product or service on radio would own their own stations. AT&T received orders for more than one hundred radio transmitters to be used in the New York area alone. The company told potential buyers that it might take years for delivery. In the meantime, AT&T recommended that those who wished to be on the air buy time from WEAF.

Most early advertising was institutional. Advertisers were satisfied with an orchestra, singing group, or program that bore their name. One of the earliest sponsors was a clothier, Browning King. Programs featuring the Browning King orchestra did not even acknowledge what the company was selling. This program became the model for the "indirect advertising" advocated by WEAF.

AT&T claimed that its approach of toll broadcasting should be adopted as the basic radio system because it best served the country. Other stations, AT&T contended, were run by special interests. AT&T bragged that it provided the "radio of the people," since only on WEAF did the public supply the programming. AT&T maintained that it should have clear channels and higher power than other stations. WEAF did, in fact, acquire a relatively clear channel and transmitted with two thousand watts, more power than most other stations were authorized to use. WCAP, the AT&T station in Washington, D.C., also was allocated high power.

Before long, AT&T had a six-station network in place, using its telephone lines for interconnection. AT&T denied other members of the patent agreement group use of telephone system lines to create networks. In October, 1924, it set up a temporary network of twenty-two stations for a presidential address by Calvin Coolidge.

Initially performers were eager to obtain the exposure provided by radio and offered to appear for free. The AT&T network began paying performers, who began balking when asked to perform without charge. In addition, the American Society of Composers, Authors, and Publishers (ASCAP) began demanding that stations pay royalties for use of copyrighted musical material.

As expenses of radio station operation increased and more people owned radios, thus offering a larger advertising market, the RCA, Westinghouse, and GE stations wanted to sell advertising as a means of financing operations. AT&T insisted that this was prohibited by the marketing agreement. In 1924, the Federal Trade Commission began investigating the possibility of a conspiracy by the RCA pool members to monopolize the radio industry. Members of the pool rapidly loosened their publicly visible close ties but continued to negotiate among themselves in private. Eventually AT&T agreed to sell WEAF for one million dollars to RCA and to transfer the authorized air time of WCAP in Washington, D.C., to RCA's WRC in the same city. The original agreement was dissolved. Stations could now carry paid advertising without the restrictions of the patent pool agreement. AT&T became the common carrier of network programs across the country. AT&T's revenue from these sources exceeded one million dollars the first year and continued to increase as the number of stations and amount of network programming continued to increase. Advertising had become established as the primary way in which broadcasting in the United States was funded.

Bibliography

Archer, Gleason L. *Big Business and Radio*. New York: The American Historical Company, 1939. A look at the business of broadcasting as technology advanced. Written largely from the viewpoints of RCA and David Sarnoff.

——————. *History of Radio to 1926*. New York: The American Historical Society, 1938. Gives details of the early history of radio in the United States. The complete script of the first commercial broadcast is in an appendix.

Barnouw, Erik. *The Golden Web: 1933-1955*. Vol. 2 in *A History of Broadcasting in the United States*. New York: Oxford University Press, 1966-1970. The story of an

era when radio touched almost every American's life. It looks at the struggles for power and documents the development of programming.

_____ . *The Sponsor: Notes on a Modern Potentate*. New York: Oxford University Press, 1978. This book covers the rise of the sponsor, examines sponsors' impact on network programming, and attempts to assess what sponsorship has meant for society, mores, and institutions.

_____ . *A Tower in Babel: To 1933*. Vol. 1 in *A History of Broadcasting in the United States*. New York: Oxford University Press, 1966-1970. Describes the development of the basic institutions and conflicts of American broadcasting. Deals with the business, governmental, sociological, and artistic problems of early broadcasting.

Hagerman, William L. *Broadcast Advertising Copywriting*. Stoneham, Mass.: Focal Press, 1989. Not so much a history as a "how-to" book for the industry, showing how radio and television advertising has developed and is currently implemented, with emphasis on the local level.

Head, Sydney W., and Christopher H. Sterling. *Broadcasting in America: A Survey of Electronic Media*. 6th ed. Boston: Houghton Mifflin, 1990. The leading text for more than thirty years. Covers the development of American broadcasting thoroughly and with tremendous insight.

Keith, Michael C., and Joseph M. Krause. *The Radio Station*. Boston: Focal Press, 1986. An exploration of the medium of radio in its present state. Written by radio professionals.

Lichty, Lawrence W., and Malachi C. Topping, comps. *American Broadcasting: A Source Book on the History of Radio and Television*. New York: Hastings House, 1975. An anthology of selections relating to the history of radio and television, including some materials not often covered elsewhere. Includes about fifty tables showing economic factors relating to broadcasting.

Paley, William S. *As It Happened: A Memoir*. Garden City, N.Y.: Doubleday & Company, 1979. An autobiography by one of the most important people in radio and television history. Discusses that history through the perspective of the head of the Columbia Broadcasting System.

William L. Hagerman

Cross-References

ASCAP Forms to Protect Writers and Publishers of Music (1914), p. 252; Station KDKA Introduces Commercial Radio Broadcasting (1920), p. 363; The A. C. Nielsen Company Pioneers in Marketing and Media Research (1923), p. 401; The National Broadcasting Company Is Founded (1926), p. 522; Antitrust Prosecution Forces RCA to Restructure (1932), p. 640; Congress Establishes the Federal Communications Commission (1934), p. 685; NBC Is Ordered to Divest Itself of a Radio Network (1941), p. 827.

THE A. C. NIELSEN COMPANY PIONEERS IN MARKETING AND MEDIA RESEARCH

Category of event: Marketing
Time: 1923
Locale: The United States

Pioneering in market research, the A. C. Nielsen Company became a leader in the field, having significant technical and financial effects on commerce, advertising, and media research worldwide

Principal personages:
A. C. NIELSEN, SR. (1897-1980), the company founder
A. C. NIELSEN, JR. (1919-), the successor to A. C. Nielsen, Sr., and company president, 1957-1959
JOHN C. HOLT (1940-), the chairman and chief executive officer of the company beginning in 1987
SERGE ORKUN, the president of the company in 1993
JOHN DIMLING (1938-), the president and chief executive officer of Nielsen Media Research in 1993
ANNE ELLIOT (1953-), the director of communications for Nielsen Media Research in 1993

Summary of Event

The A. C. Nielsen Company was founded by A. C. Nielsen, Sr., in 1923 as a firm of engineering consultants who measured product movement and market size for industrial machinery and equipment. By 1933, this service had been abandoned and replaced by a marketing information service known as the Nielsen Drug Index. This service used a standing panel of drug stores to measure sales of products distributed through retail drug stores and attempted to identify factors that influenced sales. Seven months later, Nielsen established a similar service for the food industry known as the Retail Index Services. With the establishment of these services, Nielsen grew to be the leading market research company in the world. In 1984, the company merged with the Dun and Bradstreet Corporation. As of 1993, the A. C. Nielsen Company was divided into two separate business units: Nielsen Marketing Research and Nielsen Media Research.

By the early 1960's, many United States companies had begun to expand their operations abroad. In 1959, A. C. Nielsen, Jr., then president of the company, explained the research approach to marketing and set down a number of guidelines to successful marketing, particularly overseas. He stressed adapting the product to the market, gauging the impact of customs and traditions of prospective consumers, studying differences in advertising, identifying the product with the local scene, knowing the trade channels, and understanding the consumers' views of price and quality.

The Nielsen name is best known to the general public for the television rating system established by Nielsen Media Research. Radio audience research began in 1936 as a service to advertisers, advertising agencies, and radio station business managers who looked to the medium as a means of selling products. The idea was to identify links between what people listened to and what products they were buying or were likely to buy. The company used a device known as the Audimeter, which was attached to a radio and connected to a moving roll of paper. The machine created a permanent record of the stations tuned in by a sample population of about one thousand consumers. This replaced the slower and less accurate method of telephone surveys of what people were listening to at a given time.

During the 1950's, Nielsen began measuring and indexing the audiences of network and local television stations and assigning ratings points according to how many people in a sample audience were watching a given program at a given time. To select a sample of four thousand households with television sets, Nielsen used the U.S. Census Bureau's decennial census counts of all housing units in the country and randomly selected about five thousand blocks in urban areas and correspondingly small geographical units in rural areas, then selected one household from each. Field researchers then collected data on the demographics of households and individual information on persons in each home. At first, Nielsen relied on telephone surveys and diary reports as audience indicators, but later the company developed mechanized means of data collection and reporting. Even this relatively small sample of households was statistically reliable. Each Nielsen household represented thousands of American homes. Nielsen used the sample results to project ratings for the entire American television audience. If fifteen percent of the sample watched a particular show, Nielsen would award it fifteen ratings points.

By 1964, Nielsen had discontinued its radio audience measurement to concentrate entirely on television viewership. By the late 1980's, the techniques of measuring the audience, collecting and computing data, and reporting to marketers, advertisers, and programmers who used the information had been streamlined and computerized. Television ratings could be reported overnight.

Nielsen used the People Meter, a device developed by AGB Research in the United Kingdom. People in the sample households recorded which channel they were watching by pushing buttons on the machine. The meter recorded which channel was being watched, by whom, and for how long. The machine removed some of the unreliability of diary reports. By 1987, Nielsen was relying solely on the People Meter to produce national television program ratings. Supplementary information on individual viewership was provided by weekly diaries kept by individual household members.

Data collection, computation and reporting, and technological engineering took place in an operations facility in Dunedin, Florida. As of 1993, Nielsen provided five basic services to its customers: the Nielsen Television Index (NTI), tracking national network television audiences since 1950; the Nielsen Station Index (NSI), tracking local television audiences since 1954; the Nielsen Syndication Service (NSS), track-

ing audiences for syndicated programming since 1985; the Nielsen Home Video Index (NHI), tracking audiences for cable, videocassette recorders (VCRs), and other new television technologies using People Meters, set-tuning meters, and paper diaries since 1980; and Nielsen New Media Services, providing custom research and start-up service for measurement of nontraditional markets, such as Hispanic viewers, since 1992. In 1992, the company reached an agreement with Telemundo and Univision in order to launch a national Hispanic measuring service.

Impact of Event

Nielsen Marketing Research introduced and formalized the concept of products holding percentage shares of their market. This concept can be said to have brought the overlapping disciplines of advertising and marketing closer together. Nielsen tracked what stores were selling, and advertisers tracked what people were buying and how they made their purchase decisions. Nielsen's quantitative statistics on product movement, its categorization of products moved, and its demographic statistics on buyers provided valuable information to producers, marketers, and advertisers. In 1959, Nielsen Marketing Research was operating in eleven countries. By 1991, that figure had grown to twenty-seven, and the company reported worldwide revenues of $1.2 billion.

By the early 1990's, Nielsen Marketing Research had expanded its research on product sales and the demographics of consumers to Europe, Latin America, and the Pacific Rim. It counted among its customers not only advertising agencies but also local companies or foreign branches of United States companies producing and selling food, pharmaceuticals, cosmetics, and durable goods. Targeting the emerging free economies of Eastern Europe, Nielsen established offices in Hungary in 1991, with plans to expand to Poland and Czechoslovakia. For companies engaged in multinational trade and marketing, Nielsen provided an international database service, instructional software on market research methods, and statistics on product movement. Such well-known corporations as Cheeseborough-Ponds, Procter & Gamble, and Pillsbury relied heavily on Nielsen's services and technology for the success of their operations. Giant advertising agencies including Saatchi & Saatchi and J. Walter Thompson also used Nielsen data.

During the mid-1980's, Nielsen Media Research's rating system came under criticism by television programmers, writers, and producers as well as segments of the television audience. Audience choices for viewing and the percentage of the population owning television sets had multiplied since the 1950's, when Nielsen began its television audience measurement. Advertisers relied on Nielsen's statistics for their choices of which programs to sponsor, and programmers relied on the advertisers to finance the programs they decided to air. Critics of the rating system charged that reliance on ratings as the basis for programming choices had a negative impact on the quality of commercial television programs. New programs did not get a chance to prove themselves, and homogeneity became the rule. Nielsen answered these charges by pointing out that rating points are based on statistical estimates of how many

people watch a show, not an opinion poll of what they think of it or an artistic criticism of its value. Nielsen emphasized that the quality of programming depended on how programmers and advertisers interpreted the statistics.

As network television viewership continued to decrease, network executives were ready to admit that the increase in program choices made available by cable television and VCRs was part of the cause for their declining ratings. Questions arose, however, regarding whether the Nielsen rating system was giving an accurate picture of network viewership. Ratings had become the currency of negotiation between advertiser and the networks. Air time had become extremely expensive, and the cost of it was determined by the number of Nielsen rating points expected for the program during which an advertisement was aired. Networks sometimes were forced to give refunds because ratings were lower than anticipated. In the late 1980's and early 1990's, the television networks joined forces to commission a committee on nationwide television audience measurement (CONTAM). CONTAM was asked to investigate and report on the practicality and reliability of the People Meter, the way the viewing panel was recruited, and the accuracy of data on audience size at a given time.

The People Meter had been indicating lower numbers of viewers for the networks and higher numbers for their competitors. CONTAM concluded from observations and field interviews that pressing the buttons of the People Meter became tedious and that members of the viewer panels did not always use the device. Therefore, there was no way of telling with certainty whether they were watching television at all, let alone watching a particular program at a certain time. Furthermore, telephone surveys of what people were watching at a certain time indicated that in many cases there were more people watching network television than had been indicated by the People Meter results because household members did not record themselves as watching or because household visitors were in front of the set.

In regard to how the viewer panel was selected, the committee discovered that Nielsen divided candidates for the panels into "basics" and "alternates." Basics, chosen because of the number of children in the household and the presence of cable television services, were the first people invited. If these people refused, alternates were chosen. CONTAM discovered a high rate of refusal by basics and a subsequent high recruitment of alternates. This implied that the people viewing were more committed to television watching but were not necessarily the cross section of the population that Nielsen promised.

As for the accuracy and reliability of the numbers, the committee pointed out that increasing numbers of channels available meant fewer people watching each channel. Smaller shares implied greater margins of error in estimating ratings. The laws of statistics show that smaller proportions are more difficult to measure with precision. Because the number of households watching a particular channel was smaller, each household's decision carried greater importance, and ratings were more subject to fluctuation.

Nielsen became synonymous with United States television audience measurement and expanded television audience research worldwide. By 1990, Nielsen's metered

research covered twenty-eight particular U.S. markets that included half of the country's population. CONTAM reports notwithstanding, Nielsen ratings continued to be the currency of negotiation between buyers and sellers of air time, sales of which came to $30 billion in 1990. Programming decision makers in the television industry continued to rely on Nielsen Media Research statistics to determine which programs to air.

Bibliography

Clark, Eric. *The Want Makers*. New York: Viking, 1989. This book traces the advertising process from research and creation to the worldwide impact of electronic methods of marketing research and the advertising that results from it.

Nielsen, Arthur C., Jr. "Do's and Don'ts in Selling Abroad." In *International Handbook of Advertising,* edited by S. Watson Dunn. New York: McGraw-Hill, 1963. One in a compilation of articles written by experts in the fields of international marketing and advertising. Discusses how to advertise in specific foreign markets and how international advertising is organized.

Nielsen Media Research. *The Quality Behind the Numbers*. New York: Communications Department, Nielsen Media Research, 1992. Outlines the history of the A. C. Nielsen Company in general and its media research in particular, including detailed information on Nielsen's marketing philosophy, methods, services, and technology.

Norback, Craig T., and Peter G. Norback, eds. "Audience Research: A. C. Nielsen Company." In *TV Guide Almanac*. New York: Ballantine Books, 1980. This is an overview of all factors of television programming and production, detailing the history, purpose, and methods of audience research used by Nielsen and other research companies as of the 1970's.

Schwerin, Horace S., and Henry H. Newell. *Persuasion in Marketing*. New York: John Wiley and Sons, 1981. Gives extensive coverage of consumer research and how its results can help in formulating advertising campaigns. A. C. Nielsen's research techniques are mentioned throughout.

Christina Ashton

Cross-References

Station KDKA Introduces Commercial Radio Broadcasting (1920), p. 363; WEAF Airs the First Paid Radio Commercial (1922), p. 396; The BBC Begins Television Broadcasting (1936), p. 758; The 1939 World's Fair Introduces Regular U.S. Television Service (1939), p. 803; Fred Silverman Rescues ABC Television's Ratings (1975-1978), p. 1578.

GERMANS BARTER FOR GOODS IN RESPONSE TO HYPERINFLATION

Category of event: Government and business
Time: 1923
Locale: Germany

Inflation made the German mark virtually worthless, and Germans resorted to barter as a replacement for currency transactions

Principal personages:
CHARLES DAWES (1865-1951), the vice president of the United States and chairman of the International Committee to Stabilize German Finances
HANS LUTHER (1879-1962), the German finance minister, 1923-1925
GUSTAV STRESEMANN (1878-1929), the chancellor of the Weimar Republic in 1923, then its foreign minister
BENJAMIN STRONG (1872-1928), the governor of the Federal Reserve Bank of New York, 1914-1928

Summary of Event

In 1923, inflation of the German mark, begun during World War I, reached such proportions that Germans resorted to barter for many of their economic transactions. Stores closed every day at noon so that clerks could change prices on products. Prices would often rise during the morning hours to double the price at opening time. Germans who were paid wages or salaries rushed to buy something with the money, because within hours it would have lost half its value. Farmers refused to sell their produce, for the money received had no value except to pay taxes and pay off any mortgages they had. Businesspeople rushed to take out loans at banks and then hastened to spend the money, buying virtually anything because by the next day it could be sold for far more than the loan. People with mortgages on their property paid them off in money scarcely worth the paper on which it was printed. Debtors reaped a bonanza, and creditors were impoverished.

The roots of the German hyperinflation go back to World War I. Like all major nations in 1914, Germany was on the gold standard. Any citizen could turn in bank notes and receive gold coins of equivalent value. The first measure to pass the German Reichstag in August of 1914 relieved the Reichsbank, the German central bank, of this requirement. It was the passage of this act that represented Germany's commitment to go to war to aid its Austrian ally. Relieved of the need to redeem bank notes in gold, the Reichsbank financed the war on credit. Semiannual war-bond drives were held (the bonds were perpetual, meaning that the principal would never be repaid, and carried a low rate of interest), and special loan banks were created to handle the sale of war bonds.

Many of the war bonds were discounted (used as collateral for loans) at the banks,

which in turn rediscounted them at the Central bank. These bonds provided the "reserves" behind the increasing amount of bank notes issued by the central bank. By the end of World War I, the amount of money in circulation was about five times what it had been in 1914. In neutral markets, where gold redemption still prevailed, the mark was worth no more than half what it had been before the war. The domestic price index rose 100 percent in four years.

Once stable government was restored following the German Revolution of 1918-1919, the new republic that emerged found itself faced with a formidable financial problem. It had lost 10 percent of its territory and more than 10 percent of its tax base, as many of the lands it was forced to cede to its neighbors were among the most productive economically. It owed 98 billion marks, in the form of war bonds, to its citizens. In the first years of the republic, paying the interest on this obligation absorbed most of the central government's revenue. In addition, it owed immense sums in gold to the victorious Allies in the form of reparations. Where reparations were demanded in the form of goods and equipment, it had to compensate the private owners of those goods. Between 1919 and 1923, governmental revenues never exceeded 35 percent of outlays, and a formidable debt accumulated.

One major source of financial problems were the reparations demanded by the Allies, on the grounds that Germany had caused the war. The German government had to make the payments, but it could get the money to do so only by taxing its citizens or by borrowing. Since a large portion of the economic base of Germany was lost either through territorial losses or reparations in kind, the resources to generate taxes were reduced. The German government was required to make cash reparations payments in gold. Because Germany had negligible gold deposits of its own, this gold could be acquired only by a massive excess of exports over imports. Even then, the government somehow had to acquire the gold earned by private firms and individuals through their exporting activities.

The German government resorted to printing money to pay obligations that could be met with marks. The result was inflation of prices and a tremendous increase in borrowing. Private individuals borrowed money to buy things they wanted or needed, knowing that when they had to pay the money back it would be worth far less. Governments at the federal, state, and local levels borrowed money both to finance ongoing operations and to pay off old debt. Any old debt that could be paid off made money for the debtor. Debts expressed in marks required only to be paid off in the same number of paper marks, even though they were worth, in terms of purchasing power, only a fraction of the original indebtedness. Lenders had failed to provide for inflation in setting the terms of their loans. As all these new debt instruments were presented at banks for discount, the banks needed currency to pay them off. They turned to the Reichsbank, which began printing more and more bank notes. In the early fall of 1923, the need for new bank notes became so great that although thirty paper mills and 150 printing plants were devoted exclusively to printing money, they could not keep up with the demand. As the German mark steadily became less meaningful as a way of expressing value, everyone began valuing everything in

dollars, based on the exchange rate of the moment.

In January, 1923, the French and Belgians, alleging minor defaults in reparations payments, marched into the Ruhr Valley, Germany's industrial heartland. The object was to seize the industrial plants of the Ruhr and force these to produce directly for the Allies. The German response was "passive resistance," as both labor and management refused to operate the plants. Eventually, the French and Belgians brought in operators of their own, but in the meantime the German government assumed responsibility for paying support to all those engaged in passive resistance. Money was being paid out by the government, even though no salable goods were being produced. Passive resistance and the cost shouldered by the government in connection with it caused inflation to spin out of control.

By September, it was clear that something would have to be done. The existing government resigned and was replaced by one headed by Gustav Stresemann. Passive resistance was ended. At the suggestion of Hans Luther, the minister of food and agriculture, the government decided to issue a new currency, to be called the Rentenmark, which would be backed by the agricultural and industrial real estate of Germany. The decree authorizing the Rentenmark was issued on October 15, 1923. One month later, paper marks were declared worthless and exchanged at the rate of one trillion Reichsmarks for one Rentenmark, declared to be the equivalent of one gold mark.

A new bank called the Rentenbank was created and authorized to issue up to 3.2 billion Rentenmark notes. Of this sum, 1.2 billion were to be made available to the government for the payment of salaries and other obligations. The remainder was available for loans to business, in an effort to get the economy started again. Over the succeeding six months, Rentenmarks gradually replaced the old paper currency in circulation. As the government reformed taxes, it began to receive revenue in the new, stable currency to carry on its affairs. The entire system was made possible by a moratorium on reparations payments while the issue was studied by an international committee headed by Charles Dawes, the vice president of the United States. Eventually, in what is known as the Dawes Plan, a scaled-down version of reparations was put in place, and the economic situation in Germany returned to relative normalcy.

Impact of Event

Assessing the impact of the German hyperinflation involves determining who were the winners and who were the losers. Generally, debtors were the winners. These included both public debtors and private debtors. Public debtors included both the central government, the Reich, and state and local governments. Old obligations could be paid off with paper marks worth a fraction of the old marks that were convertible to gold. As a result, the central government, which owed its citizens 98 billion marks in war debt in 1918, reduced its debt to almost nothing. Many states and municipalities also paid off old debts.

Many private debts were also paid off at a fraction of their former worth. Many mortgages contracted in an earlier era were paid off. When debts were bills for

purchased goods, late in the inflation the courts began to hold that the constitutional requirement of equity meant that a sum more nearly equal to the current value of the goods in question had to be paid. Large businesses in particular profited from the inflation. Banks had been accustomed to financing much business activity, and the time spread between the date of a loan to buy raw materials or machinery and the time when those raw materials were converted into salable items enormously magnified their value in paper marks. In effect, the interest rate on revalued debts was adjusted to compensate lenders for inflation.

Even the banks made money, thanks to the inveterate Reichsbank policy of keeping interest rates low. Commercial banks could make loans to businesses at relatively high interest rates, then discount the bills at the Reichsbank at a much lower rate. The spread represented a substantial profit.

Losers from the inflation included savers and creditors. Those who had invested their money in mortgages found the mortgages paid off in worthless paper marks. Somewhere between one-fourth and half of the German electorate had savings that disappeared in the inflation, and the Germans have never forgotten this. Almost 10 percent of the German population had lived off income from savings and investments prior to World War I. These people were reduced to abject poverty.

After the stabilization plan was put in place, a bitter battle ensued concerning the revaluation of old debts. Initially, many government officials favored a ban on revaluation, but as the outcry of the dispossessed increased, politicians changed their position. Moreover, Stresemann, who became chancellor in August of 1923, opposed a ban. Furthermore, courts were increasingly responding to pleas from creditors that the repayment of debts in worthless paper marks did not accord with equity. Several court decisions in late 1922 and early 1923 required the renegotiation of contracts as a result of the inflation. By November, 1923, the courts were stating unequivocally that creditors were entitled to relief.

The difficulty with revaluation was that the stabilization of the currency would be vitiated if revaluation amounted to any significant percentage of debts. New money would have to be printed to pay the higher debts, and inflation would return. The original proposal called for 10 percent revaluation, but this meager amount resulted in protests forcing upward revision of the percentage. In February of 1924, the government issued the Tax Decree, in which guidelines for revaluation were laid down. The level of revaluation was raised from 10 percent to 15 percent and would include municipal bonds that had been issued for income-producing activities such as gas works. Under pressure from the Social Democratic Party, the government agreed that savings deposits in banks and life insurance policies would also be revalued. This proposal won the support of the banking, industrial, and commercial interests of Germany.

Nevertheless, there was sufficient opposition to these terms in the Reichstag that the government decided to call for a new election, to take place in May of 1924. New claims for revaluation began to be heard from savings banks, the portfolios of which were full of government bonds. They began to demand revaluation of government

bonds, since they were going to have to revalue the savings accounts of their depositors. Churches, especially the Catholic church, called for substantial revaluation. Many of their charitable activities were financed by endowments, especially mortgages. Moreover, some courts were responding to individual pleas for revaluation and setting their own rates. It was clear that a new mandate from the populace, to be followed by legislation by the new Reichstag, was the only answer.

Unfortunately, the election of May, 1924, yielded no solid majority for any political party or grouping of parties. A weak minority government was formed. It decided to appoint a Committee on Revaluation to draft legislation on the subject. It was now recognized that government bonds would have to be revalued; however, as Finance Minister Hans Luther pointed out, any significant revaluation would reduce the interest rate to a negligible amount. It was now also agreed that mortgages would have to be revalued, with a revaluation rate of 25 percent finding general favor. At the same time that creditors were pressing for upward revision of the revaluation percentages, the United States government was working in the opposite direction. Benjamin Strong, the governor of the New York Federal Reserve Bank, stated explicitly that any major upward revision of revaluation would cause American loans to German firms to dry up, as Americans would believe that the added debt burden would prevent German firms from earning enough to repay their foreign loans.

The final compromise on revaluation was reached in a law passed on July 15, 1925. The legislation specified different percentages of revaluation for various kinds of financial assets. Mortgages were to be revalued at 25 percent and industrial obligation bonds at 15 percent (with an additional 10 percent in special cases). Government bonds were revalued at 12.5 percent provided that the holder had purchased the bond before July 1, 1920; bonds purchased after that date were revalued at 2.5 percent. All government bonds were required to be surrendered for new redemption bonds. Repayment of these would not take place until at least 1932. One-thirtieth of the bonds would be repaid each year, with a lottery determining which bonds those would be.

Commercial bank accounts were not revalued. Savings bank accounts were subjected to revaluation according to a complex formula that pooled claims and then divided the repayments according to the size of the claim. The interest rate for private debt was set at 1.2 percent in 1925, with incremental additions until it reached 5 percent in 1928. Employee savings accounts with employers were revalued at varying amounts resulting from individual negotiation.

Although most creditors received something from the revaluation, many remained deeply embittered. Moreover, the burden of repayment falling on the government, the restrictions imposed by the Allies on the operations of the Reichsbank and the fear of a repetition of the inflationary debacle forced all levels of government to balance their budgets. When the Great Depression hit Germany in 1930, with greater impact in 1931 and 1932, the central government found it impossible to respond with fiscal stimulus. To this day, German governments are hampered in their fiscal and monetary policies because of the deep-rooted fear of a repetition of the Germany hyperinflation of the 1920's.

Bibliography

Guttmann, William, and Patricia Meehan. *The Great Inflation: Germany 1919-1923.* Farnborough, England: Saxon House, 1975. A popular account, written in nontechnical language.

Holtfrerich, Carl-Ludwig. *The German Inflation, 1914-1923.* Translated by Theo Balderston. Berlin: De Gruyter, 1986. An economist's account, with many statistics.

Hughes, Michael L. *Paying for the German Inflation.* Chapel Hill: University of North Carolina Press, 1988. Hughes's book focuses on the struggle over revaluation. Contains many details that illuminate who were the winners and the losers from the inflation.

Ringer, Fritz, ed. *The German Inflation of 1923.* New York: Oxford University Press, 1969. A collection of materials from other sources brought together for student use. It provides a handy source for looking at a variety of interpretations of the inflation. The book concludes with a section on the contribution of the inflation to Adolf Hitler's rise to popularity.

Stolper, Gustav. *German Economy, 1870-1940.* New York: Reynal & Hitchcock, 1940. An old work, but still valuable for its wealth of details and its broad perspective.

Nancy M. Gordon

Cross-References

The Hindenburg Program Militarizes the German Economy (1916), p. 293; The U.S. Stock Market Crashes on Black Tuesday (1929), p. 574; The Credit-Anstalt Bank of Austria Fails (1931), p. 613; The Banking Act of 1933 Reorganizes the American Banking System (1933), p. 656; The Bretton Woods Agreement Encourages Free Trade (1944), p. 851; Nixon's Anti-Inflation Program Shocks Worldwide Markets (1971-1974), p. 1489; Bush Responds to the Savings and Loan Crisis (1989), p. 1991.

HENRY LUCE FOUNDS *TIME* MAGAZINE

Category of event: Foundings and dissolutions
Time: 1923
Locale: New York, New York

Henry Luce revolutionized American journalism by introducing, with his partner Briton Hadden, the first news magazine, then went on to build one of the country's most influential publishing empires

> *Principal personages:*
> HENRY R. LUCE (1898-1967), the founder, with his partner Briton Hadden, of *Time* magazine
> BRITON HADDEN (1898-1929), Luce's partner in the launching of *Time*
> JOHN STUART MARTIN (1900-1977), Hadden's cousin, who took over as managing editor of *Time* after Hadden's death
> CLARE BOOTHE LUCE (1903-1987), Luce's second wife
> ROY E. LARSEN (1899-1979), the president of Time Inc., 1939-1960
> J. RICHARD MUNRO (1931-), the chief executive officer of Time Inc., 1980-1990

Summary of Event

Henry R. Luce was born on April 3, 1898, in Tengchow, China, where his father was a Presbyterian missionary. He attended the British-run Chefoo School from 1908 to 1913 before attending the Hotchkiss School in Lakeville, Connecticut. There he became interested in journalism and began his friendship with fellow student and aspiring journalist Briton Hadden. Hadden edited the Hotchkiss school newspaper, the *Weekly Record*, while Luce was the editor of the *Literary Monthly*. The two went on to Yale University in 1916, where they joined the staff of the *Yale Daily News*, Hadden becoming its chairman and Luce its managing editor. Despite service in the Army in 1918-1919, they received their bachelor of arts degrees in 1920. After spending a year studying history at the University of Oxford, Luce became a reporter for the *Chicago Daily News* before rejoining Hadden at the *Baltimore News*.

By the fall of 1922, Luce and Hadden had succeeded in raising almost $86,000 in capital to start *Time: The Weekly News-Magazine*. The first issue appeared in late February, 1923, with a cover date of March 3, 1923. Hadden appears to have been the source of many of the ideas behind the magazine, but Luce supplied the organizational talents required to implement Hadden's ideas. The magazine's purpose, Hadden and Luce's prospectus explained, was to fill the informational gap resulting "because no publication has adapted itself to the time which busy men are able to spend on simply keeping informed." Major emphasis was placed on conciseness; initially no entry was to be more than four hundred words. Perhaps most important, the young publishers did not even pay lip service to reportorial objectivity. "*Time* gives both sides," they declared, "but clearly indicates which side it believes to have the stronger position."

Through a preferred-stock arrangement, Luce and Hadden retained full control of Time Incorporated. Hadden was president from 1923 to 1925, when Luce assumed that title. Hadden largely handled the editorial side for four years while Luce was business manager; they then traded roles.

The basic subscription rate was $5 per year, with a cover price of fifteen cents an issue. *Time* started with nine thousand subscribers recruited on a three-week trial basis by a mail campaign. The first years were financially difficult. By the end of 1927, however, *Time* was on its way to success. Circulation has risen to 175,000, annual advertising revenue was almost half a million dollars, and the magazine showed a profit. After Hadden's death in late February, 1929, from a streptococcus infection, Luce acquired majority control of the undertaking. Roy E. Larsen, a Harvard graduate who joined *Time* during the planning stage and was its first circulation manager, became Luce's second in command as president of Time Inc. from 1939 to 1960.

The cover of the first issue featured a picture of former Speaker of the House of Representatives Joseph G. Cannon, on the occasion of his retirement from Congress. Thereafter, the cover almost invariably featured the portrait of an individual. *Time*'s news coverage similarly focused on personalities. Along with conciseness, *Time* boasted of its comprehensive coverage of "all available information on all subjects of importance and general interest." Entries were arranged by subject matter into departments. Departments in the first issue that became permanent features were "National Affairs" (later shortened to "The Nation"), "Foreign News" (later retitled "The World"), "Books," "Art," "The Theatre" (expanded in 1958 to include television and renamed "Show Business"), "Cinema," "Music," "Education," "Religion," "Medicine," "Finance" (later divided into "U.S. Business" and "World Business"), "Sport," "The Press" (newspapers and magazines), and "Milestones" (a column of brief paragraphs recording births, marriages, divorces, and deaths of well-known personalities). A "Letters" department was added in *Time*'s second year and became one of the magazine's most popular features.

After Hadden's death, his cousin John Stuart Martin became managing editor, acting in that position until 1937. By that date, circulation had passed the 750,000 mark. Martin was largely responsible for *Time*'s distinctive style: an aura of omniscience coupled with what one historian of American magazines has termed "use of word coinages, blends, puns, inverted syntax, esoteric words, tropes and epithets of various kinds." *Time*'s contributions to the American language include popularization of the words "tycoon," "pundit," and "kudos." Another feature of *Time* was its proclivity for the "up-ended sentence," the most famous example of which is its oft-repeated introduction to death notices, "As it must to all men, death came last week to. . . ."

Occasional full-color covers began as early as 1929, but use of color in the body of the magazine did not come until 1945. At first, *Time* relied for copy largely upon rewriting newspaper clippings, particularly from *The New York Times*. Contemporary newspapers adhered to a rigid structure developed by the national wire services, such as the Associated Press, whereby all the important facts were jammed into the first

paragraph, or "lead." *Time* rewrote the stories in dramatic narrative form, with a beginning, middle, and end. Another favorite *Time* technique to make old news appear fresh was to lace the account with colorful but mostly insignificant details such as the appearance, age, or middle name of persons in the news. Only in the late 1930's did *Time* begin to build up its own staff of reporters and stringers. Even then, the final product followed a standardized formula. Reporters' stories were heavily edited, writers had little autonomy, and there were no names, or "by-lines," attached to entries.

Even while *Time* was still in shaky financial condition, Luce was looking to expand. In 1924, he and Hadden became publishers of the new *Saturday Review of Literature*, but they withdrew from involvement two years later. In 1928, Time Inc. launched an advertising trade journal titled *Tide*. *Tide* was sold in 1930. Luce's willingness to take risks was shown by his decision to launch a new monthly business magazine, *Fortune*, in February, 1930, when the economy was reeling from the shock of the stock market crash. Covering far more than business and finance, *Fortune* included first-rate, in-depth analysis of national politics, foreign affairs, and developments in art and culture. Luce also acquired *Architectural Forum* in the early 1930's. Roy E. Larsen was responsible for introducing, in 1931, a weekly radio program called *The March of Time* broadcast over the Columbia Broadcasting System. The program, modeled on *Time* magazine, reenacted the more important news stories of the week. A monthly newsreel version produced by Twentieth Century-Fox was begun in 1935. *The March of Time* continued on the radio until 1945, and the newsreel lasted for another six years before transfer to television. The television show was terminated in 1954.

Next to *Time*, Luce's most important innovation was the introduction of the weekly picture magazine *Life* in November, 1936. *Life* was made possible by technological advances in photography and photoengraving that had been made independently of Luce. Luce's contribution lay in recognizing the mass-audience appeal of photographs. That potential had first been exploited in Germany, and the German photographers Luce brought over to advise him were responsible for what became *Life*'s most distinctive feature—the grouping together of photographs into "photoessays" in which pictures largely substituted for words. *Life* was an immediate sales success. Circulation reached 500,000 within four weeks and 1.7 million by late in 1937. Financially, however, *Life* was a money loser during its first years, almost bankrupting Time Inc. *Life* did not begin to make money until early in 1939, when circulation passed the two million mark.

Impact of Event

Time's most direct antecedent was the *Literary Digest*, the pages of which were largely filled with quotations from newspapers. The *Literary Digest* focused on the conflict of editorial opinion, not on presenting a comprehensive summary of the news. *Time*'s success stimulated a host of imitators. Only two, however, survived to remain long-term competitors. *News-week* (the hyphen was later dropped) was started in February, 1933, by former *Time* staffer Thomas S. Martyn. Its continuing financial

losses led to Martyn's ouster and *Newsweek*'s merger in February, 1937, with *Today*, another would-be *Time* rival edited by former New Deal brain truster Raymond Moley. Generous financial infusions from its chief backer, Vincent Astor, kept *Newsweek* afloat until its purchase in the 1960's by *The Washington Post* placed the magazine upon a more solid competitive footing vis-á-vis *Time*. *Time*'s second major competitor was *United States News* (later *U.S. News & World Report*), begun in early 1933 by conservative syndicated columnist David Lawrence.

Like *Time*, *Life* had its rivals. The most successful was *Look*, launched in early 1937. Luce's innovations had an impact reaching beyond the magazine realm. *Time*'s demonstration of the existence of a large middle-class audience for synthesis led many newspapers to introduce news analysis in their own pages, in the form of weekly reviews and daily commentaries. *Life* gave a major boost to the new way of reporting events known as photojournalism, whereby visual images became the primary carriers of stories.

At first, *Time* was largely apolitical, lacking even an editorial page. Its attitude toward politics and politicians was basically irreverent and skeptical. By the late 1930's, however, Luce was moving to a more highly politicized stance. The potential influence represented by the circulation of his magazines inflated his sense of self-importance, and he had grown increasingly disillusioned with President Franklin D. Roosevelt's New Deal, blaming its hostility toward business for prolonging the Depression. Also pulling him into politics was his second marriage. Luce had married Lila Hotz in 1923; they had two children. He was divorced from her and in 1935 married Clare Boothe Brokaw, a playwright and former editor of *Vanity Fair*. She would become active in Republican Party affairs and was a member of the House of Representatives from Connecticut from 1943 to 1947.

Thinking that the Republican Old Guard was hopelessly out of touch with the electorate, Luce aspired to formulate a moderate Republicanism that could offer a viable alternative to the New Deal. Foreign policy became the major focus of Luce's political activism. By 1939, he had become convinced that Germany's Adolf Hitler represented a threat not only to the United States but also to Western civilization as a whole. He personally favored United States intervention after the outbreak of the war in Europe. He worked through his magazines to alert the country to the dangers that would result from a Hitler triumph, and he played a leading role in the capture of the 1940 Republican presidential nomination by the pro-Allied Wendell Willkie. In an influential article, "The American Century," published in the February 17, 1941, issue of *Life* under his own name, he set forth his vision of the future role of the United States in spreading throughout the world the benefits of democratic capitalism.

Sometime between late 1943 and 1944, Luce became alarmed over the potential threat of the Soviet Union. Much to the unhappiness of many members of his staff, Luce had his magazines take an increasingly anti-Soviet line. By the late 1940's, he was attacking the containment policy of President Harry S Truman as to a defensive. The transformation of Luce into a hard-line Cold Warrior was reinforced by his longtime support for China's Chiang Kai-shek. Like most other members of what

might be termed the missionary lobby, Luce had embraced Chiang as the instrument for the Americanization of China and blamed the Truman Administration's lack of support for Chiang's defeat by the Chinese Communists. In 1952, *Life* openly and *Time* more subtly supported Republican presidential nominee Dwight D. Eisenhower and the Republican platform's call for an aggressive policy to roll back Communism.

Eisenhower named Clare Booth Luce as United States ambassador to Italy, but Henry Luce did not have much influence in the new administration. Although his magazines refrained from open criticism, he was privately disappointed at its failure to carry through on its promise of a more aggressive foreign policy. As an alternative way of combating Communism, Luce took up championship of the glories of the Western European cultural tradition. Starting in the late 1940's, he required that each issue of *Life* carry at least one "serious offering" on the great art, religions, and ideas of Western civilization. Luce strongly backed United States involvement in Vietnam; *Time* even edited its own Vietnam correspondent's dispatches to accord with Luce's interventionist position.

Luce retired as editor-in-chief of Time Inc. in 1964. He died of a heart attack on February 28, 1967. Even before Luce stepped down, cracks had begun to appear in his empire. The consistently money-losing *Architectural Forum* was given as a gift to the American Planning and Civic Association in 1964. Faced with the competition of more narrowly focused business news magazines, Luce in the 1940's directed *Fortune* to limit its coverage exclusively to business matters. Its shift from monthly to biweekly publication in 1982 undercut what had been its forte of in-depth analysis. The rise of television hit all magazines hard. *Life* continued to prosper because of its color pictures and advertising displays as long as television remained black and white. By the 1960's, however, *Life* began to slide in both circulation and advertising. Its end came with the issue of December 29, 1972. *Life* was resurrected in October, 1978, as a monthly publication focusing on feature articles rather than news, but the new *Life* never came near the circulation of its namesake.

During Luce's last years, *Time* came under increasing attack for its politically motivated slanting of the news. Under his successors, the magazine drifted toward a bland middle-of-the-roadism politically. Deeper problems remained: oversimplification of complex issues, masses of trivial and insignificant details, and exaggeration of the role of the individual "newsmaker." Much of *Time*'s remaining reputation was shredded by Israeli general Ariel Sharon's libel suit in 1985. Although *Time* was saved from paying damages by a constitutional technicality, the trial exposed the shoddiness of *Time*'s reportorial and editorial practices. Worse, circulation remained stagnant, at approximately 4.5 million, from the mid-1960's through the 1980's, despite the vast expansion of its target audience of college graduates. In a bid to boost sales, *Time* underwent an extensive format revamping in 1988 (including the addition of bylines) that was accompanied by a shift from "hard" to more "soft" news.

By the 1980's, Time Inc. had become a gigantic conglomerate with a primary business of entertainment rather than journalism. Its magazines had become one of four separately incorporated subsidiaries. The other three were Home Box Office

(HBO), one of the leading cable television programmers; the American Television and Communication Corporation, the second largest cable television system; and Time Books. Within the magazine division, the stars were *Sports Illustrated* and *People*. *Sports Illustrated* had been launched in 1954 to appeal to the growing market of young and affluent sports fans. First appearing in 1974, *People* jumped within two years to a 2.5 million circulation thanks to its photograph-laden focus on celebrities. The shift was symbolized by J. Richard Munro, the chief executive officer of Time Inc. from 1980 to 1990. Munro had come to the top spot after first serving as publisher of *Sports Illustrated* and group vice president for video. Munro was a moving force behind the controversial merger in 1990 with rival entertainment conglomerate Warner Communications to form Time Warner.

Bibliography

Baughman, James L. *Henry R. Luce and the Rise of the American News Media.* Boston: Twayne, 1987. A brief biographical account that does an excellent job of placing Luce and his magazines in the context of larger trends and developments in the mass media.

Busch, Noel F. *Briton Hadden: A Biography of the Co-Founder of Time.* New York: Farrar, Straus, 1949. A workmanlike account of the brief life of Luce's partner in launching *Time*. One of the major sources of information about the magazine's early years.

Clurman, Richard M. *To the End of Time: The Seduction and Conquest of a Media Empire.* New York: Simon & Schuster, 1992. A detailed account of the wheeling and dealing involved in the merger with Warner Communications. Sharply indicts Time Inc.'s top management.

Donovan, Hedley. *Right Places, Right Times: Forty Years in Journalism, Not Counting My Paper Route.* New York: Henry Holt, 1989. An insider's look at the workings of Luce's empire during the post-World War II years by a man who rose to be editorial director of Time Inc. from 1960 to 1964 and succeeded Luce as editor-in-chief from 1964 to 1979.

Elson, Robert, T. *Time Inc: The Intimate History of a Publishing Enterprise.* 3 vols. New York. Atheneum, 1968-1986. The official company history. Uses oral histories and records in the Time Inc. archives not available to outside researchers. The first volume covers 1923 to 1940; the second 1940-1960; the third 1960-1980.

Jessup, John K., ed. *The Ideas of Henry Luce.* New York: Atheneum, 1969. Reprints Luce's more important writings, with an insightful introduction by a former aide.

Mott, Frank Luther. *A History of American Magazines.* 5 vols. Cambridge, Mass.: Harvard University Press, 1938-1968. A massive work by a leading historian of American magazines. The account of *Time* up to the early 1960's in volume 5 is especially valuable on matters of physical format and style.

Swanberg, W. A. *Luce and His Empire.* New York: Charles Scribner's Sons, 1972. The most detailed of the Luce biographies, but suffers from Swanberg's readiness to think the worst about Luce.

Tebbel, John, and Mary Ellen Zuckerman. *The Magazine in America, 1741-1990.* New York: Oxford University Press, 1991. The bulk of the text deals with the post-1918 years and draws on scholarly and popular examinations of the periodical press.

John Braeman

Cross-References
Forbes Magazine Is Founded (1917), p. 314; *Reader's Digest* Is Founded (1922), p. 390; Henry Luce Founds *Fortune* Magazine (1930), p. 585; *The Saturday Evening Post* Publishes Its Final Issue (1969), p. 1379; Murdoch Extends His Media Empire to the United States (1976), p. 1636.

GREAT EVENTS
FROM
HISTORY II

CHRONOLOGICAL LIST OF EVENTS

VOLUME I

VOLUME II

VOLUME III

VOLUME IV